Kon Ichikawa

Cinematheque Ontario Monographs

Shohei Imamura, no. 1
Robert Bresson, no. 2
The Films of Joyce Wieland, no. 3

Funding for this publication was provided by the Toronto International Film Festival Group and The Japan Foundation.

TORONTO INTERNATIONAL
FILM FESTIVAL GROUP

The Japan Foundation

Kon Ichikawa

Edited by James Quandt

A Division of the Toronto International Film Festival Group

Toronto International Film Festival Group
2 Carlton Street, Suite 1600
Toronto, Ontario M5B 1J3
Canada

The Toronto International Film Festival Group is a charitable, cultural, and educational organization dedicated to celebrating excellence in film and the moving image.

Selection, introduction, and bibliography copyright © Cinematheque Ontario 2001
Pages 443–45 constitute an extension of this copyright page.

All rights reserved. Toronto International Film Festival Inc.

National Library of Canada Cataloguing in Publication Data

Main entry under title:

 Kon Ichikawa

(Cinematheque Ontario monographs ; no. 4)
Includes bibliographical references.
ISBN 0-9682969-3-9

1. Ichikawa, Kon, 1915– — Criticism and interpretation.
I. Quandt, James. II. Cinematheque Ontario. III. Series.

PN1998.3.I25K66 2001 791.43'0233'092 C2001-930086-7

Distributed in Canada by Wilfrid Laurier University Press
75 University Avenue West, Waterloo, Ontario N2L 3C5 Canada
Website: http://www.wlupress.wlu.ca
Telephone orders: 519-884-0710, ext. 6124
Fax orders: 519-725-1399
E-mail orders: press@wlu.ca

Distributed outside Canada by Indiana University Press
601 North Morton Street, Bloomington, Indiana 47404-3797 USA
Website: http://iupress.indiana.edu/
Telephone orders: 800-842-6796
Fax orders: 812-855-7931
E-mail orders: iuporder@indiana.edu

Book design by Gordon Robertson
Printed in Canada

Acknowledgements

The Kon Ichikawa retrospective is an undertaking of Cinematheque Ontario to make the Japanese master's central corpus available to a wide audience. It involves two closely related endeavours. In co-operation with The Japan Foundation and various studios, rightsholders, and distributors, Cinematheque Ontario has ensured that new 35mm prints of many of Ichikawa's feature films were struck, and have organized a North American tour to several sites to present the retrospective. Designed to accompany this exhibition, the present volume offers an extensive survey of Ichikawa scholarship, filling a gap in the English language literature on Japanese cinema.

As with two of Cinematheque Ontario's previous tours and publications, involving the films of Kenji Mizoguchi and Shohei Imamura, The Japan Foundation was the central impetus and sponsor of the project from its inception. The enthusiasm and support—financial, functional, and affective—forthcoming from both the head office in Tokyo and the local office in Toronto, were extraordinary throughout every stage of planning and execution. North American cinephiles owe The Japan Foundation immense gratitude for continuing to provide, often in new prints, classics of Japanese cinema that would otherwise be unavailable.

The Ichikawa project has been made possible by the generosity, efforts, and support of many individuals and organizations, particularly Yuki Mori, whose fine, prodigious study of Ichikawa's films will long be the essential work on the director, and who offered meticulous advice and unstinting help on many fronts; Brent Kliewer, with whom I originated the idea of an Ichikawa retrospective several years ago and who took a keen hand in all aspects of the project; and Ted Goossen, an invaluable resource, who provided crucial contacts with various critics, scholars, and translators, and readily undertook the translations of the essays by Ichikawa and his wife Natto Wada despite many other demands on his time and expertise. Both Aaron Gerow and Michael Raine must also be singled out for their remarkable patience and exacting advice; Abé Mark Nornes was equally liberal with

information and suggestions. I also profited from the counsel of Kyoko Hirano, my cherished colleague at Japan Society, New York.

My gratitude to all of the contributors, particularly those who wrote articles especially for the book and to the participants in the symposium on *Tokyo Olympiad*; and to the writers and copyright holders who granted the necessary permissions for the reprints. Gordon Robertson accomplished the elegant book design with discernment and forbearing. Eve Goldin and Tina Meale of The Film Reference Library offered exceptional research assistance, and Robin Macdonald compiled the bibliography with her customary sense of commitment and detail. George Kaltsounakis was intrepid in the often arduous procurement of stills, and Andrei Chiose provided his acumen in both the preparatory and proofreading stages. The translators —Ted Goossen, Cody Poulton, Robert Gray, Michael Raine, Daisuke Miyao, Lara Fitzgerald, Anne McKnight—all accomplished fine work with often complex texts.

In Japan, my gratitude to Hisashi Okajima and Hidenori Okada at the National Film Centre, Tokyo, for arranging several screenings of rare Ichikawa films, and for sharing thoughts and information on the director. Similarly, the staff at Kawakita Memorial Film Institute were immensely helpful in arranging screenings, and for researching and providing many stills; our thanks to Masayo Okada, Yuka Sakano, and Atsuko Fukuda. Donald Richie graciously proffered materials and guidance, and Yasue Nobusawa at Nikkatsu generously helped with stills research. Kon Ichikawa himself was congenial in granting a career interview for the book, allowing the inclusion of his and Natto Wada's essays, and loaning us personal photographs.

In Toronto, Mariko Liliefeldt of The Japan Foundation's library and the staff of the East Asian Library, University of Toronto, offered unflagging and insightful assistance in checking facts. Aska Matsuo and Tomoko Maruya aided in the translation of letters, Eiko Mizuno diligently pursued essential permissions and loans, and Koto Sato extended her expertise during many stages of the book's preparation.

Elsewhere, Sue Jones of BFI Collections, London; Linda Hoaglund, New York; and Masaharu Ina of Toho International, Los Angeles were most helpful.

I am, of course, also indebted to my colleagues at Cinematheque Ontario and the Toronto International Film Festival Group, particularly to Piers Handling and Susan Oxtoby, both of whom have consistently championed scholarly publication as a cardinal function of our organization.

Cinematheque Ontario's monograph series would not be possible without the direction of Catherine Yolles, whose rigour, erudition, and sensibility availed the preparation of this volume at every stage, from initial research to final production. No doubt a book as voluminous and varied as this prevents her quest for purity in every detail—something she shares with Ichikawa's determined protagonists—so it goes without saying that I assume responsibility for its every fault.

– James Quandt, *Senior Programmer, Cinematheque Ontario*

Note to the Reader

Assembling a collection of material such as this, from a wide variety of sources, poses problems of consistency, which are compounded in the case of Kon Ichikawa by several factors: the sheer profusion of his films, whose titles have been translated many different ways; a marked absence of authoritative English literature about Ichikawa on which to rely; and the difficulties that attend translating and transliterating Japanese, which in many instances, especially those of people's names, introduce a considerable degree of uncertainty. We have chosen to standardize as much as possible, employing such film titles as *Kagi* and *Hakai*, for instance, rather than their more familiar, but diverse, English titles (*Odd Obsession* and *The Key* for the former, *The Outcast*, *The Sin*, and *The Broken Commandment* for the latter). However, there remain many variances that were either unavoidable, or concessions to writers' preferences; for example, Catherine Russell's use of *Being Two Isn't Easy* rather than *I Am Two*.

More vexing is the issue of Japanese name order. The tradition of transposing first and last names to conform to Western convention has slowly been giving way, primarily in scholarly studies, to the roman equivalent of Japanese name order (e.g. Ichikawa Kon rather than Kon Ichikawa). Most film journalism and common usage, at least for the moment, retains the conventional Western sequence. After consultation with various authorities, who often noted contradictions that arise in the usage of both forms, and taking into consideration the audience for and purpose of this volume, we have decided to adhere to traditional Western name order.

Name

Kon Ichikawa.

The shapes of the Chinese characters of his name are, first of all, beautiful.

The vertical and horizontal lines stand very neatly. Fewer strokes in "Ichikawa" set off the elaborate shape of "Kon."

In the roman alphabet, "KON." This looks cool, too.

And the sound of the name is also beautiful. If we read "Kon" in *katakana*, it sounds sharp. If we read it in *hiragana*, it seems humorous.

"Cool," "warm," and "humorous." All of the characteristics of Kon Ichikawa's films are already present in his name.

Yuki Mori

Contents

Introduction: Ichikawa the Innovator, or the Complicated Case of Kon Ichikawa JAMES QUANDT	1
Kon Ichikawa YUKIO MISHIMA	13
Blown by the Wind KON ICHIKAWA	15
Beginnings KON ICHIKAWA and YUKI MORI	21
Kon Ichikawa AUDIE BOCK	37
The Several Sides of Kon Ichikawa DONALD RICHIE	53
The Skull Beneath the Skin TOM MILNE	59
Interview with Kon Ichikawa JOAN MELLEN	69
Kon Ichikawa: Black Humour as Therapy MAX TESSIER	79

Nostalgia: An Interview with Kon Ichikawa 89
MAX TESSIER

Kon Ichikawa's Method 95
YASUZO MASUMURA

Kon Ichikawa 105
TADAO SATO

Between Literature and Cinema 135
KON ICHIKAWA

The Modern Outcast State: Ichikawa's *Hakai* 141
KEIKO I. MCDONALD

A Story of Cruel Youth: Kon Ichikawa's *Enjo* and the Art of Adapting in 1950s Japan 155
DENNIS WASHBURN

Contemporary Japan as Punishment Room in Kon Ichikawa's *Shokei no heya* 175
MICHAEL RAINE

The "Sun Tribe" and Their Parents 191
NATTO WADA

Viewer's View of *Kagi* 197
KEIKO I. MCDONALD

Fires on the Plain: The Human Cost of the Pacific War 205
WILLIAM B. HAUSER

The Summer of 1945 217
KON ICHIKAWA

The Ends of Adaptation: Kon Ichikawa and the Politics of Cinematization 221
ERIC CAZDYN

Ototo 237
KON ICHIKAWA and YUKI MORI

A Record of *Ototo* 243
 KON ICHIKAWA

Ten Dark Women 247
 DONALD RICHIE

The Reality of 1961 253
 KON ICHIKAWA

Being Two Isn't Easy: The Uneasiness of the Family in 1960s Tokyo 255
 CATHERINE RUSSELL

The Uniqueness of Kon Ichikawa: A Symposium 267
 KON ICHIKAWA, AKIRA IWASAKI, and KYUSHIRO KUSAKABE

Playing with Form: 273
Ichikawa's *An Actor's Revenge* and the "Creative Print"
 LINDA C. EHRLICH

Inscribing the Subject: 287
The Melodramatization of Gender in *An Actor's Revenge*
 SCOTT NYGREN

CinemaScope and Me 303
 KON ICHIKAWA

Escaping Japan: The Quest in Kon Ichikawa's *Alone on the Pacific* 307
 BRENT KLIEWER

Tokyo Olympiad: A Symposium 315
 ERIC CAZDYN, ABÉ MARK NORNES, JAMES QUANDT,
 CATHERINE RUSSELL, and MITSUHIRO YOSHIMOTO

Ichikawa and the Wanderers 339
 WILLIAM JOHNSON

The Inugami Family 349
 KON ICHIKAWA and YUKI MORI

Adapting the *The Makioka Sisters* 357
 KATHE GEIST

Space and Narrative in *The Makioka Sisters* DAVID DESSER	373
The Industrial Ichikawa: Kon Ichikawa after 1976 AARON GEROW	385
Pauline Kael on Kon Ichikawa PAULINE KAEL	399
Kon Ichikawa at Eighty-six: A "Mid-Career" Interview MARK SCHILLING	409
Filmography	429
Selected Bibliography ROBIN MacDONALD	439
Text and Illustration Sources	443

Kon Ichikawa

JAMES QUANDT

Introduction: Ichikawa the Innovator, or the Complicated Case of Kon Ichikawa

"Ichikawa, the master of paradox."
— LANGDON DEWEY

JUDGING THE ACCOMPLISHMENT of Kon Ichikawa is more difficult than that of perhaps any other Japanese director. In a career extending from the mid-thirties to the present, he has made almost eighty films, widely variant in genre, theme, style, and tone—alternately, often simultaneously, sardonic and sentimental, deadpan and apocalyptic. Perhaps because many have never been subtitled and only a handful has been distributed in the West, Ichikawa's reputation here now rests on fewer than ten films, most from one decade: three classics of postwar humanist cinema (*Fires on the Plain, Harp of Burma, Enjo*), two social comedies based on Junichiro Tanizaki novels (*Kagi, The Makioka Sisters*), the wild comic spectacle, *An Actor's Revenge*, and the documentary, *Tokyo Olympiad*, which has been released in many versions and continues to be the subject of considerable controversy. The problems of apprehension and evaluation posed by the diversity and magnitude of Ichikawa's oeuvre are compounded by other factors, notably the formidable influence of his wife and scenarist, Natto Wada, whose withdrawal from writing his scripts in the mid-sixties marked a turning point in his career; and the difficulties he encountered with the studios, who occasionally punished his failures and transgressions by assigning him dubious projects, or hired him only on "salvage operations." Among the postwar Japanese masters, Ichikawa has long been an unlikely candidate for analysis; critical and curatorial interest increasingly focuses on the

"expressive margins" of Japanese cinema, and, even if not always anti-canonical, has ignored or denigrated Ichikawa as an opportunist, dandy, or mere stylist. (French critics, with an innate auteurist bias, have largely disregarded his work, whereas British critics were among the first to champion it.) A similar preference for the extremes of the transcendental and domestic, or the kinetic and wanton, in Japanese film, forms a continuum on which Ichikawa's films can rarely be situated, further averting attention from him. While often referred to as a link between the "golden age" of Japanese cinema and the New Wave, Ichikawa has rarely been given his due as an innovator; his stylistic and thematic experiments deserve greater critical attention than they have hitherto received.

The monist impulse of auteurism tends to suppress multiplicity by ignoring or explaining away variation; if unable to do either, it devalues the filmmaker whose diversity cannot be tamed or taxonomized. Perhaps this is why, of the four Japanese directors first acknowledged in the West as masters—Kenji Mizoguchi, Yasujiro Ozu, Akira Kurosawa, and Kon Ichikawa—the latter is the least recognized, though he is the only one of the quartet still alive and, despite his advanced age, is still extraordinarily prolific.

An impediment to auteurist analysis, Ichikawa's oft-remarked eclecticism has doubtless inhibited his reputation. The Japanese critic Akira Iwasaki, wryly chastising Ichikawa for his blithe variety—even before the director's forays into documentary, detective films, and prehistoric fantasy—says in the 1963 symposium reprinted here: "For example, take Yasujiro Ozu: the Ozu Tofu Restaurant can only sell tofu and pork cutlet, but not tofu, pork cutlet, beefsteak, and tempura." Ozu made several often scatological comedies, romantic melodramas, and Hollywood-influenced films with parodically *noir* titles like *Dragnet Girl*, before arriving at the hushed, formalist domestic dramas for which he is almost exclusively now known; following Iwasaki's gustatory trope, Ozu's tofu comes, as an old *New Yorker* cartoon had it, "in many guises." But Ozu has never been characterized, as Ichikawa often has, as a master of miscellany. The former's career has been made coherent by regress to an overarching theme—the Japanese family and its dissolution, also a favourite subject of Ichikawa, Mikio Naruse, and many of their colleagues—and a convenient ranking of the "problematic" early films as negligible works or as intimations of incipient mastery: Ozu before he was Ozu, as it were.

Kyushiro Kusabe remarks to Ichikawa in the same symposium, "Although your filmography appears to be haphazard and eclectic, it is possible to classify your films." The categories imposed on Ichikawa's work have often been broad grids of tone or genre, following the director's own early division of his work into films that are "light"—"my Disney side," he calls it—and those that are "dark." This simple

antimony is complicated, as so much is in the case of Ichikawa, by paradox and prolificacy. There are not two sides to Ichikawa, but several, as the title of Donald Richie's influential early essay on the director suggests; few of the films seem comfortably placed in Ichikawa's artless chart, so anguished or dark are the comedies, so frequently sardonic the tragedies. The "deadpan sophisticate" whom Pauline Kael discovers in *Kagi* and *The Makioka Sisters* is surely not the same director one encounters in *Topo Gigio and the Missile War*. (Ichikawa's "helpful" categories seem one of many indications, like the director's famous self-deprecation, that he desires to beguile the critic; it is perhaps for this reason that commentary about his work has sometimes inclined to the ingenuous and iterative.)

Several essays included in this volume attest to the critical struggle to discern unifying patterns of tone, theme, and visual composition in the bewildering sprawl of Ichikawa's oeuvre. It is often noted that his protagonists are alienated, isolated, or obsessed outsiders, struggling to survive against implacable systems (family, army, Japan) or indifferent nature (as in *Alone on the Pacific*). One of his signature images replicates this engulfing, solitary struggle: a long shot of a lone figure in a vast landscape. (When *Harp of Burma* was released in North America, the *New York Times* reviewer commented that the film desperately needed close-ups: "The key, perhaps, is the photography itself, which brilliantly but methodically dots the players against the looming terrain." Ichikawa remade the film, in colour, in 1985, a version more suited to conventional tastes.) Ichikawa's cinema features more clocks that Ophuls', including one in a freeze frame in *Aijin* that literally stops time in mid-swing and another in *A Billionaire* that has only one setting: an apocalyptic 25 o'clock—an elaborate "in joke," as Tadao Sato points out in his essay. Many of Ichikawa's films, which are full of gallows humour, revolve around tenacity and madness (often synonymous): the entire nation is shown to be in the grips of mass madness in *A Full-Up Train* and *A Billionaire*, and poor Mr. Pu sits alone at the end of the film named after him and dazedly wonders what it would be like to capitulate to insanity. Motifs of fire (*Conflagration*, *Fires on the Plain*) and snow (*Aijin*, *Hakai*, *The Makioka Sisters*), poisoning (*Kagi*, *A Billionaire*) and nuclear anxiety define his world.

As is frequently pointed out by both Ichikawa and his commentators, his apprenticeship in *manga* films and animation (*animé*) shaped his approach to narrative structure and visual composition, which tends to be both graphically organized, asymmetrical and dynamic, cursive in its articulation. In an untranslated essay by Ichikawa, "Continuity in *Ten Dark Women*,"[1] he details his use of *manga*-like storyboards to plan every shot and sequence of that spoof. A comparison of some sample diagrams and frame enlargements that accompany the essay reveals that the storyboards have been very carefully recreated in the film. Ichikawa treasured the control of a studio shoot, building miniature sets to rehearse his actors, and avoiding, when he could, location shooting and its attendant risks. Having laboriously worked out the continuity, he hated to alter one element of it, noting that even one

change caused a domino effect, forcing him to alter everything that followed. To illustrate his concern for control, Ichikawa describes how the shot in which the protagonist of *Ten Dark Women* is pushed into the ocean was filmed on location, but the very next shot, showing the victim falling into the water, was filmed in a tank in the studio.

For Ichikawa, then, artifice did not preclude but abetted authenticity; he was obsessive in his attention to realistic detail, as his once assistant director Yasuzo Masumura notes in his acidulous essay, "Ichikawa's Method." This "method" and its emphasis on lengthy, meticulous planning initially reminds one of Alfred Hitchcock, which in turn belies the fact that the great "controllers" of cinema, those who exert the most rigorous dominion, necessarily have the most unified bodies of work. (Ichikawa was frequently compared to those he admired in his early career—Disney, Capra, Chaplin, Wilder, Sturges, Clair, Lubitsch, Cukor, Cocteau—and his list of favourite directors later extended to Resnais, Renoir, and, most surprisingly, Pasolini, whom he told Joan Mellen he considered the finest contemporary filmmaker.) But Ichikawa's perfectionism, his painterly instincts, and the emphasis in his "method" on affectless acting resemble that of a director with whom Ichikawa seems to have little similarity: Robert Bresson.*

"I was trained as a painter and I still think like one," Ichikawa has said, as was and did Bresson, though their artistic heritages greatly differed. (William Hauser's comparison of Ichikawa's images in *Fires on the Plain* to the paintings of the Catholic artist Georges Rouault points up a glancing affinity with Bresson, who obviously knew their roiled, ropy, and simply composed images of spiritual affliction.) The directors' experiments with tonal effects in their colour films are often strikingly similar; Ichikawa's use of bleaching in *Kagi* and what is called "leaving silver" (*ginnokoshi*) in *Ototo* brings a muted, even funereal elegance to those films, comparable to the subdued palettes and nocturnal obscurity of some of Bresson's later films. One also detects in the respectful but contrary attitudes of the two master cinematographers who frequently worked with Bresson and Ichikawa—L.H. Burel and Kazuo Miyagawa, respectively—a similarity of distress when the directors overrode their concerns for verisimilitude in their determination to achieve certain effects. Ichikawa's perfectionism and love of control extended to almost everything—he designed sets, adjusted the lighting, touched up actresses' make-up, went to music school so he could write scores, and proudly said of the excrement in *Fires on the Plain*, "I mixed the chocolate and brown sugar for that scene myself"—but

*Bresson and Ichikawa began their careers with somewhat uncharacteristic films—Bresson's short comedy *Affaires Publiques* and Ichikawa's doll animation film *A Girl at Dojo Temple*—both long thought lost but now archived, respectively, at the Cinémathèque Française in Paris and the National Film Centre in Tokyo. (*A Girl at Dojo Temple* is often incorrectly considered still missing.) Critics have argued that, despite their divergence from the directors' later work, these two films are important initial statements of their subsequent style.

Hakai

Miyagawa found him surprisingly "vague" and distracted by the actors when asked about camera placement.

More marked is the two directors' shared predilection for expressionless acting and blank faces. (Ichikawa, perhaps perversely, managed to isolate the vacant countenance of coaches, athletes, and spectators—ostensibly his "actors"—in the midst of the excitement of competition in *Tokyo Olympiad*.) Bresson's reduction of nonprofessional actors to what he called "models" through precise training finds an echo in the Japanese master's preference for neutral line readings: "For Ichikawa," Masumura writes in his essay, "the less an actor moved and emoted the better. He also preferred that actors deliver their lines in a monotone, without eliciting empathy in the audience." Compare this to Bresson's admonition: "I exclude the method of drama which requires expression by action, gesture, or speech." Michael Raine notes the Brechtian, even wooden, fixity of the leading actor in *Punishment Room*, remarking that Ichikawa "uses him as a prop," and Tadao Sato's analysis of Ichikawa's rapid dialogue in his early comedies stresses its intent of vacating emotion: "Perhaps by aiming for contemporary tempo, instructing his actors to speak rapidly resulted in dialogue incapable of containing any emotion. In addition, he did not let his actors assume any kind of histrionic emotional expression, or make dramatic shifts in expression. At times, the result is as inexpressive as a *noh* mask." This last comparison, which Sato repeats in his description of Machiko Kyo's stylized visage in *Kagi*—"with severe make-up and eyebrows plucked to nerve-racking precision . . . her face is reminiscent of a *noh* mask"—recalls that of director Mitsuo Yanagimachi who, in a recent homage to Bresson, writes: "I am reminded of Japanese *noh* and *noh* masks when watching Bresson's films of formal, expressionless actors." (It is perhaps no surprise that both directors each made a film which featured an animal as protagonist—Bresson's *Au hasard Balthazar* and Ichikawa's *I Am a Cat*—the ultimate in the erasure of naturalistic acting.)

Bresson and Ichikawa are also alike in basing most of their films on literary works. Bresson's films are derived from Diderot, Bernanos, and Tolstoy, from the transcripts of Joan of Arc and the Arthurian legends, and, especially, from the novels of Dostoevsky. (Tom Milne finds Ichikawa's *Kokoro* and *Hakai*, though based on Japanese novels, very Dostoevskian, with their mood of doom and "brooding torment." One might add that enclosure or imprisonment is a Dostoevskian theme shared by the two directors.) Ichikawa's sources are as varied as his expansive filmography. His promiscuous literary tastes run from Alain Robbe-Grillet, with whom he collaborated on an unproduced script, and Camus he wanted to make *L'Étranger* into a film—to contemporary Japanese writers (Yukio Mishima, Shohei Ooka, Kobo Abe, Junichiro Tanizaki) and Agatha Christie. (Ichikawa used Christie [Kurisutei] as a pen name on some of his scripts, and thought the mystery novelist should have won the Nobel Prize for Literature.) As with Bresson, much

of the critical literature on Ichikawa focuses on his literary adaptations, which are both faithful and free; many commentators analyze their transpositions and altered endings, which, as with Bresson, render the films more characteristic of the director's bleak vision.

The comparison between these two directors may seem more toil than truth. After all, it is Ozu with whom Bresson is most often bracketed, as directors with similarly "transcendental" or "parametric" styles, and one can hardly imagine two bodies of work more dissimilar than those of Bresson and Ichikawa. The former is daunting in its containment, consistency, sparseness, and rigour, the latter capacious, wildly diverse, comparatively undemanding, and not infrequently given to sentimentality—differences readily apparent in the contrast between Bresson's *Notes on Cinematography*, a set of Pascalian aphorisms, and Ichikawa's essays, ironic, expansive, and gently observant musings on such subjects as "the smile in Japanese cinema" and the similarities between the daily routines of a film director and of a salaryman. Many other diametric differences between Bresson and Ichikawa can be cited, notably their reliance on dialogue—Ichikawa's characters are often Hawksian motor mouths, garrulous where Bresson's are laconic—and use of music. Bresson's famous injunction, "No music as accompaniment, support or reinforcement. *No music at all*. Except, of course, the music played by visible instruments," would be anathema to Ichikawa, who frequently depends on music for ironic or maudlin effect: the Mahler-like score in *Ohan* and sentimental swells in *Kokoro*; the Mendelssohn wedding march in *Sanshiro of Ginza* and the Nat King Cole and Varèse-like outbursts in *Aijin*; the electronic baroque music in *The Makioka Sisters* and synthesized burblings in *I Am a Cat* and *Dora-Heita*; the odd saxophone music in *The Men of Tohoku* and strange cocktail jazz in both *An Actor's Revenge* and *I Am Two*; the modernist music and use of chant in *Enjo*; the Michel Legrand slosh in *The Phoenix*; the dance music playing on Ichiko's car radio as she drives past the burning truck at the end of *Ten Dark Women* and the famous refrain of "Home Sweet Home" in *Harp of Burma*. (It must be noted that Ichikawa wanted to end *Ototo* in Bresson fashion, suddenly and without music, but was persuaded by Natto Wada to soften the conclusion by employing gentle music.)

The comparison between Bresson and Ichikawa is, then, a case both of curious affinity and—if pressed—of strained analogy. There is nothing of the numinous in Ichikawa. Resolutely materialist, he makes abstracts inhere in objects: in *Fires on the Plain*, life and death reside, respectively, in the salt and grenade that Tamura carries, and the film abjures the transcendental premise of the novel on which it is based for a grimly ambivalent ending. (Materialist readings of Bresson's work stress the corporeality of his world, how the spiritual is often inscribed in gestures and things, but there is no question that his concerns are conspicuously metaphysical.) Just as their shared pessimism is of a very different order and nature, the "remove" or aesthetic distance that critics have discerned in each director's work is markedly

dissimilar, though its objective is the same: the avoidance of melodrama and false emotion. Bresson's omniscience is godlike, magisterial, Ichikawa's detached, sardonic. (Again, one must add a caveat regarding the influence of Ichikawa's wife, Natto Wada, who wrote many of his most important films; some critics argue that her withdrawal from scriptwriting in the mid-sixties marked the onset of Ichikawa's decline. One senses in reading her essays that she contributed a great deal of the acerbic tone—the "black wit"—that has long been attributed to Ichikawa. Who else would write an article on why she doesn't like "stupid people," whom she defines as women between the ages of eighteen and twenty-three? In an essay on satire,[2] Wada insists that she does not understand the concept of satire, though satire is ostensibly what she was writing at the time, because, she says, the tart vision of her scripts reflects the Japanese world as it actually is—grasping, over-populated, obeisant. And there is no question that Ichikawa's post-Wada films are markedly less sardonic. Extricating Wada's influence is one of many factors that makes "the case of Kon Ichikawa" so confounding.)

The ironic, often coldly detached view that distinguishes Ichikawa's cinema has been described in ways that remind one of the epithets applied to Bresson's compatriot, Claude Chabrol: "clinical," "arid hearted," "dispassionate," "contemptuous," "reserved and objective," "derisive," "venomous." A *Cahiers du cinéma* critic once compared Ichikawa to an entomologist collecting insects in formaldehyde, an image that recalls Fassbinder's claim that Chabrol, whom he greatly admired and copied, treated his characters in an aloof and analytical way, like a child collecting insects. (Bernadette Lafont complains to Jean-Claude Brialy in Chabrol's first film *Le Beau Serge*, "You study us as if we were insects," and the mother and son in *A Double Tour*, made at the same time as *Le Beau Serge*, are referred to as "sordid insects.") Another French critic, condemning Ichikawa's most Chabrolian film, *Kagi*, as "nauseating trash," compared the characters to "confused larvae moving about in a green aquarium light." And the more admiring Max Tessier called his introduction to the Japanese master "Kon Ichikawa the Entomologist," claiming that the director "observes his protagonists struggle like powerless insects with their destinies."

As if to oblige the critics, Ichikawa's cinema is replete with animal and insect imagery: the bull goring that opens *Hakai*; the killing of the dog in *Fires on the Plain*; the "protagonist" of *I Am a Cat* (who commits suicide in the typically eccentric Ichikawa ending, a world of irony apart from Balthazar's crucifixion); the parakeet *deus ex machina* in *Harp of Burma*; the ant Tamura picks up from the rock in *Fires on the Plain* (which bites him) and the ant that Ichiko regards towards the end of *Ten Dark Women*; the cooped-up collie in *Alone on the Pacific* and the pair of caged canaries in *Sanshiro of Ginza*; the flocks of birds at the end of *Enjo*, *Harp of Burma*, and, again, *Fires on the Plain*. People are frequently compared to beasts, caged or otherwise: the squalling children in *I Am Two* are presented like animals in a zoo,

and the father in *Punishment Room* deplores the brutality and license of his son's generation: "You're like animals." (Natto Wada might be the source of this motif; her essay on being both a "housewife and a scenarist" describes the pursuit of conflicting careers as akin to "chasing two rabbits."[3])

This animal imagery is not necessarily a signifier of the director's cruel authority over his characters; it can indicate a Darwinian vision of survival during the war and after, or, more generally, evidence of a deeply pessimistic sense of the world. (Bresson's mid-period films, too, are full of trapped and wounded animals.) No matter how comic, sentimental, or humanist Ichikawa's cinema, it is shot through with despair and anguish. Even when the director asserts that *Tokyo Olympiad* and *I Am Two* are affirmative "hymns to life," one returns to the films to find them full of unease, loneliness, dissolution; the former's exultant tone is dissolved in what Dai Vaughan calls "reverential mockery." Ichikawa worried that the savage erotic satire of *Kagi* would be misunderstood in the West as a portrait of "life in Japan"; it was, he said, "not really a movie about sex," but a universal "story of human vanity and nothingness," which contends with the traditional reception of the film as a perverse comedy of manners. The opulent satire of *The Makioka Sisters*, based on another Tanizaki novel and the sole Ichikawa film of his late period to become a hit in the West, blazes with postcard cherry blossoms and whispers with the swish and slither of brocade kimonos, but beneath its delicate theme of evanescence is a hard, claustral tale of money (the first word uttered in the film) and social regulation. (In this, it prefigures Hou Hsiao-hsien's *Flowers of Shanghai*.)

The gap between Ichikawa's purpose in and perception of his own work and that of his commentators points to a central paradox in his career. Perhaps because of his wry, self-deprecating tone, which deflects serious analysis, he has rarely been recognized as a significant innovator. Condemned by Nagisa Oshima as "an illustrator" for his many literary adaptations, and by others as an accommodater or opportunist, Ichikawa has humbly assumed the role of the "old pro," the veteran whose exacting, often anonymous ways are ideal for an increasingly monolithic and insular studio system, which is intolerant of the very individualism Ichikawa's early films, such as *Alone on the Pacific*, championed. (Aaron Gerow's essay on "the industrial Ichikawa" details this development.) But it is difficult to accept as conservative an artist who in the first three decades of his career so insistently experimented with formal elements—the CinemaScope frame, the tonalities of black and white and of colour, the graphic design of compositions, the use of freeze frames, masking, and flash cutaways—with unconventional registers of dialogue and acting, disjunctive sound, and with subjective or surreal imagery; who often radically revised revered literary texts for his own pessimistic ends; and who rejected Confucian values, offering a thorough critique of the conformism and rapacity of postwar Japan. His trilogy of black comedies about that chaotic world—*Pu-san*, *A Billionaire*, and *A Full-Up Train*—is among the most underrated

films in Japanese cinema, their savage satire preparing for the rude skewerings of Japan Inc. in Yasuzo Masumura's "corporate" comedies (e.g. *Giants and Toys*; *The Black Test Car*). In *Pu-san*, Ichikawa deftly drops his hero, the put-upon Mr. Pu, *Zelig*-style into documentary footage of leftist street demonstrations (a technique he would later integrate with the sweaty expressionism of *Punishment Room*). The vicious wit of *A Full-Up Train*, a great *comédie du travail* about the enforced inefficiency of Japanese industry, is matched by the film's bristling images, which are reminiscent of René Clair and presage Jacques Tati. And *A Billionaire* must be counted among the most obsidian of satires; Kubrick might blanch at its caustic cartoon of postwar political corruption, nuclear madness, and mass suicide.

The films that surround the trilogy are no less daring. *Punishment Room*, in its treatment of the brutality and anomie of postwar youth, foreshadows the student protests of a decade later, as well as such films of the Japanese New Wave as Masumura's *A False Student* and Oshima's *Cruel Story of Youth* and *Diary of a Shinjuku Thief*. The apocalyptic *Fires on the Plain* explicitly depicts cannibalism in the Japanese army during the Pacific War, and the sentimental *Hakai*, though first made as a film in 1948 by Keisuke Kinoshita, boldly deals with the taboo subject of Japan's outcast *burakumin*. The pungent pageantry of sex and stink in an isolated mountain village in *The Men of Tohoku*, Ichikawa's first Scope film, predates Shohei Imamura's ribald *The Ballad of Narayama* by almost three decades. *An Actor's Revenge* has become something of a postmodernist playground for cultural theorists, with its gender, genre, and role games, its seemingly inapt music, its slyly imbricated narrative and self-observant spectacle. And, as Catherine Russell notes in her essay on *I Am Two*, a project forced upon Ichikawa, even this comparatively traditional and sanguine work can be situated "within the contemporaneous 'new wave cinema' and its interrogation of social institutions." The catalogue could include many other examples—the controversial innovations of *Tokyo Olympiad* (discussed in a symposium in this volume), the sexual perversity of *Kagi*, the critique of the matriarchal system in *Bonchi*—all confirming that Ichikawa, certainly more than many of his colleagues in the postwar industry, was a searching, often brilliant innovator, whose influence was as considerable as his range.

That Ichikawa's restless invention was eventually subdued by studio conformity, the fond, familiar image of the director with cap and cigarette turning from icon into logo, is lamentable. But the complicated case of Kon Ichikawa does not end with capitulation. His most recent films, the animated doll feature *Shinsengumi*, and *Dora-Heita*, a long cherished personal project, based on a thirty-year-old script co-written by Ichikawa, Kinoshita, Kurosawa, and Kobayashi, suggest a return to his roots. In *Dora-Heita*'s determinedly old-fashioned, crafty recreation of the samurai genre, Ichikawa's tale of an "alley cat" magistrate who dispenses wisdom and havoc as he cleans up a corrupt fiefdom characteristically mixes tones and devices—slapstick and philosophy, moral drama and ribaldry, frantic action

and formal, static compositions, period detail and synthesized music. Ichikawa predictably denies any retrospective intent in these two films; he tells Mark Schilling in an interview conducted for this book: "I'm only interested in making films that excite me, that I can make in my own way. That's all.... Films are films. If you don't understand that, then you start filming lies."

Orientalism continues to prize design and concentration over versatility, the ineffable over the illustrative, in Japanese cinema. In defying these biases, counter- or anti-orientalist criticism searches for ruptures and inconstancy. The irony of Ichikawa's case is that he loses both ways; too varied and direct for the first, too accommodating, even in his innovations, for the latter. In his eighties, the insouciant but not uncaring Ichikawa would accept both critiques with bemusement, light another cigarette, and sit down to work on the continuity for his next film.

Note

1. Kon Ichikawa and Natto Wada, *Seijocho 271 banchi* (Tokyo: Shirakaba Shobo, 1962), 102–107.
2. Ibid., 240–245.
3. Ibid., 219–211.

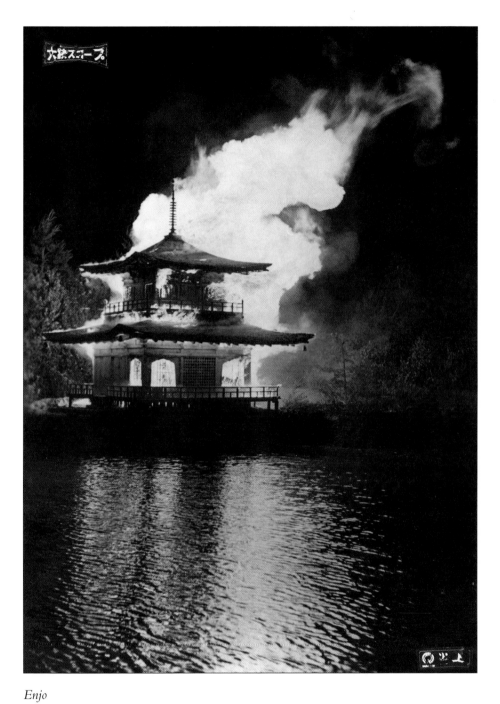

Enjo

YUKIO MISHIMA

Kon Ichikawa

The following was written as a preface to a collection of essays by Kon Ichikawa and his wife, Natto Wada, entitled Seijocho 271 banchi, *several of which are included in this volume.*

WERE I ASKED which Japanese director's films I most often watch, I would answer without hesitation those by Kon Ichikawa. I'm always interested in his work and whenever a new film by him comes out I make sure I see it. And since long before he had the reputation he enjoys today, even back when the critics chose to see nothing but a certain superficiality that is occasionally detectable in his work, I was never in any doubt that he was one of Japan's greatest directors.

There is a reason why Mr. Ichikawa's works are hard to understand and remain somewhat misunderstood. No one else has his talent for eschewing the kind of sentimentalism that has permeated Japanese films in the past. His innate nature is to be dry, without a trace of sweetness. Even where one detects something cloying (reminiscent of Edgar Allen Poe, as in *A Woman's Testament* [*Jokyo*]), such work is invariably infused with a mordant and wry sensibility. I find it a uniquely Japanese irony that Ichikawa's works, which are so far removed from what is after all the mark of truly Japanese superficiality—the tearjerker—have been accused of indulging in sentiment.

For one who has been an avid viewer of his films, what makes this book interesting is the way it so honestly reveals the tragic disharmony between his work and his life. For behind the making of Mr. Ichikawa's exquisitely lucid films, one catches a glimpse of the struggle it took to shape the unique reality he has created; it is a place filled with the contradictions of present-day Japanese cinema. Not only that: one is also struck with a strange sense of pleasure after reading about all the troubles Ichikawa and his wife have had to face. No doubt this has something to do with the light style of his writing, but perhaps it is also because, after all his trials and frustrations, filmmaking has been for him a kind of catharsis, almost a Dionysian rite of exorcism.

Translated from the Japanese by Cody Poulton

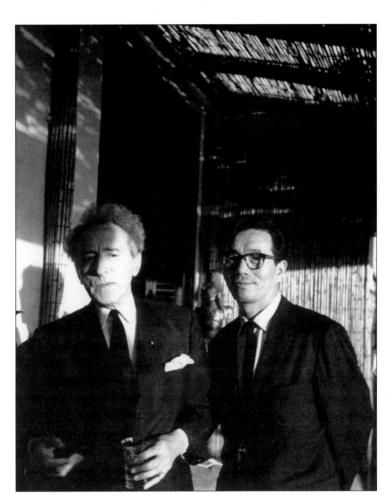
Jean Cocteau and Kon Ichikawa

> KON ICHIKAWA

Blown by the Wind

ONE NIGHT I had a dream. I was travelling down a road I had never been on before when I suddenly noticed a tall figure walking just ahead. The man spun round to face me and shouted:

HE: Who are you?
ME: Me? My name is Kon Ichikawa.
HE: Is that so. Well the name means nothing to me. Listen, you've got to stop following me.
ME: But I'm not . . . you're the one who appeared out of nowhere.
HE: This road is mine. It's the road of the poet. You're in the way!
ME: (Angrily) And who the hell are you?
HE: You don't know who I am? You miserable peasant. I am Jean Cocteau!
ME: (Kowtows before him in amazement.)
HE: Aha. You're Japanese, aren't you! Japanese are big on bowing I've heard.
ME: Sensei! How lucky I am to have bumped into you like this. There are so many things I'm dying to ask you, Sensei.
HE: Alright, but only if you stop calling me 'Sensei.' I'm not a fine enough man to deserve the term, and I don't like you tossing it around like that. It just feels like I'm being made fun of. I have a name. Call me Jean.
ME: Then . . . Jean. Can you tell me why I always find myself being blown around by the wind?
HE: There is no one to blame but fate. You see, the Japanese archipelago lies precisely in the middle of a typhoon corridor, which means it must bear the brunt of the heavy winds that come whipping in off the ocean every summer. To make matters worse, your country was recently turned into a valley of death. You have my sympathy.

ME: No, I'm not talking about real winds or seasons or anything of that sort. I'm talking about the winds of criticism. In other words, resistance.

HE: Resistance?

ME: I'm a pale, rather scrawny person as you can see, not a robust he-man type at all. I tend to be docile, even effeminate. Hardly the sort of person you would expect to be attacked. Yet when it comes to my work that's exactly what happens to me, though I've consciously tried not to think about it that way until now. Then the other day someone asked me to write about that aspect of my career. "You really seem to rub critics the wrong way," he said. It was something of a shock to discover that was the impression others had, so I tried to give it some thought, but I'm not bright enough to analyze myself.

HE: Resistance, you say? Ha ha ha. You're joking. Do you know what resistance really means? I doubt it.

ME: Are you sure?

HE: What were you doing before the war?

ME: Making films.

HE: And what were doing while the war was going on?

ME: I went on making films.

HE: And what about right after?

ME: Still making films.

HE: And now?

ME: The same thing.

HE: *Mon dieu,* you weren't doing anything at all! You can't call it real resistance if you don't take action. It's action that makes the winds really start blowing. When my country is at war, I pick up my gun and join the battle. That's where I stand. That's my posture. It's the same thing when I paint. Or when I write poetry. The same emotion drives me in each case. The will of the individual should be linked with the will of the nation.

ME: Yet they say one mustn't side with fascism ...

HE: That's why people in your country lack real autonomy. Some fight, others don't, but no one acts on their own. I see in the newspapers you're a peaceful country now, but what's the meaning of peace without personal independence? That's not a peace for people who are really alive. *Ah, vive la France!*

ME: You can wax patriotic all you wish, but how does that help me? France and Japan are different countries—we've evolved in different ways. There isn't a chance in a million that Japan will suddenly be transformed into a nation bound together by the autonomous will of its people. Besides, is France really all that great?

HE: Well, not really. You see ... those are my hopes for the future. But tell me, is it really that interesting to devote your whole life to making films? I mean, haven't you been chewing on the same bone long enough?

ME: But movies are always changing. Their life is infinite; there's no limit to what they can become.

HE: I, too, was obsessed with them for a time. But they require such an enormous pile of capital—that's their fatal flaw. And you have to make yourself understood by everybody right there on the spot for your work to be realized. Art requires waiting. Sometimes you even have to wait for the death of the artist.

ME: But isn't that why making movies is so fascinating? You can't sublimate everything to art. You wield the gaudy weapons of the artist on the one hand, while on the other, you're tied hand and foot by all that money. If you can bring those two aspects of your work together while dealing with the constant changes taking place in the world around you, then you can really achieve something. I get the shivers just thinking about it.

HE: You're the masochistic type, aren't you. How old are you anyway?

ME: Forty.

HE: Why, you're still just a baby. Look, I understand your desire, I just don't think it's achievable. But you're still young, so give it your best shot.

ME: It's always a boost to hear words of encouragement like that. But I'm afraid it's no good. In Japan, you're supposed to have settled down by the time you turn forty. I'm still unsettled; that's why I'm the target of so much criticism.

HE: Where precisely are you supposed to settle down?

ME: I wonder. At any rate, I'm supposed to be crystal clear about what I'm doing, and that's completely impossible right now. I'm still trying to discover who I really am. If I can figure that out before the end of my life I'll be happy, but I can't count on it, and I certainly can't let other people in on an answer I don't know myself! But that's not good enough, it seems.

HE: I'm not sure you have what it takes to be an artist. You're too simple-minded, too immature.

ME: It disappoints me to hear you say that, really. I hate being called an "artisan" too. It upsets me to the point I almost blank out.

HE: You, an artisan? Don't worry, you're far too naïve. I'll testify to that if you like.

ME: Then what am I?

HE: That's where the problem lies. The issue isn't other people. It's you yourself. Aha, I think I've got it! That "wind" you talk about—it's not outside you, it's blowing from within. You're being knocked about by forces that originate inside yourself. In short, you're facing the wrong direction.

ME: You've lost me.

HE: Anyway, as you say, you're still light years away from a final answer. Yet you're beginning to sense that a forty-year-old can come up with an answer that fits his age. How about it—is the wind getting stronger these days?

ME: That's exactly what I've been telling you! Finally you understand.

HE: Don't be a fool! What you're experiencing now is just a gentle breeze.

ME: (Downcast) Just a breeze?

HE: Well, let's put it this way. The time when you will have to come face to face with yourself is fast approaching.

ME: (Still in the dark) You don't say... That must be why I can't make it inside the curtained doorways.

HE: Curtained doorways?

ME: After the war, Tokyo's oldest most respected shops all re-established themselves in one particular area of the city, which came to be called the District of the Curtained Doorways, after the *noren* that used to hang in store entranceways back in the old days. Now we use the term to refer to those businesses which are associated with quality in the public mind. Even if the quality isn't really first-rate, people buy anyway. The equivalent in film is having your movie selected as one of the year's top ten. It's a tough system, but it's convenient.

HE: Convenient? Since when did convenience have anything to do with art? It's shameful!

ME: I... I know.

HE: Anyway, what would you do if they invited you behind the curtains?

ME: There's not much chance of that. To have your films recognized by Japanese critics they have to be technically flawless, and at this stage of the game, anything I make is bound to have flaws. Experimental cinema is always imperfect, always immature. That's why it never gets the support it should. (Laughs a nihilistic laugh)

HE: Idiot!

ME: What?

HE: You obviously haven't seen my films.

ME: Yes, I have. I've seen virtually all of them.

HE: Seeing and not understanding is the same as never having seen at all. In *Orphée* I criticized the critics. That mechanical shot of the notebook in the café indicates their state of mind—empty, like a blank sheet of paper.

ME: Don't talk about the critics like that! Terrible things could happen.

HE: It must be hard to live in Japan and not be able to say what you think. (Laughs) But France is no different. Well, I live there, so I guess it's a bit better. You should come and visit sometime.

ME: I would love to go, but I don't have the money, and besides there are the wife and kids.

HE: That's where your area of greatest resistance lies. (Laughs) Catch my drift?

Laughing loudly, the tall figure walked off down the road. My dream came to an end.

1956

On Meeting Jean Cocteau

This is the concluding section of the essay "My Wordless Trip to Europe," which describes Kon Ichikawa's visit to the 1960 Cannes Film Festival, where Kagi *was screened.*

FINALLY, let me set down what was the most memorable part of my trip, when I was able to realize my cherished dream of meeting Jean Cocteau. Cocteau was living about an hour's drive from Cannes at Cap-Ferrat in a stately residence that was, depending on who you talked to, either owned by him or by one of his patrons. We were ushered into a well-appointed study whose walls had been painted with the twisting, meandering lines that mark Cocteau's inimitable style. These curious designs were his famous wall frescos. And there he was, looking just like his photograph. Basically, he struck me as a cheerful, talkative old man with a certain air of innocence about him. He had the manner of a poet, in the best sense of the word. He seemed to be in great good spirits, for he talked on and on, all the while gesturing enthusiastically with his hands. Yet it seemed that this unending flow of words had virtually nothing to do with me. I had prepared a list of various questions to ask him, but no sooner had the interpreter begun than he was off again. Did he actually hear anything I was trying to say? Did he have the foggiest notion who I might be? He had probably picked up the fact that I was a Japanese filmmaker of some sort and little else. But I didn't mind. I was happy just to gaze at him in admiration. As a present, I had brought him a writing brush (cost, 500 yen) of the sort used by avant-garde calligraphers. He seemed to like this and immediately started drawing or writing (it was hard to tell which). I was pleased to see the result did indeed resemble avant-garde calligraphy. He seemed to have genuinely enjoyed our visit, for as I was leaving, in place of a signature, he drew one of his characteristic pictures in a book of his and gave it to me. I wanted to see his latest film, *The Testament of Orpheus*, but although I looked for it in all the major theatres, I couldn't find it anywhere. When I finally discovered it in a smaller theatre, my trip was almost over, so I never saw it. His claim that this was his final movie, his "last testament," is well known, but based on the energy he displayed during my visit, I expect he may come back to thrill us with many more films.

Now that I've returned to Japan, I find myself marvelling at the sheer number of films being produced. Countries like Germany and France turn out a few very fine films, but what is catching people's attention these days are the movies pouring out of "new cinemas" like those of Norway and Mexico. Cocteau has argued that the Grand Prix at Cannes should go to candidates from emergent cinematic movements like these. I, however, can only marvel at the changes taking place in world cinema today.

1960

Translated from the Japanese by Ted Goossen

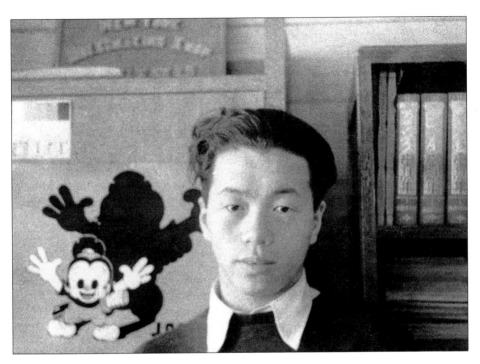

Kon Ichikawa the young animator

> KON ICHIKAWA
> YUKI MORI

Beginnings

Home

"Home" or "family" always appear in Kon Ichikawa's films.

The overhead angle shot, showing a tiled roof from above, can be called Ichikawa's trademark. Under the dark grey tiles, parents and children, brothers and sisters, husbands and wives, love and hate one another, and are sometimes driven into a deep loneliness.

How does Ichikawa's family environment influence his filmmaking? Although we are not psychologists, we cannot help asking Ichikawa about "home" when trying to understand his films.

YUKI MORI: You were born in a drapery in Uji-Yamada City, Mie Prefecture, on November 20, 1915.

KON ICHIKAWA: Now it is Ise City.

MORI: What do you think about your "home"?

ICHIKAWA: My childhood memories are vague and fragmentary.

MORI: That is...?

ICHIKAWA: I was born when my mother was forty-eight. My father died right after, and our family business failed and went into bankruptcy.

MORI: You have three sisters.

ICHIKAWA: Yes. My mother's name is Teu. My eldest sister is Chow. The second is Koto, the third is Chie, and I am the first and last son. My second sister was married and lived in Osaka. My mother took me to live there when I was four.

MORI: That's why...

ICHIKAWA: Yes. So, I just vaguely remember the white gravel of Ise Shrine, a lattice window of the drapery, and a shop curtain hanging in a dark room.

Childhood

Ichikawa's world changed when he was very small.

His mother took four-year-old Ichikawa to live with the Kanamori family, into which her second daughter married, at Kujo, Nishi-ku, in Osaka. Theirs was one of five similar houses standing in a row on a side street. Ajigawa River is close, and there were factories with many chimneys on the other side of the river.

ICHIKAWA: My sister's husband was a chief mechanic for Osaka Merchant Vessel, and he was almost always away on long voyages. My mother, my sister, her daughter, and I stayed together. All of them were nice, and I felt that was my home. I went to Kujo Daiichi Elementary School. Because my mother was old when I was born, and because I was raised in a house with only women, I was a very spoiled child. For example, my unbalanced diet. I could not eat any seafood. There was no reason. If I said I didn't want to, I didn't have to eat any. I cannot overcome my likes and dislikes about food even now. (Laughs)

I was rather cheerful, even though I was weak. I liked painting, and drew pictures when I had time. There was an amusement area called Kujo Shinmichi ten-minutes walk from our place. Around Ibara Sumiyoshi Shrine, there were several movie theatres and playhouses. I think the first movie I watched was *Jiraiya*, starring Matsunosuke Onoe, "Matsu-chan the eyeballs," when I was five or six. I was obsessed with the excitement. I saw foreign films by Chaplin, Keaton, and Lloyd, the action films of "Hurricane Hutch," but I preferred Japanese *chambara*.

I was a big fan of Momonosuke Ichikawa, Shinpei Takagi, and "Bantsuma" (Tsumasaburo Bando). Right after seeing a movie, we played *chambara* with other neighbourhood kids. We made wooden swords, and wore paper or cloth topknots and charcoal make-up. We drew pictures of the actors; mine were praised for capturing their characteristics. I thought then about being a painter in the future.

I read many books, too. Of course, they were not difficult ones, but something like adventure novels in magazines, such as *Shonen Kurabu* or *Tankai*. I liked the "Tachikawa Bunko series" too. I read detective novels by Ruiko Kuroiwa, even though they were scary.

I also liked sports, and ran in relay races. I am still a fast walker. Since I walk quickly in cities or mountains while hunting for locations, my staff can barely keep up. (Laughs)

The memory of my first love? Oh, well, it was a different time, and . . . (Laughs) I didn't have any. But there is one girl I remember vividly. She was the daughter of a neighbourhood pawnbroker, and was older than I. She had short hair and wore a long kimono. She looked strong-minded, but beautiful. She

had polio or something. She always leaned on the wall of a storehouse and could only watch us playing. She never joined us. There was a rumour that she was a daughter of a mistress. Later, I wrote a short novel about her, entitled "Edo-ya no Osome-chan." It won a prize from *Shukan Asahi* magazine.

Recuperation

Ichikawa moved with his mother to Kyoto, where he transferred to Suzaku Daiichi Elementary School. There he wrote an imitation of a typical boy's novel, and published it in a mimeographed school newspaper with his schoolmates.

One day, while he was playing baseball in the school yard, a ball hit the young Ichikawa in the back. The pain did not abate, and in hospital in Osaka, he was told that he possibly had spinal caries. To be cured, he had to rest in a box-like cast for half a year. Ichikawa found it intolerable, believing that his illness was not that serious, despite the nervous pain he suffered.

His third sister Chie got married and ran a restaurant in Shinonoi-cho, Nagano Prefecture. Ichikawa went there to rest with his mother. His pain eased as he resumed school, playing baseball and chambara *in fresh air. Ichikawa was right; his illness was not that serious. He returned to Osaka, and entered Ichioka Shogyo Junior High School.*

When he was in art school, he had a fateful encounter. That was Walt Disney's animation film, Silly Symphonies.

Animation

Kon Ichikawa and animation are inseparable.

His career as a visual artist began with animation. Its methods and aesthetic pervade Ichikawa's work: unique angles, exaggerated movements of characters, the rhythms of drastic cutting. The flow of images in animation is created from pictures painted one by one, so images are perfectly controlled. This quality of animation is closely related to Kon Ichikawa's method, which tries to control everything within the frame.

ICHIKAWA: I would not have started to make films without Walt Disney. *Silly Symphonies* was a series of short fantasy films, in which cartoon characters, such as the moon, flowers, and trees sing and dance to music.[1] We don't call them cartoon films any longer. Now they are called animation, aren't they?

MORI: They are the precursors of the feature animation *Fantasia*.

ICHIKAWA: Yes. Vivid images I had never seen before were literally dancing on the screen, and I was really moved by the film's achievement. I particularly loved

Three Orphan Kittens. All the shorts perfectly combined paintings and motion pictures, both of which I had loved since I was a child. I thought this must be my life's work.

MORI: That's why you entered the talkie animation department at J.O. Studio.[2]

ICHIKAWA: Yes. It was 1933, when I was eighteen. The white studio that Yoshio Osawa, the son of Osawa & Co., built in the middle of a farm field at a place called Kaiko no Yashiro in Kyoto was J.O. Studio. Osawa became the president of Toho later.

MORI: Later, J.O., P.C.L. in Tokyo, and some others merged into Toho.

ICHIKAWA: Yes. J.O. was the first rental studio in Japan, and they even had a developing room of the latest design, which had connections with Agfa Film in Germany. It was a modern and great studio. I heard they had a department of talkie animation, and I really wanted to get a job there. A friend of a friend of my relatives introduced me to the studio (laughs), and finally I was hired. I was lucky.

MORI: What kind of work did you do when you began at the studio?

ICHIKAWA: First, I was an assistant animator. We placed the original picture, which was painted on a thin paper, on a light box and traced the next movement.

MORI: What kind of films did you make?

ICHIKAWA: We made a series called *Hana yori Dangonosuke*. Dangonosuke, who is a sort of mixture of Mickey Mouse and Momotaro, is the protagonist, and he dispatches bad guys in each episode. It was a simple story. We began with a scenario. Music was composed next, and recorded with dialogue and sound effects, which were completed before we drew the pictures, basing the continuity on the soundtrack. We did this scientifically, even though the films were only five-or six-minute animation shorts. We were not able to draw pictures unless we could read music. So I took piano lessons, but I did not progress quickly because my fingers were already so stiff. I gave up at page sixty of the basic textbook. (Laughs) Female staff copied those original pictures onto celluloid one by one with ink.

MORI: Since there was no tracing machine at that time, you had to copy each one by hand.

ICHIKAWA: Yes. That was tedious work. For instance, we needed seven or eight pictures to show Dangonosuke moving one step.

MORI: The majority of contemporary commercial animation in Japan uses limited animation technique, which employs eight pictures per second.[3] How did you do it then?

ICHIKAWA: Our animation was detailed, using twelve pictures per second. Even when a character says a few words, we had to draw his full body. It was tough. It took more than six months for about ten staff members to make one short film.

MORI: Did you make a profit?

ICHIKAWA: Not at all. (Laughs) They were shown with feature films and newsreels, and I think it was okay. But it was brand new at that time. We enjoyed studying

Mickey Mouse, Betty Boop, and Popeye, and experimenting—we tried colour films, too.

MORI: Colour films?

ICHIKAWA: Not extensively. It was long before feature colour film. We just dreamed it would be great if cartoons were in colour. We painted three primary colours, red, blue, and yellow, one by one on our animation print. When we screened the print, the colour was visible. We cried out, "We did it!" (Laughs)

MORI: It sounds very primitive, but you seemed to be going back to the very origin of motion pictures.

ICHIKAWA: However, when the president Osawa started producing feature films himself, the talkie animation department was cut back, and I became the only animator. I did the scriptwriting, drawing, directing, photographing, and editing all by myself. I assigned the music to a composer, though. That film was *Shinsetsu Kachi-kachiyama*, one of the *Hana yori Dangonosuke* series. It was a very valuable experience to complete the entire process of making a film by myself. That experience was extremely useful when I later made feature films.

MORI: Was it then you wanted to move to feature filmmaking?

ICHIKAWA: I think I wanted to do that earlier. Uzumasa Hassei, a subsidiary of Nikkatsu, was making many feature films using J.O. Studio. Sadao Yamanaka made the great films *Kochiyama Soshun* and *The Village Tattooed Man* (*Machi no irezumimono*) there. I sometimes skipped drawing sessions to watch film shoots. (Laughs) When I watched a director, actors, and crew on a dusty set concentrating on a single aspect, I began to think that feature filmmaking was great.

Another reason I became interested in feature filmmaking was that J.O. also subtitled European films imported by Towa. There were many test screenings for checking the Japanese subtitles, which were of course restricted to those concerned, but the room next to the animation department happened to be the recording department. We could watch the screen through a small window in the recording department. I sneaked in to watch most of the films, such as uncensored versions of *Poil de carotte* (1926), *Ecstasy* (1932), *Leise flehen meine Lieder* (1933), and *Le Paquebot Tenacity* (1934).[4]

Feature Filmmaking

"I really wanted to move on to feature filmmaking." Again fate gave a helping hand to Ichikawa. J.O. started making its own feature films in 1935, and closed the talkie animation department. Ichikawa then successfully became an assistant director. "No more cartoons. Only the drama of human beings." After working on Mansaku Itami and Arnold Fanck's The New Earth, *Eiji Tsuburaya's debut film* Kouta tsubute: Torioi Oichi, *Eijiro*

Nagatomi's Katsutaro komoriuta, *Kon Ichikawa's actual career as an assistant director began with Tamizo Ishida's* Yoru no hato.

MORI: Assistant directors have to understand the film well, and they also have to be quick-witted and fast to take action. I assume that was a tough job.

ICHIKAWA: Now it is a bit different from those days, but it surely was a tough job. But I never thought it was hard or painful. Since it was my dream come true, I gave it my all. So, I think I was a good assistant director. I soon was able to clap a slate in one-sixth of a second. I was good at pushing a dolly, and climbing to the ceiling of a sound stage to make rain with a big watering can. Seniors told me that assistant directors must run. If you see a man running fast in a studio, he must be an assistant director. (Laughs) I used to run quite often. Of course I made a lot of mistakes, though, and was scolded.

MORI: What was your private life like? Since you were young, you must have gone out.

ICHIKAWA: While I was in the animation department, my mother sent me some money. After I became an assistant director, I made do by borrowing my monthly pay in advance. I listened to classical music or went out to cafés to talk about films with my friends. I played billiards, and bought books by Balzac and Gide. I was a typical film person. I was sort of in love with an actress. Later, I was given a combined nickname with another assistant director Sanpei (Toshio) Sugie, "Sanpei the love, Kon the love affair." It was only because it sounded good. I thought myself stylish, and ran up bills for clothes and shoes. Once I ran away by climbing up a fence at the back of the studio. (Laughs)

I moved into a duplex with my senior assistant director, "Brother" Kiyoshi Saeki. "Brother" was his nickname. He took care of me very well. We are still good friends. Shonosuke Sawamura, who moved from *kabuki* to J.O., was living next door; his brother Yunosuke Ito became a regular in my films.[5]

MORI: That is a strange connection. By the way, you watched many films before you entered J.O. What kind of films and which directors did you like?

ICHIKAWA: First of all, Mansaku Itami's *Kokushi muso*. Its montage of extraordinary titles, such as "perseverance," and fresh images were exquisite. The very humorous story was about a fake swordsman who manages to beat a real one. Minoru Takase's strange way of acting was also really funny. Itami's early works, all of which starred Chiezo Kataoka, were very modern and intelligent, and I was impressed. The crucial one was *Akanishi kakita*, whose original story was by Naoya Shiga.

MORI: What did you think about Masahiro Makino's period films?

ICHIKAWA: *Street of Masterless Samurai* (*Ronin gai*) and *Kubi no za* were good, but the most impressive was *Byakuya no utage*, scripted by Itaro Yamagami. As its subtitle *Prisoner of Life and Passion* indicates, it depicts an ordinary samurai's daily life and love. The film beautifully shows the coming destruction of the feudal system and the state of an ordinary samurai as a salaried worker. I saw it many times.

MORI: What did you think about Sadao Yamanaka, who died young? *A Pot Worth a Million Ryo* (*Hyaku-man ryo no tsubo*) and *Humanity and Paper Balloons* (*Ninjo kamifusen*) are highly regarded even now.

ICHIKAWA: He seemed to have been born for the movies. I was just fascinated by *Dakine no nagawakizashi*, *Koban shigure*, and *Jirokichi the Ratkid* (*Nezumikozo Jirokichi*). I was especially astonished by *The Elegant Swordsman* (*Furyu katsujinken*), which seemed to create a new film narration. His lyric and brilliant composition was unique, too. I admired him a lot.

MORI: I envy you because all of those films no longer exist. How about Daisuke Ito and Hiroshi Inagaki?

ICHIKAWA: Among Ito's films, I saw *A Diary of Chuji's Travels* (*Chuji tabinikki: Koshu satsujin hen*). I vaguely remember that my sister took me to it. I think *Zoku ooka seidan: Mazo hen* and *Samurai Nippon* are great, but the perfect one seems to be *Kobo Shinsengumi*. Among Inagaki's works, I choose *Yataro gasa*. It is a great depiction of the world of love and duty.

MORI: Almost all of them seem to be period films.

ICHIKAWA: Of course I also saw modern dramas, such as *Kono taiyo* (Minoru Murata), *Jean Valjean* (Tomu Uchida), and *Kokoro no Hitsuki* (Tomotaka Tasaka) from Nikkatsu. Among other studios' films, I was impressed by *I Was Born, But . . .* (Yasujiro Ozu), *Taki no shiraito* (Kenji Mizoguchi), *Kimi to wakarete* (Mikio Naruse), and *Kare to kanojo to shonen-tachi* (Hiroshi Shimizu).

However, I prefer period films. Among those I mentioned, *Akanishi Kakita* is a talkie and the others are silent. There was a Nikkatsu film theatre called Teikoku-kan in Kyoto, and there were popular *benshi*, Yoshito Imai, Nomura something and Ishii something. I forget their names. They interpret intertitles and dialogue, accompanied by a seven-or-eight-person orchestra. Their splendid tones perfectly matched the atmosphere of the films. I still think that silent films are the summit of film art. I am so sorry that I was not able to make a silent film myself because I was born too late.

MORI: I didn't know you were so infatuated with making a silent film. What did you think about foreign films?

ICHIKAWA: I admired Ernst Lubitsch, especially his *Design for Living*, a story of three men involved with one woman. The film was very subtle, and the refined and tasteful direction produced high-class eroticism. The cast was gorgeous, too: Miriam Hopkins, Gary Cooper, and Fredric March. In contrast, Lubitsch's *The Man I Killed* was a very serious drama. Both were excellent.

I also liked John Ford's *The Informer*, Fritz Lang's *You Only Live Once*, Frank Capra's *It Happened One Night*, Willi Forst's *Leise flehen meine Lieder*. I later learnt many things from, or simply enjoyed, Joseph L. Mankiewicz's *A Letter to Three Wives*, Orson Welles's *Citizen Kane*, Jean Renoir's *The River*, Jean Cocteau's *La Belle et la bête*.

Teacher

Who was Kon Ichikawa's teacher?

An easy answer is "movies." But the late Natto Wada, Ichikawa's wife and his partner in filmmaking, was his best teacher.[6] J.O. Studio, where Kon Ichikawa spent his training years, did not have an established apprenticeship like Shochiku. But Ichikawa worked with at least seven directors—Tamizo Ishida, Mansaku Itami, Kyotaro Namiki, Nobuo Nakagawa, Nobuo Aoyagi, Kiyoshi Saeki, and Yutaka Abe—when he was an assistant there. What did (and didn't) young Kon Ichikawa learn from these seniors, whose personalities and types of films were completely different?

ICHIKAWA: Tamizo Ishida was the first I worked with as assistant director, so I can't think of him without deep emotion. He was a heavy drinker, but warm-hearted. We learnt the rules of period films from the very beginning, not step by step, but by ourselves as we obeyed the director's instructions. For example, when I was told to bring a *yamamichi* [mountain road], I was at a loss because it was impossible. Then I was told the word meant a hand towel from the costume department. I understood that in filmmaking a hand towel with a pine leaf pattern was called "yamamichi." It seems like a tiny issue, but the accumulation of such details was important.

Regarding Ishida, he is famous for a moving *ukiyo-e*-like film *Osen* that he made when he was at Shinko Kinema. But I think *The Blossoms Have Fallen* (*Hana chirinu*) and *Mukashi no uta*, which I worked on, were excellent with their great scenarios by dramatist Kaoru Morimoto.

When *Mukashi no uta* was made, I was already a chief assistant director. I worked hard, because I thought Ishida put his trust in me when he told me to think about the music and title background. (Laughs) It was a story of the daughter of a ruined family set in Osaka in the early Meiji period. I decided to shoot the big steamboat which then ran between Osaka and Kyoto for the scene behind the titles, and we shot on location at Yodo River early in the morning. I also wrote the names of crew and cast on title boards myself. I decided to use the famous tune "Hamabe no uta" throughout the film instead of an ordinary film score. None of these seemed to fit in with the film's narrative, and they created strange effects. The director was satisfied, though, and I was very happy.

Ishida's brother Goro Kadono was also an assistant director on that film. He was a heavy drinker like his brother. He was a nice guy, too, and I have a lot of beautiful memories of them. He also became a director at Shintoho.

I worked with Mansaku Itami on *Gonza to Sukeju*. The chief assistant director "Brother" Saeki recommended me to the director. I was so happy because I could work with the director who made my favourite film, *Kokushi muso*. Itami

was not like an artist, but reticent and straight, like a teacher at a junior high school. His eyes were soft, but still scary.

One day, we shot Gonza and Sukeju in short coats carrying a palanquin on a street, and then we shot them coming home. When we saw the rushes, we realized that on the return, they were not wearing the short coats! We shot those two scenes on different days, and forgot about the short coats, so proper continuity was missing. "Brother" Saeki and I grew pale and went to the director's room to apologize, because we knew that continuity was the assistant director's responsibility. But Itami calmly said, "Why do you have to apologize? I was careless. Let's construct that set, and shoot it again." Since we had been afraid of being scolded, we were astonished and impressed. Itami was right. It was the director's responsibility, too, because he was making his film. But it is not easy to simply admit that. I thought Itami was a great director because of his confidence and tolerance. I'm not saying this because we were spared the scolding. (Laughs)

Itami's essays are great, as are his scenarios, particularly *Life of Matsu the Untamed* (*Muhomatsu no issho*). Whenever I write my own scenarios, I read that one again and again. Along with *Yojimbo*, written by Kuro-san [Akira Kurosawa], that scenario is a model.

I worked with Nobuo Nakagawa many times after I transferred to Kinuta Studio in Tokyo. By then, J.O. had become Toho. In 1939, when I was twenty-four, I came to Tokyo for Ishida's period film *Kenka tobi*. Nakagawa also moved from Kyoto. I worked with him mostly on films starring "Enoken" (Kenichi Enomoto). Nakagawa's filmic sense was superb.

He was living in a dull apartment room at Shimokitazawa. Of course, he was not married. He was rather quiet, and did not care much about his appearance. He was a heavy drinker. I can't drink, but ironically, I worked with many directors who drank a lot. Nobuo Aoyagi, whom I worked with next, was also a heavy drinker. (Laughs)

I think Nakagawa had lots of films he wanted to make, but he wasn't politic, and he undertook any project he was offered. Even though the material was not so great, the rhythm of his films was interesting. Enoken's talent was well displayed, and the shots were clever. I thought Nakagawa would make great films in the future.

Nakagawa let me revise the scenarios he did not like. I had submitted my own scenarios to the company, but they were never accepted. (Laughs) So, Nakagawa gave me a great opportunity. Even though only parts of them were based on my scenarios, it was great to see my own scenarios made into actual films, such as *Yajikita* and *Homare no dohyoiri* starring Enoken.

I was practically living in Nobuo Aoyagi's house. His wife and kids treated me like another family member. I have many good memories, such as writing

scripts for him, his teaching me how to gamble, drinking together, and so on. Aoyagi was originally a theatre director. He was theoretical, but he did not show it openly. He was rather lenient. He had many hobbies and friends, and a producer Jiro (Masayuki) Takagi, whom later I would work with when I made *Harp of Burma*, was also his pupil. I remember that we made a film with a strange title, *Yottsu no kekkon*, out of Osamu Dazai's *Kajitsu*.

Kiyoshi Saeki was more my best friend or my brother than my teacher. I worked with "Brother" Saeki for his debut film *Appare Isshin Tasuke*, whose script Kuro-san wrote.

Yutaka Abe named me as his assistant director because he liked the way I played mah-jong. He was about to go to Palau in the South Pacific to shoot *Nankai no hanataba*, and was looking for a substitute chief assistant director, because his got sick. When he was driving through Omotesando, he remembered me as a "vigorous" one. (Laughs)

We flew to Palau on a big Kawanishi-style seaplane, which was rare at that time. I was expecting a lot, because it was my first shoot abroad, especially in the South Pacific. The project was great, and the director was the famous Yutaka Abe. But it turned out to be tough.

We went in August 1941. The shadow of war was coming close to the islands. Abe had not started shooting even by November; he didn't like the script. Staff members grew exhausted, and the U.S.–Japan relationship seemed strained. So, I asked him to start shooting. An assistant director would not normally say such a thing, and I decided to resign when I got back to Japan. Abe finally began work, and we shot scenes from a plane of an island girl running among the palm trees. We returned to Japan by boat about a week before the Pacific War began on December 8. If we had stayed longer, we might not have come back alive. We narrowly escaped death.

After the war was over, I worked with Abe on *Utae! Taiyo*, *Ai yo hoshi to tomoni*, and *Hakai*, which was never completed, and I learnt his unique way of directing. I was impressed by his directing, which excluded anything unnecessary, not only in composition but also in action.

War

ICHIKAWA: When I was an assistant director, I lived my life just to become a director. However, as the Pacific War intensified, it was impossible to continue thinking that way. We were told that film is a bullet, and were unable to make films freely.

The war affected me directly. "Please forgive me." "Stop it, please," I thought so many times. I hoped I would never receive my call-up. I kept telling myself

that I shouldn't worry because I was not one who fought for war. The induction notice came in the end, though. (Laughs) I was a bit shocked when it arrived. (Laughs) It was early 1944, and the warrant was from Hiroshima. My sister Chie remarried in Hiroshima, and my mother also lived there. So my legal domicile had been transferred to Hiroshima. I received some money from the studio, amulets from my friends, and I went to the regiment in Hiroshima.

First we had the physical examination. There were two army surgeons. One was old, the other young. The line for the old surgeon moved very slowly while the line for the young one moved very fast. That means the former examined very carefully, the latter briefly. The latter seemed better to me, and I waited in his line. That was the crossroads of fate. The young surgeon asked me if I had any illnesses, and I answered not now but I was once diagnosed with spinal caries. He told me to bend my back. I did. He spanked my back, and said, "Your back bends all right! That's it!" While I was dressing, I regretted that I might have been exempted from military service if I had pretended that my back hurt.

We had to form two rows in a school yard. A sergeant with many call warrants said, "The ones I call must go home right now for physical reasons. You must be sorry, but devote yourself to the nation in the outside world." The first warrant he had was partly torn, and fluttered in the wind. My warrant was torn when it arrived. That may be mine by chance! No, it mustn't be. Two opposite thoughts struck me at the same time. At that moment, my name was called. I answered obediently and stepped forward. I should not look sorry, never mind happy. What kind of expression did I have? (Laughs) Only four of us went back home right away among hundreds of enlisted men.

I received the second warrant in April 1945, near the end of war. It was from Hiroshima again. This time I thought I had appendicitis, and mentioned it when I had the physical examination. The army surgeon asked me which doctor I preferred to have operate on me, an army surgeon or my family doctor. I answered that I preferred the latter, and went back to my family. To tell the truth, I did not have any family doctor. But, when I went to see a doctor in Hiroshima just to make sure, he told me that I should have come earlier. I was on the verge of having peritonitis, and had an operation right away. (Laughs) I saved my life because of the second warrant.

When I left the hospital, I went to the city office to ask what I should do next. They had no idea, and sent me back to Tokyo. I returned to Tokyo, and the war came to the end. Soldiers had been expendable; those who didn't know how to handle a gun were sent to fight.

On August 6, when the atomic bomb destroyed Hiroshima, my family was living there. That morning, when I arrived at the studio, the head, Iwao Mori, told everyone with a sorrowful expression that a new type of bomb had been dropped on Hiroshima and the situation was terrible. I was anxious, and wanted

to go back to Hiroshima as soon as possible. They stopped me by saying that strong gas was seeping from a heap of rubble, and I would die if I breathed it. They meant radioactive contamination. Confused by a lot of conflicting information, I finally received a letter from my family. Miraculously, all of them were safe. I flew back to Hiroshima, and saw the terrible aftermath of the bomb. I tried to find where my house used to be, but in the barren ruins, it was impossible.

A Girl at Dojo Temple

Several months before the end of the war, Kon Ichikawa directed a twenty-minute puppet film, A Girl at Dojo Temple *(Musume Dojoji, 1945). It is interesting that Ichikawa made a puppet film after his experience in animation and before directing feature films; puppet films are a unique genre that allows a director to control the images because, like animation, they do not use actors. However,* A Girl at Dojo Temple *was an ill-fated film that was never shown in theatres because of the aftermath of the war.*

MORI: *A Girl at Dojo Temple* was made for an international audience, wasn't it?

ICHIKAWA: Yes. The army was making consolation films for southern countries at that time, and Toho was asked to make some of them. Toho thought that because it was a puppet film, assistant directors were more suitable to direct. Tacchan (Tatsuma) Asano and I were chosen.

MORI: Who chose *A Girl at Dojo Temple*?

ICHIKAWA: I did. We could choose anything. First I tried to make Ryunosuke Akutagawa's *Hana*, and I even started writing a scenario. I changed my mind and instead reinterpreted the classic *Dojoji*, because I thought it would be better for foreign audience to see something Japanese and gorgeous. I wrote the script with my friend Keiji Hasebe.

MORI: It wasn't just the story of Anchin and Kiyohime, in which a girl turns into a serpent. You were already trying to approach the original from a new perspective.

ICHIKAWA: Yes. I wanted a more abstract and creative story of a young bellmaker and a princess who helps him.

MORI: It is very interesting to watch the early development of your films' unique characteristics, such as extreme close-ups and long shots, effective usage of silhouette, and quick editing of short shots.

ICHIKAWA: I made Kiyohime's dance the film's climax. I tried elaborate lighting techniques to show the puppets. The puppet master was Magozaburo Yuki, the singer was Ishiro (later Ijuro) Yoshimura, and the *shamisen* player was Kisaburo Okayasu. All of them were sort of living national treasures. I had a great crew.

MORI: Did you like *bunraku*, the puppet *joruri*?

ICHIKAWA: Yes. I liked *kabuki*, too. I often used to sit in the upper gallery, because of my financial situation. (Laughs) *Bunraku* shouldn't be watched from far above, though. It should be watched from the same level as the stage. Anyway, I went very often for study and for fun.

MORI: I am sorry that your debut film was not publicly shown.

ICHIKAWA: The film violated the censoring system of GHQ [General Headquarters of the American occupying forces]. Films whose scripts were not censored before shooting were not allowed to be publicly screened. We started making *A Girl at Dojo Temple* before the war was over, and completed it in the fall of 1945. There was no such censor system when we started. So, *A Girl at Dojo Temple* was a victim of the war, so to speak. I was very sorry because that was my first drama, though it was a short.

I started shooting the second puppet film before the war was over. It was called *I Became a Cat, But . . . (Neko niwa natte mitakeredo)*, an original animal story, in which a mouse turns into a cat. It was cancelled because Japan lost the war.

The Toho Strike

On August 15, 1945, the war was over.
Kon Ichikawa heard the news in a small rented house near the Toho studio, where he was repairing the ceiling destroyed by an incendiary bomb.

ICHIKAWA: I cried out that I could become a director at last. Yes, I went to a stand in Shinjuku and drank sake, even though I usually can't drink.

However, even film studios, the "dream factories," could not escape from the postwar social disorder. The Toho Strike, which split Toho's union in three, continued for three years. When the union occupied the studio, tanks and planes were sent in. It was said that "the only thing that did not come was a battleship."

ICHIKAWA: Many of the staff fast became devoted to leftist thought. I didn't sympathize with them so much. Of course, rightist beliefs were out of the question. I called myself a "humanist."

On November 17, 1946, however, Ichikawa became involved in the strike when a union party was held at the studio's big stage. After an intense debate lasting twenty-four hours, those who supported "Junin no hata no kai [The Ten Flags Group]," which was formed by ten film stars, including Denjiro Okochi, Kazuo Hasegawa, Susumu Fujita, Setsuko Hara, and

Hideko Takamine, finally left the Union and locked themselves in a screening room. They were against the leftist union executives. Every person in the studio had to choose a position.

ICHIKAWA: It was really a fierce and dramatic union party. Representatives of each group talked on the stage one after another, and both of them were appealing. The leftist group was theoretically consistent, though. I did not intend to support either of them, and I thought films could not be made only with theory. I decided to join the group that left the Toho Union, because it was smaller in number, and I naïvely thought it would be tougher to continue making films with small numbers of people. (Laughs) I informed other assistant directors of my decision and entered the screening room, where I was welcomed by huge applause. They needed as many people as possible, just like in an election.

Natto-san

The group that left the Toho Union created a new union, which became Shintoho. They started making films at Toho's second studio, located on a hill near the main studio. In a head-hunting competition between the two unions, Ichikawa played an active part in public relations, using his visual gifts to draw promotional posters. It was during the Toho Strike when Ichikawa met his lifelong partner and best collaborator, Natto Wada (her real name Yumiko Mogi).

ICHIKAWA: When I first met her, I thought she had beautiful eyes. She was clever, and modest. She had graduated from the department of English literature at Tokyo Women's Christian University, and she was working as a translator at the Toho studio. She was also in the group that left Toho. We got along very well from the beginning. We talked a lot about films, but I never thought about her becoming a scriptwriter. I believe it did not even occur to her.

We decided that we would get married after I had made one film and the prospects for my career as a director had improved. To tell the truth, both of us had failed in marriage once, and we were careful. I cannot talk about Natto-san briefly.

In the same year, Ichikawa worked on 1001 Nights at Toho *(Toho senichiya, 1947). Some say that this was his debut film.*

ICHIKAWA: No, no. I was not considered the director of this film. It introduced Shintoho studio, with some songs. In its credits, I called myself an "organizer." My debut film was *A Flower Blooms* (Hana hiraku, 1948).

Notes

1. A series of short fantasy films starting from 1929 with "Skeleton Dance." Seventy-three films were made by 1939. They include many masterpieces, such as *Flowers and Trees*, which combined classical music and animated images.
2. The state-of-the-art studio, which was constructed at Kaiko no Yashiro in Kyoto in 1933. In 1937, J.O. was merged with P.C.L. and Toho Film Distribution into Toho Film Co.
3. In animation, the same picture is usually photographed in more than one frame. Among twenty-four frames per second, twelve pictures or eight pictures create moving images. Of course, the more pictures, the smoother the movement. When a person or a thing moves, full animation uses all the different pictures to show the movement. Limited animation keeps one and the same picture as a base, and just moves only the parts, such as the hands or mouth.
4. A nation-wide censoring of films existed in Japan, which followed the Department of Interior regulation of 1925, "The Rule of Censoring Motion Picture Films." Scenes considered to disturb public order and public morals were often cut. *Grand Illusion* was unable to be shown because of too many cuts. In *Poil de carotte*, dialogue involving kissing and the scene in which the protagonist attempts suicide were cut. In *Le Paquebot Tenacity*, scenes of kissing were cut.
5. Yunosuke Ito was born in Tokyo in 1919. In 1946 he debuted in a Toho film *Inochi arukagiri*. He played a leading role for the first time in Ichikawa's *Pu-san* (1953). He is oval-faced, tall, and is indispensable in Ichikawa's films for his unique appearance. His role as a bus hijacker in *Taiyo wo nusunda otoko* was particularly impressive in his later career. He is the author of *Daikon-yakusha: Shodai Monku-iu-no-suke* [Amateur Actor: The Man Who Complained First, 1968]. Ito died in 1980.
6. Natto Wada, whose real name was Yumiko Ichikawa (maiden name Mogi), was born in Himeji on September 13, 1920. She graduated from the Department of English Literature at Tokyo Women's Christian University, and married Kon Ichikawa on April 10, 1948. As a scriptwriter, she wrote many masterpieces. On February 18, 1983, she died of breast cancer.

Translated from the Japanese by Daisuke Miyao

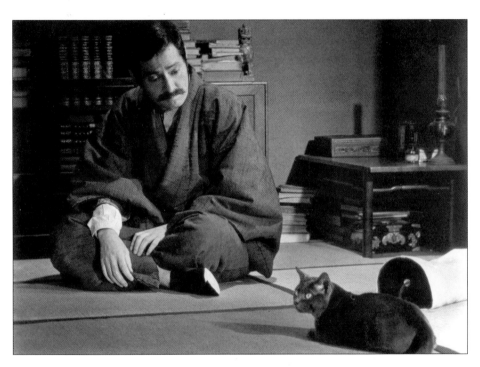

I Am a Cat

AUDIE BOCK

Kon Ichikawa

> Because he makes films only for the sake of making films, Kon Ichikawa's work has a kind of innocence and very pure pleasure. In the technical realm he has been the most influential in pointing out directions for the avant-garde of my generation.
>
> — MASAHIRO SHINODA

KON ICHIKAWA, a cigarette clamped between his teeth, his head cocked to one side, then to the other, and gesticulating for emphasis, loves to talk. He not only talks, with a broad western Japanese accent, but has written with equal enthusiasm about himself and his work, and his view of what movies are.

In his writing as well as his conversation, certain terms emerge with such frequency that they must be taken as guiding principles. "Contemporaneity" and "self-exploration" retain for him special significance that in turn applies to "aesthetic consciousness" and "self-expression." In the course of his thirty-odd years as a director, the content, tone, and look of his films have necessarily varied in keeping with these principles, of which "contemporaneity" remains the most basic. "Movies move," says Ichikawa, "with an overwhelming concreteness, unlike music and literature, which can create an atmosphere that transcends time."[1] The feature film is, in Ichikawa's mind, inextricably tied to the present, in everything from the living people and landscapes it records to its editing style.

Ichikawa insists that since film is a temporal art of such vivid concreteness, the thought that goes into its making must also be contemporary. He strives to be a man of his times, which undoubtedly accounts in large measure for his persistent energy. His approach to his times entails interpreting the works of his literary contemporaries for the screen. Regarding his start as a director he said, "My own life experience was not very rich, [so I decided to] absorb other people's ideas in my

own way, and see what sort of answers emerged from putting them on film."² He has tackled a surprising diversity of material, from serious novels by Junichiro Tanizaki (*The Key*) and Yukio Mishima (*The Temple of the Golden Pavilion*), to Taizo Yokoyama's famous comic strip, *Mr. Pu*. Not content to select subject matter from the present to reflect his sought-after contemporaneity, he has gone back to the past to reinterpret not only turn-of-the-century novels by Soseki Natsume (*Kokoro* and *I Am a Cat*) and Toson Shimazaki (*The Broken Commandment*), but also pre-World War II films by Teinosuke Kinugasa (*An Actor's Revenge*) and Yutaka Abe (*The Woman Who Touched Legs*). In the mid-1960s he began to delve still further into contemporaneity by making documentaries, such as the deeply moving 1965 *Tokyo Olympiad*, one of the first sports documentaries to favour people's feelings over the simple recording of events.

Emerging in the immediate postwar generation of directors, along with Akira Kurosawa and Keisuke Kinoshita, Ichikawa began as a maker of melodramas. These were succeeded by the ironic comedies that won him a reputation as spokesman for the postwar frustrations felt by the little man. When he then went on to do literary adaptations that included war films as well as stories about young renegades and lascivious old men, it was the critics who became frustrated. Ichikawa's constant search for new challenges through his subject matter has made him impossible to label. He himself has said, "I don't have any unifying theme— I just make any picture I like or any that the company tells me to do."³ He has therefore suffered accusations of immorality, absence of world view, and other notions, usually including that expressed by director Nagisa Oshima: "He's just an illustrator."⁴

Yet Ichikawa's evasion of labels does not diminish the clarity of his idea of what good filmmaking is. His ironic characterizations, breathtaking compositions—he is unquestionably one of the best manipulators of widescreen in the world—and abrupt editing style have assured his own aesthetic consciousness a permanent rank in contemporary film history. If his irony and aestheticism do not sit well with Japanese critics oriented to social problems, they are warmly received abroad. Since Ichikawa won the San Giorgio Prize at the 1956 Venice Film Festival for *Harp of Burma*, his foreign devotees wait with eager anticipation for each new film.

Illustration as Approach

Born in what is now part of the city of Ise in Mie Prefecture, Ichikawa grew up as a rather sickly child and spent most of his free time drawing. Asked what he wanted to be when he became an adult, he would invariably answer, "a painter." As a boy he also became an avid movie fan, going to see all the great pre-war samurai movies.

He soon became enthusiastic about foreign films as well, notably Charlie Chaplin's, and began to ponder how he could combine a painter's career with this twentieth-century moving art. His revelation came through Walt Disney. "Seeing *Mickey Mouse* and *Silly Symphonies*, I realized that pictures and film were deeply, organically related. All right, I decided, I'm going to try making animated films too."[5] Disney was the catalyst that opened Ichikawa's eyes to his own possibilities in film, and he long continued to name Disney and Chaplin as his ideals. This was not so much for their direct influence on his work (although the father in *I Am Two* is moved to buy a television set when he hears that his little son likes cartoons, and the same film contains a kind of *hommage à* Disney animated banana sequence), but for their method of production: "self-capitalized, self-written, self-directed and self-distributed. I think this is the fondest dream of the film artist."[6]

In the 1930s Ichikawa finished technical school in Osaka, and, hearing that J.O., a rental film studio in Kyoto, had its own animation department, he went to work there straight away. When J.O. later became a full-fledged production company, Ichikawa would experience the kind of work responsibility that was his ideal. The animation department was dissolved, and he alone remained to think up the stories, write the scenarios, supervise the painting and photography, and edit each animated film.

Later, Ichikawa was shifted to the position of assistant director in the new feature-filmmaking staff. He worked under four different directors, all of whom he admired as strong individualists. Among them was Yutaka Abe, who had received his film training in Hollywood as a member of Sessue Hayakawa's retinue (Abe played Hayakawa's valet in Cecil B. DeMille's 1915 *The Cheat*). Paying the highest possible tribute to his mentor, Ichikawa remade Abe's 1926 comedy, *The Woman Who Touched Legs*, in 1952. But always true to himself, he did it in his own way, giving it a coherent plot and animating parts of it.

By the time the Pacific War began, J.O. had merged with P.C.L., a company that made advertising films, to form the Toho feature film company, and Ichikawa was transferred to Tokyo. There, during the war, he worked on his first feature. *A Girl at Dojo Temple* was originally planned as an animated film, but since this would have required too much work at a time when there was a shortage of labour, he made it with puppets instead. It is noteworthy that he at first wanted to adapt Ryunosuke Akutagawa's *Rashomon, In a Grove* (later these formed the basis for Kurosawa's famous international success in 1950), or *The Nose*, but he was told that these were material for a great director and not a beginner like himself, so he went to the *kabuki* story *Musume Dojoji*.[7] But the war ended before the film could be released, and the U.S. Occupation authorities confiscated it because the scenario had not been submitted for prior censorship review. To this day Ichikawa does not know what happened to his debut creation; all that remains of it are his planning sketches.

Ichikawa takes the epithet "illustrator" as anything but an insult. It was with the intention to illustrate that he began his filmmaking career, and he still calls himself an illustrator. Since an illustrator is necessarily concerned with composition, one can safely say that a good measure of his films' breathtaking "Ichikawa look" is due to his illustrator's eye. But perhaps more than anything else, this attitude expresses the humility with which he approaches his subject matter and the reliance upon others—especially his wife, Natto Wada—to which he readily admits.

Natto and Literature

Asked why so many of his films are literary adaptations, Ichikawa first responds, "Pure coincidence," but on further reflection he decides it was "because I started working with my wife."[8] Script collaboration with Natto Wada, who had a special flair for literary adaptations, goes back to before they were married and the first film Ichikawa calls his own, *A Flower Blooms*, released in 1948. It was Wada who suggested Ichikawa try adapting Yaeko Nogami's novel for the screen. By 1949 Wada had joined the staff as co-scenarist on *Human Patterns*, and she would remain Ichikawa's closest collaborator through the 1965 *Tokyo Olympiad*.

Ichikawa has described their system of scriptwriting as something like living with the material.[9] They would both read the novel (almost invariably a company assignment), discuss it, and develop the script over a period of months in the course of their daily activities. The basic tone of the film would be decided first—melodrama, comedy, thriller—then the dramatic high point determined, and the number and personality of the characters decided. From that point they worked on the settings and dialogue, and Wada would do the final write-up.

The director looks back on those days with obvious nostalgia. "Women . . . well, my wife is very meticulous," he sighs, "so she always did a complete and beautifully detailed scenario" from which he could proceed directly to mapping out the continuity, compositions, and camera set-ups. "The way movies are made nowadays there isn't time to do that, and here I am still reworking the dialogue and even worrying about the casting after shooting has already begun [on *Rhyme of Vengeance*]."[10]

After *Tokyo Olympiad*, with such fine scenarios as *Harp of Burma*, *Enjo* (*Conflagration*), *Kagi* (*The Key*), *Fires on the Plain,* and *Bonchi* to her credit, Wada retired from scriptwriting. Ichikawa explains that his wife feels that humanity is gone from the contemporary cinema. "She doesn't like the new film grammar, the method of presentation of the material; she says there's no heart in it any more, that people no longer take human love seriously."[11] And indeed if one compares a Wada scenario like *Harp of Burma* or *I Am Two* to any Ichikawa has directed since 1965, it becomes

apparent that while humour and feeling for the human condition remain, some of the warmth of affirmation and optimism is gone.

Recently, Ichikawa has worked frequently with scenarist Shuntaro Tanikawa, whom he names as his favourite collaborator. "But," confided one of his producers, "when we really want Ichikawa to do something, the only way to get him to change his mind is through his wife."[12]

"Christie" and Humanity

If Natto Wada's collaboration has been a great asset in Ichikawa's serious literary adaptations and his early melodramas, his own personal taste runs in the vein of thrillers and biting satire. Since the immediate postwar era when translated foreign mysteries became extremely popular in Japan, Ichikawa has read everything he can get his hands on. His idol is Agatha Christie, whose view of human nature fascinates him. "I can't understand why she was never given a Nobel Prize," he says.[13] He has such great admiration for her that since 1957 he has used the penname "Christie" for his own scenarios, of which *The Pit* and *Devil's Bouncing Ball Song* have actually been thrillers. "Unfortunately," he laments, "when I'm working on a thriller myself, I can't stand reading those written by others, so one of my favourite pastimes has to be suspended."[14] As testimony to Ichikawa's abilities in the genre, his adaptation of mystery writer Seishi Yokomizo's *The Inugami Family* was the biggest Japanese movie hit of 1976, grossing nearly six million dollars.

What may be the key phrase in Ichikawa's description of his passion for mysteries is "view of human nature." He himself is able to deal with all kinds of material because he seeks to interpret different views of human nature, and in so doing find and express his own. The result is a very clinical examination of human motives that leads him away from sentimentality and toward irony. He would like to be more optimistic. "I look around for some kind of humanism," he has said, "but I never seem to find it."[15] It is from his objectivity that both his comedy and tragedy emerge, for at times the attempt to deal with the human condition is comically pathetic, as in *A Billionaire*, and at times it is tragically ironic, as in *Fires on the Plain* or *Enjo*.

Ichikawa used to divide his works into "dark" and "light" moods. He no longer does so, recognizing that his ironic view of human beings places both tones within the same film. In *I Am a Cat*, for example, the cat who observes the comic foibles of the humans around him ends his frustration by committing suicide in despair. Yet the moment his corpse is found floating in a barrel of water is one of the funniest in the whole film. Ichikawa admits he has tendencies toward black comedy—although at the time he vigorously denied that *Kagi* was a black comedy—and says

he would like to be able to make a real one, "but in Japan it's impossible. In any case, I'm a very light person, so I'm irresistibly drawn to dark things."[16]

Production and Perfection

Ichikawa, who admires Kurosawa very much, always describes him as a perfectionist and admits that he himself has many of the same tendencies. Time and money, the most difficult-to-come-by requisites in filmmaking, are the causes of chagrin for both directors. Ichikawa's arguments with the production company over his first war film, *Bengawan Solo*, as far back as 1951, caused him to virtually disown the film. Unable to meet the shooting schedule, he lost editing control to the producers and even saw footage shot by someone else put into the final product.

The most famous imbroglio occurred over Ichikawa's beautifully humanistic *Tokyo Olympiad*, which marks a near revolution in sports documentaries. The finished two-hour-and-forty-five-minute film, on which Wada also worked, eschews the mechanical recording of each event to close in on the emotional reactions of both participants and audience, and the story within the big event of the lonely runner from the brand-new African country of Chad brings out the full meaning of the Olympics on an individual scale. The company, having expected television-style records of scores and fast finishes and no more, expressed outrage by claiming one could not tell if the film was about the Olympics or about people. The foreign versions of the film were pared down to half the full length, Ichikawa left the Daiei company for good, and the film went on to claim the biggest box office to that date in Japan.[17] In short, Ichikawa insists on being allowed to make his own kind of film. No matter what the original impetus for a particular work, Ichikawa says, "I'm happy if I can express myself through it."[18]

Observing Ichikawa on the set one gets some idea of what his perfectionism consists of. He is everywhere, altering lighting, checking camera angles, joking with the staff, and jumping in to coach the actors between shots. The atmosphere is busy, but not hectic, as his authority keeps everything running smoothly and cheerfully.

Ichikawa used to draw up "continuity"—in Japan this means shot-by-shot measurement and design of each cut in advance so as not to waste any film stock—but now there is no time for this. He relies heavily on the staff to turn out a fast, quality production. He has not only preferred scenarists, but favourite cameramen, composers, art directors, and lighting experts. However, he is always ready to move with the times, as his beloved contemporaneity requires changes in personnel to achieve changes in style. This is especially true for his casting, which he says consti-

tutes sixty per cent of the finished film (in 1960 he ascribed seventy per cent to this aspect), "because the actors have to convey the intentions of the director, who does not appear before the cameras."[19]

However, despite the high percentage Ichikawa assigns to the importance of casting, he is tempted to give equal weight to editing. Once the film is shot, Ichikawa spends an equal amount of energy dubbing in the sound and supervising every cut, again to the chagrin of impatient producers. Here too is a source of the "Ichikawa look"—those abrupt cuts and startling sound effects.

Ichikawa has devoted years of study to the directors of the past, including Mizoguchi, Ozu, Kurosawa, Kinoshita, and recently Pasolini. "I learned a tremendous amount from them," he admits, "and then I started, all over on my own."[20] As meticulous as the planning may be, each film is a new experiment for him, and he maintains that only God knows what the result will be. "A director says at the outset, 'I want to convey this particular idea or bring out that particular feeling of a work, but he never knows what he will do until he has done it. Then he can look at his film and say, 'Oh, so that's what I meant.'"[21] It is because of this youthful energy, curiosity, and spirit of adventure that an Ichikawa in his sixties is still one of the most modern and active directors in Japan.

Irony in Self-expression

Like Keisuke Kinoshita, Ichikawa has made a transition from comedy to tragedy in the course of his career. But unlike Kinoshita, Ichikawa did not progress from humour into sentimentality, which is perhaps one of the reasons he has not been favoured by Japanese critics. Just as he has said he looks for humanism but cannot find it, he feels that the same objectivity that rejects sentimentality gives rise to comedy.[22]

In the first half of the 1950s, Ichikawa's most successful films, including *Pu-san, Mr. Lucky, The Blue Revolution,* and *A Billionaire*, were all comedies. The basis of the humour in these works is comedy of manners, as in the great Kinoshita comedies, but their pure Ichikawa flavour resides in their ironic view. The hero of *A Billionaire* provides a typical example of the failure of goodness as a principle for dealing with reality. A new employee of the income tax office, he is sent out to investigate a case of chronic tax evasion. The family in question lives in a hovel with eighteen children and a demented boarder upstairs who has not paid any rent in over a year and, when she is not working on a road construction crew, spends all of her spare time manufacturing an atomic bomb. The family, whose business failed years before, looks with envy at the tax official's lunchbox, extravagant by their standards. This same lowly government employee goes on to arouse widespread indignation by

confessing to taking a bribe—of 10,000 yen (about $30)—over which he tries to commit suicide, and in the process inadvertently exposes a huge tax fraud by a politician. In a touch that remains highly contemporary, the politician's refrain on the witness stand is "I have no recollection…" Ichikawa's ironic message is that the tax laws, designed for justice, oppress the poor while the rich go on abusing them, and the normal working of society sees the honest man as a mere troublemaker. When society is held up to objective scrutiny, ethical standards are a mere illusion.

The leap from comic pathos to ironic tragedy is not so great as it might seem, as Ichikawa's analytical approach to human behaviour bridges the two. In 1955, he began making films with obsessive tragic heroes whose anguish is that of the soul. Even when material suffering is involved, as in *Fires on the Plain,* where the Japanese soldiers are starving, diseased, and ill-clothed, the spiritual issues are greater: the senselessness of war, the failure of religion to preserve human decency or even to console, and the most horrifying negation of the humanity of one's fellow man—cannibalism. Consistently throughout, from the 1955 *Kokoro* to the 1973 *The Wanderers,* Ichikawa rejects the sentimentality of the happy or warmly tearful ending. His tragic heroes, like his comic heroes before, remain condemned as outcasts, rebels, obsessed or inconsolable. But this harsh perspective on life finds some mitigation in moments of humour and an exquisite audio-visual presentation throughout.

Kokoro marks the beginning of Ichikawa's grim psychological studies. Based on Soseki Natsume's early twentieth-century novel, it presents a middle-aged hero, "Sensei" ("teacher"), who is so obsessed by guilt that he ends by destroying himself. The young student who adopts this man as his mentor begins to wonder why he isolates himself from society and treats his wife with such coldness. The answer comes in a letter written to the student prior to Sensei's suicide. For his entire adult life he has felt responsible for the death of his closest school friend, who committed suicide when Sensei won the hand of the woman whom the friend had confided he wished to marry himself. Sensei has never been able to tell his wife the truth, with the result that he has closed himself off from her over the years as the living symbol of his guilt. The final denial of solace through human communication comes at the end, when the student, who has rushed back to Tokyo from his dying father's bedside at the news of Sensei's death, is turned away by the bereaved wife.

Even this bitterly pessimistic story, shot in beautiful monochrome shadowy interiors and stark landscapes, has humorous punctuation. After a long and serious discussion in a bar, Sensei leaves the student alone to continue drinking, but the boy finds the bottle empty. Later in a park, the two sit down on a bench and unwittingly frighten off a pair of newlyweds. No viewer can suppress an ironic smile as the student's mother tries to put his university diploma on display and it keeps falling down, or as a yawning postal messenger delivers a telegram bringing desperate news.

Ironic reversal prevails even in a film with a message of benevolence like *Harp of Burma,* made the year after *Kokoro* and Ichikawa's first prize-winning work. The story of the Japanese soldier who foregoes repatriation to remain in Burma at the end of the Pacific War in order to bury the dead can move the susceptible to tears. His vain efforts to persuade a hysterically fanatical group of his countrymen to surrender rather than die following the armistice, and his subsequent horror and pity facing the innumerable Japanese corpses strewn around the countryside never fail to inspire. When he plays familiar melodies on his Burmese harp, and British and Japanese soldiers raise their voices together to the tune of "Home Sweet Home," *Harp of Burma* really seems to show "men's capacity to live with one another" for which it won the Venice San Giorgio Prize. But often overlooked is the fact that this army private turned Buddhist monk has survived to become a doer of good deeds because he was rescued and nursed back to health after the massacre of the Japanese holdouts by a real Buddhist monk, whose robes he then stole with the simple intention of disguising himself to traverse the Burmese countryside unharmed. All of his exemplary moral conduct thereafter is made possible by this most ungrateful, but very human, act of base thievery.

Like *Harp of Burma, Fires on the Plain* shows the Japanese at war in Asia in an adaptation from a novel. But while Shohei Ooka's novel is narrated by a man who is repatriated and recovering, with a new Christian view of life and suffering, Ichikawa's hero is condemned, walking with his hands raised into Filipino peasants' rifle fire. Nor is this hero a moral paragon, outraged as he may be by his comrades' cannibalism. Not only does he kill the Japanese purveyor of "monkey meat," but he murders a defenceless Filipina woman in cold blood simply because she screams in terror at the sight of him.

The spiritual wasteland of *Fires on the Plain* too abounds in humour that is so ironic as to be macabre. Audiences laugh uproariously when a dying man no longer able to move points to his arm and says to the shocked hero, "You can eat this part," and when the unwary hero allows a wily old gangrenous soldier to rob him of his only valuable possession, a single hand grenade. In Ichikawa's bleakest film, this humour relieves only momentarily; its after-effect compounds the gloom.

Ichikawa reaches his peak of macabre humour with *Kagi,* his free adaptation of Junichiro Tanizaki's novel. The core group of unsavoury characters offers not one with any redeeming qualities. An elderly Kyoto gentleman of some means knows that his physical stamina is deserting him, but is determined to maintain a sexual relationship that satisfies his beautiful younger wife. He discovers that he requires not only drugs, but jealousy and prohibition to keep himself aroused, and he draws his daughter's future husband, who hopes for financing for his own hospital in exchange, into a relationship with his wife. Everyone in this little circle, including the falsely modest wife, knows what everyone else is up to. The whole game culminates in the old man's death from overstimulation, to no one's surprise but the

maid's. When the plain daughter then realizes she will have to share her husband with her mother, she tries to poison her, only to be outdone by the maid, who poisons all three of them. In this final twist—a surprising addition to the novel—laughter closes the film. The maid confesses she has killed all those horrible people, but the police think she is simply delirious with grief and send her home. Although Ichikawa has insisted that this film is not a black comedy, he does allow that of all the authors he has adapted, he feels his own aesthetic consciousness is closest to Tanizaki's, and that this proximity has something to do with perverseness.[23]

Obsessive, isolated protagonists continue to parade through Ichikawa's works, from the pariah schoolteacher who is "passing" in *Hakai* to the three country boys devoted to the gangster code in *The Wanderers*, and even to the philosophical cat who relinquishes life in despair in *I Am a Cat*. But of all the twisted, frustrated, paranoid heroes in his films, his own favourite remains the stutterer acolyte of *Enjo*.[24]

Enjo (*Conflagration*)

Ichikawa's favourite film was not one he wanted to make. He rejected the proposal several times, fearing that a film based on Yukio Mishima's bestselling *Kinkakuji* (*The Temple of the Golden Pavilion*), because it was such a highly abstract and conceptual novel, would turn out to be nothing more than a digest.[25] Finally, he allowed himself to be persuaded, recognizing the necessity of putting his own interpretation on the work. He expended four months from initiation to completion of the scenario and location hunting.

With his scriptwriters Natto Wada and Keiji Hasebe, Ichikawa assessed the various possible interpretations of Mishima's novel and met also with the author himself. The conclusion, despite Wada's wish to fashion the film into a melodrama, was to make the complicated, perverse, and finally perverted acolyte Mizoguchi into an absolutist whose own standard of purity finds nothing in the real world that measures up to it. As the primary source of Mizoguchi's disillusionment, they decided to focus on the relationship between his parents.[26] In the film, Mizoguchi (played by Raizo Ichikawa) therefore emerges as a much more sympathetic character than in the novel, and his mother takes on qualities of dim-witted villainy.

Ichikawa tells the story in flashbacks, beginning from Mizoguchi's interrogation by police after he has burned the pavilion (called "Shukaku" in the film because of opposition to the use of the real name by Kyoto monks).[27] The central time frame of the film begins with Mizoguchi's arrival at the temple and builds up to his act of arson, after which the opening time frame resumes, and the film ends with investigators getting out of a car to examine his corpse, covered with a straw

Enjo

mat, on the ground where he jumped from the train that was taking him to Tokyo for incarceration. But within the central time frame there are also flashbacks to a third time and place: the lonely coast of northwestern Japan where Mizoguchi spent his childhood. By interchanging these time frames, Ichikawa picks out the incidents and images from Mizoguchi's life that shape his obsessions and build his motivations toward destruction of his symbol of pure beauty, Shukaku.

The opposition between Mizoguchi's contempt for his mother and his worship of the purity of Shukaku emerges through these contrasting time frames with an acuteness that dialogue or narration could never convey. His mother (Tanie Kitabayashi) arrives to visit him in Kyoto, but he refuses to see her, running off to scrub the floors of Shukaku instead. She comes after him as air raid sirens begin to sound, but he refuses to let her into the pavilion, his stuttering face in close-up showing utter terror. As she drags him away from the pavilion, the scene dissolves to his dead father covering the boy's eyes as a kimono slips along the floor into the next room, followed by a shot of his mother with another man. When his father then says to him on the cliffs by the windy sea that Kyoto's Shukaku makes him forget the sordidness of the world, the relationship between the pavilion and the boy's parents has already asserted itself with visual force.

Characterization in Ichikawa's films rarely foregoes humour, and the vain pettiness of the head of the Kyoto temple (Ganjiro Nakamura) provides a fine vehicle. He first appears dressed in a white kimono in his quarters, putting on makeup in front of a mirror. Later he puts on a little show for Mizoguchi, who happens to be cleaning the garden when a beggar comes to the temple. At first the abbot ignores him, but when he catches sight of Mizoguchi, he magnanimously presents the beggar with a coin. This hypocritical monk, who later turns out to be having an affair with a geisha, becomes another object of Mizoguchi's contempt despite his good intentions toward the boy. Without these little characterizing visual details, Mizoguchi's attitude would elicit little sympathy.

In Mishima's novel, the incident of the tourist's induced miscarriage reveals the depth of Mizoguchi's self-contempt and resulting capacity for evil more than anything else. In Ichikawa's film this event is an accident brought about by the stutterer's desire to protect the purity of Shukaku, and behind it lies the contemporary "pain of the age"[28] Ichikawa feels the novel expressed. From a flashback to Mizoguchi's first view of the exquisite pavilion we proceed to a close-up of his desperate face as he runs into it to escape his importunate mother. Significantly, this is followed by a long shot of G.I.s getting off a train, which creates a visual association between Mizoguchi's inner turmoil and the U.S. presence in Japan resulting from the war defeat. People in the temple then converse with a new smattering of English words about how the finances are improving. A dissolve shows a quiet lily pond, and then the imposing Shukaku, which now appears threatened by those improving finances. Immediately juxtaposed to the magnificent image of purity is

a squabble taking place in the garden between a G.I. and a Japanese woman who is refusing to have an abortion. She runs up to the door of Shukaku and tries to get in. The horrified Mizoguchi pushes her away and she falls, clutching her abdomen in pain. The G.I. then jubilantly rewards Mizoguchi for his inadvertent service in getting rid of the baby by giving him a carton of cigarettes. In Ichikawa's interpretation, Mizoguchi's destructive view of the world gradually builds in this way as he encounters corruption at every turn. His final act of setting fire to Shukaku is to prevent it from being further sullied by such unclean human beings as his mother, these irreverent tourists, and the greedy and lascivious head of the temple. The pain of the age is that postwar reconstruction brings yet more corruption, and purity is nowhere to be found.

The tragic destruction of the symbol of purity brings with it the moment of highest audio-visual excitement in the film. Kazuo Miyagawa's photography, with its characteristic fluid movement, varied angles, and subtle light and shade, attains one of its triumphs in the roaring flames of Shukaku with the desperate, choking Mizoguchi silhouetted against the holocaust. Ichikawa triumphs as well with the sound, as the crackling blaze dissolves into Kashiwagi (Tatsuya Nakadai), Mizoguchi's club-footed sinister friend, softly and gleefully playing his flute. Through this sequence of sound and images alone, the symbolic destruction of absolute purity and the victory of corruption is complete; not a word of unnecessary dialogue intrudes.

Art above All

Since *Enjo*, Ichikawa has embarked on a staggering variety of cinematic endeavours, yet his ironic view and superb craftsmanship remain consistent. With a literary adaptation like Soseki's *I Am a Cat* he recaptured the pleasure of working with great classics:[29] with *Topo Gigio and the Missile War* and part of *I Am Two* he revived his love for animation; with *Tokyo Olympiad* and *Youth* he demonstrated a remarkable talent in documentaries; and with *The Wanderers* he interpreted *Easy Rider* as a Japanese period drama. He insists that it is only by dealing with such diverse subject matter that he can find himself and what he wishes to express.

The critics may grumble about his inconsistent world view in his excessive variety, but Ichikawa's irony prevails. The self-possessed child's-eye-view of *I Am Two* is as convincingly presented as the self-recognition attained through illness by the arrogant adolescent of *Ototo* (*Her Brother*), or the defeat met by the three innocent young men of *The Wanderers*. Ichikawa sees that a search for human understanding at times presents insurmountable difficulties; sometimes there is room for optimism (as perhaps at age two), but more often the question, as in *Tokyo Olympiad*,

remains "What have they won?" and the ironic truth is that even a gold medal provides no answer to the problems of living.

The producers may grumble about Ichikawa's work pace and expenses, but his artistry prevails. His insistence on a first-rate staff and cast and adequate time to dub and edit his films has never led him astray, as the phenomenal success of *Tokyo Olympiad* proved. Even a film as off-beat as his remake of *An Actor's Revenge*, a trite story serving as a vehicle for theatrical acting and audio-visual virtuosity, is coming into its own more than ten years after it was made. The fact remains that the grumblers keep coming back for more from this perfectionist, and there are many who reluctantly call him a genius.

If there are any legitimate complaints, they come from the man himself. In making fatuous thrillers like the all-time success *The Inugami Family*, he admits he is compromising. "All of us who want to make films now have to compromise. I look for the contemporary in my films, and contemporary Japan demands movies like *The Inugami Family*."[30] But Ichikawa is humble enough to go on making films with no moral viewpoint in the hope that somewhere along the way he will be able to express something of himself in the work—in the sharp-edged montage structure, the unsettling compositions, the intricate lighting and stylized colours, the disturbing sound effects.

Notes

1. Author's interview with Kon Ichikawa, January 1977.
2. Kon Ichikawa and Natto Wada, *Seijocho 271 banchi* (Tokyo: Shirakaba Shobo, 1962), 89.
3. Donald Richie, "The Several Sides of Kon Ichikawa," *Sight and Sound* 35, no. 2 (spring 1966): 85.
4. Author's conversation with Nagisa Oshima, May 1974.
5. Ichikawa and Wada, *Seijocho*, 81.
6. Ibid., 128.
7. Ibid., 86.
8. Ichikawa interview.
9. Richie, "Several Sides," 86.
10. Ichikawa interview.
11. Ibid.
12. Author's conversation with Kiichi Ichikawa, November 1976.
13. Ichikawa interview.
14. Ibid.
15. Richie, "Several Sides," 86.
16. Ichikawa interview.

17. *Sekai no eiga sakka 31: Nihon eiga shi* (Film Directors of the World vol. 31: The History of the Japanese Film) (Tokyo: Kinema Junposha, 1976), 204.
18. Ichikawa interview.
19. Ibid.
20. Ibid.
21. Ichikawa and Wada, *Seijocho*, 54.
22. Ichikawa interview.
23. Ibid.
24. Ibid.
25. Ichikawa and Wada, *Seijocho*, 45.
26. Ibid., 47.
27. Ibid., 50.
28. Ichikawa interview.
29. Ibid.
30. Ibid.

Harp of Burma

DONALD RICHIE

The Several Sides of Kon Ichikawa

ICHIKAWA at fifty is a spare man with large black-frame glasses, a gap between his teeth which invariably lodges a cigarette, an enormous number of anecdotes, and a multiplicity of boyish gestures. He looks very much like one of the caricatures of himself that he occasionally draws.

"I'm still a *cartoonist* and I think that the greatest influence on my films (besides Chaplin, particularly *The Gold Rush*) is probably Disney." He likes other films, Renoir's *The River* is an especial favourite, and, more recently, *Hiroshima mon amour*. "But there is a lot of Disney in me—it's just that my subjects are different."

His first picture was animated. The eighteen-year-old Ichikawa entered the J.O. Studios cartoon department after graduation from an Osaka commercial school and in 1946 completed *A Girl at Dojo Temple* (*Musume Dojoji*), a puppet-film based on a famous Kabuki dance. The Occupation authorities, concerned with discovering "feudal remnants," seized the negative and it has never been found. After that, Ichikawa joined Toho and began making "another kind of cartoon," a series of satirical comedies of which *Pu-san* (itself based on a famous comic strip) is probably the best. Until his fortieth year Ichikawa was something like a miniature Preston Sturges, a small-time Billy Wilder, not nearly as good as either but funny enough at times.

There is another side to Ichikawa. Animation stops, the funny stories cease, and he simply sits, cigarette dangling, his eyes large and sad behind his glasses. This is the Ichikawa who in 1955 made *Harp of Burma*, and went on to complete his best pictures. "*Burma*—oh, but I wanted to make that film. That was the first film I really felt I had to make." This story of a Japanese soldier who stays behind after the war to bury the dead moved many of the director's generation when it first appeared as a novel. "It said something simple and true about the difficulty of living, and I was beginning to find out just how difficult that is." In 1956 he read Mishima's *The Temple of the Golden Pavilion*, and it "seemed to me to express perfectly the 'pain of our

age.' I thought that here was something I could make which would really be all mine." *Enjo* (*Conflagration*), based on this novel, is still his favourite among his films, and one of the reasons is that "this picture marked the end of the change that was taking place in me."

The jump from comedy to tragedy—particularly in Japan—is not as wide as commonly supposed, and one can reach comedy through tragedy (Kurosawa) or tragedy through comedy (Ichikawa), the latter turning from the most satirical of comedies to the most painful of analyses. "I had become aware that men are unhappy. You can even say that they are in anguish and so the only way to show a real man is to show an unhappy one. Oh, I look around for some kind of humanism but I never seem to find it. People are always complaining, the ending of the Olympic film is an example—why show all that strain and pain, they say. And they want happy endings too. But doesn't this desire for a happy ending show how unhappy they really are?"

This anguish, this pain of our age, has in the past ten years become the theme of Ichikawa's finest pictures. (Something he himself denies, saying: "I don't have any unifying theme—I just make any picture I like or any that the company tells me to do.") And his interest in man-in-anguish has made him long want to film Camus's *L'Étranger*, and is responsible for his living in France several years ago, working with Robbe-Grillet on a script which the company—Daiei—finally turned down. In *Enjo* the anguish results in the destruction of the pavilion; in *Fires on the Plain* in the "suicide" of the hero; in *Ten Dark Women*, in the painfully comic dilemma of the trapped hero; and in *Hakai*, the refusal of love.

Ichikawa's interest in this theme is so extreme that it finds expression even in those pictures which the company told him to make and in which he had little initial interest. The young man in *Bonchi** is securely caught, and *Alone on the Pacific* is a darker and more honest film because the anguish is there. Even his current work, a twenty-six part TV serialization of *The Tale of Genji*, insists upon the unhappiness of Heian times.

Ichikawa's sense of anguish has caused him endless difficulties with those—motion picture companies in particular—who insist that life is fun and humanity happy. He has got into some kind of troubles with every company he has ever worked for, and particularly serious were those with Daiei's Masaichi Nagata (Japan's L. B. Mayer, and the man who walked out of the screening of his own *Rashomon*) who, to punish the director of *Kagi*, insisted that he make the blockbuster *The Great Wall of China*. Ichikawa refused and was suspended. Relations between the two strained to the snapping point, and then, in the local uproar over the Olympic picture (the committee had wanted a straight newsreel), they snapped.

*He is the scion of a rich merchant family, ruled over by a matriarchal grandmother who is determined that he must marry and produce a daughter so that the family power can be kept on the female side. Unfortunately his wife—and, subsequently, mistresses—produce only sons.

"Of course, there is another reason for my troubles," says Ichikawa. "Any director who is any good has to be an absolutist. Like Kurosawa. Both of us fight like anything to get what we want and that is why we both have the same reputation with the film companies. You know—uncooperative, stubborn, wasteful, etc."

Ichikawa sees that he has made "two kinds of films" in his career. Those that are light and more funny than not ("my Disney side"), and those that are not. He would divide them this way:

Light	Dark
Pu-san (Mr. Pu)	Harp of Burma
A Flower Blooms	Nihonbashi
The Men of Tohoku	Kokoro (The Heart)
Ototo (Her Brother)	Punishment Room
Ten Dark Women	Enjo (Conflagration)
I Am Two	Fires on the Plain
An Actor's Revenge	Kagi (The Key)
Money Talks	Bonchi
Alone on the Pacific	Hakai (The Outcast)
Tokyo Olympiad	The Tale of Genji

The Disney side is seen in the sentiment of *I Am Two*, a study of life as seen by a two-year-old child which even boasts some Disney-style animation; in the good-natured uproar of the gangster film *Money Talks*; and in the astonishing pop-art aspect of *An Actor's Revenge*—a film which might be compared to a *Captain January* directed by Luis Buñuel. The darker, anguished side is clearly reflected in the claustrophobia of *Kokoro*, *Kagi*, and *Bonchi*, the paranoia of *Hakai*, the frightening schizoid beauty of *Enjo*. The sides overlap, of course. The comic fate of the man in *Ten Dark Women*, of the entire cast of *Kagi*—this is laughable but is none the less serious.

Ichikawa, incidentally, denies that *Kagi* was intended as black comedy. "When I finished the book, I thought, well the novel is ended, now the story would begin. So in the film I simply went on and finished the story. It isn't supposed to be funny and no one in Japan thought it was. I suppose the difficulty is that the story is about sex and, I must say, the Japanese don't know very much about that subject. Oh, we understand it enough intellectually but you don't find sex and society related in any kind of way. Take *A Streetcar Named Desire*, now that is a real sociocultural indictment of America in meaningful sexual terms. In Japan something like that comes out very literally and we show them copulating. And that is the reason that sex comes off so badly in Japanese pictures; it doesn't have any real meaning to us. A film like *The Silence* is just meaningless to us. Anyway, in *Kagi* I wanted to make the point that the uninteresting thing about sex and society in Japan is that there can never be any kind of solution, and killing them all off was one way of doing it."

Ichikawa has said that sex can only be sex in Japan and consequently doesn't interest him—perhaps for that reason sexual references in his pictures tend to be oblique and relatively mysterious: the sexual tangle in *Ten Dark Women*, the homosexual implications of sections of *Enjo* and *An Actor's Revenge*, even the celebrated rape scene in *Punishment Room*. Sex must carry with it a further meaning before he becomes interested in it. "But that is the way I am about everything. If possible, everything in my films has to be about something else, it has to have a wider relevance than itself. I'm rather like a novelist that way."

Ichikawa tends to like novelists (Gide, Ogai Mori) for whom "everything is about something else." He also makes more adaptations from novels than almost any other Japanese director (among his recent films only *I Am Two* and *Tokyo Olympiad* are "originals"), and has occasionally referred to himself as an "illustrator." In this he is somewhat like David Lean (there are other parallels as well: a taste for irony, a predilection for specifically moral dilemmas) rather than his "favourite" director Jean Renoir. His method of illustrating, however, is quite different from most directors.

"When I know what I want to do then I sit down and study it, for months. I have to digest the whole thing, or live the whole thing before it will come out as a film." Ichikawa almost invariably works with his wife, Natto Wada. "We usually read a book we like or are given a book the company has bought, or a story or something, and we both read it carefully and then we start to work. But the work isn't sitting down and writing, it's—well, it's sort of like living with it, bringing it into the house as though it were a pet or a child. We are very close and we communicate through good-mornings and what-do-you-want-for-suppers and the script gets done page by page, a word here, a sentence there, without our thinking too much about it. It is she who finally sits down and writes it all up. Then if there is something I don't agree with we can talk some more. But I usually agree: after all, it is just what we said it would be. Her influence is absolutely crucial, I think. Without her there wouldn't be any Ichikawa film. She says no, says I am the kind of director who transforms everything, and when the film is done she can seldom see any of her own work in it."

Though her influence is indeed crucial (and an amount of darkness in the "dark" films may come from her), Ichikawa's taking the script and sitting down at his desk for the next several weeks, visualizing the entire picture, is indeed a transforming process. He spends his time drawing pictures, determining camera angles and scene length, planning movement, and editing in his head, because: "The way we work there just isn't time for that once you get started on a film. I'd like to work the way that Kurosawa can because he has his own company—lots of rehearsals with everyone knowing just what they are going to do before a frame is taken. But you can't do that if you are working for a film company. There is a kind of rehearsal and then you take it and the director has to be in there knowing exactly

what he wants. Sometimes I've improvised but nothing good ever came of that.

"Speaking of that, however, I learned a lot on the Olympic film. I knew where all the cameras were going to be, but I didn't know what was going to happen in front of them. And I discovered that accidental drama discloses itself when you've not made up your mind about it. All the best stuff in the picture is absolutely fortuitous and I could never have imagined it. From now on I'm going to take some advantage of this. I'm starting *Hey, Buddy!* with my own company [and in collaboration with Steve Parker, a Tokyo impresario, Shirley MacLaine's husband] and I'm not going to tell the actors when the camera is on and when it isn't. They won't know and so maybe I can get things out of them that they don't know about.

"The other reason that I try to visualize everything is that I'm the kind of person who has to see something—even in my own imagination—before I understand it. I started as a painter and I still think like one. That is why the camera is so important to me. I plan all the set-ups and I always check the framing, and I usually try to work with someone I know and like, a cameraman such as Kazuo Miyagawa [who did *Bonchi* and *Enjo* and *Kagi*, as well as *Rashomon*, *Ugetsu*, and Ozu's *Floating Weeds*] or Jyuichi Nagano [a discovery of Susumu Hani's, who was cameraman on the Olympic film]. I design the sets too, usually—it was fun doing the *Genji* ones—and I'd probably do the music too if I could. I don't know much about music but I'm thinking of going to school and learning."

One of the results of this intense visualization is what has come to be known in the industry as "the Ichikawa look." It owes much less to traditional art than it does to modern graphic design. The angular pattern is usually bold, the balance is almost always asymmetrical, the framing is precise, and yet the composition rarely calls attention to itself. Here the "cartoon" influence is seen strongly, not specifically Disney but those animated films (UPA was an early example) which were designed by graphic artists. A now celebrated example is that extremely long scene of the family conference in *Kagi* which is all one cut, balance and composition so cunningly poised that there is always something new to look at. Equally typical are the figure placements before and after the beautifully controlled flashbacks in *Enjo*, which both complement each other and are, at the same time, quite different.

All of this, the entire visualization of the film, is the product of Ichikawa all alone at his desk, digesting the film he is going to produce, bringing together the various sides of his nature to focus upon a specific scene in a specific film. "People are always surprised at my humour and then they are always surprised at the bleakness of whatever philosophy I have. To me they seem perfectly complementary. All sides of a person add up to that person, you know. Somebody called the Olympic picture a 'hymn to life,' and that I guess is what I am about. I'm only guessing though. I can't define it any better than I have in my films. After all, a director only has his films to talk with. If he doesn't get through then he hasn't made the film very well or it hasn't been looked at very well."

Kokoro

TOM MILNE

The Skull Beneath the Skin

FIRST IMPRESSIONS can be misleading, and there is something very wrong with the image of Kon Ichikawa—arrived at mainly by way of *Harp of Burma*, *Enjo (Conflagration)*, and *Fires on the Plain*—as a man obsessed by human suffering and expressing his pity through a series of long, slow, painful, humanistic affirmations. Ichikawa is obsessed by suffering all right, but he is not a humanist in any modern sense of the word ("I look around for some kind of humanism, but I never seem to find it," he himself accurately observes). It isn't merely that until recently we had little opportunity to see the other, lighter side of Ichikawa's work: the humanistic definition imposes much too narrow limits, and could only grapple with a film like *Kagi* by sweeping its almost mockingly flippant final sequence tidily away under the carpet as "silly."

Re-viewing a film like *Fires on the Plain* (1959) with the hindsight acquired by having seen another ten miscellaneous Ichikawa films, one is immediately struck by its central ambiguity. As Private Tamura turns from the stench of death in the plains, rejecting the final debasement of cannibalism to stagger resolutely towards the gentle plumes of smoke rising from the farmers' fires on the hills, one is tempted to agree with the critic David Robinson that he is emerging from an Inferno, and that "Ichikawa's fires are those of purification." And yet—purification of what? It is here that doubt sets in. By refusing the temptation of cannibalism, does Tamura expiate the relish with which he earlier murdered the Filipino boy and girl in cold blood (and in what sort of moral balance does one weigh the two crimes)? By throwing away his life, to preserve that which he has gone through this inferno for, and for which he has lied, cheated, and killed, does he somehow become more human?

When *Fires on the Plain* was first shown in London five years ago, more than one reviewer reproached Ichikawa for his departure from the ending of the novel by Shohei Ooka on which the film is based. In the novel, Tamura ends up in a mental hospital, where he meditates on the meaning of his experiences and on the

existence of a God who has guided him safely through them; in the film, he simply turns to the hills, towards "people who are leading normal lives," and is shot dead. The difference is an important one, and surely deliberate on Ichikawa's part. Ooka's ending is an expression of faith in man and in the possibility of spiritual progress. Ichikawa's is the exact opposite: his hero puts his trust in man, only to find that his "people leading normal lives" are still vengeful Filipino peasants, full of hate and determined to avenge their sufferings. Ichikawa is too honest (and too little of a mystic) to suggest that the repentance of a single sinner will bring rejoicing in heaven and restore the harmony of the spheres. At the end of *Fires on the Plain*, Tamura may possibly have become purified by his sufferings; what is certain is that the world around him has not.

The Ichikawa hero—not only in *Fires on the Plain* but throughout his work—is essentially an outsider, a man struggling to escape from the world in which he lives, rather than to change it or even accept it as he finds it. He may seem to take the sins of the world on his shoulders, but less to atone for them than to protect himself. In *Harp of Burma* (1956), appalled by the endless piles of war-dead strewn in his path, he becomes a priest, preferring both physical and spiritual exile to living among people like himself; in *Enjo* (1958), he destroys the only thing he loves to preserve it (and by implication himself) from contamination. The key to both films is the hero's total rejection of life while clinging desperately to a personal ideal. In *Enjo*, the ideal is represented by the Golden Pavilion of Kyoto, the national art treasure which has no other function than to be admired for its serene, immovable beauty. "I forget this filthy world just by thinking about it," says the hero's father, from whom he inherits his worship of the temple. But the "filthy world" has its revenge, and Ichikawa watches with a kind of helpless pity as his heroes are defeated by it, whether they advance to meet it (like Tamura in *Fires on the Plain*), or retreat from it (like the young soldier of *Harp of Burma* and the novice priest of *Enjo*). The ambiguity remains, of course. One *can* argue that, in his own way, each hero triumphs; but at the same time one is left with an overriding impression of futility. Tamura is dead, the temple is burned, and a soldier prays for the dead; but the filthy world remains the filthy world. There is no harmony here, no reconciliation between material and spiritual such as one finds in, say, *Un condamné à mort s'est échappé*, or even *All Quiet on the Western Front*.

Filtering through these films—and perhaps revealing a tension between Ichikawa and his source material (all three are adapted from novels) comes a strange, snarling bitterness of despair. And it is when one turns to *Kagi* (*The Key*, 1959), with its sometimes mocking, sometimes deadly serious analysis of obsessive sexuality, and its bizarre final holocaust in which the three surviving members of the family quartet die from poison at the hand of the faithful old retainer, that one begins to get a more accurate slant on Ichikawa himself. The film opens with a young doctor, square in the middle of the screen, offering intimations of mortality in the

shape of a lecture on the physical debilities which lie inescapably in wait for man during his progress through life, detailing the precise ages at which a man can expect his faculties to begin to atrophy. This gloating catalogue ends with a diabolical chuckle ("You too!" he assures the audience) which irresistibly recalls the relish for the horrors of physical decay which marked the Jacobean dramatists. "Webster was much possessed by death/And saw the skull beneath the skin," reads T. S. Eliot's celebrated *hommage*; and in his essay on "Four Elizabethan Dramatists," he observed that "Even the philosophical basis, the general attitude toward life of the Elizabethans, is one of anarchism, of dissolution, of decay."

Eliot's description might apply equally well to a host of modern writers, with Beckett at their head; but whereas Webster is dominated by relish and Beckett by pain, in Ichikawa the two go hand in hand. It is a landscape of anarchism, dissolution, and decay from which the heroes of *Harp of Burma*, *Enjo,* and *Fires on the Plain* recoil in anguish, and which recurs throughout Ichikawa's work wherever his raw material is sympathetic (and sometimes where it is not). In these three films, Ichikawa's involvement with the anguish is too deep to allow him to draw back, to set his sense of the futility of his characters' struggles to escape their dilemma in a proper perspective; but in his more characteristic, and perhaps greater films—*Kagi, An Actor's Revenge*, and (in a slightly different way) *Kokoro*—the anguish and the mockery are inextricably mingled.

Kagi, for instance, is an irresistibly funny film, full of keyhole-peeping, nocturnal wanderings and heavy breathing; and yet, as each of the four major characters aids and abets the others' odd obsessions, fully aware of how they themselves are being manoeuvred, they are all the time performing a terrifying dance of death in which, starting as normal people living normal lives, they withdraw further and further from reality into absurdity. When the old man lies in bed paralyzed from a stroke, and at his unspoken request his wife strips before him, knowing that the sight of her naked body must kill him, the scene could hardly be bettered as a ghoulish Websterian jest. And yet it also contains, in the old man's ecstasy, a strange kind of poignancy, a feeling that he might happily have chosen just this way to die.

Even more than *Kagi*, *An Actor's Revenge* (1963) conjures up the aura of the Jacobeans, with a grisly revenge plot, comic sub-plot, and ironic final twist which might have flowed entire from the pen of either Webster or Tourneur. The actor Yukinojo, a female impersonator, is in a way the perfect Ichikawa hero. As a female impersonator (*en ville* as well as on stage, as was the Japanese custom), he has withdrawn from his proper place in society; but when he is forced by convention to revenge his parents, who were driven to madness and ruin by a triumvirate of scheming businessmen when he was a mere child, he is called upon to reassume a place he can no longer fill. Ichikawa plays happily, and brilliantly, with the paradox of the twittering, trembling hero who suddenly sheds his disguise to close with his enemy, delicately and victoriously parrying the latter's sword-thrusts with a tiny

dagger. But Yukinojo is securely trapped in the kind of limbo he has built for himself. As part of his revenge plan, he makes use of a girl who has fallen in love with him and who happens to be the daughter of one of his intended victims. As a result she dies, and Yukinojo finds that his pretended affection, stimulated by pity, has come very close to the real thing. In a beautiful, intensely moving sequence he mourns over her dead body, promising to make amends: "If there is a next world we will become one, and in that way my false vow will become true." But this is again deception. Yukinojo has already quitted any world in which he might love her, and once his revenge is complete he returns to his true love—his male master and friend at the theatre.

The subplot, a comic one in the best tradition, cunningly echoes this theme of man's relationship to society in a much more overt manner. The Robin Hood-style thief who befriends Yukinojo is dominated by a girlfriend much more dashing and courageous than he is. At the end of the film, having decided that she is growing too old for such male exploits, she offers too late to yield up her leadership: the male thief laconically declares that he has now decided he has no use for women, and is thinking of taking to the stage as an apprentice female impersonator.

Visually, the film is one of Ichikawa's most striking successes, obviously owing much to *kabuki*, but also oddly reminiscent of modern-style Elizabethan staging in its use of bare stages, black drapes, and simple structural shapes to allow the director to indulge his favourite composition of a single figure picked out against some architectural detail. Most of the extraordinarily effective exteriors look unashamedly stagey, perfectly calculated to evoke the sort of no-man's-land between two worlds in which the main action takes place (the two worlds being represented, on the one hand by the glittering expanse of the *kabuki* stage, on the other by the ordinary, cosy room where Yukinojo meets the girl who loves him).

This no-man's-land is a sort of conjuror's dream, where figures suddenly materialize out of nowhere, a lasso streaks out of the darkness like a glittering serpent, swords flash and strike almost of their own volition and the exteriors follow suit: the empty street with its towering grey wall where Yukinojo meets his swordsman enemy in a blinding circle of light cut out of the surrounding darkness; the mist-shrouded heath with a ghostly forest looming behind where the heroine is driven to murder; the field of waving corn into which Yukinojo finally plunges, mysteriously disappearing towards his self-inflicted oblivion.

The effect at times is almost of Arabian Nights spectacle, but it also reflects Yukinojo's anguish at his predicament. Here, the visual style is very different from the lyrical compositions of the trio of war films, where the pensive hero is gently integrated into a dreamlike landscape (horrific, as with the endless vistas of dead and dying in *Harp of Burma* and *Fires on the Plain*, or opiate, as with the vision of the Golden Pavilion in *Enjo*). Instead, as in *Kagi*, the lines are sharp and jagged, with the characters viewed much closer and at odd angles, uncomfortably trapped

in doorways, isolated by a wall, cut off by shafts of light, as though overpowered by their surroundings. Kazuo Miyagawa, Ichikawa's favourite cameraman (who also frequently worked with Mizoguchi), uses heavy backlighting, shadows and brilliant pools of light, with a boldness which makes his colour camera-work incomparably rich: as much as anything, it is his subtle textures which convey the sense of anguish in these films, the sense of dead-white flesh consumed by the fires of darkness.

Before turning to *Kokoro*, another masterpiece but one which works rather differently, one should perhaps briefly consider some of the earlier and minor films. Here one has to tread carefully, because as Ichikawa himself confesses, he often had to do as he was told, and it isn't always easy to be sure how much he is involved with the subject. Take *Bonchi*, for instance, a comparatively late (1960) film which Ichikawa was apparently told to make. One would have thought that its story of a young man oppressed by a society in which women wield the power and demand daughters, while he can produce only sons from a variety of wives and mistresses, would have appealed strongly to him. Yet the film is lackadaisically done, with a stylish but flabby central stretch. The beginning is scathingly brilliant, with the hero's mother and grandmother solemnly scanning the lavatory pan for portents of his young wife's intimate secrets, and then cruelly forcing a divorce when she finally bears him a son. So is the end, after the fall of the matriarchal house during a wartime bombing raid, when the hero finally shakes off mother and grandmother, only to find that his three mistresses have been busily gathering power and are now by no means dependent on him. Though beautifully designed and constructed, the film as a whole somehow betrays a lack of involvement.

The same thing is true of *Ototo* (*Her Brother*, 1960) and *Punishment Room* (1956), the first a rather weepy tale of a spinsterish girl whose adored younger brother dies of tuberculosis, the second a cut-to-pattern addition to Japan's juvenile delinquency cycle. *Ototo* is extremely good of its kind; *Punishment Room* is less so, though containing some brilliant sequences which lift it out of the rut, notably the very effective simplicity of the scene in which the boy is called off the ruggerfield by the girl he has raped, and they just stare at each other, endlessly. In both cases Ichikawa contrives to turn the principal character into one of his typical outsiders: the girl in *Ototo* being cut off from pursuing her own life and marrying by her single-minded devotion to her wayward brother, the young delinquent of *Punishment Room* by his anarchic refusal to admit that he belongs either to society or to its outlaws. By Ichikawa standards however, they are undistinguished works, although here and there one does find welcome flashes of his avid mockery (a fine example comes when the boy in *Ototo*, who has constantly extracted money from his sister to pay for his playboy extravagances, finally contracts tuberculosis, gloomily contemplates the face he assumes will soon be mere skin and bone, and thinks up a new extravagance—having himself photographed).

Pu-san

More interesting are the earlier comedies, *Pu-san* (1953) and *A Billionaire* (1954). Although the former is based on a popular cartoon strip, it is difficult to see in it any reminder of Ichikawa's early days as a cartoonist and his avowed devotion to Walt Disney. If one hadn't seen *I Am Two* (1962), in fact, an innocuous comedy which deals with much feyness and some charm with the problems of infancy as seen from the points of view of both parents and child, the Disney angle would be very hard to credit. Certainly there is no sign of Disneyism in either *A Billionaire* or *Pu-san*, which are quite distinctly Ichikawa films in miniature.

Superficially, both of these films bear out Ichikawa's early reputation as the Japanese Frank Capra. Their heroes are simple, honest, little men, and the timid tax collector of *A Billionaire* even wages a single-handed war against tax evasion, pitting his naïve honesty against national cunning. The difference is that this humble tax collector, and the ineffectual mathematics teacher of *Pu-san*, also live under the shadow of their dread of war. The mathematics teacher tremblingly takes shelter in a police station from a file of military lorries rumbling past, only to encounter there weird visions, every bit as terrifying to him, of murderers staggering one by one out of the night to give themselves up; in a cinema he watches a newsreel of a nuclear test where (one of Ichikawa's best jokes) the projector breaks down in mushroom clouds of smoke; and in the end he sits pondering his motionless image in the mirror, telling himself "How simple to go mad."

In *A Billionaire*, where everyone seems to boast of belonging to a larger family than anyone else, so that numbers recur like an incantation of souls to be lost or saved, Ichikawa takes his grim, deadly-earnest jest a stage further. The tax-collector, who goes berserk when it clouds over because he is afraid that rain is contaminated, is irresistibly drawn to a family living in a broken-down shack with quantities of children and a girl lodger who is busily constructing a home-made A-bomb in the attic. Driven by their misery and poverty, the parents finally exterminate themselves and their children with a meal of radioactive tuna fish, while the tax collector and the sole surviving member of the family run from the A-bomb in the attic. The final image, of the two separating in panic at a crossroads and still running, is as apocalyptic as anything the cinema has produced. *A Billionaire* may not sound like a comedy, but it is. Or is it?

It is easy to trace a direct line of descent from *A Billionaire* and *Pu-san* to *Kagi* and *An Actor's Revenge*. The other, more lyrical, more "socially responsible" line descending from the trio of war films, seems to end up a curious byway with *Hakai* (*The Outcast*, 1962). Here, Ichikawa delves into Hollywood problem picture territory with a story, set in 1904, of a pariah boy who is a member of Japan's outcast tribe, and whose tribulations are an exact replica of those experienced by the Negro who passes for white (in Alfred Werker's *Lost Boundaries* [1949], for instance). As no one knows that he is an outcast, the boy is able to complete his education and win a job as a schoolteacher, though his terror of discovery makes

him withdraw into himself, wary of love, friendship, or even advancement in his career. He becomes fascinated by the teachings of a writer, also an outcast, but one who has openly admitted what he is and is devoting his life to obtaining social justice for his people. Dying of tuberculosis, the writer seeks a disciple to carry on his work, and the boy is faced with an agonizing choice between his faith and his instinct for self-preservation.

What makes the film so distinctive is Ichikawa's style, which lifts the film on to the same plane of brooding torment as Dostoevsky's novels. (The outcast novelist, doomed, intense, forever sweeping through dingy doorways or along snowy streets in a billowing black cape, is a particularly Dostoevskian character.) It begins superbly, with a bull and a man isolated on a lonely hillside plain, face to face for the few split seconds before the bull charges and the man dies. There is an elemental ferocity and terror in this sequence—like Ahab confronting the White Whale—which the film never recaptures, although Ichikawa makes striking use of a habit (indulged elsewhere, notably in *Bonchi*) of linking violently emotional scenes by a calming, Ozu-like shot of an empty street or landscape. The slaughterhouse sequence, for instance, with its rapid butchering of the bull in a few flash shots that hit like a sledgehammer, is followed by tranquil images of the lake and village, before proceeding with the scene where the boy returns home after seeing his dead father's body and is shocked to find the richest man in the village being hounded down as an outcast.

By such devices, Ichikawa keeps so tight a grip on his narrative that it never sags until the boy reaches the point of no return, and must discover himself or be discovered. In a protractedly tearful sequence, he confesses before the assembled children in his class, and it isn't long before everybody in the room is weeping in an agony of pity, remorse, and despair. Someone once remarked of Hemingway that, like all tough men, he leaned so far over backwards to avoid sentimentality that he fell head over heels right into it. Exactly the same is true of Ichikawa when he drops his guard of mockery to become completely solemn; not only here, but in (for instance) the "Home Sweet Home" sequence of *Harp of Burma*.

Perhaps, though, it is simply a question of finding the right material; for his earlier *Kokoro* (1955), another Dostoevsky subject of brooding torment, manages very successfully to avoid the trap of sentimentality. This, reduced to its essentials, is simply the story of a man who, obsessed by a sense of guilt for the death of his closest friend, gradually withdraws further and further into himself until he finally commits suicide. The story of his past betrayal, which he dredges up for the benefit of a sympathetic young student who befriends him, is trite enough. He and his friend had fallen in love with the same girl. Taking advantage of the fact that the friend had professed to be spiritually above such matters of the flesh, he had stolen a march on him; and the friend had killed himself. But this story, one feels, is only an excuse, something on which the hero can focus his profound sense of futility as

he meditates on his own death and the inability of his wife and young friend to understand. (In its systematic use of lingering close-ups, *Kokoro* is almost a scientific dissection of three minds.) There is a haunting scene in which the hero, thinking himself alone on the beach, swims steadily out to sea until the young student, who is watching, anxiously follows him; when he catches up, neither of them speaks, and suddenly they both stare up at the empty sky. If the film were not set in the years just before the First World War, one would be tempted to suggest that there hangs over it that shadow of nuclear destruction which is never far from Ichikawa's work. As it is, all the various strands of the film lead to the same point—the extinction of life: the hero is alive only in his past before his friend died; his love for his wife is dead; he chooses to reveal his story to the young student precisely at the moment when the latter is attending his sick father on his deathbed; and for his own end he chooses the exact moment when the death of the Emperor closes the Meiji era.

Unlike the young outcast's tearful confession in *Hakai*, which is sentimental because too great weight is attached to it, the moment of confession here is not important in itself, but only in that it is a key to a lock: it helps to account for certain gaps in our knowledge of the nature of the hero's despair. Also unlike *Hakai*, one can detect in *Kokoro*, almost concealed behind Ichikawa's sympathetic involvement, a touch of characteristic mockery. Despite his obsession with death, life goes on in the hero's household. Flowers are fussily watered; burglars are lain in wait for; the maid has to be taken to the dentist with a bad tooth; and when he invites the student for a drink in a café, he departs with a lavish "I'll pay," but leaves the student sadly contemplating an empty bottle. Underlying this beautifully modulated film, there is the hint of a suggestion that the hero is playing his own death like a chess game, carefully manipulating the pieces until he mates himself. And like most Ichikawa games, it ends in tragedy.

Bonchi

JOAN MELLEN

Interview with Kon Ichikawa

JOAN MELLEN: Is the major theme in Japanese films still the struggle between one's duty and the individual desire to be independent and free of traditional values and ideas?

KON ICHIKAWA: That is a difficult question with which to begin. I don't know how to answer. Can't we work our way to that and start with the next question?

MELLEN: Sure. The next is an easy one. What is your educational background? What did you study at school and what was the major influence which shaped your ideas?

ICHIKAWA: I didn't go to a university so I can't say in what I majored. After I left middle school [equivalent to high school] I was always painting and drawing.

MELLEN: Did you become a painter?

ICHIKAWA: No, later on, I switched to filmmaking.

MELLEN: How did you start to make films?

ICHIKAWA: When I was a youth it was the time of the Western film world's so-called renaissance. There were so many great European and American films. They had a great impact on the Japanese. Japanese then began to pursue filmmaking seriously. This influenced me considerably.

MELLEN: Which European and American films or directors most affected you?

ICHIKAWA: I should mention the names of filmmakers who moved me very much rather than individual titles. Among them, in America, Charlie Chaplin stands out, as does William Wellman. In France, René Clair. Nor can I forget Sternberg and Lubitsch.

MELLEN: Why have Japanese filmmakers been so interested in historical themes and period films?

ICHIKAWA: I don't think Japanese films lean particularly toward the *jidai-geki*, or costume drama. Some people are interested in episodes of a certain era, but

I would not want to make the distinction between *jidai-geki* and *gendai-geki* [contemporary drama or story]. To me they are the same. If I may add my opinion, films which have modern themes and modern implications should not be simply classified as *jidai-geki*, even if they are set before the Meiji era. They are indeed modern films although they may take the form of costume plays.

MELLEN: You don't think there are more historical films made in Japan than in the United States, although we do have the "Western," which may be thought of as similar to the *jidai-geki*?

ICHIKAWA: We probably have a few more and it may have some significance, in my case for one. It is true of course that there are more *jidai-geki* made here than *gendai-geki*. You see, film is an art which involves the direct projection of the time in which we live. It is a difficult point to state clearly, but my general feeling is that Japanese filmmakers are somewhat unable to grasp contemporary society. In your country there seem to be many more dramatic current themes to portray. To render something into film art we really need to understand thoroughly what we want to describe. Unable to do this, many of us go back to history and try to elucidate certain themes which have implications for modern society.

MELLEN: Is it because Japanese society is undergoing great political and social change at the present time?

ICHIKAWA: Yes, that is correct.

MELLEN: Would you like to discuss problems of distribution, production, and financing of films in Japan in relation to your own experiences, for example with your *Tokyo Olympiad*?

ICHIKAWA: We are faced now with the most difficult time for all three problems. We have a very different system from yours. We used to have five major companies which monopolized all bookings. We never had a free booking system. Now the five companies have shrunk into three, Toho, Shochiku, and Toei, and these companies still follow the old system of distribution. They don't want to change with the times; they are anachronistic. So groups are forming individual production companies and trying to survive. Financially it is a cruel struggle.

MELLEN: Have you personally formed your own company?

ICHIKAWA: At this moment it is an individual production, not yet a company. I am working right now to create a new company which I hope to start in November [1972]. This is my first independent attempt, and I have to raise the money by myself. Until now I worked with large companies like Daiei and Toho. I am working on television productions at present to raise money to start my own company.

MELLEN: Did you then make the *Kogarashi monjiro* episodes to make money rather than as serious works of film art?

ICHIKAWA: I would say for both reasons. I should like to make some money on them, but I made them seriously as well. I could never proceed aimlessly.

MELLEN: Are you interested in the theme of political apathy or indifference in the *Kogarashi monjiro* stories?

ICHIKAWA: Yes, the protagonist is an outlaw and a loner, like an "isolated wolf." He is like the character in many Westerns. He is always anti-establishment.

MELLEN: Do you suggest through this character that political action is fruitless, especially in the sense that an isolated individual attempting to do away with evil would find it impossible?

ICHIKAWA: You might say that in terms of the political implications, although the political element is not the main theme. I am much more interested in the search for what defines human nature.

MELLEN: In general would you say that you are more interested in psychological aspects than in political?

ICHIKAWA: Yes, generally so.

MELLEN: How do you account for the interest in pornography, or rather, the extreme desires of sexual life in Japanese films? I am speaking of the excessive sexual desire which appears even in the work of Imamura and in your own film *Kagi* (*The Key*).

ICHIKAWA: I really don't know how to answer the question. I thought that in Japan sex was not given the prominence that the United States has given to it. In Japan, sex itself is not treated as a force able to change an entire aspect of social existence. I am referring to plays like *Cat on a Hot Tin Roof* or *A Streetcar Named Desire*. These works face up to the problem of sexuality in the human being. Well, in Japan we don't have such plays. Sex is not as important a problem in Japan as it is in the United States.

MELLEN: Would you say that in *Kagi* the sex was treated comically or satirically rather than seriously?

ICHIKAWA: I used it as a criticism of civilization, of our culture.

MELLEN: In what way? Which aspect of civilization are you criticizing?

ICHIKAWA: The conflict between the soul or heart and desire.

MELLEN: I find that a difficult idea to grasp.

ICHIKAWA: It is difficult to explain in words, but *Kagi* is really not a movie about sex, at least not very much so. It is a story of human vanity and nothingness. It describes the humanness of the characters through the vantage of sex. I should say that the sex is deformed to impart the struggle of human beings. Sex connects to one's search for humanity, one's true thoughts and position in society.

MELLEN: Then the true subject is not sexuality, but the sex functions as a symbol?

ICHIKAWA: Yes, that is exactly it.

MELLEN: Why does the servant poison the three surviving people at the end of the film? This aspect of the plot was not in the original novel by Tanizaki.

ICHIKAWA: I wonder if I can get this across to you in Japanese via an interpreter. I'll try. These three people are representatives of the human without possessing human souls. They are not really human beings. The servant is going to annihilate them because the servant represents the director. I wanted to deny them all.

MELLEN: Then it is the moral judgement of the director on these three people?

ICHIKAWA: Yes.

MELLEN: What aspect of the original novel, *The Temple of the Golden Pavilion*, were you interested in when you made *Enjo*?

ICHIKAWA: In this film I wanted to show the poverty in Japan.

MELLEN: Who wanted to show the poverty especially, you or Mishima?

ICHIKAWA: No, I.

MELLEN: Is it a material or a spiritual poverty?

ICHIKAWA: I started from the economic and naturally pursued the spiritual also, because it is the story of man. The economic side represents sixty per cent and the spiritual forty per cent.

MELLEN: Doesn't this indicate a strong political element in your work?

ICHIKAWA: Only for this film in which spiritual poverty is caused by economic poverty. Usually I don't consider myself a politically minded director. When I am making a film, I don't think of the political side of the film very much; it is not the main thing.

MELLEN: Maybe "political" is the wrong word. By "political" I mean social consciousness, the relationship between the individual and society, not in the sense of political parties.

ICHIKAWA: Then yes, that is important to my work. I am both aware of and concerned with social consciousness.

MELLEN: Is there any similarity between your Private Mizushima in *Harp of Burma* and Goichi Mizoguchi of *Enjo*?

ICHIKAWA: They represent the youth of Japan. In the case of Mizushima the time was the middle of the war, and with Goichi it was just after the war. In this sense both, whether a soldier or not, represent Japanese youth.

MELLEN: What is the origin of their disillusionment with the world? Are they each disillusioned about the same things and could we define exactly what they are disillusioned about in a general way? Although their behaviour is, of course, different: one leaves the world to become a Buddhist monk and decides never to return to Japan and Goichi in *Enjo* burns down one of the most famous shrines in Japan.

ICHIKAWA: Both are very young and both are in search of something. Neither knows exactly what he is after, as they are still young. Both thrust themselves

against the thick wall of reality and disillusionment trying to find out what they desire.

MELLEN: As in the burning of the temple. What do they desire?

ICHIKAWA: Truth.

MELLEN: Is it the truth of themselves or of the world?

ICHIKAWA: The truth of their own lives.

MELLEN: Is the meaning they seek in their lives similar to that of Watanabe in Kurosawa's *Ikiru*? Watanabe of course is an old man.

ICHIKAWA: Possibly so. I can say it is close. It depends on the viewer's interpretation.

MELLEN: What is the statement about the nature of war that you are making in *Fires on the Plain*?

ICHIKAWA: War is an extreme situation which can change the nature of man. For this reason, I consider it to be the greatest sin.

MELLEN: Do you use a social situation like war as a device to explore the human character? The social situation would be a means of showing what the human being is capable of—as in Tamura's cannibalism, homicide, or the massacre in the film—as opposed to showing what happens in a society that leads to war?

ICHIKAWA: I use the situation of war partly for this reason but also to show the limits within which a moral existence is possible.

MELLEN: Why do you have Private Tamura die at the end?

ICHIKAWA: I let him die. In the original novel he survives to return to Japan, enters a mental institution, and lives there. I thought he should rest peacefully in the world of death. The death was my salvation for him.

MELLEN: What he saw made him unable to continue to live in this world?

ICHIKAWA: Yes, he couldn't live in this world any longer after that. This is my declaration of total denial of war, total negation of war.

MELLEN: In *Alone on the Pacific* you seem to be saying that determination is important, not what you do, nor the nature of the act.

ICHIKAWA: Yes. That was my precise conception.

MELLEN: Isn't *what* we do important? Wouldn't you say that there is some distinction between doing some useful thing and voyaging alone on the Pacific?

ICHIKAWA: No, no difference.

MELLEN: In Japanese films and in yours in particular, much more so than in Western films, there seem to be mixtures of styles or rather varied methods of filmmaking which are combined sometimes even within a single film. Many of your films, and those of Oshima or Shindo for example, are so completely different from one work to the next. Is this a special characteristic of the Japanese film? I am thinking in particular of your segment of *A Woman's Testament*.

ICHIKAWA: [Laughs] Do you think so! Probably you are examining the films in great detail. We don't see this particularly. I believe that expression should be free, so this notion may affect the fact you have just described. But I am never conscious of differentiating my methods or that I have one single special style. All depends on the story or the drama on which I am working.

MELLEN: This seems to be something unique about the Japanese film. In American films one director's works are generally similar, especially among the older directors.

ICHIKAWA: I think each should differ according to what is being expressed. As I am Ichikawa and no one else, even when I try to change the style according to the theme there is always some similarity from one film to the next. Right now I am working with an Italian director, Pasolini. I have really been influenced by him. I consider him one of the greatest filmmakers today. Do you know his work?

MELLEN: Which films of Pasolini do you admire most?

ICHIKAWA: *Oedipus Rex, Medea, The Decameron, The Gospel According to St. Matthew, Teorema.* I consider Pasolini the finest director making films today. Among American directors I was impressed with Peter Fonda, not with his *Easy Rider*, but with *The Hired Hand*. He seems to be very young, yet he has a very good grasp of his subject. He understands love so beautifully. How old is he?

MELLEN: He is about thirty-five. Whom do you admire among the younger Japanese directors?

ICHIKAWA: None among the young ones. I don't know any of their films.

MELLEN: How about among the older ones?

ICHIKAWA: Mizoguchi, Kurosawa, of course.

MELLEN: In connection with Mizoguchi's *Oharu* I visited the Rakanji [temple] in Tokyo. Didn't he film one of the main scenes there?

ICHIKAWA: But it could be that he made that movie in Kyoto. Is *Oharu* the American title? The title in Japanese is *Saikaku ichidai onna*. You know, there are several Rakanjis.

MELLEN: Is there a contradiction in the fact that you seem to praise the family system in *Ototo* (*Her Brother*) but attack it in *Bonchi*? Or were you criticizing the matriarchal family in particular in *Bonchi*?

ICHIKAWA: "Attack" is a strong word, but, yes, I have criticized the family system in *Ototo* and, yes, in *Bonchi* I attack the matriarchy. *Ototo* takes place in the Taisho era, before the war, about forty years ago, but today we still have much the same problem in our family system. I hold the opinion that each family should be accustomed to respecting the individuality of every member. This is what I wanted to say.

MELLEN: What is your viewpoint in *Hakai* (*The Outcast*)?

ICHIKAWA: The theme is racial discrimination. Japanese discriminate against

burakumin. Originally when the Koreans emigrated to Japan, they brought their slaves with them; these were segregated and called *burakumin*.*

MELLEN: Were you then treating the great discrimination against the Koreans by the Japanese?

ICHIKAWA: I think all human beings should be equal.

Did you see Shinoda's *Sapporo Winter Olympics*? Did you like it?

MELLEN: Yes, I liked it, but I thought that there might have been more insights into the psychology of the individuals competing. Visually it is extremely beautiful. Could you say something about how you used the visual details of the architecture in *Enjo* to reveal the psychology of the boy?

ICHIKAWA: Yes, I sought to do this. This beautiful structure was simply nothing but old decayed timber, no more than that. The boy didn't think so at first, but he gradually realized it.

MELLEN: What is the relationship between his feeling about himself and his feeling about the building?

ICHIKAWA: Let me add this. It doesn't have to be the Golden Pavilion. It can be any one of the so-called great monuments in our history. They are so fine. Nobody questioned their greatness because many generations were taught to revere them. Well, in actuality some people think the particular monument, in this case the Golden Pavilion, is great, but some think it is not. Varying opinions should be accepted because excellence is solely dependent upon the viewer's conception.

MELLEN: Does he hate the building and burn it down as an act of self-hatred?

ICHIKAWA: Yes, he hated himself and destroyed himself.

MELLEN: The building represented everything which oppressed him?

ICHIKAWA: Yes, that expresses it.

MELLEN: Is that why people are shown as very small and the building huge in some scenes? They are the individuals very vulnerable to and unable to control outside influences which dominate them, of which the Kinkakuji stands as a symbol.

ICHIKAWA: Yes, that's right. One further thing I wish to stress is that Goichi was

*Originally these people came from Korea and settled around the Kyoto area, and for many centuries they were discriminated against by the Japanese. There is still very strong social discrimination against Koreans in Japan, and there has been since the Meiji era, but *burakumin* were not identified as Koreans. This group of people were originally engaged in the trades of animal killing, footware making, and as executioners. Ordinary Japanese regarded them as morally unrespectable. They were outcasts, the untouchables of Japanese society for many centuries. They resided all over Japan, but lived separately from Japanese villagers. The name *burakumin* means "people who live in the small village." Toson Shimazaki, author of the novel *Hakai*, was one of the first to cast light on the social plight of the *burakumin* during the Meiji era. It is on this novel that Ichikawa based his film.

handicapped. He stutters and cannot express himself well and in a sense he closes himself off from society. He has a sense of inferiority in relation to that magnificent building and he suffers from his isolation. I myself did not think the Golden Pavilion so great or beautiful a structure. I may be wrong, but my point here is that the presence of this great structure does not secure the well-being of human beings around it, or make them happy.

MELLEN: Are you also thereby criticizing the feudal values associated with the Kinkakuji?

ICHIKAWA: Somewhat.

MELLEN: Indirectly?

ICHIKAWA: Yes, not overtly. It is implicit.

MELLEN: Then the temple itself would be a symbol of the feudal system?

ICHIKAWA: Yes, it is.

MELLEN: Has there been any influence in your work, or in Japanese film over all, of the impact of the women's liberation movement internationally and in Japan?

ICHIKAWA: I believe so. The consciousness of women is surfacing and it affects us all.

MELLEN: There is, of course, a strong feminism in the work of Mizoguchi and Hani, perhaps Kurosawa too?

ICHIKAWA: Mizoguchi and Hani, yes, but Kurosawa hasn't been so influenced.

MELLEN: Why in the recent Japanese film has the conflict between the "civilized" and the "primitive" been a prevalent theme?

ICHIKAWA: What do you mean by "primitive"?

MELLEN: The "primitive" consists of people and society before industrial technology, unaffected by capitalism or competition, a society living by ancient patterns. I am thinking of Teshigahara's *Woman in the Dunes* and Imamura's *Insect Woman*.

ICHIKAWA: The question is very abstract, and I'm not sure I agree. In Japanese films the primary conflict between two antagonistic forces is the large theme. I am saying as well that Japan as a whole is a very poor society, an economically poor society.

MELLEN: What did you mean when you said that your films were influenced in an important way by Walt Disney?

ICHIKAWA: At the time I was still painting and trying to be an artist I saw "Mickey Mouse" [probably *Steamboat Willie*]. It made the connection for me between picture drawing and filmmaking. I was very impressed by Disney's skills and methods. No doubt there were many who drew the pictures for him, but he organized the whole thing. Later came *Fantasia* and *Bambi* and so on. I entered the staff of a small cartoon-making film company around that time. The early works of Disney influenced me greatly.

MELLEN: Do you consider the Disney films an example of abstract art?

ICHIKAWA: Not really; it's a little different from abstract art. The early Disney films were done authentically. Not in the same language as regular films. He had created his work in such a way that he could translate his material into the terms of the general public. Everyone understands him. I mean this favourably. Disney's innovations, his method of revolutionizing filmmaking, deserves a Nobel Prize if we had such a prize for film.

MELLEN: In his later films he turned to praising the American system and existing values, completely ignoring the suffering and despair in our society.

ICHIKAWA: Yes, I understand that. He became very conservative. Especially in the eyes of younger people, he must have seemed very, very conservative. But you should not forget the fact that he, at one point of his career, provided dreams and hopes for children all over the world. He still should be remembered for his great contribution to the film industry.

MELLEN: He was, of course, enormously popular when I was a child. But the dreams he offered were ones that could never be fulfilled.

ICHIKAWA: Yes, probably so. The times have changed. Today young people probably don't go for him anymore. However, in those days we received much from him.

MELLEN: We can't deny him either because his world remains with us, in our minds. He is part of our childhood.

Can you tell me something of your future plans?

ICHIKAWA: After November, our production company and the Art Theatre Guild will start *Matatabi* (*The Wanderers*). It is about the tragedy of a very young outlaw. Then I will go to Munich and film the Olympic Games [*Visions of Eight*]. The movie itself will be made in the United States, but eight directors all over the world were selected to shoot the formal version of the Olympic Games.

MELLEN: Who are the others?

ICHIKAWA: Arthur Penn from the United States, Claude Lelouch from France, John Schlesinger from England, Franco Zeffirelli from Italy, and others. Each director can choose the event he wants to film. I chose the 100-metre dash.

Translated from the Japanese by Keiko Mochizuki

The Woman Who Touched Legs

MAX TESSIER

Kon Ichikawa:
Black Humour as Therapy

I N THE WEST, where Kon Ichikawa's films have rarely been shown, one tends to forget that, before the seriousness of his many literary adaptations, he was one of the postwar masters of satiric comedy and signed some of the finest examples of the genre.

What were Ichikawa's influences? As startling as it may seem, the director answers with a mischievous smile on his lips that, since he planned to become a painter and started out as a "cartoonist," the sole influence he acknowledges is Walt Disney. (Ichikawa's first film, *A Girl at Dojo Temple* [1945] was an animated puppet film adapted from a *bunraku* play.) After his early melodramas for Shintoho, he threw himself into satires of contemporary mores. His early films, at least those before 1953–54, were lampoons or screwball comedies that often heaped vitriol on the moral conventions of Japanese cinema. The best examples are *The Woman Who Touched Legs* (1952), and the two prototypes for this genre, *Mr. Lucky* (1952) and *Pu-san* (1953), both based on Taizo Yokoyama's very popular cartoon character, but adapted by the director in a highly personal manner. They featured actor Yunosuke Ito, whom one could call the Japanese Michel Simon, if Enoken is its Fernandel—just as Japanese critics had nicknamed Ichikawa the "Japanese Frank Capra."

This quality of screwball humour, visibly inspired by certain American comedies that Ichikawa had seen after the war, is found in *A Billionaire* (1954), also starring Ito and written in collaboration with Kobo Abe, the future author of *Woman of the Dunes*. It portrays, among other characters, a somewhat loopy young girl who builds a home-made A-bomb in her attic, terrifying the hero, who flees as fast as his legs will carry him and finds himself . . . 130 kilometres from Tokyo! Beneath its comic veneer one can discern the "atomic trauma," whose fallout clearly had searing effects on all sorts of films. Even though Ichikawa then turned to the dramatic films that earned him success abroad, *Harp of Burma* (1956), *Enjo* (1958), and

Fires on the Plain (1959), he never abandoned his sense of black humour and caustic irony. These qualities are present in *Kagi* (*The Key*, 1959), *Bonchi* (1960), in the extravagant fantasy *An Actor's Revenge* (1963), as well as the earlier comedy *A Full-Up Train* (1957) and the superlatively weird and grotesque *The Men of Tōhoku* (1957), one of the most bizarre films in the entire history of cinema. It depicts a band of *zummu*[1]—outcasts in the north of Japan, whose second sons were not allowed to marry—who communally take advantage of the favours of a widow bent on exorcising a curse at the behest of her late husband. In fact, Ichikawa was never the "great dramatic filmmaker" Westerners took him for, having been misled by the few exceptions discussed here. And the reputation he had in Japan of being a "director-mannequin" was not undeserved, especially after 1975, when he threw himself into a series of gruesome adaptations of Seishi Yokomizo's popular crime stories, visited on occasion by the "angel of the bizarre" who had watched over him since the beginning.

Ichikawa's reputation in the West rests on two war films, *Harp of Burma* and *Fires on the Plain*, a literary adaptation drenched with black humour; *Kagi*, based on the novel by Junichiro Tanizaki; his film on the 1964 Olympic games, *Tokyo Olympiad*; and the surprising *An Actor's Revenge*. Is this sampling representative enough of the oeuvre of a director who has made over fifty films since 1946, most of which are comedies and genre films never seen in Europe? Widely considered here as an "auteur" after *Fires on the Plain*, Ichikawa is judged in Japan far more severely by the critics. While acknowledging his technical skill, they deny him any real personality and maintain that this excellent *technician* has done nothing more than to "direct well" the scripts he was given, whatever they were. Hence, the ironic nickname, "director-mannequin," since he tackled every genre, adapted every writer. After seeing several of his films again, one must allow that while all this is perfectly true, there is, at least during a certain period, a true "Ichikawa vision"—a mixture of black humour and "cinematographic entomology" and a very recognizable aesthetic, notably in his CinemaScope films.

Ichikawa himself never wanted to draw a distinction between his "funny" and his "serious" films, and he seemed to loathe any overly rigorous (and thus, typically Japanese) categorization: "In general, we (Japanese) divide literature into two categories, 'pure' (*jun*) and 'popular' (*taishu*), and films are similarly divided into 'art films' (*geijutsu-eiga*) and 'entertainment films' (*goraku-eiga*): no one bothers to define these categories, and they do not satisfy me. Films are objects one can enjoy. And the 'purer' a filmmaker is, the subtler his philosophy, and the more we enjoy it and can learn ... but it disturbs me to see films that are didactic, which lecture and instruct us."[2]

Although he refuses labels and classifications, Ichikawa clearly opted for a new style in 1955, when he made *Kokoro*, from the novel by Soseki Natsume, one of the first of the great literary adaptations that earned his reputation in Japan and later

abroad. Set at the end of the Meiji era (one of the central scenes takes place during the funeral of the emperor in 1912), the story centres on the relationship between a professor (Masayuki Mori) and one of his students (Shoji Yasui, who played the role of the monk in *Harp of Burma*). The film is constructed in the form of literary flashbacks, opening with an explanatory letter the professor wrote before committing suicide. Admirably acted, bathed in an almost "Russian" psychological atmosphere, *Kokoro* is one of Ichikawa's finest films, and it is scandalous that it has never been distributed in France. (A mediocre remake was produced in 1973; but Kaneto Shindo's leaden directing is matched only by his heavy-handed psychology.) Soseki also inspired another of Ichikawa's films, the very amusing *I Am a Cat*, which the director adapted in 1975. But the screenplay was modified, and the film did not live up to Kajiro Yamamoto's remarkable earlier version (1936). (Both adaptations rely on predominantly verbal humour, an impediment to the enjoyment of foreign viewers.) *Kokoro* was the first in Ichikawa's very long series of literary "screenizations," the best of which owed more to the Japanese studio system than to the personality of the auteur, who, together with his wife, Natto Wada, adapted absolutely every kind of novel. Ichikawa became the central pillar of the *jun-bungaku* tendency in the 1950s and 1960s, Shiro Toyoda being another.

It is difficult to establish the continuity of an auteur in adaptations of writers as diverse as Soseki Natsume (*Kokoro* and *I Am a Cat*); Shintaro Ishihara (*Punishment Room*, 1956); Kyoka Izumi (*Nihonbashi*, 1956); Yukio Mishima (*Enjo*, 1958); Junichiro Tanizaki (*Kagi*, 1959); Shohei Ooka (*Fires on the Plain*, 1959); Toyoko Yamazaki (*Bonchi*, 1960); Aya Koda (*Ototo*, 1960); Toson Shimazaki (*Hakai*, 1962); Mishio Matsuda (*I Am Two*, 1962); Otokichi Mikami (*An Actor's Revenge*, 1963); Lady Murasaki (*Genji monogatari*, in twenty-six episodes for television, 1965–66); or, more recently, Seishi Yokomizo (a detective series, *The Inugami Family*, 1976), to mention only a few. But in the best of Ichikawa's transpositions we find evidence of the director's *gaze* that we can characterize as a curious marriage of an entomologist's perspective (Ichikawa observes his protagonists struggle like powerless insects with their destinies) and what I would call "black humour therapy," something quite rare in Japan. The characters of *Kagi* come to mind, in which Ichikawa accentuated Tanizaki's dramatic characterization by adding a dash of caustic irony, culminating in the final scene where the old servant woman is shown alone among the tins of poison. The characters painted by Ichikawa are never "heroes," but rather individuals pursuing an absurd goal, often alone: the monk-soldier in *Harp of Burma*; Goichi Mizoguchi, the Mishimian pyromaniac of the Golden Pavilion in *Enjo*; Tamura, a soldier forced to cannibalism in *Fires on the Plain*, or Ushimatsu, the "outcast" in *Hakai*; and Horie, the solitary sailor in the strange *Alone on the Pacific* (1963), who is as alone as the athletes in the magnificent *Tokyo Olympiad*.

The latter, a masterpiece, is a pseudo-documentary that also serves as an anthology of Ichikawa's tastes. Whereas nearly all sports documentarists have been

tempted by the cult of the "strength-and-beauty" of the human body, Ichikawa strives to record its mechanical weaknesses, the tremendous effort required, thus giving new meaning to the athletes' achievements. Every tensed back, drawn face and elephantine movement is hunted by the lenses of Ichikawa's 451, 600, or 1000 (the number is immaterial) cameramen—the director makes this Olympia first and foremost into a spectacle of human exertion, not of the superhuman powers of the gods of the stadium. It is in this sense that *Tokyo Olympiad* is an auteur film and not merely a collective technical performance. Visually masterful, judiciously employing all the available technical resources (particularly for the 100 metres, high jump and non-competitive sequences), the film is literally breathtakingly beautiful. Watching *Tokyo Olympiad* is a physical ordeal; one emerges from it gasping for breath—and not by accident! Ichikawa employs CinemaScope in a very particular way. Some commentators claim that he never grasped the possibilities of the format, and that he did not know how to "fill" the frame, but viewing *Tokyo Olympiad*, for which Ichikawa prepared and conceived each shot, particularly the framing, it is difficult to agree. One can say that he uses Scope in a very arbitrary way, and that, since *Enjo*, his use of *shoji* or wall partitions to divide space in the image has been deliberate. Ichikawa explains that he does not like to utilize the full surface of Scope, as his favourite director of photography, Kazuo Miyagawa, agrees.

This is easily confirmed by screening *Enjo*, one of Ichikawa's major films, based on *The Temple of the Golden Pavilion* by Yukio Mishima. Along with a few of his regular actors (Raizo Ichikawa, Tatsuya Nakadai, Ganjiro Nakamura), Ichikawa gives us a dense work in which the protagonists' psychology is a function of a precise historical situation: the American occupation in 1945, which caused numerous conflicts. Despite the beauty of certain shots, some exchanges of dialogue are wearying, but they are thankfully interspersed with visually magnificent flashbacks—such as the burial on the shore—or are advanced by tight editing that heightens interest by alternating shapes of different volumes. The masterly sequence of the pavilion burning is the film's high point, and, to depict the conflagration, Ichikawa employs a nearly impressionistic technique. The film ends with the suicide of the pyromaniac Goichi, who has burned down what he adored; the almost surprising sobriety of the sequence reinforces the meaning of the young man's gesture. *Enjo*, one of Ichikawa's most classical works, is almost totally devoid of his habitual irony.

Ichikawa is one of the only Japanese filmmakers to have adopted an exaggerated distancing gaze towards his characters—expressed in his camerawork, his aesthetic, and in his manner of directing his actors—which is tinged with a certain black humour (Machiko Kyo, Tatsuya Nakadai and Ganjiro Nakamura in *Kagi*, or his actors in *Bonchi*, and a particularly absurd black comedy, *Ten Dark Women*, [1961]). Director of photography Kazuo Miyagawa, who often worked with Ichikawa at Daiei, has commented: "I found it rather difficult to work with

Ichikawa, because his directions for photography were generally rather vague, and he was much more interested in acting and the direction of actors. Whereas other directors don't much like cameramen to interfere in the making of the film, Ichikawa was very easy about that and let me follow up as many suggestions as I wanted. In the frame, he would use fragmentation of the screen much more than other directors. He thought the camera should be more 'involved' in the film, almost like and actor. So, quite often, half the frame was filled by a *shoji*, or even sheer darkness ... I wonder what the public thought about it."[3]

From these remarks and from seeing his films, we are left to decide either that Ichikawa felt ill at ease with CinemaScope when he first started using it in 1957 with his unusual comedy *The Men of Tōhoku*, or, more likely, that he tended to imprison his characters in a universe that is essentially defined by the Japanese house in which most of his black comedies take place—and especially houses in Kyoto (*Kagi, Enjo*) or Osaka (*Bonchi*), cities whose linguistic particularities he knows how to use to perfection, much to the delight of Japanese audiences.[4] Ichikawa demonstrates an extremely personal aesthetic refinement that makes his best films so highly prized among those receptive to his form of black humour or "touch of madness": think of *Harp of Burma*, with its plains strewn with corpses; the elegiac landscapes of *Kokoro*; the burial on the beach and the flames engulfing the golden pavilion in *Enjo*; the drenched Philippine jungle and stony landscapes of *Fires on the Plain*; the fabulous stylized sets of *An Actor's Revenge* or the flattened spaces of *Alone on the Pacific*, with Yujiro Ishihara adrift on his boat; or of *Tokyo Olympiad*, where the athletes are captured by telephoto, overcome by exertion. All these sequences, and many others, testify to one constant in an aesthetic attitude that may be artificial, but that has created a fascinating kind of cinema in which mankind is trapped by the camera.

A major example of this theme can be found in Ichikawa's highly personal adaptation of Junichiro Tanizaki's *Kagi*. The film presents the auteur's hallmarks—formal stylization, black humour, and a sense of cruel detail—indispensable to the story of the poisoning of a family and of sexual senility. A man (Ganjiro Nakamura), troubled by his advancing age, is afraid of becoming impotent. To bolster his virility, he pushes his beautiful wife (Machiko Kyo) into the arms of his future son-in-law so that his desire will be excited by jealousy. Ichikawa denies that the ending is in any way comical, and classifies the film among his "dark" works.

In the realm of sexual perversion and anxious ambivalency, Ichikawa is without equal: witness *An Actor's Revenge*, in which an *oyama* (a male actor who plays women's roles on stage) murders the enemies of his family, who are responsible for his mother's suicide by hanging. Well served by his incomparable cast (especially Kazuo Hasegawa, in two perfectly contrasting roles), Ichikawa here gives free rein to his visual and structural fantasy. Everything is stunning in its mastery and humour: the abstract use of colour, judicious stylization of amusing interludes

taken straight from *kabuki* (to a very funny and completely appropriate jazz score—a recurring feature with Ichikawa), the ambiguity of the multi-faceted characters, and extreme beauty of the sets. (One is surprised by the bizarre "pop" aspect of this highly elaborate visual geometry, shot, it should be noted, in studio—an approach that facilitated a desirable stylization—by an Ichikawa who deemed that a realistic recreation of the exteriors would have been out of place and no doubt ridiculous.) The changes in tone—fearsome obstacles for an audience—are perfectly orchestrated.

The film's fantastical atmosphere springs from accumulated artifice and the tension between the "timeless" aspect and the few curiously interspersed historical references, such as the unexpected mention of the pillage of rice reserves, an actual event precipitated by the social unrest of the time. Perhaps the finest scene is the murder of the old speculator by the shogun's mistress (the stunning Ayako Wakao). His awkward defence provides an extraordinary moment of fright during which movement can barely be distinguished through the mist. The final shots of Yukinojo moving away through an unreal field reinforce the beauty of the legend and underscore the film's fundamental ambiguity. One notes in passing that its detractors have judged Ichikawa guilty of the crime of aestheticism, claiming its interest is only visual. Considering the incredible melodramas both Ichikawa and Mizoguchi made—outdated and ridiculous, even in the eyes of the Japanese—Ichikawa's "rescue operation" appears every bit as justifiable as that of Mizoguchi, despite their very different approaches. Where the latter insists on the human element to attain a sublimation of melodrama, a method whose finest application is surely found in *Sansho the Bailiff* (1954), Ichikawa evades reality and stylizes it to the point of abstraction, enabling him to develop an extremely rich, almost experimental cinema. He pushes the exercise to its conclusion, by including historical and sociological references, never satisfied with the sensible and tasteful illustrations of a Kinugasa (*The Gate of Hell*, 1952). Thus he touches us, confirming the breadth of his vision.

Although he has made several films dealing with sexual problems and perversions, Ichikawa flatly denies he is "obsessed" with sex, and points out to all who will listen that the tidal wave of Japanese erotic-pornographic cinema is literally senseless, especially because the "cases" it depicts are totally foreign to Japanese sexuality. He declared to Donald Richie, "In *Kagi* I wanted to make the point that the uninteresting thing about sex and society in Japan is that there can never be any kind of solution, and killing them all off was one way of doing it."[5] In Ichikawa's view, the sexual aspects are specific to Japan, and thus of no interest to him. His increasing interest in a manner of human entomology finds its culmination in *Tokyo Olympiad*: the acuity of his gaze, which pitilessly seeks out a detail to isolate it, enlarge it, and truly give it a role, most often a cruel one, is a trait shared by the majority of Japanese filmmakers. This cinema has enormous potential for

personal expression, for which the human–insect represents an inexhaustible subject that would lend itself equally well to surrealistic poetry—perhaps that of Buñuel, who many young filmmakers claim to follow. One need only mention a few recent films that incorporate and develop this embryonic idea: Imamura's *The Insect Woman* (1963), Teshigahara's *Woman of the Dunes* (1964), and the films of Susumu Hani in general, especially *Bwana Toshi* (1965).

The entomological emerges vividly in Ichikawa, who studies, dissects, and manipulates his protagonists, whether the old man in *Kagi*, the infant in *I Am Two*, the solitary navigator in *Alone on the Pacific*, the miserable derelicts in *Nobi*, or the athletes in *Tokyo Olympiad*.

It is in *Fires on the Plain*, based on the novel by Shohei Ooka, that this tendency reaches its apex. *Fires* is completely desperate, one of the blackest films ever made. Still, it is emphatically humanistic for an artist to denounce the abjection engendered by war and the loss of every semblance of dignity in humans who are reduced to an animal state. Here, Ichikawa's bitter sincerity is total. One tell-tale sign: the total absence of humour, which is present in even his most serious films. His approach is admirable for its simultaneous restraint and violence, resulting in individual scenes that are almost unbearable and a film that is a gigantic wave of horror and degeneracy. It is probably Ichikawa's only film in which he does not seek to aesthetically transcend his subject, thereby proving his sincere involvement.

If there is a kind of humanism in Ichikawa's films, it is far from Kurosawa's redemptive philosophy. Ichikawa has said, "Oh, I look around for some kind of humanism, but I never seem to find it. People are always complaining, the ending of the Olympic film is an example—why show all that strain and pain, they say. And they want happy endings too. But doesn't this desire for a happy ending show how unhappy they really are?"[6] The humanism Ichikawa declares he is searching for is tentatively manifest in a few films that are unfortunately not among his most successful. For example, the redemptive morality and vaguely mystical elements of *Harp of Burma* ruin a very fine subject. (Formally, too, the film is of little interest.) The failure of *Hakai* is perhaps more lamentable. The screenplay, adapted by Natto Wada, Ichikawa's wife, and the author of many of his scripts, is compelling: the search for equality by a young teacher, the son of a social outcast, in Japan of 1904. Aside from the inherent interest in this little-known aspect of Japanese social history, the film is made rich in implication by Ichikawa's generosity. The protagonist, who, at first, seeks to hide his social status from his friends and superiors, meets a famous writer, who reveals that he was born an outcast and teaches the protagonist the meaning of struggle before being betrayed. Ichikawa, although clearly impassioned, treats his subject too seriously, almost academically, and fails in his overwrought melodrama. The film includes too many long scenes of dialogue—his weakness—that undeniably induce boredom. A few imaginative sequences, where the filmmaker employs an original technique showing first the action as it

is imagined by the protagonist, and then the same scene in reality, break up the speeches, but they do not provide the balance the film needs.

No doubt aware of this partial failure, Ichikawa resumes his satiric and humourist manner in his next film, *Alone on the Pacific*, the epic of Horie (Yujiro Ishihara), a young man who crosses the ocean alone. Here, the filmmaker does not content himself with the pure and simple illustration of an ocean crossing; rather, he exposes the reasons that led the boy to undertake it. By means of flashbacks judiciously interspersed at key moments, when the contemplation of the boat risks becoming monotonous, we discover that it is Horie's dull social life that caused his obstinate determination and precipitated his action. His desire to flee the world is primordial, and on the sailboat he finds himself "one-on-one," that is, facing his double—a sort of guardian angel emanating from himself. But the outer world re-establishes itself quickly enough when he meets up with an ocean liner, much to the surprise of the passengers. The young man strives to appear completely normal and detached, for fear that they will rescue him. In fact, the jubilation at reaching the Golden Gate Bridge is short-lived, and no one is relieved by Horie's unwilling reunion with humanity. The ending is very Ichikawaian, with the boy, exhausted, falling asleep in a strange bathroom, where everything becomes erased from his mind, and he even misses his parents' phone call.

A disillusioned and hence cruel observer of human endeavours, Ichikawa is a filmmaker whose works are served by his humour and an apparently arid heart. He was unquestionably the direct inspiration of the new generation of Japanese directors, more than Mizoguchi or Kurosawa, who were somewhat unapproachable in their respective careers. Given his concept of "entertainment cinema," it was logical that, after his crisis of the sixties (when he worked for television and again started making animated films in Italy, with his curious *Topo Gigio and the Missile War* [1967] and taking a few stabs at independent cinema [*The Wanderers* (1973)], a rather interesting low-budget *jidai-geki*), Ichikawa would be willing to compromise. He regained commercial success with his Yokomizo series and other commercial films (*Queen Bee*, 1978), sacrificing his personal talent to produce a series of spectacular effects, whose only goal is brute impact. Is Ichikawa, with his legendary beret—one of the few filmmakers of his generation who continues to be active—still a disillusioned observer of human endeavours? He has, to be sure, become one of those "cinematographic insects" that he so often sought out in the undergrowth of the studios.

Notes

1. A deformation of the name Jimmu, the first emperor of Japan.
2. Kon Ichikawa, *Aru eiga-sakka no tawagoto* (Nonsensical Works by a Maker of Films), quoted by Donald Richie.

3. Max Tessier and Ian Buruma, "Japanese Cameraman: Kazuo Miyagawa," *Sight and Sound* 48, no. 3 (summer 1979): 189.
4. In Japan, the dialect of the Kansai region (dominated by Kyoto and Osaka), is known as *Kansaiben*. It is equivalent to the "*accent du Midi*" in France, Scottish in the United Kingdom, or Texan in the United States. Sibilants are aspirated, and unique local expressions are used (*oki-ni* for "thank you," instead of *arigato*).
5. Donald Richie, "The Several Sides of Kon Ichikawa," *Sight and Sound* 35, no. 2 (spring 1966): 85.
6. Ibid.

Translated from the French by Robert Gray (Kinograph)

Actress

MAX TESSIER

Nostalgia:
An Interview with Kon Ichikawa

This interview took place during the filming of *Princess from the Moon* (*Taketori monogatari*) in Kyoto in April 1987.

MAX TESSIER: Your best-known films in the West, such as *Kagi* (*The Key*), *Fires on the Plain* (*Nobi*), and *Enjo* (*Conflagration*), are all adaptations of famous works of literature. Why did you choose to adapt so many novels during the fifties and sixties and even afterwards?

KON ICHIKAWA: It came about somewhat by accident. At the time I was collaborating closely with my wife, Natto Wada, who had become my preferred scriptwriter. Ideally, we would have liked to make films from original subjects, but we didn't have enough life experience to do so. Moreover, our life experiences were certainly less rich than those of well-known writers such as Yukio Mishima or Junichiro Tanizaki, whose works explore a number of important questions. It was very interesting to blend our experiences with theirs, and to see what would arise out of such combinations.

TESSIER: Given that you were directing a great deal at the time—from two to four films a year—what was your approach in working with your wife?

ICHIKAWA: We would think a great deal about a project. Once we had agreed on it, I entrusted her with the writing of the entire script, including, of course, the literary adaptations. She was my wife; we shared everything. We were both responsible for the education of our children, and she knew all my strengths and weaknesses. She was the person who knew best what I was going to do on set, and who could feature my qualities as a director. I had complete confidence in her when it came to writing a script.

TESSIER: Among the literary adaptations, which is the one you most prefer, as a viewer?

ICHIKAWA: I can't say whether or not it's the best adaptation, but I prefer to watch my version of Mishima's *Enjo*.

TESSIER: To what extent did you collaborate with authors like Mishima (*Enjo*), Tanizaki (*Kagi*) or Ooka (*Fires on the Plain*)?

ICHIKAWA: In general, authors tell the director: "Figure it out (*O-makase*), I let you be!" Which is no doubt very different than what happens in Europe, where the author is often involved in the writing of the script. This is not the case in Japan. Even when we adapted Ooka or Tanizaki, we greatly modified the story. With *Enjo*, we remained more faithful to the original text, perhaps because Mishima was inspired by an actual news item—the story of a young pyromaniac who set fire to the Kinkakuji [Kyoto's Golden Pavilion]. For *Kagi*, however, the original story was obviously invented, fictional, and we modified it a great deal for the film adaptation. Shohei Ooka based *Nobi* on his experiences in the Philippines, but there too, I altered the story quite a bit. For example, in the novel, the hero, Tamura, was a Christian soldier. But it somehow didn't seem plausible to show a Japanese soldier saying "Amen." So I changed this character.

TESSIER: During the filming of *Enjo*, however, Mishima himself was often on set, as many of the photographs from the shoot testify.

ICHIKAWA: Yes, that's true. It was very difficult to write the script for *Enjo* because Mishima's style is so sumptuous, so very brilliant. Our producer, Mr. Fujii, brought us the notes Mishima compiled during his investigation of the young pyromaniac Goichi. Thanks to Mr. Fujii, we put aside the novel somewhat and worked more from Mishima's notebooks. That's really what allowed us to write a more realistic script.

TESSIER: The scene of the fire at the Golden Pavilion must have been very difficult to shoot?

ICHIKAWA: Yes, indeed. First of all, we could not film in the area of the University of Kyoto, which is protected. So we rebuilt the Golden Pavilion near Arashiyama, alongside the river, when, in fact, the temple lies next to a swamp. Usually we film using models, but for this particular scene, we built a real temple, very large, which cost the production a great deal. In fact, it was a scale replica of the original, and the way in which fire was set to it was quite different than how it actually happened. In the end, I think the scene is quite successful.

TESSIER: Why didn't you shoot the film in colour? Did you see Yoichi Takabayashi's 1976 remake?

ICHIKAWA: No, I haven't. At the time, people were shooting quite a bit in colour and Masaichi Nagata, the president of Daiei Studio, insisted that we shoot *Enjo* in colour. But I was opposed to that. I absolutely wanted to shoot in black-and-white, precisely to avoid the banality of colour. I worked with the famous cameraman Kazuo Miyagawa, with whom I had several professional arguments, but the result was excellent, I believe.

TESSIER: Before this period of literary adaptations, you made many comedies. Wasn't the best of these *A Full-Up Train (Man'in densha)*?

ICHIKAWA: Oh no! I think that film is a complete failure! Personally, I prefer *Pu-san*, or even *I Am Two (Watashi wa nisai)*, for example. *A Full-Up Train* was an original script. It was made during the period when I was very influenced by René Clair's comedies. We discovered them after the war, as did Kinoshita, although he digested this influence much better in his early comedies.

TESSIER: Of all your films, which five do you prefer?

ICHIKAWA: Above all, *Enjo*. But also *Actress (Eiga joyu)*, *Harp of Burma (Biruma no tategoto)*, *Pu-san*, as well as *Ototo (Her Brother)*. The latter was shown at Cannes, and I was sure it would win a prize. I couldn't attend the festival as I was in production on another film. The president of Daiei went in my place and told me that the film was very poorly received. I asked myself then if the French really understood anything at all about cinema! I had worked a great deal on the colour with Miyagawa, and never understood why it failed at Cannes. I also like *An Actor's Revenge (Yukinojo henge)* quite a bit, a film I very much enjoyed making.

TESSIER: To return to literature, the trend of "pure literature" (*jun bungaku*) seems somewhat exhausted or subsumed now by adaptations of popular literature, of bestsellers mainly, in the style of Seishi Yokomizo, whose work you also have adapted. Why is this?

ICHIKAWA: I think that contemporary writers who have to speak about "today" have a great deal of difficulty doing so, because it is very hard to grasp. This is a universal phenomenon. The world seems to me to be plunged in a kind of fog through which we can see very little. It can be very interesting, since several phenomena are all taking place simultaneously, but it simply has become very difficult to draw a straight line, a clear line, through the confusion. This is no doubt why I am now turning towards ancient tales, but with a modern man's sensibility. And recently, even someone like Kurosawa has turned exclusively to historical films (*Kagemusha*, *Ran*), which seems to me significant. Since *Dodes'kaden*, he hasn't made a modern film, no doubt because the world today has become too difficult to comprehend for someone of our generation. In fact, ideally we would make *gendai-geki* [contemporary subjects], but for now, we have abandoned this idea. The solution, then, is to deal with older subjects, but with the spirit of modern man and try to apply these stories to our era.

TESSIER: Is that the reason then that you are now directing *Princess from the Moon*, a fantastic legend about ancient Japan?

ICHIKAWA: Yes, but I have wanted to film this tale for a long time. The project was delayed due to high production costs. But Toho has finally agreed with Fuji television to co-produce the film. It's an old dream that is finally being realized. I use a lot of special effects since it's a story filled with supernatural elements. As far as the principal actors are concerned, other than Toshiro Mifune

and Ayako Wakao, who play the adoptive parents, the princess is played by Yoshuko Sawaguchi, and Kiichi Nakai, the son of Keiji Sada, plays her lover. It's a film of pure diversion, and I am very happy to be able to direct it.

TESSIER: For how long have you wanted to make a film about Kinuyo Tanaka, the famous actress whose life you retrace in your last film, *Actress (Eiga joyu)*?

ICHIKAWA: For about fifteen years! It's not really a film about her life, but rather the history of Japanese cinema seen through her character. I wanted to make a human drama, and when Kinuyo Tanaka's life story was published as a book, I added my own memories and my own ideas to it. My film goes beyond a simple biography of an actress.

TESSIER: Why does the film suddenly end in 1952 during the shooting of Mizoguchi's *The Life of Oharu (Saikaku ichidai onna)*?

ICHIKAWA: I followed the chronology of her life. If my film ended on this particular scene of the shooting of *Oharu*, it's because I thought that Tanaka, just as much as Mizoguchi, had reached the peak of her creativity. They had gone beyond the agony of giving birth to a work of art, passing through every step of creation. They were both driven by the same passion. Of course, there were other films and other successes, like *Ugetsu* at Venice, and then disagreements: Tanaka died alone, long after Mizoguchi. But if I had gone beyond this point, my film would have been too long, and in any case, I think it was better to end on *Oharu*, on this shared moment of incandescence.

TESSIER: Watching the film, I got the impression that you felt a kind of nostalgia for older Japanese cinema, which you knew so well.

ICHIKAWA: It's true, but not only for Japanese cinema, for cinema in general. I think the cinema of the past was far better than that of today; there were a number of magnificent films, and there are a lot fewer today. That's why I think one must love and study the cinema of the past, and to think about it if one wants to be a director today.

TESSIER: You knew Mizoguchi and other directors whose careers began in the period of silent films?

ICHIKAWA: Yes, a few. Especially Heinosuke Gosho. But I never met Kenji Mizoguchi, because we didn't work in the same studios. I was at Toho when he was at Daiei. Unfortunately he died in 1956, the year I went to Daiei.

TESSIER: Have you seen Kaneto Shindo's film on Mizoguchi, *The Life of a Film Director (Aru eiga kantoku no shogai: Mizoguchi Kenji no kiroku)*?

ICHIKAWA: Yes, I have, but it's really a documentary while my film is an attempt at a fictional reconstruction. It's a completely different approach.

TESSIER: Do you continue to go to the cinema?

ICHIKAWA: No, I don't have a lot of time and not much desire either. But I continue to watch Kurosawa's films.

TESSIER: That's easy, since he now only makes a film every five years!

ICHIKAWA: Yes, it's true, but I would like it if he filmed more often, and took less time. He is the director who best represents Japan and is really one of the world's greatest directors. My other colleagues, like Kinoshita or Kobayashi, with whom I started the company The Four Horsemen (*Yonki no kai*) in 1969, don't shoot much any more. This is unfortunate. As far as the young filmmakers are concerned, I have to say I don't know what they are trying to do.

TESSIER: What do you think of the directors of the intermediate generation, like Oshima, Yoshida, Shinoda, and Imamura?

ICHIKAWA: They are very different and I don't understand them well. But I do think Imamura's *The Insect Woman* (*Nippon konchuki*) is a very interesting film. In fact, I remain fascinated by Kurosawa's work. Of course, *Ran* is not entirely successful, but it's still a tremendous film. For me, that is truly great cinema.

TESSIER: Thank you for agreeing to this interview.

Translated from the French by Lara Fitzgerald

Nihonbashi

YASUZO MASUMURA

Kon Ichikawa's Method

YASUZO MASUMURA (1924–1986) was a key pivotal director of his period, who, like Ichikawa, linked the tradition of the postwar "golden age" of Japanese cinema with the New Wave of the sixties. An intellectual renegade drawn to Western ideas of existential individualism and socialist liberation, Masumura studied both law and literature at Tokyo University (where he befriended classmate Yukio Mishima, who later starred in Masumura's *Afraid to Die*), and finished his thesis in philosophy on Kierkegaard as he began his career as an assistant director at the Daiei studio. There, he assisted Kon Ichikawa and Kenji Mizoguchi, the latter on such films as *Princess Yang Kwei Fei* and *Street of Shame*, and Daiei groomed him to follow in those masters' footsteps. When he went it alone, however, Masumura repudiated their legacy, laying the groundwork for the New Wave with his wild *Kisses*. Masumura was determined to destroy the traditional Japanese cinema, which he thought was moribund, premodern in its fealty to literary sources and forms, its characters defined by resignation, suffering, self-sacrifice, and submission to the collective. Rejecting the emphasis on emotion, humanism, and "atmosphere" of traditional Japanese cinema, spurning both formal classicism and abstract social concern, Masumura argued for a new subjectivity, energy, individualism, and for narrative modes that would both encourage and reflect personal liberation. Ranging from the Tashlin delirium of *Giants and Toys* and Sirkian satire of *Warm Current* to the stringent elegance of *The Wife of Seishu Hanaoka*, *A Wife Confesses*, and *Thousand Cranes*; from the political critiques of *A False Student* and *Hoodlum Soldier*, which remind one of Oshima, to the Suzuki-like yakuza thriller *Afraid to Die*; from the erotic exhilaration of *Seisaku's Wife* and *Manji* to the sexual extremities of *Warehouse*, *Vixen*, *Red Angel*, *Tattoo*, and *Play*, his work is distinguished by idiosyncratic sensibility and style, and unfailing nerve.

Masumura was assistant director to Kon Ichikawa on three films made in 1956 and 1957: *Punishment Room*, *Nihonbashi*, and *A Full-Up Train*. The following article, written just before Masumura's death in November 1986, illustrates the younger

director's simultaneous contempt and respect for the master's capricious ways. What remains to be examined is the influence each had on the other. Certainly, Ichikawa shared with his assistant a fond regard for outsiders and rebels, a dark, ironic vision of the dehumanization of postwar Japanese society and its economic miracle, and an interest in the grotesquerie of its burgeoning "image culture." It is easy to discern similarities between the taboo-breaking sexual permutations of Ichikawa's *Kagi* and Masumura's *Manji*, both based on Tanizaki novels; between the closed worlds and violent youths of Ichikawa's *Punishment Room* and Masumura's *A False Student*; and between the satire of television and advertising in the former's *Ten Dark Women* and the latter's *Giants and Toys*. That Masumura remade one of Ichikawa's early comedies, *The Woman Who Touched Legs*, which was produced by Ichikawa, perhaps signals that the assistant had less a classic case of the "anxiety of influence" than a sneaking admiration for the master whose method he here so firmly rejects.

— JAMES QUANDT

Kon Ichikawa signed with the Daiei Studio in 1956, where he began production on his first film *Punishment Room*, based on the novel by Shintaro Ishihara. The crew that welcomed Ichikawa to the Daiei Tamagawa studio was shocked when they saw the film's script. On the last page Ichikawa had written, "I will not permit one word of dialogue to be altered." For people who were accustomed to Kenji Mizoguchi's rewrites right up to the time of shooting, forbidding changes to the dialogue seemed a bizarre and arrogant edict.

Why would Ichikawa do this? Certainly, he was a perfectionist, and the script may well have been perfect. The dialogue was written by Ichikawa's wife, Natto Wada, so perhaps he wanted to follow it as closely as possible. Or perhaps—since this was Kon Ichikawa, who considered the image and its composition far more important than dialogue—he thought the script was good enough already. In fact, this declaration was Ichikawa's challenge to the Daiei Tamagawa studio: "I'll make my films my own way—I won't let you interfere."

Once the shooting for *Punishment Room* began, Ichikawa said that he could feel the crew defying him, that they all hated him and refused to follow orders. Every time a director works with a new crew there's a sense of dislocation, of gears not meshing perfectly, but to say that he was "surrounded by enemies" was a bit of an exaggeration. However, Ichikawa was so highly strung that he hated technicians who didn't do exactly as he ordered and treated them as enemies.

Conflicts with the crew became more frequent as the shooting on *Punishment Room* progressed. The cinematographer [Yoshihisa Nakagawa] was talented but a bit coarse: he rubbed the delicate Ichikawa the wrong way. In turn, Ichikawa behaved so rudely that the cinematographer blew up and shooting had to be suspended. Things didn't go well with the sound engineer either. He objected when told to include the atmospheric noise of the barley field [in the opening scene of the film], insisting that extraneous offscreen sounds would be heard. In the end, he had a nervous breakdown and had to be replaced. Ichikawa even thought that the driver for the location shoot was too haughty and had him replaced too.

All directors wish to work with a crew sympathetic to them, but Ichikawa was more than extreme in this regard. He was exceedingly shy with strangers, almost womanish in the intensity with which he liked or disliked people; if he disliked someone, he would dismiss them from the crew no matter how skilful they were. Anyone he thought secretive, arrogant, overbearing, rough, or loud would soon be expelled, till only the gentlest, quietest, and most co-operative remained. Ichikawa was not a director to scream at or scold the crew to get results. He worked in a relaxed atmosphere, burnishing his artistic sensibility and creating a succession of interesting images. Ichikawa's reason for ejecting anyone he thought resisted or opposed him, until he was left with a crew that would work quietly in the way he wanted, was to protect his sensitive method of directing.

So that is how *Punishment Room* was made. It was a film full of Ichikawa's genius and superior technique but whether or not it was a criticism of the *taiyozoku*,* whether it showed approval or disapproval of Shintaro Ishihara's novel, was left unclear. The film simply followed the novel's action and plot line. Since the story was quite immoral for the time, the film was quickly attacked by important right-wing critics, who wrote "talent and technique without ideas are dangerous." Ichikawa refused to back down: "Sensibility and technique in themselves *are* art, in themselves *are* a form of thought." In any event, Ichikawa was quick to make enemies and struggled fiercely to drive them away, though the way he fought was somewhat childish—less like a lion or a leopard than an angry cat.

Ichikawa's second film at Daiei was *Nihonbashi*, based on the novel by Kyoka Izumi. Yet again, there was trouble between director and crew, although this time it wasn't about the director's personality preferences. Instead, there was a disagreement about the approach to making the film. Daiei had already produced many *Meiji-mono eiga* [films set in the Meiji period, 1868–1912] and the crew had a detailed knowledge of the clothing and customs of the period. But Ichikawa disregarded the historical background. For example, geisha of that period wore only simple kimono embroidered with small patterns, but Ichikawa demanded that

*The "sun tribe," described by the picture magazine *Asahi girafu* in 1956 as "people in their teens or early twenties [who] seek action before reason and are keen about the pleasures of the flesh."

Iwata Sentaro [the historical advisor on the film] design a gaudy kimono featuring large coloured checks for the lead actress. The assistant director in charge of these historically inaccurate costumes protested strongly but was completely ignored.

Another incident involved the main road over the bridge of Nihonbashi, which, during the Meiji period, was spread with gravel. The chief set decorator went to great lengths to find some beautiful gravel and spread it generously over the road on the film's open set. However, Ichikawa rejected the gravel, and curtly ordered it removed. The head set decorator was furious. Great directors such as Teinosuke Kinugasa, Daisuke Ito, and Kenji Mizoguchi had never ignored the historical accuracy, established through detailed research, of their costume and art directors. "Who does this Kon Ichikawa think he is?" the set decorator shouted—but he was overruled. Grudgingly the crew hauled away the gravel. This incident does not indicate that Ichikawa completely rejected realism. He simply wanted the composition on the screen to conform to the image in his head.

Ichikawa wanted to create images that matched the strange but beautiful poetic world of Kyoka Izumi, and so decided to retain a certain "blackness" in his compositions. However, the cinematographer, following standard practice, placed faint lights on the dark areas of the sets that appeared in the frame, turning the black into what he called "exposed black" [*ate kuro*]. But Ichikawa wanted an image that included a black with no light on it whatsoever, and after a week of argument he finally prevailed over the cameraman, and continued to compose images with his absolute black.

Ichikawa wanted to avoid ordinary realism in *Nihonbashi,* and create something true to his own vision, a wholly visual film. Kyoka Izumi's *Meiji-mono,* however, was not the best choice. There really is no alternative to showing the Meiji period as the Meiji period. Ichikawa's Osaka roots [in western Japan] made it impossible for him to fully portray the world of Kyoka Izumi, who was born in Edo [old Tokyo, in eastern Japan]. Despite the struggle to impose his point of view on the crew, the film ended up a mess. But that was Ichikawa's childish nature—always looking for fights.

Ichikawa next made *A Full-Up Train* at Daiei. In his trademark satirical comedy style, this film (from an original script by—of course—Natto Wada) is an excessive caricature of a young man's struggle to survive in an overpopulated Japan. Ichikawa piles on scenes of crowding and chaos: a tiny dentist's waiting room crammed with about forty patients, buses not stopping as they pass each other in one-lane street markets, gridlocked traffic, and so on. There was no longer anyone in the studio who resisted Ichikawa. His crew obeyed him as if they were his own limbs, and the shooting progressed smoothly to completion.

However, *A Full-Up Train* was no comic masterpiece since the original script was too schematic and abstract. Making a comedy requires a true critical spirit and high level of education but the scenario lacked both. It was simply a succession

of not particularly insightful scenes about overcrowding in Japan, giving the audience little to ponder. Perhaps the ironic theme of a "full-up Japan" didn't correspond with contemporary Japanese society, in which high-level economic expansion had already begun. Ichikawa's comedy *Pu-san* was more successful: behind that film one could detect the keen critical eye of the original *manga** writer, Taizo Yokoyama.

A Full-Up Train also failed because it merely exaggerated everyday realism, producing images lacking in interest. Though Ichikawa was adamant about avoiding everyday realism, the film ended up merely clownish, moving frantically without breaking free of its realist frame. That is no way to make a truly interesting social comedy. Ichikawa enjoys comedies and made another, *The Pit*, after *A Full-Up Train*. However, this too was a failure, a completely incoherent piece of work. So what was Ichikawa to do?

Ichikawa has the ability to create superb images. He possesses tremendous compositional skill, rivalled only by Akira Kurosawa. His talent allows him to create first-rate images that easily escape realism and result in superior films. But how could he best go about achieving his goal of visual cinema? After pondering the question long and hard, Ichikawa seized on a solution and realized it wonderfully.

Ichikawa has neither the grounding nor the talent to deal with logic or abstractions. However much he likes comedies, every time he writes an original script the film is a failure. Reflecting on this problem, he realized that he must choose the original work carefully—by selecting not just any novel, but a first-rate work of literature. Using the novel as a foundation, he would produce draft after draft until he had a workable script. The resulting scenario would contain the elevated logic and abstractions, the poetry and truth of the original: the drama would emerge from skilful arrangement. This strategy, at least, would not end in failure.

If we think of the films that Ichikawa made after *A Full-Up Train* and *The Pit*, it is apparent that he uses major literary works as the basis for his films: Yukio Mishima's *The Temple of the Golden Pavilion*; Junichiro Tanizaki's *The Key*; Shohei Ooka's *Fires on the Plain*; Aya Koda's *Her Brother*; Toson Shimazaki's *The Broken Commandment*; and so on. Rather than produce a clever interpretation of the novel, Ichikawa and Natto Wada obediently extracted and refined their scripts from the source. It was as if they wanted to make the film abound with all the beauty, depth, and interest of the original text.

Using the original as a foundation, they created a solid script. Directing and filming his actors according to the script, Ichikawa established his own unique way of making films [*enshutsu hoho*]. He didn't ask for enthusiasm or co-operation from his actors. Rather, he rejected it. If the actors performed badly, he would be left

*Literally a comic strip or illustration, but also used to refer to any non-live action animated film using puppets, silhouettes, or, in particular, drawings.

with banal realism. For Ichikawa, the less an actor moved and emoted the better. He also preferred that actors deliver their lines in a monotone, without eliciting empathy in the audience. He absolutely rejected dialogue dripping with emotion; in fact, he didn't think dialogue was important at all.

As a result, Ichikawa's work was often called "dry and intellectual," but this opinion shows a certain misunderstanding. It's not just that an impassioned performance would turn his film into everyday realism; it would also destroy the "pictures" that the director had created. Actors became a kind of thing, just like the sets and props: it was enough that they occupied Ichikawa's compositions. If the actors moved around like real people, the composition and the mood that Ichikawa wished to create would be destroyed. Unlike other directors, Ichikawa did not seek to create drama through the actors. He wanted to make the film out of pictures alone. And unlike Mizoguchi, who wrote and rewrote the dialogue and worked his actors astonishingly hard, chasing them around the set with his camera crane to create cinematic realism, Ichikawa went in a completely different direction.

Ichikawa makes films out of pictures. You may object by saying, "That's obvious. Films have been composed of pictures since Keaton and Chaplin made silent movies." Although the objection is certainly correct, directors these days are spoiled by the talkies. They find it almost impossible to create a feature-length drama through images alone, without relying on actors or dialogue, since if the particular composition doesn't have inherent force then the film itself doesn't work. It seems to me that Akira Kurosawa and Kon Ichikawa are the only directors in Japan who can create a fictional narrative through images alone.

How does Ichikawa create such powerful and affecting images? His secret lies in *manga*. After graduating from Ichioka Technical School at the age of eighteen, Ichikawa joined the J.O. Studio in Kyoto as a layout artist. After that he worked as a one-man production team in all aspects of *manga* film production—story, script, continuity, direction, and cinematography. To that end, he exhaustively studied the Popeye and Disney cartoons that J.O. bought as reference material. Perhaps that's the reason he loved cartoons so much, and in later years wrote and directed comedies that used a cartoon form to dissect Japanese society. However, his comedies were failures. Now more than ever he is determined to make his compositions even more *manga*-like.

Ichikawa takes a magnificent work of literature and examines it in order to create his characteristic compositions. That is no easy task. First he must eliminate all abstract theory and thought, a simplification that does not particularly concern Ichikawa, who went only to the Ichioka technical school. Then with an eye as sensitive and unclouded as a child's, he penetrates to the essence of the original literary work and creates simple and clear *manga*-like images that at the same time are saturated with mood and suggestion.

Ichikawa is a master of that difficult task. Take *Hakai* (*The Broken Commandment*), for example. The main character in the original novel, Ushimatsu Segawa, is a "New Commoner," the popular name given in the late nineteenth century to those born in the *hisabetsu buraku* [settlements of outcasts under the previous Tokugawa administration]. How could the director portray a "New Commoner" of the Meiji period in a cinematic way? Ichikawa focused on a black bull in the opening shot of the film. The animal is to be killed by the New Commoner, and stands frightened, on the point of running away. The terrified black bull, its eyes filled with tears, becomes an image of the sad figure of the New Commoner, then and now. Ichikawa represents the New Commoner through that image of a transfixed black bull.

In another scene from *Hakai*, a cow is slaughtered. A New Commoner strips the skin from the cow and butchers it. Ichikawa had an actual cow killed, cruelly detailing the process, not only to illustrate the fact that butchering cows was a New Commoner profession, but also to represent the cruelty of their existence without using a single line of dialogue. Through the butchering of one head of cattle, Ichikawa created a powerful portrait of the position that New Commoner Ushimatsu Segawa found himself in, of his psychology, and of the society that constrained him.

This is Ichikawa's method of adapting literature to images. The assassination of Rentaro Inoko in *Hakai* is another example. The scene is set in northern Japan, in a small outpost blanketed in snow, without a soul in sight. Inoko is attacked by an assassin on the narrow road. Ichikawa pulls his camera back to an extreme long shot and intently observes their struggle. Eventually Inoko falls and the assassin flees, but the camera, without moving, continues to film the setting. During this entire scene there is absolutely no dialogue, but the composition overflows with the horror and sadness of the murder. The town covered in snow stands in for Meiji Japan, its wintry desolation telling us just what kind of society produced this killer. Here, too, we find a magnificently cinematic rendering of a literary masterpiece.

We should recognize that this method of narrating a complex literary work in images is no longer realism but symbolism. Ichikawa succeeded in his desire to escape realism—not in the comedies that he scripted himself, but in the symbolic method of his literary adaptations. The marvellous imagistic sequences in those films are not simply adaptations of literary works but realizations of a completely independent world of images.

How was Ichikawa able to conceive such exquisite images? His artistic sensibility was keen and free, like a child's. If he behaved like a child, picking fights with those around him and constructing his own little empire, it was in order to preserve that unfettered sensibility. Compared to Ichikawa, ordinary filmmakers are set in their ways. Their personal sensibility is besieged by so many theories, abstract ideas, and received opinions that they cannot form original ideas of their own.

Ichikawa's love of *manga* also contributed to his ability to create superb images. *Manga* do not force him to abandon his extravagant childish innocence; their images are simple and clear designs that catch people by surprise with their trenchant contents. It seems that Ichikawa, who has long thought in terms of *manga*-like expressions and designs, can create his own personal compositional style from his first rate *manga*-like ideas and images, even when he is dealing with a work of literature.

Ichikawa's talent, however, is not that of a natural genius. I don't suppose that images come easily to him when he reads a literary work. I expect he reads the book again and again, wracking his brains until he manages to condense and transform the contents of the literary text into "compositions." That is to say, his symbolism is not simply a product of his talent and sensibility. It is a symbolism manufactured with great effort, after a terrific struggle to create and amass "images."

Ichikawa once responded to a critic who attacked him by asserting, "Sensibility and technique in themselves *are* art, are in themselves a form of thought." That is surely the case. It is quite easy to produce a film out of theory and abstract ideas. Nor is it particularly difficult to make a film which relies on dialogue and the performance of the actors. But turning the contents of a literary work into "images" that narrate themselves is an almost impossible task. Employing a keen sensibility and precise technique to translate the theories and abstract ideas of a literary source into images is surely, as Ichikawa claimed, an art in itself. Moreover, those images are themselves overflowing with ideas.

I wrote that in Japan only Akira Kurosawa and Kon Ichikawa could narrate a film using images alone. Yet the contents of Kurosawa's and Ichikawa's images are completely different. Kurosawa's images are without question splendid: beautiful, exciting, and dynamic. Kurosawa is a realist to the last; compared to Ichikawa, he does not employ a single symbolic composition. In *Seven Samurai* Kurosawa shows the fearsome and chaotic battle in the mud against the bandit enemy, and the battle against the warriors attacking on horseback. Kurosawa's compositions are tremendous, sometimes achieving a superb formal beauty. But the images neither express nor suggest anything more than the desperate struggle of the seven samurai and the battle against the armoured warriors. In sum, Kurosawa's films string together consummate images according to a realist method.

Ichikawa's compositions, like the image of the black cow in *Hakai*, usually express or hint at something more. Where does the difference between these two directors' compositions originate? Kurosawa chooses relatively simple popular stories and attacks them head-on with his powerful craft, while Ichikawa chooses complex literary texts and expresses their contents in restrained imagery. Without such symbolism it is impossible to fully depict the depth and value of a literary text.

Also, like most people from Osaka, Kon Ichikawa has a sense of humour and irony. Isn't it embarrassing and foolish to portray human drama using straight-

forward realism? Ichikawa does not present us with the humour, anger, sadness, and joy of humanity in all its rawness, but instead observes it with an ironic and detached gaze, sublimating it through symbolism, thereby giving the whole work a unified beauty.

Translated from the Japanese by Michael Raine

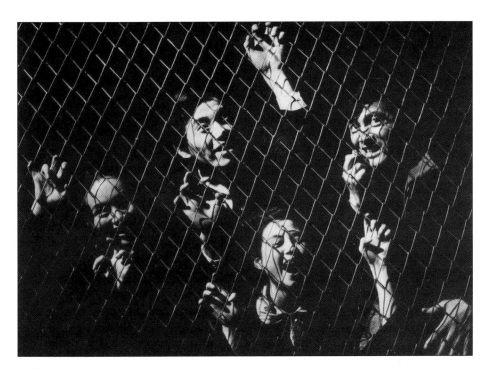

A Billionaire

TADAO SATO

Kon Ichikawa

What Is a Director?

SOME DIRECTORS write their own scripts, while others never do. Those who contribute to screenplays as writers have fairly strong notions about how their ideas will play out in the script. But even if we make a distinction between directors who write, and those who don't, there are many variations in between. For example, directors such as Keisuke Kinoshita direct only films from scripts written by themselves. Others, such as Yasujiro Ozu, collaborate with writers, and manage to incorporate the writer's individual style, whatever it might be, into their own vision. Then there are directors who are totally averse to writing scripts, but who treat the screenwriter as an extension of themselves; they work only with writers whom they can totally assimilate into their own style. Finally, there are directors of whom Kenji Mizoguchi is a good example, who work with writers who can produce, even in an emotionally volatile atmosphere, a paradoxical kind of intimacy that makes the screenwriter "one of the family."

When Mizoguchi was acting as head of the Film Directors' Guild, Toei Studio's Iwao Mori introduced the "producer system," whereby the producer held absolute authority over the production, ostensibly directing the director. The producer had the authority to dictate, for instance, that the director reshoot a scene. This system was introduced at Toho's inception by Mori, who was in charge of production. At that time, the director's title that appeared in the credits was changed from *kantoku*, which emphasizes the qualities required to create and manage the entire production apparatus, to *enshutsu*, which refers only to the task of directing the actors, or giving instructions to the cameraman, denoting essentially, a technical administrator. *Enshutsu* therefore has less status.

The Directors' Guild hotly opposed the *enshutsu* system, and lodged a protest with Iwao Mori, demanding that its members have the right to the title of *kantoku*.

Kenji Mizoguchi and Yasujiro Ozu both approached him, and Mizoguchi stated, "I'm responsible for everything that the director does. I run the production, I do everything on the shoot, I direct everything that happens on the set. Not to mention that the person who directs the writing of the script is naturally the director. If you call this position *enshutsu*, it is on the same level as the screenwriter, which is intolerable." Mizoguchi emphasized that since he directs the writing, he did not bill the script as co-written, even though he may have thrown around ideas or instructed the writer to do various things. As long as he was called the *kantoku*, that was sufficient.

Mizoguchi never authored or edited the scripts himself. However, he tirelessly pushed the screenwriter, often issuing changes until the very last minute. On the set, when a line change occurred to him, he would have the writer comply on the spot. Thus, although his name never appeared in the credits as such, Mizoguchi effectively worked as a co-writer on many of his films.

Most directors who write their own scripts cannot pursue many themes, so they generally have a set of key concepts which they follow throughout their work. This does not mean, of course, that directors who don't write scripts lack originality. The roster of great directors who do not write their scripts includes Tadashi Imai, Satsuo Yamamoto, Kozaburo Yoshimura, and, until the 1960s, Kon Ichikawa himself. On occasion he did contribute to the writing, and at times he wrote for other directors under the pen name Kurisutei (after Agatha Christie). But at the beginning of his career, Ichikawa was not known for his screenwriting.

In most cases, the director will supervise the writer, but in the case of Ichikawa's *Ototo* (1960), Yoko Mizuki worked alone to adapt Aya Koda's fictional work. The script was judged to be virtually flawless, and so was filmed without any directorial intervention. A strong script, so complete that even edits seemed unnecessary, meant that Ichikawa's desires didn't figure in the planning or the writing stage. All that was needed was to direct it. Ichikawa was indeed literally a director (*enshutsu-ka*), and the directing that followed was marvellous.

Put in extreme terms, *enshutsu* is restricted to the domain of technique. The *enshutsu-ka* is more of a technician, rather than an artist wanting to impart a vision. From the very beginning of his career, Ichikawa has made films of many genres and tones, including melodramas, action movies, farces and sophisticated, urbane comedies, profound films like *Kokoro* (1955), and psychological epics like *Harp of Burma* (1956). There are also works which seem designed to ride a certain wave of fashion, such as *Twelve Chapters about Women* and *All of Myself* (both 1954).

Ichikawa has also adapted literary works like Kyoka Izumi's melodramatic period piece *Nihonbashi* (1956), as well as Shintaro Ishihara's *Punishment Room* (1956), a hard-hitting work about youth culture, written and set in the mid-fifties. It is hard to imagine any continuity between the conceptual worlds of Ishihara and Izumi. Ichikawa also adapted Yukio Mishima's *The Temple of the Golden Pavilion*, an incongruity that gives pause, especially when one considers that he also directed *I Am*

Two (1962), with its bratty two-year-old protagonist. (The mystery of life as seen by the child is the central concept, but the technical challenge of directing a two-year-old is perhaps even more compelling.)

The Challenge of Filming the Impossible

Kon Ichikawa is a director who has applied himself with consummate rigour to the image. Among real directors (*kantoku*), none is oblivious to the technical aspects of production, but Ichikawa in particular seems to have frequently set himself a challenge. In many works, he appears to begin by posing a problem—is this theme possible from a stylistic and technical point of view?—and throws himself into it to explore the possibilities, an approach apparent in *Pu-san* (1953), *A Billionaire* (1954) and *A Full-Up Train* (1957). At the time of their release, these films were viewed as idiosyncratic, avant-garde slapstick comedies, whose characters are symbols or conceptual tools derived from contemporary cultural critique. In *Fires on the Plain* (1959), Ichikawa attempted to capture through images the ways morality is pushed to the absolute limit when confronted with death; and in *I Am a Cat* (1975), he took on the unprecedented challenge of trying to direct a cat as hero. These risks all display Ichikawa's brilliant creative abilities. Even a classic subject, like the *chambara* epic *An Actor's Revenge* (1963), turns into an ambitious experiment, rejuvenating a stale genre as a spectacle resembling a modern graphic design book.

Such ambitious experiments were not, however, always successful. Alongside such brilliant and inspiring films as *Fires on the Plain*, there are a few works of overweening ambition. Some Ichikawa films that enchanted me, even though they were ambitious, may appear banal and not obviously experimental at first glance, like *Nihonbashi*, *Ototo*, and *Bonchi* (1960). Because he cut his teeth in the film industry working at an animation studio, Ichikawa's first film was an animated short, and he also made a full-length feature that flopped, *Topo Gigio and the Missile War* (1967), a doll action film

Within the wide-ranging and experimental body of Ichikawa's work, some films stand out as almost meaningless in content, where it clearly seems that the director relied on his genius to exploit just the technical possibilities of the medium; others, not a few, appear to aim solely at commercial success. Aside from these completely lacklustre efforts, his varied explorations of genre and theme are not without a unified vision. Because in Ichikawa's oeuvre the form and visuals are often far more immediately striking than the content, it is very difficult to isolate the thematic continuity. However, I might suggest that Ichikawa consistently tries to render visual something metaphysical that is invisible, like the heart or the soul. It goes without saying that any truly important director shares this aesthetic aim, so I will offer a couple of concrete examples to illustrate what I mean.

Ichikawa's first theatrical feature, *A Flower Blooms* (1948), was an adaptation of Yaeko Nogami's novel *Machiko*, a serious work which places the story of a young intellectual woman in the turmoil of the prewar years. The film seemed to me strangely profound, but perhaps more memorable was the review written by critic Tadashi Iijima, in which he relates how Ichikawa evokes the pervasive psychological stress of the era by describing a moan emanating from the mental hospital next door to where the heroine lives. With this in mind, I realized that while Ichikawa's subsequent works, such as *Passion without End* (1949), *Heat and Mud* (1950), and *The Man without a Nationality* (1951), might seem to be melodramas, they achieved great power by having their protagonists emit a tragic "cry of the soul."

Ichikawa became recognized for his particular mastery of technique after he completed a string of urban comedies of manners, which included *The Sweetheart*, *Stolen Love*, and *Wedding March* (all 1951); *Mr. Lucky* and *The Woman Who Touched Legs* (both 1952); and peaked for the first time with the adaptation of Kaoru Morimoto's play *The Lover* (1953). These films were highly enjoyable, their sensibility akin to sophisticated American comedies—extremely smooth, with a flowing rhythm, and witty rapid banter.

While Ichikawa showed off a flippant and ostentatious vigour with these films, which distinguished them from the work of earlier directors, at the same time he released the films *Bengawan Solo* (1951) and *Young People* (1952), which follow the pattern of *A Flower Blooms*. They may seem like conventional romantic melodramas, yet they impart a serious "cry of the soul." With the release of *Pu-san*, this design became clear.

Pu-san falls under the general rubric of comedy, but its tone is almost the extreme opposite of the fluid, rhythmic snappiness of *The Sweetheart*. It's a curious work whose every shot, every scene, and every image stands out. *Pu-san* is set during the "reverse course," a set of policy changes that occurred in tandem with the growing dominance of Cold War mentality, when many of the reforms of postwar democracy were suspended, under the pretext of the nearby spectre of the Korean War, and old institutions and ways of thinking re-emerged. The era is depicted through the figure of a teacher (Yunosuke Ito) at a cram school—a job regarded at the time as somewhat pointless—as he wanders about and is treated with contempt by those around him. The aspects of society he holds in doubt are presented to the audience successively, without explanation or argumentation.

The unique cinematic form of *Pu-san* devised by Ichikawa and his wife, screenwriter Natto Wada, is worth noting. They abandoned the conventional method of realism by which a prescribed "problem" is presented, explained, and then morally evaluated. Their strategy is to present us with a series of doubts: "This we cannot understand." There is a shift from images that explain to images that question; less to question the viewer than to interrogate the nature of reality, asking, "just what

are you?" This way of using images to examine how reality is constructed began with this film.

Ichikawa's images sometimes confront the viewer with such sudden questions. This surprise might seem to be merely mugging or caricature, or simply a meaningless evocation of mood through visual associations. To a certain degree, they are probably just that. However, these images often transcend mere novelty, in the way they take a seemingly incomprehensible object and render it in images. Questioning the meaning of unintelligibility is, itself, a kind of Zen interrogation in images, a moment reaching for a metaphysical truth or concept.

The Absurd Comedy *A Billionaire*

As Kon Ichikawa made his way up the ladder of the film industry, he was given nicknames, most often "Boy Wonder," or "Kon Cocteau," due to the eccentricity of his films, such as *A Billionaire* (1954). While the avant-garde director Jean Cocteau made films following the aesthetics of symbolist poetry, Ichikawa's *manga*-like satirical films often transcended realism. The nickname may not exactly jibe with Ichikawa's aesthetic, but at that time any film that strayed from conventional modes of filmmaking was categorized as heretical.

Ichikawa's credit as director/screenwriter for *A Billionaire* is nowhere to be found, because the distributor of the film asked that the last sequence, a fantasy in which a nuclear bomb explodes, be cut. Since the producer had apparently borrowed money from the distributor during production, the request couldn't be refused. As a result, Ichikawa removed his own name from the titles, leaving four people listed as writers: Kobo Abe (fiction writer), Taizo Yokoyama (*manga* artist), Keiji Hasebe (screenwriter), and Natto Wada (screenwriter). It's uncertain whether this four-person team from such disparate fields co-operated on the whole story, or whether they only contributed individual ideas. Most likely someone cobbled together the story after a number of ideas were proposed. Perhaps for this reason, the film is a collection of odds and ends. Its morphology is one of a stunted dragonfly: it has fragments of brilliance, offset by stale and pointless episodes. Because of its unevenness, *A Billionaire* is not truly polished or coherent, but the film is difficult to completely disregard, because its satire is so ambitious and inventive.

The film begins with four little sketches of one shot each, with the titles "New Hot Spots of Tokyo: Sukiya Bridge," "New Hot Spots of Tokyo: Kosuge Jail," "Haneda Airport," and "Akasaka Gourmet Restaurant." At Sukiya Bridge, Yoshiko Kuga, playing a young woman who seems somewhat disturbed, gives a speech asking for contributions: "Let's build nuclear bombs—for the sake of world peace!" She appears again later, sitting on the second floor of a ramshackle house, solemnly

assembling a "nuclear bomb" from bits of coke. As someone who seems to have lost all of her family in Hiroshima, she appears to represent the madness of modernity. We, however, only understand that intention conceptually: since it conveys neither the humour of the situation nor the "ideological chill" in a new way, we must judge it a failure. The very idea of a homemade nuclear bomb probably was a bit ahead of its era. At the time, I thought it so inconceivable that an individual would be able to construct a nuclear weapon that this scene fell flat; but these days, the idea seems more plausible. It is now possible that many people could be motivated to make nuclear bombs for the sake of world peace.

The Haneda airport sketch features the send-off of a small factory operator (Jun Tatara) as he flies to America to find new markets for the spoons he manufactures. Japan has just emerged from the ruin of war, and thanks to the boom spurred by the Korean conflict, businesses like his are able to prosper. The episode deftly sketches the touching but still comic enthusiasm of Japan's economic overseas expansion. This character will soon die in an airplane accident, providing a big opportunity for his widow (Tanie Kitabayashi). In the Akasaka sketch, Isuzu Yamada plays the proprietor of a *ryotei*, a fancy dining establishment employing geisha, who assembles her charges to give them instructions. Most important, she says, is a geisha's duty to guard the secrets of the clients, and to ensure that, for instance, corruption is not discovered. The sequence satirized an actual contemporary incident in which a big corruption scandal had been exposed by a geisha.

The true masterwork among the sketches is the one set in Kosuge jail. The same politicians of both ruling and opposition parties who had been implicated in the corruption scandal of the Akasaka *ryotei* find themselves in a big room in Kosuge jail facing each other. In the centre, displaying his eloquence, is the ruling party representative, played by Yunosuke Ito. His long-winded speech is excellent: being arrested for corruption may be a setback for a politician, he argues, but there is no greater delectation than the pleasure of having one's name splashed across the front page. Due to a lack of evidence, he is released, but is later required to testify in front of a special committee of the National Diet about corruption. The Diet member from the opposition party questions him about a meeting he had at the Akasaka *ryotei* with a member of the tax office during which they cut a deal about tax evasion; he replies that he has no memory whatsoever of the occasion.

A Billionaire was screened at the National Film Centre at the time the Lockheed scandal filled the news every day. The audience exploded into fits of laughter, since this scene was the spitting image of the interrogation in the National Diet of those indicted in the scandal. No doubt my own reaction was affected by seeing the film by chance at the height of the Lockheed affair, but I walked away thinking that even if times change, politicians don't one bit. And, I thought, in its ability to capture the enduring quality of politicians, filmmaking itself was made for occasions just like these.

After these opening sketches, the film cuts to a shot of the clock tower in Ginza's Wako Department Store. The only mark on its face is the numeral "25" at the very top. When the hand approaches the five-minute mark before twenty-five o'clock, the voice-over chimes in, intoning that although this should be the most accurate clock in Japan, no one seems to notice that it is completely off-kilter. The voice-over wonders if he himself is crazy, or everyone else. The camera is on top of the Mitsukoshi department store facing Wako, looking down on the crowd at Ginza 4-chome, swinging like the pendulum of the clock, in time with the voice-over.

The full impact of this sequence can't be appreciated unless one knows that Constantin Virgil Gheorghiu's novel, *The Twenty-Fifth Hour*, was then drawing a great deal of critical attention. It describes a future society in which the world is ruled by three dictatorships continually at war with each other, and all is darkness. The novel works on the premise that no one is aware that such a dire reckoning is waiting just around the corner. However, when *A Billionaire* was released, none outside a small circle of critics actually knew this obscure novel translated from the Rumanian, so the symbolism itself was a bit self-satisfied, a sort of puzzle, like a sign in baseball that only those who know the code can understand.

After these introductions, we finally get to the main story of the film, and meet the protagonist, a timid and bleary tax clerk, Koroku Tachi (Isao Kimura), whose job is to lean on people who hardly seem able to pay their taxes, such as the widow of the man who dies in the plane crash, and the women living in the derelict house burned out during the war. He gets wind of the fact that his boss is involved in some kind of corrupt scheme with the Diet member from the first sequence, and the geisha. The clerk is righteously indignant about these dealings, and based on information the geisha slips him, composes a memo which blows the whistle on his boss. But when Koroku realizes that the geisha hopes to blackmail the others with the memo, he becomes more and more despondent.

The film's most entertaining sequence involves the spoon manufacturer's widow offering the tax man ten thousand yen in exchange for a break on her taxes. She gives him an either-or choice. Either he implicates himself by taking the bribe, or, she threatens, the entire household will commit suicide, effectively making him a killer: "Well, well, you wanna take a bribe, or you wanna be a killer?" she hounds him. The best part of the film is the oddness of the skewed logic dreamed up by its characters, who actually live for and thrive on that desperation, such as the Diet member's speech in the jail sequence.

Though there are many entertaining episodes like this, the film's humour is spoiled, closed in on itself, because Ichikawa believes, as the "twenty-five o'clock" example illustrates, that only the filmmaker knows that everyone is an idiot. One tries to laugh but gets the feeling that, as an enlightened person, one should look upon such folly with sorrow, and therefore does not laugh.

Rapid-fire Dialogue without Emotion

Pu-san, *A Billionaire*, and *A Full-Up Train* are filled with wonderful, *manga*-like images, which spring from Ichikawa's apprenticeship in the cartoon film department at J.O. Studios, where he moved from drawing the cels, to animating, to directing. He then became an assistant director in the narrative film department of J.O., and when the company merged with Toei, he became a director there.

It is highly significant for Ichikawa's later style that his first works were animated films, which are created entirely from scratch. With a conventional narrative film, even if you don't have an image in mind, you can somehow still make a movie just by giving directions. If the actors have no technique, don't give any directions; just tell them they're lousy. The actors will then do something. If they do something, the cinematographer will shoot. If he shoots, at a certain point you can yell "cut," and some kind of film is made.

However, a director of animated films can't get away with this. To begin with, he has to actually draw all the images, so he can't depend on other crew members to salvage a project. In a *manga* film, since there is no artful cinematographer or great actors to hide behind, the filmmaker can't simply get by putting on airs. The director must painstakingly create all the artistic details of the world within the frame, figuring out how to arrange and fill the space. This is important to keep in mind when thinking about Ichikawa's work as a whole. He has an acute awareness of how to construct a frame in terms of its overall design and the use of space. For example, to accentuate a character's isolation, he will establish a wide open space and position one lonely person in the middle of it. Or to express an overwrought emotional condition, he will place a person's back in the foreground of the frame, and the object of the character's gaze small and faraway in the background. As a director, Ichikawa has an extremely strong sense of all the elements in the frame, especially in the meticulously composed *Kokoro* and *A Full-Up Train*. Unlike some directors who let the cinematographer decide where to place the camera, while concentrating their energy on eliciting good performances from the actors, Ichikawa's style is not one in which, if the actors perform well, it doesn't matter if they are in a medium shot or a long shot.

In contrast to those who entrust the matter of camera position to the cinematographer, there are directors, such as Ichikawa or Ozu, whose goals are realized through their camera angles. (Eisenstein is the quintessential example of this method in foreign films.) Ichikawa is extremely skilled at using frame composition to suggest the psychological relations between his characters, for instance how he depicts the feeling of being pursued or the sense of being crushed by someone. When Ichikawa focuses on a character who lives a discreet and humble life, perhaps because of a guilty conscience, he doesn't position him walking down the centre

of the image, but instead will confine him to one small part of the screen, literally illustrating his peripherality through his position in the frame.

In the films of Akira Kurosawa and Shohei Imamura, the actors' vigorous movement is what impresses us, but in Ichikawa's films, actors don't seem to exert themselves to express what is in their souls. Rather, the actors are restrained by a sort of encumbrance. At the beginning of his career, Ichikawa was known as a B-list director, but from the time he made *The Woman Who Touched Legs* and *The Sweetheart*, he was singled out for having the actors speak at a rapid-fire pace. Afterwards, directors like Yasuzo Masumura and Ko Nakahira took up this style, and its uniqueness wore off, but when Ichikawa was the only one making his actors speak like auctioneers, everyone was shocked.

What is the significance of having actors speak at such a breakneck speed? The same phenomenon of rapid-fire dialogue can be heard in French drama, perhaps to proudly display the French nationality. There, it resonates from a linguistic tradition with a long cultural history, and when spoken with such rapidity, a French "accent" is all the more present. However, Japanese is a language without such an "accent." When a character speaks at high speed, the usual cadences that identify it as "Japanese" disappear. What specific mode of spoken Japanese is most dense with emotion? There are, for example, the lines of *kabuki*, *noh* songs, *katarimono* (stories recited with *shamisen*), *naniwa-bushi* (a working-class singing style born in the Meiji era), *kiyomoto* ballad drama (a style of narration, accompanied by *shamisen*), and *gidayu* ballad dramas (songs accompanied by *shamisen*, played mostly in *bunraku*). In these oral forms, the slowing of tempo allows the articulation of exaggerated emotion. By playing at this ultra slow tempo, you can fold a range of feeling into a language impoverished of accents. Without such a strategy, the Japanese language will not bear this kind of emotion.

However, as dialogue gets more and more rapid, the language loses its ability to contain emotion. One can speak only in a mechanical fashion. Ichikawa managed to pull it off. Perhaps by aiming for a contemporary tempo, instructing his actors to speak rapidly resulted in dialogue incapable of containing any emotion. In addition, he did not let his actors assume any kind of histrionic emotional expression, or make dramatic shifts in expression. At times, the result is as inexpressive as a *noh* mask.

So what exactly does Ichikawa achieve by advocating this directorial style? The rejection of manufactured emotion.

Peering into the Heart: The Theme of Introspection

In Ichikawa's early Shintoho films, such as *Passion without End*, *Heat and Mud*, and *The Man without a Nationality*, characters go into passionate tirades, and scream at

the top of their lungs over trivial matters. Ichikawa probably decided he was finished with this sort of film for the rest of his career, and must have learned by trial and error what kind of director he wanted to be. He began developing his singular style with the rapid delivery of dialogue, and the deft positioning of characters within the frame to express psychological conflict. I think once he understood his stylistic technique, his thematic was born. What would happen if he rejected exaggerated emotions and acting styles? When he began to create characters who viewed their own emotions with cynical humour, Ichikawa's directing reached a new level of energy and creativity.

Such introspection became one of his principal themes. Righteous antagonism, where a character stands up to another and tells him what he ought to do, disappears from his films, and Ichikawa begins to focus on characters who conceal and contemplate their problems. Spectators are not overwhelmed by surging emotion; Ichikawa's framing instead invites them to look for something hidden within the composition. He will often compose a frame with a figure positioned in the corner, or a shot such that if the spectator is not looking closely, the character's face will not be seen. The viewer must search the image to look into the heart of the character, in the same way that the character gazes into himself.

Films like this form an extremely important part of Ichikawa's repertory, the first being *Kokoro*, followed by *Punishment Room* and *Harp of Burma*. *Harp of Burma* takes place during the first days after the Pacific War, when Japanese soldiers held in POW camps were allowed to demobilize. But the protagonist, a soldier who has seen too many of his friends die, is unable to return home. *Harp of Burma* becomes the story of the soldiers who stay. Their interior lives are not depicted through exaggerated emotion, but inferred from the compositions. The positioning of characters within the landscape or against each other subtly guides the spectator's feeling—for example, by the way a figure dominates the image; bears down on another from the top of the screen; or approaches the centre of the composition. Ichikawa's skill with compositional layout renders the entire image extremely beautiful, to the point that it becomes a craft of good graphic design. In that case, Ichikawa can produce curious and entertaining films based simply on that craft. Even without governing themes, the film can still succeed through its pretty images; for example, the *chambara* film *An Actor's Revenge*.

Other Ichikawa films sometimes make one wonder if they have any ideas behind them or not, which probably indicates the director's confidence in his technique. Or it may suggest the excitement of a new inspiration, which prompts him to start over, so as to make an even more entertaining film. One must also remember that in order to survive as a commercial film director, Ichikawa could not just make the films he wanted to make, and had to compromise. However, in the grand scheme of Ichikawa's oeuvre, there is a governing motif, that of looking into the mind of a diminutive figure in a vast landscape.

One classic example is *Alone on the Pacific*, based on the true story of a young man who crossed the ocean in a small boat. Throughout the entire movie, as the solitary craft floats on the sea, the protagonist is depicted as a little figure diminishing in the distance, an image that artfully expresses his silent introspection. However, a single image can't express an array of meanings. Because drama must impel the story, *Alone on the Pacific* uses a flashback structure to depict the protagonist's life. From the time he embarks on his voyage, the film flashes back to his family life in Osaka to reveal his personality. These flashbacks are insistently repeated, depicting him as a youth almost totally opaque to his family and parents. They show less his alienation than his resistance to being understood, to having to explain himself to his family. We thus comprehend his internal conflicts, and his desire to test them by cutting himself off from society and becoming totally solitary. We come to understand the meaning of the image of a man alone on a boat floating on the Pacific.

The Stakes of Humanity in the Midst of War: *Fires on the Plain*

Unlike the comparatively luxurious adventure story of *Alone on the Pacific*, *Fires on the Plain*, an adaptation of the 1952 novel by Shohei Ooka, depicts human beings in a much more serious situation. Ooka was mobilized to fight in the Pacific war, captured, and held prisoner in the Philippines. His debut was the fictional *Taken Captive: A Japanese POW Story*, published in 1948. Since then, his war experiences in the Philippines have increasingly become a focal point of his writing; *Fires on the Plain* is counted as one of the masterworks of postwar Japanese literature. Many works concern themselves with the Pacific war, but *Fires on the Plain* is strikingly different in that it not only frankly depicts the terror of that conflict and the wretchedness of its participants, but also produces a rigorous meditation on a metaphysical problem: whether respect for human life can still be maintained when people are pushed to the brink of death.

Here Shohei Ooka enters a somewhat theological realm. In the novel's climax, Tamura is confronted with a dilemma, and decides that no matter how much he is starving, he will not eat the flesh of other humans. The novel suggests the decision is based on some divine will, or at least on the will of the protagonist himself who deeply believes in that divine will.

In transposing the novel to the screen, Natto Wada and Ichikawa are largely faithful to the original story, but they exclude the scene of God trying to save Tamura by restraining him, probably because, even though it was possible to articulate the divine in the novel, it could not be represented in images. They also made an addition: when Tamura desperately tries to eat some dried meat—obviously

human flesh—his teeth fall out due to malnutrition, and he is unable to eat. Moral revulsion becomes physical.

At the start of his career, Ichikawa relished making comedies. In *Fires on the Plain*, even as the film represents the grim realities of losing the war in a very "realistic" manner, it is inlaid with episodes of dialogue and movements characteristic of comedy. Eiji Funakoshi plays private Tamura who, although a straggler from a losing war, at the end of his rope with physical exhaustion, doesn't perform the part with the heavy, pained face and lugubrious gait characteristic of war movies, but with an expression suggesting a smile and a weaving walk reminiscent of drunkenness. There are other elements, such as the officer who has gone mad, that are in a sense comic. The intention is not to regale the viewer or indulge in satire. Rather, a certain comedy—one very close to tears—emerges from desperately trying to live like a human in conditions that make it impossible.

Fires on the Plain focuses on a soldier, separated from his unit on the front, left to wander in the mountains in the Philippines. Completely alone, he is abandoned in this vast landscape, quickly separated from the companions he encounters, and pursued by enemy soldiers. At the end, he spies a wisp of smoke rising from a fire on the other side of a wild, open field. Having almost eaten human remains, he feels that if he had succumbed to that need, he would have ceased to be human. So whatever the risks, he feels he must cross the field to a place where other people are. If nearby Filipinos catch him, they will probably kill him, but he desperately needs fraternity, so he descends from the mountains to the flatlands, where he arrives at an almost deserted plateau.

Since this incident is in the original story, one can say that the film is just being faithful to the novel. But the film version does feature a characteristic Kon Ichikawa shot. The soldier sees a grass fire on the other side of the deserted field. Thinking people must be there, he begins to walk toward the fire, but a hail of machine gun bullets erupts from the other side of the field. He might get killed. However, he has decided that it is better to die than to descend to a level lower than humanity, and keeps walking, hands in the air. In this last scene, the human form is but a speck, alone, disappearing in a huge expanse. At the small faraway vanishing point, smoke rises. Human beings need an object, no matter how small, to strive towards—even in prayer, which must be concentrated. The smaller the goal, the better. So it is natural that Tamura turn his attention to that tiny point in the distance, in the middle of the image.

The Allure of the Women of *Nihonbashi*

The original story for *Nihonbashi* was one of Kyoka Izumi's popular plays, written in the modern style of *shimpa*. *Shimpa* was the dominant style of popular Japanese

theatre from the mid-Meiji period (1868–1912) to the beginning of the Showa era (1926–1989). *Shimpa* tended to feature contemporary tragedies of love, with a heavy influence from *kabuki*, and were aimed at female audiences. Most female roles were played by *onnagata* (men playing women's roles, also a convention from *kabuki*), and many used the refined cadences of the seven-five syllable metre. Most *shimpa* featured emotional stories of tormented lovers whose lives were sundered because the *giri/ninjo* rift between passion and duty characteristic of pre-modern mores did not allow them to express their love publicly. Due to the plays' antique themes, many have been forgotten. However, even today, as illustrated by the one troupe which continues to mount such plays and attract viewers, the beauty of the stylized stage is hard to let fade into oblivion, because what exists there is a dramatic world, full of emotion, characterized by a seductive elegance that transcends mere feeling. Because the kinds of pathos *shimpa* displays seem antiquated, a contemporary audience may find it difficult to endure many that were once popular, though not those based on Kyoka's works. They still maintain their brilliance and are performed again and again because they create a beautiful, romantic world above mere feeling, one that is not of our realm, just this side of pure illusion.

Kyoka stories like "A Woman's Pedigree" (1908), "Taki no Shiraito" (based on an 1894 story), "The White Heron" (1909) and "The Song of the Troubadour" (1910) have been made into films many times, often to great popular enthusiasm. In many cases, the stories have slighted the aesthetic dimension and descended to the level of common melodrama, but the recent adaptations of *Kageroza* (1981), by the visual master Seijun Suzuki, and the avant-garde director Shuji Terayama's production of *Grass Labyrinth* (1983), have provoked an exceptional revival by critics and readers of Kyoka, as an aesthete unusual in the history of Japanese literature. Ichikawa's 1956 adaptation of *Nihonbashi* was the first to take the work of Kyoka—until then regarded as a writer of common tragic melodramas—and re-evaluate it as a *sanbi-ha* work of decadence, aestheticism, and intrigue. Ichikawa's film presents the tragic plot of the young geisha who is unable to enact her love for a man publicly in any way other than a histrionic story of torment, a heart-rending tale of lovers being crushed by fate. Instead Ichikawa shows the contest of wills that transpires as two geisha, Oko (Chikage Awashima) and Kiyoha (Fujiko Yamamoto), fight for the top spot in Nihonbashi, the pinnacle of the Tokyo geisha world. *Nihonbashi* is an elegant, if steely, exposition of manners. The young doctor, Shinzo Katsuragi (Ryuji Shinagawa), is the object of affection for both women, but appears to be more the choice reward for the plotting and thieving of these two early modern superwomen, than a lover they swoon over. The film emphasizes the luscious glamour of the women, dwelling on their eroticism and chivalric codes. We don't feel pathos for the two geisha, even as we realize Oko will never attain Shinzo Katsuragi's love and starts to go mad, or when we see that Kiyoha cannot become involved with Katsuragi because she is already attached to a patron.

Instead we see the allure of the way the geisha, precisely because they are geisha, are able to throw themselves utterly into love as more proper women never could. When Oko's former patron, Igarashi Denkishi, who has lately declined in the world, threatens her with a short sword, she blusters, shows her back, and demands he write Shinzo Katsuragi's name on her body with the weapon: "Even if the entire name is impossible, I can stand one or two characters." Precisely because Oko is a geisha, she can suffer the agony and ecstasy of being overcome by love; this scene most likely will bring roars of approval from the gallery. The handsome Katsuragi is completely besotted with Kiyoha, because she is the very picture of his elder sister who has gone missing and to whom he owes a great debt. It is a fairly standard convention that the geisha of the *shimpa* drama cannot fall freely in love, often living a life in shadow; but in this case, the geisha shine, thanks to the chorus of men's praise and admiration. The young and dashing Katsuragi so looks up to women that he wanders the country looking for his sister, and the formerly rich Denkishi, who had lavished money on Oko, has now become a beggar, eating maggots from a bear hide. He hangs around Oko, hoping to have her care for him once more. As should be clear, this is a drama praising and revering women, one that passes beyond the usual *shimpa* play that prompts tears through the story of the pitiful life of a geisha. Likewise, it is also the narrative of men who lower themselves in order to gaze up at the fabulous women; Denkishi's grotesque behaviour can be seen as the masochism that results from an extreme worship of women.

Whatever the emotions that make up the world of the geisha, Ichikawa instead tries his best to bring out the verve and power of his female protagonists; the two star actresses, Chikage Awashima and Fujiko Yamamoto, respond brilliantly to the challenge. They both appear in the prime of their beauty. The young Ayako Wakao adds a beauty and freshness to the production, and the rising star Ryuji Shinagawa, in the role of Shinzo Katsuragi, offers his best piece of work. (Denkishi is played by Eijiro Yanagi, an actor famed for his stage performances of *shimpa*.)

In phrases like, "Winding the back alleyways / In low wooden clogs" and "In the haziness of spring / A fresh verdant day," the stylized prose of Kyoka's seven-five metre is rendered beautifully in subtitles, creating the effect of an elegantly painted Meiji-era Nihonbashi scene.

According to Yasuzo Masumura, who worked as assistant director on *Nihonbashi*, Ichikawa brushed off the recommendations of film staff who were experts in Meiji popular culture. The staff maintained that geisha of the time would sport only restrained, finely-patterned kimono, but Ichikawa commissioned Sentaro Iwata to make a louder design, kimono on which big checkers were splashed. And, when large-sized gravel was laid on the set, based on the opinion of the chief prop man that the Nihonbashi avenue was paved that way in the Meiji era, Ichikawa had that gravel replaced, forthwith. He also declared that one part of the screen must always remain black, and controlled the number and position of lights that

the cinematographer used. In this way, elements of the screen image were composed as a product of Ichikawa's elegant imaginary world down to the very last detail.

A *Taiyozoku* Masterwork: *Punishment Room*

Punishment Room, released in 1956, is a representative work of the *taiyozoku* ("sun tribe") films about rebellious youth culture.

In 1955, Shintaro Ishihara was still an anonymous college student when his fiction work *Season of the Sun* came into the critical spotlight. Most people still thought of college students as members of the future elite, so dedicated to their studies that they would work part-time to earn tuition money in the difficult postwar climate. Thus the novel was shocking merely for showing there were college students whose ambitions consisted of tooling around the ocean on yachts and chasing girls. And that was not all. The characters in *Season of the Sun* were not just bad-boy types, but represented the resurgence of passion, a cadre of people who followed the impulses of carnal desire, in opposition to the strictly moralistic attitude of left-leaning intellectuals and their politics. Ishihara became the hero of the times.

The film world seized on this phenomenon, and the studios fell over each other to adapt Ishihara's novels, which became the series of films dubbed *taiyozoku*. Their depiction of the sexual misconduct of delinquent college students made conservative opinion makers bristle in opposition and put pressure on Eirin, the industry board in charge of regulating film, for approving these movies.

Eventually produced at Daiei, *Punishment Room* is a particularly strong example of Ishihara's works of this period. It was adapted by Natto Wada and Keiji Hasebe, who stress the antagonism of the students toward their parents and teachers by emphasizing the portrayals of the vulgar teacher and the weak, ineffectual parents, so that the film makes rebellion credible. The parents' miserable lives are so vividly etched, the film provides us with an opportunity to grasp the young people's feeling that they do not want to be "that kind of loser" when they grow up. *Punishment Room* also criticizes the young people's failure to understand the hardships of their parents' generation, and their tendency to boast about rebellion. In contrast to the original story, which glorifies the youths' irritation with and rejection of the impoverishment and cowardice of contemporary society, the film also powerfully shows the pain of those under critique. This complexity is its primary strength.

Punishment Room, however, became controversial because it was thought that the scene in which the protagonist Katsumi, a student, played by Hiroshi Kawaguchi, slips some sleeping medicine into Akiko's beer and rapes her, might incite copycat violence. The moralistic film critic of the *Asahi Shinbun*, Jun Izawa, jumped into

the debate, suggesting the film's inflammatory effect depended upon the skill of Ichikawa's cinematic technique. Izawa wrote a lengthy article to this effect, directed to the president of Daiei, going so far as to declare that "technique is an offensive weapon." Ichikawa was affronted, and in a debate with Izawa in an August 1956 issue of the influential film magazine, *Kinema Junpo*, strongly disputed the charge:

> I have absolutely no memory of ever intending to make a film to promote filial duty, or to create juvenile delinquents, or anything of the kind. I make films for the express purpose of looking straight-on at the self, which is understood by examining the anxiety of modern times.... *Harp of Burma* pursues the idea of Buddhism, and this film pursues the existence of one Shintaro Ishihara. But I recognize Shintaro Ishihara as an author to the same extent you do. What made me recognize him is the explosive resistance in his book. At a certain level I understood that. Or rather, I once felt the same thing.... In young people today that kind of rebellious spirit is always boiling up, and I think that we really need to take a good hard look at what's going on. I think that's one of our tasks today.

Taiyozoku films were generally regarded as the product of studios who exploited the boom in *taiyozoku* novels by cramming as much lurid youth sex and violence as possible into their movies. The films were criticized by the media and social commentators, as Jun Izawa's censure indicates. Ichikawa's strong response shows that he did not take his job as a director nearly as lightly as the general critique of the genre would suggest. In fact, there's an impressive strength in how *Punishment Room* shows the young people's impatience with their elders, as one can see in Katsumi's reaction when the teacher flatly refuses to listen to the students' protests.

Punishment Room even seems to predict the eruption of student protest ten years later, ignited by the Korean conflict, which affected Japan and ultimately the world. The clashes with authority in the film are probably no great shock to today's viewers, since we've become used to all kinds of violence against school authorities. But in the mid-fifties, scenes such as a college student suddenly tackling a professor on the street were truly shocking.

The lead actor, Kawaguchi, often played such rebellious youths then. The rising young star Ayako Wakao, who plays Akiko, had become popular in teen genre pictures, and at that time was beginning to become famous for her acting, not just her looks. Also of great interest is the fact that one of the delinquents, who opposes Katsumi is played by Keizo Kawasaki, who later attracted a strong following among housewives with his mild-mannered presence.

Kagi: From Comedy to Nothingness

When Junichiro Tanizaki's novel *The Key* (*Kagi*) was published in the literary-political magazine *Chuo Koron* in 1956, its explicit sexual descriptions incited controversy; it was even debated in the National Diet. However, given the high regard in which Tanizaki was held, and the literary quality of *The Key* itself, the book never became a scandal.

The novel is composed of the diaries exchanged between a fifty-six-year-old university professor in Kyoto, and his forty-five-year-old wife. The husband is aware that his sexual powers are dwindling as he ages. Rather than stoking his own passions, he reacts by wanting to stimulate his wife's sexual desire, which though unrivalled in degree, is highly conventional in practice, due to the discipline of her proper family upbringing. The husband hopes that if his wife puts more effort into pursuing her sexual longings, that he too will be stimulated. He composes a diary to document his own fantasies and actions, and waits for his wife to read it "secretly." To insure that she does, he leaves the key to the diary so that she may easily find it. This is the key of Tanizaki's title. Meanwhile, his wife pretends to have no idea of the diary's existence—even though she does—and fills her own with scribblings in response to his secret "confessions." Each purposely uses the diary as a forum to write the things they desire of the other, and each acts in order to inflame the other's jealousy. The husband arranges to place his wife in proximity to a younger professor, Kimura, attempting to stimulate his own desire through stage-managing his own jealousy. The wife begins to loathe her husband's aged body after experiencing young Kimura's, and knowing the dangers that excitement poses to his high blood pressure, overexcites him, causing him to die. After the professor expires of a brain haemorrhage, the novel ends with the wife confessing her plot in the pages of her diary.

The elaborate plotting in diary form works quite well in the novel. The husband and wife confect "secret" exchanges of their mutual deceptions—ways of drawing close to one another, and ways of arousing one another. But simply transposing the diaries into film would not be compelling, so *Kagi* is something more than just a screen adaptation. Essentially, the film borrows the contours of the fiction plot to create a wholly independent work. The original story focuses on the psychological tactics the couple deploy concerning sex, but pays hardly any attention to character development or setting. Thus the film adaptation had to invent and fill in the blanks of these highly abstracted characters with concrete detail—their work, their day-to-day lives, and their everyday conversations. The first decision was to omit the couple's psychological negotiations in the diaries. The film instead centres on the drama of the husband and the wife, as the elderly man (until the 1950s a man in his fifties was counted as "elderly") becomes aware of his

dwindling capacity for sex, shifting his attention to obsessing about his wife's desire, and the middle-aged wife, who replaces her husband with a younger lover. Kimura, who becomes the object of the wife's desire and transgressions, is not an academic, but a young internist, of a highly calculating disposition. In the original story the old maid plays a very peripheral role, but in the adaptation her role is magnified, so that through a series of careless but fatal mistakes she poisons the wife, Kimura, and Toshiko, the couple's daughter and Kimura's fiancée. The death of these three following the husband's death has been added from the original story.

The team of Natto Wada, Keiji Hasebe, and Kon Ichikawa wracked their brains to adapt the story. During the process, the dense psychological drama that characterized Tanizaki's novel vanished, and the story was refashioned into a highly entertaining comedy. Tanizaki's plot is fundamentally comic, with the elderly man in the clouds of sexual reverie, earnestly devising all kinds of ruses to service his fantasies. The film magnifies this sense of amusement. That the old man, played with remarkable personality by Ganjiro Nakamura, puts on a sour and serious face when he is in fact thinking of nothing but sex, is itself comical. With finely tuned humour that does not play for cheap laughs, Nakamura brings a light touch to the comedy. It is truly a consummate performance. Machiko Kyo plays the role of the middle-aged woman in the prime of her life with voluptuous elegance, but with an expressionless face reminiscent of a *noh* mask; with severe make-up and eyebrows plucked to nerve-racking precision, she keeps her eyes downcast, and speaks in a fashion that reveals nothing of her emotions. In Tanizaki's original story, the wife's lack of emotional display irritates her husband, but Kyo's performance is almost a *manga*-like, abstracted rendition of that character. Moreover, she is very elegant, with a bewitching erotic quality. The spectator can perfectly understand the great pain of her husband's desire to put her in an immodest position.

Right before the husband dies, he asks his wife to disrobe and show herself to him. In his eyes, her body's expanse of abundant curves is like the undulations of a desert. This scene, more or less the climax of the film, is also nowhere to be found in the book. But the novel is not just a story of perverse infatuation, but derives a solemn feeling from its profound sense of the transience of things, from the pathos of this man's attachment to sex. In the same way, the film reaches beyond comedy, to a place of absolute nothingness, and ends with the absurd, yet also solemn death of three people.

Objectifying Mishima's Fiction: *Enjo* (*Conflagration*)

The Temple of the Golden Pavilion, published in 1956, is known as one of the finest of Yukio Mishima's novels, distinguished even in an outstanding body of work. The

story is based on a crime committed at Kinkakuji temple in Kyoto in 1950, by a young acolyte who had contracted tuberculosis. While in training, he set the temple on fire, burning it to the ground. The young man was motivated to commit arson by a sort of metaphysical jealousy of the temple, an envy of its beauty. This shocking event struck people as incomprehensible, a crime that could have been committed only by a member of the *apure* (*après*), or postwar generation, a term in great currency. Mishima himself was part of the postwar generation, and wrote several works analyzing the interior world of these young people, giving it form and speaking on its behalf. *The Temple of the Golden Pavilion* is the most stunning example of that body of work.

Daiei planned the adaptation of the novel, appointing Kon Ichikawa to direct the film. Ichikawa had made many kinds of comedies and melodramas, and was generally regarded as a talented director with a distinctive aesthetic sensibility. He had also previously adapted Soseki Natsume's *Kokoro* for Nikkatsu, and due to its success, Daiei understandably had high expectations for Ichikawa's capacity to translate the dense psychology and interiority of Mishima's novel to the screen.

At first, however, Ichikawa turned the job down flat. He thought it was an impossible task, that the theme of the story was too psychological. While the protagonist's obsession with absolute beauty could be elaborated in the stunning prose of a writer like Mishima, Ichikawa felt it would be almost impossible to manifest in the comparatively "objective" medium of film in a way the audience could accept. Ichikawa describes the process of writing the script, after he finally agreed to take on the project:

> I worked with Keiji Hasebe and Natto Wada. After three months of nothing but headaches, we finally figured out a way to treat the story. We decided to quietly dramatize the interior lives of Mizoguchi and his father and mother, all raised near the Sea of Japan, the darker landscape within Japan. We came to the conclusion that we could enter Mishima's world of beauty not by depicting the first half of Mizoguchi's life as merely leading up to an inevitable tragedy due to his obsessive pursuit of an absolute; but rather by quietly showing an ordinary relationship between parents and child, one visible in everyday life.

In this way, Ichikawa decided not to depict the sublime Kinkakuji through the subjectivity of the young monk, but rather to film objectively a monk who saw the temple that way. A set of notes that producer Hiroaki Fujii borrowed from Mishima proved to be instrumental in the aesthetic of objectivity the production team aimed for. Written in two notebooks, they documented a great deal about the childhood and life of the young man who was the model for the character of Mizoguchi. An image of the boy began to evolve from these notes: how he had grown up in a poor temple family in a gloomy, northern part of the country, suffering

from an inferiority complex caused by a severe stutter, and from oppressive wartime conditions. It ultimately turned out that their version of *The Temple of the Golden Pavilion* was more a creative reconstruction based on the facts in Mishima's notebooks, than a literal adaptation of the novel.

Nevertheless, the substance of the story is more or less faithful to the original, with the exception that the name of the temple in the film has been changed to Shukakuji, at the request of the Kinkakuji temple.

The film begins with the young acolyte Mizoguchi (Raizo Ichikawa) undergoing interrogation in a Kyoto police station. He had been arrested for setting the temple, a national treasure, on fire. The film then turns to narrate the story in flashback.

Mizoguchi is born into a small and poor temple in the outskirts of Maizuru. He stutters from the time he is a child, which burdens him with a sense of inferiority and imbues him with a dark personality. Mizoguchi's father dies of tuberculosis in 1944, as Japan's defeat in the war is becoming apparent. Still a middle-school student, Mizoguchi goes to Kyoto to visit a close friend of his father's, the head of Shukakuji, Tayama (Ganjiro Nakamura). He is allowed to stay and become an acolyte at the temple, and begins commuting to school in Kyoto.

Though the life of Mizoguchi's father was harsh, he often reiterated his conviction that Shukakuji was the most beautiful thing in the world; Mizoguchi inherits that feeling of longing and adoration. He silently endures the daily hardships of the temple by reminding himself of its abstract beauty.

After the war ends, Shukakuji becomes a tourist destination in Kyoto. A soldier in the occupying American army visits with his escort, a prostitute. Mizoguchi is ordered to show them around, but as the woman, flirting with the soldier, tries to enter the temple, Mizoguchi intervenes and throws her to the ground. She has a miscarriage, and following her protests, the elder monk settles accounts by paying her a sum of money. Now regarded with disfavour by the monk who had formerly looked after him, Mizoguchi thinks himself misunderstood, and becomes progressively more alienated.

After it is decided he will enter college, Mizoguchi falls in with another student, the crafty Kashiwagi (Tatsuya Nakadai), whose diabolical nature is revealed when he displays his deformed leg to get a woman's attention, feigning pain to seduce her. Mizoguchi grows close to Kashiwagi, attracted by his derisive attitude towards everything that lies in his way.

Mizoguchi's mother (Tanie Kitabayashi), no longer able to survive on her own in the country, takes a job as a housemaid at the temple, a decision Mizoguchi opposes. When his tubercular father was still alive, the young boy had witnessed his mother committing adultery with one of his relatives. Reaching from behind, his father had placed his hands over Mizoguchi's eyes. To Mizoguchi, his mother's essence has been stained, and he cannot permit her to mar the beauty of the grounds of Shukakuji. After an argument with Tayama, Mizoguchi leaves the temple and

walks into town, where he sees the elder monk strolling with a geisha. His faith in the older man is shaken, and his affection transforms into antagonism. The elder monk, in turn, vows that Mizoguchi will not follow in his footsteps as the successor to the temple. Mizoguchi borrows money from Kashiwagi, and sets out on a trip to the seashore near where he grew up. Besieged by memories of his father, his suspicious behaviour draws the notice of the police. They question him, and he is sent back to the temple to the cold reception of the elder monk; he can no longer go to college. Trying to stave off his desperation, he visits Kashiwagi, who is carrying on a cruel and passionate liaison with a young tea ceremony instructor (Michiyo Aratama), and wanders the back alleys of the entertainment district. That does not ease his desperation, and the only thing left to him is to set fire to Shukakuji, in its incarnation of absolute beauty, in order to make it his possession alone, something which cannot be sullied by anyone. As the flames leap into the night sky, Mizoguchi is transported into ecstasy.

When he played Mizoguchi, Raizo Ichikawa was at the height of his career as a *jidai-geki* performer, famed as an actor who combined a masculine presence with youthful beauty. For Daiei management, it was hardly a good business move for Raizo to play a stuttering criminal plagued by an inferiority complex, and they strongly opposed the choice. Ichikawa stuck to his decision, however, and postponed shooting for a year so Raizo could star in the film. Raizo lived up to Ichikawa's expectations, and acted the part of Mizoguchi at a level far beyond what his stardom required.

In the film magazine *Kinema Junpo*, the popular culture historian Hiroshi Minami comments on Raizo's acting technique: "Raizo plays the part fantastically. The way he portrays Mizoguchi's awkwardness, with his mouth always half open, is so perfect he would hardly even recognize himself." Minami's evaluation of Raizo's performance shows that he is well acquainted with the substantial differences in modes of expression between the original prose work and the film adaptation. He astutely recognizes that it would be difficult to imagine Mizoguchi from the novel in the way Raizo plays him, as a figure frantically and impatiently always trying to question people about his own self. In the novel, the more Mizoguchi's soul is beset by feelings of inferiority, the more he paradoxically bursts with pride. The novel is written in first-person narration, with Mizoguchi's stuttered words appearing in only a fraction of the text. What he does not say out loud but speaks in his heart is written with an exceptional eloquence that is inversely proportional to the words he utters. Mishima's own eloquence is refracted through Mizoguchi's interior speech. This means that in Mishima's fiction, Mizoguchi is one of the most deft manipulators of the Japanese language to be found in print, a loquacious and broad-ranging speaker.

Ichikawa avoids using Mizoguchi's interior eloquence in a voice-over. In the film, Mizoguchi is bumbling and miserable with his extreme stutter, a person who

can rarely put his thought into words. As the masculine, graceful Raizo plays Mizoguchi, with his mouth half open and a pitiful expression, you can feel the anguished impatience of his struggle to articulate.

Absolute beauty is conveyed through the dour atmosphere that envelops Mizoguchi as he is wounded at nearly every turn, rather than in the appearance of Shukakuji itself. Mizoguchi is alone in being restive and estranged amid the traditional architecture of Kyoto. He berates himself for not being able to harmonize with its calm quietness. Through this contrast of anxiety and stillness, the atmosphere of Kyoto and the restlessness of Mizoguchi stand out all the more strongly. Kazuo Miyagawa's masterful cinematography depicts the tranquil feeling of the old capital of Kyoto by emphasizing the still darkness of its traditional architecture. Ichikawa comments on *Enjo*: "Until that point, I think my work had gotten too involved. If the theme was strong, I'd dive into it, and the same was true if the main character was interesting, so I thought that they weren't really deep enough, as films. But as I was making *Enjo*, I set myself the task of seeing how objectively I could make a film. This was the first time I tried the strategy of telling an incredibly tragic story in a very banal way, asking the viewer to come up with his own opinion. I wanted to present in a detached manner the fact that what transpired on the screen actually existed in the world and was in no way extraordinary.

Bonchi: A *Fuuzoku* Film Brimming with Humour

Bonchi depicts the sticky relations between a set of very energetic characters in an almost clinically cold directorial style. Through this disjunction of characters and method, Ichikawa creates a masterpiece of a *fuuzoku* film—a film which uses contemporary fads, material culture, and local colour to show the mores and customs of a place—whose humour resembles the style of a *manga*. The whimsical humour of *Bonchi*'s beginning, however, gives way to gathering shadow.

Osaka is a metropolis with several hundreds of years of tradition as a commercial city, during which its merchant class developed a unique sensibility. One of the notable features of merchant culture is the role of matrilineal families. In order for a store to prosper, the proprietor has to have real business know-how, but those who inherit businesses certainly do not always have such acumen. If it happens that the son of the family is not too smart, the owner will marry his daughter to the best and brightest of his employees, retaining the business in the family through the marriage. The stereotype insists that in such cases, the daughter is raised like a princess, while the son-in-law is doomed to be a work-horse.

Japanese society once followed feudal conventions, including the elevation of men's social status at the expense of women. But there were regional twists to this

custom, as well. From pre-modern times, Osaka has produced its own culture, particularly in the realm of theatre, and many dramas and comedies revolve around strong-willed women of merchant class families. This kind of local or regional tradition, with its independent ways of thinking, customs, and social life, is a regular treasure trove for film.

Toyoko Yamazaki, who wrote the original story on which *Bonchi* was based, was born in the Kansai area and has written several volumes incorporating the particular culture of Osaka's merchant class, of which this film is representative. Natto Wada, who adapted *Bonchi* for the screen, is, as I've pointed out, married to Ichikawa, and writes screenplays exclusively for his productions. It was Ichikawa who encouraged her, a former script-girl, to begin writing. In an interview with NKH, he remarked that by strongly encouraging Wada to write scenarios, when she originally had no such inclination, he secured his own position in the arena of Japanese film.

Ichikawa's follow-up to this statement is quite amusing. He added, when you get Natto-san to write you a script, you're in for a lot of trouble. If your opinions clash about something like a character's role, the disagreement might escalate to a discussion of divorce. She may say, "If this is really the way you think, I simply cannot live with you a moment longer." It's certainly true that Wada writes screenplays only for her husband, but there is no mistaking that she has a strong personality, and is capable of justifying her artistic decisions.

Bonchi is the nickname for the son of one of Osaka's top merchant houses. Kikuji, played by Raizo Ichikawa, is the son of the family which runs a sock emporium called Kawachi-ya. The store has been handed down through his grandmother (Kikue Mori) and his mother (Isuzu Yamada), both of whose husbands worked at the store. In this house, absolute power resides in the hands of the women, and Kikuji's father (Eiji Funakoshi) acts almost like his wife's lackey. He is proud that he has worked hard to double the assets of the house since he joined the family, and when he becomes ill and confined to bed, he apologizes profusely to his wife and mother-in-law. However, they hardly give his welfare a second thought.

Kikuji has a great deal of sympathy for his father. Knowing that his father has been involved with a geisha for the past eight years, Kikuji lies to the doctors that she is a nurse, so that she can take care of his father in the hospital. His father, overwhelmed, weeps, and after thanking him profusely, dies. When Kikuji's mother bursts into tears, her mother upbraids her, "It figures, you did depend on that poor excuse for a husband of yours. Stop your crying. It's so inappropriate." Before his father's death, Kikuji's mother and grandmother had been pressuring him to get married, so he marries Hiroko (Tamao Nakamura), the daughter of another merchant house. However, the all-powerful mother and grandmother become dissatisfied with Hiroko when she balks at being treated like a maid, and ultimately drive her out of the house. Sensing that with relatives like this, a successful marriage is

almost impossible, Kikuji instead takes on a series of lovers. First, he becomes involved with a geisha, Bonta (Ayako Wakao). She goes through the proper channels of visiting Kawachi-ya, and politely introducing herself to Kikuji's mother and grandmother as his mistress. The grandmother, praising Bonta for making a proper introduction, gives her some money.

Next is Ikuko (Mitsuko Kusabue), another geisha who also becomes Kikuji's mistress, after whom he meets Hisako at a café and takes her as his lover. Kikuji's mother and grandmother declare that others will frown on them if they don't give the third woman money as well, but Kikuji, saying that Hisako is only his lover, turns down the offering.

Ikuko bears a child and dies. Kikuji's grandmother provides for Ofuku (Machiko Kyo) to be his mistress, hoping that she will bear a girl who can continue the family traditions by marrying a hard-working man and helping Kawachi-ya to continue to prosper. Ofuku, it turns out, cannot bear children. Kikuji actually falls in love with her when she confesses her inability. He is not, however, a frivolous Don Juan figure. He takes his job seriously, works hard, and introduces many new successful innovations to the family business.

As time passes, the war arrives, Osaka is bombed, and Kawachi-ya burns, except for one storehouse which Kikuji has desperately protected. Bonta, Hisako, Ofuku, and Kikuji's mother and grandmother all flock to the storehouse; they have all become dependent on Kikuji. He divides his remaining money equally among his lovers, and tells them to flee to a country temple where they will be safe. His grandmother, however, becomes despondent at all that she has lost, and dies. A year passes. Kikuji has remained in Osaka, working hard until he finally has the means to live comfortably. He goes to the country temple where the women are living. Entering the bathhouse next to the temple's main building, he stumbles on the three women in the bath chatting like old friends. In fact, they are having a good time, exchanging stories about future money-making enterprises. Kikuji, without a word, turns around and heads back to Osaka. The next day, he gives some money to a messenger, whom he sends off to the temple to sever all relations with his former lovers. Afterwards, he describes his impression of the time:

> When everybody else was having such a rough time, they were whooping it up, they were all plump and rosy. Even when I try to rethink what I was doing with these women, each of whom had her own charms, it was doomed from the beginning. I saw them only as these fleshy things called women. Oh boy, was I ever happy. That was the end of my life as a prodigal son. I had never thought I could free myself of women with such a clean, refreshed feeling.

At the time of this reminiscence, Kikuji is already an old man, but the very incongruity of the figures of the three beautiful women chattering happily in the bath of

the country temple makes this an interesting scene. The film is compelling not because it serves as the diary of an amorous man, to use Saikaku's phrase, but because, as the victim of a matriarchal household, the protagonist Kikuji can't have a normal marriage, and gets in the bizarre fix of assembling a whole series of mistresses. The unexpected arises from situations that violate common sense, like mistresses going to their consort's mother to demand money, or the three women becoming fast friends and nonchalantly discussing their affairs like professionals. The scene at the bath is the culmination of this pattern. The more the image of the three beauties in the warm water joking with each other begins to resemble an *ukiyo-e* print, the more heightened is Kikuji's complicated feeling of both disappointment and liberated joy.

"Bonchi" probably feels at once the sacrificial victim of his mother and grandmother, and at the same time he feels guilty about making the three women his mistresses, and turning them into social outcasts. However, the women form an alliance and turn the tables on him. There was no need for him to feel any kind of guilt about taking advantage of them. His realization of this, which frees him of his attraction to women, is itself humorous.

The sensual *ukiyo-e*-like scene of the bath shifts suddenly to show the figure of Kikuji as a poor old man, living in a back-alley store, supported by the two children born to his mistresses. This shift is clearly aiming at a Buddhist sense of transience, but the humorous way the film takes this one small nest of very particular affections and exaggerates them, adding more and more unexpected episodes to the story, makes this film a joy to watch.

Tokyo Olympiad: A Feeling of Richness in the Midst of Loneliness

When watching the documentary *Tokyo Olympiad* (1965), certain shots and scenes often remind the viewer of similar ones from Ichikawa's narrative films. For instance, the shot during the passing of the Olympic torch that captures the expression on the face of a sixtyish woman standing in the crowd. As she is jostled from behind, her face crumples in discomfort, making everyone laugh. This recalls an even more intense shot from the beginning of *Punishment Room*, a vivid and unsettling image which I believe appears during the opening title. It takes place at the Meiji Jingu Baseball Stadium, during a competition between cheering squads, as they shout fight songs and throw streamers in the air. In the group of students who should be fervently cheering on their team, the camera swivels all of a sudden to show the slack, expressionless face of one student, leaving a powerful impression as the scene ends. This scene's role in the narrative is not necessarily clear—it may have even happened accidentally during the shoot, and the director was piqued by

it, and used it. If the reaction had been delivered by an actor who blended into the crowd, it would have been singled out as quite a performance.

Seen in the simplest light, this sequence is expressly about the fervour of the crowd. But if we look with more nuance, it doesn't merely depict the single-minded emotion of the crowd's enthusiasm—it seems that Ichikawa also wanted to call attention to one curious young man who appeared only to be bobbing alone on the collective euphoria. However, where the glance of this young man in *Punishment Room* effectively casts a sharp critical look at the surrounding mass elation, the crumpled face of the woman in the throngs in *Tokyo Olympiad* has a humorous edge. But having said that, Ichikawa's film stands in stark contrast to Leni Riefenstahl's propaganda film about the 1936 Berlin Olympics, *Olympia: Festival of the Nations*. *Olympia* treated the passing of the sacred flame as a *tableau vivant*, dramatized with ostentatious solemnity. *Tokyo Olympiad* attempts something far more interesting than *Olympia*'s portrait of the masses as a group which expresses a single will and a single order.

A slackened facial expression was also something Ichikawa was aiming for in *Fires on the Plain*. Eiji Funakoshi plays a soldier, Tamura, who is left behind in battle when Japan is about to lose the war. In the midst of a hail of bullets aimed at him, Tamura suddenly seems to jump up, in slow motion. At that precise instant, it seems as if a smile passes over his face, though he is about to be shot to pieces. That he is able to smile at that moment makes him appear to be something of a fool. The fact he is already far beyond the point of controlling his body or emotions eloquently shows his extreme condition.

From this and other scenes, we can argue that one of Kon Ichikawa's fundamental tenets of filmmaking is to capture people in situations which they cannot control by exerting their own will. In the opening sequence of *Tokyo Olympiad*, the city of Tokyo is shown bursting to the seams with hordes of people, while workers undertake a frenzy of construction in preparation for the Olympic festivities. Shot with a long-focus lens, through a haze of summer heat, several construction workers wearing yellow helmets appear in the middle of the crowd. One worker stares out into space towards the camera, but we can't gauge his look. Paradoxically, that face leaves quite a deep impression as it stares openly towards us with an unreadable expression. In Riefenstahl's *Olympia*, the faces of the athletes and the crowd are eminently expressive with the will for ethnic competition, which colours the image. Even sixty years after it was made, I still have a vivid impression of two things from the film: the incredibly mystical way in which the passing of the flame was shot, and the finely-wrought montage of the reactions in the grandstand during the competitions. These sequences feature intercutting between event and crowd, such that each time an event is won or lost, the film shows the crowd standing up in unison and their reaction. One of these montage sequences captures the women's 400-metre relay race. At the last handoff, one of

the German runners drops the baton and it falls to the ground. Following the shot of the runner's own disappointment, Hitler is seen in the VIP stand, wringing his hands, a grimace of disappointment crossing his face. We might conclude from this sequence that one camera was devoted to filming the events on the field, while a separate camera was trained on the VIP seats.

We can suppose that the camera lavishes so much attention on the figure of Hitler because the Nazis themselves lavished so much money and equipment on the production of this film, thinking of it as part of the national enterprise. But it seems a stretch to suggest they had another camera to capture any unexpected events. If we guess correctly, we can hazard that scenes like this one, where Hitler wrings his hands and makes a disappointed face, were taken "on spec" during other events in the competition, and patched into events like the relay race to produce an even more heightened dramatic effect.

While we continue to call *Olympia* a documentary film, it is in fact constructed in a highly dramatic fashion. When the athletes from Germany lose, the Führer feels deeply chagrined. The film is clearly aiming to juxtapose images through editing to provoke a patriotic effect. I'm thinking of a sequence that I believe happened in the pole-vault competition, a kind of see-saw match between athletes from the United States and Japan. When one side would make a successful jump, a section of the stands would burst into cheers and rise in unison. Then when the other side made a successful jump, their part of the stands would erupt in the same frenzy. The film cross-cuts between the competing athletes, and the supporters from their own country and allied countries. Of course the result of this montage is that each athlete seems to compete not for himself or herself, but on behalf of his or her entire country's honour.

The crowd at the Berlin Olympics very well may have reacted this way, but the effect created by the cutting back and forth between the competitions and the crowd's reactions is extremely mechanical; it treats the members of the crowd as if they were a trained cheering section. One also has the feeling that the competitors down on the field are acting as the representatives of the masses sitting in the stadium seats. In the 10,000-metre competition, when the Japanese runner Murakoso is pushed out of the lead by three taller Finnish runners, a chant wells up from the crowd, "Mu-ra-ko-so." The chorus of voices cheer on this one Japanese guy and his valiant effort, and look to intimidate the Finns, but standing up to the applause, the three Finnish runners also appear heroic, running impudently in the face of intimidation.

Olympia highlights the passion of the crowd along with Hitler's reactions because it celebrates from beginning to end the concept of heroism via sports. The mystical sequences showing the passing of the Olympic flame also serve this purpose. This aesthetic is also found in the ceremonies for the medal winners. Through close-ups, *Olympia* depicts them like so many Greek statues, gazing up with

awestruck expressions and pursed lips. They sport laurel crowns, and are shown in a double-exposure with their national flags flapping in the wind.

When the Tokyo Olympics were broadcast on television, one of the most interesting things was the expressions of the winning athletes as they climbed onto the dais to receive their medals. They were often unexpectedly shy, or oblivious to all the fuss around them. Scenes of the same occasion in *Olympia*, in contrast, feature strong expressions. The film seemed to operate on the preconception that an ideal "winner's face" existed, and that it was displayed in those receiving the medals.

Olympia was constructed under the assumption that the expressive faces and actions of athletes and crowd could be interpreted exclusively through the guiding concept of ethnic competition. There was an assumption guiding *Tokyo Olympiad* as well, which is that the goal of the Olympics is to promote world peace, and to promote the exchange of people at a level which transcends ethnicity. However, Ichikawa did not simply think that as long as he shot images of a harmonious international fraternity, that goal would have been successfully expressed.

Ichikawa did indeed shoot the audience, along with the competing athletes, but attempted to capture these people as distinct, autonomous individuals. Just as with the face of the construction worker in the yellow helmet, which tells us little of what he is thinking—perhaps he appears absent-minded—the athletes are brilliantly chosen to be shown one by one, poised at a moment of inattentive detachment. These are images of superlative beauty.

Until this point in his career, in comedies like *Pu-san*, *A Billionaire*, and *A Full-Up Train*, Ichikawa's films persistently focused on the image of aloneness in the crowd. (I think the shot I mentioned earlier from *Punishment Room* may be the most extreme instance of this tendency.) But for the most part these shots are critical, asking if it is right that people are losing their sense of themselves in the multitude. For example, *Alone on the Pacific* concerns a young boy who can't bear the vast feeling of aimless alienation welling from the masses around him, so escapes to experience a loneliness more fulfilling to the individual and sets off in a boat across the Pacific Ocean.

In *Tokyo Olympiad*, each of the lonely individuals in the crowd seems to undergo a sudden change, achieving a kind of splendour. They are alone, but do not live under some oppressive set of strict rules, forcing them in prescribed directions. Rather, each seems to maintain his or her own interior life, inscrutable to others, giving us virtually no idea of what they are thinking. Each of the athletes is the same: at the height of competition, their faces are blank, having nearly reached the state of no-mindedness. At the same time, however, their feelings of loneliness contain some inexplicable richness. An immense kind of solidarity is constructed at the point where these feelings of solitude and richness converge. The loneliness of the crowd operates as a moment uniting the immense assembly of individuals with the feeling that the world is one, without need of ideologies like nationalism and

"the folk." Ichikawa emphasizes that this feeling is what the Olympics are all about.

If we take the official goal of the Olympics to be world peace, Ichikawa's film is one hundred per cent faithful to that. He was, however, severely criticized by one element of the political and intellectual world in Japan, which attacked him for not including more of the matches won by Japanese athletes. Despite the official goal of world peace, at least one faction of politicians and dignitaries from the world of athletics was absolutely unwilling to question their belief that the purpose of the Olympics was to promote the glory of the Japanese nation.

Ichikawa's conception of converting the idea of the lonely crowd into a dream for peace by passing through the aesthetic realm of sports—to the point of "no-mindedness"—while perhaps problematic for its idealistic passion, is incomparably more respectable than *Olympia*. Even so, the film is a bit soft. If *Tokyo Olympiad* had been made completely independent of government influence, Ichikawa would have naturally had to deal with the return of North Korean and Indonesian athletes to their countries before the opening ceremonies, not to mention Shin Geum Dan, who, while practising in the training facility, was forced to return home before competing in the Games.

Even more important, it is necessary to demonstrate that, although sports is an aesthetic wonder, and, although spectators intoxicated with competition appear essentially peaceful, in fact many people who exploit sports are incredibly corrupt. Because this qualification is ignored, *Tokyo Olympiad* lives up to the standards of a masterpiece, but somehow misses the mark of a *great* masterpiece. Had he been able to incorporate angry politicians, the undignified media world, and the venality of sports organizations, then *Tokyo Olympiad* would have stood as Kon Ichikawa's most masterful comedy.

Translated from the Japanese by Anne McKnight.
With contributions from James Quandt and Aaron Gerow.

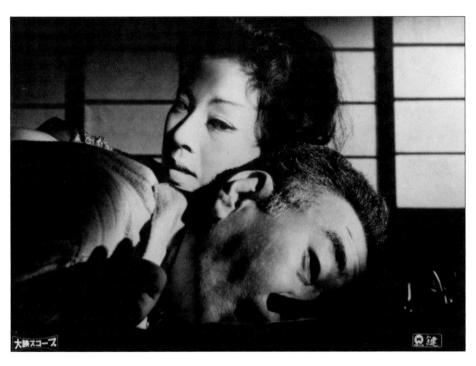
Kagi

KON ICHIKAWA

Between Literature and Cinema

WHEN DIRECTORS EXPLAIN why they are making a certain film, they tend to use phrases like, "I'm trying to explore such and such an issue," or "I want to describe such and such a situation." In fact, however, these kinds of comments are really just for convenience's sake, since we usually don't know what we are trying to explore or describe until we have seen the finished film, at which point we exclaim, "Ah, so that's what I was doing!" I think this pattern is an exceedingly natural one.

So when I'm asked to explain what my purpose is in adapting Junichiro Tanizaki's *The Key* (*Kagi*) for the screen, I can only reply that I won't really know until I've had a chance to view the final cut.

Many people maintain that *The Key* is one of those novels that can't be turned into a film, that it just isn't the right sort of material. I have come to believe, however, that in the last analysis it is possible to adapt a movie from anything if you can distill its means and methods of expression to a single point. It is not my intention to be so perverse as to rush to make a movie out of something just because others say it can't be done. For a time I couldn't make up my mind whether *The Key* was "Art" or "Pornography." That, however, was because I hadn't really understood it. Finally, after rereading the novel a number of times, it struck me that it actually would work. (I am ashamed to say, though, that I was so wrapped up in the practical aspect of things I wasn't able to completely immerse myself in the novel's eerie atmosphere. I feel I owe the author an apology for my failure in this regard.)

The Key's originality emanates from its style, which juxtaposes the diary of a husband, written in the angular "male" *katakana* script, with that of his wife, who writes using the more flowing and "feminine" *hiragana*. This is a brilliant way to structure a work, but what would be the fate of a film that tried to duplicate it? Most likely it would turn out to be little more than a clumsy digest of the original. I resolved to steer clear of this danger by totally revamping the structure. An

entirely new dramatic principle was needed. The scenario for *Kagi* was crafted in response to this need.

As a first step, I decided to make the motif of the film "repressed passivity," and the theme a comedy of murder. (In Tanizaki's original, the infirmity of age drives the narrative, the machinations of the characters underlie its style, and death constitutes the "drama" of the story.) As my research progressed, I became fascinated by the potential of the principle of passivity, something generally overlooked by Japanese filmmakers. For example, in a typical Japanese murder scene the killer pulls out his gun, shouts "I'm going to kill you," a couple of times and then "bang," blows the victim away. In the passive indirect mode, however, the killer tells the victim how nice and gentle he is, how much he likes him, and then "phht," does him in. Such an approach is common in European film, but not in Japan. Maybe it's the way we're built, or maybe we're just too straightforward. We tend to swallow words whole, and act on their surface meaning. "I'm going home," a character says, and then goes home. Seldom does he or she say, "I'm going home," and then sit down and refuse to leave. Yet that's precisely where a whole range of questions and complex shadings begin to emerge.

Repressed feelings tend not to disperse. Instead they accumulate in the heart. If one tries to resolve an issue in this emotional state, the impulse is to explode, to blow all that pent-up feeling away. Yet one's very passivity makes that impossible. Consequently, as in the case of the wife in *Kagi*, congealed emotion can transform itself into murderous intent. In this way, the motif of my film becomes entangled with its theme.

Nevertheless, when we sat down to write the scenario, we had to deal with the fact that the passive personality does not express itself in dramatic terms. Rather, the comments of extremely repressed people tend to be limited to things like, "Isn't it nice weather we're having," or "It's raining today." This put us in a bind, since it meant that the dramatic conflict in the story could not be expressed in open and concrete terms. Yet drama was key to the story, so a way had to be found to get it rolling. In the end we developed a two-step process; first we wrote the scenario in our customary way with lots of dramatic dialogue, then gradually stripped that dialogue away, shifting the focus to the characters' hidden motivations. In short, the structure of the narrative was based on a dramatic confrontation between two rivals who could never openly confront each other. We had to rewrite and rewrite to make it work.

The novel *The Key* provides the reader with almost nothing in the way of social context. That, I feel, is one of the secrets of Tanizaki's masterpiece. Yet it also seems to me that a film must have at least a minimum of social setting.

On the infirmity of age as a driving force in the film. Since time immemorial, people have feared losing their physical powers to the ageing process. In fact it can even be said that human drama is truly born the moment one becomes aware of

one's own physical deterioration. The desire to live forever has been a constant since the days of antiquity; yet the human life span is limited, so the desire remains unfulfilled. Indeed, the struggle against this limitation has defined human history, making it both tragic and comic. This is an underlying theme of *Kagi*, and I believe, rather greedily perhaps, that if it emerges subtly in the course of the film the finished product will be extremely interesting.

The caption, "A barren tale taken from infertile soil" can be found on the title page of the screenplay. This is because the main character's highly contrived intrigue, a direct result of his terror of old age, ends up enslaving all the other main characters—the wife, the daughter, and the young man who is her fiancé –to the dictates of the flesh. As a result, their lives become as dreary and desolate as a treeless, grassless desert.

A clever and amusing story outline is no longer a sufficient base from which to launch a portrait of the modern. Times have completely changed. Movies, I think, are bound to become more and more conceptual as a result. I believe we can see an extreme form of this tendency in those new films that take a frank, straightforward approach to issues, grasping them tightly and virtually hurling them at the screen.

In the decades that followed the advent of sound, filmmakers grew infatuated with their own scripts, synopses, and explications, like toddlers who get so excited over learning to talk that they can't shut up. The brand of realism they relied on to capture the private realm became more and more extreme as time went on. That we should be forced to become more conceptual for a second time at this juncture is thus very interesting.

In my opinion Louis Malle's film *The Lovers*, hotly discussed these days, is built upon a very conceptual foundation. Were that not the case, such a film could never have been made. Popular opinion holds it to be extremely sensual and romantic, and I suppose people are free to regard it that way, but I see the way Malle brought the material together—the hidden weakness and fragility of humanity, the role of impulse, and the accidental nature of love—as reflecting a highly conceptual principle. In my opinion, the most conceptual films are also the most sensual. Instead of following a story line or what have you, they present what is essentially a mental landscape. No framework is erected to explain the lovers' accidental meeting in Malle's film, or to dramatize the way in which they gradually come together.

Marcel Carné's film *Les Tricheurs* stands in direct contrast to this approach. Carné closely follows the old story-based principle of organization, concluding with the sort of empty melodramatic flourish that teenage audiences demand. No matter how perfectly such a film is made, however, its reliance on "story" cuts it off from the rawness of modern reality. For example, when the heroine is deceived by her lover, she kills herself by crashing her car at a tremendous speed. These days, a suicide like that would be presented far less dramatically; instead, the girl would quietly find an out-of-the-way building or bridge to jump off. The

bigger a commotion is made out of an event, the more its sense of reality fades. I have no idea whether this pattern corresponds to the real world or not. The fact is, rather, that we have reached a point in time when movies must be presented in this new way. Some may complain this makes them hard to understand, but actually the conceptual approach is more straightforward, and thus easier to grasp.

The difficulty of filming *The Key* exists in the gap that lies between the image and the written word. There is what the world calls the "Tanizaki mood." That mood and the expressive technique I am developing for the film may be essentially different. If that is the case, then there will be times when the two sides will clash, and other times when they will work in concert. Although Tanizaki's so-called aestheticism will probably find its way into the film, I hope to limit its presence to the visual imagery. In other words, although the film's sexuality will be immediately apparent, the depiction of sexuality is not the purpose of the film.

I'm not sure if the term fits or not, but I thought the depiction of sexuality in *The Lovers* was handled in a very fresh and original way. It just goes to show, I think, that a filmmaker can go as far as he wishes in this area if he has the self-confidence to follow through with no lapses in moral judgement. If, however, he uses his material to shock or titillate the audience, then it's fair to say it becomes sex for its own sake. When you use sex scenes merely to inflame the lust of your viewers, your film will probably be a sordid failure.

Louis Malle did not shoot his film around such scenes—rather, he had to include them to achieve his frank portrait of the natural love between a man and a woman. They are sexual but not just sexual. Yet even so, outrageously, he had to cut two minutes and fifty-one seconds from them before the film was released.

It is said that film is a highly sensory medium, which leaves an exceedingly intense impression; but literature is capable of evoking our emotions just as powerfully through its ability to make us feel what is "between the lines." So-called erotic magazines are especially adept at this, since they arrange their words to make us imagine particular sensations and thus fan the flames of our passions.

Tanizaki's *The Key* on the other hand is highly explicit, even to the point of describing the wife's private parts. This does not imply, though, that Tanizaki is dabbling in pornography or anything like that. Rather, he takes the approach that he is going to write what has to be written, what reveals the husband's compulsions, and if people want to edit out those sections, then let them. Tanizaki's readers sense this commitment: they realize that nothing nasty or dirty is going on, and respond to the vision of the raw, wild side of humanity that he reveals to them.

Like Tanizaki, I am committed to shooting whatever is essential to the flow of my film. Yet it also goes without saying that I respect the universal convention that one must be clothed when appearing in public.

Critics have been comparing my adaptation of *The Key* to *The Lovers* ever since I began working on the film. This puts me in a difficult position. I appreciate the

fact that they see a correspondence between the sex scene in *The Lovers* and the more graphic sections of Tanizaki's novel, but although sex scenes may all have something in common, the two cases are intrinsically different. Besides, I haven't even started shooting yet, so what is there to compare!

I am continually amazed at how many geniuses there are out there who can picture a film that hasn't yet been made so clearly in their minds.

Finally, let me apologize for the rambling nature of this brief essay, which is the revised written version of a question-and-answer round-table session I took part in recently.

1959

Translated from the Japanese by Ted Goossen

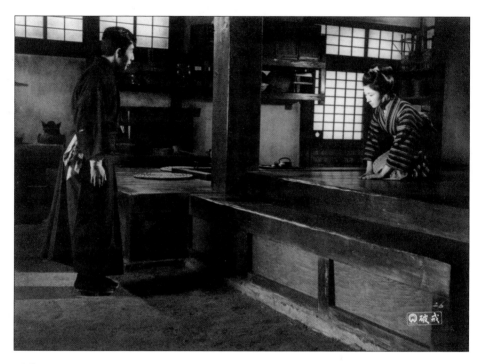
Hakai

KEIKO I. McDONALD

The Modern Outcast State: Ichikawa's *Hakai*

KON ICHIKAWA'S *Hakai* (*The Broken Commandment*) began in 1961 as a televised dramatization of Toson Shimazaki's novel of the same title first published in 1906. Toson's pioneering work of social realism created a sensation on television, so the director collaborated again with his wife and scenarist, Natto Wada, on the film the following year. It, too, was a great success. The prestigious film journal *Kinema Junpo* ranked it as the fifth best film of 1962.

Set in 1903, during the late Meiji period, both novel and film depict a young teacher's coming to terms with himself and society's lingering feudal prejudice against his class of *burakumin*, then Japan's minority group. But novel and film take strikingly different approaches to a topic still sensitive in the Japan of the 1960s.

Making the best use of "literary properties," Toson took pains to explore the psychological dimensions of his hero's struggle in great detail. Ichikawa, in contrast, relies on cinematic properties, especially visual legibility. Counting on the camera's expressive power and temporal freedom Ichikawa dispenses with Toson's lengthy literary discourse. Instead, he lets us see and feel the suffering and pain of the outcast in a more direct way. In fact, one critic points out: "Generally, Ichikawa's method is to accommodate the original source to his own taste and critique it through visual images. Accordingly, his film version of *The Broken Commandment* reflects this mode of representation and is highly acclaimed, as *The Broken Commandment* is in a sense Ichikawa's own."[1]

In order to see how Ichikawa achieves this desired effect, we need to go back to Toson's novel. Most critics consider *The Broken Commandment* the crystallization of modern realism.[2] Written during the Russo-Japanese War of 1904–5, it probes the conflict of a young teacher, Ushimatsu, who was born a *burakumin*.[3] The drama spans a relatively short period from October 26 to December 12, 1904, a time in

which external and internal factors closely interact to determine the fate of the social outcast hero. As is often mentioned in the novel, the Meiji government's edict of 1871 freed the *burakumin* of their burden of exclusion from the Edo period's four-class system. Their new status was to be that of *shinheimin*, or "new commoners." Nevertheless, this legal redefinition had no effect whatsoever on the actual lives led by *burakumin*. They were still subject to the prevailing view of them as, in effect, subhuman. In 1902 a campaign on their behalf was mounted by various members of the upper classes in such places as Okayama and Osaka Prefectures, but little progress was made. It was felt that discrimination could be fought only with improvements in the education, manners, and hygiene of *burakumin*. Those concerns delayed actual political measures eight years after the publication of Toson's *The Broken Commandment* in 1906. The first nationwide group, the Imperial Organization for Equality, was formed in 1914 with advice and help from some noted politicians.[4]

The central problem of *The Broken Commandment* involves Ushimatsu's coming to terms with himself. It maps out the various stages of the young protagonist's identity crisis until he finally accepts his difficult social status. Ushimatsu's conflict unfolds on two levels: he must defend himself against an oppressive society with all its prejudice and insularity. This combat with the external world in turn triggers inner conflict, as he is torn between liberated ego and constraints of reason. Should he reveal the social identity he has managed to conceal and thus lead a life faithful to his conscience? Or should he continue to lead a deceitful life as a respected member of society? That question of choice shapes the novel. Needless to say, events conspire to bring this conflict into the open. Faithful to his father's parting command to conceal his social origins by every means possible, Ushimatsu becomes a master of deceit.

Toson shows the reader what it means to live as an *eta* (a derogatory term used for this minority group) in Iiyama, a small country town in Shinshu. People there consider *burakumin* "defiled." We read about one Ohinata who is dismissed from the hospital because he is rumoured to be a *burakumin*. He is also kicked out of his boarding house when the other lodgers refuse to live under the same roof with the likes of him. All Ushimatsu can do is suffer internally: "Taking pity on the unfortunate Ohinata and lamenting the irrational, inhuman treatment meted out to him, he thought about the *eta*'s miserable fate."[5]

When Ushimatsu's father is gored to death by a bull, Ushimatsu must witness the slaughter of the beast after the funeral. Toson uses this appalling scene to underscore his young hero's sense of inner conflict. The splattering blood and hacked-up carcass suggest a horrifying parallel between the fates of beast and his outcast com-

munity of *burakumin*. Then, too, the butchered animal supplies an especially gruesome and forceful reminder of his moral dilemma:

> "Don't forget!" His father's deathbed warning promised to seep into every part of Ushimatsu's body during his lifetime.... "Will you forsake a parent?" the voice seemed to ask in a reprimanding tone.... Ushimatsu could not help thinking how much he had in fact changed. He was no longer the innocent child who obeyed his father without hesitation.... And now this chasm had opened up, this difference between a mentor [Inoko] counselling courage, outraged by a merciless world, and a father demanding subjugation. Ushimatsu was at a loss, not knowing which to follow. (*The Broken Commandment*, 155)

Such is the nature of his inner struggle as the bull is reduced to bloody chunks of beef. That horrid transformation fixes itself in Ushimatsu's mind even as he prepares to obey his father's command: "Nothing to do but go back to Iiyama and lead the life he knew so well" (169). But the novel turns on that failure of courage. Ushimatsu returns to Iiyama, where things change rapidly. Rumours of Ushimatsu's outcast origins spread among his fellow teachers, changing his principal's attitude drastically.

Ushimatsu's conflict takes on a far more drastic dimension. He is set in direct personal opposition to an entire small society, one characterized by prejudice and insularity: no wonder the young man felt "as if some fierce, invincible force was directed against him" (210).

How, exactly, is the rumour spread among the teachers? What will Ushimatsu do? The novelist spends five chapters portraying Ushimatsu's sufferings before he answers these basic questions. Because he is a novelist, Toson balances his hero's misery between forces good and evil, even as the reader has to wonder if and how the young man will survive his ordeal.

Ushimatsu's colleague Ginnosuke Tsuchiya is the embodiment of goodness. His evil opposite is one Katsuno, son of a government education inspector. Toson endows the latter with all the prejudice, hypocrisy, arrogance, and sycophancy one could hope to find in an unworthy educator. It is Katsuno who spreads the rumour about Ushimatsu's lowly status and presses the principal to dismiss him.

Toson invests Tsuchiya with qualities of innocence, rectitude, and benevolence. He also uses him for a deft bit of narrative double take. It begins when Tsuchiya, in all innocence, mistakes Ushimatsu's aloof and melancholy air for love sickness. The principal's inclination to dismiss the young teacher is deflected by this news.

Tsuchiya's goodness runs so deep that his friendship for Ushimatsu is unaffected when he learns the truth about his origins and personal conflict. This is not

to say that the good man is blind to the horrors of prejudice and discrimination in Iiyama. In fact, by the end, he is quite ready to leave for a job in enlightened Tokyo.

The climax of the novel, Ushimatsu's disclosure of his identity, occurs in chapter 22. Ushimatsu resigns his position at the school. Toson reiterates the father's commandment yet again:

> No matter how you are treated by others, no matter who they are, never tell them where you come from. If you allow yourself to be led astray by emotion, if you forget my commandment, then you will be well and truly made a social outcast. (307)

Ushimatsu tells his class what he is and asks his pupils for forgiveness:

> "When you go home, please tell your parents about me. Tell them how sorry I am for hiding my lowly birth.... I am an *eta*... an impure human being...."
>
> Thinking that he had not done enough, he took two or three steps back, knelt down on the floor, and repeated his plea for forgiveness.... (320)

The novel quickly resolves Ushimatsu's fate, and Toson concentrates on the responses of the major characters to his confession. The author is forced to rely on a *deus ex machina* to bring Ushimatsu and the woman he has secretly loved, Oshiho, together. More important, the outcast whom Ushimatsu saw expelled from his inn returns as his benefactor. He is about to leave for Texas, where he plans to farm; he needs the help of a young man. Toson has been accused of taking the easy way out, but one might consider the history of discrimination in many a twentieth-century context and conclude, with Toson, that Texas is not too far to go if you are a Japanese outcast seeking release from centuries of prejudice.

The conclusion of the novel does work rather hard to show that prejudice has remarkable staying power, even in a rapidly changing world. We are shown how childhood innocence is betrayed by adult knowledge. The principal, jealous of Ushimatsu's success in the classroom long before there was any question of a shameful secret, is now pitted against Ushimatsu's pupils, who are still emotionally attached to him even after they know about his background. They want a half day from school to see him off at the station. The principal responds with a character assassination, criticizing Ushimatsu's motives and behaviour.

All those who are in tune with the changing times and friendly with Ushimatsu leave this insular community in the end. The innocent children's education

will be left to those who resist the currents of the times, as the conclusion echoes the principal's earlier remarks:

> The principal considers himself already an educator of an older generation, a far cry from this of Ginnosuke and Ushimatsu. . . . Times have changed, and nothing is more threatening than the new age. He himself has no intention of growing old and feeble. . . . He will not be pushed aside by these brash newcomers. He will take appropriate action with any who display sympathy with these so-called new ideals. (310)

The novel ends with Ushimatsu's last glimpse of this small-minded provincial town. Its idyllic landscape is powdered with snow, as if to emphasize its faraway character, safe from any turmoil in the outside world with all its political upheavals and social change:

> The row of houses on the opposite bank was broken first by tall temple buildings, then by the old castle ruins. All were covered in obscuring snow. The white walls of the elementary school, and the bell tower, both clearly visible in fair weather, today seem swallowed up by snowy sky. Ushimatsu looked back at the town two or three times, sighed deeply, then turned away for good with tears running down his face. His sled began its run across the snow. (349)

While remaining faithful to the central problem of Ushimatsu's coming to terms with his life, Ichikawa's film version is, in its own right, an ambitious attempt to deal with the plight of the oppressed. Ichikawa is also not afraid to give Ushimatsu's moral dilemma a more convincing avenue of escape than Texas. As we have seen, Toson's contemporaries criticized that exit as being just too much like a ready-made solution. Of course, we now live in an age that prides itself on confrontational directness, so leaving for Texas will never do as a resolution. In fact, the Wada-Ichikawa reading of *The Broken Commandment* is notably willing to accommodate the present-day audience. Their treatment of the wife of Inoko, the outcast writer whose *Confession* has such a profound effect on Ushimatsu, is a good example. As we later see, she is much more fully developed in the film than in the novel and is a woman endowed with a strong personality and beliefs.

Although Ichikawa retains most of the important narrative events that bear directly on Ushimatsu's moral conflict, he radically simplifies most of them. This is welcome relief from Toson's penchant for lengthy and often redundant descriptions of his suffering hero's inner reality.

At the same time, Ichikawa takes full advantage of his medium. He uses the camera to help us see and feel Ushimatsu's misery in ways peculiar to cinematic art. Ichikawa makes the best of cinema's nimble shuffling of chronology. His flashbacks

give us direct and insightful access to cause and effect, especially when he combines Ushimatsu's recollections with their immediate psychological consequences.

In the novel, the reader's knowledge of the historical setting is taken for granted, where Ichikawa feels obliged to offer his audience this introductory title: "This is a story from the past when class discrimination still existed." Toward the middle of the film he adds some more signposts, reinforcing a reference to war with shots of soldiers going off to battle. Another intertitle concludes the drama by giving the scene of Ushimatsu's suffering as an outcast a very specific time and place: "It was in December, 1904, the first year of the Russo–Japanese War, that Ushimatsu left Iiyama."

The novel opens in Iiyama, where it will close. Ushimatsu witnesses the spectacle of an entire small-minded little town shunning a *burakumin* like himself. Things in Iiyama have not changed when, at the end, we see a sadder and wiser Ushimatsu turning his back on the place. Ichikawa approaches the story differently, opening in Ushimatsu's village, with the bull's attack on his father and the son's return to attend the funeral. This narrative change emphasizes the personal, inescapable circularity of *eta* life. No matter where he goes, no matter how skilfully he conceals his identity, the *burakumin* will never escape the torment and anxiety of having been born—there. His birthplace defines him, literally casts him out.

The opening scene reveals Ichikawa's desire to capture the life of an unfortunate man who must live cut off from the outside world. After surveying the surrounding mountains, the camera offers a long-shot view of a man and a bull as part of this natural setting, then witnesses the gamekeeper's death. He approaches the bull with some salt. A close-up shows us the bull's fierce eyes. The camera conveys the rhythm and the momentum of the animal's charge. The gamekeeper's surprised attempt at evasion is shown in crosscut. Shots of various sizes in a reverse-field set-up capture the goring. A close-up shows us the gamekeeper's terror of approaching death. His body rolls. The camera studies his corpse lying among stems of bamboo, then follows the bull's retreat: shot size decreases as he gallops away and disappears.

The dissolve yields to a shot of a hired hand walking down a mountain path in the evening. Another shot introduces a small *buraku* with a number of houses crouched together at the foot of the mountain, confirming our sense of the isolation in which all outcasts suffer. The next scene brings these *burakumin* together in the small shack in which Ushimatsu's father lived. The camera's survey of its dilapidated interior offers a poignant commentary on the dismal life of the *burakumin*. This narrow room does not even have regular *tatami* mats; only rough straw mats are spread on the earthen floor.

Only now do we learn that the opening sequence is more than a merely factual depiction of a fatal accident. It turns out that Ushimatsu knows about it only through a premonition. Suddenly that opening sequence may be understood as an

extension of the son's imagination. As the camera closes in on him, a flashback shows the young man taking night watch in the yard of the school where he teaches. The serene atmosphere is broken by the sound of a man sobbing. A close-up registers Ushimatsu's consternation as he realizes that it is his father's grieving call he hears, which merges with music at the end of the flashback.

Ichikawa introduces an element absent in the novel in the sequence of the father's funeral: another outcast's response to the death of Ushimatsu's father. As if to curse the fate of being born under the unlucky star, or to indict the society that takes discrimination for granted, an old hired hand reminisces:

> "When I heard Mr. Segawa calling to the bull, I thought that he was going to kill himself.... I don't think he was forced to die, but his cry seemed to be appealing to Heaven. He wanted to tell Him about the sorrow and humiliation of the *burakumin* and the agony of living in such a mountain like a hermit or a dead person."

The funeral sequence concludes with another death scene, this one in the slaughterhouse. Toson belabours the appalling details in order to elucidate the plight of *burakumin* and Ushimatsu's witness, which is all the more painfully ironic because butchering was a monopoly of the despised *burakumin*. Ichikawa simplifies this episode by giving a quick, newsreel view of a cow methodically butchered, emphasizing the horrific irony that a young man like Ushimatsu would have been relegated to this "profession," if he had not escaped to become a teacher.

After providing ample evidence of *burakumin* suffering on home ground, Ichikawa takes us to Iiyama. There we finally see the scene that opens Toson's novel, as townspeople chase an outcast out of the local inn. Echoing the images of defilement in the slaughterhouse, some of the outraged guests refer to this *burakumin* as defiled. After he is dragged away, some even sprinkle purifying salt.

The rest of the film includes the major events of the novel, following Toson's central theme of Ushimatsu's coming to terms with his life. Ichikawa does, however, enrich his account with many flashbacks, which offer a somewhat different access to Ushimatsu's inner struggle. This method renders legibility to the close interaction or causality between the past and the present as it enlarges our view of Ushimatsu's suffering.

The first example of this occurs after Ushimatsu sees the unfortunate outcast thrown out of the inn. Ichikawa's young man is much more outspoken in his indictment of society's treatment of the *burakumin*. Ginnosuke Tsuchiya has come to visit him at the inn. Still agitated by what he has seen, Ushimatsu says:

> "What's the difference between the *burakumin* and the ordinary citizen? We know that historically, the *burakumin* class was created to satisfy the needs of

politicians.... We live in a new age now. Aren't many *burakumin* going to war as infants of the Emperor?"

After Tsuchiya leaves, the overwrought Ushimatsu gives vent to his feelings by stabbing himself in the arm with a small knife, exclaiming: "Look! This is human blood, no different from any other Japanese. Why do I have to be discriminated against? Why do I hide my identity? Father! Teach me why!"

A dissolve flashback returns us to his father's funeral. Ushimatsu is seen clinging to the freshly dug burial mound, a powerful reminder that, even after death, the *burakumin* are shut out, cut off from full and proper burial ritual.

As in the novel, Ushimatsu's relationship with Inoko is central, but the latter's influence on Ushimatsu's decisions is approached differently, particularly in matters of chronology. Ichikawa employs flashbacks to chronicle Ushimatsu's gradual recognition that the alternative Inoko offers—an open life and social justice for the *burakumin*—is best.

For instance, Ushimatsu surreptitiously purchases Inoko's *Confession*, as he does in the novel. Why would he take this risk in a small-minded small town like Iiyama? What does this young fellow have in common with an author famous for choosing to share the difficult fate of the *burakumin*? Ichikawa satisfies our curiosity in an explanatory flashback. The opening line of *Confession*, "I am from a *buraku*," dissolves into the recollection of Ushimatsu's journey home, with a shot of a mountain road shrouded in mist and peopled with obvious *burakumin*. The soft orchestral music of the soundtrack yields to the vulgar twang of a beggar's *samisen*, an Ichikawa touch that underscores the dismal setting.

Another dissolve leads to the mountaintop, where Ushimatsu meets Inoko for the first time, and we see how different Ichikawa's outcast hero is from Toson's. In the novel, this encounter "locates" Ushimatsu's radical transformation in a moment of insight into his inner conflict. Inspired by his mentor's fidelity to his own soul, Ushimatsu is almost led to follow the same path. Yet, in the company of the others, he misses the opportunity for full confession. Ichikawa instead gives us a suffering hero still bound by his father's commandment. It takes Inoko's strong leadership to show Ushimatsu the way to self-awareness. The director emphasizes Inoko's mission both verbally and visually. He delivers a hectoring, unsettling sermon to the young men on the mountaintop:

> "My fellow outcasts are content to lead a hand-to-mouth existence in seclusion, even as they envy others who are truly free.... They never want to address the social injustice which ruins their lives.... The greatest obstacle in the way of my movement for *buraku* liberation lies in the *burakumin* themselves. Don't you think it is our mission to strengthen their resolve?"

Inoko then challenges Ushimatsu directly: "Once I was cowardly enough to hide my identity. Do you want to be a coward for the rest of your life?" A series of reverse-angle shots in close-up examines each character's emotional intensity until Ushimatsu is singled out as he adamantly denies his outcast status. Yet the camera takes note of his drooping shoulders, an index of his weakening defences.

Inoko challenges Ushimatsu's hidden life, because his own health is failing and he sees a possible successor in the young man. But their second meeting suggests otherwise. Ichikawa has shown us Ushimatsu selling his copies of all Inoko's works, and Inoko now comes to the temple to visit Ushimatsu, who insists that he does not know him! Thanks to a convenient shadow, a third party witnesses their encounter: the abbot, who turns out to be breaking a commandment of his own as he lusts after his adoptive daughter, Oshiho. Ichikawa lightens the moment with some characteristic black humour, skewering the abbot's hypocrisy. Though harbouring incestuous desires, the abbot finds the very idea of being foster-father to a *burakumin* utterly abhorrent.

Inoko's murder prevents Toson's hero from making his confession. Ichikawa's protagonist has shown us a more complex reaction to this charismatic reformer. Drawn away from his father's command by Inoko's forceful arguments, Ushimatsu rejects his mentor, only to suffer more when he learns of the murder.

Again, Ichikawa uses a flashback to reconstruct the circumstances of the crime as Ushimatsu knows them. This sequence begins and ends without any cinematic punctuation cueing us to a shift in time. The abrupt transition, a direct cut to a close-up of Inoko's face, emphasizes the immediacy of Ushimatsu's feelings about his death.

The next sequence is even more intense: Ushimatsu breaks down in class and asks his pupils to forgive him for deceiving them. As in the novel, Ichikawa creates a gradually mounting tension. While Ushimatsu is handing back assignments, the song "Momotaro" ("Peach Boy") comes from the next room, which connotes childhood innocence for Japanese audiences, an ironic counterpoint to Ushimatu's confession. A low-angle long shot takes in Ushimatsu starting to describe the plight of *burakumin*. The camera looks at him from the back of the room as he stands at his desk. The students listen intently. This long low shot subtly celebrates the teacher's courage as he accepts his fate at last.

Ichikawa retains most of the novel's soliloquy. He and Wada add dialogue, giving Ushimatsu this urgent appeal to his pupils: "I beg you to remember that I am the one who told you this: that *burakumin*, despised as they are, are human like you. They are born innocent babies, and remain human until they die. They are not demons or animals!"

Ichikawa lets the camera do the work of the novelist's many words describing this traumatic moment for teacher and pupils. The opening long shot yields to a medium shot of Ushimatsu when he says that he comes from the *buraku*. We see

his trembling hands and legs, the desk that keeps him from collapsing completely. The camera cuts to groups of the children in medium shots. Some sit open-mouthed; all clearly show their consternation. As Ushimatsu reminisces about the happy days he spent with them, teacher and pupils share the same emotions. A close-up singles out Ushimatsu's tear-stained face. The children's sobbing merges with the lyrical music that has stolen in. Then the camera draws back at a 90-degree pan as Ushimatsu begins to act out his repentance. He is shown stepping forward from his desk. Another shot, this time in a medium take, shows him kneeling; we do not see his face, but his bent back speaks for his feelings.

Ichikawa again takes a shortcut, switching to a room where a teacher is telling Ginnosuke what is going on in Ushimatsu's classroom. We see Ginnosuke's reaction as he rushes out and into Ushimatsu's class. A long shot shows him approaching Ushimatsu, still in the kneeling position, surrounded by pupils and colleagues. Ginnosuke takes him away.

This climactic sequence concludes with a cut to the snow-covered forest in which Ushimatsu wanders. A long shot registers the young man's sense of dejection and alienation, as his solitary figure merges with the inhospitable wintry setting. The camera closes in as he begins to ask his late father's forgiveness.

Throughout this rather lengthy soliloquy, Ichikawa provides much more narrative legibility to his hero's feeling, even as he falls into the verbose sentimentality that was Toson's besetting sin. Ushimatsu summarizes various stages of his suffering: his father's sacrifice to educate him; the spiritual freedom offered by his education; the internal conflict that, paradoxically, freedom bred in him; his betrayal of his mentor, Inoko; and, ultimately, his betrayal of his father. What can he do but turn to thoughts of self-imposed exile? "I am alone, Father. I am nameless, and my love is unrequited. I am on my way to a journey of repentance for the broken commandment...."

Withheld information is significant in reversing the course of action to which Ushimatsu has resigned himself. He has yet to realize that people unprejudiced against *burakumin* exist, and Ichikawa expertly employs his blinkered view of the world, arranging a twist of fate for Ushimatsu that is far more convincing (not to mention interesting) than the novel's sentencing him to a transport to Texas. The director does this by combining two causal lines: Ushimatsu's shifting response to his father's commandment, and his liaison with Oshiho.

In both novel and film, their forbidden love reinforces the primary theme of Ushimatsu's struggle to come to terms with himself, but unlike Toson, who concentrates on Ushimatsu's psychological responses to Oshiho, Ichikawa makes the source of his hero's romantic anguish external. The narrative device of withheld information becomes especially important as Ushimatsu gradually discovers the details of Oshiho's unfortunate life, including the fact that she was put up for adoption after her mother's death. When her father urges a marriage between the

two youngsters, Ushimatsu has not revealed his secret, so the eager parent has no idea that he is proposing what would be viewed as a monstrous misalliance between a girl of the samurai class and an outcast. (Unlike Ichikawa, the novelist leaves this possibility in the realm of chance and of Oshiho's individual courage.)

The music on the soundtrack suddenly stops, leaving only the sound of a restless wind. The scene ends with father, daughter, and potential suitor in a pensive mood. A medium shot shows father and daughter facing the camera, while Ushimatsu's back is toward us. The wind persists. Ichikawa gives us a few tentative clues to explain each character's sudden lapse into contemplation; for instance, the wind suggests that the father's proposal increases Ushimatsu's anxiety.

Though the film's narrative follows the novel in the sequences involving the alliance of Ushimatsu and Oshiho after his confession to his students, Oshiho is endowed with a much stronger, more sensitive personality. Her strength of character is evident, for instance, in the close-up that emphasizes her lively, determined expression as she says, "Even a woman can stick to what she knows is right if she really wants to!" Similarly, Ichikawa (or possibly scenarist Wada) transforms Inoko's wife, who in the novel is submissive, into a more complex, strong-willed character. Ichikawa uses her long conversation with Ushimatsu to offer us some insight into the plight of a woman married to an outsider, placing the *buraku* liberation movement in its historical context. In essence, she argues that the new constitution of the Meiji Restoration guarantees equality to all citizens. She sees life as a struggle for everyone, regardless of social status. Ushimatsu, she insists, must not blame all his suffering on his lowly origins.

Her sense of independence now compels her to go to Tokyo, where she will work as a kindergarten assistant. Ushimatsu's transformation is sudden, as he announces his intention to accompany her to the capital to follow in her late husband's footsteps. A cut to the principal's office shows us that hypocrisy and prejudice still flourish in that supposedly enlightened place. As in the novel, the principal is adamantly opposed to Ushimatsu's pupils going to see him off. But again, Ichikawa is not about to follow the novelist's path of least resistance, making Ginnosuke a considerably more courageous figure. He is more than Toson's right-thinking man who knows a hopeless cause when he sees one. He turns down the offer of a better position in Tokyo to become "the only educator" in this provincial town dedicated to guarding its children against the contamination of prejudice.

Ichikawa seems anxious to deal fairly with the confrontation between Ginnosuke and the principal, portraying the latter as another victim of social forces, in particular the prejudice characteristic of an insular little community. He confesses that he, too, was once imbued with the ideals of an educator; but, alas, a lifetime of accommodating the manners and mores of Iiyama has made him a petty and vindictive opportunist.

The conclusions of film and novel diverge substantially. Toson's protagonist leaves Iiyama an exile and quite alone. Even Oshiho's promise to marry him has no real narrative legibility since the novelist gives us no sense of her real feelings.

Ichikawa is, if anything, too solicitous for his young man's future, uniting him with his supporters and loved ones. Ginnosuke, Oshiho, Inoko's widow, and his own devoted pupils all offer the exile a support so resolute that questions of narrative legibility become almost superfluous.

The final sequence begins with a shot of the snow-covered, deserted banks of the Chikuma River. A dissolve yields to a shot of Ushimatsu and Inoko's wife pulling a sled through the desolate winter landscape. Ichikawa conveys a touching sense of solidarity between the two, and gives Inoko's wife ample opportunity to voice his views about Ushimatsu's decision. Their conversation is shown in a series of reverse-field shots. Ichikawa's anxiety to impart his message makes for a rather repetitious reprise of Ushimatsu's declaration of intent to follow in Inoko's footsteps. The camera shifts dramatically to underscore his determination with a low-angle shot aligning Ushimatsu and Inoko's widow against the wintry sky. The rustling wind merges with Ushimatsu's voice. The camera's ostentatious angle and spatial arrangement unmistakably celebrate the bond forged between these two by their difficult mission. A close-up reveals the woman's tearful gratitude for Ushimatsu's commitment to her late husband and his cause.

Ichikawa risks oversaturating the sequence of Ushimatsu's departure with visual and verbal motifs of bonding. Oshiho offers Inoko's wife her hood. Ginnosuke and Ushimatsu shake hands, promising to meet in Tokyo. The scene ends with a long shot of waving well-wishers and departing sled. Accompanied by a sentimental rendering of the theme music, a title places Ushimatsu's fate in the context of Japanese history: "Ushimatsu left Iiyama in December, 1904, the first year of the Russo-Japanese War." The film ends with a dissolve to the temple where the orphan Shota vigorously strikes the gong, establishing a poignant, hopeful valedictory tone that is swept up in the soundtrack's crescendo.

Ichikawa recasts *The Broken Commandment* for an audience more confident of social change than Toson's had reason to be. If, by some miracle, readers of that era could become viewers in our own, what, one wonders, would they think of Toson's women as presented by Ichikawa? What old commandments has the director broken in order to give them such strength of commitment and conviction?

Notes

1. Yoshiyuki Oshikawa, "*Hakai*"(The Broken Commandment), in *Nihon eiga sakuhin zenshu* (A Complete Collection of Japanese Films) (Tokyo: Kinema Junposha, 1973), 205.

2. For example, see Hiroshi Noma, "*Hakai* ni tsuite" (On *The Broken Commandment*), in *Nihon no sakka: Shimazaki Toson* (Japanese Writers: Toson Shimazaki), ed. Nobuo Ooka et al., vol. 4 (Tokyo: Shogakkan, 1992), 118–19.
3. Nowadays, the correct term would be *hisabetsuburakumin*, literally "discriminated people from the *buraku*." Though "*eta*" is a derogatory term now, I use it here as Toson did.
4. Ken Hirano, "Buraku kaiho undo no nagare" (The Progression of the Movement Toward the Improvement of Buraku), afterword in Toson Shimazaki, *Hakai* (Tokyo: Shincho, 1954), 395–96.
5. Toson Shimazaki, *Hakai*, 6. The translation is the author's. For a complete English translation of *Hakai*, see *The Broken Commandment*, trans. Kenneth Strong (Tokyo: University of Tokyo Press, 1974).

This is an abridged version of the essay "The Modern Outcast State: Ichikawa's *The Broken Commandment*," originally published in *From Book to Screen: Modern Japanese Literature in Film* (Armonk, N.Y.: M. E. Sharpe, 2000).

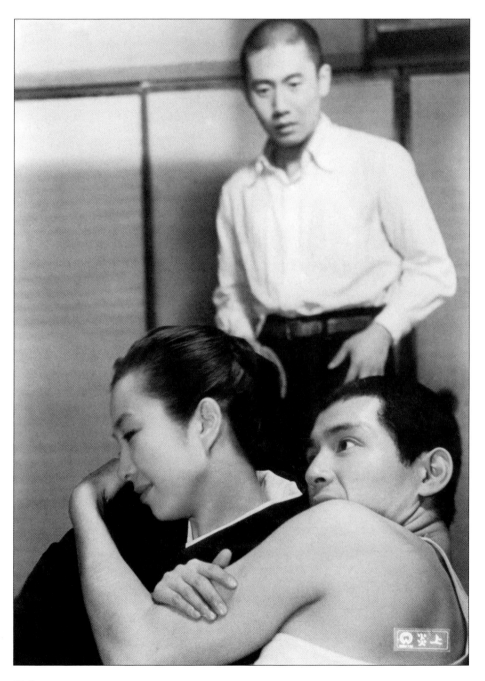

Enjo

DENNIS WASHBURN

A Story of Cruel Youth: Kon Ichikawa's *Enjo* and the Art of Adapting in 1950s Japan

ENJO (*Conflagration*, 1958) is widely considered one of Kon Ichikawa's best films and is reportedly the director's favourite of his own works.[1] In many respects it is the most successful realization of the prodigious gifts that Ichikawa has brought to filmmaking: a powerful sense of composition; a deep understanding of the potential of the widescreen format; a feel for economical editing; and a mastery of black-and-white cinematography. Based on the novel *Kinkakuji* (*The Temple of the Golden Pavilion*, 1956) by Yukio Mishima, *Enjo* also demonstrates Ichikawa's penchant for adaptation as a primary mode. In collaboration with his wife, Natto Wada, he has translated to the screen a number of canonical works of modern Japanese literature. *Enjo* is nonetheless an especially accomplished film. Its sensitive treatment of the emotionally disturbed protagonist, Mizoguchi, confirmed Ichikawa's status as a so-called postwar humanist, and displayed the sensibility of a director whose concern for artistic expression and experimentation pointed the way to developments in the Japanese cinema of the 1960s.

Enjo was made at a key point in Ichikawa's career just as he had reached maturity as an artist. It was also released at an important moment in postwar cinema when the studio system in Japan was beginning to feel the effects of the country's economic boom and the challenge of new visions of the cinema that led eventually to the emergence of the New Wave. Although it is not practical to explore the historical context in depth in this essay, several broad trends are worth noting, given their relevance to the conception of Ichikawa's film.

The famous government white paper, "The Japanese Economy and Economic Growth," that appeared in 1956 was more than a summary of Japan's postwar recovery. The report's pronouncement that Japan was no longer in the postwar

period (*mohaya sengo de wa nai*) heralded a change in material living standards and signified a psychological turning point for the country. Still, problems persisted. Japan's economic revival during the 1950s is usually described by the breathless term "miracle," but in fact many Japanese did not reap significant benefits from it. The disparity between economic growth based on supplying goods for other consumer societies and the actual lifestyles of most Japanese was not lost on the general public, and became a source of tension, especially among the younger generation whose desires and expectations were being raised by a government intent on recovery.

Although the export-driven economy was growing rapidly, many Japanese were not yet able to afford the kinds of consumer goods, especially television, that were producing such profound social changes in the United States. Thus, the studios in Japan were not under the same immediate pressures as their counterparts in Hollywood, since the consumer base for films was still solid. All the same, the competition from other media was growing, and while it would take another decade for the economic impact of that competition to affect studio production, changes in style and subject matter in the films of the late 1950s reflect the emergence of a consumer society with its concomitant rise in expectations and frustrations.

Perhaps the most important example of the influence of changing tastes and desires on the film industry is the emergence of the film genre known as *taiyozoku*.[2] The word *taiyozoku*—literally, "sun tribe"—derived from the title of the 1956 Akutagawa Prize-winning novella, *Taiyo no kisetsu* (*Season of the Sun*) by Shintaro Ishihara, a writer who more than anyone caught the temper of that particular moment in Japan's postwar culture. Ishihara's story, which was made into a controversial hit film, deals not with dispossessed youth, but with privileged young people who lead amoral, hedonistic, and violent lives against the backdrop of some of Japan's toniest resort areas. The problem of youth culture, and the dislocations suffered by the younger generation around the world in the postwar era was a popular subject of novels and films; and the studios' willingness to exploit that problem as a subject for mass entertainment is an indication of the influences on the industry that arose from the effects of the so-called economic miracle.

Changes in the economy and in consumer tastes coincided with the growing internationalization of certain aspects of Japan's culture, especially its cinema. The recognition of Japanese cinema in the West, like the recognition of its vibrant literary culture, is primarily a product of the early Cold War period. A crucial factor behind this recognition was the emergence of a number of foreign scholars and artists who had the linguistic and cultural expertise to be able to make contemporary Japanese film and literature accessible to a Western (primarily English-speaking) audience. Motivations for introducing and promoting aspects of Japanese culture were undoubtedly rooted in an appreciation of the intrinsic worth of particular

works of art and scholarship. Nonetheless, the internationalization of Japanese culture took place in an environment created by the Cold War aims of the West, particularly the United States. Foremost of these was the rehabilitation of the reputation of Japanese culture to overcome the effects of wartime propaganda and to facilitate the move of Japan into the Western sphere of influence as not only a military and economic ally, but as an ally in the cultural conflicts that were raging against the Soviet Union. The international marketing of Japanese authors and directors at the time was no different in motivation from the efforts to present artists such as Jackson Pollock as icons of American freedom and creativity. Interestingly, in the case of Japanese cinema it was not the popular, albeit controversial, films of the *taiyozoku* genre that found a foreign audience. The *taiyozoku* films themselves presented their young characters as essentially foreign, that is, as decadently Americanized, an element that had little appeal overseas. Instead, the version of Japanese culture that travelled best was one that presented Japan as feudal romance through period dramas recounting the exploits of heroic samurai, or, in the case of stories set in contemporary times, as a culture struggling with the contradictions created by the remnants of that romance.

The internationalization of Japanese culture in the 1950s brought with it a cult of the auteur. And the emphasis placed on individual genius has deeply influenced the criticism of Japanese film and literature in both Japan and the West. At the heart of this conception of the director is a fundamental problem—the solitary vision of the artist-director was expressed within a form that is necessarily collaborative. Moreover, the business of cinema, which must account for current tastes in order to be viable, runs counter to the notion of the integrity of the artist. There was of course nothing new about this tension—it had been a fact of life for prewar Japanese directors, just as it had been for their Hollywood counterparts. Nevertheless, the changing economy of the film industry in the mid-1950s, and the perceived change in the status of directors, exacerbated issues of autonomy and integrity, echoing larger tensions in Japanese society that eventually found expression in the New Wave.[3]

Ichikawa's work in the mid-to-late 1950s suggests that he was keenly aware of these tensions. Certainly *A Full-Up Train* (*Man'in densha*, 1957), a satire on economic growth and displaced youth, is an effort to address the state of contemporary society. Still, the tensions of the era are apparent in deeper aspects of his filmmaking. By 1956 Ichikawa was senior enough to begin to have more control over his projects, and his prize that year at the Venice Film Festival for *Harp of Burma* (*Biruma no tategoto*) established his reputation and gave him more clout. Ichikawa belongs to one of the most interesting groups of filmmakers in Japan whose careers began after the war and who were products of the mature studio system. Though praised as an auteur, Ichikawa began as a craftsman who regularly did studio assignments that often did not appeal to him. A recurring struggle in

the 1950s was how to reconcile his view of himself as an artist with the constraints imposed on him by the studio production system.

Ichikawa was a product of the studio system, and for all his concerns over artistic integrity, his work has been consistently aimed at a commercial audience. For example, the same year that he made *Harp of Burma*, 1956, he also made *Punishment Room* (*Shokei no heya*), a *taiyozoku* film based on a story by Ishihara. The work was a commercial success, but like other films and stories of this genre it was highly controversial and made Ichikawa a target of severe criticism. Looking back on the period leading up to the filming of *Enjo*, it seems clear in retrospect that various, sometimes contradictory, motivations were guiding his approach to directing. And the tensions created by those competing motivations render the label "postwar humanist" inadequate as a description of Ichikawa. It would be just as misleading to see him merely as a transitional figure, but the fact that his emergence as a mature director coincided with an important transitional phase in the film industry must be acknowledged. *Enjo* reveals a sensibility shaped equally by the commercial instincts of a director who came of age in a studio system and by a powerful desire for artistic autonomy and integrity.

The complex motivations that inform Ichikawa's works have not escaped notice in critical assessments. Nagisa Oshima, for example, has criticized Ichikawa's tendency to approach filmmaking mainly from the viewpoint of a craftsman who does not have an overt political or aesthetic agenda to guide his work. Given Oshima's propensities, it is not surprising that he once described Ichikawa as "just an illustrator."[4] There is a degree of calculation in this assessment, for it emphasizes certain facts about Ichikawa's career—his early interest in animation and in Disney, and his perfectionism toward the composition of shots. It also points to the eclecticism of Ichikawa's choices of subject matter; and it is the willingness to play and experiment with the techniques of film narrative without an underlying aim or ideology that has irritated critics such as Oshima. Even so, it is the attention to technique, the willingness to play with the medium as a narrative form, that links Ichikawa to many New Wave directors, who profited from his experiments even as they rebelled against what they perceived as the apolitical products and atrophied aesthetics of mainstream cinema.[5] For that reason Oshima's remarks seem calculated to deny any debt or influence.

A different, more sympathetic view of Ichikawa—though a view no less driven by ideology and self-interest—is provided by Yukio Mishima in a preface he wrote to Ichikawa's and Wada's 1962 book, *Seijocho 271 banchi*. Mishima's relationship with Ichikawa and Wada of course grew out of their collaboration in adapting *Kinkakuji*, but from the time he was a young man Mishima had cultivated friendships in the theatrical world and the film industry. By the time he wrote his preface, Mishima had seen several of his novels turned into films and had himself written a number of film treatments. He was in fact closely enough connected to the film industry

that, in a rather bizarre turn, he was invited to play the role of yakuza boss in Yasuzo Masumura's 1960 gangster film, *Karakkaze yaro*, written by his acquaintance Ryuzo Kikushima.[6]

The title of this film—literally "Dry-wind Son-of-a-bitch"—denotes not only the kind of tough-guy role that Mishima idealized for himself (an ideal with homoerotic overtones), but also the dry, unsentimental aesthetic that underpinned his skepticism. This aesthetic, a kind of postwar equivalent of the detached worldliness embodied by the aesthetic term *iki*, underlies both the appeal of and the controversy surrounding *taiyozoku* films, in which values and traditional relationships were displaced by a sexually charged cult of the body.[7]

It is hardly surprising, then, that Mishima would see in Ichikawa a kindred spirit, and he praises Ichikawa precisely because his works embody the "dry" ideal. In his preface, Mishima states unequivocally that the director whose works he has seen the most is Ichikawa, and he pats himself on the back for having recognized that Ichikawa is one of Japan's most representative directors much earlier than most critics, who, Mishima claims, saw nothing beneath the surface of his films other than an "elusive charlatanism."[8] Mishima argues that the reason Ichikawa has not been fully understood and appreciated is that there is no director as capable of avoiding the sentimentalism that permeates earlier Japanese films. He asserts that Ichikawa's sensibility is "dry"—he uses the word "sec" in an analogy to dry wine—without a trace of "sweetness"—again the term he uses, *amakuchi*, refers to sweet wine or sake. Even in works where there is a kind of extreme sweetness—and here Mishima points to what he calls the "Poe-like sweetness" of the film *A Woman's Testament* (*Jokyo*, 1960)—that sweetness is filtered through Ichikawa's "intellectual, dry sensibility." Mishima concludes it is ironic that Ichikawa's films should be thought of as charlatanesque, when in fact "the true charlatanesque in Japan are the tear-jerkers."[9] Mishima ends his preface by praising the book for giving the viewer of Ichikawa's "sharp, transparent" films an honest glimpse into the struggles and dilemmas that confronted the director and his wife.

Mishima's assessment of Ichikawa is very different from Oshima's, but in its own way it is no less self-serving. More than most other Japanese artists in the 1950s, Mishima was anxious to secure for himself an international reputation as a serious artist, and his ambition drove him to be an enormously successful and prolific writer. Many of his early works lament what he perceived as the emptiness and sterility of life in Japan, and they are tinged with an erotic violence that borders on sensationalism. The sensational elements of his writing help to explain their appeal, but his instincts for commercial success left him open to the accusation that he was squandering his talents. Whatever the merits of that criticism, Mishima's skepticism went hand-in-hand with his sharp attacks on postwar Japanese culture; and yet throughout his life Mishima's dissatisfaction with his culture coexisted uneasily with his crass exploitation of it. Mishima was an artist in revolt

against the aesthetics of modern culture, but his struggle at times seems to lack seriousness of purpose and authenticity.

Although he was ten years younger than Ichikawa, Mishima made a name for himself with the publication of *Confessions of a Mask* (*Kamen no kokuhaku*) in 1949, and in 1956 he published *Kinkakuji*, the work that secured his critical reputation. Mishima based his story on the actual burning of the famous Zen structure in 1950 by a mentally disturbed young priest. The novel is wholly fictitious and set entirely in the mind of a young acolyte, Mizoguchi. Mizoguchi is a stutterer whose condition makes it hard for him to connect with the world around him. The weariness and impotence that always come over him as he contemplates the beauty of the pavilion are caused by his unceasing struggle to reconcile reality with his perception of it. He had hoped that the war would provide a way out of his predicament either through his death, or through the destruction of the Kinkakuji by American bombs. Because neither happened, he resolves to commit the nihilistic acts of arson and suicide in the hope that by destroying the barrier between his vision of beauty and the reality of the temple he will at last resolve his personal struggle.

In the build-up to the climax of the novel, Mizoguchi ponders the beauty of the temple one last time. That beauty has so enthralled him that it is now as much a product of his memory as it is the product of his direct experience of it. Therein lies the discovery of the true nature of the temple's beauty. Unable to make out the details of the building in the darkness of the night on which he sets the fire, he closes his eyes and relies on his own inner vision to determine what it is that has such a hold on him: "Through the power of memory, the details of beauty came sparkling one by one out of the darkness, and, as the sparkling diffused, at last the Kinkakuji gradually became visible beneath the light of a mysterious time that was neither day nor night. Never before had the Kinkakuji appeared to me in such a completely detailed form, glittering in every corner. It was as though I had gained the powers of vision of a blind man."[10]

By the end of Mizoguchi's account, beauty, which has been the key problem for him, is no longer connected to the real presence of the temple. The world of art and the world of experience are completely sundered for Mizoguchi, who is forced to create an architecture of the mind. And in that architecture he finds the beauty of each detail "filled with an uneasiness in itself. While dreaming of perfection, it was drawn toward the next beauty, the unknown beauty, never knowing completion. Foreshadowing was linked to foreshadowing, and each foreshadowing of beauty, *which did not exist here*, became, as it were, the theme of the Kinkakuji. Those foreshadowings were the signs of emptiness. Emptiness was the structure of this beauty. Thus, naturally the foreshadowings of emptiness were contained in the incompleteness of the details; and this delicate construction of fine timber, like a devotional necklace swaying in the breeze, was trembling in the foreshadowing of emptiness."[11] The nature of beauty is likened to the Buddhist notion of the empti-

ness of experience. The existence of beauty is not an absolute, but depends on the relationship of individual details, images, or memories. And the subjective ordering of those relationships in turn requires an acceptance of the relative, empty nature of aesthetic values. In Mizoguchi's twisted mind, however, this concept becomes a debased form of nihilism.

Mizoguchi's nihilism is double-edged. The emptiness he finds at the heart of the beauty of the pavilion is also at the heart of his own aesthetics. That recognition finally gives him a kind of power over the building, but it is a destructive power only. His decision to immolate himself along with the temple acknowledges that fact by suggesting that his own death is required to give his actions an aura of creative integrity and authenticity. Mizoguchi's failure to kill himself shows the limits of his nihilism and reveals that he is a false artist as superficial as the culture around him. His capacity to destroy the object he blames for reflecting his ugliness back at him makes him self-conscious and isolated. But his extreme self-consciousness causes him to lose nerve, and he is incapable of completing his vision of immolation. Having committed arson, he retreats to a nearby hill and watches the blaze, casually smoking a cigarette. By failing to extinguish his self, he fails to destroy the subjective, inner vision of the Kinkakuji that is the cause of his turmoil.

Kinkakuji is a disturbing psychological profile of a young man whose values become terribly distorted. The novel is also a powerful treatment of the debased culture that produced such a deeply troubled individual. The broad themes of the novel thus offered enormous potential for a director like Ichikawa, who shared with Mishima a critical, skeptical outlook toward postwar society. Though not nearly as self-absorbed an artist as Mishima, his decision to adapt *Kinkakuji* to the screen is understandable given his artistic interests.

Ichikawa was initially reluctant to undertake the project, since he believed that a film version of the book might turn into nothing more than a catalogue of scenes based on Mizoguchi's memories.[12] Indeed, the difficulties he and the writers, Wada and Keiji Hasebe, faced at the outset were considerable. First, the novel is a long interior monologue, a kind of confession in the first-person voice that takes us deep into Mizoguchi's psyche to reveal his inner life and motivations. Finding a visual language to convey that interior narrative was a daunting challenge.[13] Even when Mizoguchi interrupts his own narrative to present the views and words of others, the characters often speak in long orations rather than a natural pattern of speech (a stylistic trait that also marks some of Mishima's more successful plays, such as *Rokumeikan* or *Madame de Sade*). Second, Mishima's protagonist is not a sympathetic figure, and his nihilism is difficult to conceive in dramatic terms in a film narrative. Third, the novel presents several erotically charged scenes that, given the censorship codes of the day, were impossible to depict directly in the film.

There are elements of the book, however, that translate rather more easily to the medium of film. The episodic nature of Mizoguchi's memories, while they

lack an intrinsically dramatic structure, still provide a narrative centre for the film. More importantly, the setting itself, the pavilion in the temple grounds that is Mizoguchi's obsession, is a site that acts as a tangible projection of his psychological state. To that extent, Ichikawa had the foundation for a visual language, which he exploited brilliantly with his use of CinemaScope (the widescreen process is called DaieiScope in the credits) and deep focus photography. The exquisitely balanced, dispassionate architecture frames off each individual, simultaneously throwing into relief the states of mind of the various characters and underscoring the contrast between permanence and change—a contrast that constantly reinforces the film version of Mizoguchi's notion of beauty as something unchanging and incorruptible.

The emphasis placed on the architectural space of the temple as the crucial element in translating Mishima's narrative language to film is apparent from the very opening credits, which are superimposed over architectural drawings of the pavilion. These drawings are mathematical and abstract, suggesting, or foreshadowing, the notion that the beauty of the temple is also an abstraction, a product of the mind. At the same time the drawings also reveal the emptiness of the temple's beauty, not only by presenting them as imaginative designs, but also by reminding the audience of the arson that took place, and the subsequent reconstruction of the real Kinkakuji made possible by such drawings.

Two other elements at the beginning of the film emphasize the importance of architectural space to Ichikawa's conception of the story. One is the music of Toshiro Mayuzumi, which combines chanting with a discordant modernist score in order to aurally infuse the site of the story with a sense of foreboding and disturbance. The other element is the title itself. *Enjo* is a word that literally means "up in flames," but it also has a more specific usage, dating from Japan's medieval period, to refer to the burning of a temple. *Enjo* thus specifies a particular space, and thus the exact nature of Mizoguchi's crime. It should be noted that the title was changed out of deference to the wishes of the priests of the Kinkakuji. The official name of the temple in the film is the Soenji, and the pavilion is a national treasure called the Shukaku. Ichikawa nonetheless makes it clear that the Shukaku refers to the real pavilion in Kyoto when he slyly slips in a brief shot of an English-language pamphlet printed for foreign tourists that gives the name Shukakuji in Chinese characters, but the name "Temple of the Golden Pavilion" in English.

The film begins after the temple burns, and Ichikawa gets us to the primary narrative space by using the framing device of a police interrogation. This device permits an economical exposition that draws the viewer immediately into the story. The police read off the charges and list the facts they have gathered to a silent and sullen Mizoguchi, who is played throughout with tremendous skill by Raizo Ichikawa. However, this framing device also fundamentally changes the nature of

Mizoguchi's story. The police interrogation, which does not appear in the novel, effectively externalizes the narrative point of view. Because Mizoguchi is being looked at as the subject of an investigation, we do not initially share in his world view. Also, his story is now being told from the point of view of the structures and values of conventional morality. We are informed that he attempted suicide, and see the drugs and razor with which he planned to end his life. One of the interrogators mentions that a doctor thinks Mizoguchi has no serious mental problems, but the officers are frustrated by his absolute refusal to talk.

The film shifts to its primary narrative space, which is an extended flashback depicting Mizoguchi's life at the Soenji that takes up most of the film. He arrives as a student with a letter of introduction to Tayama Dosen, the head priest. Tayama was a friend of Mizoguchi's father, who has died of tuberculosis. After reading the letter Tayama reminisces, and agrees to the father's request to take Mizoguchi in as an acolyte. An assistant priest objects to the offer, thinking that Mizoguchi may become a potential successor to Tayama. Mizoguchi is asked to step out, and he goes to look at the Shukaku which he gazes at with a complex mix of wonder and longing.

In the opening sequence of Mizoguchi's life at the temple Ichikawa uses the austere, geometric patterns created by the temple and grounds to frame off all the activities of the priests. The widescreen format creates a sense of rigid placement of the individual characters within their environment that physically diminishes their presence in the picture frame. In their priestly roles and worldly desires, the characters are consistently subordinated to the presence of the temple.

The opening sequence of shots culminates in a scene where Mizoguchi is shown carrying a bag of rice. He attempts to give the rice to another acolyte, Tsurukawa, but Tsurukawa drops the bag and Mizoguchi scolds him for being stupid. These are the first words from his mouth, and we learn that he is a stutterer. The assistant priest states, "Oh, a stutterer. No wonder he never says anything," thus providing an answer to the question raised by the police. Mizoguchi, kneeling on the floor and trying to scoop up the spilled rice, is mortified and can sense everyone looking at him. The frames created by the temple's architecture emphasize Mizoguchi's utter isolation, and Ichikawa drives the point home first by a medium long shot of the scene, showing the shamed Mizoguchi as the object of everyone's gaze, and then by moving to a close-up of his agonized face, which is tightly framed by the room behind him and by the menacing authority figure of the assistant priest.

Mizoguchi's face is then highlighted by strong backlighting, which dissolves into the first of several secondary flashbacks that take us into Mizoguchi's mind and his past. Mizoguchi is sitting alone on the grounds of his middle school. He is being stared at by a group of classmates and a soldier, a graduate of the school who is back home on leave. The soldier comes over and asks him why he isn't with the

group, and a student makes fun of him by imitating his stutter. They all laugh, and the soldier tells him that if he joins the army they'll get the stutter out of him on the first day of training. Mizoguchi replies at once, without stuttering, that he will not join the army, that he is going to be a priest. His response deflects the boys' taunts, and so they ask the soldier to train at sumo with them. The young soldier disrobes and places his uniform and sword on the bench where Mizoguchi was sitting. While the others are playing, Mizoguchi secretly takes out a knife and disfigures the soldier's scabbard.

On the whole this flashback closely follows Mishima's story, though the erotic beauty of the young soldier's body is de-emphasized in the film. There is, however, a crucial change in the meaning of this memory for Mizoguchi. As the scene ends with a dissolve back to a close-up of Mizoguchi, his sweaty face conveys feelings of shame, guilt, and desperation as he tries to pick up the spilled rice. In the novel Mizoguchi reflects on his petty act of vandalism: "From what I have just said some people might come to the hasty judgment that I am a young man with the inclinations of a poet." He then assures the reader that he has never written a poem or anything else, because he had no ambition to outdo others by cultivating some ability. "In other words," he tells us, "I was too proud to be an artist."[14] The film's dissolve to a close-up, however, suggests not the disconnected, cold Mizoguchi of the novel but a young man suffering emotionally. Does the memory cause him guilt over disfiguring the sword, or shame at his stuttering, or does it merely remind him of his isolation, his inability to connect with the world around him?

It is difficult to read Mizoguchi's emotions, and we are snapped out of his memory and back into the space of the temple by the assistant's voice repeating, "What a terrible stutterer!" Mizoguchi realizes the implications of his handicap, and jumps up to assure the older priest that he never stutters when he recites sutras. But the assistant won't let go of his advantage and insists that a priest's role includes duties that Mizoguchi's stuttering will interfere with. As the assistant speaks, Ichikawa presents a tight close-up of his face, which is framed by the entrance to a hallway. In the distance we see the head priest looking at the scene. He seems to be concerned, but his emotions are also difficult to interpret and we are left with the sense of a man who has a distant, enigmatic relationship with the life of the temple: a relationship that explicitly foreshadows his troubled relationship with Mizoguchi.

The opening section of the film, which reveals the pain, shame, and guilt Mizoguchi feels about his stuttering, his isolation, and his disturbing actions, presents on the whole a more sympathetic view of him than Mishima's novel. The sequence of scenes that follow reinforces the note of sympathy Ichikawa introduces into the story by suggesting that Mizoguchi is also surrounded by adult hypocrisy. This is shown first when the head priest Tayama notices a beggar at the

front gate. He intends to ignore the man, but when he catches sight of Mizoguchi raking the temple grounds he pulls out his purse at once and gives the man a coin. Even as he tells the man to use the back gate from now on, he makes a grand show of his generosity. Continuing the charade, he calls Mizoguchi over, talks fondly of the young man's father, and exhorts him to remember that all who come to the temple could be the Buddha. Tayama's petty hypocrisy, played to wonderful effect by the veteran actor Ganjiro Nakamura, initially fools Mizoguchi, who looks at the older priest with the same rapt expression he had looking at the Shukaku earlier—an expression accompanied in both cases by dreamy, tinkling music, providing a unifying audio element.

The film cuts suddenly to the scene of a house being pulled down, then cuts to a close-up of a mother with a baby on her back watching the demolition. The woman wears a headband that reads *hisshi*, "to the death," and as the dust from the rubble of the demolished house swirls around and obscures her face the outside turbulent world of wartime Japan is thrust into the world of the temple.

The war is a constant presence throughout Mishima's novel, but it is there because of Mizoguchi's internal reflections about it. Ichikawa was thus challenged to look for ways to bring the war to bear on the film without shifting the focus away from Mizoguchi's state of mind. The shots of the demolished house and the mother's headband give a clear visual point of reference that establishes the time of the film's action, and it provides a bridge to the next section of the film, which shows how Mizoguchi's past, in the figure of his grasping mother, impinges on his life in the temple.

The expanded role of Mizoguchi's mother in the story is a major departure from Mishima's novel, but given the need to find an external, visual language to convey the interiority of the novel, it is a necessary change. The mother becomes a foil for her son and a personification of the pressures that are building inside him. The actress Tanie Kitabayashi plays the mother as a passive-aggressive character, and her sly performance is a counterpoint to the hypocrisy of Tayama. She appears at the temple one day and chats with the head priest about the war. When Mizoguchi returns from school he is visibly annoyed and walks past her without a word. Embarrassed, the mother laughs and says he's "a self-centred child." She then reveals that she has brought the funeral tablet of her deceased husband and asks the head priest to say prayers for her.

There is a brief comic interlude as the film cuts to the empty entranceway. Air raid sirens are heard and the assistant rushes in, obviously frightened. The temple cook is amused, and the assistant priest, obviously shamed by his own cowardice, scolds him for looking. This interlude brings the war directly into the temple and reinforces the hypocrisy of the priests, but its main function is to set up in dramatic terms the crucial scenes that follow. The film cuts at once to Mizoguchi's room, where he is talking with his fellow acolyte, Tsurukawa. They talk about their

unhappy relations with their parents, and Tsurukawa reveals that he is afraid of his father. He then speculates that Mizoguchi is lonely because of his grief over the death of his father. Mizoguchi tries to correct this misinterpretation by talking about his stuttering, but Tsurukawa assures him that he doesn't care about that. Mizoguchi abruptly ends the conversation by saying that he must go clean the Shukaku.

A series of shots of the pavilion—in the distance, mid-distance, and interior—give us the first close look at the national treasure. Mizoguchi is cleaning the floor, and he looks up when air raid sirens sound. His mother runs in a panic to get him, and even though he tells her to go back she drags him to a bomb shelter. Inside the shelter she tells him that she did not come just to have the head priest read sutras for Mizoguchi's father. It turns out that the father's temple in Maizuru, which Mizoguchi would have inherited, has been lost because of debts accumulated during the father's long illness. The camera closes on Mizoguchi's shocked expression, and again Ichikawa uses strong back lighting to initiate a dissolve to a memory flashback. We see the same shocked expression as a younger Mizoguchi witnesses his mother having sex with another man. Suddenly his father's hand appears and covers his eyes. The father leads his son out to the temple grounds. The mother stumbles after them, but stops and breaks down. Her lover, who remains in the background, comforts her. Mizoguchi and his father go down to a promontory overlooking the ocean. The father tells him not to say anything about what he saw, then promises to take him to see the Shukaku in the near future. He says that there is nothing in the world as beautiful as the Shukaku, and that when he thinks about the pavilion he is able to forget the sordidness of the world. The father collapses in a fit of coughing, and as Mizoguchi tries to help him he looks back at his family's temple. The scene dissolves back to the bomb shelter.

Mizoguchi scolds his mother for losing the temple, but she refuses to accept the blame. She urges him to ingratiate himself with the head priest and become his heir, but he resists, saying he doesn't understand her, and that he'll probably be drafted and die in the war anyway. She calls him a fool, reminding him that the army won't take a stutterer. Mizoguchi, who is now very upset, runs out of the shelter saying that he would be happy to die in an air raid inside the Shukaku. Ichikawa is able to use the troubled relationship between mother and son as a way to represent one of the key elements of Mishima's novel, which is Mizoguchi's destructive association with the pavilion. We see Mizoguchi running to the Shukaku, then get a close-up of him looking at the building with the same reverential expression, accompanied by the same musical motif as before. Another brief memory flashback shows Mizoguchi in the same spot looking at the Shukaku with his father, who is explaining the history and architectural style of the building. The film cuts back to show Mizoguchi running into the pavilion; and his emotional and psychological states, which have been gradually delineated for us,

are condensed to a single image of him crying, his figure framed and diminished by the doorway.

The story jumps to a time right after the war. Soldiers are getting off a bus in front of the temple, and we learn in the next scene that they are tourists, when the assistant priest talks to an official about the business of turning the temple into a tourist site (and shows him the English-language pamphlet). The official tells him that his big days will be the "weekend," but he has to explain to the assistant priest that the word means Saturday and Sunday. This brief exchange cleverly summarizes not only the enormity of the changes that will overtake the temple, but also the debasement by commercial interests of religious institutions and cultural artifacts. Ichikawa's treatment thus neatly dovetails with Mishima's novel. However, in the scenes that immediately follow, the film departs radically from the book.

Mizoguchi is at the Shukaku watching a Japanese woman and a GI arguing in the garden. The woman slaps the GI, and runs toward the pavilion. The soldier yells to her that she must get rid of the kid, that is, have an abortion. As the woman tries to go inside Mizoguchi stops her, saying that she must not harm the temple. They struggle, and she falls off the steps. Her accident causes a miscarriage, and Mizoguchi, who is horrified, tries to help her. The GI stops him, however, thanks him for causing the miscarriage, and leaves him with two cartons of cigarettes. Mizoguchi gives the cigarettes to Tayama and tries to explain what happened, but the head priest is so happy to get the cigarettes that he does not give Mizoguchi a chance to talk. Instead, he tells Mizoguchi that he will soon enter college and exhorts him to study hard. Tayama then gets out his books and abacus.

Up to this point the film has presented a more sympathetic view of Mizoguchi than the book, though the overall characterization is basically the same. Ichikawa's version of the scene with the GI and his pregnant lover, however, fundamentally changes Mishima's conception of the character. In the novel the miscarriage is not caused by an accident. The cruel GI tells Mizoguchi to step on the woman's stomach, and Mizoguchi's reaction when he complies with the command is shocking: "The sense of discord I felt when I first stepped on her changed to an exhilaration that welled up inside me. So this is a woman's stomach, I thought, and this is her breast."[15] The joy he feels at his own cruelty is mixed with sexual excitement; and he compounds this sick thrill by deciding to engage in a "delightful exercise in hypocrisy" by giving the cigarettes to the head priest, who would remain ignorant of their true meaning.

Mishima's book gives us a frightening portrait, but Ichikawa, Wada, and Hasebe obviously felt that if they were absolutely faithful to that portrait they would likely muddle the delineation of Mizoguchi's personality, making the film harder to follow and potentially off-putting. Since they collaborated with Mishima on the script, and since he was familiar with filmmaking, it is probable that he understood their concerns. So the incident is turned into an accident, and Mizoguchi, who

wants to tell the truth, is misunderstood and given no chance to explain his actions or reveal his honest intentions. Ichikawa thus generalizes Mizoguchi's anguish; he makes it accessible, in a sense, by turning the motive for Mizoguchi's actions into a desire to protect the pavilion against defilement—a change in the story that resonates with the film's depiction of the corruption of Japanese culture in the face of foreign influence and the new consumer society.[16]

The next scene begins with a telephoto shot of Mizoguchi and Tsurukawa high on the veranda of a different temple, the Nanzenji. Mizoguchi asks why the head priest seems displeased with him, and Tsurukawa tells him that the prostitute who suffered the miscarriage came to the temple demanding money. Mizoguchi tells his side of the story, and Tsurukawa urges him to apologize right away and offers his help. At that moment they see a beautiful woman in a kimono sitting in a room below, in front of a traditional flower arrangement. The shot substitutes for a more erotic scene in Mishima's novel, but it serves two purposes here: to suggest, in rather muted terms, the sexual longings of the young men; and to foreshadow the introduction of the character Kashiwagi.

When Mizoguchi returns home he finds that his mother has returned and intends to move into the temple. He then learns that Tsurukawa has been called back to his family in Tokyo, and will not be able to help him. After seeing Tsurukawa off, Mizoguchi tries to apologize to Tayama but is rebuffed by the older priest. At this crucial moment of uncertainty the film cuts to Kashiwagi, a student whose clubfeet prevent him from walking normally. He is bitter, cynical, and nihilistic, but his powers of observation are acute and he seems to be able to see right through Mizoguchi, who because of his problems has been skipping classes recently. Kashiwagi is one of Mishima's most vivid creations, and his cruelty and menacing presence are captured extremely well in Tatsuya Nakadai's bravura performance. Kashiwagi is the worst possible companion for Mizoguchi. A young man who preys on the weakness of others, especially their sympathy for him, he scoffs at Mizoguchi's reverence for the pavilion. When Mizoguchi explains that the beauty of the building lies in the fact that it never changes, Kashiwagi is the one who points out that it could burn down anytime.

When we return to the temple we learn that Tsurukawa has died, and with his death Mizoguchi's isolation is complete. He has a terrible argument with his mother in which she tries to make him feel guilty and he responds by telling her he knows of her affair. He walks out, and ends up wandering through the entertainment district of the city. He runs into the head priest, who is with a woman, and Tayama calls him a fool for following him. Ichikawa then presents two scenes that comment on the head priest's affair. The first is a brief conversation between Tayama and the assistant priest during which Tayama expresses doubts about his fitness to be head priest. He mentions Mizoguchi, and, in another foreshadowing moment, expresses his worries about being able to protect the temple. The second

is a conversation between Mizoguchi and Kashiwagi about the head priest. Mizoguchi says that Tayama has changed, but Kashiwagi dismisses that as foolishness, claiming that everyone is hypocritical. The juxtaposition of these scenes creates some sympathy for Tayama, while giving us an insight into the degree of Mizoguchi's alienation. Mizoguchi is vulnerable and Kashiwagi has no compunctions about trying to tempt him. He lets Mizoguchi witness his manipulation of a young woman for his own perverse gratification; and in an effort to lead him further astray he presents Mizoguchi with an alternative to the beauty of the Shukaku by giving him a *shakuhachi* (a traditional flute). Significantly, the beauty of Kashiwagi's playing elicits from Mizoguchi the same rapt expression as the beauty of the Shukaku.

On his way home from Kashiwagi's room that night, Mizoguchi stops by a geisha house and obtains a photograph of the head priest's lover. The next morning he puts the photograph in Tayama's newspaper. That night the head priest gives a lecture on the Nansen koan. This Zen riddle tells the story of a Chinese priest, Nansen. One day the priests in Nansen's temple discovered a kitten, and the animal became an object of dispute between the East Hall and the West Hall. Seeing the argument between the two groups, Nansen grabbed the kitten and told the priests that if anyone could say why the kitten should be saved, it would be saved. When no one answered he killed the animal. The next day Nansen's chief disciple, Joshu, returns and when Nansen asks him what should have been done Joshu puts his dirty shoes on his head and leaves the room. Nansen then laments that if Joshu had been present the kitten would have been spared.

This riddle appears twice in the novel. It is told on the day of Japan's surrender by the head priest, who gives the standard interpretation: that while Nansen's action illustrated the way to kill the illusion of the self and thus end discord, Joshu's action was an illustration of humility and selflessness that would have spared the kitten. The riddle is repeated later in the novel by Kashiwagi, who gives it a twisted reading as illustrating the evil of beauty (the kitten, in this case, representing the concept of beauty).

The film recasts the riddle, suggesting the head priest's knowingness in presenting a sermon on forgiveness and magnanimity. The lesson is not lost on Mizoguchi, who visibly fidgets and coughs during the sermon. Hurrying back to his room he finds the photograph has been secretly returned to him. Tearing up the picture, he goes back to see Tayama, who is meditating before an altar. Tayama says that he had intended to make him his successor, but has changed his mind. Mizoguchi says that he is lying, that he never had such an intention, but Tayama calls him a fool and says that he knows all about Mizoguchi. When Mizoguchi retorts that he knows all about him as well, Tayama drives home the point of his sermon by telling the young man that if he knows and doesn't understand it is the same as not knowing.

This moment is, in terms of Mizoguchi's motivations, the turning point of the film. Tayama goes back to his meditation and Mizoguchi is utterly defeated. The next day we see Mizoguchi buying the sleeping pills and razor that the police brought out at the beginning of the film. He then goes to borrow money from Kashiwagi, who suspects that he is suicidal. Mizoguchi assures him the money is for a trip back to his home village. Kashiwagi is skeptical, but lends him the money, forcing him to sign a note for it. He then makes Mizoguchi play the *shakuhachi*. When Mizoguchi plays beautifully, Kashiwagi is disappointed and in an act of extreme cruelty claims that he only gave him the flute because he wanted to hear it played by someone with a stutter.

The film cuts to the promontory near Mizoguchi's family temple. Mizoguchi takes out the drugs and razor, but does nothing with them. He walks back toward the temple. As he gazes intently at the gate, a memory flashback to his father's funeral and cremation by the ocean culminates in a shot of the flames of the pyre, an ominous foreshadowing image that dissolves back to Mizoguchi's intent face.

Mizoguchi stays for several days alone in a room at a boarding-house, and his odd behaviour alarms the proprietress, who calls the police. Mizoguchi is sent home and has a final falling out with his mother. His troubles are compounded when Kashiwagi shows up and demands repayment of the loan. Tayama pays off the loan without the interest, but warns Mizoguchi that he will not have another chance.

In despair, Mizoguchi tries to reach out to others one last time. He goes to Kashiwagi's room to apologize and pay him the interest he owes. When he arrives he finds Kashiwagi with the woman he had seen from the veranda of the Nanzenji. The woman is teaching Kashiwagi flower arrangement, and it is clear that they have an intimate, tempestuous relationship. Kashiwagi becomes friendlier and says he envies the soft life awaiting Mizoguchi, who will be able to live off the proceeds of a national treasure. Mizoguchi insists that Kashiwagi doesn't understand, and explains once more that the beauty of the Shukaku lies in the fact that it is unchanging. Kashiwagi again mocks this, and when he and the woman get into a violent argument Mizoguchi leaves. He seeks out a prostitute, but his profound alienation, which comes across to the woman as a kind of feckless innocence, blocks him from establishing any meaningful connection with her and he leaves without having sex.

He returns to the temple to find the head priest entertaining an important guest, the head priest of another temple. When Tayama is called out by a phone call from his lover, who we learn is pregnant, Mizoguchi asks the guest what he thinks of him: Is he just a mediocre student? Can the priest see his thoughts? The guest just laughs and tells him it is best not to think. Mizoguchi abruptly walks out and goes to the Shukaku, which he addresses directly for the first time: "Is there no

one who will understand me? No one understands. There's only one thing I can do. No one understands, do they?" At that moment Tayama, who has been praying at the Shukaku, spies the acolyte in the garden. Mizoguchi yells at Tayama for following him and runs away. But he returns later that night with all his belongings and sets the fire. Tayama and the other priests try to save the building, but by the time they arrive it is engulfed in flames—a sign, Tayama believes, of the judgement of Buddha. In the meantime Mizoguchi, who intended to die in the pavilion, cannot stand the smoke and heat and escapes up a hillside behind the temple compound. He collapses, watching the flames, becoming enraptured by their beauty.

Mishima's novel ends at this moment. Mizoguchi takes out a pack of cigarettes: "Feeling like a man who is having a smoke after finishing a task, I thought that I might as well live."[17] Given the way the film reconceived the character of Mizoguchi, however, such a chillingly nihilistic ending makes no sense. The primary flashback ends and we are back at the police station. The police press him to confess, to be reborn as a human being, but Mizoguchi remains silent.

The story cuts to the burnt ruins of the pavilion, where Mizoguchi silently acknowledges his guilt. Staring into the pond, he sees a pristine reflection of the untouched building, but when he looks up he is horrified by the ruins and shuts his eyes. The beauty of the temple has become wholly his now, which is to say absolutely abstract, and he is no longer able to live with that fact. In a brief dénouement the film cuts to a train station. Mizoguchi is being escorted to a prison in Tokyo. People stare and talk about him, and in a final major departure from Mishima's novel, Mizoguchi tries to escape and is killed when he jumps from the train. It is not absolutely clear if he has intended to kill himself, though that is the strong implication of the scene, but the effect of his death is to turn him into a victim and thus make him a more sympathetic, and authentic, figure than the Mizoguchi of the novel. The final shot of the film shows police and a doctor walking toward his body, which is covered with a straw mat—a striking image that completes the dramatic structure of the film by reasserting the social order and the authority of conventional morality.

In the process of translating Mishima's novel to the screen, Ichikawa ends up creating a very different type of narrative. This does not in any way imply a criticism of the film, and the intent of my reading is neither to point out simply the differences between the works, which is a rather pointless exercise, nor to privilege the source novel as a work of art. Instead, by noting the changes the original story underwent in the course of adaptation I believe we get a better understanding of Ichikawa's conception of the narrative *as film*. Reading the film in this manner emphasizes its special qualities, and renders the particular historical context that shaped the process of adaptation more vividly apparent.

Certainly Ichikawa shared with Mishima a critical view of postwar Japanese society; and like Mishima he was motivated at a particular historical moment by

growing tensions in a society that was recovering from the war but still deeply wounded by the experience. Mishima's novel captured the ambivalence of the time with a finely wrought depiction of a disturbed mind. Ichikawa's interpretation retells that story through conventional film techniques, but *Enjo* goes beyond the cinematic conventions of the time by its experimental play with widescreen format and with elements of *taiyozoku* film—in particular the recurring story about cruel youth that indicated underlying dislocations in Japan in the late 1950s. The film grounds itself on Ichikawa's mastery of film narrative and on the psychological depth of the novel, but its achievement lies in its success at exploding the bounds of the *taiyozoku* genre to create a sympathetic and serious portrait of a deeply troubled young man. *Enjo* is an adaptation that in turn became a source work—a film that thematically and visually anticipates the work of directors such as Oshima, Teshigahara, and Shinoda in the 1960s.

Notes

1. Audie Bock, *Japanese Film Directors* (Tokyo: Kodansha International, 1978), 228.
2. For a more complete discussion of the phenomenon of the *taiyozoku* film, see Michael Raine, "Ishihara Yujiro: Youth, Celebrity, and the Male Body in Late-1950s Japan," in *Word and Image in Japanese Cinema*, eds. Dennis Washburn and Carole Cavanaugh, (New York: Cambridge University Press, 2001), 204–209.
3. David Desser, *Eros plus Massacre: An Introduction to the Japanese New Wave Cinema* (Bloomington: Indiana University Press, 1988), 4–10.
4. Bock, *Japanese Film Directors*, 220.
5. Desser, *Eros plus Massacre*, 41–42.
6. Mishima wrote a number of brief essays about his experience, including "Eiga shoshutsuen no ki" (A Record of My Debut in Motion Pictures). See *Mishima Yukio zenshu* (The Complete Works of Yukio Mishima) (Tokyo: Shinchosha, 1973–1976), vol. 29: 492–94.
7. Raine, "Ishihara Yujiro," 216–18.
8. *Mishima Yukio zenshu,* vol. 30, 250. The translation is mine.
9. Ibid., 250.
10. *Mishima Yukio zenshu*, vol. 10, 265.
11. Ibid., 267.
12. Kon Ichikawa and Natto Wada, *Seijocho 271 banchi* (Tokyo: Shirakaba Shobo, 1962), 45.
13. Keiko McDonald has explored in depth the difficulties the novel presents in her analysis of Yoichi Takabayashi's 1976 adaptation of the story. See Keiko I. McDonald, *From Book to Screen: Modern Japanese Literature in Film* (Armonk, N.Y.: M. E. Sharpe, 2000), 287–311.

14. *Mishima Yukio zenshu*, vol. 10, 15
15. Ibid., 86.
16. Bock, *Japanese Film Directors*, 229.
17. *Mishima Yukio zenshu,* vol. 10, 274

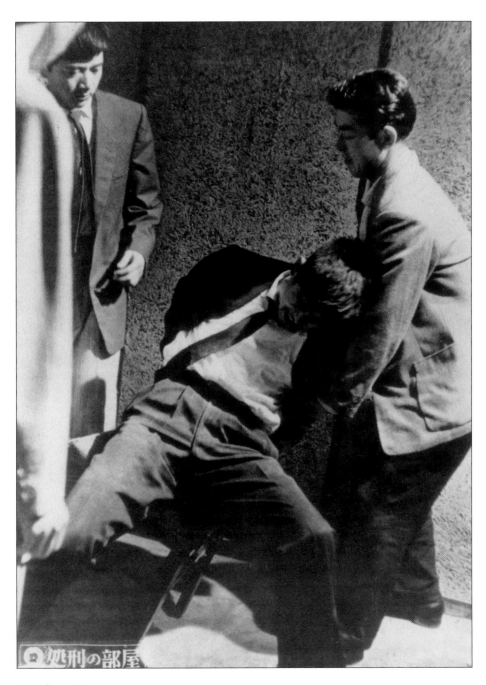

Punishment Room

MICHAEL RAINE

Contemporary Japan as Punishment Room in Kon Ichikawa's *Shokei no heya*

Forty-four years before Kinji Fukasaku's *Battle Royale* (2000) was attacked in the Japanese parliament for its violence and deleterious influence on youth, Kon Ichikawa's *taiyozoku*[1] film *Punishment Room* (*Shokei no heya*, 1956) faced similar criticisms all over Japan. In the summer of 1956 PTA groups and "housewives associations" picketed cinemas to prevent students entering, while the Minister of Education declared that contemporary youth "has *taiyozoku* tendencies. These must be removed!" Youth violence, like schoolgirl sexuality and the power of the mass media, are hardly novel objects of societal concern, but I think there is more at stake in *Punishment Room*. A closer look back at the film and its reception reveals that this pilloried adaptation of a mediocre novella marked a shift in the history of Japanese film style.

Ichikawa's first assignment after arriving at Daiei was an adaptation of hot new novelist Shintaro Ishihara's *Punishment Room*. Ironically, Ichikawa had left Nikkatsu when it shifted from a policy of literary adaptation (for example Ichikawa's *Kokoro*, based on the novel by Soseki Natsume[2]) to a youth exploitation slate spearheaded by adaptations of Ishihara's novels. By all accounts, *Punishment Room* is a minor work, produced quickly and cheaply to cash in on a sudden boom. Yasuzo Masumura reports that production was plagued with battles between Ichikawa and his staff and claims, "whether or not it was a criticism of the *taiyozoku*, whether it showed approval or disapproval of Ishihara's novel, was left unclear. The film simply followed the novel's action and plot line." A brief comparison of book and film reveals that this is simply untrue: while the film attempts to construct a sociological framework to motivate the protagonist's romantic nihilism, it is also parodies the only figure of identification in the novel, leaving the viewer adrift in an absurd and

violent world. It is that sense of impasse that is new in Japanese film. Most mainstream studio productions and leftist films of the "independent production" movement alike insisted on moral epiphany: by the end of the film characters would be wiser if not happier and the moral hierarchy clear if not righted. Ichikawa's insistence on impasse connects *Punishment Room* to later changes in the youth film genre, connected in turn to changes in film criticism and popular culture, out of which came Nagisa Oshima and the "Shochiku *nouvelle vague*."

Although not well served by auteur criticism—his output seems too varied, his "world view" too obscure—Ichikawa's films, as many critics have acknowledged, often discard ordinary realism in search of visual correlatives for their topical concerns. From the *manga*-like distortion of Yunosuke Ito's hangdog face in *Pu-san* (1953) to the speeded-up motion and superimpositions of *A Billionaire* (*Okuman choja*, 1954) that diagram the tax clerk's (Isao Kimura) inability to escape the nuclear bomb being built by the tenant (Yoshiko Kuga), Ichikawa has never shrunk from stylistic excess. Masumura may be correct that Ichikawa lacked the education to produce a thematically dense, original work of fiction yet it is precisely the violent emptiness of Ishihara's novella that, despite scriptwriter Natto Wada's sociological contextualization, allows Ichikawa to find in this tawdry tale of drugged rape and gang beating an excuse for *mise en scène*, drawing out all that is perverse and nihilistic in the story while mocking Ishihara's romantic anger. For all the attacks on Ishihara's moral irresponsibility he was, as his subsequent incarnation as a right-wing politician and current governor of Tokyo indicates, something of a moralist. Indeed, once the backlash against the *taiyozoku* started, Ishihara claimed that he had nothing in common with these delinquent youths, but was instead writing a social critique, albeit in a Hemingwayesque style that, he said, was itself a form of cinematic perception. Ichikawa, like Oshima, was looking for something else: an image of the impasse created by the uncoupling of economic and political liberalization in postwar Japan. Many of Ichikawa's 1950s films aspire to that moment of absurd impasse: for example, the endless cycle of graduating students without a future in *A Full-Up Train* (*Man'in densha*, 1957) or the atom bomb, waiting to explode at the end of *A Billionaire*.

In *Punishment Room*, crowd shots at a spring college baseball game behind the titles announce that the film will be about a new generation: not dutiful and poor students studying to "rise up and get ahead in the world" but a raucous mass, dedicated to hedonism and bodily display. The documentary-like disjointed montage juxtaposes the distinctive faces of a relatively well-fed rising cohort with the more wizened figures of a few older spectators, and then cuts to the supporters' groups, cheering and swaying in unison. As Tadao Sato points out, this sequence is no simple paean to robust adolescence: in the midst of the chaotic festivity the camera picks out the ambivalent expression of a solitary face in the crowd (fig. 1). Cut in among the already disjointed opening images, it strikes a strangely dissonant note.

Perhaps the shot is Ichikawa's way of linking the documentary montage form to his narrative proper: the opening shots are repeated midway through the film and followed by the mass celebration in nearby Shinjuku, then beginning to replace the Ginza as the centre of Tokyo's youth culture. As in the opening sequences, Ichikawa alternates crowd shots with cutaways to drunken participants (fig. 2) and scandalized spectators before allowing us to recognize the lone figure of Katsumi, our protagonist, refusing to join the motion of the crowd. This alienation motivates the central event of the film—and the tagline of its advertisements—Katsumi's drugging and rape of Akiko, a co-ed he met in an economics seminar. Ishihara then claims that Akiko falls in love with Katsumi, only to be dumped by him and then taunted into taking her revenge when Katsumi is tortured by rival gang members with whom he had formed an abortive alliance.

If the narrative is sordid, characterization provides no relief: Hiroshi Kawaguchi, a notorious *taiyozoku* playboy, plays Katsumi in an aggressive style almost Brechtian in its rigidity. Katsumi's vehemence, his fixed stare and "in your face" attitude transgress appropriate social distance and leave friends wiping spittle from their faces and—in a memorable montage sequence—professors prostrate on the sidewalk. Kawaguchi's woodenness matches Ichikawa's antipathy to emotionally expressive performance. In the classroom discussing Weber, he is left in mid-sentence, posed in foreground profile as the class dissolves around him (fig. 3), a motif that will be repeated several times in the film. Rather than ask his actor to express an emotion, Ichikawa uses him as a prop, making significant the contrast between Katsumi's intense fixity and the indifference of the crowd. In classroom, coffee shop, and drunk in the street, scenes end on young faces stuck in poses of blank impasse as they find themselves unable to act. Only Ayako Wakao as Akiko complicates the picture. Familiar already as the most innocent of the wayward girls in Daiei's "Teenage Sex Code" series, Wakao's passionate refusal to be a victim carries us through Ishihara's implausible characterization as a co-ed who falls in love with her masterful rapist to make us feel the price she pays for his nihilistic behaviour.[3] In this film, close-ups of the main characters are almost always grotesquely unflattering (fig. 4) but they work much more subtly for Wakao's flickering gaze and the hurt she reveals when Katsumi suddenly rejects her, then peers curiously at her face as if to measure by her expression how much pain he has caused (fig. 5). If Ichikawa in *Punishment Room* undermines even Ishihara's heroic romanticism, the author's sympathy for Katsumi's predicament, perhaps Wakao restores to the film a sense of what the director's nihilism destroys.

Technique gains salience over narrative and performance in many of Ichikawa's films. As Masumura argues in this collection, Kon Ichikawa was one of the few visual stylists in postwar cinema. In *Punishment Room* he disrupts the visual and aural surface of the film, challenging the audience with bursts of unanchored noise and raucous jazz music, just as his visual compositions create images of conflict that

inform the narrative situation itself. For example, the first shot of Katsumi's father contrasts the wild crowd noises of the credit sequence with a silent shot of his small and vulnerable figure in a midsummer farm landscape, before cutting to a close-up of his bandaged elbow.[4] Instead of the typical library recording of summer insects, this bucolic scene fades in discordant music, anticipating the narrative detail that the local businessman is more interested in the new youth magnet of Shinjuku than in his local area. The opening sequence undermines the moral superiority of peripheral over metropolitan areas seen in earlier films that dealt with youth and sexuality such as Senkichi Taniguchi's *Shiosai* (1954), based on a Mishima novel. Instead, provincials are desperate to become metropolitan, just as Katsumi's father impatiently urges his brother-in-law to sell the family land to a developer. The first scene between father and son inverts the expected generational hierarchy. A somewhat low camera position and a wider than normal lens ensure that the black figures of the students in the foreground will dominate the slight frame of the older man as they extort money from him (fig. 6). Students are an autonomous, almost military, force in this film, filling the frame with their dark uniforms and driving other customers from public spaces like the coffee shop. In a decade in which the student population quadrupled—a necessary condition for the development of the 1960s "underground"—delinquent students were popularly known as *kinbotan no yakuza*: gangsters with college insignia.

The visual surface of *Punishment Room* abounds with dislocations that must have traumatized the studio-trained Daiei crew. The shots from the car with their blurred and rapid, albeit rear-projected, travelling shots turn the vehicle into a dislocated perception machine (fig. 7), like the helicopter that suddenly introduces its own striking perspective on the city (fig. 8). The helicopter shot became an index of the new directors' attempts to break out of standard studio *découpage*, most notably one of the few other *taiyozoku* films of 1956, Ko Nakahira's *Crazed Fruit* (*Kurutta kajitsu*). When Katsumi pours Akiko's beer after slipping her the sleeping powder, the bottle extends unsteadily past the plane of the camera in an expressionist distortion that dissolves to an image of what the bottle contains—a near-comatose co-ed (fig. 9).

Even when the device itself is routine it can be estranged by repetition as in the intense sequence of reverse shots that link Katsumi and Akiko at the rugby field. This persistent use of quasi-point of view links desire with an aggression contained within the gaze. Point of view in the cinema is insistently personal: a protestant, direct form of communication opposed to the subtle and generalized working of social power common to older Japanese films. The other is literally "up for grabs" in this film; free of the power of *seken* (society; the opinion of others) that dominates famous renunciatory melodramas of the 1950s such as Hideo Ohba's *What Is Your Name?* (*Kimi no nawa*, 1953–54) and Mikio Naruse's *Floating Clouds* (*Ukigumo*, 1955). The repetitive descriptions of point of view in Ishihara's novels would lead

one to think that he believes this argument, but it's hard not to see this scene as a parody of the sweaty masculinity that Ishihara the sportsman thinks is so attractive to Akiko. When his girlfriend arrives, sultry saxophone music starts up on the soundtrack and Katsumi sniffs at his sweaty rugby shirt, grimaces, and then walks topless toward Akiko. After the exchange of loaded gazes, the last shot of the sequence shows them walking past a row of cherry trees in bloom—a parody of traditional romantic imagery absent from the novella.

Lighting in *Punishment Room* also ignores familiar cinematic resources. The film borrows its high-contrast lighting scheme not from the shadows of Naruse's traditional Japanese house but from the harshness of the new fluorescent lights that illuminated the tawdry dwellings of Japan's striving lower middle class. That space is made to seem all the more crowded by setting conversation scenes in depth, filling the image with heads in separate planes and leaving no breathing room (fig. 10). Against these dark spaces of disease and disappointment (added by scriptwriter Natto Wada) the film juxtaposes the space of the dance party: filled with light, American jazz, and illicit sexual viewpoints (fig. 11). The film works to produce a kind of paradox: at home the characters are contained in a cramped location but kept apart in the image (fig. 12), whereas the two dance halls we see are both capacious and overflowing with bodies interlinked by dance. The "Americanization" that conservative critics found so threatening to Japan's "post-postwar" polity is the only ground of intersubjectivity in the film, while resentment and alienation characterize family life.

The scene in the classroom is also the filmmakers' invention, Wada's attempt to give sociological motivation to the rape that in Ishihara's novella is merely another index of the central character's angry nihilism. It's no accident that the students are debating the value of Weber's social theory. In a recapitulation of the postwar *shutaisei* (subjectivity) debate between economistic Marxists and leftists influenced by existential philosophy, Yoshimura the bookish leftist insists that a purely economic analysis is sufficient while Akiko insists on the importance of *seishin bunka* (spiritual/mental culture). Suddenly interested, Katsumi agrees but his earnest declaration that contemporary youth must find their identities through a process of trial and error is cut short by his teacher, who is less interested in encouraging debate than in meeting with his publishers. Katsumi's subsequent rape of Akiko then becomes not just an attempt to put her in her place (as the novella's omniscient narrator tells us) but an act of aggression against the only person who seems to share his view of the predicament of contemporary youth.

Despite the film's title, the rape scene featured at least as prominently as the beating in the debate about *Punishment Room*. More scandalous than the rape itself is the film's attitude toward it. If *Rashomon* elided the act in a montage of overwhelming passion, and Koji Shima's *Teenage Sex Code* (*Judai no seiten*, 1952) elided it through a sudden excess of religious imagery,[5] *Punishment Room* insists on the repulsive physicality of rape. After making clear that we and Akiko's bookish friend

know what he plans to do, Katsumi and his friend drug the co-eds and, in a narratively superfluous sequence, carry them up the stairs of the apartment building like sacks of potatoes (fig. 13). Power is measured precisely by camera angle in this sequence—the look down at the unconscious object and the glazed look up at the perpetrator (fig. 14). That objectification is reinforced when it comes to choosing victims: Katsumi's friend suggests playing rock-scissors-paper to decide but he is shouted down. As the scene continues we expect the usual ellipsis but instead it only becomes more explicit. We watch as Katsumi tears off Akiko's clothes and mocks her for her powerlessness. Only when he jumps on her does the camera finally look away, to a perverse close-up of Katsumi's shoe (fig. 15) and then, when that leaves the frame, a longer shot of Akiko's gently bouncing hand.

Not until the sustained long take leading up to the rape in Oshima's *Cruel Story of Youth* (*Seishun zankoku monogatari*, 1960) would a Japanese film put an audience in such an uncomfortable position. Despite the bravado of Ishihara's dialogue—Katsumi claims he's the only one who "does what he wants," insisting that the rape is just a means to force Akiko to do more quickly what she wants to do anyway—the animalistic incoherence in this scene suggests that Katsumi is rather devoid of subjectivity, a blank slate of rage. Perhaps we should not look for anything deeper than that in the film. *Punishment Room* is essentially an exploitation film, spinning out a literary boom into a new medium. Yet Ichikawa's refusal to reassert familiar morality in this youth film, ending ambiguously with a wounded Katsumi crawling toward a small patch of light at the end of an alley (fig. 16), points toward later and more well-known films that this text helped make possible.

Of course, *Punishment Room* was not alone. *Blackboard Jungle* (known in Japan as "Violent Classroom") and *Rebel Without a Cause*, released in Japan in 1955 and 1956 respectively, had already announced a global "youth explosion" that would decisively reorient Western commercial cinemas away from the mythical "family audience" to the wealthy postwar cohorts of the young. Hollywood films were not yet subject to the Japanese film industry's voluntary rating system, allowing these films to be released in Japan despite being cut in culturally more "familiar" countries such as England. That fact caused a certain amount of anguish in Japan, especially to conservative commentators who supported government attempts to reintroduce prewar style morality classes in the schools. The ground then was prepared for 1956, when *taiyozoku* films became the target of a "moral panic" over the corrupting influence of cinema, and the ancillary medium of film advertising, on youth in Japan. PTA organizations and nominally independent housewives groups called for the films to be banned,[6] and joined Minister of Education Kiyose in demanding official government censorship rather than the voluntary system (modelled on the American MPAA) established in 1949. Eventually, the bureaucrats were kept at bay by the constitution's guarantee of freedom of expression, though the system of voluntary censorship was tightened: enforcing age

limitations, restricting salacious advertising outside cinemas, and forcing American and independent filmmakers to submit their films for classification. Conservatives also applied indirect pressure, and the studio heads announced in early August that they would make no more *taiyozoku* films.

Although it would seem that the net effect of the *taiyozoku* scandal was the strengthening of Japanese censorship, the films produced permanent changes in Japanese film style. While the overt immoralities of rape and torture were avoided, the more stylistically significant shifts in editing rhythms, extreme range of shot scales, and anti-melodramatic irony soon returned at other studios in the youth films and action films of Yasuzo Masumura, Kihachi Okamoto, and (somewhat belatedly) Nagisa Oshima. That genealogy ties my account of *Punishment Room* to a larger study of the geopolitical, cultural, and industrial pressures on the representation of youth, body, and subjectivity in late 1950s Japan. As the "king" of contemporary mass culture, film was both last to the debate and its most influential participant. "Youth" in its mental constitution and physical embodiment, became an unstable sign, standing both for the future of the country, the producing and consuming generation that would make the economy grow, and for the disaffected and frustrated masses shut out of the Japanese gerontocracy. If Ichikawa, Nakahira, Masumura, Okamoto et al. were in the vanguard, then Oshima (in the wake of Ampo[7]) was the most explicitly political, using the youth film genre to violently expose the impossibility of achieving subjective engagement in Japanese society after the failed postwar socialist revolution, and the establishment of a conservative dominance that continues today. All the problematic aspects of these films—in particular their representation of sexual violence—are tied to that rejection of "relative stability" (in the leftist catch phrase).

The youth film invented the tropes that soon migrated to the larger action film genre, borrowed directly or the result of the ageing of popular youth stars. From Kihachi Okamoto's *Desperado Outpost* (*Dokuritsu gurentai*, 1959) to the Nikkatsu action films starring Yujiro Ishihara, Akira Kobayashi, and Keiichiro Akagi, heroic masculinity took on a more dynamic and cynical edge that contrasted with the idealized passivity of Shinjiro Ehara in Tadashi Imai's *A Story of Pure Love* (*Junai monogatari*, 1957) or Miyoji Ieki's *Naked Sun* (*Hadaka no taiyo*, 1958). Yukio Mishima even attempted the new youth film's dangerous bodily presence in Masumura's *Afraid to Die* (*Karakkaze yaro*, 1960) while nothing in the *taiyozoku* films surpassed the breathtaking brutality of Shintaro Katsu in the same director's *Hoodlum Soldier* (*Heitai yakuza*, 1965).[8] In that sense, Masumura's critique of *Punishment Room* is a little short-sighted: it was precisely by leaving its approval or disapproval of the *taiyozoku* unclear that *Punishment Room* broke with the moral blatancy of previous cinema. The film's cynicism invited such an intense reaction by installing pathetic parents and unsympathetic protagonists in an anti-climactic narrative structure that refused the adult perspective and moral epiphanies of earlier sex melodramas.

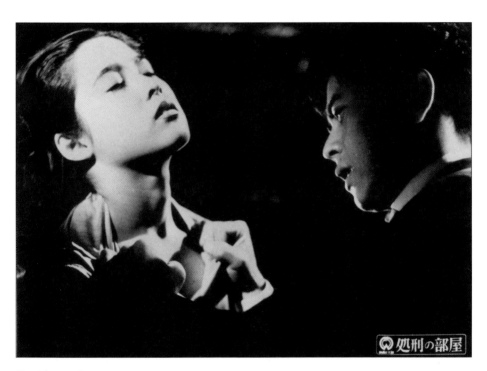

Punishment Room

Ichikawa's idiosyncratic films are distinctly his own. However, as Béla Balász understood seventy years ago, films change in interaction with changes in film culture. Nagisa Oshima has pointed out the importance of television in turning film style away from scenes of subtle dialogue.[9] Yet style responds to discursive as well as industrial factors: changes in film criticism are as influential as other films and industrial conditions in changing film style. In the mid-1950s a round table of film critics could still be satisfied that they were *tema-shugi* (theme-oriented) critics.[10] They demanded that films have a clear narrative line that was both believable and socially edifying. However, the late 1950s saw a generational shift not just in film production but in the film criticism establishment too. Tadao Sato became an editor of the important film journal *Eiga Hyoron* (*Film Criticism*), while young critic and filmmaker Susumu Hani followed the development of new approaches to film at French journals such as *Cahiers du cinéma*. Assistant directors at Shochiku published the short-lived *Shichinin* magazine, and Nagisa Oshima demanded that critics pay attention to the struggles of young directors making program pictures.[11] Film study circles supervised by young critics such as Yoshio Shirai spread among elite universities, and the increased social respectability of the film industry allowed the studios to choose only the most intellectually ambitious applicants. Although Masumura, a double graduate of Tokyo University, dismisses Ichikawa's intellectual accomplishments, *Punishment Room* as both novel and film emerged from a newly intellectualized (Masakazu Yamazaki calls it "middlebrow") popular culture.[12] Even Ishihara claimed to be on the left wing of the socialist party, while his advisor at Hitotsubashi university, Hiroshi Minami, introduced social psychology to Japan and wrote what we would now call cultural studies of Japanese cinema—analyzing Ayako Wakao's fan mail, for example.

Although it was a tremendous commercial success, *Punishment Room* was for the most part badly received by the critics. Mainstream critics complained that the content of the film was sociologically unjustified, while the more film-literate Jun Izawa criticized not so much its content as its emptiness—for him *Punishment Room* was style without substance, its success merely an incitement to make more cheap exploitation films.[13] At the same time, Ishihara joined the attack, claiming that none of the three *taiyozoku* films made from his stories in the summer of 1956 had come close to his novels. Yet Ichikawa's film was not without supporters. Philosopher and avant-gardist Kiyoteru Hanada praised the film for cutting through the melodramatic orthodoxy of Japanese cinema to what he called an "antihumanist" cinema.[14] More importantly, Ichikawa himself responded to the attacks. This in itself was unusual: until then the critical and production spheres had been kept quite separate so Ichikawa's critical engagement connects him to later director-critics such as Hani, Masumura, and Oshima. Masumura denies the resemblance, distancing himself from Ichikawa in his essay in this volume, and claiming elsewhere that he was not influenced by Ichikawa during the time that he worked

with him at Daiei. Yet the criticisms he makes of Ichikawa's flashy and abstract style tend to repeat the charges that have dragged on Masumura's own critical reputation—his numerous adaptations of Tanizaki were regarded more highly than the distinctive visual style of less edifying films such as *Blind Beast* (*Moju*, 1969).

The debates between Ichikawa and Jun Izawa and between Ichikawa and Ishihara put the film at the centre of a growing convergence between filmmaking and film criticism,[15] another echo of the French new wave realized in such figures as Masumura, Nakahira, Hani, and Oshima, who were active as critics as well as filmmakers. Ultimately, it is Oshima who waits outside the door of *Punishment Room*. Surely we can see in this film the linkage of "youth" and "cruelty" that Oshima claimed he had invented in his second film. More importantly Ichikawa's films, like Oshima's, centre on characters who suffer from an uncompromising and self-destructive belief in "purity," and feature a level of formal obtrusion[16] that seeks to recreate the sense of "impasse" that those characters encounter in a corrupt and gerontocratic Japan. The freeze-frame shooting of the pigeon at the end of Oshima's *Town of Love and Hope* (*Ai to kibo no machi*, 1959) is one such moment, as are the eccentric framing and ambiguous sound-image relations at the end of *Cruel Story of Youth*.[17]

Punishment Room played as large a role as any film in a partial shift of the youth film *optique*[18] from the idealized and conformist version of early 1950s studio films to the slightly more cynical and far more violent mainstream genre of the Nikkatsu and Toei action films, as well as to the alternative cinema of the 1960s that depended for much of its power on the collision of youth and sexuality. On a less thematic level, the film introduces a modernist ambiguity that would reach its apotheosis in the independent films of the 1960s. On top of its moral reticence, *Punishment Room* employs a stylistic device of isolating close-ups of faces in impossible or unreadable situations, a device repeated in Oshima's *Cruel Story of Youth* and in particular *The Sun's Burial* (*Taiyo no hakaba*, 1960).

All that ascribed influence is a large burden for a single film to sustain, and is especially suspect in a high production/high turnover system like Japan's. Yet the particular conditions of the *taiyozoku* scandal, along with the changes in film culture I have mentioned, conspire to keep *Punishment Room* central to this debate. The film was not simply shown in the cinemas for a week or two and then retired. Daiei had seen the success of Nikkatsu's Ishihara film, Takumi Furukawa's *Season of the Sun*, and advertised *Punishment Room* accordingly, listing the rape and beating as the film's main "attractions." Once it had finished its first and second runs the film was still shown in non-studio cinemas in a double bill with *Season of the Sun*. The latter film was a far more conventional version of Ishihara's interchangeable stories—mainly notable for its last line: "Adults don't understand." That line became the Japanese title of Truffaut's *400 Blows*, released in Japan in 1960, again linking the *taiyozoku* films to the "Shochiku *nouvelle vague*," a term

invented as a Japanese counterpart to the French original. As I have described elsewhere, that complex cultural location and confused temporality are the legacy the *taiyozoku* films of 1956 bequeathed to the "Shochiku *nouvelle vague*"—which, in the stark illumination of *Punishment Room*, doesn't seem so *nouvelle* after all.[19]

Notes

1. *Taiyozoku* is usually translated in English as "sun tribe." The word was coined to refer to the rich, bored, and vicious youth of Shintaro Ishihara's novella *Taiyo no kisetsu*, translated in English as *Season of Violence*, on which the film *Season of the Sun* was based. By extension, it included the Japanese students and young workers who aped the lifestyle of the privileged bourgeoisie, camping out at the same resorts during the summer months, away from the supervision of their parents. Whatever the sociological merits of the term, the public reputation of this "arbitrary young generation" is probably best described by an English caption in the graphic magazine *Asahi Gurafu*. "These young people in their teens or early twenties seek action before reason and are keen about the pleasure of the flesh."
2. As Yasuzo Masumura's article in this volume points out, Ichikawa would go on to build his mature reputation on prestigious literary adaptations—of Mishima, Tanizaki, Ooka, Shimazaki, and others.
3. This film helped institute one of the most pernicious aspects of gender depiction in Japanese cinema: sexual violence becomes an index of a kind of inarticulate emotional intimacy—and the woman falls in love with her rapist. Wakao, for example, would play variations on that theme for Yasuzo Masumura in *Afraid to Die*, *A False Student*, *Red Angel*, and *Tattoo* at least.
4. Played by Seiji Miyaguchi, he's fallen a long way from his best-known role as the superlative swordsman Kyuzo in *Seven Samurai*. In this film adults are associated with weakness and stupidity—the father's various illnesses and the mother, laughing at a comic strip when in the *haha-mono* (mother films) in which Teruko Kishi often appeared she would be crying.
5. We cut from the crucifix on the Christian victim's neck to her distraught flight through the snowy woods in which all the branches make the shape of the cross. *Punishment Room* uses some of the same striking visual distortion (and the same cinematographer) as *Teenage Sex Code* but in a completely different way: the film doesn't express an emotional anguish that is finally resolved but undermines both social hierarchy and Ishihara's hierarchy of masculine Will. We're left instead with a strange amalgam of radical ambiguity and the exploitation film. Oshima makes reference to those hysterical sex melodramas when he has Makoto (the name means "Purity") attend a Christian school in *Cruel Story of Youth*.

6. See Sheldon Garon's *Molding Japanese Minds: The State in Everyday Life* (Princeton: Princeton University Press, 1997) for evidence that, despite constitutional prohibitions, the Japanese government paid for these groups. It is only against the official discourses of hard work and obedience which Garon anatomizes that this film's transgressions could come to seem "progressive."
7. The Ampo protests of May–June 1960 were against the U.S.–Japan Security Treaty and became a widespread opposition to a political system that gave power to the conservative provinces over the modernizing cities. When one of the students was killed, protestors' placards asked if the police also wanted to kill popular youth action star Yujiro Ishihara. This popular cultural affiliation rejected the United States but also the conservative government *and* the established left.
8. The history of the modern action film (invented by Kurosawa but not widespread until the 1960s) shares a secret relation to the history of political disaffection; with the end of the "Shochiku *nouvelle vague*," explicit political critique disappeared from studio productions, but radical students then took gangsters as heroes in their battles against the state.
9. Nagisa Oshima, *Cinema, Censorship, and the State: The Writings of Nagisa Oshima 1956–1978*, ed. Annette Michelson (Cambridge: MIT Press, 1993), 33.
10. "Masa komyunikeshon ni okeru eiga to shinbun" (Film and Newspapers in Mass Communication), *Kinema Junpo* 148 (15 June, 1956): 40–45.
11. Oshima, "To Critics Mainly—from Future Artists," *Cinema, Censorship, and the State*.
12. Masakazu Yamazaki, "The Intellectual Community of the Showa Era," in *Showa: The Japan of Hirohito*, eds. Carol Gluck and Stephen R. Grauberd (New York: Norton, 1992).
13. Round table with Jun Izawa, Kin'ichi Tanimura, Hajime Togaeri, Hiroshi Minami, and Shinbi Iida in *Kinema Junpo* 164 (15 December, 1956): 43–46.
14. In discussion with Takeshi Muramatsu and Kiichi Sasaki in *Shin nihon bungaku*, October 1956. Hanada implicates the Fumio Kamei–scripted documentary *Ikiteite yokatta*, but his criticism applies to the left-sentimentalism of *A Story of Pure Love* and *Naked Sun* too. In place of this passivity, Hanada wanted to harness the "energy" of youth, lest Ishihara's "thoughtless philosophy" of action lead to fascism instead.
15. See *Kinema Junpo* 154 (15 August, 1956): 25–28; and *Mainichi Shinbun*, 20 and 25 July 1956.
16. By "formal obtrusion" I mean those moments when a film's style interrupts its narrative—the striking high-angle long take at the beginning of *Cruel Story of Youth*, for instance, or the sudden and unmotivated music that starts and then stops when Makoto announces that she is pregnant, or the incredibly long shot of Kiyoshi eating an apple in the same film. As with the unstable depth relations and sudden bursts of editing in *Punishment Room*, I think these moments work to bring us up short, looking for a way to impress upon an audience the trapped, impossible situation of the protagonists. It's the "nothing but cinema" that Jean-Luc Godard praised in

Nicholas Ray's similarly uneven films of the 1950s, some of which remains in the "popular baroque" of sixties and seventies *eizo hyogen* (visual expression) films by such directors as Masumura, Seijun Suzuki, Kihachi Okamoto, and many others.

17. Of course, three of Oshima's four early films were shot in a colour widescreen format that was not yet current in Japan in 1956. Whatever Oshima's formal debt to the *taiyozoku*, we cannot ignore the technological intertext of Nikkatsu's version of the youth film genre that informs all of the so called "new wave" films of 1960.

18. See Dudley Andrew, *Mists of Regret: Culture and Sensibility in Classic French Film* (Princeton: Princeton University Press, 1995) for a sophisticated discussion of the complex interrelation of sensibility, norms, and mode of address that constitutes a particular "optique."

19. Michael Raine, "Youth, Body, and Subjectivity in Late-1950s Japanese Cinema," Ph.D. Dissertation, University of Iowa, forthcoming.

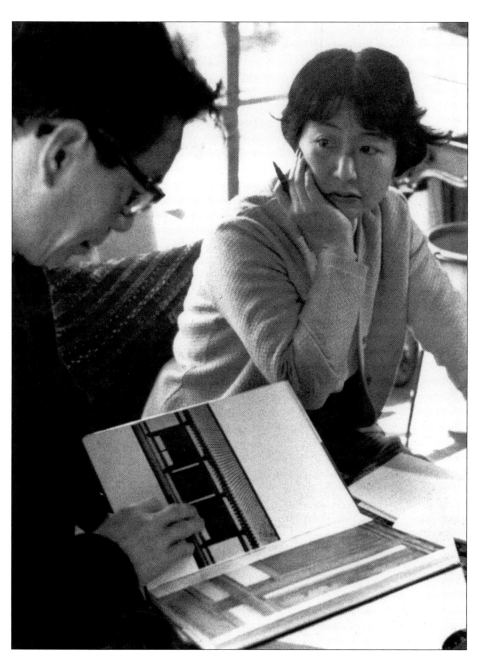

Natto Wada (with Kon Ichikawa)

NATTO WADA

The "Sun Tribe" and Their Parents

I HAVE BEEN ASKED to explain why, in my scenario for *Punishment Room* [*Shokei no heya*, 1956, based on the novel of the same name by Shintaro Ishihara, presently governor of Tokyo], I inserted a new protagonist—the hero's mother—who did not appear in Ishihara's novel, and what exactly I was trying to convey through her character. These are very difficult questions, which cannot be answered in a few words.

In the first place, since a scenario is one step towards the making of a film, and a completed film should, I believe, be judged on its particular merits, it is excruciatingly painful as a screenwriter to be asked questions of this sort. When I hear, "Why did you introduce such and such a character?" or "Why did you structure the film in such and such a way?" I can only be forced to reflect on my own lack of talent (although I do critically re-examine my own work from a professional standpoint).

In the second place, to get slightly technical, when you base a scenario on a literary work, as in the case of *Punishment Room*, you are faced with two options: you can either remain faithful to the original work or, conversely, deal with it critically in order to bring its spirit to life. The latter option, however, places you in a difficult position as a screenwriter, for not only is it likely that your film will clash with the image held by those who have read the original, it will also almost certainly put the author's nose out of joint. Optimally, of course, you would like to avoid making enemies on either side, but there are still occasions when you have no choice. There are even times when you opt to take the risk voluntarily. *Punishment Room* was one such time.

As my son is only five years old, and I have no close relatives aged twenty or thereabouts, I had no opportunity to learn about the so-called "*Après*" generation of postwar youth in any concrete way until the appearance in 1955 of Ishihara's

prize-winning novel *Taiyo no kisetsu* [literally "Season of the Sun," but published in English as *Season of Violence*]. Like mothers everywhere, I was shocked by the novel, and the others that followed. Still, once I had decided to produce a script based on one of Ishihara's books, shock alone was insufficient. Leaving aside the debate about whether Ishihara's novels can really be called literature, the fact remains that his kind of writing is now a part of our world. Rather than closing my eyes to the reality it represents, I resolved to confront one of his works head on. This may sound overly dramatic, but the society in which I grew up is so radically different from the one today's young people inhabit that none of my youthful experiences could provide me with a handle to grasp the significance of their actions. Faced with this utter incomprehension, there was no alternative but to take a direct approach. Yet if that approach yielded no more than a disparaging attack on the new generation, there would be no point in struggling to adapt Ishihara's novel. I am not trying to give you a sob story about the difficult position this particular scenario put me in. Rather, I am attempting to convey a sense of the process I undertook in order to understand these young men, as a woman and as a mother.

All of us have experienced that period of emotional instability which occurs around the age of twenty. Things adults dismiss as trivial assume a vital importance during that time: the very act of living can seem a torment; life in general a target of skepticism. Indeed, the very fact our elders treat the dilemma in such a blasé fashion makes them appear all the more loathsome and stupid in our eyes. Depending on the individual, this condition can be expressed in various ways: in milder cases, it may cause a young person to break into tears at the mere sight of the moon, while at the other extreme it can lead him or her to commit suicide in despair at the impurity of our world. Youth, in this sense, can be seen as a time of suffering, for although body and mind may already be fully developed, there remains a poverty of life experience. Yet I believe there is no more beautiful suffering in this life. Adults, of course, have been through it all before, but for most the memory has disappeared like smoke, leaving them to snicker and scoff at the torment of the young.

Compared to when we grew up, today's world is filled with a multitude of stimuli. The good and evil that men do are laid bare for all to see, so it is hardly surprising that the number of youth who weep at the sight of the moon is shrinking. Politics is increasingly problematic, making a living more and more taxing, the outlook for the future less and less rosy. The battle-lines of the world of business cross the boundaries of student life, once a protected space for leisurely growth and the kind of "pure" suffering I have just described. Look, for example, at the way a typical middle-class girl is manipulated by the cosmetics industry. "Use our product," she is told, "and the hearts of at least four young men will be yours!" Such shameless entreaties were not used in the past. Yet it would be a mistake to dismiss them as sordid and blatant, and turn the other way. For practically everything today seems

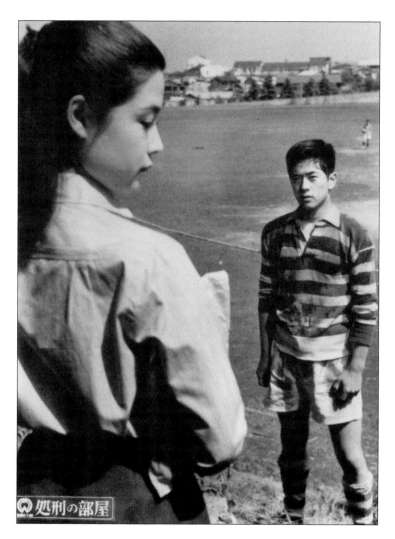

Punishment Room

to follow that pattern. Moreover, girls growing up now are quite unlike the protected hothouse flowers of past eras.

Back then, educating children was usually left to the mother. This arrangement worked fairly well. As long as a father was there to wield his social influence when his son was looking for employment, or when his daughter was getting married, he was considered to have done his job. Now that the looming pressures of contemporary society are forcing Japanese students to open their eyes to the outside world, however, the old way doesn't work so well anymore. Nevertheless, it is still almost always the mother who is expected to educate her children. Among these mothers are women so progressive they would put a man to shame. Others are doing a splendid job as providers in the workaday world. Most, however, continue to live as before under the protective wing of the men who are their husbands. Since they have never done battle in the social realm, however, they naturally find it difficult to retain their traditional authority. From their children's point of view, fathers, being experienced in the world, have more to offer than mothers who are innocent of such experience. Yet those very fathers are so immersed in the struggle to provide their families with financial security, they have little spare time or energy to devote to their children's education. Indeed, most remain firmly convinced that educating children is a mother's job. Parents and children alike are trapped in this woeful set of circumstances, which in my opinion shape one of our modern tragedies. It was from this perspective that I approached *Punishment Room*.

This does not mean, however, that I believe young Katsumi turned out the way he did because of the kind of mother he had. No such narrow cause-and-effect principle guided my thinking. Rather, I had Katsumi's mother assume the position of those women known as "mothers" in modern Japan. Katsumi, too, can be taken as a similarly representative figure.

Though it may be that no youth has behaved in real life as Katsumi does in the novel and the movie, this does not rule out the likelihood that youths like him exist. Should we conclude, therefore, that he should have acted differently, perhaps following the examples of friends like Yoshimura and Ryoji? As I see it, those characters also embody aspects of their generation. Each of the three struggles in his own way to deal with the world he inhabits: Yoshimura by escaping into a protective cocoon of ideology; Ryoji by submitting to the dictates of a social system he questions; and Katsumi by toppling established morality in search of some sort of meaning. Since young people today are generally more intelligent than we give them credit for, it is my conjecture most belong to the types represented by Yoshimura and Ryoji.

Looked at in this way, Katsumi is stupid; but he is also pure, and it is this purity that drives him to act. "I defy you!" he shouts, "I'll do what I want!" Yet the harder he pushes against the system, the more frustrated he becomes.

What might bring an end to this pitiless exercise in futility, and provide Katsumi with some form of salvation? I approached the scenario to *Punishment Room* with

the purpose of thinking about this question, which strikes me as especially meaningful.

An article written by a university co-ed criticizing the film as "insulting to women" was published in a certain newspaper. It was a very short piece, so I'm not sure exactly what she meant, but I must confess that I felt something similar while writing the script. When I stopped to examine why I felt insulted, I realized that it had to do with Katsumi's way of dealing with "love." From start to finish, *Punishment Room* rejects the conventional ideal of love. Given that love is a theme of special interest to women, I imagine that co-ed was not the only person who felt antagonized by the film.

What, then, might put an end to Katsumi's pitiless futility? I contend the answer is, in fact, love. But Katsumi rejects it. When Akiko says, "I love you," he fends her off with the comment, "I don't know what the hell love is." He is not being entirely honest here, yet the love directed his way comes in forms he cannot accept: his mother adjusting the bottom of his quilt at night so he won't catch cold, for example, or her worrying over his lack of a job. What precisely is this "love" young men like Katsumi are supposed to heed? Mustn't we seriously reflect on this question first? What is this thing that mothers and girlfriends elevate above all else, like a flag on some field of battle? If it proves to be no more than the manifestation of an abstract concept of "ideal love," or a tepid, vague statement of universal brotherhood, I think we can assume it will be rejected, rendering all further discussion irrelevant.

In my opinion, Katsumi and his generation are searching desperately for a new, more believable kind of love, one filled with vigour and power. Rather than clinging to our fixed and stable concepts, shouldn't we rouse ourselves to join them in their struggle?

1956

Translated from the Japanese by Ted Goossen

Kagi

KEIKO I. McDONALD

Viewer's View of *Kagi*

K ON ICHIKAWA's *Kagi* (*Odd Obsession*, 1959) is based on the novel by Junichiro Tanizaki that shocked Japanese readers by dealing frankly with sex. The film, like the novel, does more than that. It satirizes a respectable middle-aged couple in contemporary Japan who determine to rejuvenate themselves through sex rather than resign themselves to advancing age in the traditional Japanese manner. The nature and function of satire demand a degree of detachment. What is fascinating about Ichikawa's directing is the enrichment he brings to the satirical mode by manipulating the audience's point of view. He does this is in several ways.

First and most obviously, Ichikawa gives us the novelist's characters: people whose values are strikingly at variance with the accepted norm. Thus, we are confronted with a disparity tested in action. Ichikawa improves on the novel by giving the servant Hana a more important role, and a more troubling rhetorical presence. She is not directly involved in the ugly sex game played by the four major characters, but functions as a detached observer of the scene—with an important fillip of irony to add at the end.

Ichikawa's use of irony, being both visual and verbal, is somewhat more complex than in the novel. The film constantly directs our attention to important and revealing differences between what the characters say and do, and how, deep down, they feel and respond. Satirical disparity reveals their obsession as odd, but also augments psychological insight, as irony suggests more truth than can be presented directly.

Finally, there is Ichikawa's finesse with camera technique. His style in *Kagi* uses standard devices like wide-angle shots, crosscutting, and camera placement both to position his subject with great insight and suggestive power; and more importantly, to distance the audience, involving us, through a carefully detached point of view, in a coherent vision of this other world in which people scheme and betray one another so "oddly."

At the very outset, Ichikawa presents the central problem of the film in beautifully ironic, clinical fashion. The young intern, Kimura, delineates the physical symptoms that a man exhibits at various stages of aging: "Our physical deterioration begins at the age of ten when our eyes lose their resilience. At twenty, our auditory sense begins to decline. At forty, our palate is no longer sensitive to subtle tastes. At sixty, our olfactory sense deteriorates."

This seems reasonable enough, so as Kimura continues, we are lulled into acquiescence, tempted to see in his prognosis the reliable physician's objective statement, the plain truth told by a detached observer. Viewers are even tempted to identify with him, until a subtle mocking, ironic tone intrudes as Kimura points a finger directly at the audience, saying: "No one can escape growing old. Not even you, spectators, who are going to watch this film."

Suddenly, we are truly detached, doubtful about the value of Kimura's argument, and wary of his purpose in turning it against us. And when he appears as a character in the drama, we recall the distance between him and us. Thus, Ichikawa dramatically poses the central problem of his film: "How is a middle-aged couple to cope with the fact of aging?" Implicit in that problem are two conflicting choices: submission to the flux of time, or a perverse denial of it.

Kagi deals with the second choice made by Kenmotsu and Ikuko, husband and wife, who try to use sex as a weapon against old age. It is, ironically, a neat family drama, since Kimura is to be married to Toshiko, the daughter of Kenmotsu and Ikuko. This young couple will be drawn to their destruction through compliance with the dangerous sexual strategy of their elders.

Thus, we have Kenmotsu, a collector of antiques, refusing to accept old age himself. He deliberately contrives to have Kimura make advances to his wife in order to arouse his own jealousy. Kenmotsu reasons that jealousy, being sexually stimulating, will help him recover the physical gratification that he enjoyed with Ikuko in their youth—and, therefore, to recover youth itself. Kenmotsu is asking far more than mere gratification, however; he wants to reverse the very passage of time.

Similarly, after a period of reticence, Ikuko abandons the social mask of wifely modesty, and sees in Kimura the husband who no longer exists: the vigorous, youthful mate who can give her the utmost in sexual pleasure. By putting herself in her daughter's place, she too is trying to recapture the past by indulging in sex. As odd as anything in this drama is the fact that Toshiko connives in her fiancé's affair with her own mother.

Ichikawa offers a variety of points of view as we detach ourselves from this complex conflict of characters and values, so we may seek the sense of wholeness that satirical insight offers.[1] Initially, we identify with Kenmotsu's fear of death, as he receives his treatment in a dim medical office. Then we learn that he insists on this therapy, despite the doctor's advice to the contrary, and discover that his visits

to the hospital are made on the sly. Detached, we shift from sympathetic observers to objective, amused spectators. A universal human problem has narrowed to the perspective of individual choice. Kenmotsu's obsession with sex is too singular, as it were, to take us in.

Kenmotsu emerges from the hospital and boards a trolley. The squeaking of the trolley suggests the erratic beat of an ailing heart. He gets off, and Ichikawa freezes his image. With this visual jolt, does the director mean to suggest that Kenmotsu's heart has stopped? Or is this a visual emphasis only, enhancing our expectation of some scene to follow in a crosscut? We are caught between the subjective state of sympathy for Kenmotsu and the objective sense of narrative development, encountering a mode of transition back and forth between the elements of a complicated action.

The freeze frame does indeed lead to a crosscut. The rhetorical tension dissolves as Ikuko now appears in the doctor's office. Ichikawa has made use of a moment of transition to confuse us momentarily so that he can educate our caution in the face of these events. The alert viewer will be aware of being positioned for detachment.

Ikuko's behaviour seems perfectly normal, modest, and wifely. Hesitantly, she converses with the doctor, Kimura's boss, about sex, saying in all apparent innocence: "My husband says that he is very creative about sex." When her eyes then meet those of Kimura, her pointed display of indifference detaches us from a character whose "universal" has become a "particular." Just which particular, we do not yet know. Naturally, we suspect that behind her respectable wifely social mask lies a latent unruly sexuality. Ikuko goes home in a taxi. When she steps out of it, her image is frozen. This time we are certain of the pay off promised by the detachment.

As expected, Ichikawa crosscuts to the same doctor's office. Toshiko stands in the doorway, asking Kimura why he has failed to show up for a date. Her cynical tone is surprising, not what we expect from a Japanese girl of her age. She also conveys a certain furtiveness, which adds to our feeling of mild repulsion—just enough to distance us from her.

Now we are "in place." The scene is set for our first outside view of all four characters together. They are seated round a table in Kenmotsu's living room. In place of close-ups and other point-of-view shots, Ichikawa gives us a number of wide-angle frames, as if to avoid establishing any definite point of view on this scene. We get the message: these are four *dramatis personae*. Ichikawa has made his position clear. He presents these particulars and puts them through their motions; it is up to the viewer to make them yield to universals.

From here on, the film is structured by two parallel movements. The first concerns Kenmotsu's pursuit of rejuvenation through sex, focusing on its absurdity and ironically fatal consequence. The second movement charts Ikuko's progress in

the same direction. Once she hesitates, and chooses passion over reason, the consequences are equally ironic and fatal.

The movements begin together, as we see Kenmotsu arranging to leave his intoxicated wife alone in the living room with Kimura. He spies on them, hoping to stoke his libido with jealousy. Meantime, Toshiko is spying on her father spying on her mother who is left alone with Toshiko's fiancé. We disengage with a vengeance from this dangerous game, and prepare to witness the consequences. But our witness is not passive. In lieu of merely adopting one or the other character's view of events, and the values they confirm or contradict, we assimilate all the evidence and synthesize it. A complex film like this gives us a new sense of seeing.

Kenmotsu organizes more arrantly compromising situations to feed his desire. He takes nude photographs of Ikuko and asks Kimura to develop them for him, then intoxicates Ikuko, forcing Kimura to help him carry her unconscious from the bathtub to her bedroom. Afterwards, we see Kenmotsu valiantly passionate over his unconscious wife and realize how absurd he is, how his determination to deny the fact of aging is downright comical, how this would-be monster of depravity is just a pathetic, silly old man.

This major movement of the film completes itself in two striking scenes that complement each other with deft irony. The first shows Kenmotsu taking nude pictures of Ikuko lying on the bed. Ichikawa employs an extremely wide horizontal shot, using Kenmotsu to cover Ikuko's shame, as it were. There is a sense of the director's camera surreptitiously photographing Kenmotsu surreptitiously photographing his nude wife. Positioned this way, blocking our view of the indecent picture he is trying to snap, amateurishly, in bad light, trembling with insufficient lust, Kenmotsu is, quite objectively, ridiculous. We are detached, mocking observers. We have him now.

Or so we think. The other striking scene confronts us with one of the paramount ironies of the film. Kenmotsu is making love to Ikuko. Suddenly, he shakes and collapses on top of her, an amusing display, it seems, of the middle-aged man's orgasm. But the next scene shows that Kenmotsu, in fact, has had a stroke, a reversal that makes us laugh more. The lustful enterprise of the perverse old Kenmotsu is universalized right under our noses. When Kenmotsu dies later, we cannot pity him, because his fate seems proper. Our opinion of Kenmotsu's death is detached; we are light-hearted observers studying man's folly, not Juvenalian satirists out to remedy it.

The second major movement of the film involves the other three characters. Amusement yields to repulsion as we see the victims of Kenmotsu's obsession themselves turn into obsessive schemers.

Our first impressions of Ikuko are unpleasant. Ichikawa presents us with a symbol of her uneasy, suppressed sexuality: a deformed female cat she sees on returning home from the doctor's office. A close-up of its face suggests a resemblance

with Ikuko, emphasizing the very animal sexuality she wants to hide. When she throws the cat out, she seems to banish an urge she sees as perverse.

Later, after she has fainted in the bath and Kenmotsu has made love to her, Ikuko tells him innocently that she does not remember what happened, but we are aware that she was not only conscious of her husband's game, but also enjoyed it. Kenmotsu mentions that Ikuko's upbringing in a temple has endowed her with virtuous modesty. He is sincere, while we weigh the irony in his remarks.

Ichikawa develops our sense of the difference between visible action and hidden motive. He is a master of revealing discrepancies in a likeness, showing the face of the benign Kannon, Goddess of Mercy, to suggest its similarity to Ikuko's face. The likeness is ironic. Passion, not compassion, is Ikuko's true quality. We see this in an image of appalling clarity: as she stands at the sink cracking ice for her bedridden husband, the look on her face, the ice pick in her hand, bespeak a desire to kill the man she is nursing.

Our sense of Ikuko as repellent is complete when we see her giving her future son-in-law a key to the house. She will pursue infidelity under the same roof where her ailing husband is confined to bed. We are prepared for the moment when Ikuko takes off her clothes, knowingly eliciting the lust that will lead to her husband's death. Her behaviour is outrageous for a Japanese woman brought up as a priest's daughter, contravening every norm.

As previously noted, Kimura arouses suspicion at the very outset of the film. His compliance makes us watch his every move, looking for clues about the nature of his feelings for Ikuko and Toshiko. He is, in his way, a model of discretion, yet even his bedside manner betrays him as he examines Ikuko after she swoons in the bath. We sense that Kimura's interest in Ikuko is purely sexual, especially since the mother is prettier than the daughter.

Kimura's relationship with Toshiko is more visible. He shows her the nude pictures of Ikuko that her father has asked him to develop. Toshiko promptly challenges his interest, offering to take her mother's place in the flesh. Ichikawa interrupts the love scene that follows in the cheap hotel with a view of two trains coupling. This parody of Western cinematic technique is more than a touch of Ichikawa's famous black humour. Its visual pun suggests that Kimura is literally out to make connections. He mentions Kenmotsu's patronage a number of times, and confesses that his own family is poor, so we can surmise that Kimura plans to marry Toshiko for reasons of gain. After Kenmotsu's death, he states: "I am so disappointed that the family is now destitute. Ikuko is pretty, but not a money maker. Toshiko is by no means pretty. Why in hell did I get involved with this family?" Kimura stands fully revealed, and is easily judged: he is a social climber caught in his own trap. No ambiguity attaches to him, and the case is dismissed.

Toshiko's motives are more difficult to judge. She is repellent in a subtle way, and her behaviour is puzzling. She spies on her parents and seems remarkably well

informed about their goings-on. Ichikawa also allows us to spy on Toshiko. We see her willingly enter into the sex game that her father has set in motion. She goes so far as to help her mother arrange a tryst with her own fiancé. All this suggests that Toshiko's motive is fairly direct; she wants to get back at her tyrannical father.

The situation, however, is more complicated. Toshiko tests the effect of the truth on her father, inflaming his jealousy by telling him about Kimura and her mother. But she also tests Ikuko by implying that she knows about her involvement with Kimura. Toshiko is dangerous; playing the sex game with her own set of rules, she is attempting to destroy both her father and her mother. Any connection we might have felt with Toshiko is broken; her sardonic pleasure in destruction is too much.

The pattern of irony is completed by the servant Hana. In earlier scenes, Ikuko has taunted the old woman for her poor eyesight. Yet Hana is something like a seer, effecting the ultimate judgement when she poisons Kimura, Ikuko, and Toshiko. Vengeance is an elderly maid. It appears that Hana, like us, has been aware of all the goings-on in the house. She is a model of detachment, yet she gives the film its finality. Ichikawa explained the reason in an interview given to Joan Mellen in 1974:

> **MELLEN**: Why does the servant poison the three surviving people at the end of the film? This aspect of the plot was not in the original novel by Tanizaki.
> **ICHIKAWA**: I wonder if I can get this across to you in Japanese via an interpreter. I'll try. These three people are representatives of the human without possessing human souls. They are not really human beings. The servant is going to annihilate them because the servant represents the director. I wanted to deny them all.
> **MELLEN**: Then it is the moral judgement of the director on these three people?
> **ICHIKAWA**: Yes.[2]

It is one thing for a director to kill off his villains, quite another to ask us to accept the dispatch as the moral judgement satire dictates. On the contrary, the director's act strikes us as too didactic, too obtrusive an attempt to force us into an identification with Hana or, by extension, with Ichikawa himself.

Can he really mean it? Does he offer one twist of irony too many in the interview? Certainly, the final scene is rife with detachment. Hana confesses to premeditated murder. Her eyesight is not to blame, she insists, for the mix-up of containers, one red and one green; one poison for the rats and one soap for the dishes. Yet the policemen cannot believe it. They have too much common sense, too much bureaucratic and unimaginative experience of human nature to credit the old lady's tale. The psychology behind this shocking parody of respectable family life escapes these law-and-order men entirely. They can only conclude that Hana is *non compos mentis*. Their explanation is stolidly conventional; Ikuko and

Toshiko, left impoverished, committed suicide, and the young intern Kimura joined them in sympathy. We smile at this four-square paradox. The case is closed. The dead can rest, respectable in peace. Hana is free to go.

Still, a question lingers: Just whose odd obsession have we been viewing with detachment, anyway? (The Japanese title, *Kagi*, means simply "the key," though it has a sexual connotation in the film.) Was it really that of the four, whose game took over their lives? Was it that of Hana, who was obsessed with watching them destroy each other before she decided to destroy them herself? Was it that of the police, obsessed with the norms and therefore blind to human complexity? Or was the odd obsession some aspect of ourselves, some dangerous bit of *otherness* that the satirist displays for all who have eyes to see?

Notes

1. William Cadbury states: "The basic distinction between the outside and the inside view, then, is directed most strongly towards the singularizing attributes or the universalizing problems of character." "Character and the Mock Heroic in *Barchester Towers*," *Texas Studies in Literature and Language* 5 (1963): 569. The article is an excellent explication of the different points of view of the individual characters that the audience must assume in order to achieve a coherent reading of the novel.
2. Joan Mellen, *Voices from the Japanese Cinema* (New York: Liveright, 1975), 123.

This is an abridged version of the essay "Viewer's View of *Odd Obsession*" originally published in *Cinema East: A Critical Study of Major Japanese Films* (Rutherford, N.J.: Farleigh Dickinson University Press, 1983).

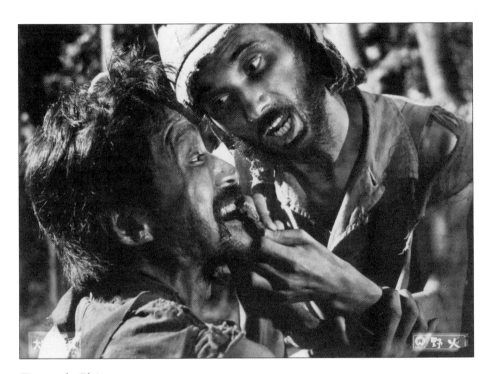

Fires on the Plain

WILLIAM B. HAUSER

Fires on the Plain:
The Human Cost of the Pacific War

KON ICHIKAWA'S *Fires on the Plain* (*Nobi*, 1959) represents one of the most graphic statements of anti-war and anti-military sentiment in postwar Japanese film. As a portrayal of the degradation and dehumanization of the surviving Japanese forces in the Philippines in the last year of the war, it is a disturbing film which offends many. Yet several of its themes—the nature of army life, relations between officers and men, comradeship, provisions and war matériel, relations with the enemy, and the sense of purpose and objectives of the fighting men— are conventional in Japanese war films made during and after the Second World War. However, Ichikawa's film achieves its singular power—greater even than the Shohei Ooka novel on which it is based—by forcing viewers to immerse themselves in the Japanese army's hardships, particularly in the struggle for survival by the protagonist, Private Tamura (Eiji Funakoshi). This essay, through a narrative and analytical discussion of Tamura's struggle, will show how Ichikawa's film constitutes a major challenge to values championed in wartime Japan.

From the opening frames when Tamura's squad leader slaps him across the face, the tone of brutal desperation takes us aback, leaves us stunned and unsure of what to expect next. After the close-up of Tamura's gentle visage, which captures his confusion and hurt, the camera pulls back, revealing that he is miscast in the Japanese army, is an innocent victim of the war and of military service. The squad's position is hopeless. Tamura is an embarrassment, and his squad leader expresses both his own anger, and the futility of the Japanese military situation in general, by assaulting the helpless private. Tamura's superiors consider him a failure because he has failed to die for the emperor and uphold the honour of the Japanese army, and because his tuberculosis makes him unfit for continued service. Unable to help dig fortifications and scavenge for food, he is a drain on his unit. His duty is to persist in demanding admission to the military hospital and to stay there as long as his

rations last. Failing that, his final duty is to die, using his hand grenade. Tamura's authorized choices both offer only death. He must gain admission to the hospital to better prepare himself to give his life for the emperor, or he must kill himself to remove the burden on his unit. Within the army, there is no provision for life, only a determination to achieve victory or die.

Tamura's dilemma is given visual and emotional power by the stark black-and-white photography, its strong contrasts reminiscent of the paintings of Georges Rouault. The desperation of the Japanese military situation is emphasized by the lack of grey tones in the cinematography; the choices offered Tamura similarly provide no middle ground: they are matters of life or death. The predominance of black and limited use of white accentuate the doomed finality of Tamura's and the Japanese army's situation.

The opening scenes focus on the degrading conditions faced by the Japanese army in the final phase of the war in the Philippines. The men are starving and ill-equipped. They stand on guard duty and mechanically dig trenches with broken shovels, helmets, and sticks; yet the squad leader accepts the hopelessness of their position, admitting they no longer even bother the advancing enemy. The unit's clerk dutifully fills out requisitions for food and equipment but has no place to send them, as the supply system has fallen apart and the squad is isolated and alone. Their situation is futile. Victory, which seemed so attainable early in the war, is now unimaginable. Surrender is unacceptable, as it violates the Japanese code of military conduct. Survival instincts, the normal human responses to life-threatening situations, are inconsistent with the behaviour expected from Japanese soldiers.

Tamura tells the guards who challenge him at the perimeter of the position that he is returning to the hospital, as he is no longer useful to the army. "This time I'll stick it out until they take me," he says. He has accepted the judgement of his commanding officer. Saluting, he marches off to his fate. When he stops to rest and dumps out his haversack, the hand grenade rolls out. Tamura picks it up and seems to fondle it. This is the symbol of his redemption, the agent of his final obligation as a Japanese soldier. When he prepares to leave, he eyes some potatoes, pushes at them with his boot, unsure if what they represent—life—is an acceptable alternative. Unwilling to commit himself to death, he slowly picks them up and goes on his way. His options remain open, but the choice may not be his to make.

The obedient Tamura accepts orders without question: his duties are to fight and to die. While death appears inevitable and his hand grenade seems more valuable than his rations, something spurs him onward. Army service has eliminated his right of self-determination, but he has not entirely yielded. The focus of the film, while never explicitly stated, becomes the struggle between civil and military value systems, between duty to nation and duty to self, between the instinct for self-preservation and the demands for self-destruction. Can Tamura, miscast as a warrior and caught in a hopeless conflict, preserve himself and his civilized values?

Tamura is no ordinary soldier. The film frequently contrasts him with his fellow combatants. His polite language betrays him as a member of the educated elite, while most of his fellow soldiers are from working-class or farming backgrounds. Whether or not he is Christian, he knows and understands Christianity. His concern with humanitarian values, sense of individual worth, and awareness of the possibility of personal choice, differentiate him from most of his comrades in arms. He is in, but not of, the army. Tamura is a cultured intellectual, representing a form of universal compassion suppressed by militarism and war.

The importance of human will and individual choice has many cultural implications in Japanese society. The capacity to transcend material limitations, the belief that determined efforts can overcome all odds, the conviction that the power of Imperial Will enabled Japan, alone among non-Western states, to attain equality with the industrialized nations of the West, are all basic themes in modern Japanese history. The uniqueness of the Japanese polity was for many wartime proponents of Japanese expansion both a justification for Japan's special rights in Asia, and an explanation for their country's victory over larger, more powerful Western societies. Imperial Will would enable Japan to triumph, just as divine winds (*kamikaze*) had protected Japan against invasion in the thirteenth century. Now Imperial Will and the dedicated efforts of Japanese citizens would protect Japan from defeat. Tragically, as the images of desperation and deprivation in *Fires on the Plain* illustrate, Imperial Will was unequal to the tasks confronting it. Tamura is expected to dedicate himself to serving Imperial Will. He faces a choice denied him by the Japanese code of military conduct. Which will dominate, individual will or Imperial Will?

This struggle between military and civilian values governs Tamura's response to his plight. His choice is subtle and emerges gradually, Tamura's instincts slowly transformed into conscious choice. The film implicitly concludes that personal needs and objectives must transcend national or communitarian demands on the individual. Free will, free choice, and self-determination—all values associated with democratic societies—must triumph over militarism. It is not merely Tamura's survival which is at stake; it is the survival of civilized society and civil values.

This conflict is especially apparent in the relations between Tamura and his military colleagues. As conditions worsen, only the fittest and most ruthless survive. Soldiers prey on each other, and Tamura stands out for his refusal to totally subordinate himself to the military, whose rigid hierarchy devastates the lives of the enlisted men. At the hospital, the medical officers exploit their patients to gain control over their rations. They reject Tamura as a patient, telling him he is too healthy because he is still mobile. The hopeless medical situation reflects that of the military. The army doctors cannot treat all the sick and the wounded. Forced by limited resources, they pick the lost causes, rejecting any whose conditions might improve. Rather than look to the future and protect their patients for service to the postwar nation, the doctors assist the helpless cases to attain their ritualized

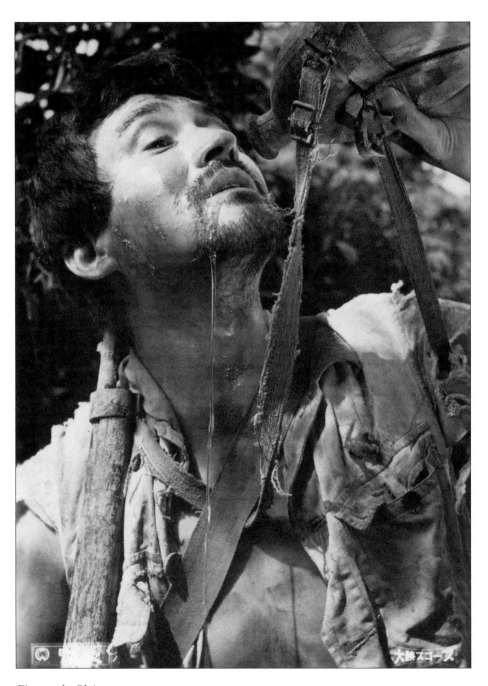

Fires on the Plain

duty of death. Militarism has perverted their sense of purpose. The only survival which concerns them is their own.

Rejected for admission, Tamura joins the stragglers camped in the trees on the edge of the hospital clearing. They are wounded, sick, and abandoned, most on the verge of starvation, except Yasuda, an older soldier who trades tobacco for food. When American artillery destroys the hospital, the doctors steal the remaining rations and abandon their patients to their fate. The already limited sense of community shared by Tamura and the other stragglers vanishes as they rush to save themselves. Fleeing from the hospital clearing, Tamura collapses by a stream, drinks hungrily and fills his canteen. Pondering his situation, he thinks: "I was told to die and intend to do so. Why am I running? Why did I fill my canteen?" He takes out and examines his hand grenade and laughs at the inconsistency of his actions. In the distance he sees the burning hospital with the dead and dying sprawled around it. He cries out: "I won't try to help you, even though some of you are probably alive. Soon, I'll be dead myself." Despite his own best instincts, he accepts the inevitability of death.

Tamura wanders alone for days, unsure of where he is, where he is going, why he is struggling to live. He is frightened by the signs of Filipino life around him, but is even more frightened by war and the spectre of death. This gentle yet determined Japanese soldier is distinguished from those around him by his recognition that life without civilized values is life without substance. He removes his boots to soak his feet in a river. Seeing an ant on the rocks, he gently picks it up and carefully examines it, only to have it bite him. His isolation is complete. Rejected by the army, chased by Filipinos and the advancing Americans, he now finds that not even a lowly ant will accept him as a fellow living creature. His only option is to fend for himself.

In the distance he notices the sun reflecting off a cross on a church spire. The symbol of Christian love and sanctuary beckons to him, suggesting the remoteness of redemption. Arriving in the deserted village surrounding the church, he discovers empty cigarette cartons and other evidence of an American presence in the area. Attacked by a wild dog, he kills it then washes his bayonet at the village tap. His will to live is strong.

Yet this is not the only, or even the most important, point of the scene, for Ichikawa shows us how quickly Tamura's humanity can be stripped away. Walking to the church after cleansing himself at the tap—a Shinto ritual of purification—he finds the steps and the sanctuary littered with the remains of Japanese soldiers. He is repulsed at the scene of a church transformed into a mausoleum. Crows are feasting on the decaying bodies, despoiling the image of the church as a place of spiritual purity and repose. All the symbols of civilized society have been tarnished by the war: communities are abandoned, individuals left to their own devices, even religion is contaminated.

When Tamura attempts to befriend a young Filipino couple who come to the village searching for food and salt, he ironically becomes the killer they presume him to be, shooting the woman when she screams at his overtures, and chasing her boyfriend as he flees. Threatened, Tamura reacts like a soldier. He carefully arranges the dying girl's clothing and shows compassion for her suffering, but when he spies a salt cache under the floor, he roughly pushes her aside. The rapid oscillation between Tamura the humanitarian and Tamura the desperate soldier reflects the severity of his struggle to survive. Having filled his haversack with salt, he continues his quest. As he crosses over a stream, he ceremoniously drops his rifle into the purifying waters of the stream. While he has killed to protect himself, Tamura attempts redemption by discarding his weapon.

Tamura's haversack now contains both life-giving salt and the agent of death, his hand grenade. The grenade was provided by the army, while the salt came from the deserted village, a remnant of civilized society in the Philippines. Unable either to abandon the army or to join with the natives, Tamura is isolated from both his fellow Japanese soldiers and the Filipino victims of the war.

Days later, Tamura encounters three Japanese soldiers, who greet him not as a comrade but as an intruder. The sergeant challenges his right to join them, asking why he wasn't killed with the rest of his unit, wiped out by the advancing Americans. In an instance of foreshadowing, the sergeant, who is prepared to survive by any means, jokingly tells him, "Better be careful, we might eat you." He feels no responsibility for Tamura as a Japanese soldier, but lets him tag along once he discovers that he has salt in his haversack, something they need to assure their own survival. Noting that Tamura has lost his rifle, he finds him a replacement. This symbolically transforms Tamura from a useless straggler into a combatant. When Tamura asks how he found it, the other men caution him not to ask questions. The sergeant is shown to be a brute, prepared to survive at all costs. Tamura and the others, while followers, are also potential victims. The patron-client relationships which characterize Japanese society are replaced in the army by ties between the strong and the weak, lowly soldiers being subject to exploitation and brutalization by the hierarchy.

This image of military exploitation is in direct opposition to the messages of wartime films, which presented the image of a family-style army, with the officers and NCOs portrayed as father figures, taking care of their men; interactions between the ranks are warm and sensitive. The camaraderie of army life, and the communal satisfaction provided by military service to the nation, were important themes for wartime audiences. Consequently films, such as Tomotaka Tasaka's *Five Scouts* or Kozaburo Yoshimura's *The Story of Tank Commander Nishizumi*, present military life and training as a happy experience where all work together for the common good. Soldiers are selfless, sharing their rations and cigarettes, and treating each other with care and compassion. *Fires on the Plain* and other postwar films contra-

dict this image, depicting the brutality of military life and the NCO often as the victimizer of enlisted men, such as those in Masaki Kobayashi's *The Human Condition* and Yasuzo Masumura's *Hoodlum Soldier*.

While Ichikawa's 1956 film, *Harp of Burma*, offered a more ambivalent view of army life, here he presents military life as harsh and dehumanizing. In *Harp of Burma* the sensitive, humanistic captain of Mizushima's singing company, which surrenders and survives the war, is contrasted with the inflexible, domineering captain, who refuses to surrender and is consequently exterminated with his men by the British. In both these companies, despite their different fates, there is a sense of solidarity among most of the men. While many of the holdouts would have surrendered had their officers allowed it, most seem prepared to die for the emperor rather than admit defeat. In *Fires on the Plain*, there is no sense of community or common interest among the Japanese soldiers, merely a desperate struggle to survive as individuals. Comradeship is replaced by constant victimization of the weak by the strong. Military discipline becomes brutal repression. The officer is no father figure, but a domineering, violent overseer, whose will trumps all, whatever the costs.

In *Fires on the Plain*, as in other postwar films, there is a vestige of fellowship among the enlisted men. Several scenes in the film, however, show that fraternity extends only so far as self-interest is not compromised. When the unit clerk tells Tamura, "Die only if you have to," one senses a bond of feeling between them. Likewise, when Tamura talks with the guards as he is leaving the unit, they share his chagrin for the dressing down he received from the squad leader. The two enlisted veterans also show sympathy for Tamura, and try to protect him from their sergeant. Yet, as the film progresses, the fragility of these instincts becomes apparent. Desperate conditions force the Japanese soldiers to fend for themselves, whatever the costs to their fellows. Even Tamura is compromised, though he, more than the others, struggles to protect his humanitarian beliefs.

Tamura's dilemma is similar to that faced by Kaji (Tatsuya Nakadai) in Masaki Kobayashi's *The Human Condition*. This nine-hour trilogy, made between 1958 and 1961, develops its protagonist to a degree impossible in a traditional feature-length film. Kaji is a socialist-humanist, determined to better the conditions of the Chinese prisoners under his supervision at a Japanese mine. Like Tamura, Kaji finds that the war and the army make it impossible for him to make choices consistent with his principles. First as a labour supervisor, then in the army, and finally as a war prisoner in Soviet prison camps, his circumstances force him to commit actions which, while prolonging his survival, undermine his integrity as a civilized man. Both Kaji and Tamura are decent men, aware of the ethical implications of their actions, yet forced by the war to compromise their values to survive. Despite their best intentions, to preserve their moral integrity and civilian values, both are contaminated by their status as combatants. Neither is able to protect himself against the

brutalization and dehumanization of war, and are both rendered unsuitable for normal civil society as a consequence. Both can be redeemed, returned to the human community, only by death.

In the subsequent march to Palompon, Ichikawa introduces a bizarre combination of humour and hopelessness to bring a surreal quality to the Japanese retreat and the soldiers' desperate struggle for survival. The troops pass a man with his face in a puddle. "I'll be like that soon," one jokes. Raising his head from the water, the dying man asks, "What?" his face falling back into the puddle. In an even more striking example of dark humour, boots are exchanged by a series of soldiers for those left behind by others, pointing up the inadequacy of Japanese supplies and the desperation of those marching to Palompon. In each instance, the boots taken are in better shape than those abandoned, until Tamura completes the sequence of exchange. He pulls off his own torn and tattered boots and, pulling on those left behind, discovers his new boots have no soles. Padding in place, he finds he likes the feel of the puddles on his feet. Discarding both pairs of boots, he walks off barefoot. This sequence creates a sense of absolute futility, of cynical defeatism, making the march to escape the advancing American forces both comical and pointless.

Coming to a branch in the trail to Palompon, the retreating Japanese forces are confronted with a highway they must cross. They see American military vehicles, and GIs in one of the trucks randomly fire their weapons toward the jungles, shouting, "Hurry up, you Japs." The hidden Japanese exclaim: "They're all fat as pigs. They must get plenty to eat. First time I've seen them after being chased by their shelling. Ridiculous, isn't it?" Again, humour emphasizes the desperate plight of the Japanese forces. The sergeant whom Tamura has been following tells his men they have to cross the highway. Tamura, who had fallen behind, rushes up at the sound of the sergeant's voice, greeting him with enthusiasm. Still the naïve, well-mannered follower, Tamura is contrasted sharply with the others by his language and his attitude, a stark reminder of how seemingly unblemished he is by his plight and by his army service. It also illustrates the degree to which he has isolated himself from his surroundings.

In fact, unlike the other soldiers fleeing toward Palompon, Tamura is free.

His language and bearing, his ability to read the English lettering on an American jeep, and his brief thought of surrendering to the Americans, distinguish him from the other Japanese soldiers. Wandering through the mist and smoke, Tamura moves across a field littered with bodies and into the hills. A soldier collapses in front of him and dies. Tamura strips off his boots, but there is no humour in this exchange, for Tamura is now hardened in his determination to survive. Passing a wounded man leaning against a tree, he hears him calling to the Buddha to transport him to the Western Paradise. "A special plane will come for me," the crazed man tells him. "I will be saved." Convinced of his salvation, he offers himself to

Tamura: "Eat me after I die. Take this flesh off my arm and eat it." Tamura turns away and runs off in disgust. He tells himself, "Whatever happens, I won't eat human flesh." His survival instincts are strong, but his sense of humanity refuses this one possibility for extending his life. Later, when he finds his friend Nagamatsu and is offered water and "monkey meat," he is unable to eat it and loses several teeth as he tries to chew. When he drops the dried meat, Nagamatsu picks it up, brushes it off, and carefully replaces it in his haversack. For him, the meat represents a guarantee of life. For Tamura it is too tough, illustrating that both physically and morally, the eating of "monkey meat" is beyond his capacity.

Tamura will eventually not only acknowledge the source of the meat, but he will also be witness to the final confrontation between Nagamatsu and Yasuda. They are still together, still dependent on one another, even though neither trusts the other. Under no illusions about how the two have survived, Tamura asks Nagamatsu, who offers him assistance, "Did you mistake me for a monkey?" Nagamatsu's reply is telling. "Don't be foolish," he says, "I wouldn't shoot you. I know you have TB." It is not their friendship which has saved Tamura from slaughter, but rather Nagamatsu's fear of his disease. Desperate for meat, Nagamatsu and Yasuda eventually confront each other, each determined to kill his companion in order to survive. In the end, Nagamatsu calmly shoots Yasuda and savagely butchers the corpse with his bayonet. Revolted, Tamura picks up Nagamatsu's rifle and confronts him. Nagamatsu, his clothes and face drenched with blood, tries to reason with him. Tamura shoots him, disgusted by his cannibalism. Dropping the weapon, he walks off in search of a moral and civilized community. He has preserved his principles but sacrificed his last remaining friend. He is now forever isolated from the remainder of the Japanese army.

Throughout the film, the fires on the plain have symbolized the enemy. Tamura has fled in fear from the plumes of smoke, a visual metaphor for the commonplace life of Filipino farmers and the agricultural cycle of harvest and renewal. Repelled by the desperate efforts at survival by the remaining Japanese, Tamura has come to see the fires as his only hope for a return to a civil society. Raising his hands in the air in a gesture of surrender, he calmly walks toward the burning corn stalks, the fires on the plain. Shots are fired at him, bullets kicking up the dirt around his feet as the voices of Filipino farmers are heard joking behind the smoke. Fearlessly pushing forward, Tamura falls, and appears to be dead. Titles announce that it is "February 1945, someplace on Leyte," and the film ends.

In the Ooka novel, Tamura writes from a mental hospital where he has confined himself following his repatriation to Japan. He cannot deal with the apparent normality of postwar Japan. In the film, he engages in a final act of self-sacrifice to reaffirm his humanity. While he has refused to eat human flesh, he has nevertheless crossed the boundary between civilization and barbarism. His own survival required that he take another's life. By killing Nagamatsu, his friend and protector, he

allows violence to breach his commitment to normal civil society. Tamura is prepared to risk death to achieve reintegration in that community. By walking toward the fires on the plain, he is declaring that life without integrity, life without moral substance, life without the company of his fellows, is devoid of meaning. Despite the innate decency that has protected him from much of the contamination of the war, he has been irrevocably tarnished as a human being. Only the redemption offered by the acceptance of others can sustain his life. He submits himself to his fate as he walks toward the fires on the plain.

Ichikawa's film transforms the message of the original novel and takes it one step further. For the novelist Ooka, the horrors of war and the degradation of defeat make a normal life impossible for Tamura, hapless survivor of the Philippines campaign. He can only retreat to a mental hospital where, isolated from postwar Japanese society, he can live out his remaining years in the company of his private ghosts and terrors. In the film, even this is unattainable. Survival itself is unacceptable unless the victims of the war will accept him into their community. Only their reaffirmation of his humanity as an individual without nationality, without status as either victim or oppressor, can justify his continued survival. While he has rejected cannibalism, he has so compromised himself that he requires absolution by the victims of Japanese oppression. All his civilian values have been despoiled. He must pay for his sins and for the sins of the Japanese army. His final rite of purification, the final cleansing of his guilt, will be at the hands of the innocent Filipino farmers. Just as the burning of the corn stalks represents the culmination of the harvest, so, too, does Tamura's death symbolize the culmination of the war.

Fires on the Plain is an important declaration of the need for all Japanese to purify themselves of the contamination of militarism and war. By illustrating Tamura's inability to accomplish this objective, it reaffirms the importance of moral values and civilized norms of individual behaviour. By showing how the senses of community and nationality were destroyed, by illustrating the brutalization of the human spirit by military discipline and behaviour, by presenting the human costs of overseas expansion and war, the film forces the viewer to reconsider the place of nationalism, imperialism, and conflict in the human community. The simple Filipino farmers represent a more traditional agricultural society than that of Japan. But in the film it is obvious that only they have preserved the essence of civilized community life. They work together, look out for each other's interests, and show sympathy for their fellows. Both in the final scene and elsewhere in the film, one gets a sense of communal solidarity among the Filipinos encountered by Tamura.

In contrast, the Japanese are brutal, self-serving, and unable to sustain a sense of common interest or adhere to conventional norms of moral action. The film's sense of hopelessness is emphasized by Tamura's willingness to offer himself as a sacrifice in order to atone for his sins as a combatant. If even this kind and gentle man, this soldier who seemingly preserved his civilian outlook in the face of severe hardships

and military discipline, was unable to maintain his personal integrity, what chance is there for the rest of us? Is war always unacceptable, given its degradation of the human community? If so, how do we learn to resolve conflicts peacefully? Ichikawa offers no answers in *Fires on the Plain*. However, he forces his viewers to confront essential questions about the fragility of moral society, and makes a major statement about the cultural impact and human costs of war.

This is an abridged version of the essay "*Fires on the Plain:* The Human Cost of the Pacific War" originally published in *Reframing Japanese Cinema: Authorship, Genre, History*, eds. Arthur Nolletti Jr. and David Desser (Bloomington: Indiana University Press, 1992).

Tokyo, 1945

KON ICHIKAWA

The Summer of 1945

IT WAS THE LAST YEAR of the Pacific War. I was newly married and living with my wife in the vacant home of a friend of ours. He had just been sent to the front, and his wife had abandoned Tokyo for the relative safety of the countryside. Unexpectedly, however, circumstances changed: she came back to the city, and we had to look for a new place.

The term "housing crisis" meant something different in those days, when B-29s were dropping incendiary bombs on the city. The actress Tokie Sanjo suggested that I take a look at a house across the street from hers, which seemed to have been vacated. I say "seemed" because an incendiary bomb had made a direct hit on the roof some days before, and when the neighbourhood association fire brigade had rushed inside to put it out, they had found the bomb sputtering on the floor, and the occupants all moved away.

I wasted no time locating the owner of the house. He had heard nothing from the previous tenants, and since it was unsafe to leave the house empty when bombing raids were occurring almost every night, he readily agreed to rent the place to me. Located in the Soshigaya district, it was an elegantly modern residence erected on a property about 200 square yards, with three Japanese *tatami* rooms of three, four, and eight mats, a Western-style room the equivalent of six mats in size, and a detached bathhouse. I moved in immediately. Inside, things were a bit different than the outside view suggested. A hole six feet across had been opened in the roof and ceiling. This was where the incendiary bomb had made its direct hit. Rainwater had entered through the opening, and the blackened pillars, door frames, sliding partitions, and *tatami* mats were already beginning to rot. Realizing we could not live under these conditions, I headed to the studio for building supplies. These were in short supply at the time, but a movie studio is a place where a lot of building and tearing down occurs, so they let me have some used sheet-metal roofing and plywood at cost. They also shared a few of their used *tatami* mats with me, including one used in Hisatora Kumagai's great film *The Abe*

Harp of Burma

Clan (Abe ichizoku, 1938), which had the slogan "To a Glorious Death!" written on it. I set to work at once, sealing the hole with the plywood and roofing, and, when the *tatami* turned out to be insufficient, reversing scorched mats to hide the damage. Since it was summer, I removed the sliding doors and partitions altogether. The more I worked on the job, the more enjoyable it became. Although I had always faced household chores with the greatest reluctance, now I enthusiastically scrubbed the wooden floors until they glistened, pulled the weeds out of the garden, and then turned my attention to the air-raid shelter, a necessity in those days. Once again I set off to the studio, where I obtained some of their discarded beams and boarding, carried them home, and began the task of building the shelter.

The sunken shelter was six feet wide, six feet long, and six feet deep, with boarded walls. I covered these with paper, and painted a variety of designs on them. I took special care with the lid that fit over the opening. I set it at a 40-degree angle to perfectly deflect bomb blasts, and used light materials to make it easier to open. I was just screwing the hinges in place when an old friend, Goro Kadono, gingerly let himself down into the space where I was working. "Hey Kon," he said. "Have you heard? There's going to be an important radio broadcast at noon. You haven't? Well, it seems Japan is going to unconditionally surrender . . . Look, I'll come back again later."

I hadn't had a clue what was taking place. While I'd been so absorbed by the idea of building my own home, the war had come to an end.

1960

Translated from the Japanese by Ted Goossen

Kokoro

ERIC CAZDYN

The Ends of Adaptation: Kon Ichikawa and the Politics of Cinematization

1

KON ICHIKAWA is renowned for adapting almost seventy per cent of his over seventy feature films from literary sources.[1] Ichikawa is also renowned for changing the endings of some of the most key original texts. For example, in Shohei Ooka's *Fires on the Plain* (*Nobi*), after Private Tamura discovers the unbridled cannibalism among the Japanese soldiers in the Philippines, he falls unconscious only to find himself in a Japanese mental hospital. But Tamura is already too far gone and thus Ooka resigns him to chronic suffering as his post-traumatic life collapses and the sadly deficient psychiatrists look on. Ichikawa, on the other hand, shows Tamura shot and killed. By radically altering the ending Ichikawa effectively grants Tamura his salvation (a peaceful rest "in the world of death") and declares his (Ichikawa's) "total negation of war."[2] There is also the classic reworking of *The Key* (*Kagi*) in which Ichikawa, in the final scene, has the maid poison and kill off the three remaining irritating characters, while Tanizaki, in a less "humanistic" move, lets them live. Once again Ichikawa takes liberties with the narrative content in order to stake out his own position and historical relationship to the primary literary text. I read Ichikawa's penchant to adapt and make rather striking changes to the original texts as political symptoms, symptoms that take on significance when read within (1) the history of cinematic adaptation in Japan and (2) the intellectual debates over the nation occurring at the time.

The Japanese term *eiga-ka* (meaning "to make into film" or "to cinematize") refers to that process generally called film adaptation in English. Of course, the most famous example of *eiga-ka* is the over one hundred films made from the story

of *Chushingura*. And then there is the *shosetsu* (the prose narrative). Almost every work in the canon of modern Japanese prose fiction has been made into a film, usually more than once. In two works that track the *eiga-ka* of Yasunari Kawabata and Junichiro Tanizaki, Tatsuki Nishikawa's 1994 *Izu no odoriko monogatari* (The Story of "The Izu Dancer") and Nobuo Chiba's 1990 *Eiga to Tanizaki* (Film and Tanizaki), both authors depart from the *shosetsu* to see what has been done to it over the many decades of remakes.[3] There is much to be gained by tracking how a particular scene has transformed over seventy years as each version, made at a different moment, will necessarily extend its historical concerns—in however unconscious or heavy-handed a way—over the representation of the narrative. One problem with this approach, however, is that although changes in particular *eiga-ka* are tracked, the very concept of *eiga-ka* and how it has transformed over time is usually left unexamined. Thus the very stability of the concept of *eiga-ka*, and the very stability of the *shosetsu* from which the *eiga-ka* departs, remains unquestioned.

For example, what grounds the work of both Nishikawa and Chiba is a well-nigh ontological privileging of the word over the image, the *shosetsu* over the film, and, most important for the task at hand, the original over the adaptation. If these issues are not rethought in relation to film adaptation, then every adaptation of literature serves only to recanonize the *shosetsu* and delegitimate the film. Perhaps as important, the refusal to theoretically question textual origins is almost sure to prevent any extended analysis of how cultural origins might dynamically relate to ideologies of national, political, and racial origins. Rather than examining the transformations of particular *eiga-ka* over time—say Ichikawa's 1959 adaptation of Tanizaki's *The Key* versus Kumashiro Tatsumi's 1974 version, or both of these adaptations (in addition to subsequent ones made by Takanobu Kimata [1983] and Tinto Brass [1984]) versus Tanizaki's 1956 original—I position Ichikawa's work within the transformation of the more general category of *eiga-ka*. I will distinguish two dominant modes of *eiga-ka* that occur at two different moments of modernization (1930s; late 1950s–early 1960s) and show how each mode's conception of "origins" (in relation to an original literary text) differs from the others, and how each relates to dominant ways in which the nation is being thought at its particular historical moment. The task, therefore, is not only to elaborate Ichikawa's position on cinema and aesthetics, but also his position on the most crucial socio-political problems facing Japan during the postwar moment.

2

In the latter half of the teens, the contours began to appear of the *jun-eigageki undo* (pure film movement) that was bent on modernizing the Japanese film industry.

Norimasa Kaeriyama and Yoshiro Emasa of Tenkatsu, Tanizaki and Thomas Kurihara (Kisaburo) at Taikatsu, Kaoru Osanai at Shochiku Research Lab and Eizo Tanaka at Nikkatsu led the movement. Inspired by *shingeki* (new theatre) and Western film, and intent on bringing Japanese film in line with Western developments, the movement was fiercely opposed to the *onnagata* (male performing female roles), *benshi* (the in-house commentator who would accompany Japanese film up until the early thirties), and acting styles that reflected the highly stylized movements of *kabuki* and *noh*. The force of the movement slowed by 1924, the same year that Japanese film experienced a huge surge in production and for the first time surpassed the number of imported foreign films.[4] The movement was short-lived but its effects were extensive.

They can be seen in the first important *eiga-ka* movement to emerge in the mid-thirties.[5] With the "Fifteen Year War"(Imperial Japan's war of aggression in Asia, 1931–1945) already begun, censorship became tighter by the day. One way for directors and the studios to circumvent censorship was to base films on already proven "pure" literature (*jun-bungaku*). Heinosuke Gosho's *eiga-ka* of Kawabata's *Izu no odoriko* (*The Izu Dancer*, 1933) and Shiro Toyoda's *eiga-ka* of Yojiro Ishizaka's *Wakai hito* (*Young People*, 1937) are typical examples of this movement, while standing at the forefront is an *eiga-ka* of Tanizaki's *A Portrait of Shunkin* (*Shunkinsho*) by Yasujiro Shimazu in 1935 (*O-Koto to Sasuke*). This first important *eiga-ka* movement corresponded to the most significant ideological return to "origins" that modern Japan had yet to experience. Whether it was the origins of the Japanese people, in which a single identity ("spirit") is traced back to its origins without being racially sullied; or the origins of economic production, in which Japanese capitalism, with its unique origins based in Japanese industriousness, wondrously avoids the usual effects of labour exploitation, extraction of surplus value, and class divisions; or cultural origins, in which cultural canons are installed with convenient touchstones of genius that neatly advance forward while burying in their tracks the history of cultural contestation, the early thirties marked the moment when film would need to straighten itself out and become an equal partner in advancing the war effort.

Thus, the first important moment of *eiga-ka* occurred in the early to mid-thirties, with the movement following a line of fidelity—one in which the story of the *shosetsu* is linearly traced by the film and the plot is quite literally (and cinematically) granted centre-stage/frame. The second important moment can be located in the late-fifties to early-seventies, with some of the *eiga-ka* connected to the Art Theater Guild's (ATG) productions of canonical *shosetsu*, usually the same works that the first group used. The ATG was (and still is) composed of young film and theatre directors, actors, activists, and other cultural producers in search of an alternative space free from the rigid hierarchies for which the Japanese film corporations are traditionally known. Works within this second moment commonly exceed the

original text by either focusing on a particular section or adding content to the narrative (for example, Kaneto Shindo's 1973 production of *Kokoro* focuses on just the third section ["Sensei to isho"] of Soseki's famous prose narrative; " Ichikawa's 1955 version of the same novel comprises its entirety). It is here where we can situate Ichikawa's *eiga-ka* in the late 1950s and 1960s.

The dominant aesthetics of *eiga-ka* during these two stages interestingly connect to the dominant national discourses of their respective historical moments. The 1930s was a decade in which the Japanese imperialist project was being ideologically justified at home. The West was attacked by both the Japanese left and right in which Western history was being rewritten and native texts recanonized. The highest philosophical defence for nationalist based aggression came from the Kyoto school thinkers who, in building on Kitaro Nishida's search for metaphysical certainty, theorized Japan's optimal position to lead Asia. During the sixties and seventies, the West was still a target of mass social movements, but it came second to the Japanese state itself. It is within this context that various *eiga-ka* make noticeable departures from the original literary text. Despite the differences of the two movements, they are united in their comparable dependence on the identity and integrity of the original *shosetsu*. The same can be said about the nation. Whether the nation is ferociously attacked or frenetically defended, what remains is the integrity of the nation as such: it provides leverage, a centre, a point to coordinate with or against. The stability of the national form during two different moments of political upheaval, then, can be compared to the stability of the *shosetsu* form at two moments of *eiga-ka*.

By delineating these two moments and assigning a dominant form of adaptation to them, I do not want to suggest that there are not diverse modes of adaptation occurring throughout these decades of Japanese film history. Even though I detect an emerging form of "fidelity"-based adaptation in the mid-thirties, it does not exclude the existence of radically alternative forms: ten years earlier, for example, Kisaburo Kurihara's 1926 film *Sanjigoto*, an adaptation of D.W. Griffith's 1911 *Enoch Arden*, itself an adaptation of the 1864 Tennyson poem of the same name. Kurihara whimsically transforms a rather staid morality tale into a Chaplinesque farce about greed and self-indulgence. Ozu's 1935 *An Inn in Tokyo* (*Tokyo no yado*) portrays itself as an adaptation of the original story by a writer named Winthat Monnet, a fanciful move on Ozu's part since Winthat Monnet is nothing but a sly parody of "Without Money." Any number of contemporary nostalgic adaptations of canonical literature (such as *The Tale of Genji* and *Botchan*) in animation form (intended as learning tools) never question the identity of the original text. To set up these two modes of adaptation that occur at two moments of Japanese modernity, then, is not to obliterate the heterogeneity of production during each moment, as these examples illustrate. In fact, it is to do the exact opposite: to draw attention to the coexistence of other modes whose meanings and effects can be

more significantly registered when examined in relation to the dominant. Fredric Jameson calls such a dominant mode a force field "in which very different kinds of cultural impulses must make their way." He continues, "If we do not achieve some general sense of a cultural dominant, then we fall back into a view of present history as sheer heterogeneity, random difference, a coexistence of a host of distinct forces whose effectivity is undecidable."[6] Only by isolating these two moments of adaptation am I able to reflect on their political meanings and speculate on how film both shapes and is shaped by the most profound problems of Japanese modernity, and by the Japanese nation as well.

3

One of the most interesting elements of the early *benshi* system is how the identity and integrity of an original text is severely undermined. For example, since early films were usually under an hour long and early Japanese film audiences were accustomed to three-to four-hour theatre experiences (as was regularly the case in *noh* and *kabuki*), theatre owners might employ four *benshi* to comment on the same series of images. In this way the same film could be transformed, depending on the proclivity of a particular *benshi*, from a melodrama, to an action-adventure, to a period piece, even to a documentary about the Russo-Japanese War. Hiroshi Komatsu has written that the *benshi* Toyojiro Takamatsu would travel around the country, walk into any theatre showing any film, and always transform the film's narrative into a statement about labour issues.[7] With the *benshi* able to compensate for any incoherence that the film might not be able to manage visually, directors would be less concerned with producing continuous narratives. In this way early films were left "incomplete," always anticipating a subsequent transformational/translation process.

The openness of the *benshi* system suffered attacks from both the political right and the cultural left. Beginning in the early twenties the deregulation of the *benshi* system was streamlined by the Japanese police who began a *benshi* licensing system. In 1926, bureaucrats in the Ministry of Education held seminars in order to teach "proper" film commentary techniques and distribute written materials that outlined step-by-step rules. Indeed, one effect of this pedagogy was to privilege the original film over and above its transformation or adaptation by the *benshi*.

The cultural left also attacked the *benshi* system for inhibiting progress and development of Japanese film. With the *benshi* more famous than both directors and actors, audiences were becoming dependent on having commentary and explanation always provided for them. Moreover, the high-culture pretensions of some artists were interrupted by the bustle and noise the *benshi* provoked in the theatres.

For example, Kaoru Osanai was always impressed with how Western theatre audiences sat still and quiet during a performance and how this type of spectator focus was more conducive to transmitting political, social, and aesthetic agendas. Osanai, along with Tanizaki himself, believed that only by producing films that stand on their own, without the interference of the *benshi* (or too much dialogue or titles for that matter), could a more artistic and modern film culture prosper in Japan.

A. A. Gerow argues that an important transformation occurred within the lifespan of the *benshi* system. This shift is marked by a change in terminology from *benshi* to *setsumei-sha* (explainer). The former term suggests more freedom from the film being screened (such as incorporating personal commentary, historical background, peformative dialogue); the latter a more constricted role in which the accompaniment would transmit only the established meaning.[8] With the shift, finally, comes the strengthened identity of the original text as the *benshi* takes on the role of the passive translator.[9]

The privileging of the original in the *benshi* system occurred at a time when nationalist discourse in Japan itself was transforming. The global economic crises of the inter-war years abruptly shattered any hope of an integrated world economy. By 1913, ideals of free trade were quickly discarded and capitalist economies were moving precipitously toward state-managed models. Supported and guided by the government, the Japanese economy was no exception. The result: a reformulated nationalism and a retrenched nation-state. On the global situation, Eric Hobsbawm writes, "... as the economic blizzard swept across the global economy, world capitalism retreated into the igloos of its nation-state economies and their associated empires."[10] Of course, Japan differed considerably from its Western counterparts, but it still remained part of, and influenced by, the world system. As with the economy, so too with culture. Any hope during the Taisho democracy period (1912–1926) of a hybrid culture, one not limited by the strictures of Japanese tradition, was dashed. Just as with the *benshi* commentary, many cultural forms saw their progressive possibilities snuffed out by nationalist ideologies that—on the level of the aesthetic—held tight to the absolute separability of an original and its translation/adaptation. Indeed, from Taisho to early Showa (1926–1989) a return to national and aesthetic origins (however much "invented" in the present) occurred with a vengeance. And this intersection of aesthetic and national imperatives comes into sharp focus precisely at the site of *eiga-ka*.

4

In 1935, Tanizaki wrote an article in a local film magazine regarding his recent impressions about film and the 1935 *eiga-ka* of his *A Portrait of Shunkin*.[11] The essay is

at once a sour critique of recent film currents in Japan, as well as a harsh discouragement against ever being able to successfully adapt his *shosetsu* to film. These are not the impressions, however, of a writer who resents the popularity of the new medium and rejoices in bashing film's inferior status while privileging the more important work of literature. Tanizaki, in fact, was one of the most important spokespersons for the great potential that film offered. Only twelve years earlier he wrote several articles explaining film techniques and terminology ("Eiga no tekunikku") and his own excitement over Robert Weine's *The Cabinet of Dr. Caligari*.[12] His "Katsudo shashin no genzai to shorai" ("The Present and the Future of the Moving Pictures," 1918) was a well-informed paean that celebrated the new medium and prepared Tanizaki's own entrance into film production the following year for the newly developed Taikatsu film corporation.[13] Of course, after the Great Tokyo Earthquake in 1923, Tanizaki moved to Osaka and began experimenting with more traditional content, as exemplified in his three *Genji* translations as well as the *shosetsu* he produced in the 1930s (such as *Momoku monogatari* [*A Blind Man's Tale*, 1931], *Bushu ko hiwa* [*The Secret History of the Lord of Musashi*, 1931] and of course *A Portrait of Shunkin* in 1933). But traditional content does not require the use of traditional form. And it is on the level of form, just as with his first of three translations of *The Tale of Genji*, that Tanizaki made his most significant interventions during this period. Tanizaki's critique of the *eiga-ka* of *A Portrait of Shunkin*, therefore, was not an orthodox attack against film, but an attack on how the *eiga-ka* of the 1930s would obliterate what was most radical of the *shosetsu*—its formal strategies.

A Portrait of Shunkin begins with a writer (the I of the *shosetsu*) visiting the graves of a famous blind musician (Shunkin) and her assistant/disciple/lover (Sasuke).[14] The writer, who is narrating in the present, the early 1930s, attempts to piece together the fascinating story of the young lovers' lives by reading an official tract on the couple, speaking with a woman who worked for them (Teru Shigizawa), reading newspaper articles, and so on. Tanizaki leaves the various details of the *shosetsu* ambiguous, for example the very truth or falsehood of the legend itself. The authorship of the "Legend" (the official tract), moreover, is also questioned for, although there is no ceremonial mark of identification, the narrator can only guess that the writer is Sasuke on account of how white-washed the representation of Shunkin is. These principal ambiguities then serve to direct suspicion to the other details within the narrative. As in most of his work, Tanizaki is able to foreground problems of representation and pull apart the usually seamless threads of a narration, while—at one and the same time—weave a delicate story that delivers aesthetic compensation for its reader's hermeneutic trials. It is this form of providing a positive and negative hermeneutic at the same time that is the most profound feature of Tanizaki's work produced during the war years.

In a 1933 essay Tanizaki writes about how he would produce an *eiga-ka* of *A Portrait of Shunkin*: ". . . if I were to produce an *eiga-ka*, I would eloquently paint

Shunkin's fantasy world, from the point when Sasuke is blinded, and combine this with the real world. In fact, I'm not sure whether or not this could be done, but if it succeeded I really think it would produce a tremendously interesting work."[15]

This plan is certainly far from what Yasujiro Shimazu produced with his 1935 *eiga-ka* of *A Portrait of Shunkin*, entitled *O-Koto to Sasuke*, one of the most significant works of the *bungei eiga* movement (films based on literary masterpieces) that was emerging at the time. The aim of the movement was to produce *eiga-ka* from recognized literary works in order to (1) legitimate the artistic qualities of film, (2) evade the growing censorship at the time, which coalesced in the 1939 Film Law, and (3) further instantiate Hollywood codes, thus further marginalizing the role of the *benshi*. (Ichikawa was to rely on similar measures to defend his adaptation of Shintaro Ishihara's controversial 1956 novel *Punishment Room* against accusations of incitement to violence.) When we look at the data on film production between the years of 1924 and 1945 (as provided by Mitsuo Inoue's *Nihon eiga kyoryuki no sakuhin kiroko* [A Film-by-Film Record of the Periodic Rise in Japanese Cinema]) what is most striking is the rapid increase in films based on literary texts.[16] As for Nikkatsu, one of the largest corporations at the time, in 1924 only seventeen per cent of the films were based on an original literary text. There is then a steady increase with the rate moving to forty-four per cent by 1930, forty-eight per cent by 1935 and fifty-eight per cent by 1941. One way to explain this dramatic increase is to place it in relation to the parallel increases in censorship; with the chosen text already approved, the film project had jumped through the first hoop of legitimation. When we look at the most successful *eiga-ka* of the thirties (by Gosho, Toyoda, and Shimazu for example as well as Kimisaburo Yoshimura and Minoru Shibuya) we locate a dominant form that (1) presents a linear temporality, (2) focuses primarily on dialogue to advance the plot, (3) centres on characters in the frame and overall narrative, (4) de-emphasizes narrative complexity, (5) contains little non-diegetic sound, and (6) refrains from adding or cutting elements of the original text that might distort its dominant canonical reading. These characteristics represent a "fidelity"-based adaptation.

Starring Kinuyo Tanaka, one of the best known actresses of the time, *O-Koto to Sasuke* is as "faithful" to Tanizaki's *shosetsu* as film could be at the time. (It should be remembered that the talkie was less than five years old while female film acting was less than fifteen.) The multiple levels of narration as well as the "I" of Tanizaki's *A Portrait of Shunkin* are eliminated; thus the problematic of representation that is so central to Tanizaki's work also disappears. Whereas the *shosetsu* cuts up time by referring to various sources, Shimazu's film establishes a simple chronological ordering of events. Time is subordinated to the cause-effect chain by, as Bordwell and Thompson note in *The Classical Hollywood Cinema*, "omitting significant durations in order to show only events of causal importance."[17] Shimazu employs another classical Hollywood characteristic with the hard close, leaving no loose-

ends that might undo the narrative itself. Finally, the centreing of narrative events and the cause-effect chain is matched by a compositional centreing of the characters in the frame. Without the narrative sophistication and meta-text on textuality itself, the action generates from individual characters as causal agents. Stripped of all the *shosetsu's* idiosyncrasies and not "adding" anything to it, *O-Koto to Sasuke* was bound to disappoint Tanizaki. (This, of course, contrasts with Ichikawa's later adaptations of Tanizaki, *Kagi* and *The Makioka Sisters*, which certainly fulfill the novelist's desire for freedom in adapting and autonomy from the *shosetsu*.)

Tanizaki admits to have never seeing Shimazu's film. He writes:

> Yasujiro Shimazu sent the script to me, but I'm really embarrassed to say that I never read it. Speaking about film scripts: because film and literature are really two separate things, to make *Shunkinsho* [*A Portrait of Shunkin*] into a sufficiently cinematic film would require one to *freely* deconstruct it and then reconstruct it again. Since this is the best way to proceed, there is sure to be difficulty if the person in charge of the script cannot be trusted.[18]

Tanizaki goes on to add, "... I have no hope for the film.... But this is not simply a comment about *Shunkinsho*, I have been unhappy with all of the previous films made from my own work."[19]

When Tanizaki's work becomes mere narrative content, as it did in Shimazu's *eiga-ka* of *Shunkinsho* (and as was the underlying quality of the *bungei eiga* movement), all that remains are the most reactionary and conservative elements. But, as Tanizaki makes clear in an article at the time, "if the film would exceed the *shosetsu* ... then something extraordinary might result."[20] Only by moving beyond the *shosetsu*—without leaving it—could there be the possibility of such a project. But when Tanizaki writes, "in fact, I'm not sure whether or not this could be done," one wonders whether he is referring to the technical possibility or the historical one.[21] In other words, is it that he personally would not be capable of producing such a work, or that film technology was not capable of producing such a work, or that the historical situation itself prevented the very possibility of producing such a work?

Whatever he may have intended, the historical limitations are what interest me here. The *eiga-ka* that Tanizaki dreams of making has less to do with solving the aesthetic riddle of how to make a film from a *shosetsu* and more to do with articulating an imaginary solution to the growing paradoxical situation of the Japanese nation in the years leading up to the Second World War. To push this relation between the aesthetic and the national even further, Tanizaki's dream *eiga-ka* could be read as a dream *nation* in which Japan could reach utopian heights only by moving beyond the *West* without leaving it. Thus, Tanizaki produces an aesthetic solution to an impossible problem at the time, that of criticizing the West without

at the same time embracing a destructive ultra-nationalism. By constructing a formal utopia on the level of aesthetics Tanizaki negotiates the most crucial social contradiction of the 1930s: between being colonized and being a colonizer nation.

But in the postwar moment both the technical and historical limitations have transformed, and Tanizaki's dream film (one that carves out a new relation to the original literary text) is in fact made by Kaneto Shindo (his 1972 *Sanka*, adapted from *A Portrait of Shunkin*), not to mention Ichikawa's *eiga-ka* of *The Key*. Yet with a transformed historical situation in which both the nation—and the world system—function differently, the meaning of Tanizaki's dream-film is not entirely clear. At precisely the moment when the film can be made, the very social contradiction (colonized/colonizer) that produced the need for its formal solution slides into something else. To put this another way: precisely when Japan finally threads the needle, thirty years later, between East and West (by what came suspiciously to be called the Japanese "economic miracle"—synthesizing "Western" capitalist practices and "Eastern" spiritual ones; for example, Japan Inc.; Zen Capitalism) the very problem of East/West is no longer the most pressing social issue of the day.

5

Shindo's *eiga-ka* of *A Portrait of Shunkin*, in the spirit of Tanizaki, undermines its own sources. For example, we see the author walking into an old folks home where he is to meet Teru (the former servant of Shunkin and Sasuke). Sitting across a table from her, the author explains that he has come to inquire into the legend of Shunkin. Teru, played by Nobuko Otowa who is also director Shindo's wife, appears to want nothing to do with her inquisitor. "I have nothing to say," or "I don't know a thing" is the extent to which she replies. When Teru stands up to leave, the author pleads with her to stay and reminds her that he has reserved the whole morning so she might as well relax. Teru begrudgingly agrees but not before lending doubt to her own motivations for, and thus credibility of, the narrative she will tell.

There is also the matter of the author character himself. The film is fraught with shot/reverse-shot sequences of the author speaking with Teru. These are always shot frontally, with the camera on the centreline, so that the entire face of each character occupies the frame. This technique is most conspicuous when the narrative returns to the old folks home and there is an abrupt cut to the author's face in which his eyes are blankly staring forward and a stream of blood is slowly running out of his mouth. The shot (at three different moments during the course of the film) is held for a few seconds before cutting to Teru's face and then back again to the author's, but this time without the blood and with a slightly more reflective expression. These scenes are always positioned after long excursions,

approximately fifteen minutes in cinematic time, back into the narrative of Shunkin and Sasuke. In other words, right at the moment when the author (or the viewer) is gaining uncritical interest in the legend, the stills of the author's bloody face ingeniously shake us out of our reverie and back into the problems of representation.[22]

Despite these formal similarities, on the level of narrative content Shindo's film and Tanizaki's *shosetsu* differ quite significantly. Many of the scenes that are merely suggested by Tanizaki are filled in and embellished by Shindo. Take, for example, the sex. Tanizaki writes in his *shosetsu*, "Sexual relations are infinite in their variety. Sasuke, for example, knew Shunkin's body in the most exhaustive detail: he was bound up with her in an intimacy beyond dreams of any ordinary husband and wife or pair of lovers."[23] In the film, however, as Shindo has Teru spy on the two lovers, we see Shunkin fully naked and in the throes of ecstasy while Sasuke, with knitted brow and still wearing his cotton kimono, is wholly focused on pleasing her.

It is precisely these excesses that obligated film critic Kenichi Matsumoto, in a 1973 article in the journal *Eiga Hihyou*, to pan the film.[24] Entitled "Kindai shugiteki meishi no kansei" ("The Pitfalls of Modernist Transparency"), Matsumoto essentially attacks *Sanka* for shining too bright a light on the dim beauty of Tanizaki's imaginary. He argues that Shindo makes a fatal methodological error by constructing the Teru character as a seer, thus providing more detail than necessary. Matsumoto writes, "To be able to see right through the misty beauty of Shunkin and Sasuke's world is the hubris of rationalism, or rather of the rationalism that is part of modernism."[25] Matsumoto concludes his polemic by writing, "By shining the light on the details one is unable to see what is unseeable."[26]

With this last line, Matsumoto implies that Tanizaki's shadows and lack of detail render the unseeable seeable.[27] What Matsumoto fails to see, however, is how the accuracy of what Teru sees is itself undermined in Shindo's film. More importantly, Matsumoto's assumptions about Tanizaki's *shosetsu*, and his assumptions about aesthetics and adaptation in general, need to be questioned. When Matsumoto compares Shindo's film to Tanizaki's *shosetsu* he does not account for the fact that the cultural and politico-economic situation has transformed. And it is precisely this modified situation that must be accounted for before a more subtle analysis can be conducted of the aesthetic meanings and effects of Shindo's *Sanka*.

6

This brings us the work of Kon Ichikawa, for I position his reworkings of literary endings in the late fifties and early sixties as prefiguring and akin to Shindo's approach. I read these experiments in cinematic adaptation as political allegories in the context of the rise and fall of social activism at the time, such as the student

movement and the rapid growth experienced by the Japanese economy. Of course, the struggle leading up to the ratification of the U.S.–Japan Security Treaty (Ampo), the threat of nuclear weapons, the start of the Korean War, the signing of the San Francisco Treaty, and the Vietnam War mobilized the students to think more about the role of the Japanese nation-state. The struggles at Waseda University and the University of Tokyo, in which courses were cancelled as students barricaded themselves in university buildings, are symptomatic of hundreds of other demonstrations and sit-ins across the nation. The movement began to wither, however, after the ratification of the U.S.–Japan Security Treaty in 1960 and when Prime Minister Ikeda and his cabinet presented a new model of growth for the Japanese economy. Ikeda's plan was not only met but exceeded, and by the 1964 Olympic Games in Tokyo, the commencement of the Bullet Train services on the New Tokaido Line, and the completion of the Meishin Expressway between the eastern and western parts of the country, Japan was finally considered one of the advanced capitalist nations of the world.

These strong economic indicators made any anti-capitalist politics difficult to sustain. For example, dissent would often be met by an appeal to the visible growth in living standards and impressive additions to the built environment. The demise of the left in Japan was further exacerbated during the 1970 ratification of Ampo and the *Sekigun's* (Japanese Red Army) hijacking of a Japan Airlines flight to North Korea in the same year. The hijacking marked a time when public sentiment became highly critical of the student movement in general and its militancy in particular. All of this marked the end of a certain utopianism in Japan: not only did the critical force and political urgency in the universities cool, but there was also a redoubled acquiescence to the rhetoric of the Japanese "economic miracle."

During these years whether one was criticizing the nation or defending it, the nation as the central organizing unit was essential. Which leads us back to the relation between national discourses and cinematic discourse on adaptation. Both Shindo's and Ichikawa's adaptations, no matter how experimental they were in relation to the original *shosetsu*—like the nation for the coterminous social movements—the *shosetsu* remained the central organizing unit. Thus far I have presented two stages of *eiga-ka* and how each relates to national discourse. The first moment of *eiga-ka* in the 1930s, represented by Yasujiro Shimazu's *eiga-ka* of Tanizaki's *A Portrait of Shunkin* and other *bungei eiga* works, is dominated by a more "faithful" allegiance to the original *shosetsu* in a way not unlike the "faithful" allegiance to the mythic origins of the Japanese nation held by most citizens during the wartime years. The second phase is dominated by a more "free" connection to the original *shosetsu* (represented by Shindo's *Sanka* and the *eiga-ka* of Kon Ichikawa) and its reconfiguration of the original *shosetsu* so as to engage the different social problems of the present.

But it is here where I want to make a distinction between Ichikawa and Shindo. Shindo, one of the more politically active Japanese film directors, suggests that his

film can be read as a response to the social movements of the day.[28] Ichikawa, less radical than Shindo but equally as critical of the one-way street of economic modernization, is similarly suspicious of the reverse course the nation has taken in relation to the immediate postwar ideals of democratization and demilitarization. I read Ichikawa's film adaptations of that time, therefore, as attempts to criticize the Japanese nation and the continuities it shared with the pre-war era, while at the same time not wanting to give up the possibility that the nation could still be employed in an effective and progressive way. Ichikawa and Shindo, and many others tied to the social movements of the sixties and seventies, attacked the Japanese nation, *but only on the level of content*—which is to say that they attacked officials, laws, security treaties, and so on. The *form* of the nation, however, was spared and strengthened as an effect of being placed at the centre of debate. These dynamic categories of form and content can also be employed to think about how Ichikawa and this second wave of *eiga-ka* engaged original literary texts. Shindo and Ichikawa, for example, seem to be critiquing the narrative content of Tanizaki's *shosetsu* (by adding more to them, or by shining a light on what is already there) but the form is respected and brandished as what is most valuable.

No matter how critical the political and cultural movements were toward the nation or toward older cultural forms—fundamentally—they remained securely anchored in them. Likewise, Ichikawa critiqued the content of Ooka's *Fire on the Plain* and Tanizaki's *The Key*, while still retaining the identity of the work. And all of this prepares the way to examine the transformations in adaptation and the nation at the present moment—a moment in which there seems to be a turn to different forms of adaptation based less on an essential relation to the literary text and more on a radical decentreing and destabilization of the original text altogether.[29] Is it a coincidence that this is occurring at the very moment when the decentreing and destabilization of the nation-state itself is occurring in the face of global capitalism?

Notes

1. Kon Ichikawa and Yuki Mori, *Ichikawa Kon no eigatachi* (The Films of Kon Ichikawa) (Tokyo: Waizu Shuppan, 1994).
2. Joan Mellen, *Voices from the Japanese Cinema* (New York: Liveright, 1975), 124–25. Also see Mellen, *The Waves at Genji's Door: Japan through Its Cinema* (New York: Pantheon Books, 1976), 194.
3. Tatsuki Nishikawa, Izu no odoriko *monogatari* (The Tale of "The Izu Dancer") (Tokyo: Firumu Aato, 1994); and Nobuo Chiba, *Eiga to Tanizaki* (Film and Tanizaki) (Tokyo: Seiabou, 1989).
4. In 1923 Japan produced 4,686 films and the West 9,896, while in 1924 Japanese

production grew to 9,379 films while the Western production dropped to 7,636. From *Kinema Junpo* (1 April 1930): 166.

5. Before this time, there were several different modes of adaptation experiments, but no dominant form that emerges with any historical significance (at least in the way I argue the "fidelity" mode emerges in the 1930s).

6. Fredric Jameson, *Postmodernism, or, The Cultural Logic of Late Capitalism* (Durham: Duke University Press, 1991), 6.

7. Hiroshi Komatsu, "Some Characteristics of Japanese Cinema before World War I," trans. Linda C. Ehrlich and Yuko Okutsu, *Reframing Japanese Cinema* (Bloomington: Indiana University Press, 1992), 240. Also, Chieo Yoshida, *Mo hitotsu no eiga-shi: Katsuben no jidai* (Tokyo: Jiji Tsushin-sha, 1978).

8. Gerow, A.A., "The Benshi's New Face: Defining Cinema in Taisho Japan," *Iconics* 3 (1994): 73.

9. Kokatsu Takeda, *Setsumeisha no shimei, katsudo kurabu* 4.12 (1921): 96. Writing in 1921, Takeda lobbied for the *benshi's* role to be limited to translators (*honyakusha*) in which it would be restricted to uninspired translations of the foreign language films.

10. E. J. Hobsbawm, *Nations and Nationalism Since 1780: Programme, Myth, Reality* (Cambridge: Cambridge University Press, 1990), 132.

11. Junichiro Tanizaki, "Eiga e no kansou: Shunkinsho eig-aka ni saishite," *Tanizaki Junichiro zenshu* (The Complete Works of Junichiro Tanizaki) (Tokyo: Chuo Koronsha, 1958) vol. 21, 317–21. Originally published in *Sande haru no eigago* (April 1935).

12. Junichiro Tanizaki, "Eiga no tekunikku," *Tanizaki Junichiro zenshu*, vol. 28, 113–120, originally published in *Shakai kokka* (October 1923); "Karigari hakushi wo miru," *Tanizaki Junichiro zenshu*, vol. 28, 107–112, originally published in *Katsudo Zashi* (September 1923).

13. Tanizaki, "Katsudo shashin no genzai to shorai," *Tanizaki Junichiro zenshu*, vol. 28, 13–21; originally published in *Shin-Shosetsu* (October 1918). Tanizaki, along with Kurihara Thomas, were both recruited by the new Yokohama start-up film company, Taikatsu, in 1920. On Tanizaki's films and work at Taikatsu see Chiba's *Eiga to Tanizaki*, especially pages 7 to 22.

14. The *shosetsu* appears in *Tanizaki Junichiro zenshu*, vol. 1, 67. I will refer to this edition unless otherwise noted.

15. Tanizaki, "Eiga e no kansou," *Tanizaki Junichiro zenshu*, vol. 21, 321.

16. Mitsuo Inoue, *Nihon eiga yoryuki no sakuhin kiroku* (Tokyo: Fukui Shokai, 1988).

17. David Bordwell and Kristin Thompson, *Film Art: An Introduction* (New York: McGraw Hill, 1997), 108.

18. Tanizaki, "Eiga e no kansou," *Tanizaki Junichiro zenshu*, vol. 21, 317.

19. Ibid., 317–18.

20. Ibid., 317.

21. Ibid., 317.

22. Almost inexplicable, these blood scenes seem to comment on the seduction of storytelling and the ceaseless back-and-forth movement between losing ourselves in the content of a story (legend, ideology, etc.) and regaining our critical attention to the means of representation. As for Shindo, his only explanation of the scene is the following enigmatic line: "the author's drops of blood relate to him eating the lives of Shunkin and Sasuke." Quoted in Matsumoto's "Kindai Shugiteki meishi no kansei: Shindo Kaneto *Sanka* to Tanizaki Junichiro *Shunkinsho* no kiretsu" (The pitfalls of modernist transparency: The gap separating Shindo Kaneto's *Sanka* and Tanizaki Junichiro's *Shunkinsho*), *Eiga Hihyo*, vol. 1 (1973): 37. Indeed, it is this image of consuming past narratives for present sustenance that seems consistent with the argument being made here.
23. For this quotation I have used Howard Hibbett's translation from *Seven Japanese Tales* (New York: Vintage International, 1996), 44.
24. Matsumoto, "Kindai Shugiteki meishi no kansei," 32–40.
25. Ibid., 38.
26. Ibid., 38.
27. Matsumoto predictably refers to Tanizaki's *Inei raisan* (*In Praise of Shadows*) to dramatize Shindo's misrepresentations. *In Praise of Shadows*, trans. Thomas J. Harper and Edward G. Seidensticker (New Haven: Leet's Island Books, 1977).
28. Shindo has actively participated with leftist political movements from the 1950s to the present. Known for living an extremely modest lifestyle with Nobuko Otowa (before her death in 1995), Shindo is a prolific writer and public speaker and has a dedicated following among Socialist and Communist party members.
29. I see this most conspicuously in a number of documentary experiments, most notably by Kazuo Hara and his 1994 film *Zenshin shosetsuka* about prose narrative writer Mitsuharu Inoue.

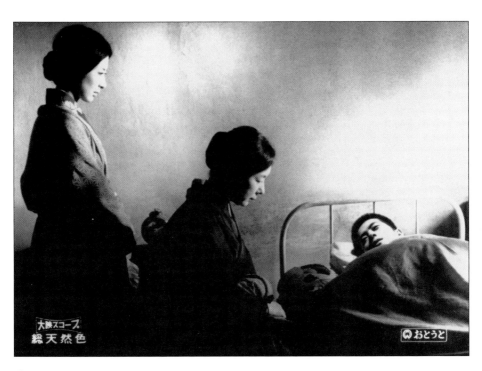
Ototo

KON ICHIKAWA
YUKI MORI

Ototo

YUKI MORI: *Ototo* (*Her Brother*, 1960) is one of your most important works, together with *Tokyo Olympiad* (1965) and *Enjo* (*Conflagration,* 1958). I heard a lot went on behind the scenes before shooting began.

KON ICHIKAWA: Yes, I wrote about it in detail in *Seijocho 271 banchi*. Initially I was moved by Aya Koda's original novel, and was again impressed by Yoko Mizuki's script, which was published in a magazine called *Scenario*. I envied whoever would make a film out of it. But the project began to drift . . .

MORI: From Shochiku to Tokyo Eiga, and . . .

ICHIKAWA: I heard that Tomotaka Tasaka would direct it. I followed the project eagerly, and finally discovered that no one would make it. So, I insisted that I would do it. After obtaining the rights, I persuaded Daiei. It took years, but a young director's devotion made the dream come true. (Laughs)

MORI: Yoko Mizuki wrote great scripts for Tadashi Imai and Mikio Naruse, but this was your first film since *The Blue Revolution* (*Aoiro kakumei*) based on a script not written by Natto Wada.

ICHIKAWA: Yes, it was. Natto-san also liked Mizuki's script very much. Both of us thought it would be a waste if no one made a film from it.

MORI: It's strange, but whenever I watch this film, I forget the fact that the script was written by Mizuki, because *Ototo* is very consistent with your and Wada's inquiry into human nature. (Laughs) It may be an odd question, but have you ever asked yourself what it would have been like if the script had been written by Wada?

ICHIKAWA: No, never. I changed the opening sequence, though.

MORI: The scene with the umbrella?

ICHIKAWA: Yes. I added it with Mizuki's approval.

MORI: After the sister and brother separate, water drops stream onto the image and

the credits appear and disappear on a surface of white water. Transience is emphasized in this opening. What in particular did you like about Mizuki's script?

ICHIKAWA: I was impressed by her brilliant depiction of essential human problems within the drama of one family. I also strongly felt the protagonists' loneliness.

MORI: The family members in the story have a very difficult relationship with each other. The father is a literary scholar who doesn't take much care of his family, the mother is his second wife who suffers from rheumatism, the sister is reliable, and the brother is on the verge of going astray. When you made the film, you said that a human is lonely even if he or she is in a family. You insisted that it was important for each member of a family to know that everyone was lonely and, then, to love one another. I think this is a consistent message in your films. Even though I don't think your filmography can be categorized simply on the basis of thematic statements, I believe that the interpretation of loneliness and love is your basic and important theme.

ICHIKAWA: I agree with you.

MORI: Do you still think so?

ICHIKAWA: Of course. Time has changed, and the way I express the theme might be different, though.

MORI: Your films propose one idea about communication. As long as two human beings exist, there will always be a distance between them. The characters in Ichikawa's films always calmly struggle to fill the gap. How did you come to consider loneliness in this way?

ICHIKAWA: Of course it came from my own experience, from experience in my youth like everyone else. More simply, the occupation of film director is a very lonely one.

MORI: Yes?

ICHIKAWA: Since directors work surrounded by large crews and cast, they are called a "group" or a "family." But a director is alone after all. His occupation is to create something sitting in a chair in a room all alone.

MORI: Do you mean that a director is responsible for all the work?

ICHIKAWA: No, it's a totally different level of responsibility from collective work; in filmmaking, a director has to think that he or she is making a film by him or herself. Of course, I have other people's advice, I learn many things from other people, and, on the contrary, I openly say what I feel. On the one hand, a director must, as a leader, instill his passion in the members of his staff. On the other, a director has to think about harmony among people. Other than daily life with my family, my body and mind are always preoccupied with these complicated situations. Therefore, I think I tend to arrive at the theme of loneliness whenever I make films.

MORI: You mean you have reached that theme after a journey of making films?

ICHIKAWA: I don't think I have arrived at the last stop.

MORI: Your story strikes me as true to nature. This may sound impudent, but I think it is a great conclusion that we should love one another after understanding everyone's loneliness. I am very attracted by the humane nature of your films. I am really glad your films are not nihilistic, dealing only with the anguish of loneliness. (Laughs)

ICHIKAWA: At one time I often lost myself because I was too anxious about what other people feel.

MORI: You have expressed yourself by painting, filmmaking, and so on, since you were a small child, which means you have always had to maintain your individualism.

ICHIKAWA: I have always sought it. But the truth is I want to communicate with other people and I love to understand others because I am lonely.

MORI: What do you think about Natto-san's loneliness, then?

ICHIKAWA: We talked about it a lot, and it's difficult to put it simply. Since scriptwriting means considering the fundamental issues of humanity, we had many quarrels. Sometimes those quarrels influenced our family life. We were ready for such things, though.

MORI: Speaking of family, some say that the father Masayuki Mori played in *Ototo* is incapable of leading his family. I think he tries to care about his family in his own way.

ICHIKAWA: I tried to show the father from a certain distance. Though the model for the character was the great novelist Rohan Koda, I wanted to show an ordinary father. I think this kind of family life is perhaps inevitable for such a man. He has left the family to his wife or to his daughter, but still he has to show his presence in the family.

MORI: In that case, what do you say about the somewhat cold mother Kinuyo Tanaka plays, who is suffering from rheumatism in her limbs and turns to religion?

ICHIKAWA: I don't think she is cold. Anybody would become like her, with such a condition. That is why she's able to reconcile with others, with great emotion.

MORI: This was the first time you worked with Keiko Kishi, who played Gen, the daughter, wasn't it?

ICHIKAWA: I had sensed the beauty of a Japanese actress in her. She had the beauty and reality of a Japanese whether she wore Western clothes or kimonos. I wanted to work with her since she impressed me as a prostitute in Heinosuke Gosho's *Growing Up* (*Takekurabe*). And then, in my film *Ototo* Keiko's acting was very, very good.

MORI: The combination between Kishi's dynamism and the sweet, sulky nature of Hiroshi Kawaguchi, who played the brother, Hekiro, worked very well. I believe Kishi was a little bit older than Gen.

ICHIKAWA: I didn't mind the difference at all. (Laughs) She was an excellent Gen.

MORI: You subsequently worked with Kishi many times. I know she often maintains that she always ended up in your films if you asked, even when she thought it was miscasting.

ICHIKAWA: She has helped me on many occasions. (Laughs) I am very happy that she trusts me like that. She lives in France, but I want her to sometimes be in Japanese films in suitable roles.

MORI: By the way, some foreign audiences read a "special meaning" in the scene in which Gen takes care of Hekiro, who is in the hospital suffering from tuberculosis, and they sleep together, tied to each other's hand with a pink ribbon. They probably thought it seemed incestuous.

ICHIKAWA: The foreign audience seems to be prejudiced. (Laughs) That was not my intention at all. I am proud of that beautiful scene.

MORI: As far as I can remember, in order to have a tea party with the nurses at midnight, Hekiro promised Gen that he would wake her up by pulling the ribbon.

ICHIKAWA: Yes. However, when Gen wakes up, Hekiro doesn't look well. When she gets up to run out of the room, she is pulled back by the ribbon. I wanted to show her reaction at the moment when she gets up. She is so panicked that she has totally forgotten the ribbon. That clearly shows the deep affection between sister and brother. That was my directing device. Regarding the last sequence that follows, I have something interesting to tell you.

MORI: You mean that unique last scene. Hekiro dies, and Gen gradually becomes conscious. When she leaves the waiting room of the hospital saying, "Please rest, Mom," all of a sudden the end title appears.

ICHIKAWA: Yes. First I completed the last scene without any music. As soon as Gen is out of the room, the film ends. Right after the first screening, Natto-san told me that the ending wasn't good because there was no music—it was nothing to do with the image. It was unusual for her to say such a thing at that point, but I responded that ending the film without any music emphasized the sister's loneliness and courage.

MORI: The sudden ending was on purpose.

ICHIKAWA: Yes. But Natto-san insisted on soft music to end the story gently, because everything else in the film was perfect. She usually doesn't insist upon her opinion so strongly. I thought that our positions were the other way round, because usually I was more sentimental than she was. (Laughs)

MORI: Oh, you were. (Laughs)

ICHIKAWA: Yes. Of course, I believe she gave me that advice because she liked the film, and she thought the ending was very important. I changed my mind. I asked the producer to allow me to add music, and I dubbed the final reel again.

MORI: It's really an interesting anecdote, because the music is imposing at the end. It may have been more shocking if there were no music as you had originally planned, but if so, the feeling might have been colder.

By the way, this film is also famous for its use of a unique colour technique called "*gin-nokoshi*" [leaving silver], which provides muted colour closer to black and white.

ICHIKAWA: I attempted to use colour to express the atmosphere of the Taisho era. That is, I thought that Taisho was a calm period, compared with the stormy Meiji and Showa periods. I tried to depict the dusky nostalgia of Japanese daily life in neither colour nor black and white.

Gin-nokoshi is a shooting technique that uses colour film but with black-and-white lighting. We also treat the film in a special way during developing. Since it was a new effort, Kazuo Miyagawa, the director of photography, and Tomoo Shimogawara, the art director, had a hard time.

MORI: *Kinema Junpo*, the film magazine you consider first-class, chose *Ototo* as the best film of the year. How did you feel about that?

ICHIKAWA: Well, of course, I said to myself that "I did it!" (Laughs) I received many prizes for this film, but *Kinema Junpo* was the most influential at that time.

Translated from the Japanese by Daisuke Miyao

Ototo

KON ICHIKAWA

A Record of *Ototo*

AYA KODA'S autobiographical *Ototo* was serialized in the woman's journal *Fujin Koron* between January and September 1956. When I read it I was fascinated by Koda's description of the way she had been brought up, largely because my memories of childhood and family are all sentimental, happy ones. Still, I did not consider turning her account into a movie until much later, by which time Shochiku had already purchased the rights. This was disappointing news, for by then the fresh and youthful figure of Gen, the elder sister, had taken on a life of its own inside me. Like a baby waiting to be born, my Gen was filled with a chaotic mixture of weakness and strength, sweetness and spite, and I hated to have to give her up.

For some reason, though, Shochiku eventually forfeited their rights to Koda's work. I promptly approached Hiroaki Fujii in our planning section and tried to convince him to obtain the rights for our company, but while the planning committee was screening the proposal (some members apparently judged the work as too dark and lacking a strong story line) Tokyo Films bought the rights. Another year and a half passed. From time to time I would glance at Yoko Mizuki's script, which had been published in the journal *Scenario*, and wonder why on earth the film hadn't yet been made, given the superb quality of Mizuki's work. It seemed strange, even infuriating, in an era when everyone bemoans the lack of good scripts. Then, to my great good fortune, the project unexpectedly came in my direction.

Tokyo Films had decided not to make the film (as with Shochiku, the reason was never made clear, although Toei apparently showed an interest in taking over the project). At that point, a number of people interceded on my behalf, including Toho's Masakiyo Fujimoto and our Yukio Matsuyama. Finally it was agreed that I would make the film for Daiei. I was struck by the fact that, as in so many things, persistence turned out to be the key to success.

It is said that a "family" is built upon the various forms of familial love—paternal, maternal, conjugal, and filial. Yet, even when all these are present, everyone is

essentially alone. Indeed, familial love is based on this premise of loneliness; and its beauty stems from the comfort family members afford each other. Many other things may have changed over the years, but the way young souls suffer and triumph remains the same. *Ototo* is a tale about the ancestral home of the human soul.

So, I thought, if one starts out with the premise that everyone is essentially alone, then what follows?

The first step is the crucial importance of realizing one's aloneness. I feel sorry for those who live out their lives without ever achieving this realization. Still, it by itself is not enough.

All of us establish families of some sort. Viewed from the outside, each seems to embody a similar domestic happiness. Take a step inside, however, and you are brought face-to-face with a whole host of complications and contradictions.

A small group of isolated people living together in a single residence, bound by the tenacious fetters of consanguinity. Just being related, however, does not mean they can love freely and naturally. The task of loving one another—parent and child, husband and wife, sister and brother—only comes to be understood as taxing, irreplaceable, and precious once an active awareness of aloneness is achieved. Doesn't this mixture of isolation and love form the essential shape of our souls, whether today or in ages past? Now more than ever, perhaps, it deserves our serious attention. Compared to the Taisho period (1912–1926), our circumstances are harsh. People have learned to speak the word "loneliness" openly. They use it in a very abstract and convenient way, as a place of escape perhaps, or a talisman of passive self-righteousness. I myself dislike this usage. In my opinion, loneliness is the province of each individual soul, an internal thing, while "judgement" is something that possesses the power to link the self with the outside world.

I felt I could describe this kind of judgement through my portrait of "Gen."

Yoko Mizuki's original screenplay was a massive work, three hundred manuscript pages long. Had I followed it faithfully, my finished movie would have filled ten thousand feet of film stock, so with her permission I shortened it to two hundred and forty pages. It was the first time since *The Blue Revolution* (*Aoiro kakumei*, 1953) that I worked with a scenario not written by my wife, Natto Wada.

I decided to experiment with the chromatic scheme of the film. Couldn't I use it to somehow evoke the feeling of Taisho? The preceding Meiji Period (1868–1912) had been an era of borrowing from the West, when Japan's future had seemed vast. Our present period, Showa, on the other hand, is characterized by a certain rawness. Taisho, sandwiched in between, comes across as a dark and featureless time. To convey this impression, I tried emphasizing light and shadow against a greyish backdrop, suppressing all bright colours. This technique fit my desire to focus on the human relationships in the film while de-emphasizing the historical context. It also reinforced my conviction that we become less and less conscious of colour in our daily lives. Instead, we naturally sense its presence. I thought that I might be

able to reproduce this sensation on the widescreen. My cinematographer Kazuo Miyagawa took great pains to achieve this effect. He set the lighting as if we were shooting in black and white, and strove for a partial, incomplete level of transparency in the developing process. I'm not familiar with the technical details of this method, but I can tell you that both a keen eye and careful calculation are required to pull it off. Our film stock was Agfa Color. I am grateful for the co-operation we received from Tokyo Film Developers. Great care was also taken to match the sets with the colour scheme of the film. Our art director, Tomoo Shimogawara, wracked his brains to provide just the right design and colour for the interior beams, walls, *tatami* mats and *fusuma* panels.

All of us were joined in the determination not to let this become just another formula film.

1960

Translated from the Japanese by Ted Goossen

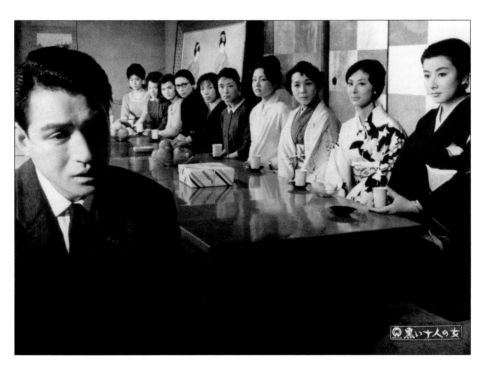

Ten Dark Women

DONALD RICHIE

Ten Dark Women

KON ICHIKAWA made *Ten Dark Women* (1961) just after the caustic *Bonchi* (1960) and before the reproving *Hakai* (1962), a period during which the director and his scenarist, Natto Wada, who was also his wife, were turning from the sarcastic humour of their earlier pictures to the more serious social censure of the later ones. *Ten Dark Women* is thus balanced between categories: it is both a black comedy about sex and a serious criticism of relationships between the sexes.

Women opens like a film *noir*, a genre which Daiei, the studio for which Ichikawa worked, had made something of a specialty. Nocturnal city street, long shadows, a single, hurrying figure. Over this, cool, noncommittal "modern" jazz. The Warner Brothers look, of which sixties Daiei modern melodrama was fond, establishes just what kind of picture one thinks it is going to be.

The single hurrying figure (Fujiko Yamamoto, Daiei's big star, playing the wife of the philandering husband) stops, hearing someone in pursuit. The gliding camera reveals that the pursuer has taken off her shoes for silent stalking. It then turns to reveal that there is more than one in pursuit—many, a small procession. Yamamoto stops, cornered.

This opening sequence, all deep black and dead white, contains the central theme of the film. Ten women, all of them "dark" in the unlighted street, are gathered to exact what is shortly revealed to be their vengeance. They have been united by their determination to punish the single man responsible for deceiving them all—the husband.

At the same time, the sequence establishes the tone of the film. It is *noir* all right, but we are invited to share in a mockery of the genre. The shadows are too long, the night-time streets are too wet, the pursuit is too dramatic, the reactions are too emphatic. It is Sam Spade in Tokyo with too much overhead light and pooling shadow, too many back-lit louvre window shades. As genre, it is over the top.

That the picture is a parody soon becomes apparent. With Yamamoto cornered, the other women start to threaten her. Their language is that of men,

eventually they grapple and roll about on the ground. Not a traditional Japanese woman in sight. Sam Spade is wearing a skirt.

The dialogue emphasizes this. It is forthright, containing none of the reticence thought to be a desirable feminine quality. When the husband is told about the women's plan, he says to his wife: "It's probably some kind of joke, but I heard that you are all going to try to kill me." To which she replies: "What makes you think it's a joke?"

When he asks who first thought of the plot, she responds: "All ten of us." "Ten?" he asks, surprised, at which she turns, even more surprised: "Are there more?" Later he asks: "Why do you want to kill me? I just don't understand." To which she answers: "*That's* why we want to kill you!"

This kind of directness is usually (in the movies at any rate) attributed to men. Woman are not supposed to talk like this. But they do in this film. As in the later scene where the wife and the most formidable of the other dark women (Keiko Kishi) discuss how to dispatch the husband. They are having their talk in the elegant Japanese restaurant run by the wife, and they are sitting in front of just the kind of *nihon-ga* that such fine establishments always have.

This picture shows two apprentice geisha, all gotten up, demurely having tea; and in front of them, drinking whiskey out of the bottle, are two real Japanese women, slugging it back and talking about murdering the husband of one of them.

If the women are turned into men in this serious comedy, then the man is given the role of the conventional woman. He is played by Eiji Funakoshi, an actor who specialized in those light male leads called *nimaime* in Japan—secondary roles, the men attractively weak so as contrast with the *tachi*, the typically strong macho hero.

(Except that in this film there are no *tachi*—every last male is *nimaime*. This includes the good looking if ineffectual young man who has itchy dermatitis due to nervousness over his career—Juzo Itami in his acting days, long before he became the famous director of *Tampopo*.)

Funakoshi, with his conventional good looks, his childlike preoccupation with himself, and his air of needing a mother more than a wife, was made for this role and indeed reaches something like tragic heights when (however comically) he finally bursts into tears and says to Kishi (whom he has been "given" by his wife): "Let's just make a baby."

This willingness to retreat into conventional family patterns is made even more ludicrous when it becomes clear that Kishi will not allow him to return to his job (TV executive). "Why work? What's your purpose?" she asks. He turns, shocked: "But men must work!" She shakes her head and as she leaves says, as though to a child: "Don't be afraid."

Afraid he may well be because Kishi has questioned his entire means of identification. Depriving a Japanese man of his work, she implies, deprives him of his

self. And when, like some Antonioni hero, he finally bursts into unmanly tears, she can show only a motherly if transient concern.

Ten Dark Women pushes an outrageous assumption (it is advisable that "betrayed" women murder their betrayer) to a logical conclusion. We play our roles since they are all we have, but they are false. One may be taken in, as the husband certainly is in his male role. Or one can move beyond them. This is what the ten dark women attempt.

As in another extraordinary (and even more misunderstood) black farce, Nagisa Oshima's *Max, Mon Amour*, the film suggests that the conventions we live by are hollow, but retain them we must. In *Max*, when Charlotte Rampling's husband asks why she chose an ape to be unfaithful with, her retort is generically correct but magnificently irrelevant: "No. *He* chose *me*."

The husband in *Ten Dark Women* earns his conventional life through that conventional medium, television. Concerned only with appearances, the tube reflects attitudes toward reality rather than reality itself. In the TV sequences, we see artifice carving its subject (the cowboy rockers, the Krazy Kats comedy team) into narrowly conventional slices of banality. When a woman opens her mirrored handbag in the TV station, we see a reflection of her face that is no different from her face on the tube, which is no different from her face on the movie screen. All surface, no depth.

The television station is seen as a TV tube itself in a brilliant sequence in which the husband and his superior leave the square, brightly lit, crowded lobby, and follow the camera as it backs into the still night. As we move away from that lively, glittering square, it is shown as the box it is, and as the distance increases the conversation becomes more relevant.

In the many office sequences, everyone is "on" in the TV manner, including the movie camera, behaving like a television monitor as it glides through its practised manoeuvres.

The look of the film itself is that of TV graphic design: the "stark" contrast of dead white and dead black (Japan did not yet have colour television in 1961); the "accidental" obscuring of the screen; the fluid cuts, in which composition is reversed in alternate shots. Ichikawa was himself originally a graphic artist, and his films have always benefited from his interest in design. Here he pushes the visual style right through the roof. Only in the equally sly *An Actor's Revenge* (1963) did he have as much fun playing around with ocular aesthetics.

As part of his general send-up, Ichikawa also mischievously messes with chronology. Like Hammett, Chandler, and other masters of the *noir*, Ichikawa loops into flashback at first opportunity. The opening sequence of the wife being gumshoed by her cohorts actually belongs well past the middle of the ensuing narrative, after the staged murder of the husband, and just before the final sequence in which he is revealed in a bare room (the only decoration a single cactus) with Kishi, regarding a single insect—an ant, blatant symbol of his helpless self.

One of the reasons for the lengthy flashback, which is the film proper, is that film *noir* often does this. Another is that it allows the director a way to emphasize the "ghost" of the one of the ten who is feminine enough to commit suicide. Yet another is that it creates an amount of suspense which could be used to convince Daiei that a conventional suspense film was being made.

And indeed, suspense *is* created by the chronology in that the final sequence is rendered opaque and the film does not "end" at all. We have seen that eight of the ten women have hurriedly (cravenly) dispersed once they learn that even though the husband is not really dead, his "murder" may still be investigated. Wife Yamamoto has washed her elegant hands of the entire matter. Now Kishi alone carries the plot. Funakoshi is locked in the room with his cactus and his ant. She is driving back to him.

And we remember the beginning of the film, when Kishi drove up. No one else drives in the movie, and she is thus accorded an amount of power. In the end she is again behind the wheel, an obvious winner. But her face tells us nothing—no expression, eyes on the road. And then she passes the only overtly violent image in this covertly explosive picture.

A truck is burning, flames are everywhere, a holocaust, some terrible accident has occurred. Kishi does not even turn to look, drives right past it. The end.

Though this conclusion baffled its original audience in 1961, it now seems less mysterious. We can say that things do not bode well for the husband, or that some kind of cause and effect is being implied, or that the whole thing was really a road picture anyway and we are moving on. Then we remember a line of Kishi's dialogue in her first sequence with Funakoshi: "I want to die."

The picture was originally viewed (and much criticized) as feminist propaganda. And so, of course, it gloriously is. It was particularly noted that the scenarist, Natto Wada, the director's wife, had been up to this sort of thing before.

Indeed she had. She wrote all of Ichikawa's finest films, beginning with *Human Patterns* (1949), and ending with *Alone on the Pacific* (1963) and parts of *Tokyo Olympiad* (1965). (Though she was credited with the 1985 *Harp of Burma* and the 1988 *Crane*, these were both from scripts completed long before her death in 1983.) It was Wada's script that turned a mediocre Toyoko Yamazaki novel into that wonderful account of matriarchy, *Bonchi*; she who made the cardboard girl in the Shintaro Ishihara novel, *Punishment Room* (1956), come alive in Ichikawa's film of that name.

She could empower her women until they simply took over, as did the maid in *Kagi* (1959). Usually, however, hers was a genius (so rare in Japan) for levelling all the playing fields. The women in *Enjo* (1958) are all real, no matter how artificial they seem in Mishima's novel; the girl in *Hakai* lives and breathes as she does not in the Toson Shimazaki original.

Those interested in auteur-sports (a critical passion in Japan) have long been concerned with Wada's influence on Ichikawa, and rightly point out that it must

have been considerable, since the quality of his films so fell off after her death. This is true, but I think of their films more as a rare example of cinematic symbiosis; director and scenarist, husband and wife each supported the other, lending qualities to sustain the other's intentions.

Without the feminine/masculine balance of Yukinojo in the Wada script, Ichikawa could not have accomplished the wonderful ambivalence of *An Actor's Revenge*. And without the brilliantly straight-faced parodies in *Ten Dark Women*, the forceful sexual dualities of Wada's script would have gone unrealized.

As it is, the film remains as a perfect point of balance among genres, between attitudes, and amid generalizations. It speaks precisely for its time, and this perhaps accounted for the general miscomprehension.

Ten Dark Women invites us to enjoy the very subject it criticizes, and was therefore disapproved of and neglected, until recently. Tellingly, it was the only one of Ichikawa's sixties comedies chosen for revival by Daiei. Now thirty years later, we have reached the point where women are much more outspoken about men, where bumping off a philanderer is no closer to actuality, but can at least be contemplated, even relished. The joke (like all jokes) reveals a desire. The picture finally made some money at the box office in its second life, since most of Japan's disposable income is in the pockets of young, unmarried, working women who, across the intervening decades, apparently feel a kinship with their ten dark sisters.

Kon Ichikawa *circa* 1961

KON ICHIKAWA

The Reality of 1961

GET UP every morning at eight o'clock. Twenty minutes to wash, eat breakfast, and read the newspaper. Another twenty minutes to travel by car from home to studio. On arrival, head directly to the staff room. It is less than nine feet square enclosed by painted plywood partitions, a single window on one wall. Four identical rooms are arranged alongside it. Small wooden tags are hung on each door identifying the director's family name and, below that, the name of his "team." At nine, loudspeakers announce the beginning of the workday. I go to the stage set. Am greeted by darkness, dust, and a whiff of dank air. Carefully I pick my way towards the spot where a number of people have gathered. These are the actors, and my staff. The actors pose, the lights are set, the cameras begin to turn, and suddenly that small space glows with an illusory beauty. I walk from my chair beside the camera to where the actors are, then turn around and go back again, over and over, countless times. I bark out my commands, smoke a ridiculous number of cigarettes. The result is about two minutes of actual screen time. Lunch. I have no appetite. The afternoon is identical. Work ends. I go home. I prepare the continuity for the next day's shoot. Watch some television. Read a detective novel. Turn out the lights. I guess this will be my life for the coming year as well. (Heaves a big sigh.)

1961

Translated from the Japanese by Ted Goossen

Being Two Isn't Easy

CATHERINE RUSSELL

Being Two Isn't Easy: The Uneasiness of the Family in 1960s Tokyo

> Although the objective existence of children seems self-evident, the "child" we see today was discovered and constituted only recently.
>
> — KOJIN KARATANI

TOWARD THE END of *Being Two Isn't Easy* (1962), a film that is set mainly in closed domestic sets, Ichikawa inserts a brief glimpse of motorcycles roaring through the downtown neon-lit streets of Tokyo. The shots are blurry with the speed of the city, and the colours are bright and many hued. It's as if a hole were ripped open in the film, allowing the world of 1960s Tokyo to interrupt the claustrophobic domesticity of the film. Cut to Grandma reading about a motorcycle accident in the newspaper. She exclaims: "No feelings for his parents who raised him. Good riddance! Serves him right! Japan's overpopulated isn't it?" In the very next scene, Grandma suddenly slumps over and dies. This sequence of events is indicative of Ichikawa's sly irony and subtle narrative authority in *Being Two*. It also invites us to read this treatise on the nuclear family as an historical drama; it must be read against the accelerated pace of Japanese modernity, which in the early 1960s, was transforming the terms of the family itself.

Most descriptions of *Being Two* will tell you that it is a story told from the point of view of a two-year-old child. It is true that the child, Taro, does have an intermittent voice-over, but the only point-of-view shots attributable to him are two brief fantasy sequences. In fact the boy's parents, Chiyo and Goro, are the real subjects of the film; and the point of view is predominantly that of an objective omniscient narrator, intent on playing games with his characters and with the

viewer. Although the Japanese title of the film, *Watashi wa nisai* translates better as "I am two," the more common English title, *Being Two Isn't Easy*, contains a nice pun that captures the real point of the film: the difficulties in being a couple, which is to say, the task of forming a viable social unit.

According to David Desser, Ichikawa was assigned the project by Daiei as "punishment" for being over-budget on a previous film. However, this "routine adaptation of a book of essays by a child-rearing expert" turned out to be a commercial and critical success, winning the *Kinema Junpo* prize for 1962.[1] While the novelty of a child narrator may partially account for this surprising achievement, the film also addresses a range of topical issues that would have made it especially relevant to audiences of the period.

The narrative structure of *Being Two*, like most Japanese domestic comedies, home dramas and *shomin-geki*, is episodic and meandering. For the first two-thirds of the film, we watch the couple learn the techniques of childcare, and manage a series of near crises, while Taro comments perfunctorily on their inability to understand his needs. The key narrative conflict occurs late in the film when the couple move in with Goro's mother. Grandma spoils and indulges the child, and causes her daughter-in-law Chiyo no end of anxiety over their different attitudes toward child rearing and housekeeping. But when Goro, absorbed in sports on the new TV set, allows Taro to wander away and nearly die by suffocating himself in a plastic bag, the two women gang up on him. Taro observes in voice-over: "It doesn't pay to be a man. He has to go to work even if he's scolded just to bring home the bacon." Shortly after this, Grandma dies, leaving Chiyo and Goro to belatedly discover the values of family, and talk about having another child.

As Joan Mellen has pointed out, *Being Two* is ultimately an ambivalent film. While the first part satirizes the institution of the family and the rigid gender roles that it fosters, the critique is not sustained.[2] In the final scenes, Chiyo congratulates her husband on finally becoming an adult, after he states that he "understands family ties for the first time." Taro's love for his dead grandmother, whose face he sees in the moon, and whose plethora of birthday candles he imagines around his own cake, seems to be the catalyst for the final triumph of the family. We could perhaps dismiss the end as a *deus ex machina*—which, structurally, it is—or we could explore the contradictions of this film that bridges a tenuous gap between the studio period of Japanese cinema and the new independent cinema of the early 1960s.

On one hand, *Being Two* is evocative of Ozu's family dramas. The middle-class setting, the salaryman and the housewife, the spoiled male child, the grandmother who passes away along with her way of life: these are all familiar, as is the Japanese domestic architecture of *tatami*, *futon*, and *shoji*. But this may be where the parallels with Ozu end, as Ichikawa treats this material with a characteristically ironic hand. Instead of Ozu's peaceful transitional or "pillow shots," Ichikawa inserts an animation sequence and the abruptly violent glimpse of downtown Tokyo described

above. The acting is far more expressive and the montage more dynamic than Ozu's rigidity; the lighting is highly stylized throughout, keying out faces from the dark shadows of the home. Stylistically, the film is very much in keeping with the fragmented, technicolour aesthetics of Oshima and Imamura's films of the early sixties, and also with other Ichikawa films such as *An Actor's Revenge* and *Tokyo Olympiad*.

Particularly important to the irony of *Being Two* is the casting of Fujiko Yamamoto as the mother, Chiyo. According to Tadao Sato, Yamamoto was considered to be one of the most beautiful women in Japan,[3] and she does seem to be more glamour queen than mother in this film. Yamamoto's physiognomy constitutes an ideal of the Japanese beauty, and she performed almost exclusively in *jidai-geki* or period films where her "noble" features are best accommodated. That sense of not being quite connected to the real world is an important element of Ichikawa's depiction of "the mother." Yamamoto is introduced in a soft-focus close-up in the opening scene, following an obscure sequence of unfocused lights accompanied by the child's voice-over describing his coming to consciousness as an infant: "I felt the weight of my body. I felt lonely." The shadowy lights gradually dissolve into Chiyo/Yamamoto's face, saying "He smiled!" Taro counters, "I was just moving my facial muscles," introducing the film's central conceit of the precocious child narrator. Here, as elsewhere, the effect is principally to make fun of the parents' misguided techniques of parenting. The scene also cues us as to the unreliability of the visual field, and indicates that *Being Two* is a film in which we can take nothing for granted. The initial close-up of Yamamoto is so highly coded as that of a movie star, the child's point of view is essentially undermined as soon as it is introduced. Moreover, despite the dialogue, we are clearly being asked to look at her face rather than the child's, and thus her gaze is equally undermined.

Confirming our suspicions about Yamamoto's performance of the unmaternal mother is a scene in which Chiyo assists her sister-in-law Setsuko bathe her infant. Setsuko, played by Kyoko Kishida, wears a loose blouse showing her cleavage as she bends over the baby. Kishida would perform a famously erotic role in Teshigahara's *Woman in the Dunes* two years later, but even here, Ichikawa highlights her sensuality. Her skin glistens with sweat and her hair comes unbound as she gazes at the child. This is in marked contrast to Chiyo who is always immaculately dressed and coiffed. She is never shown demonstrating any tenderness towards Taro, only worried despair, often bordering on hysteria. When Taro wakes in the night, she and her husband convince themselves that there is a bee in the bedding. They tear apart the bedclothes and Chiyo is framed looking quizzically through her son's pyjama bottoms which encircle her face.

The satirical depiction of the family in *Being Two* can, to some extent, be described as a critique of gender roles. Even if this critique is ultimately sublimated into a restoration of the family unit, the commentary on gender situates the film

within the contemporaneous "new wave cinema" and its interrogation of social institutions. Chiyo complains that she spends four-and-a-half hours a day preparing food and feeding the child, to which Goro responds that at least she doesn't have to "bow down" like he does at the office. Later he plays with Taro's toys, acting out his frustrations with the corporate hierarchy in which he is nothing but a lowly salaryman. The family's destiny does seem to rest with the whims of the "bosses" because when Goro's brother is transferred to Osaka in an apparent demotion, Chiyo and Goro are able to move out of their cramped apartment and into grandmother's house. Chiyo takes over Setsuko's role of live-in daughter-in-law, and although she gets help from grandmother with childcare, she also faces a loss of domestic authority. At the heart of the film is thus a contest between the "modern" nuclear family as the couple united by the child, and the more traditional inter-generational family unit and its hierarchical relationships. In the end, despite Ichikawa's affinity with new wave stylistics and critical consciousness, the film falls back on a typical Ozu trick of having it both ways: the modern nuclear family survives precisely through its respect and love for the dead grandmother, whose absence is deeply felt by both the couple and the child.

Among Chiyo's complaints about the grandmother is that her husband no longer helps with the housework. He tells her that his mother disapproves of men doing housework, and that the neighbours might see him. This exchange suggests that Chiyo is somewhat liberated from traditional social expectations of gender roles. Although there is not much additional evidence of feminist reform in the film, in 1962 even this negotiation of household chores marks a small breakthrough. The grandmother's ways of doing things are clearly marked as "old fashioned" in comparison with the younger couple's "modern" ways of doing things, which extends to the husband's contributions to housework. On the other hand, the film can also be read as a trajectory from one of Taro's early remarks, "I don't know if I'm a boy, but I'm a human being," to his very last statement, blowing out his candles on his second birthday, "I will become a man." Mellen points out that "Ichikawa darkly views such invocations to the baby's 'manhood' as absurd, although he doesn't remain with this theme long enough to measure its full destructiveness or to challenge the patriarchal structure of the society which so early and so vigilantly inflicts such views on us all."[4]

Goro is played by Eiji Funakoshi, who plays the lead in Ichikawa's 1959 film *Fires on the Plain* (*Nobi*), a performance that is in many ways the centrepiece of that work. He is, above all, a comic actor, and in *Being Two* he portrays the emblematic salaryman trying to do the right thing in a world that is stacked against him. The figure of the salaryman emerged in the 1930s as a symptom of a crisis of Japanese masculinity; men were reduced to being pawns in the corporate world, with little more in life than "bringing home the bacon." Funakoshi may not give as virtuoso a performance as he offers as Tamura in *Fires on the Plain*, yet his comic

facial expressions are an important element of the film's discourse of irony. He has the ability to portray a blankness upon which the events around him are inscribed. The grandmother is played by Kumeko Urabe, who was one of the first women to perform in Japanese motion pictures with a key role in Minoru Murata's *Seisaku no tsuma* (1924).[5] She portrays the grandmother as an energetic and stubborn woman who plays with the child as vigorously as she argues with his parents. Her large gestures and expressive facial expressions, like Funakoshi's, evoke the comic techniques of the silent era.

In contrast with the adult characters, Taro is something of a void. There is little connection between his blunt voice-over statements and the toddler on the screen. Ichikawa in fact toys with our ability even to recognize the child hero in two separate instances. In the first, the parents lose Taro at the zoo. Following a quick montage of animals, we cut to the "Lost Children's Room" full of screaming kids. A series of different close-ups and children's voice-overs crying, "It's my father who's lost," "Was I abandoned?" and "My voice is the loudest!" precede the eventual discovery of Taro by his frantic parents. Because we haven't been shown how Taro is dressed that day, when he is plucked out of the crowd of children and identified as the boy with the black-and-white hat, it comes as a bit of a surprise. Ichikawa also implies that an oblique connection exists between zoo-going and film-watching; animals and children can be both entertaining and caged. In the second instance, we see a child fall from a balcony and get caught by a passing milkman in a spectacular save. This dramatic sequence is completed by a shot of Chiyo running, but it turns out that she is not running to the scene of the accident, but to the playground where Taro is playing. She sighs with relief and tells the woman there that a child has fallen. In one of the film's most bizarre moments, the woman responds calmly that, from Chiyo's description, it must be her child. She asks, even more calmly, whether the child is dead.

This confusion over children helps to establish how the central couple are typical of a larger social group, and how their problems are not theirs alone. At the same time, it constitutes an important destabilisation of the visual field, as Ichikawa sublimates Taro's identity to his status as an object that is lost, found, endangered, and saved. Indeed, the parents' approach to child-rearing, and the depiction of parenting in the film is as a system of production. When Chiyo complains about the grandmother's indulgent approach to Taro, she says to her husband, "Don't blame me if he doesn't come out OK." Likewise, the grandmother herself accuses the dead motorcyclist of being disrespectful of his parents and thus violating the "Family System." It's a system that only works as long as the children remain products, not people. In fact, the film is about the negotiation of this system as it intersects with the dynamics of modern Tokyo. One of the central practices of this parenting system is the discourse of medicine, illness, and disease. *Being Two* features two doctors who give the most overtly comic performances of the film. The first looks like

a nerdy Jerry Lewis character who diagnoses Taro with "autointoxication," a nervous disorder that afflicts pampered children. When Chiyo returns for an inoculation against the measles, another mother holds up her measles-infected daughter saying, "Here, you can have it," after the doctor recommends that Taro be exposed to the disease. This absurd health-care theme continues when another doctor subsequently does an elaborate demonstration of the whooping cough before ruling it out as Taro's problem. The grandmother insists that the boy get an injection to cure his cough, despite the parents' and doctor's advice that it is unnecessary. She wants to make him feel better, so does the rounds of the clinics until a nurse finally injects Taro with a huge syringe of an antidote, followed by another of glucose. Taro tells us that it hurt far more than the cough, but "kids will do anything for a toy."

The first time Chiyo raises the subject of another child, Goro lists all the childhood diseases in the book, followed by "earthquake, fire, and thunder. No peace at all." In other words, children are a constant catastrophe waiting to happen. When Chiyo and Goro do have their own crisis and Taro almost suffocates himself, both parents alternately freeze before being able to do anything constructive, such as taking him out of the plastic bag that he crawled into. Finally Chiyo manages to pump air into the boy's chest, and there is a collective sigh of relief, but again, no hugging, and no real sense of affection. The helpless appeal to medical knowledge, combined with the lack of any real tenderness, is what renders the system of parenting mechanistic and difficult.

Clearly this is a film that works on many levels at once, inviting us to sympathize with the two bumbling parents, and also to laugh at them. Perhaps the single most important element of the film's irony is the soundtrack, credited to Yasushi Akutagawa. Fragments of jazzy lounge music and melodramatic riffs rise up at the most inopportune—and thus most ironic—moments. For example, in the very first scene after the opening introductory sequences, Taro escapes the apartment and we see him from behind crawling up the stairs. Chiyo breathlessly sneaks up behind the boy, grabs him and leans with relief against the door. With this last movement, the music rises up in a powerful melodramatic surge, releasing the tension of the scene. Thus, an over-determined layer of hysteria is added to an extraordinarily banal scene, introducing the film's discourse of absurdity.

The use of the stairs in this scene, along with the surging music, is strongly evocative of Hitchcock, as is the scene described earlier of a child falling from the balcony, which is actually a virtuoso piece of editing, comprising twenty shots from the first image of the child to Chiyo running. It builds up with eight shots from different angles and focal lengths of the child wiggling the loose balcony, accompanied by the sound of it squeaking. Overhead shots of the milkman create a strong sense of verticality; unfocused pans suggest the experience of falling; a shot of the child upside down in the air is followed by the milkman bracing to take the weight, and a long shot of him catching her. The rhythm and the angles of this

sequence may be classic Hitchcock montage, but again, this is not a murder mystery, but a simple domestic accident. When Chiyo tells the woman what happened and she asks simply, "Is she dead?" the soundtrack features the jazzy lounge music. Similar music accompanies the scene of Chiyo and Setsuko bathing Setsuko's baby. The soundtrack is very much informed by Hollywood motifs, but they are all placed at the wrong moments. Another example is when Goro is scolded by his wife and his mother after he allows Taro to get in the plastic bag. They tell him he should be watching educational and cultural TV programmes and not just sports. When they finally leave him looking totally dejected and deflated, a mournful trumpet solo line, like something out of a film *noir* or Hollywood melodrama, takes up his suffering. It eventually segues into the background score of the following scene, and yet its first emergence is anything but invisible.

Without the stylized music, lighting, and editing, *Being Two* would be simply a tedious, sentimental family drama. But Ichikawa manages to inject a sense of dramatic urgency, passion, and depth that lifts the film onto another level. The undercurrent of historical significance culminates in the brief scene of motorcycles roaring through Tokyo, but it is apparent in these moments of stylized excess. The family drama becomes simply a narrative facade on another, more pressing story. Within *Being Two* is a commentary on Tokyo and the transformation of urban space that took place in the 1950s. During the rapid rebuilding of the postwar period, the city was drastically altered by highways, skyscrapers, apartment blocks, and new rail and subway lines. If the war time destruction was traumatic, the reconstruction was equally dramatic. Although *Being Two* is shot mainly in studio, the city imposes itself on the narrative in a number of significant ways.

When Chiyo and Goro move from their apartment building to the grandmother's house, Chiyo notes, "A house is a better place to raise a child than an apartment." The apartment is dark and cramped, and the stairs and balconies present dangers to wandering children. Ichikawa offers no establishing shots of the apartment building, which we only see as the background to crises such as the fall from the balcony and a dog-biting incident. A single shot, dominated by train tracks and electric poles, of Goro heading off to work in the rain suggests the bleak suburban setting of the apartment block. In the playground after the balcony incident, Chiyo and her neighbour discuss the possibility of starting a nursery. The woman points out, "Our office says that nurseries are for the poor, not for apartment dwellers." Childcare in Japan is still notoriously inadequate, and mothers are often able to work only when they have family members available to look after their children during the day. While this is hardly an "issue" in this film—as Chiyo shows no signs of wanting to work—this dialogue suggests that there is a certain status associated with living in an apartment, even if it makes childcare unavailable. Apartment life is depicted as an atomization of family life, a kind of compartmentalization which is constitutive of the corporate world that supplies the salary to the

men, and relies on the women to maintain households that are independent of any community or family support structures. If the apartment signifies independent economic success and security, the house that Goro and Chiyo move into signifies their status within the Japanese Family System. The establishing shot of the house, which we never actually see from the front, is a high-angle shot of the tiled roof. Perhaps because of the flattened space, or perhaps because of its familiarity as an icon of Japanese domestic harmony, these shots of the house surrounded by greenery indicate an inheritance of tradition. Earlier in the film, a brief shot is inserted of the grandmother with her grandsons buying sweets in a nearby market, indicating that the house, despite its garden and quietude, is in fact deep in the city. It may be one of the few traditional homes remaining in Tokyo after the war, whereas the suburban apartment complex is the more typical residential architecture of the period. The interior of the house is spacious and airy, framed by polished wood floors and window frames. When Goro's brother and his family leave the grandmother's house for Osaka, there is the suggestion that Goro is the only sibling available to move in, which someone must do to live with the grandmother. It is thus out of obligation that they move, and through the house itself, they seem to discover the value of family ties. Implicit in the move is the availability of childcare, although, again, this is hardly an issue in the film. In one of the final scenes of the film, Goro and Chiyo close and lock all the sliding doors that open onto the garden, shutting out the world with the soft sound of wood sliding on wood.

Chiyo has an older sister who visits the apartment from her home in the countryside, only to ask Chiyo for money to buy a refrigerator. She looks jealously at the iced drinks that Chiyo serves, but her request is turned down by her younger sister, who instructs her to save the money she gets from the child bonuses for her eight children, rather than spend it on travel. This seems to be the extent of Chiyo's family, this rather unpleasant person who says she was "like a mother" to Chiyo. She is depicted as a country woman, and her sister has clearly outclassed her with her urban ways. Thus, the family values that are negotiated in the film are deeply implicated in the urban space. The apartment is a step up from the country life that Chiyo has left behind, but Goro's family house is another step up from that, even if the couple don't quite see it like that. The film effectively relocates the "modern couple" from the apartment building to the inherited family home. Between the apartment building and the traditional Japanese house, which is likely set within the city, is the chaotic downtown scene figured in that single explosive shot of the motorcyclists. This is what must be locked out; this is what seems to cause the grandmother's death—her dismissal of the new youth culture as a bunch of ungrateful children. The fragmentation of urban space, characterized also by the salaryman's long commute (we get one shot of Goro squeezed into a crowded subway car returning to the apartment), is what threatens the Family System; and while Ichikawa may in the end uphold and even celebrate that sys-

tem, he does not do so without first of all highlighting its repressive effect of containment, precisely by challenging it with the film's various forms of excess. The roar of the bikers through Tokyo is thus the climax of the film's discourse of excess, linking it to the transformation of urban space, and the new youth culture inhabiting the changing city.

In fact there are two competing Family Systems in the film: the modern nuclear family and the *ie* system which was originally that of the warrior class, but was established in the Meiji Civil Code as applicable to all classes. In that system, "the protection of the male bloodline was sanctioned within the structure and institution of marriage."[6] The *ie* system functions as the foundation of the Japanese system of nation-as-family, in which "the imperial household holds the position of the main house, and the people become branch families" (23). Japanese feminist Yayoi Aoki points out that: "Fundamentally, what the household head and the emperor had in common was the fact that neither of them had the rights of a dictator in the modern sense of the word. The authority they could claim was only whatever came to them as representatives of their ancestors" (24). This system comes into play in *Being Two* when Goro and Chiyo move into the family home and its hierarchical structure that subordinates the wife to the husband's family. Goro's own authority as patriarch is clearly curtailed by his obligations to his mother and extended family.

The modern nuclear family, on the other hand, is introduced in the film's title sequence as the Oedipal triumvirate of mommy-daddy-me. A lithograph of a father holding out his hands to a child taking his first steps away from a protective mother is displayed under the credits. Ichikawa zooms into the father's black-and-white face. The scene is set in a garden, and the drawing style is more Victorian than Japanese. The faces in the drawing have indistinct racial characteristics, so that the family is "any family," or rather it is the bourgeois family—Japanese or not. This scene is followed by Taro's voice-over description of being born and the close-up of Yamamoto described above. Then we get a re-enactment of the lithograph in which Taro takes his first steps into Goro's waiting arms, and Taro's perceptive observation that he may not be a boy yet, but he is a human being.

Both Family Systems may be inherently patriarchal, but they constitute quite different social structures: one grounded in a psycho-social construction of the individual, and the other *ie* system, based in the spacial and communal form of the home and its ancestral lineage. We can perhaps map the two systems onto the opposition between apartment and house. While the parents are clearly caught between the two systems, unsure of where they best fit in, the question the film poses is how to raise a child within the confluence and contradictions of these two Family Systems. The *ie* system requires that the child be raised as a good national citizen and member of the group; whereas the bourgeois Oedipal model requires that the child negotiate his or her place within the family through the formation

of a sexual-social identity. This is precisely the crux of the challenge posed by Japanese modernity, a challenge first met during the Meiji period, and continues to evolve as Japanese culture is increasingly enmeshed within an international, global social formation. We should perhaps turn to a leading theorist of Japanese modernity to better understand the role of the child in this process.

Kojin Karatani has suggested that the discovery of "the child" was commensurate with the origins of literature in Japan, which is to say, the discovery of interiority, expression, and the self. He distinguishes between "rites of passage" (rituals of maturation) and the absolute division between child and adult that we find in a text such as *Being Two*. Projected onto the child is the "self" as the basic construct of the individual—a construction Karatani identifies as a product specifically of Western Europe, and contextualizes within the "capitalistic reorganization of contemporary society."[7] He traces the discovery of the child to Romanticism and its embrace of "youth." This, he says, created the division between child and adult, and initiated the genre of children's literature (119). He claims that before Meiji, "Japanese folktales were not meant for children and games purely for children were unknown" (121). The division that he identifies is however, ironic, as it actually creates a continuity between child and adult, an identification that is entirely lacking in the "transformation that occurs in rites of passage" (124). The division Karatani notes in bourgeois culture is precisely the Freudian understanding of the child as the "small adult" (127).

While Taro's selfhood and self-expression is undoubtedly inscribed in his voice-over narration, the child's world in *Being Two* is in many ways cut off from that of the adults. Taro's perception of events is very different from his parents', although the critical break between child and adult is represented most vividly in the short animated sequence inserted about half way through the film. Initiated by Taro's observation that the moon looks like a banana, an animated boat is accompanied by a soundtrack that might have been lifted from a Hollywood musical. The operetta score lilts crazily as banana and boat dance on a moving sea. Later, Taro watches cartoons on TV with his grandmother, whom he also sees in the moon. Thus, Taro acquires his own discursive sphere of shapes, colours, and lines that is inaccessible to his parents—but apparently legible to the grandmother. It is significant that although *manga* is in fact consumed by all generations in Japan, here it is associated only with children. Ichikawa may indulge the child's fantasies in the final scene of the birthday cake, but in doing so, the ironic representation of the parents is lost, and the film ends with a strong sense of something missing. In the confluence of the two Family Systems, the child is ultimately only a structural component.

The utter banality of Taro's fantasies, like his narrative commentary, has the effect of separating him from his parents without really endowing him with a strong sense of personality. The sentimentality of the ending, while very conventional for

Japanese *shomin-geki,* is especially disappointing in a film that has been so preoccupied with the division between child and adult. This division, as Karatani points out, is very much bound up with the structuration of bourgeois individualism. At the end of *Being Two* the family unit is established with the child at the centre. Blowing out his two candles, Taro is really more object than subject. He is what entitles the family to the house with its aura of tradition—and also to their modernity as a functioning entity in bourgeois culture. Thus the child is the key to the mechanism of society and the parents' representation of society as a couple is likewise dependent on the child-object.

And yet, at the same time as we are invited to recognize the smooth workings of the mechanisms of the family, and the reconciliation of the two Family Systems, we must also recall the threat posed by the burgeoning youth culture of the 1960s. For that brief scene of the motorcyclists is not merely an intervention of the city and an eruption of excessive sex and violence, it is also the film's only acknowledgement that children grow up. Being two is not, after all, a permanent condition. If the family in Japan is to some extent always an allegory for the nation, it is also its bedrock. In 1962 this is an "uneasy" formation. Ichikawa may allow only a glimpse of the erosion of the family, but *Being Two* demonstrates the inevitability of such erosion, given the contradictions of the Family System(s) within Japanese modernity. The tragedy of the film is the understanding that Taro may hope to be a man one day, but that man will be a salaryman, destined to "bow down," like his father, to the system that produced him.

Notes

1. David Desser, "Learning and Growing: Three Films," in *Childhood and Education in Japan*, eds. Mary White and David Desser, (New York: Japan Society, n.d.), 21.
2. Joan Mellen, *The Waves at Genji's Door: Japan through its Cinema* (New York: Pantheon, 1976), 340. Mellen's analysis, in keeping with the thesis of her book, is that *Being Two* is about the parents' refusal to understand or respect the child's rights.
3. Tadao Sato, *Currents in Japanese Cinema*, trans. Gregory Barrett (Tokyo: Kodansha, 1982), 87.
4. Mellen, *The Waves at Genji's Door*, 340.
5. Sato, *Currents*, 21.
6. Yayoi Aoki, "Feminism and Imperialism," in *Broken Silence: Voices of Japanese Feminism*, ed. Sandra Buckley (Berkeley: University of California Press, 1997), 21.
7. Kojin Karatani, *Origins of Modern Japanese Literature,* trans. and ed. Brett de Bary (Durham N.C.: Duke University Press, 1993), 121.

Kon Ichikawa on the set of *I Am Two*

KON ICHIKAWA
AKIRA IWASAKI
KYUSHIRO KUSAKABE

The Uniqueness of Kon Ichikawa: A Symposium

KYUSHIRO KUSAKABE: The purpose of this series of symposiums is to discover unknown facets of various films. The films of Kon Ichikawa are the subject of today's discussion, which may prove to be interesting since we have you here with us, Mr. Ichikawa.

KON ICHIKAWA: I don't really understand myself, so I'll just smile.

KUSAKABE: Your most recent films are *I Am Two* (*Watashiwa nisai*, 1962), *Hakai* (*The Outcast*, 1962), and *An Actor's Revenge* (*Yukinojo henge*, 1963). *I Am Two* attracted a great deal of public attention and also was ranked among the ten best movies of the year. We'd like to begin with this film since it is regarded as a film in a class by itself.

AKIRA IWASAKI: *I Am Two* is a film that only you could have made. I saw it in a theatre in Ikebukuro [downtown Tokyo] and found that the audience was composed mostly of middle-age housewives, the kind that you see in your neighbourhood or anywhere carrying their shopping bags. I was deeply moved by the atmosphere in the theatre. The women wept during the movie and there was something which strongly affected me as well. I think this film is very different from your previous films in the way it affects its viewers.

ICHIKAWA: Can you tell me what does this?

IWASAKI: Well, one of the hallmarks of your films is a piercing and ironic view of humanity or a detached and satiric vision of society. But in this film your usual bite has been replaced by compassion and warmth. Both the over-indulgence and the distress of the parents are presented through the eyes of their two-year-old

child; however, your attitude is very warm. You used to achieve irony by having characters smile sardonically or by piercing a character to the quick. And there is irony in this film too, but it is not venomous. Of course, if this made the film merely innocuous, it wouldn't be good; but its venomlessness takes the form of compassion. That's why it won the hearts of all those women.

KUSAKABE: There are two views of life in *I Am Two*. One is an ironical view of the adult world through the eyes of a baby, and the other is a vision of the value or dignity of human existence as seen in the continuity of life from the grandmother to the mother and from the mother to the baby. This second view is what the women appreciated.

ICHIKAWA: I originally had no intention of criticizing society through a baby's eyes. The staff talked about what is the most important thing in life. We felt that we adults need to discern what life is—a problem of the human heart and soul. Therefore the film was meant to be a "hymn to life." I don't deny that some irony comes out, but quite frankly, I wrote the script in hopes of making a little imprint on my heart. But I feel this film is a failure. Of course there's never anything that can be called perfect.

KUSAKABE: In what sense?

ICHIKAWA: I was chided by my wife. She says that the images she gets from this film are not mine. They're too easy to understand, that is, they lack artistic or personal innovation.

IWASAKI: You use a kind of image of *doga* which has two meanings—animated cartoons and children's drawings—and the film is influenced by both of them. Perhaps Mrs. Ichikawa couldn't see you in the film's softness and tenderness, which is the source of the film's compassion. The film makes a deep philosophical impact—the continuity of life—and yet its form is easily understood by most people. That's why I'm greatly impressed.

KUSAKABE: Don't you think your three recent films show the three styles or streams of Ichikawa films? Every Ichikawa film has its own style, but can also be classified as one in which you emphasize experimental techniques like *An Actor's Revenge*, or as one in which you emphasize ironic observation of man like *I Am Two*, or as a traditional drama like *Hakai*. Although your filmography appears to be haphazard and eclectic, it is possible to classify your films.

IWASAKI: Kusakabe sees three streams but I think there are two. One is comedy (or comic thrillers); the other is great traditional drama, such as *Punishment Room* (*Shokei no heya*, 1956), *Enjo* (*Conflagration*, 1958), *Fires on the Plain* (*Nobi*, 1959), *Ototo* (*Her Brother*, 1960) and *Hakai* (*The Outcast*, 1962). Good qualities can be found in your comic thrillers, but most of them are not successful. Your masterpieces are all traditional dramas; this is where you reveal your real ability.

ICHIKAWA: For me the theme of a film is not so important. I'm not very concerned about it. That is whether or not I decide to make a film about a certain thing is

determined by whether or not I'm interested in it. Although I say so myself, my intuition for making these decisions is very acute compared to other directors. In this I am a perfectionist. I must have my own way—this is "me" as a director. My wife says it's my sense of beauty, which may be the motivation for my activities in film.

IWASAKI: You are unconcerned about theme and can work passionately on any type of film because you have confidence in yourself, in your style and technique. But speaking objectively, you cannot work on *any* theme. The person Ichikawa must have limits, and therefore the director Ichikawa must have thematic limits he can work on. For example, take Yasujiro Ozu: the Ozu Tofu Restaurant can only sell tofu and pork cutlet, but not tofu, pork cutlet, beefsteak, and tempura. Thus, unless you choose or focus on your themes, you will fail as you did in *An Actor's Revenge*. Your experimental temperament is certainly a good quality which no one else has, but I feel that both an accomplished master and acolyte are dwelling in you at the same time. Sometimes you become one and sometimes the other. But somehow when you become an acolyte, you fail. Your fresh, youthful attitude and your experimental temperament are definitely some of your virtues. But your excessive self-confidence in style or technique seems to coexist with your lack of concern about theme. This is what I'm afraid of.

ICHIKAWA: I see, I appreciate your observation. You understand the content of *An Actor's Revenge*, but I was thinking about a stylistic beauty which sprouts from my previous films. Simplicity and artistic innovation are the basis of stylistic beauty: as Natto says [Natto Wada, Ichikawa's wife and collaborator], they lead to a sense of beauty. I wanted to embody this and make it clear, I don't recall how resolutely I decided to do this, but I made the film with this in mind, I wanted to explore and distill my sense of beauty so that it would be crystal clear, and I wanted it to integrate my style and my thinking. I was also trying to achieve this when I made *Ten Dark Women* (*Kuroi junin no onna*, 1961). My attitude toward beauty has now settled and solidified so vigorously in Natto and myself that it may become my next phase.

KUSAKABE: The combination of Natto Wada as scriptwriter and yourself as director seems to be the secret ingredient or mysterious core that produces the uniqueness of an Ichikawa film. Your collaboration brings out something extra.

IWASAKI: Actually I've never known any director-scriptwriter team that has gotten along for such a long time without having trouble. All husbands and wives experience quarrels and boredom as well as love; and besides that, you must also experience these things as artists. I've never heard of such a case.

ICHIKAWA: It's because Natto is such a great person. [Laughs]

KUSAKABE: Turning to Japan United Artists, was your reason for founding this that you felt something must be done about the movie industry in Japan?

Ten Dark Women

ICHIKAWA: Well, the movie industry is on the decline everywhere in the world. Recently I happened to see Bresson's *Diary of a Country Priest*, John Ford's *The Informer*, and Carol Reed's *The Third Man* on television; they are definitely first-rate films to which nothing being made today can be compared. These days we directors advocate big productions when what we should be doing is seriously investigating real, orthodox filmmaking—what production should be.

IWASAKI: The rise of independent production is related to the world-wide decline in big productions.

KUSAKABE: If the decline in the movie industry is accompanied by a decline in artistry, films will lose their validity and significance. The decline in Hollywood several years ago was due to this very coincidence. The companies tried to recuperate with bigger productions, and the artists—a group of independent producers called the New York School—tried to recover their art. As a director, what do you think is the most important thing in maintaining your existence, your artistic career?

ICHIKAWA: Well, I'd like to preserve my personality from extinction—that would be the most important thing.

IWASAKI: Independent production is needed to drive the Japanese film forward again. But as long as the present system of distribution remains unchanged, Japanese films will be limited to the big studios, and the most efficient kind will be a unit-production under one of them. If you really want to establish an independent production in the true sense of the word, the only way would be to make a low-budget film which can be distributed internationally—like Kaneto Shindo's *The Island*.

ICHIKAWA: Shindo is trying to cut his way through, but even he will find himself trapped in the corner of being forced to make very peculiar films. Therefore, one way to establish an independent production is to make the most of the present organization.

KUSAKABE: When your idea is realized, will a new kind of Ichikawa film be produced?

ICHIKAWA: Not necessarily. [Laughs] But I would feel good if one was. [Laughs] Don't you think that even a little effort to improve the system is important?

KUSAKABE: Yes, I agree with you. Japanese directors have been too negative to make the effort. That's why your activities have great significance for film production in Japan. We hope you continue your efforts.

Translated from the Japanese by Haruji Nakamura and Leonard Schrader

An Actor's Revenge

LINDA C. EHRLICH

Playing with Form: Ichikawa's *An Actor's Revenge* and the "Creative Print"

> That kind of artistic sincerity [of painting in the twentieth century] has never been present in printmakers; from the very nature of their work. They work in reverse; they create obliquely...
>
> — FRANK AND DOROTHY GETLEIN [1]

WHEN WRITING of the relationship between the Japanese visual arts and that nation's cinema, the tendency is to look to the classical forms of pictorial art. One points, for example, to the similarities between *sumi-e* paintings and the muted quality of the black-and-white cinematography in films like Kenji Mizoguchi's *Ugetsu* (*Ugetsu monogatari*, 1953). Or note Donald Richie's perceptive description of Keisuke Kinoshita's *The River Fuefuki* (*Fuefukigawa*, 1960) as a story recounted "in a period manner: partial colouring of scenes in the manner of early *ukiyo-e* prints, long scroll-like dollies and asymmetrical compositions—a self-conscious reconstruction of a Japanese style."[2]

Often overlooked is the relationship between certain Japanese films that feature a formalistic playfulness and daring, and the aesthetics of the more contemporary "creative print" (*sosaku hanga*). This new art form originated during the Meiji and Taisho periods (1868–1926) as another manifestation of the enthusiasm for Western ideas the Japanese displayed during those tumultuous years, following over two hundred years of virtual isolation. Many Japanese artists rushed headlong to learn about Western artistic techniques and sense of expressiveness.[3] It is well known that artists like Vincent van Gogh, Théophile Alexandre Steinlen, and

Henri de Toulouse-Lautrec, among others, were influenced by Japanese art, but it is equally true that many Japanese artists of the Meiji period were inspired by Western art toward their own brand of modernism.

In the catalogue to the exhibition entitled "Paris in Japan: The Japanese Encounter with European Painting," Shuji Takashina and Thomas Rimer identify a central problem which faced Japanese artists during this period of great change: the need to project an air of difference from others—a sense of individualism, which went against standard artistic practice and social conditioning in Japan.[4] Scott Nygren notes: "Insofar as Japanese artists sought in Western modernism's borrowing of Japanese tradition a modernism to position against Japanese tradition, they became caught in mirrors within mirrors, an aporia, or collapse of meaning."[5] While some Japanese artists flourished in this bohemian milieu and served as role models for a new generation of Japanese artists, the strain of individual assertion proved too much for others.

One group of Japanese artists from this period chose more of a middle ground. Reacting against the limitations of the traditional *ukiyo-e* woodblock print, the *sosaku hanga* artists also turned away from the more ponderous qualities of Western oil painting, maintaining a closer affinity (but not a blind allegiance) to characteristically Japanese themes and printmaking techniques. In the words of one contemporary printmaker, Un'ichi Hiratsuka: "Western art gave me my technique but Japanese art gave me my approach."[6]

The formalistic boldness found in *sosaku hanga* was one outgrowth of the interest in a Western-style individualism that developed in Japan during that early period of contact with the West. The exploration of that individualism was one component of the "technique" of the prints, while a renewed exploration of traditional Japanese themes could be considered a common "approach" (to use Hiratsuka's terms). This resembles the two tendencies in Japanese art described by Joan Stanley Baker: an "outward-looking" mirroring of the external world through imitation, and an introspective, poetic nature which takes into consideration human qualities of imperfection.[7] *Sosaku hanga* artists looked outward for new skills, such as those of perspective and foreshortening, but they also turned inward to re-examine indigenous aesthetic values.

It is important to view the *sosaku hanga* movement against other trends in the art world of the Meiji and Taisho periods. Western-style paintings (*yoga*) remained more bound by techniques and theories imported from abroad, particularly those of impressionism. Through this European influence, some Japanese painters showed a concern with such new avenues of expression as the depiction of light and shadow, and the visual interpretation of current political affairs. In contrast, the "creative print" artists tended to use more indigenous materials and techniques, drawing on the Japanese genius for flat, two-dimensional abstraction.

Also in the Taisho period, there was the "new print" (*shin hanga*) movement of

such artists as Goyo Hashiguchi, Shinsui Ito, and Hasui Kawase. In general, this movement, whose prints often featured the traditional themes of landscapes, beautiful women, and *kabuki* actors, was more closely aligned with the aesthetics of *ukiyo-e* and lacked the thematic and formalistic boldness displayed by the work of the *sosaku hanga* artists. Lawrence Smith notes that the *sosaku hanga* artists have "the intensity, inwardness and obliqueness of much traditional Japanese art; they also have the direct humanity which it has often lacked."[8]

These same tendencies are true of experimental films like Kon Ichikawa's *An Actor's Revenge* (*Yukinojo henge*, 1963), a remake of Teinosuke Kinugasa's 1936 film of the same name, based on the story of a *kabuki onnagata*, a male actor who plays female roles.[9] In Ichikawa's film, the black-and-white stylistics from the 1930s are taken over by a widescreen perspective in which formalistic boldness and traditional subject matter combine to produce an unforgettable visual experience. Ichikawa's *An Actor's Revenge* draws on the same modernist tradition found in the *sosaku hanga* movement, which aims at highlighting the individual as artist.

Japanese "creative prints" and films share similar successes: both are (relatively) widely distributed and exhibited, and both have enjoyed great international appeal. The success of print artists like Shoko Munakata in the 1955 São Paulo Bienal and the 1956 Venice Biennale helped raise the stature of the *sosaku hanga* artist in Japanese eyes as, paradoxically, the successes of filmmakers like Akira Kurosawa and Kenji Mizoguchi in the Venice film festivals of the 1950s helped the Japanese consider their own films a serious art form. It is unfortunate that both "creative print" artists and Japanese film directors have often had to rely on foreign approval to convince Japanese critics and viewers that their work is worth taking seriously. As Oliver Statler explains: "In Japan, [*ukiyo-e* prints] had long been regarded as plebeian trifles, vulgar souvenirs of the vulgar crowd. A print was a print, in Japanese eyes, and modern print artists suffered decades of scorn and neglect because of this attitude."[10]

This ambivalent attitude toward new forms of art mirrors the ideological debates of the late Meiji and the Taisho periods, when the nation moved from a period of national isolation (*sakoku seisaku*) to a national policy of "civilization and enlightenment" (*bunmei kaika*) and "opening of the country" (*kaikoku-ron*). During the 1920s, for example, "radical restorationists" and nationalistic groups reacting against Western influence became embroiled in "desperate and even violent resistance against the West."[11] This love/hate relationship began before the period under study in this essay, and continues into the present time. As Carl French noted in his introduction to an exhibition entitled *Through Closed Doors: Western Influence on Japanese Art, 1639–1853*, there is a "strong element of paradox in the Japanese response to the outside world," a response which runs the gamut from conservative nationalism to an abundant fascination with novelty.[12] Perhaps it would be helpful to look at this relationship between Japan and the West, and at ourselves, with more of a sense of humour.

While the status of "creative prints" as serious art has now been established, the playful nature of these works of art and, one may add, of many Japanese films has often eluded the critic's glance. As critics and scholars, we have tended to consider play and fun too trivial or as something "without limits, rebellious, radically other."[13] It may only be through the comic, through playfulness, however, that we can learn of the pastiche of images that make up the modern consciousness—images like the geisha consuming a Baskin-Robbins ice cream cone, or the young samurai, glimpsed through cherry blossom, tying on jogging shoes in screens by the contemporary artist Masami Teraoka.

The essence of play, as described by J. Huizinga in his *Homo Ludens: A Study of the Play Element in Culture*, is something which lies outside seeming dichotomies of wisdom and folly, truth and falsehood, good and evil.[14] This disinterested, yet ordered, activity, as described by Huizinga, also invokes a sense of freedom and secrecy to achieve its effects. Following the line of least resistance, playfulness serves as a force for *building* community through a playful indulgence in "exaggeration, inversions of the common order, depictions of vanity," to cite Henri Bergson's definition.[15]

In the theatrical and pictorial arts, the traditional Japanese sense of comedy lacks the satirical or moralistic tone often associated with the comic in the West. In the performance style known as *kyogen*, comic interludes, frequently featuring an inversion of the common order, are interspersed between the more serious *noh* performances. Junko Berberich adds to the definition of *kyogen* the idea of individual or collective "rapture" (absorption, the act of being carried away by an intensifying emotion).[16] In his *Playfulness in Japanese Art*, Nobuo Tsuji states that he considers the idea of playfulness a third category to be added to the two categories of Japanese art elucidated by Sherman Lee (decorativeness and realism).[17] Tsuji considers this Japanese artistic playfulness to be simple and life-affirming, influenced by Chinese Taoist antecedents but lacking the large-scale quality of much Chinese art. According to Tsuji, examples of playfulness in Japanese art include the naïveté of *haniwa* figures, the *haboku* splashed-ink paintings, the *karakuri-e* (mirage, or trick, painting), the Kamakura-period *Scrolls of Frolicking Animals* (*Chojugiga*), which feature metaphoric animal caricatures of priests, and the works of Edo-period "eccentric" artists like Ito Jakuchu, Taiga Ikeno, and Shohaku.

In her article on "The Parameters of Play," Liza Dalby points out how traditional forms of play in Japan, such as moon viewing or catching fireflies, have now been transformed into solitary hours at pachinko and other mechanized amusements, and how the traditional value placed on pilgrimage has been transformed into the group honeymoon tour and other such modern excursions.[18] In the same (but more visually pleasing) manner, the *sosaku hanga* converted the traditional modes of playfulness to a new and bold level of visual incongruity.

The *sosaku hanga* movement aimed at establishing the printmaker as an artist, not merely as a craftsman. Unlike the *ukiyo-e* print which was a popular (and therefore stigmatized) art in Japan, the *sosaku hanga* movement was born of a sense of individual difference, where the depiction of personal impressions was considered paramount. Rapid reproductions of the print marked the *ukiyo-e* movement, while the *sosaku hanga* artists stressed the uniqueness of each design and each artist. At least three people (what Statler referred to as the "time-honored artist-artisan-publisher team"[19]) were involved in making a traditional print; but with the *sosaku hanga*, the printmakers were responsible for all aspects of their work, from design to execution. Although ukiyo-e artists tended to belong to a stylistic school, the same was not true of the "creative print" artists, despite the formation of small professional societies of such artists.[20] Smith describes how the main unifying force of the *sosaku hanga* artists was "devotion to the idea of the print as a primary, creative work of art which was not a reproduction of something else."[21]

In general, the *sosaku hanga* has tended toward a joyful celebration of life, and toward the uncluttered line suited to the nature of the woodblock itself. Michiaki Kawakita compares the natural resistance of a block of wood to the Japanese ability to react "with sensitivity and flexibility to an obstacle and produce something decorative."[22] Examining the relationship between the *sosaku hanga* and certain free-verse Japanese poetry from the early twentieth century to the present, Thomas Rimer points out that, no matter how abstract they became, the "creative prints" still maintained a sense of "muted realism" and "a sense of craft rooted in instinctive apprehension of the power, the wholeness, of nature itself."[23] This sense of "muted realism," in which the wholeness of nature and the everyday are joyfully celebrated, can be seen in the prints of artists like Reika Iwami, which draw on the natural grain of the wood (even incorporating actual pieces of driftwood in the composition [fig. 1]) or in Tetsuya Noda's large-scale diary pages based on family photographs, with their seemingly mundane, yet resonant, themes. Shigeki Kuroda's etchings of figures on bicycles speeding along also provide a perfect "moving pastiche" of the traditional and the rush of modernity (fig. 2). Although the press of modern life is

1. Reika Iwami, *Song of Water A*, 1970

2. Shigeki Kuroda, *Sky Course*

not usually considered a comic or playful topic, the sheer mass of Kuroda's bicyclists illuminates the "mechanical encrusted on the living," to borrow Bergson's phrase for a source of comedy in everyday life.

Writing of printmaker Ay-O's use of the rainbow as a leitmotif, Joseph Love notes how that artist (like many other *sosaku hanga* creators) "rejects that serious artistic moralism which would remove the play element from art."[24] Ay-O's exuberant, almost flamboyant, celebration of exaggerated form infuses his prints with a pulsating flow of energy that plays with the borders of the frame as if to draw the observer within. As we shall see, Ichikawa employs similar techniques in his highly eclectic remake/transformation of *An Actor's Revenge*.

Playfulness in *An Actor's Revenge*

In Ichikawa's *An Actor's Revenge*, the viewer is made aware of the humanity of the actor, as both character and self, through the fact that Kazuo Hasegawa appears both as an *onnagata* and as a ruffian, as well as playing himself—the consummate actor who had performed the same roles in the earlier film version.[25] The story, set in the mid-1800s, is itself full of conventional melodramatic touches—a festering

desire for revenge against the three Edo-period merchants who had driven Yukinojo's father to suicide, a manipulation of innocence, evil brought to justice—but this "melodrama of triumph" as presented by Ichikawa is primarily a pretense for a grand visual and theatrical display which modifies the sense of melodrama. As David Williams points out in his review, the "idiosyncratic visual style" is both "the key to the film and in a way part of its theme."[26]

"Stylized realism" and "naturalistic spectacle" may seem to be contradictory terms, yet it is exactly the tension in these apparent contradictions that marks the power of *kabuki* and the beauty of this film. Noted Japanologist Donald Keene writes that the dramatists of the eighteenth century felt they could depict life realistically *through* stylization, not in opposition to a stylization that also included the supernatural or transcendental.[27] In avant-garde films like Ichikawa's *An Actor's Revenge*, the traditional and the melodramatic are points of entry, not destinations. The formulaic provides a comfortable base from which we can see beyond the formulas. Commenting on the "bizarre mixture of the realistic and theatrical" in *An Actor's Revenge*, Keiko McDonald writes: "One might say that [Ichikawa's] replay of Hasegawa's earlier triumph takes the form of an affectionate look at traditional *kabuki* conventions, even as it parodies them."[28]

This postwar treatment of a popular prewar hit foregrounds the contemporary nature of cinema rather than the original spirit of the Edo-period tale. Ichikawa's frequent division of the frame into various geometric sections in which figures are highlighted and then "erased,"

3. Toko Shinoda, *Saga*, 1982

reminds the viewer over and over of the theatrical nature of the tale. Kazuo Miyagawa, cameraman for such Ichikawa films as *Enjo* (*Conflagration*, 1958) and *Kagi* (*The Key*, 1959), reported in an interview that Ichikawa used fragmentation of the screen more than other directors with whom Miyagawa had worked. "He thought that the camera should be more 'involved' in the film, almost like an actor."[29]

As in prints by artists like Shoichi Ida and Ay-O, the use of vibrant, symbolic colours and unnatural proportions are logical, not as reproductions of some outer reality, but within the closed world of the work itself. On stage (in the film), a snow scene dissolves into what appears to be a real scene of snow falling—delighting, and yet mystifying, the viewer. Actors enter scenes in the film in the manner of *kabuki* actors approaching the stage on the *hanamichi* walkway that traverses the audience space. In one scene a seemingly endless rope is tossed across

the screen to an unseen destination, playing on, and defying, the limits of the CinemaScope screen, as in calligrapher-lithographer Toko Shinoda's print *Saga* (1982, fig. 3) in which the image extends beyond the edges of the frame. Although this is a common trait of Japanese composition, it is carried to an extreme in *An Actor's Revenge*, in which the black background within the Scope format highlights figures in the corner or along a horizontal axis. In the same way, the light and heavy elements of Toko Shinoda's design expressively interact with the white background. These are worlds at once in harmony with traditional Japanese aesthetics, and yet separated from the sphere of ordinary life—worlds in which reality becomes play.

As Ichikawa denies the viewer the expected image in this melodramatic tale, he allows for a new range of narrative and visual meaning to emerge, especially through the use of comic touches.[30] Hasegawa in the dual roles of Yukinojo and a Robin Hood (or the *kabuki* character Nezumi Kozo) type of thief, Yamitaro, comment about each other, and even "flirt" with each other, with obvious delight at the self-reflexive punning.[31] "I somehow feel like you're my brother," one declares to the other (i.e., to himself). David Desser identifies this as a source of "distancing humor, a kind of 'in' joke."[32] Just when we think we have discerned a visual pattern to the film, the next sequence begins in a new area of the screen—figures suddenly emerge from a corner or rooftop, as if defying gravity—causing the viewer both surprise and amusement. Like the revolving stage on which the *onnagata* performs, the director whirls us from one scene to another, capitalizing on the element of surprise.

4. Umetaro Azechi, *Mountaineer*, 1952

Through this sense of the comic, we as viewers are prevented from taking the narrative of *An Actor's Revenge* (and ourselves) too seriously. Cartoon-like aspects—for example, the appearance of faces in the theatre audience within "bubbles"—remind us of inserts in Japanese prints or of comic-strip aesthetics. In true melodramatic fashion, a young woman puts her hand over her heart, sighing deeply out of love for the *onnagata* performing on stage. Ichikawa himself began his training as an animator, and many of his films, like *Pu-san* (1953), based two serial comic strips by Taizo Yokoyama) and *I Am Two* (*Watashi wa nisai*, 1962), display the director's skill in this art form.[33] In

many ways the characters in *An Actor's Revenge* also seem to be viewing, rather than precipitating, the development of the story. Suspense is maintained, but the performers are primarily engrossed in playing with the play itself.

The artificial nature of many of the sets reminds one of the presentational aspect of this tale of revenge, and helps to foreground the human factor. A similar technique is employed in the print *Mountaineer* by Umetaro Azechi (fig. 4), in which the stylized mountains in the background seem to recede, causing the figure of the mountaineer to assume larger-than-life proportions. Although this could potentially appear grim and heroic, the actual effect is one in which objects assume the charming proportions that one might expect from a child's drawing. Like the odd forest in which the female pickpocket Ohatsu declares her love for Yukinojo, stylized Nature announces, and indulges in, its own artifice.

An Actor's Revenge alternates rapidly between scenes of breathtakingly clear colour, scenes in which mist and uncertainty predominate (like the shot of the half-hidden moon), and a darkened screen ("stage") in which close-ups of objects or of parts of the human body add a subtext to the unfolding tale of revenge. In fact, the entire film is a study of incongruous juxtapositions—in its striking visual compositions, in the mixture of traditional Japanese music and nondiegetic contemporary jazz and "lounge music" on the soundtrack, in the movement from old-fashioned full-body "proscenium" shots to zoomed-in close-ups, and in the nature of characters like the "masculine" aggressive female thief Ohatsu and the "feminine" actor Yukinojo.

Another factor which adds a note of wry comedy to the story of *An Actor's Revenge* is the gender-switching inherent in the *onnagata* role.[34] This gender-switching is further highlighted by Kazuo Hasegawa's playing not only the *onnagata* (a man playing a woman) but also Yamitaro (a man playing a man), and the actor par excellence (a man playing himself). We marvel at the intertextuality of this elegantly dressed man who remains an idealized woman both on and off stage, while at the same time maintaining the inner nature of a virile fighter. This kind of gender-switching provides a Brechtian alienation effect which allows the viewer a chance to relax rigid preconceptions about the nature of personal identity, while it also clearly points to the division between the actor and the character.

Ichikawa daringly highlights the sexual nature of the *onnagata* by focusing on this character's complex love relationship/manipulation of the beautiful Namiji (Ayako Wakao), daughter of one of the evil merchants. (This love affair is itself not without a touch of absurdity, or painful reality, as actor Kazuo Hasegawa was then a somewhat "over-the-hill," pudgy fifty-five-year-old, while Ayako Wakao was yet an ingenue in her twenties.) In the role of the beloved, Yukinojo is unmasked and also is the one who coldly carries out the unmasking of others. As the two main female characters (Namiji and Ohatsu) profess their love to the *onnagata* in turn, we cannot help but laugh at the parodies of the *nureba* love scenes from traditional *kabuki*, and at the pitiful countenances of the "macho" men these women are scorning for this mixed-gender character.

5. Hiroyuki Tajima, *Stone Cutter and His Apprentice*, 1971

6. Kiyoshi Saito, *Clay Image (Haniwa)*, 1952

In "The Secret Ritual of the Place of Evil," Hirosue Tamotsu addresses the fact that, to the audience, the *onnagata*, as female surrogate, was both an object of aspiration and a scorned outcast (like the courtesan whose roles the *onnagata* frequently played).[35] Hirosue's thesis is that both the actor and the courtesan were viewed in an arena, based on ancient animistic/shamanistic beliefs, in which "nobility and debasement, beauty and wretchedness, were indivisibly mixed." In Edo-period Japan, the official reaction to *kabuki* was one of disdain, yet there was also a sense of fascination with the *demi-monde* of which it was a crucial part.

Hirosue classifies the eroticism associated with the *onnagata* as a reconstruction of a "predifferentiated eroticism,"[36] but it is important to remember that this is an eroticism based on fiction, just as the *onnagata* represents a basically fictitious ideal of "feminine perfection." Ichikawa plays on this ambiguity in his film by transforming, in the words of the *kyogen* master Toraaki Okura, "the real into the unreal."[37]

The formalistic simplicity of line of many contemporary *sosaku hanga* also allows for this kind of ambiguity. Hiroyuki Tajima's *Stone Cutter and His Apprentice* (1971), for example, abstracts the figures into an amorphous body, of undetermined gender, a human form that merges with the element it is meant to control (fig. 5). These figures, like that of the Mountaineer, or like the *haniwa* figure in Kiyoshi Saito's print of the same name (fig. 6), are both monumental and objects of light amusement.

The ending of Ichikawa's version of *An Actor's Revenge* shows the *onnagata*—his revenge completed—performing on stage to the admiration of Ohatsu (the female pickpocket), Yamitaro (Kazuo Hasegawa's alter character), and others. The protagonist, dressed as always in the garb of the *onnagata*, appears to have given up on acting as he wanders off alone into a field of pampas grass, disappearing from sight. At this point, Yukinojo has become both individual and nonindividuated form. Is this last highly stylized scene a merging with nature or the beginning of yet another play? We as viewers are left with a sense of having seen something eclectic and refreshing, a playful dialogue

between form and content, between the traditional and the modern, so apparent in Japanese arts like the "creative print" which present an image of the modern age.

Notes

1. Frank Getlein and Dorothy Getlein, *The Bite of the Print: Satire and Irony in Woodcuts, Engravings, Etchings, Lithographs, and Serigraphs* (New York: Clarkson N. Potter, 1963), 14.
2. Donald Richie, *Japanese Cinema: An Introduction* (Oxford: Oxford University Press, 1990), 58.
3. For a detailed discussion of painters like Tsuguji Fujita, Seiki Kuroda, and Ryuzaburo Umehara, note *Paris in Japan: The Japanese Encounter with European Painting*, eds. Shuji Takashina and J. Thomas Rimer (St. Louis: Washington University Press, 1987).
4. Takashina and Rimer, *Paris in Japan*, 75.
5. Scott Nygren, "Reconsidering Modernism: Japanese Film and the Postmodern Context," *Wide Angle* 11, no. 3 (July 1989): 13.
6. Ibid., 38.
7. Joan Stanley Baker, *Japanese Art* (London: Thames and Hudson, 1984), 7–8, 11.
8. Lawrence Smith, *The Japanese Print since 1900: Old Dreams and New Visions* (New York: Harper and Row, 1983), 28.
9. The *onnagata* was not originally an essential entity of the *kabuki*. With the banning of female performers (of *onna* or *yujo kabuki*) in 1629, and of male performers (of *wakashu kabuki*) in 1652, the *onnagata* developed as a necessary invention. The *onnagata* distils essential aspects of womanly speech and movements, and its artistic goal is to portray the decorative essence of womanhood, rather than its reality.
10. Introduction, catalogue, "Japan's Modern Prints—*Sosaku Hanga*" (Chicago: Art Institute of Chicago, 1960), 2.
11. Najita Tetsuo and H. D. Harootunian, "Japanese Revolt against the West: Political and Cultural Criticism in the Twentieth Century," in *Cambridge History of Japan*, vol. 6, ed. Peter Duus (Cambridge: Cambridge University Press, 1988), 711, 713. Note D. William Davis's discussion of the conscious use of tradition by Japanese ideologues in "Back to Japan: Militarism and Monumentalism in Prewar Japanese Cinema," *Wide Angle* 11, no. 3 (July 1989): 16–25.
12. *Through Closed Doors: Western Influence on Japanese Art, 1639–1853*. Rochester, Mich.: Oakland University/Meadow Brook Art Gallery, 1977–78, 1.
13. R. L. Rutsky and Justin Wyatt, "Serious Pleasure: Cinematic Pleasure and the Notion of Film," *Cinema Journal* 30, no. 1 (fall 1990): 7.
14. J. Huizinga, *Homo Ludens: A Study of the Play Element in Culture* (London: Routledge and Kegan Paul, 1949), 6.
15. Henri Bergson, "Laughter," trans. Fred Rothwell, in *Comedy*, ed. Wylie Sypher (New York: Doubleday, 1956), 748. Bergson describes these exaggerations and inversions as "something mechanical encrusted on the living."

16. Junko Sakaba Berberich, "The Idea of Rapture as an Approach to *Kyogen*," *Asian Theatre Journal* 6, no. 1 (spring 1989): 32.
17. Tsuji Nobuo, *Playfulness in Japanese Art*, trans. Joseph Seubert (Lawrence, Kansas: Spencer Museum of Art, 1986). Note, in particular, 9–15, 34, 61–86.
18. Liza Dalby, "The Parameters of Play," in *Tokyo: Form and Spirit*, ed. Mildred Friedman (New York: Harry N. Abrams, 1986), 201–18.
19. Oliver Statler, *Modern Japanese Prints: An Art Reborn* (Rutland, Vt.: Tuttle, 1956).
20. By 1918, there was an organization devoted to the *sosaku hanga*, the Nihon sosaku hanga kyokai (reorganized in 1931 as the Nihon hanga kyokai). Early journals devoted to the *sosaku hanga* included *Hosun* (started in 1907) and *Tsukubae* (in 1914).
21. Smith, 13. In his catalogue to a 1972 exhibition of contemporary Japanese prints at the Los Angeles County Museum of Art, George Kuwayama divides the *sosaku hanga* artists into three generations: the early generation of artists like Koshiro Onchi and Un'chi Hiratsuka, who tended to move between abstraction and representation, focusing on naturalistic themes; the second generation of artists like Shiko Munakata, Kiyoshi Saito, and Umetaro Azechi, whose works tended toward a more abstract, reductive sense of natural forms and an experimentation with new techniques and materials; and a third generation, exemplified by works of a highly decorative or fanciful nature, by artists like Rokushu Mizufune and Hideo Hagiwara. One can now add a fourth generation of artists like Ay-O [Takao Ijima], Tetsuya Noda, and Shusaku Arakawa, who play with what could be termed a postmodern montage of elements from both "high" and "low" culture. These latter generations frequently move from the woodblock medium to employ intaglio techniques, the silk screen, or even photographic images. (Of course, none of these generational divisions are absolute, as there are also variations within the works of the artists mentioned in Kuwayama's general categories.) Statler adds one more generation to this list in a catalogue from an earlier *sosaku hanga* exhibition: the pioneering "first generation" of artists like Kanae Yamaoto, Kogan Tobari, and Kunzo Minami.
22. Michiaki Kawakita, *Contemporary Japanese Prints*, trans. John Bester (Tokyo: Kodansha, 1967), xx.
23. J. Thomas Rimer, "A Lyric Impulse in Modern Japanese Prints and Poetry," *Asian Art* 2, no. 1 (winter 1989): 48, 53.
24. Joseph Love, "The Radical Artist and the Print," *Japan Quarterly* 20, no. 2 (1973): 187.
25. Kazuo Hasegawa (whose original name was Chojiro Hayashi) entered the Shochiku Kyoto film studios in 1926, while still a young performer in the *kabuki* theatre. Appearing in many of Teinosuke Kinugasa's silent films, Hasegawa became known for portraying a quiet kind of savoir faire and a gentleness within strength, which marked a new style for Japanese actors. Ichikawa's *An Actor's Revenge* was commissioned by Daiei Studio to commemorate Hasegawa's three-hundredth film appearance. Hasegawa actually plays three roles in the film, as he makes a brief appearance in a flashback as Yukinojo's mother.

26. David Williams, "*An Actor's Revenge*," *Screen* 2, no. 2 (March–April 1970): 5.
27. Donald Keene, "Reality and Unreality in Japanese Drama," *Landscapes and Portraits: Appreciations of Japanese Culture* (Tokyo: Kodansha, 1971), 52.
28. Keiko I. McDonald, *Japanese Classical Theater in Films* (Rutherford, N.J.: Fairleigh Dickinson Press, 1994), 147.
29. Max Tessier and Ian Buruma, "Japanese Cameraman: Kazuo Miyagawa," *Sight and Sound* 48, no. 3 (1979): 189.
30. This sense of playfulness is related to the kind of playfulness elucidated in David Bordwell's *Ozu and the Poetics of Cinema* (Princeton: Princeton University Press, 1988). Bordwell describes Ozu's exact, and yet unpredictable, sense of playfulness regarding such formalistic devices as eyeline (mis)matches and colour links. Bordwell also points out the playful nature of Ozu's narration which "teases, equivocates and deflates. By appealing to unity, the narration sets up a rigorous, self-contained system and then undermines that through withheld information, flaunted gaps, and self-conscious asides" (72). Ichikawa's more flamboyant film does not set up such a unified, subtle system, although the director does tease the viewer with the unexpected.
31. Nezumi Kozo (whose name can be translated as "rat thief") is the main character of a *kizewamono*-style *kabuki* play by Kawatake Mokuami (1816–1893). The *kizewamono* were written in the latter part of the Edo period and reflect a society in crisis. Thieves like Nezumi Kozo are outlaws who help the poor as a means of atoning for their past evil deeds.
32. David Desser, *Eros plus Massacre: An Introduction to the Japanese New Wave Cinema* (Bloomington: Indiana University Press, 1988), 179.
33. As in the subsequent *An Actor's Revenge*, physical humour abounds in *Pu-san*, the story of a timid man who attempts to rise above his lowly station but is continuously "tripped up."
34. Of course, this myth of androgyny is not limited to artistic forms like *kabuki*. It can also be seen on the Western stage in the boy actors and breech roles of the Restoration theatre, in cross-gender casting in the modern stage and screen in works like *M. Butterfly* (1986), and *Victor/Victoria* (1982), and in the Linda Hunt character (Billy Kwan) in Peter Weir's *The Year of Living Dangerously* (1983).
35. Hirosue Tamotsu, "The Secret Ritual of the Place of Evil," *Concerned Theatre Japan* 2, no. 1-2 (1971): 20.
36. Ibid., 17.
37. Makoto Ueda, *Literary and Art Theories in Japan* (Cleveland: Press of Western Reserve University, 1967), 103. In Okura's five-volume set of writings entitled "For My Successors" (*Warabe Gusa*, 1660), translator and editor Ueda quotes the lead actor of the Okura *kyogen* troupe Toraaki Okura (1597–1662) as saying that "the *noh* transforms the unreal into the real; the Comic Interlude [*kyogen*], the real into the unreal" (103). Okura is referring to comedy's ability to present stereotyped characters in a somewhat unreal world; that is, to "make true things funny and funny things true" (105).

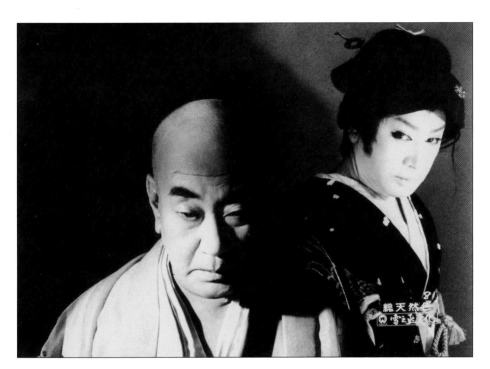

An Actor's Revenge

SCOTT NYGREN

Inscribing the Subject: The Melodramatization of Gender in *An Actor's Revenge*

> In *The Revenge of Yukinojo* [Ichikawa] triumphed over his material so completely that the result is something of a masterpiece—though just what kind is difficult to say.
>
> —DONALD RICHIE

ICHIKAWA'S FILM *An Actor's Revenge* (*Yukinojo henge*, 1963) has long been acknowledged as an eccentric "masterpiece."[1] In this chapter, I would like to consider the film as the site of contestatory discourses of power and gender identification, through a play of apparently contradictory theatrical and cinematic styles. Specifically, the film foregrounds melodrama as a style that uneasily pivots between traditional *kabuki* theatre and Western cinematic realism. As such, it invites a reconsideration of the role of *shimpa*, the Japanese melodramatic theatre popular between 1890 and 1920, in its relation to cinema and Japanese culture.

Shimpa derived from a form of political theatre designed to promote liberal political thought prior to the 1890 establishment of the first Japanese constitution and embodied emerging middle-class values parallel to the role melodrama played in France after the Revolution.[2] All but forgotten after the triumph of *shingeki*, or Western-style realist theatre, and *shingeki*-influenced cinema, *shimpa* marks a boundary between what later would become clearly delineated Western and Japanese traditions in both political organization and narrative representation. These different traditions came to be known as "feudalism" and "humanism," yet both terms are sweeping generalizations that erase the complexity and contradictions within

each tradition. As such, they mythologize cultural difference as a polarization of unitary transhistorical forms.

This essay argues that *An Actor's Revenge* sets *kabuki* and Western melodrama against one another, as two forms of excess, in order to destabilize the assumptions inherent in each. "Feudal" and "humanist" distributions of power are both undermined through an ironic intertextual bracketing of modes of representation associated with each. These modes can be seen to regulate the distribution of power and the relative positioning of women within discursive formations.

At the same time, gender destabilization in the film provides a means of discussing the difficult question of psychoanalysis in a Japanese context. Gender identification is undermined by the deliberate casting of Kazuo Hasegawa (Yukinojo) as an *onnagata*, the type of male *kabuki* actor who specializes in playing female roles, and the actress Ayako Wakao in romantic love scenes. This juxtaposition recalls the historical moment in Japanese film when women first replaced *onnagata* in female roles during the 1920s and undermines any simple sense of what constitutes gender identification.

Textual Features

According to Donald Richie, Ichikawa was assigned to remake *An Actor's Revenge* as punishment, "almost a calculated insult," by the Daiei studio after their dissatisfaction with his productions of *Enjo* (*Conflagration*, 1958), *Bonchi* (1960), and *Hakai* (*The Outcast*), 1962). This "old tearjerker," or "tired melodrama," was seen by the director and his wife Natto Wada (who adapted the scenario) as "so bad as to be good."[3] In short, the scenario is conceived as a melodrama at the historic moment when negative attitudes toward the form begin to reverse into a positive appreciation. Appropriated shortly after its release into the Western concepts of "camp" and pop art, Ichikawa's reinscription of melodrama can perhaps now be re-examined on its own terms.

The story centres on Yukinojo, a celebrated *kabuki* actor during the Tokugawa period who, as an *onnagata* or *oyama*, specializes in female roles. During a performance at the Ichimura Theatre in Edo (Tokyo), he recognizes Lord Dobe and the merchant Kawaguchiya, who were responsible for the ruin and suicide of his parents. He seeks vengeance through subterfuge, most significantly through the manipulation of Lord Dobe's daughter Namiji who has fallen in love with him. Economic depression has produced a rash of burglars, who by turns interfere with or assist Yukinojo's schemes. Eventually, Yukinojo traps his enemies by a charade in which he pretends to be the ghost of his dead father, and overcome by exposure and guilt, they kill themselves.

The story is filled with instances of social corruption and class power. Lord Dobe and Kawaguchiya exemplify the alliance of samurai and merchant classes that dominates Tokugawa Japan. Kawaguchiya's speculation in the rice market is characterized as greed responsible for the famine and uprising that devastates the city. Lord Dobe claims that the Shogun is in his power because of Namiji, linking his corruption directly to the nominal ruler. When the story of Yukinojo's father Matsuuraya is told at the end of the film, Lord Dobe is revealed as the former magistrate of Nagasaki, the sole Japanese city where even limited trade with the West was permitted during the rigid isolation of the country enforced by the Tokugawa Shogunate. Lord Dobe had been bribed by Hiroyama, whose "rare clock" had been smuggled from abroad, and then conspired with Hiroyama and Matsuuraya's clerk Kawaguchiya to blame Yukinojo's father for the crime. Matsuuraya, driven mad by the false accusations, committed suicide.

At the same time, numerous roles are mirrored by parallel relationships or names. Ohatsu, a woman boss of a band of burglars, is infatuated with Yukinojo, mirroring across class lines Yukinojo's aristocratic affair with Namiji. Yukinojo's "real" name in the film is Yukitaro (Yukinojo is his stage name, which partially explains why his enemies don't recognize him), a name mirrored in Yukitaro's rival Yamitaro, a burglar and Ohatsu's principal cohort. In a *tour de force* performance not untypical of *kabuki*, the same actor plays the roles of both Yukitaro and Yamitaro. This doubling is then noted within the film when Yamitaro claims he feels as if Yukitaro were his brother, and again when Ohatsu remarks that their profiles are similar. Yamitaro is in turn rivalled by another burglar Hirutaro ("*yami*" means dark and "*hiru*" means light), Yukitaro is rivalled by yet another burglar Heima Kadokura (a former fellow student of the sword instructor Issoshai at the Tenshin School, where the school "secrets" are recorded on a piece of paper that turns out to be blank), and so on.

Part of the doubling cuts across the difference between stage performance in *kabuki* and offstage "life," that is, the film's representation of the characters' social context. Ichikawa's film has been often noted as an anti-realist experiment with all the artificial and theatrical devices available to a filmmaker at the Daiei studio in Kyoto. Yukinojo maintains his *onnagata* costume and performance both onstage and off, creating several layers of sexual ambiguity during love scenes, especially with Namiji. The wide screen becomes an arena for graphic display: a horizontal fan fills the screen against a red background, a fight is filmed as slashing swords isolated by light against total darkness, a rope stretches completely across the screen (again isolated against darkness) with the characters pulling the rope offscreen. In addition, any sense of historical realism seems wilfully and even frivolously violated. Authentic *kabuki* music alternates with a muted jazz trumpet or violins and vibrophone, and outdoor scenes can seem conspicuously painted as if to recall Western landscapes. Traditional *kabuki* and Western-style cinema reflect each other as equally artificial constructs.

The effect of all these proliferating plot turns, conspiratorial revelations, character doublings, and formal devices is to create a narrative maze in which rational comprehension of all detail becomes difficult or perhaps impossible on first viewing. Narrative clarity tends to dissolve into an illusion of infinite recession, as in a hall of mirrors. In this, the story is not unlike the Byzantine workings of many *kabuki* plays (or eighteenth-century opera in the West), but the film does not stop there.

Plural Intertextuality

If *An Actor's Revenge* seems like a labyrinthine text in itself, another part of its fascination comes from a layering of intertextual references so complex that the effect of infinitely receding mirrors extends well into the social fabric of Japanese film history and cross-cultural influences between Japan and the West. First, Ichikawa's film is a remake of Teinosuke Kinugasa's *The Revenge of Yukinojo* (*Yukinojo Henge*, 1935), a film made during the militarist period of closure against the West as strict as that of the Tokugawa regime in which the story is set. As in the Ichikawa film, the Yukinojo character in the original film also maintained his *onnagata* role both on- and offstage, and the same actor again performed the roles of both Yukinojo and the burglar (and in the first film, of Yukinojo's mother as well). Further, as is well known, Ichikawa specifically chose the same actor who had starred in the 1935 film to recreate his role in the 1963 version, and Ichikawa's scenarist Natto Wada adapted the original scenario by Daisuke Ito and Kinugasa, which had been based on a novel by Otokichi Mikami.

Interestingly, the actor involved had changed his name between films, reversing the film character's adoption of a stage name after he left Nagasaki. When the actor had moved from Shochiku to Toho, he had been forced to leave his stage name of Chojiro Hayashi behind and revert to his birth name of Kazuo Hasegawa. In a famous incident, a Korean gangster hired in part by the Shochiku labour-gang boss slashed Hasegawa in the face with a razor; only afterward did the public sympathize with the change and accept his new name.[4] Hayashi/Hasegawa's face was then reconstructed through extensive plastic surgery, making his "real" face as much an artificial construction as that of his *onnagata*'s role's makeup. Shortly after Ichikawa's film, Kobo Abe's novel *The Face of Another* would make the trope of plastic surgery and new identity a metaphor for the Japanese experience of cultural change; by 1966, Hiroshi Teshigahara had made Abe's novel into a film.

In 1963, Ichikawa's choice of Hasegawa for the role of Yukinojo already suggested the violence of identity change between the militarist period and the post-Occupation cinema of "modern" Japan. This disjunction specifically resonates

with the difference between *kabuki* tradition and Western realism: the enforced mythologies of militarism that attributed divine origin to the emperor had been displaced by the humanist realism of the American Occupation as vehicle of an equally imposed ideology. For those Japanese who had lived through the militant enforcement of such contradictory ideologies, a cynical distance tended to undermine absolute belief in any single system of meaning, as can be seen in the films of the Japanese New Wave contemporaneous with Ichikawa's film.

But many more ironies surround the names of personnel associated with *An Actor's Revenge*. Kinugasa, the director and co-scenarist of the first version, is best known in the West both for his experimental films of the 1920s, *A Crazy Page* (*Kurutta ippeiji*, 1926) and *Crossroads* (*Jujiro*, 1928), and for his later *The Gate of Hell* (*Jigokumon*, 1952). However, Kinugasa was himself originally an *onnagata* at the Nikkatsu film studio and played the heroine in such films as Eizo Tanaka's *The Living Corpse* (*Ikeru shikabane*, 1917). Kinugasa led the 1922 *onnagata*'s strike against Nikkatsu to protest the introduction of women to play female roles in films, before making a career change and becoming a director. Although Kinugasa had between these two periods reversed himself to lead the fight to modernize Japanese filmmaking, his 1935 production of a film narrative centreing on an *onnagata*'s revenge unavoidably recalls the conflict between traditional *kabuki* stylization and Western cinematic realism earlier in Japanese film history.

Unfortunately, few complete films from this period survive, even at the Film Center of the National Museum of Modern Art in Tokyo or in the Matsuda collection, and *The Living Corpse* is so far extant only through written descriptions.[5] This was the period when *onnagata* and *benshi** dominated Japanese film production, together with the exaggerated *shimpa* techniques for which Tanaka was primarily known. Tanaka, however, idolized Ibsen and attempted to introduce "new-style" films beginning with *The Living Corpse*, substituting such devices of Western realism as location shooting for the theatricality of *shimpa*. According to Anderson and Richie, Kinugasa's female appearance in the film was contradicted only by the heavy workmen's boots that he wore due to the heavy mud encountered during November shooting. However, no one objected because "the audience had not yet been trained to expect the illusion of complete reality."[6]

The Living Corpse, then, apparently participated in a remarkably mixed style of film in some ways unique to Japan, but also characteristic of the intersection of traditional non-Western aesthetics with cinematic representation. The omniscient style of camera narration characteristic of Western realism is framed by the *benshi* as interpretive narrator, location realism combines with contradictory costume

* Benshi acted as the narrators of silent films. With origins in the commentary of traditional drama they developed their explanatory functions into an art which often made them more famous than the actors. *Ed.*

elements, and photographic realism combines with *onnagata*. This mixed text is conceived as a move against the theatricality of *shimpa*, and marks what is perhaps Kinugasa's most important role as an actor in early cinema. Although Kinugasa's relationship to Western modernism has been debated, concerning his avant-garde films like *A Crazy Page*,[7] the effect that his disjunctive stylistic background had on his interest in antirealist filmmaking has yet to be discussed. Ichikawa, in remaking *An Actor's Revenge*, is in some ways more faithful to Kinugasa's film experience than Kinugasa's original version could be. Through his deliberate undermining of cinematic realism by studio theatricality, Ichikawa reconsiders precisely those early conditions of production that helped shape Kinugasa's wildly diverse career and incorporates those into his remake as a critique of the text.

Daisuke Ito, who co-wrote the original *Actor's Revenge* scenario with Kinugasa, was himself a major director of silent films. Ito originated the *chambara* or swordfight film, which recreated the fight scenes of previously filmed *kabuki* and *shimpa* plays with greater cinematic realism. Curiously, *chambara* films are linked with ideas of left-wing social activism, which circulated in Japan during the 1920s, and often feature an outlaw hero fighting against a corrupt and oppressive social order. The most famous actor portraying such outlaw heroes was Tsumasaburo Bando, but Hayashi/Hasegawa was almost as popular.

Although again few films survive, it is possible to draw some guarded conclusions from Ito's only extant silent film, *Jirokichi the Ratkid* (*Oatsurae Jirokichi goshi*, 1931), together with Buntaro Futagawa's *The Outlaw* (*Orochi*, 1925) and Tsuruhiko Tanaka's *The Red Bat* (*Beni komori*, 1931).[8] All these films can be considered as part of the Ito school, through their increased physicality of performance combined with dynamic camerawork and editing during combat sequences. Most interestingly, a comparison of *The Outlaw* and *Jirokichi* suggests the kind of innovations Ito introduced. *The Outlaw*, in contemporary terms, is a far more experimental film. The climactic fight scene at the end of the film is represented through a series of stylized combat tableaux directly transposed from *kabuki*: the central character is tied in by police ropes drawn across the screen like a spider's web, and a close-up presents his face in cross-eyed anguish as if in a Sharaku *ukiyo-e* (Edo-era woodblock print) portrait of a *kabuki* actor. Intercut with this, the film rapidly jumps across static compositions of the surrounding police in a machine-gun rhythm of staccato Soviet-style montage. Accordingly, *The Outlaw* follows a paradoxical pattern of inversions where Western modernism and Japanese traditional aesthetics seem to coincide, as I have discussed elsewhere.[9] In contrast, Ito's own film *Jirokichi* radically eliminates both such theatrical effects and disjunctive montage, substituting a dynamic style of physical performance and cutting on action to centre attention on character within narrative continuity. Yet even in *Jirokichi*, as Burch has noted of Ito's style as perpetuated in *The Red Bat*, visual stylization exceeds Western continuity norms. Rapid swish pans (e.g., between two men at a

tense moment) interrupt Western conventions of narrative action but in Ito seem designed to intensify viewer involvement with screen action.

It is perhaps impossible to reconstruct with any historical certainty how the *benshi* (or *katsuben*, as *benshi* for cinema were called) interacted with specific films. However, if Shunsui Matsuda's *benshi* performances on the soundtracks that now accompany both *The Outlaw* and *Jirokichi* are any evidence, then *benshi* performance may also have been modified in relation to shifts of visual style. In Matsuda's *The Outlaw*, the *benshi*'s voice frequently interrupts the action, as for example to introduce each new character who appears on screen. This produces an unintentional Brechtian effect of distancing the viewer from total identification with the action. In contrast, in Matsuda's *Jirokichi*, the *benshi* narration conforms far more precisely to the outlines of the action visualized on screen, again inviting a more direct identification with the central character within narrative continuity. If this is not simply coincidence, the difference is highly suggestive of possible innovations within the mixed textual construction of *katsuben* performance.

Accordingly, such tropes as national xenophobic isolation, a name change masking violence, the transposition of the *onnagata* role within cinematic realism, and sword fights against social oppression all extend past Ichikawa's film text into its social and historical context. Ichikawa's easy mixture of realist and anti-realist devices recalls and transforms the discordant styles within a text that characterized early Japanese cinema. Of course, one could object that any Japanese film could be traced to its origins in early cinema, but such an objection would miss the point. Ichikawa's *An Actor's Revenge*, through its concatenation of specific and highly charged intertextual citations, invites consideration of the cultural and cross-cultural contexts in which narratives are produced. These contexts are situated at the intersection of Japanese traditional theatre and Western cinematic realism, and are addressed in *An Actor's Revenge* by a rereading of melodrama.

Melodrama as Avant-garde

In the histories of Japanese cinema available in English, melodrama is usually treated briefly. The predominant view is that melodrama can be equated with *shimpa*, or "new school theatre," the form of Japanese theatre characteristic of the Meiji era. *Shimpa* originated in the 1890s and maintained a dominant popularity from about 1900 to the mid-1920s, and was the primary source both of cinematic style and of film actors and directors during the early period. *Shingeki*, or "modern theatre," thereafter displaced *shimpa* as a primary cultural influence, beginning with experiments in theatre in 1909 and becoming dominant in cinema by the 1930s.

Opinion has then often diverged in ways that leave *shimpa* equally marginalized. Most often, *shimpa* has been dismissed by both Japanese and American writers as a transitional, "half-modern" movement, not yet sufficiently realist to sustain audience attention as a fully adequate representation of the modern age. Tadao Sato, for example, argues that its character types were drawn from *kabuki* and dismisses its "antiquated forms" once *shingeki* appears.[10] Donald Richie refers to *shimpa* as "almost instantly fossilized" and again contrasts it to a *shingeki*-influenced cinema that seems obviously superior because "*shingeki* at least concerned itself with a kind of reality."[11] Faubion Bowers, in his classic postwar text on Japanese theatre, dismissed early *shimpa* as silly and insignificant melodrama and again reserves praise for the "serious" theatre with realism that followed.[12] Alternatively, Burch praises *shimpa*, but as a form of resistance to Western models of narrative form that preserved elements of traditional Japanese theatre. Burch argues that the originators and practitioners of *shimpa* knew little or nothing about the Western models they were supposedly emulating and, as a result, unavoidably recapitulated the traditions they sought to abandon.[13] The difficulty with either of these positions is that neither examines *shimpa* on its own terms. Both instead immediately slide past *shimpa* to another form privileged as "serious" in its influence on cinema, regardless of whether realism or an anti–realist reading of *kabuki* is so privileged.

Yet *shimpa*, even when it is described by its detractors, is clearly an energized intersection of conflicting forms, an unstable and multiple movement that functioned as a pivot between traditional Japan and the modernized West. *Shimpa* directly derives from the "political dramas" (*soshi-geki*) originated by the Liberal Group in 1888 to promote the policies and platforms at stake once the Meiji constitution would be put into effect in 1890. Yet *shimpa* is also clearly related to efforts made to reform *kabuki*, to imports of Western plays, and to contradictions between Western and *kabuki* norms of representation. In *kabuki*, Danjuro IX's nationalistic "Plays of Living History" (beginning in 1878) and Kikugoro V's "Cropped Hair Plays" (beginning in 1879) both radically broke with the prescriptive stylization of *kabuki* that characterized the late Tokugawa period. Danjuro sought to eliminate the inconsistencies of traditional *kabuki* texts and rewrite them as unified nationalistic propaganda based on historical research. Kikugoro first adapted a Western play into Japanese and staged performances in contemporary dress; cropped hair indicated the recent abolition of feudal social distinctions and the hairstyles that had signified them. Both Danjuro and Kikugoro adapted Western models of narrative construction (history, theatre) to promote the social and political agendas of modernization, yet pursued these representational goals within the framework of *kabuki*.[14] As a consequence, both produced performances that mixed styles as freely as *shimpa*.

Shimpa as a term first refers to the work of Otojiro Kawakami, beginning in 1891 with his elimination of overt political material from the "political dramas" he

had been writing. Enough legends surround this "sensational charlatan," who is acknowledged as the "father of modern drama in Japan," that he seems like a Meiji version of O-Kuni, the woman whose dance in the bed of the Kamo River supposedly created *kabuki*. One narrative claims that an audience member once murdered one of Otojiro's fictional villains, because he was supposedly unable to distinguish art and life even in the initial stages of realist aesthetics.[15] (Godard restages a similar story in *Les Carabiniers* about the confusion of art and life for viewers of early cinema.) Another narrative claims that Otojiro, after touring Europe and America with *shimpa*, returned to Japan in 1902 to stage a version of *Hamlet* in which the central character entered on a bicycle.[16] This particular story (also appreciated by Burch) joins Shakespeare with a signifier of the European avant-garde, because the bicycle was in the late nineteenth century the principal emblem of the modern among Bohemians.[17] European tradition appears avant-garde in Japan, in a mirror reversal of the paradoxical link of Japanese tradition and Western modernism noted in *The Outlaw*.[18] In his work on the *Origins of Modern Japanese Literature*, Kojin Karatani also notes that the onset of the modern period in Japan is characterized by a series of such inversions.[19]

Shimpa after 1895 was capable of mixing forms of representation in a way that can perhaps only be appreciated in the West after the postmodernist re-evaluation of pastiche and contradictory styles within the same work. Both men and women appeared onstage at the same time in female roles,[20] a circumstance often criticized as partially regressive or progressive but not appreciated as a meaningful contradiction in itself that usefully problematizes representation. *Shimpa* also first combined film with live performance in "chain-drama" (*rensa-geki*), as early as 1904 and as late as 1922, with significant popularity beginning in 1908.[21] In this mode of representation, exterior scenes were shot on film and alternated on stage with live performances for interiors. In its capacity for such innovative mixed forms, what is called melodrama or *shimpa* in Japan ironically seems to share certain features with what in Europe is called avant-garde: a passion for the politics of representation, a distancing from total identification with any single system of meaning, and a disruption of the ontology and epistemology of the image.

Shimpa, it could be argued, was a volatile generator of tropes that first marked the collision of Japan and the West. As such, this marginalized form functioned to help produce the determining tropes that served to orient Japan's entry into the modern period, and which are later repressed in dominant forms of representation from the 1930s on. Ichikawa's *An Actor's Revenge* redirects our attention to what is called Japanese melodrama, through a text informed by a complex intertextual understanding of melodrama's multiple determinants. The determining tropes of *shimpa* then begin to self-destruct through representational contradictions made apparent by their recontextualization in an era of dominant cinematic realism. The film reinstates the representational indeterminacy of the period when *shimpa*

was dominant, and signification had not yet become comfortably polarized into the mythologized terms of tradition and realism.

In *An Actor's Revenge*, melodrama appears as a boundary site between *kabuki* and cinematic realism. Through an inversion, by which melodrama is reprioritized long after it had been conceived as superseded by realism, the style is made to comment on the logocentric assumption that realism is central. In part, the film recalls the historical origins of realism for Japan in a mode of excess, undermining realism's pretensions to an origin in an objective, mute nature. *An Actor's Revenge* retells a melodramatic story of love and vengeance by freely mixing realist and anti-realist devices and, by so doing, suggests that a totalized illusion of realism depends on a denial of sexual difference and of class violence. Through a strategy of excess, realism is seen as grounded in a desire for power over the other, both ideologically and sexually.

On the other hand, Ichikawa's reinscription of melodrama also relocates *kabuki* as a necessarily complementary mode of excess. By 1912, Nikkatsu had divided its production into *shimpa* ("new school"), which signified the production of dramas in contemporary settings at its Tokyo studio, in contrast to *kyuha* ("old school"), the period dramas produced at Kyoto.[22] From the historical break that marked the emergence of Japanese melodrama, *shimpa* and *kabuki* reinvented one another, each in a way that mixed traditional—modern and Japanese—Western values. As a result, neither *kabuki* nor *shimpa* is the Tokugawa theatre or European melodrama it may at first appear to be. At Nikkatsu, *shimpa* worked to redefine the parameters of period drama, not as a tableau transposition of *kabuki*, but as a domain in which a middle-class Meiji personality-type confronted tradition. At the same time, *shimpa* preserved the character stereotypes of *kabuki*, producing a specifically Japanese version of melodrama. As described by Sato, these types are the *tateyaku* ("standing role"), the *nimaeme* ("second"), and the *onnagata*. The *tateyaku* is the male lead of the *kabuki* troupe, who represents the idealized *bushido* samurai and never places romantic love or family interests above his loyalty to the feudal lord. The *nimaeme*, in contrast, were weak men who fell in love with geisha or prostitutes and preferred to commit suicide with them rather than subordinate emotional intimacy to *bushido*. The *onnagata* played all female roles, but especially the idealized woman whose virtue is demonstrated by the degree of sacrifice she endures. Sato argues that these values contrast sharply with feudal ideology in the West, in which warrior virtue is identified with romantic idealism. In *shimpa*, excess functions to reinforce polarized values of good and evil, as in Western melodrama, but the ideological terms so valorized are quite different.

Kabuki was itself often a form of social protest against a corrupt Tokugawa regime. Sato relates the *kabuki* male-character split to the difference between samurai tradition and the emerging merchant class during the Tokugawa period, with their respectively different attitudes about the role of women. Ito's active

translation of such protest elements into left-wing *chambara* films reinscribed *shimpa* melodrama as a critique of emerging Japanese capitalism, constructing a parallel style from different sources to the Western melodrama that had emerged in the West during the capitalist development of industrialization. In Ito's reweaving of the multiple determinants that characterize a specifically Japanese mode of melodrama, the *tateyaku* becomes the vehicle for an Old Left trope of heroic socialism. The ironies of this formation become especially obvious once feminism emerges as a component of social critique.

Kinugasa's mid-1930s *chambara* is more ambiguous: although his narrative's representation of a corrupt elite might suggest an extension of Ito's critique to the militarists by then in power, Yukinojo's dedication to his vengeance also suggests an ethical purity valorized by Japanese fascism. Given the intensifying repression of dissent during the 1930s, Kinugasa's text hides behind a double reading: the corrupt elite could just as easily be read as the dominant Westernized class that revolutionary fascism considered itself to be fighting against. Ichikawa's satirical quotation of the trope of a corrupt dominant class after the Occupation recalls both Ito's and Kinugasa's prior usages. Early *chambara*'s anti-capitalist protest is recalled in the context of renewed post-Occupation capitalist development, but so are the ambiguous consequences of such protest during the militarist period and the Occupation.

By satirical displacement, Ichikawa does not so much negate the social critique of *chambara* as turn our attention elsewhere. The film problematizes an identification of social activism with an unconsidered conjuncture of *tateyaku* and a realist aesthetic. As such, a principal target of the film's critique becomes the samurai humanism of postwar period films by Kurosawa and others, including such "masterpieces" celebrated in the West as *Seven Samurai* (*Shichinin no samurai*, 1954). Although Richie has argued that Mifune is "definitely a post-war type," Sato argues that Kurosawa's casting of Toshiro Mifune is a classic example of the *tateyaku* role.[23] Yet, Mifune's role in *Seven Samurai*, as has often been noted, is to defend the peasants rather than exploit them. Kurosawa's samurai tend to revive early *chambara*'s reinscription of *tateyaku* as socialist protest, but shift the politics by developing the character of individual samurai. The *tateyaku* role is reinscribed once again to suggest humanist individualism, but still within the value system of Japanese melodrama, the traces of which remain in Japanese cinema long after the surface style of exaggerated action has disappeared. In *Seven Samurai*, the enemy has also been recast from an oppressive dominant class to the chaos of uncontrolled criminals, a shift that ironically returns the samurai to a position of legitimate, if temporary, authority over the peasants who mistrust them. Ichikawa's Yukinojo in part satirizes this recuperation of democratic activism (whether socialist or humanist) by the unavoidably rigid hierarchies of feudal heroics condensed within the figure of the *tateyaku*. Equally important, his film undermines

the embedding of this contradictory figure within the naturalizing form of a totalized realism.

In Ichikawa's *An Actor's Revenge*, the "truth" of both social oppression (Yukinojo's re-enactment of his father's ghost to confront his enemies) and of sexual difference (Yukinojo's theatrical construction of sexual identity juxtaposed with Namiji as voyeuristic object) is represented as a confrontation of the theatrical against a dominant realism. The most significant danger is the violence of representations embedded in ideological rigidity, and the effective response is not vengeance but *jouissance*, a play of forms. If the characteristic activity of *chambara* from Ito through Mifune is to valorize a negational rage against social oppression, then the figure of Yukinojo works to undermine the categorical absolutism enforced by negation. Through its parody of the Hasegawa type of social protest, *tateyaku*, Ichikawa's melodrama works to reverse the tendency toward representational identification with totalitarian control that has characterized both the left under Stalinism and the humanism of corporate hierarchization. In contrast to the similar concerns of Oshima's *Night and Fog in Japan* (*Nihon no yoru to kiri*, 1960), Ichikawa further plays with the problem of how to reinscribe violence into a positive project of textual pleasure that unlocks the anxious isolation of the subject.

Gender Indeterminacy

The parody of Yukinojo functions as a playful critique of what Lacan would call the paranoid construction of the cogito, and its dependence on a categorically objectified other to defend itself against anxiety. Nowhere is this parody more fully developed in *An Actor's Revenge* than in the treatment of gender. The juxtaposition of *onnagata* and actress in a love scene generates contradictory tensions that cannot be resolved within any expectation of a unified text. This juxtaposition recalls the same mix of performers of female roles in *shimpa*, at the "origins" of "modern cinema," but here recedes into an indeterminacy that cannot be contained by an imaginary progress toward one representation or the other.

This destabilization rests on the simple device of sustaining the images of both *onnagata* and actress within the conventions of a love scene characteristic of realist continuity, inviting the same emotional transference and identification with character that classic cinema constructs. As a result, the viewing subject is placed in an untenable position. It is not just that identification is undermined by transgressive sexual implications, but that those implications become undecidable. If the images of what appear to be two women together suggest a lesbian relationship, then an eroticized image of an *onnagata* as a male offstage also shifts the appearance of female costume toward transvestism. Is the woman a voyeuristic object of male

desire mirrored back by the man's cross-dressing? Or the man an image of the woman's narcissistic desire for a weak *namaeme*, literalized in the form of emasculation? The effect of receding mirrors earlier observed both textually and intertextually is here reinscribed at the position of emotional identification to trouble the formation of the subject.

One might object that such tensions are a mirage created by seeing the film out of context, that *onnagata* are completely conventional in Japanese tradition, and that only Westerners would imagine sexual complexity by misreading an *onnagata* as if he were a transvestite. Yet this objection overlooks the 1958 passage of the anti-prostitution law in Japan, a law designed to bring Japanese sexual practices into conformity with the appearances demanded by the West. It also overlooks Ichikawa's many previous films such as *Enjo*, *Kagi* (*The Key*, 1959), *Bonchi*, and *Hakai*, which specifically represent a neurotic or perverse psychology in a Japanese context, some adapted from novels by Tanizaki and Mishima, which themselves are psychoanalytically informed. Since the Meiji period, numerous translations of Western texts (both books and films) have circulated in Japan, often the same texts through which Westerners develop their own unconscious assumptions or reading formations through which they interpret the world. Unavoidably, many Japanese have become well aware of how Westerners are likely to view certain things and have often incorporated Western discursive formations into their own work. Tanizaki and Mishima are but two examples. Wim Wenders's nostalgia in *Tokyo-ga* for an imaginary Ozu-style Japan to the contrary, no pure Japan has ever existed. This fantasy is of recent invention and is inextricably linked in Japan with a xenophobic and authoritarian right wing seeking justification for an imaginary cultural superiority over Japan's Asian neighbours and the West. In the United States, a fantasy of an innate Japanese difference is linked with a similar narcissism, one that imagines that only ignorance of Western formations of knowledge and power would explain any limit to American cultural totalization.

Cultural difference remains but not through ignorance of the West. Multiple determinants always affect the complex intertextual formations we call culture, never any single source. Accordingly, as *An Actor's Revenge* seems to demonstrate so well, texts that invite multiple and even contradictory readings can be constructed. The process of cross-cultural translation is unavoidable, and the film functioned from the outset in both Japanese and Western readings, a doubling that contributes to its effect of receding mirrors.

For Lacan, of course, mirror identifications are a mark of the mirror stage and its unavoidable component of undifferentiated aggressivity.[24] Lacan argues that during the period when a child first identifies the image in the mirror as a signifier of the self, that image is still relatively undifferentiated and remains transferrable among other children. This phenomenon, which he terms a transitive relationship, means that children at this stage are unable to conceptually distinguish between

others and themselves. Transitivism leads to both the spontaneous identification of children with one another and, simultaneously, to intense unresolvable disputes whenever desires come into conflict, because the child has no conceptual apparatus to distinguish intersubjective difference clearly. For Lacan, this apparatus requires the locating of the self in language, a project accomplished through gender differentiation. Accordingly, Lacan warns against appeals to emotional identification, often produced in the name of "humanism," as a means of resolving conflict.

In these terms, the undecidability of gender relationship in the *onnagata*-actress love scenes becomes a mark of its cinematic "language," and its displacement of fetishized love object toward a representation of *jouissance*. Located at the site of narrative and visual mirroring, *onnagata* and actress become interchangeable or transitive. The classic realist camera image that constitutes woman as the object of the gaze is equated with the theatrical construction of the idealized female object by the male. In other words, the realist image that embeds woman in a naturalized objectification is itself seen as a mask, and the "truth" of the realist image is recast as a mask of power.

The formation of the body in representation becomes a contested terrain through the sexually ambiguous figure of Yukinojo, so that mastery of the other by reduction to a unitary object becomes impossible. Reciprocally, the plural representation of gender raises the questions of authorship and authority in textual construction. Ichikawa has never been identified with the single set of concerns classically used to identify the body of work belonging to an auteur. Instead, his work has been remarkably diverse and open to a play of contradictory forms, similarly impossible to master by reduction to a unitary object.

In Yukinojo, the body becomes a scene of teaching, in the sense in which Gregory Ulmer refers to Lacan's seminars as a combination of the psychoanalytic scene and pedagogy. However, here the disciplinary boundaries that frame the possibility of the subject are themselves called into question.

Notes

1. Donald Richie, *Japanese Cinema* (Garden City, N.Y.: Doubleday, 1971), 191.
2. See Peter Brooks, *The Melodramatic Imagination: Balzac, Henry James, Melodrama, and the Mode of Excess* (New Haven: Yale University Press, 1976).
3. Richie, *Japanese Cinema*, 190–91.
4. Joseph L. Anderson and Donald Richie, *The Japanese Film: Art and Industry* (Princeton: Princeton University Press, 1982), 86–87.
5. Regarding the scarcity of surviving materials from this era, see Noël Burch, *To the Distant Observer: Form and Meaning in the Japanese Cinema* (Berkeley: University of California Press, 1979), 111.

6. Anderson and Richie, *Japanese Film*, 39.
7. See James Peterson, "A War of Utter Rebellion: Kinugasa's *Page of Madness* and the Japanese Avant-Garde of the 1920's," *Cinema Journal* 29, no. 1 (fall, 1989): 36–51, and Burch, *Distant Observer*, 123–39. Peterson argues that Kinugasa was a modernist, while Burch sees him as a traditionalist.
8. See also Burch, *Distant Observer*, 110–16. In his discussion of Ito, Burch provides a formalist critique of *The Red Bat*, the only film from this school he had been able to see. He does not, however, discuss the influence of socialism on *chambara*, and instead sees the form as an expression of a dominant class. I am indebted to Larry Greenberg of Matsuda Films and Kyoko Hirano of the Japan Society for their assistance in permitting me to see *Orochi* and *Jirokichi*, and to Akira Shimizu of the Japan Film Library Council and the Film Center of the National Museum of Modern Art in Tokyo for enabling me to see *The Red Bat*.
9. Scott Nygren, "Reconsidering Modernism: Japanese Film and the Postmodern Context," *Wide Angle* 11, no. 3 (July 1989).
10. Tadao Sato, *Currents in Japanese Cinema*, trans. Gregory Barrett (Tokyo: Kodansha International, 1982), 20.
11. Richie, *Japanese Cinema*, 7–8.
12. Faubion Bowers, *Japanese Theater* (Rutland, Vt.: Charles E. Tuttle, 1952; 4th ed., 1982), 208–12.
13. Burch, *Distant Observer*, 59–60.
14. Bowers, *Japanese Theatre*, 201-8.
15. Ibid., 208-11.
16. Ibid., 210. See also Burch, *Distant Observer*, 59–60.
17. Roger Shattuck, *The Banquet Years* (London: Cape, 1969).
18. Nygren, "Reconsidering Modernism."
19. See Brett DeBary, "Karatani Kojin's *Origins of Modern Japanese Literature*," and Kojin Karatani, "One Spirit, Two Nineteenth Centuries," *South Atlantic Quarterly* 87, no. 3 (summer 1988): 591-628.
20. Bowers, *Japanese Theater*, 212.
21. Anderson and Richie, *Japanese Film*, 27–28.
22. Ibid., 31.
23. Ibid., 403; Sato, *Japanese Cinema*, 19.
24. Jacques Lacan, "Aggressivity in Psychoanalysis," in *Écrits*, trans. Alan Sheridan (New York: Norton, 1977), 8–29; selected from *Écrits* (Paris: Éditions du Seuil, 1966).

An Actor's Revenge

KON ICHIKAWA

CinemaScope and Me

THE MIGHTY NABOBS who run the studio passed down the word after one of their production meetings. "It has been decided," they intoned, "that your next film will be shot in CinemaScope." My first response was one of utter confusion. How could I possibly learn to master that monstrously elongated screen in a way that would benefit my filmmaking?

The more I thought about it, the more I realized that the standard-sized screen—just slightly wider than square—had become so familiar over time that it was almost a part of me. In the thirty years that had passed since I had seen my first movie, Charlie Chaplin's *The Kid*, I had taken it for granted that was how the screen was shaped. During the decade I had worked as an assistant director, my grasp of the interplay of light and shadow had been shaped by those dimensions—it was within their borders that my "artistic volition" had been formed. Nothing changed once I became a director. Day after day, from morning to night, I focused on how to best take advantage of that predetermined space. It was the crucible in which my skills were forged, the window through which I observed humanity.

Now, all of a sudden, new windows had appeared to the right and left of that original one, and it was up to me to learn how to connect them. The way in which I perceived the world had to be revised, and quickly. Much practice would be required before I could understand how beauty operated in this new stretched-out format. To be frank, I found the whole idea quite unsettling.

I considered complaining to the nabobs. "J-just hold on a minute," I could hear myself stammer. "Is this really necessary? I mean, why don't we do it the normal way?" "Well, well," they would reply condescendingly, "we assumed you were more enterprising. We didn't think you would reject CinemaScope just like that."

In the end, though, CinemaScope completely won me over. There is something about that screen stretching from one end of the stage to the other that makes watching a film strangely pleasurable, even when it is actually quite mediocre. In fact, thanks to that format, I have been able to recapture the sense of being one of

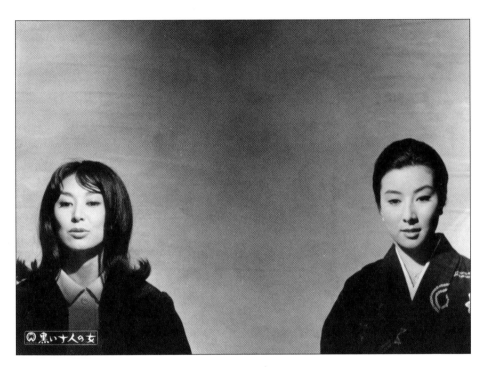

Ten Dark Women

the audience, something I had lost during my many years in the business. The sordid concerns of the filmmaker—artistic ambition, the investigative spirit, and the like—scattered like dust the second my eyes met that sprawling monstrosity. I found myself filled with wonder again, like a child. This is why I love CinemaScope so unequivocally. It is, I think, a physiological response.

Recently, noted foreign directors have set about taming the format. Though I haven't seen any of this new work yet, I have heard that films like *East of Eden* strive to replicate the effect of movies shot for the traditional screen. This fits the pattern. Film artists are a greedy bunch, who habitually chew their fingernails while studying the new technologies that studios develop to pull in the audience. Once they have figured out how to add these new weapons to their artistic arsenal, however, they strike quickly.

Before long, therefore, we can expect that ridiculously elongated screen to spawn new artistic masterpieces. Although from the standpoint of cinematic development I suppose this should be cause for rejoicing, somehow the prospect leaves me cold.

The true value of CinemaScope can be found in movies which, like *Seven Brides for Seven Brothers*, are absurdly excessive in their scale, and the enjoyment they give their viewers. I don't really care if the centre of the screen is a bit blurry—I simply enjoy the sensation of being a fan again, and forgetting all about "art."

1955

Translated from the Japanese by Ted Goossen

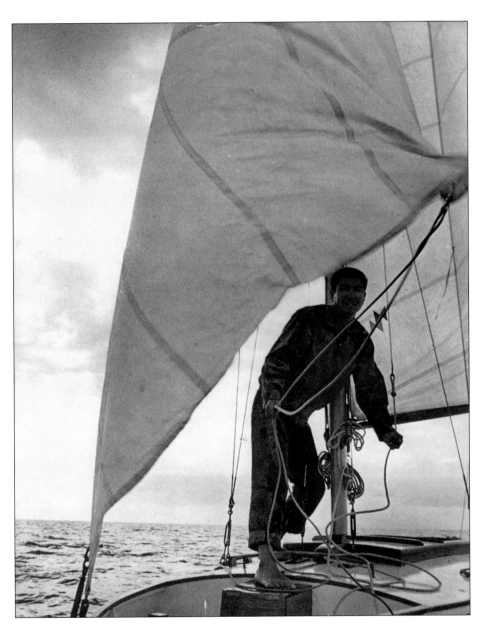
Alone on the Pacific

BRENT KLIEWER

Escaping Japan: The Quest in Kon Ichikawa's *Alone on the Pacific*

> "In floods of life, in the storm of deeds, I move up and down, weave to and fro! Birth and grave an eternal sea, a shifting life! So I work at the whirring loom of time and make up the living garment of divinity."
>
> — THE EARTH SPIRIT IN GOETHE'S *Faust*

Kon Ichikawa's *Alone on the Pacific* (*Taiheiyo hitoribochi*, 1963) is based on the actual experience of a young man, Kenichi Horie, who in 1962 sailed from Osaka to San Francisco in his nineteen-foot yacht, *The Mermaid*. It prefigures Ichikawa's revolutionary sports documentary, *Tokyo Olympiad* (1965), specifically the story of the lonely runner from Chad, whose agonizing cross-country race is told in isolation from the other participants. Caught up in an inner world of obsession and pain, both Horie and the runner from Chad exhibit extraordinary tenacity and endurance.

Though heroic, even epic, Horie's story is filtered through Ichikawa's ironic viewpoint and preoccupations, both aesthetic and psychological, which make *Alone on the Pacific* one of the most curious oddities in the director's oeuvre, even considering its staggering variety of subjects and genres. Ichikawa and screenwriter Natto Wada's audacity in transmuting Horie's solitary, ninety-four day voyage into a hundred-minute narrative surely ranks with the daring of the excursion itself: a daunting task to say the least, especially when the main action is neatly summarized in the film's title. Condensing Horie's logbook into a series of moments at sea, abetted by voice-over narration, Ichikawa and Wada integrate fictional flashbacks to construe Horie's psychological make-up and tense family relationships, and to

construct a narrative chronology leading up to the voyage. Obsessive dream transpires into obsessive reality.

Before it evolves a Zen ideal of oneness, *Alone on the Pacific* presents Horie's struggle as an archetype of Western Romanticism—a mystical dualism where man and nature, the physical and the spiritual, do battle. (The film's alternative English title is *My Enemy the Sea*.) Classical mythology having inspired the Romantics, it is therefore not inapt to read *Alone on the Pacific* as a reconfiguration of the epic voyage of Jason and the Argonauts. Both the film and the myth are chronicles of a quest in which the hero sets himself a number of impossible tasks, coming through each unscathed. The respective ships, *The Argo* and *The Mermaid*, are expressly constructed for their singular quests: Jason's delivery of the golden fleece to Pelias, which will ensure him the throne of Iolcus, and Horie's reaching the Golden Gate Bridge, a quest less driven and defined—if no less noble. If we equate the Golden Gate with the golden fleece, in as much that it represents the object of the quest, the question arises: What will Horie have won when he reaches his goal?

Ichikawa sustains the mythical reading, making Horie's quest a parable of the human condition and its transcendence, a common theme in expedition or epic films. He digresses from the classic motif, however, in his hero's original intent; Horie's aspirations in conquering the sea are both ineffable—literally, "because it's there"—and pragmatic. Horie wants to escape: his family, Japan, his old self.

If a quest, by definition, is to search or seek for something, tangible or not, implying forward motion to a goal, a point of destination or deliverance must be assumed. Even a spiritual quest, such as Zen enlightenment, is attained through evolution. A quest, then, precludes the notion of "escape"; getting away from something is not the same as seeking something. Horie's departure from Japan therefore does not follow the logical motivation of the classic epic form; his desperation to flee has a somewhat obscure, psychological impetus, which only slowly is transformed into a true quest, as Horie interrogates himself during his voyage. He seeks, finally, personal liberation, and achieves a kind of transcendence. Passage underneath the Golden Gate Bridge offers not only deliverance from the sea, but (momentary) deliverance from Japan.

A prisoner of Japan and, more fundamentally, of "Japaneseness"—the oppressive sense of having to fit into a monolithic system that governs all his future options—Horie prepares his mission like a clandestine operation, akin to drug smuggling or wartime espionage, culminating in his stealing out of Osaka Bay in the middle of the night. The getaway scene is strategically placed at the beginning of the film, announcing the theme of "escape" even before we are made aware in subsequent flashbacks of the dire situation that has compelled Horie to abscond. Even the threat of drowning doesn't dissuade him; for Horie, remaining in Japan constitutes a fate worse than death.

Horie's risk is very high indeed, given his want of practical sailing experience. He commissions the plans of a "kingfisher class" boat and supervises its construction, but his ability to gauge the vessel's structural soundness, its capacity to withstand the furious gales over the long haul, remains questionable—more a leap of faith than empirical assessment.

Horie's naïveté is indicated by the exhaustive "laundry" list of items he compiles for the voyage. As the camera pans down the written list on the left, Horie's idealized, larger-than-life image of each item appears superimposed on the right. The list goes on and on, matter of factly, Horie narrating item for item, until all we can imagine is the boat sinking in Osaka Bay under the excessive weight. Tellingly, the only item missing from the list is his passport: the one official document that identifies his Japaneseness.

As the sailboat stalls in Osaka Bay, crippled by windless conditions, drifting only one half-mile in eighty minutes, Horie, all too mindful that Japanese law prevents small craft from going far offshore, panics. Dodging the coast guard searchlights until the next morning, which still finds him in Osaka Bay, Horie narrates: "I expected slow going in home waters, but Japan seems to be holding me back. Why won't she let me go?" The "system" that is Japan seems to have a kind of preternatural power; as in mythology, the elements seem to conspire to defeat the hero, only it is not a god but an all-powerful order that appears to control even the wind and waves.

When Horie was queried by his mother (played by the great Kinuyo Tanaka) in an attempt to understand her son's endeavour, he replied that individuals from other nations, but no Japanese, had made solitary treks across the seas. "It's disgraceful. We're a seafaring nation," he told her, his contemptuous tone and the look in his eye dispelling what seems a whiff of nationalistic fervour and patriotic pride, directing his disgust towards Japan itself. A schism, not uniquely Japanese, informs his actions. A successful voyage in accomplishing what no other Japanese has done flaunts victory—his victory—in the face of Japan's defeat in the war.

Ichikawa's vision of Osaka, commercial centre of the Kansai and therefore emblematic of Japan in its so-called "economic miracle," emphasizes the city's bleak urban landscape. The dismal setting represents Japan's all-consuming social, psychological, and spiritual malaise, a nation demoralized by the consequences of postwar reconstruction and rapid industrialization: foreign influences, poverty, overcrowding, noise, and pollution. Perhaps more importantly, Japan's ancient stratified social order—the belief in assuming one's proper station in accordance with the hierarchy, which defines each person's relation to each other, to the State, and to institutions like family, religion, and business—seems set on a collision course with the values of the post-nuclear age.

Just as the mythic Ino, in the events that eventually lead to Jason's quest for the golden fleece, has the women parch the corn seed so that when it is sown nothing

grows, the ingrained Japanese obeisance to the collective and its social conditioning prohibits individual growth. Unlike the Boeotian king whose sacrifice of his son will rid his country of famine, Horie's father seeks (figuratively), by killing his son's independence, to renew Japan's "famine"—the barren patriarchal hierarchy, which, only twenty years earlier had led the nation down the path of destruction, and threatens to render the country, as Ichikawa's vision of Osaka suggests, a modern wasteland. (The critique of patriarchy is just one of many affinities *Alone on the Pacific* shares with Japanese New Wave films of the sixties, especially those of Susumu Hani. Hani's themes centre on the sins of the father, the ostracization of women, the dissolution of family, xenophobia, the fear of the "other" [domestic outsiders], and the pressure to conform.)

Horie resides with his family in cramped quarters above his father's spare auto parts garage. Heir to a kingdom of junk (part of the wasteland metaphor), he is mandated to assume the patriarch's place. When Horie shouts at his father, "I'll never be a second generation master," he breaks the golden rule of Japanese social conditioning. The gifts bestowed by his mother and sister on Horie for his trip—money and a pillow, respectively—while seemingly insignificant, help emancipate him from the family structure, if only in recognition of their own hopeless predicament. Their acquiescence legitimizes his escape, a small subversive act against the domineering father who, as the departure date draws near, stops speaking to his son. (Ichikawa tellingly composes his Scope frame to show their mutual isolation; father and son literally drift apart within its ample space.)

Horie is, as one of his friend calls him, a "lone wolf," referring to his emotional detachment and non-conformity, signalled by his awkwardness and inept communication skills. Only his border collie, Pearl, always seen cooped up in a tiny barred cage—she is, like her owner, a kind of prisoner—seems to garner his affection.

Horie's outcast status, however, should be distinguished from the kind of social pariah (ie. the mentally retarded or disenfranchised) found in a Hani film. Nor does he resemble the rebellious juvenile delinquent of the *taiyozoku* genre as does Katsumi in Ichikawa's *Punishment Room* (1956). Horie's anti-social behaviour, like that of many Ichikawa protagonists, has its origins in a pathological obsession, a compulsion that precariously toes the line between rugged individualism and neurotic self-absorption. Ichikawa's conception precludes martyrdom and political and social idealism. The fact that accusations of selfishness and callousness are raised against Horie by the hateful, unsupportive father and puzzled friends make them no less true. He *is* selfish and callous, like Mizoguchi in Ichikawa's *Enjo* (1958), and obsessed like so many Ichikawa protagonists: Mizoguchi, Tamura in *Fires on the Plain*, Yukinojo in *An Actor's Revenge*, Nobuchi in *Kokoro*.

Horie's growing alienation from his family makes his dependence on them more pronounced, as he bounces from job to job, hoarding the income for his "mission." In these sequences, the ability of Ichikawa's art to assay the intimate details of

Horie's mundane existence and psychological state through stylistic flourishes—particularly abrupt editing and dynamic manipulation of the anamorphic ratio by cinematographer Yoshihiro Yamazaki—is astonishing. (*Alone on the Pacific* was the only film Ichikawa made with Yamazaki, after working almost exclusively with Setsuo Kobayashi or Kazuo Miyagawa; that the new cinematographer, a favourite of director Ko Nakahira, delivers many classically Ichikawa compositions, particularly in his handling of the claustrophobic space of *The Mermaid*'s cabin, confirms Ichikawa's visual mastery as an auteur.)

The compression of events in the Osaka sequences, and their merging of internal deliberation with external reality, are rendered with a miraculous combination of objectivity and Ichikawa's wryly personal viewpoint. This dialectic informs all of *Alone on the Pacific*. At once claustrophobic and expansive, the film is constructed around a series of opposites and parallels—imprisonment and freedom, transgression and redemption, past and present, land and sea, even, perhaps, Japan and America—which are often conjoined through the use of flashbacks. The gloomy recesses of the father's garage, the chaotic, overcrowded Osaka street life (captured with a raw immediacy by telephoto lens), the cramped interior of the boat's cabin, and the spacious, open-air of the boundless sea, all define Horie's dialectical space.

Ichikawa visualizes the tension in an occasionally literal way in Horie's debates with himself, the contending voices representative of the forces that drive him in his solitary voyage. Once out of Osaka Bay, the retreat from Japan seemingly complete, Horie is "alone on the Pacific," subject to the impersonal whims of the sea, with no one but himself to keep him company. "It's a challenge, both stupendous and frightening!" exclaims Horie. Plagued by fear and guilt, he suddenly faces his utter solitude, which provokes something akin to a split personality. The Faustian exchanges that ensue manifest the contradictory demands that life imposes on him, the contradictions of Japaneseness, at times so intense that an apparition of himself joins the discourse. One voice exudes confidence, know-how and determination—not that Horie ever lacks in obstinacy, but his is a stubbornness compensating for self-esteem—while the other one plays the devil's advocate, best characterized as the ideal son of his father, weak and whiny, who implores him to quit, go home and fall back in line. This voice also embodies authority and accountability (to his father and Japaneseness); when Horie eludes the coast guard it scolds, "It's the law. It's designed to protect you," or after an encounter with a typhoon it admonishes, "This is your punishment for sneaking out."

The voices subside—their cessation roughly coincident with the father's silent treatment in the flashbacks—marking a turning point in the film, where Horie's escape evolves into a genuine quest, a quest for liberation. (For many the essence of a solitary voyage could only be captured through quotidian repetition, in the manner of Bresson's *A Man Escaped*, but Ichikawa rarely repeats actions that in a ninety-four day journey would be daily occurrences. Only once do we see Horie

brush his teeth, air his laundry, "flush" his slops pot, clip his whiskers, cross the day of his calendar, etc., never in a sequential pattern or rapid montage. Flashbacks aside, by choosing to ignore the ritualistic, by randomly showing these actions, Ichikawa bypasses the materialist for a more abstract approach.)

Ichikawa's clinical, incisive method puts Horie under the microscope with the fascination of an entomologist, capturing his every movement and emotion, which are unfettered on the open sea. Storm-tossed, he longs for his mother, his memory of her saying, "If you're near death, call to me," triggering one of the film's most poignant flashbacks. (Tellingly, in this sequence, Horie is at the bottom of the stairs that connect the garage with the living quarters above, and she is at the top.)

Horie bawls like a baby, noting with characteristic Ichikawa irony that "crying is good for the morale, as long as nobody is watching." Certain nobody *is* watching, Horie slips into his swimming trunks top board, glancing around to make sure he cannot be seen. Despite the fact that there's nothing from horizon to horizon except deep blue sea, he modestly recedes into the cabin to finish his change. While we're laughing at his ridiculous paranoia, Ichikawa traduces us with an ironic flourish, when a few minutes later a cruise liner with brash American tourists appears out of nowhere, threatening to crush Horie's tiny boat.

It is at this moment that Horie's quest for personal liberation begins to point toward transcendence. One of the obnoxious American tourists asks if he needs any food. His food supply is depleted, but he declines: "No, thank you," then, in Japanese: "Now go away." His voice-over muses, "How awful to beg for food after coming this far." As so much in this film does, Horie's thought flickers between two meanings: a reversion to the values of Japaneseness he is attempting to flee: a concern with pride, appearance, and self-sufficiency, a contempt for even the aspect of need. Conversely, one can see this perhaps foolish refusal to admit his condition as a proclamation of fortitude, a willful strength that sustains Horie during his struggles with the sea.

Horie's individualism, both naïve and noble, initially appears to partake, as I have said, of the Romantic idea of man against the elements, particularly in the typhoon. Horie manages to overcome "his enemy the sea" in bitter contest. But as he endures, the journey slowly turns those triumphs into a transformation of self. The calm between the storms shows Horie's awareness shifting from excitable naïveté to humble serenity, indeed a kind of mystical unity with the universe. The extraordinary long shots of the tiny boat as an integral part of rather than separate from the sea and sky that surround it suggest this union. Whether an instance of Emersonian transcendentalism, Spinoza's philosophy of pure order—"God is in everything and everything is God"—or its Eastern counterpart, the Zen ideal of mergence, these images signal something more than Horie's mere being "at peace" with the world after the alienation of his life in Japan. His quest, it turns out, is

spiritual; his "goal" is nothing as material as a golden fleece or as exigent as mere escape, but something more profound: a serenity borne of self-recognition.

Ichikawa, ever the ironist, does not, of course, leave it there. After Horie's triumphant arrival at the Golden Gate Bridge, his father, rushing to expunge his son's offence against the system, apologizes to the Japanese nation and promises that it will not happen again. Across the ocean, in San Francisco (marvellously shot to emerge from the night mist as a magical kingdom), Horie dozes in a bathtub at the Japanese Embassy, the latter an indication of the official requisite to absorb him back into his country and the collective. We're shown the dirt ring Horie leaves in the tub—a classic Ichikawa touch—and then Horie fast asleep. Someone knocks at the door to tell him his parents are on the telephone, but he is oblivious to the world. Does Horie dream of the sea, his tranquil days alone on the Pacific, or of the land he will soon be forced to return to—he did not, after all, bring his passport—and of the father whose role he might now have to assume, regardless of his escape from Japan, his brief transcendence?

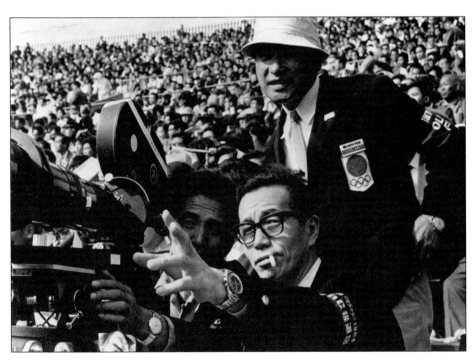
Kon Ichikawa filming *Tokyo Olympiad*

ERIC CAZDYN ABÉ MARK NORNES
JAMES QUANDT CATHERINE RUSSELL
MITSUHIRO YOSHIMOTO

Tokyo Olympiad: A Symposium

ICHIKAWA frequently courted controversy in his career, dealing, for instance, with the cannibalism committed by Japanese soldiers during the Pacific War in *Fires on the Plain*, the violent anomie of Japan's postwar generation in *Punishment Room*, and the sexual peculiarities of a "respectable" family in *Kagi*. The Ichikawa film that incited the most controversy, however, turned out to be the comparatively "innocent" and potentially uplifting official documentary of the 1964 Tokyo Olympics, commissioned by the Japan Olympic Committee and released by Toho. A rare documentary in Ichikawa's massive filmography, and the best (along with his poetic portrait of the city of Kyoto made for Olivetti), *Tokyo Olympiad* turned out to be something very different from what the commissioning bodies expected. As critic Jacques Demeure noted, Ichikawa's film was made "under the sign of gigantism": 164 cameramen furnished with over one hundred cameras, including five Italian Techniscope cameras, equipped with almost 250 different lens, and fifty-seven sound recordists who used 165,000 feet of tape, captured the events in stereo and CinemaScope, rare and lavish formats for documentary filmmaking. (The noise of the high-speed cameras was so intense that Ichikawa muffled them with blankets.) Despite the massive forces, equipment, and money expended upon the project, the result was anything but the vast, inspiring spectacle anticipated by the Olympics officials. From seventy hours of footage, Ichikawa shaped an idiosyncratic, formally innovative, and surprisingly intimate film, which he positioned in the artistic tradition of Leni Riefenstahl's *Olympia* rather than in the conventional genre of other Olympics films and sports documentaries.

Attacked from both sides of the political spectrum, disliked by the emperor, and rejected by the Olympics organizers, who intended to have their own film made

from his footage, and, failing at that, demanded that Ichikawa re-edit the film, *Tokyo Olympiad* was released in many different versions after the rights were sold off somewhat indiscriminately. (An American company promoted a half-hour version to civic and business groups, which focused exclusively on U.S. gold medal victories.) The film became an international phenomenon after being acclaimed at the 1965 Cannes film festival; and at home, despite the saturation coverage of the Olympics by Japanese television (a new but ubiquitous medium in the country), *Tokyo Olympiad*, in a version slightly shorter—154 minutes—than the one originally planned, quickly became the highest grossing film ever released in Japan.

Despite its renown and complexity, its high standing in Ichikawa's filmography, and its importance in the history of the documentary, *Tokyo Olympiad* has elicited relatively little analysis in the West. The controversy surrounding its making and release, though frequently commented upon by Ichikawa's critics, has never been detailed in the English literature on the film. To address some of these issues, the following symposium was conducted by electronic mail—a form known as *zandakai* in Japan—involving four scholars of Japanese cinema and culture: Eric Cazdyn, Assistant Professor, Departments of East Asian Studies, Comparative Literature, and Film Studies, University of Toronto; Abé Mark Nornes, Assistant Professor, Film and Video Studies and Department of Asian Languages and Cultures, University of Michigan, Ann Arbor; Catherine Russell, Associate Professor, Mel Hoppenheim School of Cinema, Concordia University, Montreal; and Mitsuhiro Yoshimoto, Associate Professor, Japanese, Cinema, and Comparative Literature at the University of Iowa. Moderated by James Quandt, Cinematheque Ontario, the symposium took place during the weeks leading up to and continuing through the 2000 Sydney Olympics. The original exchange was elaborated upon and structurally modified for publication.

The Controversy I:
Tokyo Olympiad and Its Official Critics

JAMES QUANDT: Let's begin at the beginning of *Tokyo Olympiad*. The film opens, famously, with an extended Scope "close-up" of a red sun, an image that is employed again halfway through the film just before intermission, and, symmetrically, at the end of the film. The image has, of course, been read, perhaps too literally, as a signifier of "Japan" (we see its symbol in the flag that is raised at various medal ceremonies in the film, if the connection needed underlining). The still, shimmering roundness of the sun is replaced in the next scene by the hard, oblate, swinging form of a wrecking ball as it crashes into a wall, introduc-

ing the idea of the destruction/transformation of old Japan for the Olympics.

The 1964 Olympics were a key event in the postwar transformation of Japan. The burgeoning economic power of the country, the willingness, even desire, to demolish the old (and all it represented) to achieve that transformation, were expressed in the momentous rebuilding of Tokyo. Even now, the website for the Taisei Corporation trumpets "the glory of the Olympic City," the grand buildings such as the Hotel New Otani, and the transportation revolutions—the Tokyo monorail and the development of "the world's largest and most complex road structures"—all built or developed for the Olympics. But this physical transformation also signalled a political or ideological "revision." Japan wished to remake itself in the eyes of the world, to present a new international image twenty years after the war and at the end of the American Occupation. The Olympics was to be its "coming out party," a celebration of a prosperous, peaceful, technologically advanced and cosmopolitan country.

Though Ichikawa later told Yuki Mori that he considered Tokyo "the protagonist of the film," we actually do not see a great deal of the city in his film: some establishing (and rather deflating, or at least inglorious) shots of the Olympic Stadium, a few street scenes, including those in the marathon race at the end of the film. But the American comedy *Walk Don't Run*, a remake of *The More the Merrier* (and Cary Grant's last film), or Chris Marker's contemporaneous "essay-portrait," *The Koumiko Mystery*, both set during the Olympics, give us more of a sense of the "new Tokyo" than does Ichikawa's film. And there are certainly none of the expected official advertisements for the new, transformed Tokyo (and, by extension, the new, transformed Japan). Is this perhaps one of the reasons the funding agencies were so unhappy with Ichikawa's film? How do you read the film's treatment of these matters?

MITSUHIRO YOSHIMOTO: Could anybody provide the background information about the "controversy" surrounding *Tokyo Olympiad*? Was it really "rejected" by the commissioning agencies? Did Ichikawa have difficulty making fiction films after *Tokyo Olympiad* because of the lack of funding? Ichiro Kono, Minister of Olympics, told newspaper reporters that the film may be a work of art but not a truthful record of the games. (Actually according to Ichikawa, Kono made this remark to the governor of Tokyo, and newspaper reporters "distorted" his personal comments.) The Ministry of Education immediately cancelled its recommendation of the film, and the controversy spread throughout the country. But the film was released as was originally planned by Toho in March 1965 and as we all know it was a huge hit, seen by eighteen million Japanese. Why did so many Japanese see this film? (Were they mobilized by schools, companies, community organizations and groups? Or did they see the film voluntarily?)

QUANDT: Some partial, inadequate answers to some of the questions you have posed: there is a discussion of the "controversy" in *Sekai no eiga sakka 31: Nihon*

eiga shi (Film Directors of the World, vol. 31: The History of the Japanese Film) (Tokyo: Kinema Junposha, 1976). Alas, I don't believe it is available in English. My rather general understanding of the "controversy" is based on various accounts of the film in English volumes, so is perhaps skewed. Audie Bock says in her introduction to Ichikawa's films in this volume:

> The most famous imbroglio occurred over Ichikawa's beautifully humanistic *Tokyo Olympiad*, which marks a near revolution in sports documentaries. The finished two-hour-and-forty-five-minute film, on which [Natto] Wada also worked, eschews the mechanical recording of each event to close in on the emotional reactions of both participants and audience, and the story within the big event of the lonely runner from the brand-new African country of Chad brings out the full meaning of the Olympics on an individual scale. The company, having expected television-style records of scores and fast finishes and no more, expressed outrage by claiming one could not tell if the film was about the Olympics or about people. The foreign versions of the film were pared down to half the full length, Ichikawa left the Daiei company for good, and the film went on to claim the biggest box office to that date in Japan.

Ian Conrich reports in *The International Dictionary of Films and Filmmakers*:

> In adopting such an approach, Ichikawa opened himself to strong criticism from the Japanese Olympic Organizing Committee. One member, Ichiro Kono, stated that they had required something more glorious and that "the main defect in the movie lies in the absence of descriptions of the Olympic facilities such as those for yachting, canoeing, and rowing. Spectators of the film could not know where these competitions had been held." As Ichikawa added, "They even asked whether I could reshoot some of it, but I was able to reply truthfully that circumstances prevented it as the entire cast had left Japan."

A typically wry, ironic Ichikawa jest!

MARK NORNES: Kono's criticism (which was foreshadowed by gossip that spread after a preview of the film before the emperor), was followed by various politicians, reporters, and sports figures complaining that it didn't show off Japan's athletes or facilities enough. At the same time, the left criticized the film for being too nationalistic, centreing on the images of the flag. Some of this criticism was localized in Kansai [a region in Western Japan encompassing Osaka, Kyoto, and Kobe]. An outgrowth of this was a discussion of documentary as art versus record, a very, very old debate raised by people who didn't know better. (Marathon run-

ner Tsuburaya Kokichi, about whom another documentary was made, which was suppressed, commented after seeing *Tokyo Olympiad* that he was really moved by the film, and that to criticize it for the alleged lack of documentary truthfulness misses what the film is about.) Susumu Hani and Taihei Imamura gave smart responses. Monbusho [Japan's Ministry of Education, Science, Sports, and Culture] pushed quite publicly for a complete reworking of the film, only the second time they tried this as far as I know. (The first time was during the war!)

The following is a detailed chronology of the controversy, based on newspaper reports of the time. Word of potential trouble started right after the staff screened the film for the first time on March 7, 1965. The next day it was shown to members of the Japan Olympic Committee and the government. Afterwards, the JOC complained to Toho that there were not enough scenes of the Japanese athletes, the children performing in the opening ceremonies, the new Olympic facilities, and things like that. They promptly asked Toho to recut the film. According to the critic Akira Shimizu, the March 10th preview in front of the imperial family and select politicians and film critics was a tense, uncomfortable affair. Minister Kono, who had managed the Olympics for the government, dropped a bombshell at a press conference he called that day. Kono said, "I saw the preview of the film made to leave a record of the Tokyo Olympics. It overemphasizes artistic aspects and I do not believe it is a proper record of the event. As the minister in charge of the Olympics, I feel it is inappropriate to leave this for future generations as a documentary film." He added, "We will make a new film that emphasizes 'record' (*kiroku chushin*) in addition to the film about to be released."

Speaking as a representative for all the politicians and athletics officials, Kono made his main point that, as a fiction filmmaker, Ichikawa went overboard on the expressive side of the filmmaking. This made it worthless as a document of what actually happened in Tokyo. Kono compared the film to *Olympia*, noting how Riefenstahl's film attempted to show why athletes compete and how they win. He called *Olympia* an "unrivalled textbook for the world's athletes and coaches." In contrast, Ichikawa wrongly concentrated on the quirky toss of the shot-putters, with slow motion of the balls hitting the grass, along with strange music and bizarre techniques. After this, the scandal spread through the newspapers, sports papers, and weekly magazines.

By the 11th, the JOC announced that they would make their own film, but what exactly would be sent to the International Olympic Committee was unclear. There was also a subcommittee in the Diet that quickly convened to criticize the film on the same grounds and send Toho a formal request to make a new film that "properly records" the Olympics, preferably with Ichikawa directing. The new film would be a "pure record" of the Olympics. A new phase of the scandal started on the 16th, when the Minister of Education announced that he would not give his department's recommended status to the film. Minister Aichi

was quoted as saying, "The film is artistic, but there's a question as to whether children could understand it. The film is inappropriate as an education film. Since the JOC is producing a new film [from Ichikawa's footage] that will be primarily a documentary film (*kiroku chushin eiga*), this is the film that will be recommended." This flew in the face of the ministry committee actually assigned to making these decisions, which had already previewed and approved Ichikawa's version (a fact revealed publicly by member Naoki Togawa, a prominent film critic).

The Minister's comments threw a wrench in the plans to show the film at every school in the nation. However, prints had already reached many cities, and not all schools fell into line. Education officials in Nagasaki publicly announced that their previews were successful and they would proceed as planned. Several days later the local government in Okinawa followed suit, especially because few Okinawans had been able to watch the games on television. However, the plans of most schools were thrown into crisis because of the chaos at the centre of the education system.* On the 24th, the general committee for the Tokyo Olympics met, and not a single member supported Ichikawa's film. Some went so far as to call for the current release to be halted; all considered it a failure. Their complaints were that Ichikawa's film didn't show enough of certain sports and the city itself was hardly represented. One committee member said Ichikawa's finished film would, in the end, only be the preview for the single, official Olympic film they would produce. This provoked the Directors Guild of Japan to criticize the government's actions as "absurd." They said that the move to recut the film not only breaks copyright law, but violates Ichikawa's human rights.

Ichikawa had laid low through this entire affair, but finally decided that the only way to stop things would be to meet Kono. He finally visited the politician at his home on the 27th in order to secure Kono's blessing for the two-and-a-half-hour version of the film Ichikawa had been cutting for Toho. Release dates and high profile premieres had already been set long ahead of time in every part of the world. Kono promised to reconsider, and complimented Ichikawa on his favourite part of the film, the blazing rising sun images shot by the famous news cameraman Shigeo Hayashida. "Those suns were great, weren't they? I'll bet they cost 5 million yen," he told Ichikawa (the director noted parenthetically that he was close: 2,800,000 yen.) At any rate, when Kono saw the new version a couple days later, he gave his approval: "It got better," proclaimed the headlines.

*The education system in Japan is centralized in the Ministry in Tokyo. The structure is controversial, since major decisions such as acceptable textbooks are made at the centre and sent to the schools as top-down directives. In the case of *Tokyo Olympiad*, the ministry's wrangling over the film was being ignored by the schools; thus the Ichikawa controversy was connected to power struggles within the education system, and it is probably not surprising that the renegade schools were in places like Okinawa.

The rest of the bureaucrats toppled like dominoes. The swift, collective retraction of their disapproval suggests that the completion of the foreign version simply allowed everyone an easy exit from a messy situation they really didn't care much about. Throughout the controversy, the terms of the debate never strayed from Kono's original critique. All the commentators parroted the term *kirokuchushin* (record centric), in contrast to *geijutsuteki* (artistic). In a *Chuo Koron* article that put the controversy to rest at the end of the stormy month, Ichikawa wrote that he underestimated Kono's power as a *jitsuryokusha*, or someone who can make things move. Before Kono called his original press conference, Ichikawa's attackers were actually complimenting him on the rushes and work prints. To the very end, Ichikawa couldn't figure out what everyone's problem was. Indeed, judging from the press reports, no one was actually arguing a point. They simply critiqued the film as a "bad record." On the one hand, this phrase "record centric" conveniently condensed all the problems bureaucrats had with the film into a neat, easily repeated code word. Every time they used it they summoned the same meanings: that there weren't enough scenes of Japanese athletes, the national flag, the imperial family, the new arenas, the new Tokyo, and the like. At the same time, the stark, simplistic contrast between art and record made this scandal the latest episode in the long debate over whether or not documentary film can or should aspire to artfulness. Ironically, the first Japanese debate over this issue occurred in the 1930s and was resolved by the critical and financial success of Riefenstahl's *Olympia*!

The Controversy II: *Tokyo Olympiad* and the Japanese Cinema of Opposition

CATHERINE RUSSELL: Thank you, Markus, for illustrating the controversy surrounding the film so nicely. It makes me appreciate the film even more, knowing how upset people became. I wonder about those 2.8 million-yen rising sun shots. Is the sun not setting at the end of the film? And if it is, doesn't Ichikawa still get the last laugh, especially in the context of Oshima's concurrent use of rising/setting sun metaphors of the same period?

NORNES: Catherine, I noticed the setting meatball, too. Oshima was hardly the only one playing with the *Hi no maru* [Japan's flag with its image of the rising sun]. My favourite comes from Masao Adachi's *School Girl Guerilla* (*Jogakusei gerira*, 1969), a black-and-white film that abruptly switches to colour to show the guerillas' flag—a red flag with a hole cut out of the middle.

RUSSELL: I wonder if the auteurist model is really the most appropriate frame for the film. I am intrigued by its use of *vérité* and cinema direct techniques, and the way that it takes some familiar shooting and editing styles—close-ups, fragmentation, candid camera, low angles, collage—and sets them in an epic form, and in colour too. I wonder how it might relate to other Japanese documentaries of the period, or of the late fifties, both in terms of these stylistic characteristics, and in terms of its anti-documentary, or anti-official ideology.

NORNES: As for documentary at the time, Eric Cazdyn points out [below] two of the key figures that bookend the period before and after Ichikawa's *Tokyo Olympiad*: Susumu Hani and Shinsuke Ogawa. (Fumio Kamei's documentaries and writings of the 1930s were indeed central to the debates over the artfulness of documentary. However, by the 1960s he had a stature that set him apart from the rest of the crowd, even if he was closely aligned with the Japanese Communist Party [JPC].) What was going on between Hani in the 1950s and Ogawa in the late 1960s—precisely during the Olympics—is pretty interesting. Iwanami, a major book publisher in Japan, had assembled a remarkable collection of talent for their film division. Following Hani, they explored all the possibilities of cinema within the bounds of the PR film. Fuelled by the high growth economy, they were making large scale, 35mm colour PR films in CinemaScope (thus, there was a pool of skilled documentary filmmakers that could have been tapped by the JOC). Because of the limitations imposed upon them by the strictures of the sponsored film, most of the talented filmmakers quit and went independent. The impact of the former Iwanami filmmakers on the cinema of the 1960s and beyond has yet to be fully appreciated. At the same time, the inclination towards innovation of these filmmakers is inseparable from the radical experimentation of filmmaker Toshio Matsumoto and his leadership in opposing the domination of the Communist Party over much of the PR film business.

I think the best way to place *Tokyo Olympiad* in this context is to contrast it to two contemporaneous films. Kazuo Kuroki's *Record of a Marathon Runner* (*Aru marason ranna no kiroku*, 1964) and Noriaki Tsuchimoto's *Exchange Student, Chua Sui Rin* (*Ryugakusei Chua Sui Rin*, 1965). Both directors came out of Iwanami. Tsuchimoto, one of the founders of the Zengakuren [the leftist student protest movement], left the comfort of PR filmmaking to make an ultra low-budget agitprop film for Chua Sui Rin, a Malaysian student activist being deported for his efforts at Malaysian independence. This was one of the first times that a documentarist stood firmly behind the barricades with students, and the film was a big hit among its target audience. Made on a minuscule budget, Tsuchimoto's film marks the beginning of the radical independent documentaries that culminate with his own films on Minamata and Ogawa's films on Sanrizuka [the site of the contested Narita airport]. Kuroki's film was a sponsored documentary on one of the Japanese marathon runners, Kenji Kim-

ihara. It ran into trouble when, in the spirit of the era's anti-authoritarianism, Kuroki ignored the coach, the JOC, and the institutions surrounding athletics to concentrate completely on the athlete. The production company (which was run by JPC members) made changes without Kuroki's permission, and replaced all the filmmakers' credits with the sponsor's products (Fuji Film).* A small movement started to protest the incident, foreshadowing what would happen later with the arrest of Ogawa's cameraman at Sanrizuka, the confiscation of high school students' riot film by police, and the Seijun Suzuki Problem.[1] The heart of the problem was the rights of documentary film artists versus the predilections of capital and the top-down policies of the JPC. So you've got Tsuchimoto representing the total departure of politicized documentary filmmakers from the strictures of PR filmmaking on the one hand, and the assertion of an anti-authoritarian artistic integrity by Kuroki on the other. Compared to these two works, I'd have to say Ichikawa's *Tokyo Olympiad* is actually a minor film in the history of Japanese documentary. It's disengaged—by design—from the context you'd expect it to be so close to.

By the way, this wasn't the only film that offered a different vision of the Olympics. There was also another interesting Olympic short film by Shinkichi Noda, an ally of Toshio Matsumoto even though he was older than the New Left generation. It's called *The Isolation of Two Long Distance Runners* (*Futari no chokyori ranna no kodoku*, 1966), and was an experimental film based on a sixteen-foot snippet of film that caught an unauthorized runner trying to beat Abebe Bikila in the marathon.[2] Noda repeats this audacious bit of spectacle over and over, adding other shots to provoke spectators to consider the nationalist politics underlying the events.

Ichikawa as Auteur: Formalism and Thematics

QUANDT: Catherine questions whether the auteurist model is appropriate for analyzing *Tokyo Olympiad*. The issue of placing the film in an auteur grid is indeed vexing. (This is, of course, the central problem with Ichikawa's oeuvre, and *Tokyo Olympiad*, perhaps more than any other of his films, challenges our sense

*If this sounds like a knot of contradictions, it is exactly that. While the company's president and producers were active members of the party, they were also businessmen. In their attempt to reign in the younger generation's passion for independence and ambition to artfulness, they ended up siding with the corporate sponsor. It should be noted that other sponsors included labour unions, political movements, and the party itself.

of auteurism as imposing a unified field on a director's work.) To begin with something vague and ineffable, I would say that the film *feels* like an Ichikawa film. It has the same sense of wry detachment—the "voyeuristic" use of 1600mm ultra-telephoto lens adds to that distance—and a characteristic focus on solitude, on the outsider, the loser, the determined but fallible "outlander" (less obsessive, perhaps, than his other outsiders, like Horie in *Alone on the Pacific* and Mizoguchi in *Enjo*, etc.) Ichikawa also characteristically (perversely?) seeks out inexpressive or absent looking faces, even in the heat of competition, reflecting his oft-commented proclivity for *noh*-like emotion. All this doubtless contributed to the organizing committee's unhappiness with the film; there is little that is triumphant (or triumphalist) in it.

Tokyo Olympiad is also punctuated with moments that remind one of other key moments and images in Ichikawa's films: the sea of umbrellas, for instance, which commentators have compared to a similar shot in Hitchcock's *Foreign Correspondent*, but which, I think, connects more with a scene in Ichikawa's *A Full-Up Train*. (Umbrellas are an "Ichikawa thing"—he even revised the opening sequence of *Ototo* to include an umbrella.) Or the way he isolates the first gymnast as a kind of ballet artist, against a black background—we see only the athlete and the bar, the rest is abstract; this reminds one of the way he uses visual devices in *An Actor's Revenge* to isolate details in the Scope frame, masking and irising to focus on certain elements in the image. Tadao Sato finds a great deal in the film that reminds him of other Ichikawa works; the woman's face crumpling in pain as she is jostled in the crowd of onlookers as the Olympic flame passes by, recalls for him a similar moment from the beginning of *Punishment Room*, for instance. He also connects the film's theme of "being alone in the crowd" with other Ichikawa films, particularly the trilogy of black comedies: *Pu-san*, *A Billionaire*, and *A Full-Up Train*. And in his essay comparing *Tokyo Olympiad* to Leni Riefenstahl's *Olympia*,[3] Dai Vaughan, unconcerned with Ichikawa as auteur—he does not discuss any other film by the director—notes the typical derisive Ichikawa tone: "The suggestion that *Tokyo* needs to suppress elements of the Olympic reality in order to expose latent alternative social meanings may account for the oddly ambivalent mood—a sort of reverential mockery—which pervades this film."

YOSHIMOTO: Can we contextualize *Tokyo Olympiad* in the entire career of Kon Ichikawa, spanning over fifty years and consisting of more than seventy films? (He was extremely prolific compared to his contemporaries—Kurosawa, for instance, made only thirty films.) Is it an "aberration" or, as James suggests, can we find Ichikawa's signature themes and stylistic features in it? Originally Kurosawa was supposed to direct the film. Ichikawa was hired when Kurosawa quit because he was not given as much control as he wanted. Interestingly, this makes *Tokyo Olympiad* a "typical" Ichikawa film; so many times he was hired as

a replacement for somebody else, or as a "consultant" whose role was to salvage disastrous projects initiated by incompetent filmmakers. What makes the case of Ichikawa interesting is that he was popular as a "rescuer" not because he was regarded as a mere artisan but as a technician who can make art out of almost any material (thus, very different from such filmmakers as Masahiro Makino or Issei Mori). Ichikawa was accepted as a serious filmmaker (auteur?) not in spite of but precisely because of his versatility.

QUANDT: Considering Ichikawa as artisan, many commentators suggest that his apprenticeship as a *manga* filmmaker was formative, its influence readily apparent in the graphic design of his films, in their rapid dialogue and abrupt cutting, and in the precise positioning of characters within the frame. Catherine mentions in her catalogue of Ichikawa's formal arsenal (below), his peculiar combination of Scope and telephoto lens in *Tokyo Olympiad*, its unnervingly perfect lighting, the sometimes abrupt montage and use of freeze frames. Can these stylizations specifically be seen, at least in part, as a heritage of Ichikawa's training in *manga* (which would, again, support an auteurist reading of the film)?

YOSHIMOTO: Ichikawa is a very strange figure among Japanese directors, and there are at least a couple of reasons for this. Unlike other masters, he doesn't seem to be closely associated with any particular film studios—e.g. Kurosawa (Toho), Ozu (Shochiku), Mizoguchi (Nikkatsu, and then Daiei), Kinoshita (Shochiku), Masumura (Daiei), Oshima (Shochiku), Suzuki (Nikkatsu), etc. Ichikawa made films for Toho, Shintoho, Nikkatsu, Daiei ... yet it is not easy to identify any strong stamp of a particular studio. Unique as they are, Kurosawa's films are clearly a product of the Toho system; it was probably impossible for Ozu to continue making his kind of films at Nikkatsu or Toei. Such a close link between the studio flavour and Ichikawa's style is largely absent. I wonder if this might have been one of the reasons why Ichikawa was chosen to replace Kurosawa for the film *Tokyo Olympiad* (which shouldn't be a Toho, Shochiku, Nikkatsu, or Toei film, but instead, a film of the Japanese nation).

Ichikawa's versatility is also quite unique. Mizoguchi made all kinds of films, yet his effort was successful only when he dealt with a particular set of subject matters and motifs. Ichikawa was, of course, not a mere contract director blindly following orders. He had projects initiated by him and which he felt passionate about. Interestingly, all these projects have original sources; that is, what Ichikawa really wanted to make, his so-called representative works, are often not his "original" ideas but adaptations of literary works—*Harp of Burma*, *Enjo*, *Fires on the Plain*, and even comics (*Pu-san*). Ichikawa is first and foremost an interpreter of the already existing text, and there is always a sense of detachment in his films (he makes an effort to do something more than a simple adaptation or "translation" of the original text). This is probably why Yukio Mishima liked Ichikawa very much—the presence of ironic, sarcastic, critical distance—while ridiculing

others such as Kurosawa, who, Mishima said, had a mentality of a junior high student. How Ichikawa started his career may partly explain his preference for interpreting texts (as opposed to representing "reality")—he is the only master who began his career as an animator. Does this characteristic also explain why Ichikawa was chosen as a director for *Tokyo Olympiad*? That is, was the committee looking for somebody who can best interpret the text (the Olympic games) rather than create the event itself? (One of the reasons for Kurosawa's dismissal was that he wanted to have total control over the opening ceremony; he wasn't interested in simply directing the documentary film but wanted to supervise the ceremony as a gigantic spectacle by placing, for instance, huge speakers outside the stadium to make the ceremony itself a live cinematic experience—here there is no longer a distinction between the event and the representation of the event.)

QUANDT: Mitsuhiro raises a question discussed by many contributors to this book: Ichikawa's fealty to literary adaptation (especially those adapted by Natto Wada, who "wrote" parts of *Tokyo Olympiad*). It is often pointed out that Ichikawa/Wada revised, sometimes radically, the substance, especially the ending, of the novels they adapted: *Fires on the Plain*, *Kagi*, *Hakai*, and, much later, after Wada's death, *The Makioka Sisters*, are all central examples of this kind of revision. Sometimes the reasons for their changes are purely pragmatic, sometimes they are moralistic (as in the mass poisoning at the end of *Kagi*). Does *Tokyo Olympiad* fit into this pattern of revision/adaptation? Does it "change the ending," as it were, of the 1964 Tokyo Olympics? I am thinking, perhaps too literally, of the irony that subtends the stentorian text: "Gone now are the barrier of race, creed, and religion . . . World peace and unity," and the singing of "Auld Lang Syne," with the shot of the emperor and the plaintive, poetic text: "Night / and the fire returned to the sun / For humans dream only once in four years / Is it enough for us—this infrequent, created peace?" The Olympic flame slowly being extinguished is replaced by the burning sun that opens the film. Catherine suggests that with this final image Ichikawa gets the last laugh, which concurs with many of his ironic endings: *Kagi* and *A Billionaire*, for example.

CAZDYN: I think this wider conceptualization of adaptation is important and that *Tokyo Olympiad* can be understood in relation to Ichikawa's other adaptations, such as *Fires on the Plain* and *Kagi*. As my essay included in this volume argues, in the late 1950s many directors began rethinking the relationship between the original text and the adapted film. It is true that there are several examples throughout the history of Japanese film of directors radically revising original texts, but I detect an emerging dominant form of adaptation that hits a critical mass by the time Ichikawa makes *Tokyo Olympiad*. I also recognize this desire to rewrite the original text connected to the desire to rethink the nation in the midst of so much political activity of the 1960s. There is a general rethinking of

origins—including both the origins of the literary text in film adaptation and the origins of the Japanese nation in social activism. It is for this reason that I think we can follow James's suggestion and see *Tokyo Olympiad* fitting into a larger pattern of revision/adaptation. Of course, *Tokyo Olympiad* is a very different film (than Ichikawa's other literary adaptations) in terms of genre and its documentary status, but if we recognize the official version of the Olympics as dreamed by the JOC as the original text, then, yes, Ichikawa "changes the ending" by reconceptualizing the very meaning of documenting reality.

The Historical Moment: Images of the Olympiad and the Inscription of War, Race, and the World

QUANDT: It is perhaps inevitable that *Tokyo Olympiad* reflects world politics, as the Olympics always do, but I find the film's representation or "inscription" of global politics, the portrait of Americans in particular, more than incidental and fascinating in that regard. This is most apparent in the formal elements of the opening ceremonies.

NORNES: Could you elaborate? In what way is the depiction of Americans in the opening ceremonies (and elsewhere) different from that of the others?

QUANDT: I have a notion that their representation shares a little of the "ugly American" portraits in contemporaneous films by Imamura, Suzuki, Fukasaku, etc. In other words, though the military occupation is not present in the film, there is an inscription of it in the way the Americans are treated in the early sequences, through the opening ceremonies. The aggressive montage of the Pan Am jet arriving seems to me very militaristic; the jet comes across as a fighter plane. In the opening ceremonies, the Americans are shown first from the back. The shot is typical Ichikawa, very graphically organized: strong diagonals, serried ranks of white Stetsons, again almost military in its precise formation. These are the male American athletes, who seem cocky, cowboys, a bit swaggering. When we see the women athletes, Ichikawa captures (focuses on?) one woman turning back and snarling, scowling something to another athlete—I can't make it out, I think it is "shut up!"—a moment of ugliness that is contrasted with . . . the SOVIETS, who are shown from the front, smiling, open, waving their red flags. One cannot presume that any of this is "accidental," mere notation, because Ichikawa had a phalanx of cameramen shooting the ceremonies, so, one presumes, had a great deal of alternative material with which to construct his commentary.

In terms of graphic analogies, though, what then does one do with the fact that the last country, Japan, is shown also from the back, in the same diagonals

and ranks of white hats that seem to make an equation with the Americans? And what does one make of the narration: "They have slaved for this day of glory, proud young elite of the host nation"? And the convenient lie by omission: "It had been decided to hold the Olympics in 1940, but the war prevented it." This makes the war sound distant and abstract, an unfortunate incident that Japan seems to have had no part in. And it raises the question of Ichikawa's own politics—what are they? In his interview with Yuki Mori, he rejects both left and right, and describes himself as a "humanist."

RUSSELL: I was watching *Tokyo Olympiad* on video and when I turned it off there was one of the numerous inane pre-Olympic news pieces on TV about some Canadian athlete, her sponsors, her family, blah blah blah, and I realized how valuable Ichikawa's film is as a document of the Olympics. It's not surprising that it was so controversial, because he manages to cut right through all the hype, the pettiness, and the nationalism that pervade the event. The 2000 Olympics haven't even begun and I'm sick of them. The 1964 Olympics, on the other hand, I could watch over and over again, and in fact some of us have, precisely because *Tokyo Olympiad* is a film about bodies, endurance, and strength. And of course, it also documents the re-entry of Japan onto the world stage, or rather the encounter between the New Japan and the international community. I think it is significant that in doing so, it is adamantly anti-official and even anti-Olympian in so many ways. *Tokyo Olympiad* is unquestionably a virtuoso piece of documentary filmmaking. Dai Vaughan has described a number of the techniques that Ichikawa uses, and notes that the use of slow motion in the film especially serves to deflate the competitive grandiose quality that pervades most Olympic coverage (not only Riefenstahl's *Olympia*). The slow motion breaks down movements into component parts that never actually add up to complete actions. Everything is in fact fragmented. Nothing is filmed from start to finish, except perhaps a swimming competition, which is accompanied by a sportscaster's narration that frames it as an "event" such as many others that are never shown.

In any case, one of the effects of Ichikawa's virtuosity is that we tend to be distanced from the athletes, watching them as we watch the spectators also, slightly disinterestedly. I can't think of any other documentary film in widescreen that uses the telephoto lens so much. It's a very weird combination that allows us to spy on people in well-lit CinemaScope. I have no idea how some of the shots can be so perfectly lit, but sometimes they are so perfect that it's hard to believe they were filmed live. And then there is the soundscape with so many layers of ambient sound, jazz music, overheard conversation, narration, and multiple miking. (I think there are several narrators, and some seem to be "genuine" as if taped from TV [found narration?], and some seem to be post-synched, recorded for the film.) Throw in the freeze frames, black-and-white footage and the abrupt

montage effects of leaping from one sport to another (e.g. archery to bicycles!) and you get a very reflexive, stylized piece of filmmaking.

The aestheticization of the athletes invites a gaze that is fascinated, but not involved in the action. This in itself is radically contrary to most sports coverage. The film has lots of melodramatic indulgences in the suffering of athletes, but we are rarely drawn into their plights or their contests. This has partly to do with the stylization of the cinematography and soundtrack, but also because of the film's practice of Othering. In fact, I'd say these work hand in hand. Even when the Japanese women's volleyball team beats the Russians and they all burst into tears, we cannot cry with them, but rather watch in awe as one after the other breaks down. *Vérité* documentarists have always loved teary scenes, but this is very different, and it's in keeping with off-centredness of the whole film. Think of the male coach of the team who is given equal screen time, and who is utterly expressionless. Are these different reactions to victory symptomatic of the Japanese gender system? The film merely poses the question.

Once the actual sports events begin, the interest in bodies switches from their ethnic differences to their athletic and physical characteristics, and the film might be said to "work" toward a better understanding of the global community. It is true that two Africans are singled out for dramatic treatment, the runner from Chad and the Ethiopian winner of the marathon, and in these instances the film remains within a limited ethnographic paradigm of Othering. The former has only lately graduated from a primitive, tribal society; the latter is virtually monstrous in his superhuman ability to win a marathon. He seems to slay all the other competitors who are collapsing around him. Neither has a life that Japanese audiences could in any way identify with, so these African athletes become vehicles for insights into the lives of the Other.

But let's not forget that this is a film with a very definite message that links the Olympics to Peace. If it is somewhat indulgent in the human suffering of the marathon runners, the injured cyclists, the disappointed losers, it is so in the name of social justice. The film does not hide its intention to co-opt Olympic heroism and transform it into postwar humanism. I think Eric Cazdyn puts his finger on the context of this "message" in his following analysis. The palpable sense of defeat in the film may well correspond to a certain collapse of the left in the post-Ampo [U.S.–Japan Security Treaty] sixties. However, I would not be so critical of its lack of explicit references to the "outside." I find that those initial images of the wrecking ball and the Pan Am jet go a long long way toward filling in that "outside." If anything, I would be critical of the heavy-handedness of the film's final message. After all, it is we the spectators who are outside looking in, and the film invites us to observe the bodies and their struggles through the aesthetic framework that Ichikawa and his crew have constructed around, between, above and alongside the Olympic events.

CAZDYN: To contextualize *Tokyo Olympiad* is at once to move in several different directions, including the historic, the cinematic, the biographic, and the political-economic. As for the historic, there are two primary contexts—one national and the other global. Ichikawa's film can be situated in relation to the heated-up Cold War, the rise and fall of Japanese social activism in the fifties and sixties, and the rapid growth experienced by the Japanese economy from 1960 to 1975. Of course, Ampo, the threat of nuclear weapons, the Korean War, the signing of the San Francisco Treaty, and the Vietnam War mobilized the students, farmers, and others to think more about the role of the Japanese nation-state. The movement began to wither, however, after the ratification of the U.S.–Japan Security Treaty in 1960 when Prime Minister Ikeda and his cabinet presented a new paradigm of growth for the Japanese economy. Ikeda's plan was to work toward an eight per cent growth in the gross national product for the next ten years in order to double the GNP by 1970. Ikeda got more than he bargained for as investments in capital facilities by private enterprises showed an almost forty per cent increase in 1960 compared to the previous year. By the 1964 Olympic Games, Japan not only made it to the party but became the host; from ashes to asphalt in only twenty years, Japan was finally considered one of the advanced capitalist nations of the world. These spectacular economic indicators made any anti-capitalist politics difficult to sustain. For example, dissent would often be met by an appeal to the visible growth in living standards and impressive additions to the built environment. At bottom, *Tokyo Olympiad* marked the end of a certain utopianism in Japan: not only was there a deMarxification in the universities and public discourse no less profound than in France after 1968, but there was also a redoubled acquiescence to the rhetoric of the Japanese "economic miracle."

All of this brings me to a certain symptomatic reading of *Tokyo Olympiad*: how the film succeeds and fails to gesture to this historic "outside." To begin with, there is the constant spotlighting of the banal within the spectacle of the Olympics. The scenes are numerous: a schoolboy stretching on his tippy-toes to see; a baby crying; a cutaway to two lovers embracing; kids covering their ears as the starting pistol fires; individual raindrops sliding off an umbrella; the conspicuous shot of the Italian athletes' shoes; a tender and tight close-up on the double chins of two officials; a Japanese hurdler spinning cartwheels to shake out her nerves; the young runner from Chad eating alone in the athletes' cafeteria. Or perhaps the most banal scene of all, the wrecking ball and hard-hatted Japanese lumpen destroying older structures to make way for the new. All of this seems to indicate that there's something else to see when watching the Olympics, there's something else without which the spectacle of the Olympics (from the emperor's speech to the finish lines and fireworks) would not exist. Without the sacrifice of the postwar Japanese (sacrificing not only their bodies and labour but their immediate postwar ideals of democracy, freedom, and

individualism) the Olympics would not have reached Tokyo. Without the suppression of internal dissent that allowed Japanese officials to link their chariot to the U.S. Cold War star, the Olympics would not have reached Tokyo. Without the geo-politics of the day (the strategic Asian theatre, Domino hysterics, Zero-Sum logic) the Olympics would not have taken place in Tokyo in 1964. But where are these references in Ichikawa's film? If the thoughtful long take of Japanese farmers sitting on the fringes of their rice fields and watching cyclists and runners pass by is a way for Ichikawa to exceed the official line of the Olympics, then why not include all of the other integral banalities? Why not, to take just one example, include a lone demonstrator? Or can the cutaways and stylistics that landed Ichikawa in so much trouble be read as allegories of the larger outside, one that, given the constraints, can only be referenced by a slick shot of the Cuban delegation walking with the Japanese flag instead of their own?

NORNES: Eric, by posing this "gesture to the outside" as a matter of success or failure, you indirectly raise the issue of auteurism. *Who* is succeeding or failing? Ichikawa himself? Many of the specific examples certainly look like the wonderful flash cutaways that became so typical of his films from the early 1960s on. They are less "banal" than a momentary spectacle in the bleachers. In a stylistic sense, the film does seem to bear his mark. But this explanation sidesteps the political context Eric raises. Since this was truly a film made by committee—the JOC, Monbusho, Toho, Ichikawa, his wife and some 500 other professional filmmakers—wouldn't it be more profitable to look for evidence of the committee members' ambitions to authorship all over the film? From this perspective, the fact that the specifics of Eric's historical contextualization seem shuttled to the film's introduction and the short montage of falling walls and modernist architecture is very curious. Considering the sponsors of the film, wouldn't you expect more of this? The other scenes that seem shuttled to the margins are the sequence on the runner from Chad and the anonymous pentathlon athlete who couldn't make the grade (apparently, he was Korean). Eric, what do you make of those scenes? What might they be allegorizing?

CAZDYN: I pose the "gesture to the outside" not as a matter of success or failure, but as one of success *and* failure. This subtlety makes a world of difference, especially when understanding the impulse of my symptomatic reading and what this might mean for the issue of auteurism. By stressing the "and," I want to emphasize the way *Tokyo Olympiad* works and the way it (as does any other film made during this moment) expresses in formal terms one of the most profound socio-political problems of Japanese modernity, namely the sudden reverse course from democratization and demilitarization in combination with a globalizing world system. Less interested in thumbs-up/thumbs-down evaluation, I look at *Tokyo Olympiad* as an attempt (however failed and successful) to represent the unrepresentable.

Kon Ichikawa and Leni Riefenstahl

For example, in my reading I'm attempting to link the relation between banality and spectacle (a snoozing spectator and a world record breaker) on a narrative level to the relation between banality and spectacle on a larger historical level (a CEO with a line worker, a general with a grunt). In this way I'm reading the formal structure into a type of content and I'm interested in *Tokyo Olympiad*'s cinematic language as representing (in however unconscious a way) a political language. This last parenthetical statement is important because it suggests that all film (not just the great ones) necessarily gestures to its outside in the way it organizes aesthetic choices. Sure, I'm prevaricating a bit on the auteur question by granting subjectivity to the film. This is not to ignore the importance of the relation between Ichikawa's agency and the 556 person production staff, 164 camera operators, and 57 sound people, or between the objectives of Toho, Monbusho, and the Japan Olympic Committee.

I guess I still haven't emerged from the auteur-structuralist debates of the 1960s and beyond—the ones where the rock-bottom desire was to have it both ways: a conscious auteur (either as the individual director, the collective, or critical construct) together with the director as just another term in the process of spectating: the death of the director (to tweak Barthes's more fashionable language). Here I share Mitsuhiro's idea (as presented in his new and wonderful book on Kurosawa[4]) of authorship as a site of negotiation, in which (to return to the specific issue at hand) Ichikawa does not disappear at all from the mix, nor does he (or the more heavy-handed ideologies of the agencies involved) serve as the golden ticket to all meaning and interpretation. So, when Markus asks me what the sequence on the runner from Chad and the anonymous (Korean?) pentathlon athlete might be allegorizing, I must return to my original formulation in which these scenes point less directly to historical referents (first-world/third world relations, racial relations, colonial history) and more to the film's system of formal strategies, the ones so fabulously described by Catherine, such as fragmentation, the use of telephoto lenses (there were 232 different lenses used!), the complex soundscape, and the exceptional crash of melodramatic indulgences with cinematic detachment and off-centredness. It is this overall formal system, finally, that I see allegorizing the historical context. At bottom, my concern is in the way *Tokyo Olympiad* produces a cinematic language to come to terms with a historical situation (national and global transformation), one in which there is yet to exist an available or effective language of expression.

NORNES: As for Ichikawa's politics, I suppose you could call him a liberal humanist. (I suspect one reason they went for a feature film director is that the PR film industry was dominated by leftists, and in fact was embroiled in a bitter fight between old stripe communists and new left upstarts.) "Liberal humanism" strikes me as a good description of the politics enunciated by the film itself. For

a film about the Olympics it is remarkable how little attention is paid to who is competing and from what country. Television coverage provides a convenient counter-example. As Taihei Imamura pointed out at the time, a consequence of de-emphasizing winning and losing and nationalism and individuation is lack of drama. This film involves mostly the tension of bodies in motion. Virtually the only scenes with real drama are of the shooting events ... when is that gun going off!?! Other scenes are almost parodies of the typical dramatic structure of sports; recall Joe Frazier going down a long, deserted hallway into his locker room, the complete opposite of the usual hallway tracking shot of sports films. The fact that politicians like Kono complained there weren't enough *Hi no maru*, and communists like Ryuho Saito complained there were too many, suggests that Ichikawa was attempting to sidestep politics by way of the human body, a levelling commonality for all of us human beings. The glaring exception to this levelling spirit is the back story on the runner from Chad, which is why I was curious about Eric's reading of this scene.

RUSSELL: Eric mentions the inclusion of so many banalities, those details that point to the contingencies of everyday life that the Olympics are designed to efface. Behind the heroism, the ambition, the competitiveness, and the internationalism of the event are ordinary people doing ordinary things, and they deserve screen time too. I didn't see the portrayal of the Americans as necessarily "ugly" (as James has suggested) and I'm not entirely sure if the Soviets are necessarily depicted in a better light, although there is no question that Ichikawa's techniques are "open" enough to generate any number of interpretations of the images. My own reading is more along the lines of an ethnographic Othering, as I have already suggested. And again, this refers to the banalities of the appearances of all the foreigners arriving on Pan Am jets. I love the touchdown scene, because it suggests that the world is coming to Tokyo in a very powerful way. And then I find that the camera picks out the blonde American women, the darker Italians, the blacks, inviting us to stare at their different colours, their distinctive physiognomies, and catch snatches of their different languages.

Genre: *Tokyo Olympiad*, Riefenstahl's *Olympia*, and the Sports Documentary

QUANDT: We have discussed *Tokyo Olympiad* in terms of other Japanese cinema, including Japanese documentary. Can we place it in the international tradition of documentary filmmaking, by making the inevitable comparisons with Riefenstahl's *Olympia*, which Ichikawa was inspired by, and, ironically, was used

by some of his critics to fault his approach? Ichikawa's sequence of the Olympic flame travelling across the world is perhaps more a "narrative inevitability" than an homage to the Riefenstahl film, but, to my mind, the descent of the flame into Hiroshima is ironically modelled on Hitler's descent through the clouds, the god coming to the mortals, in Riefenstahl's *Triumph of the Will*. (I could be hallucinating this!) As Dai Vaughan's is the only substantial article in English on *Tokyo Olympiad*, what is your reaction to his approach (which seems to me very ahistorical)?

RUSSELL: It is true that Dai Vaughan's approach is extremely ahistorical, and he does not attempt to locate *Tokyo Olympiad* within the cultural or political context or climate of its production. However, it is rare to find such a close textual analysis of a documentary film, and I think his comparisons can be instructive. It is interesting that he notes that once he had compared Riefenstahl's film to Ichikawa's, he better understood the dynamics of her fascist aesthetics. I think he could have pushed his analysis a bit further to think about how Ichikawa's montage creates ironic effects, and what these might mean in the Japanese political context.

Another element missing from Vaughan's analysis and from our discussion of the film in general is how Ichikawa's use of "effects" like freeze frames, slow motion, and tricks with focal lengths is characteristic of much of the Japanese cinema of the period. I'm thinking not only of Ichikawa's other films, but also those of Oshima, Teshigahara, Shindo, Shinoda, et al. There is a real playfulness that runs against the documentary realism of much of this cinema that could be analyzed in a number of ways—one of which is in terms of a Brechtian aesthetic. Perhaps because I'm immersed in Walter Benjamin right now, I'm tempted to fit the comparison of Riefenstahl and *Tokyo Olympiad* onto Benjamin's distinction between the Fascist aestheticization of politics and his alternative politicization of aesthetics. Certainly the representation of spectatorship in *Tokyo Olympiad* is above all the "distracted spectator," as is the spectator of the film, who is pushed and pulled in so many directions at once.

QUANDT: More generally, as we write during the 2000 Olympics, given how the representation of the Olympics and sports in general changed since *Tokyo Olympiad*, does it then look like a more radical film than we have given it credit for?

RUSSELL: The more I see of the 2000 Olympics, yes, the more I appreciate *Tokyo Olympiad* for its preoccupation with the pain and suffering that athletes endure. The way the current games are packaged, it's all hugs and smiles, victories, and world records that are used to sell products and world peace. Moreover, the athletes appear to be this year more than ever, well-oiled machines, with all the latest in technologies of wardrobe, training, and pharmaceuticals. One can sense in *Tokyo Olympiad* the closeness that Japan and the world still was to the catastrophes

of the war, and the urgency of world peace is sold on the basis of misery and physical trials and not on the triumphs of new technologies. In this sense I see *Tokyo Olympiad* as very much a humanist project, and if it fails to show off Tokyo to the world (as its critics were quick to point out), it definitely indicates how the world came to Tokyo, and the Japanese bewilderment at the throngs of foreigners. To the extent that that bewilderment is overcome in the shared experience of the body, the film's humanism indicates a certain coming to consciousness that I would describe not as a radical project but as a humanist one.

If the humanism of the film is keeping with some of the late fifties cinema of Kurosawa, Ichikawa, and Kobayashi, we could thus locate *Tokyo Olympiad* as straddling the divide between postwar humanism and the New Wave. To the extent that those categories are useful, Ichikawa is interesting to me in the ways that he often challenges that distinction, and points to the way that those phases of Japanese cinema in fact blur together.

Notes

1. Director Seijun Suzuki, self-proclaimed "studio hack" in the fifties, turned renegade stylist of the *yakuza* genre in the sixties, became a hero and martyr for the Japanese New Wave when his studio, Nikkatsu, dismissed him in 1967 for making "incomprehensible and unprofitable" pictures. The film that prompted the dismissal, among his most baroque, *Branded to Kill* (*Koroshi no rakuin*), is now considered one of the most important works of sixties Japanese cinema. Despite mass demonstrations by directors and students, Suzuki was never rehired. His career languished for some years, but was renewed in the eighties with an independently produced trilogy of strange, ornate films set in the Taisho period.

2. Abebe Bikila (1932–1973), the Ethiopian runner who became famous at the 1960 Olympics in Rome for running the marathon barefoot over the cobblestones of the Appian Way. Setting a world record, he became the first African athlete to win an Olympic medal. Six weeks before the Tokyo Olympics, Abebe underwent an appendectomy; he credited the warm reception of the Japanese people with helping him recover from the surgery. He set another world record in the 1964 marathon (which provides one of the most celebrated sequences in Ichikawa's *Tokyo Olympiad*). He had to withdraw from the marathon in the Mexico City Olympics of 1968 after the first fifteen kilometres. Soon after, he was in a car accident that left him paraplegic, and he died in October 1973.

3. See Dai Vaughan, "Tokyo versus Berlin," in *Documentary: Twelve Essays* (Berkeley: University of California Press, 1999), 90–110, a close, complex reading of the use of slow motion in the pole-vault and marathon competitions in Leni Riefenstahl's *Olympia* and Ichikawa's *Tokyo Olympiad*. Vaughan contrasts the monumentalizing,

low-angle slow motion in the former, its invitation to a "mystical union with the athlete," with Ichikawa's anticipatory, occasionally mocking, and humanist employment of the same device, emphasizing that in *Tokyo Olympiad* "the marathon runners embody no ideal which transcends them." "Devices which serve synthesis in [*Olympia*] serve analysis in *Tokyo*," he writes, and contrasts the "Manichean opposition of light and darkness" in *Olympia*'s pole-vault competition with the darkness in *Tokyo*, which "merely makes things difficult to see." Vaughan tellingly compares the two films' portrayals of the athletes' suffering, and of their treatments of the winners: "Where [*Olympia*] has [the medal winners] salute, starry-eyed and extrovert, *Tokyo* [*Olympiad*] prefers them to weep, smile inwardly, or just look embarrassed.... Where the *Tokyo* athletes suffer in the mortality of the flesh, [*Olympia*] seems to countenance only the apotheosis of victory or the crucifixion of failure." One infers that Ichikawa's film radically revised Vaughan's perspective on the Riefenstahl work: "It is perhaps relevant to observe that whereas, before seeing *Tokyo*, I understood [*Olympia*] as a relatively neutral film about a relatively fascist subject, I came subsequently to understand it as a fascist film about a subject which, though by no means ideologically neutral, offered at least the potential for other constructions. Further, it would be more accurate to say that I came to understand it as a would-be fascist film about such a subject...."

4. Mitsuhiro Yoshimoto, *Kurosawa: Film Studies and Japanese Cinema*, (Durham: Duke University Press 2000).

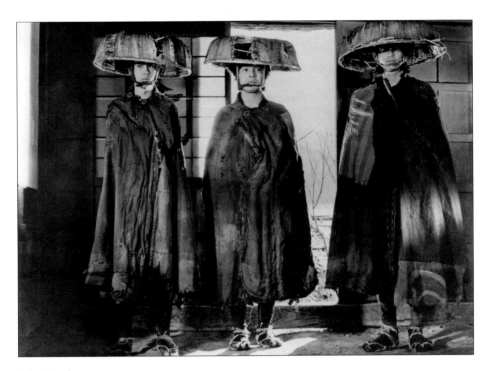

The Wanderers

WILLIAM JOHNSON

Ichikawa and the Wanderers

THERE IS NO OBVIOUS CLAIM to depth or originality in Kon Ichikawa's 1973 film, *The Wanderers* (*Matatabi*). Set in rural Japan in the turbulent years of the early nineteenth century, it draws on many elements of the samurai film. But its total effect is much more: comic, elegant, mordant, heartbreaking, breathtaking. It's easy to appreciate the technical mastery behind the film—an almost flawless sense of timing and imagery. It's less easy to see just how this criss-cross of moods attains such cumulative power. Indeed, full understanding requires a broader perspective, since the intricate balance of forces in *The Wanderers* is something that Kon Ichikawa has been working toward for a long time.

In a directorial career that spans more than a quarter of a century and some fifty films, Ichikawa has shifted unpredictably between stylization and naturalism and between gravity and off-beat humour, often incorporating both opposites in the same film. Unlike other well-known Japanese directors such as Ozu, Kurosawa, and even the much younger Oshima, Ichikawa cannot be associated with a single dominant tone. This elusiveness is no doubt one reason why Western critics, while lavishing praise on some of his individual films, have rarely attempted to evaluate his work as a whole.

A simpler reason is that few Westerners have had an opportunity to see more than a fraction of that work. (Even with assiduous following of film society and other special screenings, I have caught only about one-third of his output.) Of course, this is true of most Japanese directors; but the handful of Ichikawa's films that have had theatrical showings in the States can give a particularly exaggerated impression of his diversity. The one which had the widest distribution was a documentary on the 1964 Olympic Games, *Tokyo Olympiad* (1965)—and that came in a butchered American version. There were limited releases of only three films in their original form: *Harp of Burma* (1955), *Kagi* (*The Key*, 1959), and *Fires on the Plain* (1961).

Harp of Burma and *Fires on the Plain* both deal with the experiences of defeated Japanese soldiers in the final months of World War II, but there the resemblance seems to end. In the former (based on a novel by Michio Takeyama originally intended for children), a private named Mizushima decides to stay on in Burma disguised as a Buddhist priest in order to devote the rest of his life to burying the war dead, and Ichikawa makes no attempt to conceal the symbolism of the soldier and his mission. The film won considerable praise, as well as a prize at Venice—largely, I suspect, for the obvious nobility of its sentiments.

Fires on the Plain (from a novel by Shohei Ooka derived from his own wartime experiences) tells a more abrasive story. Japanese soldiers are stranded on Leyte without supplies, and the dramatic crux of the film is whether the central character, a private named Tamura, will resort like others around him to cannibalism; he refuses and dies. The film won a prize at Locarno, but many American reviewers dismissed it as a gratuitous stomach-wrencher.

It's true that the situation is gruesome, and that Ichikawa evokes a powerful sense of bleakness from the barren landscape across which the doomed men wander, but he does not rub the viewer's nose in repellent details. A careful look reveals that the film depends largely on stylized close-ups of Tamura's face and, in general, underscores the symbolic nature of his speech and behaviour. Conversely, a closer look at *Harp of Burma* reveals that Ichikawa has punctuated its idealism with sharply naturalistic touches: a buzzard flapping up from a corpse, Mizushima wincing at the smell of a funeral pyre. It begins to appear that the two films differ not so much in basic ingredients as in the proportions in which these are mixed.

Kagi, however, seems to spring from an entirely different source. It is set in a well-to-do household in present-day Osaka. A middle-aged man tries to stimulate his flagging potency by examining and photographing his wife's naked body when she's asleep, and by making himself jealous of their daughter's boyfriend. He resorts to these subterfuges because his wife, though highly sexed, was brought up in the strict Japanese tradition of female modesty and cannot respond directly (a point that emerges more clearly in the novel by Junichiro Tanizaki than in the film, despite the helpful casting of Machiko Kyo, who combined tradition and sexuality in such films as *Rashomon* and *Ugetsu*). The husband's plan succeeds too well: his wife is liberated with a vengeance, she and the young man become lovers, increased sexual excitement gives the husband a heart attack, and the wife deliberately kills him by overstimulation.

It's easy to imagine a director milking this story of its potential for pornography, moralizing, or horror. Ichikawa disconcerts the viewer by endowing it with beauty—a rhythmic flow of elegant compositions, in widescreen and colour, which distantly suggests Alain Resnais and which can be enjoyed as an audio-visual symphony (there is a fine music score by Yasushi Akutagawa). Yet from time

to time this stately flow breaks up into splashes of off-beat humour. A tense family discussion is interrupted by the arrival of a masseur, a sinister Hitchcockian figure in dark glasses who proceeds to twist and pummel the husband while the discussion continues. And in an epilogue (not in the book), the young man informs us through an interior monologue that the maid has poisoned the family meal and he is now dying. With his elegance, Ichikawa encourages the viewer to see that life even at its most perverse can be beautiful; with his humour, he discourages blind infatuation.

Stylistically, then, a tentative link emerges between *Kagi* and the two war films: all three combine detachment with a realism that may be grim or comic. But does this have any more meaning than the superficial resemblance between *Kagi* and *Last Year at Marienbad*? Or between a thriller and a historical epic both made by the same Hollywood workhorse?

There appears to be something of the workhorse in Ichikawa's own career. In the mid-fifties he joined the fashion for violent "juvenile delinquent" films with *Punishment Room*, which (though it survives better than a pretentious "youth drama" of the late sixties like *Zabriskie Point*) remains trapped within the exaggerated melodrama of the genre. In 1962 Ichikawa ran over budget on *Hakai* (*The Outcast*) while waiting for the right location weather conditions, and his production company took revenge by giving him three routine assignments—which he accepted. The first choice for making the Olympics film was Kurosawa, who demanded a bigger budget; the Japanese Olympic Board then made the same offer to Ichikawa, who accepted. He seems adaptable not only to working conditions but also to subject matter determined by other people: most of his films are based on novels, and he has even referred to himself as an "illustrator."

Yet all of this gives a misleading impression. In his quiet way, Ichikawa has asserted an impressive independence. He turned at least one of those "routine assignments," *An Actor's Revenge* (I haven't seen the other two), into a dazzling triumph, and allowed no sign to reach the screen that the budget of *Tokyo Olympiad* might have been inadequate. Most of the novels he has adapted have been of his own choosing; his wife, Natto Wada, has worked on most of the scripts, and he himself has collaborated on many. And the magnificent *The Wanderers* has an original script by Ichikawa with Shuntaro Tanikawa.

When Ichikawa's other films are taken into account, the link between his three features released in the States no longer appears tenuous. In style and content, *Enjo* (*Conflagration*, 1958) stands almost midway between *Harp of Burma* and *Kagi*. Adapted from Yukio Mishima's novel *The Temple of the Golden Pavilion*, it concerns a young Buddhist monk, shy and stuttering, who loves the temple both for its traditional quietude and for its associations with his dead father. Goichi Mizoguchi's superiors, however, seem more interested in attracting the tourist trade, and the outraged youth ends by destroying the temple with fire.

Enjo pivots stylistically between the simple narrative flow of loose compositions in *Harp of Burma* and the brilliant visual orchestration of *Kagi*. In widescreen black and white, it tells its story through flashbacks within a flashback, and it rises from time to time to peaks of visual splendour (such as an extraordinary long shot of the night sky filled with sparks from the burning temple). Goichi is clearly a more sombre version of *Harp of Burma*'s Mizushima: noble determination, triumphant in the earlier film, gives ground in *Enjo* to neurotic obsession. The husband in *Kagi* completes the reversal of values, since he becomes incapable of caring about anything except the satisfaction of his obsessive sexual desires. Though differing sharply in mood and style, the three films can be seen to belong to the same continuum.

The comparison of these films may suggest that the diversity of Ichikawa's work results from a general progression toward more sombre subjects and a more controlled style. This is roughly true—but very roughly indeed. Some years ago Ichikawa divided his films into the categories of Light and Dark, and stated that he had come to see more and more of the dark side of life; yet the "dark" *Kagi* and *Fires on the Plain* were followed by the "light" *Alone on the Pacific* and *An Actor's Revenge*.

As to style: Ichikawa entered filmmaking as an artist in a cartoon studio and his first directorial effort was a puppet film which indicates that he was accustomed from the start to keeping tight control over composition and rhythm. Yet his first noteworthy film, *Pu-san* (1953), about the misadventures of a Harry Langdon–like figure in postwar Tokyo, came across with clear and realistic sobriety; while *A Billionaire*, made on a similar theme a year later, evinced a surreal ebullience that anticipated such films as *Shoot the Piano Player* and *Pierrot le fou*. Any simple curve in Ichikawa's development can be abstracted only from a zigzag of continual explorations. He has always been willing to take chances, to try out new mixtures of stylization and naturalism, of gravity and humour, in percentages that run almost the whole range from zero to one hundred.

There is also a less elusive continuity in Ichikawa's work. Nearly all of his films can be found to revolve around a recurring set of themes. I have already pointed out a similarity between Mizushima in *Harp of Burma* and Goichi in *Enjo*. Many of Ichikawa's protagonists share in this kinship, being innocents, little men, misfits, outsiders, chickens surrounded by foxes. Mr. Pu in *Pu-san* establishes the prototype. A shy and gangling schoolteacher, he responds to most of the unpleasant surprises in his life with a patient "*So des'ka?*" (Is that so?), foreshadowing the selflessness of Mizushima. But there are also hints of the more aggressive and unbalanced behaviour of Goichi: occasionally Pu gives way to ineffectual anger, as when he clutches his desk to try and prevent the principal from firing him, and at one point places a cabbage on his head to see if he might escape from his troubles by feigning insanity.

Some of Ichikawa's protagonists are so innocent that they survive without scars. The naïve young tax collector in *A Billionaire* cannot understand why his insistence on honesty annoys his superiors as much as the taxpayers. The hero of *Alone on the Pacific*, who casually sails his boat out of Osaka harbour early one morning, heading for San Francisco, suffers less from the many hardships of his voyage than from the few embarrassments, as when an American on a passing liner shouts, "Do you have a visa?" The spoiled eldest son in *Bonchi* (1960) drifts through thirty years of family and national upheavals with hardly a dent in his *savoir-faire*. Other protagonists are more vulnerable. In *Hakai*, which focuses on the *burakumin* (untouchables) of Japan at the turn of the century, the involuntary outsider is torn between pride in his parentage and fear of revealing it. In *Men of Tohoku* (1957), about a group of outcasts in a remote village, the protagonist is an unhappy outsider among outsiders, notorious for his bad breath.

One reason for the richness of *The Wanderers* is that it centres around three different innocents. They are *toseinin*—peasant imitations of masterless samurai who wander from village to village, ready to work or fight for anyone who will give them food and lodging. Ichikawa does not try to make them superficially distinct from one another, like Richard Lester's Musketeers; in fact, the three are physically quite similar and walk and talk in much the same way, so that their appearance quickly establishes them as an "all for one" trio. But Ichikawa soon draws out unmistakable differences. Genta is closest to the Goichi type of innocent, being most vulnerable to emotion; Mokutaro has more of the calm and self-assurance of Mizushima; and Shinta, the most pragmatic of the three, has a foot in both camps. The film gains considerable depth from this double image of the *toseinin*, as they respond both corporately and individually to the turbulent events around them.

I may have given the impression thus far that Ichikawa's interest centres on rather freakish people in rather freakish circumstances. But most of his characters seem unusual only because they lack the veneer of sophistication with which most of us mask our naïvetés and obsessions—and which Ichikawa removes in order to focus more clearly on human realities. At the same time he chooses circumstances that will throw light on *social* realities. If the foreground events sometimes look bizarre, it's because they stem from an all-too-familiar tension in the background.

This is the second element in Ichikawa's recurring set of themes: an environment which threatens his characters, buffets them, takes them by surprise. Most of Ichikawa's films are set amid the breakdown of some kind of moral, social, political, or cultural order. Beliefs, customs, and laws are called into question; they shift, collide, collapse. Sometimes the process may be muted and subtle, as in *Kagi*, which implies rather than underlines the breakdown of traditional family relationships. In other films collapse is explicit: *Fires on the Plain* hinges both on the defeat of militaristic Japan and on the breakdown of moral and human values among desperate survivors.

Ichikawa does not reduce his protagonists to passive figures in a panorama of collapse, any more than he reduces his filmic environment to a backcloth for larger-than-life characters; he fuses the two elements into a dynamic whole. In *The Wanderers* he does this with magisterial ease. Dispensing with "establishing shots" of the world his wanderers live in, he follows their adventures and misadventures in such a way that the larger picture steadily accumulates. I cannot recall seeing any other film which so brilliantly combines microcosm and macrocosm.

This is all the more remarkable because the late feudal era has been as happy a hunting ground for Japanese directors as the late nineteenth-century West has been for Americans, and its salient features have been trampled into clichés. Of course, some directors have set out to bring the clichés back to life. Kurosawa has done it by stressing involvement in the action: telephoto lenses suck the viewer into the muddy battles of *Seven Samurai*; widescreen and quick cutting amplify the sword whacking in *Yojimbo*. But in emphasizing the foreground, Kurosawa lets the background fade away; the social context shrinks into a pretext.

Ichikawa takes a very different approach. In *The Wanderers* (as to a lesser extent in *An Actor's Revenge*, also set in the late feudal era), he gives an ironic, detached view of the foreground action. The fights, for example, are stylized, sometimes evoking a rhythmic dance, sometimes the flicker of an abstract film, but never settling into any formalist rigidity. This is the secret of Ichikawa's stylization: he takes it just far enough to achieve great visual clarity, to open up the viewer's eye and imagination.

Thus the story of *The Wanderers* emerges in brief, graphic, sometimes abrupt vignettes. At first the adventures of the *toseinin* are linear, and shared. They are given shelter at one house and help repel an attack by the owner's enemy. They move to another house and take part in another fight. They chase away a group of gamblers and seize the abandoned stakes. But now this simple plot breaks up into apparently unconnected subplots. The *toseinin* lodge with a gambling boss; one of the boss's debtors is a mean old man with a young wife, Okumi; the debt collector is trying to sell the boss out to a rival. Then connections appear. Genta rapes Okumi and asks her to go off with him; the debt collector turns out to be Genta's runaway father; the boss, learning about the betrayal, requires Genta to execute revenge. After hesitation, Genta does kill his father—whereupon the boss evicts the *toseinin* on the grounds that he cannot condone parricide. The three of them, with Okumi, go back on the road. Their experience becomes linear again, but now it is running downhill. They travel to Genta's home village to find out what happened to the rest of his family: his mother has moved away, leaving neighbours to look after a younger son (who refuses to recognize Genta). Shinta, who has cut his foot while on the road, dies of an infection. Since Genta is wanted by the police, he "places" Okumi as a B-girl at an inn, promising to return for her when the heat is off. He and Mokutaro move on. They lodge with a lord who is about to be betrayed by his

steward. Mokutaro wants to kill the steward, but Genta violently objects; in chasing after Mokutaro, he falls over a cliff and is killed.

Even this synopsis shows how the sense of a disintegrating society is embodied in the characters and the action. The *toseinin* have left their village homes for a precarious way of life—which suggests that a peasant's way of life is even more precarious. Similarly, Okumi's readiness to go off with Genta indicates how little *she* has to lose. Political life is glimpsed as a series of petty power struggles between local bosses. Ties of blood, loyalty, and friendship continually fall apart: a father abandons his wife and children, a mother leaves her young son, a wife runs away from her husband, retainers betray their masters, the two surviving *toseinin* come to blows—and, most flagrant of all, a son kills his father.

Here Ichikawa plays brilliantly with one of the stock elements of the Japanese period film (and also of Japanese literature): the conflict between two different obligations, or between obligation and desire. Normally such a conflict would dominate the action; in *The Wanderers* it seems to drop out of nowhere, allowing Genta little time for prior soul-searching. He confronts his father with drawn sword, and hesitates; Shinta blurts out, "It's the code!" and Genta strikes. In the final quarrel, Mokutaro accuses Genta of having wanted to kill his father; but this is beside the point. The real conflict that Genta faces goes beyond any obvious duties or desires and involves the whole meaning of his way of life.

Ichikawa prepares this conflict right from the start. The film opens with the three *toseinin* presenting themselves to the steward of the house where they hope to be lodged. Shinta rattles off a lengthy ritual greeting and offers a token gift (which he makes sure to retrieve). Then Genta steps up and repeats the whole procedure. Mokutaro is about to do the same when the steward says, "Why don't we stop all this?" Nevertheless, the *toseinin* go through the repetitious formula at each house they come to. They cling to it because it helps elevate their random mercenary transactions into a lofty and universal code.

They cling to this code not because it flatters them but because it injects at least the semblance of order and structure into the chaos of society. When Genta is assigned to kill his father, he has to weigh the objective value of the code against this subjective value. Objectively, the code has no meaning; but if he rejects it, he strips the meaning from his own life. He cannot bear to think of this enormous disparity for very long; hence his almost involuntary response to Shinta's cry. But the conflict does not end there. Much later, when Mokutaro goes after the treacherous steward, Genta does reject the code: one cold-blooded killing for its sake was too much, and he cannot allow another. Appropriately (though Ichikawa does not emphasize the symbolic connection), this decision leads at once to Genta's death.

The Wanderers may sound like a gloomy film relieved only by the impersonality of Ichikawa's style. But this is doubly wrong. Much of the content is not gloomy at all, and the visual clarity of Ichikawa's style often intensifies the viewer's emotional

response. There is considerable warmth in the relations of the major characters. The solidarity of the *toseinin*, however shaky, is real. Thus Mokutaro does his best to cure the dying Shinta, and at the end, not knowing that Genta has fallen to his death, calls for him in a friendly voice. Okumi is accepted as part of the group, and Genta shows genuine affection for her. Of course, these relations spring partly from the horror of loneliness; people are something to cling to, like the code. But this is where Ichikawa's clarity adds weight to the positive side.

After the killing of Genta's father, a scene opens in darkness punctuated by sparks; then a lamp is lit and, in its soft glow, Genta tenderly lays out his father's body. While it may be going too far to equate the sparking of the flame with the kindling of sorrow within Genta, the visual surprise followed by the warmth of the lamplight directly establishes a new and gentler mood. In similar ways, Ichikawa focuses sharply on the satisfactions which remain amid all the instability: not only food and sex but also the pleasurable awareness of being alive, as reflected by shots of the *toseinin* walking against a backdrop of misty mountains, or through a forest flecked with snow, or past a tranquil pond with an expanding ring of ripples. Such scenes are commonplace in Japanese films when they are used to express *aware*, the nostalgic perception associated with haiku poetry, but instead of lingering on them, Ichikawa summons them up briefly and dynamically, stressing the moment's joy without its melancholy.

Although *The Wanderers* contains hardly any camera movements and no flashy cutting (restraints which might suggest the style of Ozu, the master of filmic *aware*), it crackles throughout with a dynamism which sets it quite apart. Sometimes the compositions are oblique, offbeat: Ichikawa shows us only half the ripples in the pond, or sets up a torturer chopping off a man's finger with the visual elegance of a jeweller cutting a precious stone. More often he gives an equivalent twist to the structure and rhythm of the film: he cuts in on some scenes in mid-action and pares away explanations, so that the full grasp of a scene may be delayed; and he either omits linking scenes or reduces them to brief vignettes, letting the film skip elusively through time and space. While these devices never approach the point of obfuscation, they help keep the viewer slightly on edge and off balance, and thus induce an alertness and concentration quite different from the contemplative mood of Ozu.

Ichikawa's dynamism springs most of all from his mating of opposites (stylization and naturalism, humour and gravity) without upsetting the film's formal and emotional balance. Often in *The Wanderers* the opposites appear together, creating dense and vivid signs—comparable to the Sino-Japanese ideograms which unite two or more disparate concrete terms (fire, water) to create a new and larger concept (disaster).

The most dramatic fusion of opposites takes place with the killing of Genta's father, where comedy joins with horror. As Genta strikes, blood spatters his face;

Shinta, whose cry triggered the act, scampers away like a small boy who has broken a window; the father's obtuse mistress appears in the doorway, shrieking, and Genta turns on her; there is a ludicrous chase between blood-spattered Genta and the fast-waddling mistress—who gets away. With these few rapid strokes Ichikawa depicts the appalling deflation of the code.

More typical is a recurring scene which shows the three *toseinin* on the road. They wear wide-brimmed wicker hats rather like inverted salad bowls, and they walk as briskly as they can over the rough terrain. Ichikawa films them from the front with a long-focus lens, accentuating both their jerky, almost mincing gait and the wobbling of their hats. Though the scene is thoroughly naturalistic, it also comes across as stylized and comic, since the men look very much like puppets; and the total effect goes further, with the oversize hats standing in for the invisible burdens under which the three men are struggling to survive.

This dense yet crystalline image sums up Ichikawa's vision. In all of his films—and with dazzling success in *The Wanderers*—he sets out to bring the struggle of life into the sharpest possible focus. He embraces both the general and the particular, conjuring up formal elegance without betraying the sheer grittiness of the phenomenal world. He refuses to exaggerate either the good or the bad of mankind and of society; and he also refuses to imply that the bad is susceptible either to a panacea (the activist's temptation) or no cure at all (the escapist's). Yet he also triumphs over the occupational hazard of the moderate, who may end up defined only by the extremes he is trying to avoid. The most positive of moderates, Ichikawa works from the conviction that nothing is more important than to *see*.

In *The Wanderers*, this insistent vision strikes a powerful sense of immediacy out of remote characters and events. I find that the film touches me far more closely than most American attempts at "relevance"—especially such period pieces as *Tell Them Willie Boy Is Here* and *Bonnie and Clyde*, in which anachronistic attitudes are poured over superfluous historical details. Willie Boy and his counterparts are way out in never-never land; it's the *toseinin* that are here.

They are here in a society that is cracking up—where the law has lost its vigour, where people clutch at illusions and brief satisfactions—and yet where life obstinately goes on. Ichikawa doesn't draw any parallels with the world of today, but there's no need. He has captured the essence of almost any society under pressure to change.

The Wanderers is a *tour de force* that looks simple. In it, the polar opposites that have marked all of Ichikawa's work meet in a consummate point of balance. In it, too, this sixty-year-old filmmaker has achieved a remarkable fusion of technical mastery and creative vigour. It is a film to be seen and vividly remembered by anyone who cares about the cinema, people, society, or survival.

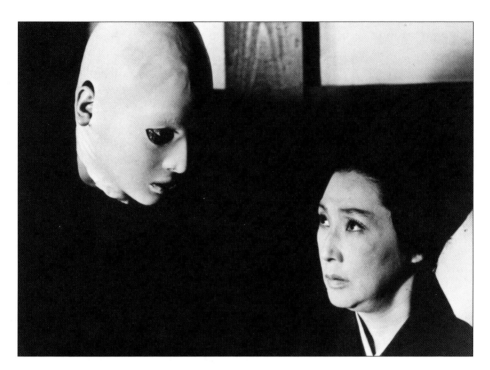

The Inugami Family

KON ICHIKAWA
YUKI MORI

The Inugami Family

YUKI MORI: *The Inugami Family* (1976) is the first of your films that I saw not retrospectively, but when it was released. Could you talk about how you got involved with this project?

KON ICHIKAWA: I don't know how this project came to me. Directors are not usually informed about such things. (Laughs)

Producer Kiichi Ichikawa told me that Haruki Kadokawa [ex-president of Kadokawa Publishing] wanted to make a film by himself after he succeeded in partnering with a film company and a record company to publish the novel on which the American film *Love Story* was based. So Kadokawa made Seishi Yokomizo's *The 8-Tomb Village* (*Yatsuhaka mura*) at Shochiku.

MORI: Did *Yatsuhaka mura* (directed by Yoshitaro Nomura) start shooting earlier than *The Inugami Family*, which opened first?

ICHIKAWA: They started shooting much earlier than us. Their shoot was delayed for many reasons. If we go back to Haruki Kadokawa, when he intended to produce a film by himself, Shochiku told him that he did not have to invest because they would make the film alone. It wasn't usual at that time that a company unrelated to the film business would invest in a film. Kadokawa felt offended, and he decided to co-operate with Toho after talking to many people. The film he chose was *The Inugami Family*. Then, the project came to me.

I was a big fan of detective novels for a long time, but I had not been involved in a project like this one before. I accepted because I had been waiting to make a detective film.

MORI: *The Inugami Family* was the first "Kadokawa Film," which would drastically change the system of filmmaking in Japan. What was your first impression of Haruki Kadokawa?

ICHIKAWA: He was very young and modern. He said that many projects were

under way, and this film was one of them. (Laughs) I received a script written by Norio Osada, but Haruki wanted me to rewrite it because he did not like it. I didn't know about *The Inugami Family*, even though I had read some of Yokomizo's novels.

MORI: Which Yokomizo novels do you prefer?

ICHIKAWA: *Honjin satsujin jiken* [*The Honjin Murder Case*] is the best. The second best is *Gokumonto*.* Then, there are many short masterpieces, such as *Kura no naka*. Since Yokomizo used to be editor-in-chief of a famous, fashionable pre-war magazine *Shin Seinen*, his novels have a complex, interesting tone, which mixes modern sensibility with an eerie atmosphere.

MORI: What kind of person was Yokomizo himself?

ICHIKAWA: Despite his fantastic and mysterious novels, he was an affectionate person. He told me that he trusted me when we first met. I rewrote the script with Shinya Hidaka.

MORI: Since a detective film doesn't work if there are any contradictions in its plot, the most important thing is the script.

ICHIKAWA: Alibis are almost never broken in Yokomizo's novels. They're so vague that we should not pursue them strictly. (Laughs) Therefore, we took the original novel apart, and composed the script as if writing a detective novel ourselves. We also had an idea of changing the character of Kosuke Kindaichi, with Yokomizo's approval. Of course, Kindaichi's famous appearance, his untrimmed hair, his worn-out hat and flimsy serge *hakama* [pleated, skirt-like Japanese garment], was absolutely necessary. Yet, I wanted to make him look like a messenger of God. Instead of a great detective coming back from America, as in the original novel, I wanted to portray him as somebody who never gets involved with a case.

MORI: Many people talked about the scene in which Kindaichi receives the detective fee. What did you want to show regarding his sense about money matters?

ICHIKAWA: He appears to be aloof from the world, but he is precise by nature. Otherwise, he could not be a detective. That is, he is a "modern man" as well as a "God." (Laughs)

MORI: It's not so interesting if he is just good-natured.

ICHIKAWA: Yes. A person is not very appealing without some cynicism. He doesn't wear what he really likes. He leads a frugal life, and his food and hotel expenses are of acute importance for him.

MORI: Many actors have played Kindaichi since Chiezo Kataoka, such as Joji Oka, Ken Takakura, and Akira Nakao. Here, the character of Koji Ishizaka is perfect for the role. Who chose Ishizaka?

*Adapted by Ichikawa in 1977, the film version of *Gokumonto* (*Island of Horrors*) includes scenes of a stage performance of *A Girl at Dojo Temple*, a reference to Ichikawa's first film, a puppet version of that famous tale. *Ed.*

The Inugami Family

ICHIKAWA: I did. Both Haruki and Kiichi opposed me in the beginning, because Ishizaka was too handsome for Kindaichi, but I didn't give in.

MORI: Why did you stick to Ishizaka?

ICHIKAWA: Because he is fresh, modern, and not too handsome. It was I who chose Mieko Takamine as the criminal. Somebody was talking about Haruko Sugimura for the role. Of course, Sugimura is a great actress, but I wanted a sensual beauty to be the criminal. I chose Takamine because I was a big fan of hers since *Warm Current* (*Danryu*) and *Asakusa no hi*.

MORI: It had been a long time since Takamine had last appeared in a film.

ICHIKAWA: Yes. She rejected my offer at first, because she had not played such a horrifying woman who killed people. I cajoled her, and finally she accepted. However, she wasn't in good shape at the beginning. She was totally different from what she used to be, looking more like a singer than an actress. She had been a singer for a long time, and had learned a strange way of walking and moving, unique to a singer. It's natural for a singer to act like that, and all we had to do was correct it, but Takamine used to be a great actress. (Laughs) Why did she change? I assume that she tends to be absorbed in whatever she is doing. But once she got over it, she returned to her true self.

MORI: What made her go back to being an actress?

ICHIKAWA: You remember the scene in which she kills her "son," whose face is hideous. She hits him with an axe, and his blood splashes upon her chest. We told her to swing the axe down with great force and absolute hatred, because we wanted the blood to splash on her chest, not on her face. She said she understood. Once the shooting started, Inagaki, the one who took care of the blood, was so nervous that he missed the target, and the blood hit Takamine's face directly. I don't believe she was even able to open her eyes. I said "Oh, God" to myself, but I didn't say "Cut!" Takamine calmly continued acting. Every time she swung down the axe, the blood splashed upon her face.

MORI: The audience was astonished at that scene. Every time she swung down the axe, the female audience screamed.

ICHIKAWA: As soon as the shoot ended, I asked her if she was all right. She said that the blood got in her eyes. We cried: "Bathroom, bathroom," "Medicine," "Water." We stopped shooting for the day. Normally an actor would get angry and stop acting if something like that happens, but she kept it up with her face covered in blood. She impressed me very much. By the next day, her acting had changed drastically; her movement became totally different. I knew there were many scenes that I had accepted earlier, even though her acting was not so good. I told her that we would reshoot some scenes, and we replaced those scenes with her "revived" acting. Neither Takamine nor other staff members understood why we shot the same scenes again. (Laughs)

MORI: It's interesting that a mistake in a shooting improved the final film. In any

case, Matsuko Inugami played by Takamine had a strong presence, like a female monster. You successfully balanced her with Ryoko Sakaguchi as a hotel maid. Of course, the chief of the police played by Takeshi Kato, who says "OK, I understand" was great, too.

ICHIKAWA: That line suddenly came to me during shooting.

MORI: Though many directors have made detective or mystery films, your "Kindaichi series" is epoch-making because you cleverly tell the dark stories with humour. The audience can comfortably enjoy the tension. (Laughs)

ICHIKAWA: In Yokomizo's original novels, there were lots of obscure issues such as cause-and-effect or old customs. If we had pursued only those things, the films would have become heavy and far from entertaining. I prefer films that the audience finds totally appealing. That's why I knew from the beginning that comic relief is indispensable.

MORI: The war lies behind the murders related to the succession of property. You clearly depict a situation in which all the characters are at the mercy of the war. For example, the army bought drugs from the Inugami pharmaceutical company, and the fake son was wounded in the face on the Burmese battlefield.

ICHIKAWA: It is also a story about human love. In opposition to old Sahei Inugami's grudge, which causes the tragic incidents, we show relationships of loneliness and love. That was the way I felt when I read Yokomizo's original novel. It's not only a story of scrambling for property.

MORI: In addition to its interesting story, the fascinating thing about this film is that its cinematography and art design elaborately display the atmosphere of Shinshu in the late 1940s. Of course it's set in a place I didn't know before I was born, so I can only imagine. (Laughs) I was attracted by the film's period atmosphere, expressed in such things as the black corridor of a hotel or a reddish wooden shoebox. The film looked as if it were set in Japan and not in Japan at the same time. Was the "Nasu Hotel" a studio set?

ICHIKAWA: No, we shot that in Shinshu. We found that kind of old hotel at the edge of the town of Ueda.

MORI: Then what about the Inugami house?

ICHIKAWA: That was a studio set. We constructed it in the Toho studio. Except for the front of the house, for which we shot a big sake brewery in Shinshu.

MORI: Speaking of images, the visual rhetoric you developed since *Tokyo Olympiad* exploded here. This film contains the results of all the techniques you introduced before, such as a sharp contrast of black and white, which reminds us of the eerie images of German Expressionism, still photographic images, and some special effects from the development process.

ICHIKAWA: I also inserted many very quick flash shots. Since the relationships among the characters were very complicated and it seemed impossible to introduce them with subtitles every time, I inserted quick shots of the characters

when they were mentioned in conversations. I used the same technique in flashback. Even though the audience doesn't understand the meaning of those shots when they first appear, those fragmented images stay in their minds, so they understand them later.

MORI: Your explanation sounds both sensuous and logical. When a lawyer played by Eitaro Ozawa explains the family tree of Inugami to Kindaichi and mentions the eldest daughter Matsuko, a close-up of Matsuko's sister's fingers playing the *koto* is inserted. That kind of device functions not only to visually accentuate, but also to advance the detective narrative.

By the way, whenever I think about the "Kindaichi series," I remember the design of the credit titles. Big, white letters laid out in the shape of a hook on a black background.

ICHIKAWA: To tell the truth, that design was born by chance. When we ordered the photocomposition of thick Mincho type letters from Den Film Effect, they sent us a page filled with sample letters. It was very interesting, and we decided to use it. Kiichi Ichikawa was surprised, and said that it was the first time since he entered the film world that his name was shown on screen that big. (Laughs)

MORI: I always look forward to seeing your elaborate work on credit titles.

ICHIKAWA: A title is like a face for a human, and a nameplate for a house. I think it is an important element to signify the content of a film. I have always designed the titles myself since my debut film *A Flower Blooms* (*Hana hiraku*, 1948).

In foreign films, famous designers such as Saul Bass create beautiful titles such as those for *The Man with the Golden Arm* or *Bonjour Tristesse*, but in Japan we don't have enough money to hire the specialists. We have to do it ourselves. (Laughs)

MORI: In contrast to the "Kindaichi series," the titles of *Ototo* or *Bonchi* appear in the middle of the screen in tiny letters.

ICHIKAWA: I thought it would be beautiful to show a title very small in Cinema-Scope. Generally speaking, those were too small, but I wanted them smaller. (Laughs)

MORI: You usually use Mincho type letters for the names of casts and crew following the main title.

ICHIKAWA: I personally like Mincho type. I sometimes use Gothic type for modern drama, but I prefer Mincho a lot. I like old handwriting style, too. When I was an assistant director, I earned money writing titles myself. (Laughs) Whenever I asked the directors, they let me write the titles. By using poster colour and blushes, I wrote a title, names of cast and crew, and I received about twenty yen. I wrote for most of Nobuo Nakagawa's films including the films starring Enoken. I am proud of Naruse's *Travelling Actors* (*Tabi yakusha*). I usually do not write for my own films, though.

MORI: Then, why do you always use the character for "Kan" rather than "Owari" at the ends of your films?

ICHIKAWA: Because I like the shape of the character, and it suits the screen perfectly. The couple of minutes before a film ends are very important. Therefore, I have strong opinions about the end credits.

MORI: At the end of *The Inugami Family*, as soon as Kindaichi jumps on a train at a station, the character "Kan" appears on the edge of the screen. I think it is a simple and sophisticated ending, compared with the gorgeous opening.

ICHIKAWA: There were lots of stories regarding the ending. That ending was shot on location at Shinonoi station in Shinshu. The station had a good ambience, but there was no steam train running there. So I cheated, in a positive sense, by only using the sound of a train leaving. (Laughs) I also wanted to express Kindaichi's character through the brisk ending without any music. He is so shy that he leaves on a train earlier than scheduled, in order to avoid everybody seeing him off. It is better not to reveal his actual self, because he is the "God." If he is seen off, people will know where he comes from. (Laughs)

MORI: The fact that he moves out of the right side of the frame implies that he also departs from the film world.

ICHIKAWA: It is true that there was no train. (Laughs)

MORI: Many staff members appeared in the film. For example, Seishi Yokomizo played the host of the hotel, and Haruki Kadokawa played a detective. I didn't realize you yourself were in the film. Which part?

ICHIKAWA: I was supposed to play the mask maker. But the staff killed the idea because Ken-chan (Kenichi) Okamoto, the lighting director, was more suitable because of his white hair. (Laughs) Therefore, I appeared in an old photograph of Sahei, through a special effect. (Laughs)

MORI: *The Inugami Family* was not only critically praised, but also loved by the general audience. It was an auspicious film. I still remember the first day of its roadshow at the old Hibiya Eiga theatre, where there was a very long line in front of people who were asked to come back the next day because the house was full for the day, but they left reluctantly. Once the film started, the theatre resounded with the screams of the female audience during shocking scenes, and with laughter at the jokes. Everybody thoroughly enjoyed it, and I will never forget the feeling of immense satisfaction we had after watching such an entertaining film.

Translated from the Japanese by Daisuke Miyao

The Makioka Sisters

KATHE GEIST

Adapting *The Makioka Sisters*

KON ICHIKAWA claims to have wanted to adapt Junichiro Tanizaki's *Makioka Sisters* (*Sasameyuki*) in 1948, when the novel first appeared and he was still an assistant director. The dream faded, particularly when others adapted the book for the screen, first in 1950 and later in 1959, but was revived when a Toho producer asked him, in the early 1980s, to direct a new version of the literary classic. A large budget was assigned to the consequently lavish production, whose release was scheduled to coincide with Toho's fiftieth anniversary in 1983. Despite a budget that could have accommodated the necessary special effects, Ichikawa's version is stately and quiet and omits the most dramatic occurrence in the novel: the Kobe flood of 1938. Nevertheless, the film preserves the ethos of the novel, essentially an upper-middle-class "home drama," and in spite of the inevitable condensation required to adapt a 500–page novel to film,[1] the story, characters, and even minute events from the novel are clearly recognizable. There are, however, minor changes as well as obvious omissions that subtly rework the novel's ideology. Tanizaki's paean to a lost world of leisurely and refined upper-middle-class culture becomes, in Ichikawa's hands, not only a tribute to an earlier style of filmmaking, but also an exercise in traditionalism, intended to affirm Japanese identity at a time when Japan was re-emerging as a major commercial and industrial power.

Tanizaki's novel covers five years in the lives of the four Makioka sisters, daughters of an old, respected, and once-wealthy merchant family in Osaka, Japan's traditional centre of bourgeois culture. The story focuses on the attempts of the two older, married sisters to find suitable matches for their younger siblings. The plot is constructed around five *omiai* (marriage interviews) for Yukiko, the most conservative and "Japanese" of the four. Amidst these are woven the misadventures of the youngest sister, Taeko, a modern, independent girl with questionable morals. The story is seen mostly through the eyes of Sachiko, the second sister, whose house in the suburb of Ashiya attracts the two younger sisters more than does the family home in the old merchant quarters of Osaka. Tsuruko, the

eldest sister, charged with maintaining the family's integrity, finds herself thwarted in this endeavour on two grounds. First, the younger sisters prefer Sachiko's home in Ashiya and spend most of their time there, where Sachiko and her husband Teinosuke are less strict and tradition-bound than are Tsuruko and her husband Tatsuo. (Both husbands are *yoshi*, who have been adopted into the Makioka family and taken the family name.) Second, less than a year into the story, Tatsuo's bank transfers him to Tokyo. With the old Makioka store and most of the wealth gone, the adopted husbands must work in modern businesses to support their wives. Once in Tokyo, Tsuruko has even less control over the three younger sisters, and, with no need to maintain the Makioka name in a city where no one knows them, she and Tatsuo live rather shabbily in an attempt to save money. Unlike Sachiko, who has managed to bear only one child, Tsuruko has six children to support.

The book, whose Japanese name means "a light snowfall," the kind that disappears as soon as the sun comes out, is Tanizaki's elegy to a lost culture—that of bourgeois Kansai—one that he, a Tokyoite, had embraced after his second marriage in 1935, only six years before he began writing the novel in 1941. Completed after the war in 1948, the novel is filled with that peculiarly Japanese nostalgia for passing things, but its central irony is that while the Makioka sisters mourn the changes that come with the passing of time, in terms of both traditional seasonal change and in various personal losses,[2] outside forces, which seem distant from cozy Ashiya, are moving quickly to obliterate their entire way of life. That irony is underscored, for example, toward the end of the novel, when Sachiko receives a letter from her German friend and former neighbour, who writing of wartime hardships, adds, "We are both young nations fighting our way up, and it is not easy to win a place in the sun. And yet I do believe that we will win in the end" (*The Makioka Sisters*, 465).

In creating a structure for his film, Ichikawa reduced the novel's five-year time span to one year, neatly framed by the sisters' annual *hanami* (flower viewing) pilgrimage to Kyoto, but retained most of Yukiko's *omiai*.[3] Between the *omiai*, he interwove Taeko's story, some of which has occurred before the plot begins. Five or six years in the past, Taeko ran away with her boyfriend Okubata, son of a jewellery merchant, an incident that got into the newspapers and created a scandal. Too young to marry, and obliged in any case to wait until Yukiko married, Taeko was forbidden to continue seeing Okubata. She turned to doll-making, a hobby she has parlayed into a small business, for which she maintains her own studio. She has continued to see Okubata, however, and the plot concerns her romantic involvement with him, his friend Itakura, once an apprentice in the Okubata business, and a bartender named Miyoshi.

In the film, Taeko's past is told in black-and-white flashbacks. The black and white is emblematic of the newspaper stories that recorded the scandal; it is also reminiscent of Japanese *taiyozoku* (rebellious youth, literally, "sun tribe") films of the 1950s and 1960s, many of which were shot in grainy black and white. To a large extent, in

fact, the film's Taeko resembles the emotional, rebellious teenagers from 1960s films more than Tanizaki's sophisticated, self-contained *moga* (modern girl) from the 1930s.[4]

As in most adaptations from novel to film, many of the modifications condense the story, make it easier to follow, and make characters easier to identify. For example, Yukiko's groom in the book is the son of a viscount's concubine, in other words, a bastard. Ichikawa simply made him a second son and therefore, like his counterpart in the book, not the viscount's heir. He also changed the man's name from Mimaki to Higashidani, presumably because Mimaki is too much like Makioka, a similarity, which, in the book, is intentional.

A more important example is the postponement of Tsuruko's move to Tokyo, which occurs in the first third of the novel and allows various themes to develop: the exacerbation of tensions between the two older sisters over the residence and behaviour of the two younger sisters; Sachiko's dismay over her sister's lack of decorum in her Tokyo residence; and an unfavourable comparison between Tokyo and Osaka that testifies to Tanizaki's infatuation with Kansai. To give the film greater unity, Ichikawa kept the four sisters together throughout the film and postponed Tsuruko's move until the end, where it neatly pairs with Yukiko's impending marriage to signal the breaking up of the old family, the parting of the four sisters, and, given the soldiers we see in the station, the eventual disappearance of their whole way of life.

This farewell scene is only the second time we glimpse any of Tsuruko's children. Although she has six in the book and claims, in the film, to have a lot (we never see more than three) they are heard offscreen only once and seen only twice. In the book the children's noisy presence is frequently remarked on, particularly in the small Tokyo house, and they are, in fact, the main reason Tsuruko and Tatsuo try to live so cheaply in Tokyo. When Sachiko visits her sister in Tokyo she is appalled: "The wild disorder; ... the clutter that left hardly a place to stand, was far worse than she had imagined ... the whole house shook when one of the children ran up or down stairs" (195). In the film, Keiko Kishi's regal bearing as Tsuruko is never undermined by the presence of unruly children, nor is Ichikawa's quiet, stately *mise en scène* disrupted by them.

Modelled on the quiescent home dramas of directors like Ozu, the film omits the book's few highly dramatic episodes: the Kobe flood, Taeko's battle with dysentery, Itakura's operation and death scene, Taeko's pregnancy and the delivery and death of her illegitimate child. While most of Ichikawa's changes were necessarily subtractive, one plot device in particular was added to the original story—Teinosuke's infatuation with Yukiko. Passages such as the following suggest this infatuation, but nowhere in the book is it made explicit:

> With Yukiko back, the Ashiya house was gay and noisy again. Yukiko, so inarticulate that one hardly knew she was about, added little to the noise, but one could see from the difference she made that something bright was hidden

behind that apparent melancholy and reserve. And it was like a spring breeze to have all the sisters under one roof. The mood would be broken if one of them were to go. (257)

Tanizaki attributes these sentiments to no one in particular, but since Sachiko's consciousness is the one most present in the book, these thoughts could well be hers. In reality, they are Tanizaki's, who also had his wife's sisters living in his house and was particularly fond of one of them.[5]

Ichikawa took passages like this, added what was known of Tanizaki's own inclinations and the obsessiveness he so often wrote about in other works, and created for Teinosuke, who tends to float along in the background of the novel, a quiet obsession with Yukiko. However, scenes like the one in which he steals a kiss while helping her dress, and later fights with Sachiko about it, are entirely absent from the book. The scene in which he comes upon Yukiko and Taeko chatting in their room, in which Yukiko seductively pulls her kimono over her leg while gazing at him, is based on the passage in the book in which Teinosuke, fearing that Taeko and Yukiko have alienated one another, finds Taeko clipping Yukiko's toenails: "Yukiko quietly pulled her bare feet out of sight and took a more lady-like posture. As he closed the door, Teinosuke saw Taeko kneel to gather up the shiny parings. It was only a glimpse, and yet there was a beauty in the scene, sister with sister, that left a deep impression on him." (258).

Yukiko's action and Teinosuke's feelings here are more innocent and more diffuse than those presented in the film.[6] Moreover, the film develops a theme around the difficulties of being a *yoshi* (adopted husband), which is absent from the book. In one plot development, the elegant Tsuruko refuses at first to accompany her husband Tatsuo to Tokyo and only relents toward the end of the film. In a scene with the matchmaker Itani, which has no counterpart in the book, Teinosuke says, "A rich merchant's daughter and a clerk's son can never agree." Markus Nornes discusses at length both the "masochism," the pain Tanizaki's men enjoy at the hands of women, that is, Teinosuke's obsession with Yukiko, and the abasement of the *yoshi* husband as it appears in the Ichikawa film version of *The Makioka Sisters*. Neither theme is pursued in the book.[7]

The scene at the end of the film in which Teinosuke, distraught over Yukiko's impending marriage, drinks sake alone and remarks to the waitress (after she tells him that sake without food is poison) that "poison will do fine," is a nod to Ozu and has no counterpart in the book. It recalls the Ozu fathers who drink alone after their daughters marry, particularly the father in *An Autumn Afternoon* (*Samma no aji*, 1962), who, when asked by the barmaid if he has just come from a funeral, says, "Something like that."

Another substantial change from book to film is in the character of Taeko. The book's Taeko is the model of a thirties *moga*; she is sophisticated, unemotional, has

short hair and smokes. The only similarity here to Ichikawa's Taeko is the smoking. While his costumers put Taeko into something resembling 1930s fashions, they left her hair long and wavy to satisfy contemporary standards of beauty. More important, however, is the difference in her personality. While both characters have very youthful faces, Ichikawa's Taeko *acts* childishly, throwing temper tantrums and storming out of the house at times. In contrast, Tanizaki's Taeko simply does what she wants to do, breezing in and out of the household, entertaining the family with her friends, her stories, and her passion for traditional Japanese dancing, then disappearing for days at a time whenever the family registers disapproval of her actions. True, she once slams the front door so hard the house shakes, but this is the only indication she gives of being angry. When Itakura dies, the film's Taeko throws herself on the floor and then into Sachiko's arms, distraught. Although the book's Taeko regularly visits Itakura's grave, she shows little emotion when he dies. "She spoke with the usual calm," reports Tanizaki of Taeko when she tells Sachiko she is pregnant (*The Makioka Sisters*, 443).

The degree of Taeko's moral lassitude also changes from book to film. The book's Taeko has not only eloped unsuccessfully with Okubata as a young girl, but she also continues to see him, takes money from him, and apparently realizes that he is stealing from his family in order to give her presents. She becomes involved with his friend Itakura, a photographer who was once an apprentice in the Okubata family's jewellery business, and, after he dies, lives with Okubata, who has by now been disowned by his family for stealing from them. At this point, the Makiokas semi-disown Taeko, forbidding her to live at home anymore. Increasingly bored with Okubata, Taeko becomes involved with a bartender named Miyoshi and becomes pregnant. Hoping to avoid a scandal, the Makiokas ship her off to Arima Springs and bring her back only shortly before the birth of her daughter. In delivering the baby, who is no longer in the right position, the doctor's hand slips, and the infant dies. Not only does the Makioka family take Taeko's transgressions seriously enough to disinherit her, Tanizaki parallels the corrupt streak in Taeko with revolting descriptions of her battle with dysentery, Itakura's death from gangrene and the difficult delivery of her child. Although Sachiko has a miscarriage and both she and her daughter Etsuko become ill at various times, only those illnesses associated with Taeko are described so graphically and horrifically.[8]

Although Ichikawa was faithful to the outlines of Taeko's story, he toned down her transgressions, omitting the most dramatic and compromising, and generally presenting Taeko in a more innocent light. Okubata threatens to blackmail the Makiokas with tales of Taeko's misdeeds, but these are never made explicit, and she never lives with Okubata, nor becomes pregnant by Miyoshi, although she moves in with him at the end of the film. She lies to Yukiko about the source of some jewellery and a camel-hair coat she has recently acquired but is apparently unaware that Okubata has stolen to give them to her. Toward the end of the film she explains

that she became involved with all these men because she was jealous of the family's preoccupation with Yukiko. In other words, she is a rebellious teenager trying to get some attention. When Sachiko visits her at the end of the film, she is the image of a proper Japanese wife: her hair is tied back in a braid, she wears a kimono, serves tea, and is generally demure and self-effacing. There is some precedent for this in the book: Taeko takes up a modest life with Miyoshi after the baby's death, but we never see her within the context of this life, nor find out what she thinks about it. The last portrait Tanizaki gives us of Taeko is of her is weeping bitterly, along with Sachiko and Miyoshi, at the death of her child after the harrowing delivery. If there is a sense of repentance here, it is for real sins, whereas Ichikawa's Taeko has simply "settled down" after a rebellious youth.

Taeko's relationships with men of a lower social class beg an issue that is fundamental in both book and film, but it is treated differently in each. The film makes a point of the family's callousness toward its servants. Taeko, for example, is deliberately rude to the young servant Oharu when Oharu tries to console her; Tatsuo yells at his servant when in truth he's angry at his family. As soon as the old man, who agrees to live in the family house while Tsuruko and Tatsuo are in Tokyo, finishes his short speech of acceptance, the family ignores him. The most moving of these scenes is that involving Tsuruko's maid Ohisa, who has just learned of her brother's death in the war. Tsuruko has hung out Yukiko's kimonos and against this background mentions to her husband that the maid Ohisa is crying because she has lost her brother. He responds, "We must console her. He died for the country. Send money to his parents." Then they talk about the kimonos, and Tsuruko comments, "We couldn't get such good ones now we're at war." There is a cut to Ohisa in the dark kitchen washing the tears from her face, and we see clearly what the war means, at this juncture anyway, to the Makiokas as opposed to what it means for the lower classes, whose peasant sons and brothers made up the backbone of the Imperial Army.[9]

This obviously critical view of master/servant relationships does not exist in the book, where the relationship between the Makiokas and their servants is close, even affectionate, and their superiority is simply taken for granted. While Sachiko takes great pains to keep her servants from hearing matters she fears they will gossip about, she is, at times, forced to rely heavily on her maid Oharu who deals with sensitive matters and keeps family secrets. At one point she describes her feelings about Oharu in great detail to her sister Tsuruko. A bumptious, slovenly girl with irrepressible good spirits, Oharu, who dislikes washing, offends the other maids with her bad smell and only the pleadings of her parents, who find her too difficult to keep at home, have persuaded Sachiko to retain her. Yet Sachiko muses, "After five years I almost think of her as my daughter. She may be a little tricky at times, but . . . she does have her good points. Even when she is more trouble than she is worth, I can never be really angry with her" (209). Something of this relationship is suggested in the film in a scene in which Sachiko gives Oharu a *koto* lesson, but for

the most part, the servants are used in the film to illustrate the barrier between the Makiokas and the lower classes.

Markus Nornes has written an insightful analysis of class in the film in terms of the Japanese concept of *uchi* (inside) and *soto* (outside) or "us and them." In his analysis, the servants as well as Taeko's lower-class lovers, Itakura and Miyoshi, are *soto*.[10] In the book, however, the servants are clearly part of the family, therefore *uchi*, but Itakura, and Miyoshi are not, and the Makiokas react strongly against Itakura, in particular. Ken Ito has suggested that "Tanizaki purchased the smoothly ordered world of *Sasameyuki* at the expense of his previous insights into class and power.... The illnesses that strike down first Itakura and later Taeko leave the impression that Sachiko's values are those of the novel itself."[11] On the contrary, as stated earlier, these illnesses, as symbolic devices, are connected to Taeko's moral impurity rather than her breach of class barriers. Interestingly, Taeko's relationship with Itakura, rather than with the bartender Miyoshi, is always the issue in the book, in part because, by the time Miyoshi arrives on the scene, Taeko has already slipped beyond the pale socially, but also because Itakura is a social climber and consequently a much more complex and problematic character. In portraying Itakura and the Makiokas' response to him, Tanizaki candidly exposes their cruelty when he records Sachiko's reaction to Itakura's fatal illness: "To be honest, Sachiko could not keep back a certain feeling of relief now that the possibility of Taeko's marriage to a man of no family had been eliminated by natural and wholly unforeseen circumstances. It made her a little uncomfortable, a little unhappy with herself, to think that somewhere deep in her heart she could hope for a man's death, but there was the truth" (286). Moreover, Itakura's fate makes an angry case for the fact that inferior medical care is the lot of those lacking the money and sophistication of the upper middle class.

In the film Itakura is lumped with the servants to illustrate the Makiokas' exclusivity, and he is made to resemble them. The book's Itakura has lived in America, acquired egalitarian ways, and is something of a swashbuckling hero when he saves Taeko from the flood, but he strikes the other Makiokas as presumptuous and insincere. By contrast, the film's Itakura is a deferential country bumpkin, who always hangs his head in Taeko's presence.

Ichikawa has long had a reputation as a social critic and his identifying Itakura with the servants and both as subject to the Makiokas' slights is an unsubtle criticism of class barriers, one which champions a democratized Japan. Nornes insists, however, that the film's structure and ideology reinforce an *uchi/soto* dichotomy that is very much at the heart of how the Japanese see themselves in relation to the rest of the world, and that the film therefore unconsciously legitimizes the myth of Japanese homogeneity and the exclusivity this myth implies.[12]

Within the film's conscious, liberal agenda, there is also the implied criticism of the characters' obliviousness to the coming war. The film makes reference to the war several times, in addition to the scene where Ohisa mourns her fallen brother;

twice we see soldiers boarding or riding on trains and once we are shown the headline of a windblown newspaper, "Japanese Army Occupies Canton." The sound of a soldiers' farewell party heard from a room next to one of Yukiko's *omiai* initiates the characters' only discussion of the war, which quickly turns back to a discussion of fish—those found in Wuhan. The characters also refer at times to wartime shortages. Tsuruko and Tatsuo use the war as an excuse to save money on their parents' memorial service: "It's wartime, and we mustn't have big parties." This comment summarizes those made frequently in the book to the effect that all manner of fun, frivolity, and display must be reined in because the government is exhorting austerity and self-sacrifice.

The book's Makiokas have more of an awareness of the developing war and what it may mean for them as they watch the war develop in Europe. Sachiko has written to her former neighbour, Mrs. Stolz, that "the Makiokas were well, although with the China Incident dragging on they were gloomy at the thought that they too might soon find themselves in a real war; they could not but be astonished at how the world had changed since the days when the Stolzes were next door, and they wondered wistfully if such happy times would ever come again ..." (411).

Besides suggesting the Makiokas, while not politically sophisticated, do not welcome the prospect of war, the passage is part of an ever-present ethos of ephemerality that runs through the book. Whether it's the Stolzes moving, the war clouding the horizon, the cherry blossoms falling, the Hirado lilies fading, or the *kabuki* ending its Osaka run, Sachiko is always acutely aware of passing time and its tolls. "The tall white hagi shedding its blossoms in the garden made Sachiko think of that garden at Minoo and the day her mother had died" (336).

The film evokes this sense of ephemerality through its many references to season and climate: cherry blossoms at the beginning, autumn leaves in connection with Yukiko's last two *omiai*, snow in the final scenes. At times Ichikawa borrows from Ozu, whose films foreground ephemerality and transience.[13] A shot of clouds bridging scenes of Taeko at Sachiko's house and Taeko in her studio is reminiscent of Ozu, as are the boat and train whistles that occur from time to time, first at the beginning and end of the *omiai* with Nomura. These seem to refer particularly to Teinosuke's unrequited love for Yukiko, for in each instance the sound is over a shot of him looking at her. The singing from a soldier's farewell party in a neighbouring room is also one of these signs of transience or nostalgia, for it is Yukiko who will soon be leaving. (As in the book, the cosmic shifts brought on by the war evoke a more narrowly personal sense of nostalgia in the Makiokas' world.) Boat whistles also occur in connection with Taeko and Miyoshi—when we first see her in his bar and the first time Sachiko visits Taeko after she has gone to live with Miyoshi. The whistles are, of course, part of the working-class, waterfront milieu Taeko has consigned herself to, but given their occurrence earlier in the film, they also suggest the loss of Taeko to the family.

One hardly needs Ozu as a referent to understand the meaning of the train whistle or the close-ups of the whistle blowing and the wheels turning as Tsuruko leaves for Tokyo; the second whistle, however, sounds over a close-up of Yukiko watching the train leave with tears in her eyes, and refers not simply to the parting with Tsuruko, but again to Teinosuke's loss of Yukiko, for he is shown watching her in the background.

More than an evocation of transience is apparent, however, in Ichikawa's nature footage. The opening sequence, extra long because it contains the credits, unfolds as follows. A shot of the rounded hills of Arashiyama in the rain cuts to an extreme long shot of the Togetsu bridge, an Arashiyama landmark, where tiny figures carry umbrellas. A close-up of branches with cherry blossoms, dripping with rain, is followed by a closer shot of a single branch. After an interior sequence with the family, there is another long shot of Arashiyama with petals fluttering down, followed by another close-up of a branch of blossoms, and then an extreme close-up of a single cluster. We watch the kimono-clad women, framed in the *shoji* doorway, watching the blossoms, then a montage sequence of the family wandering under the sun-drenched blossoms next to Osawa Pond. This is followed by shots of the Heian shrine. The family enters the last of these, and four shots of weeping cherries, deep pink in bright sunshine, follow. Then we see a telephoto sequence of family members through the blossoms, which appear as a screen of pink blurs. Eleven more shots of the weeping cherries follow, allowing the credits to play out, and these include a two-shot sequence of schoolchildren walking beneath the cherries, a row of cherry trees reflected in a pond, and a close travelling shot over individual branches and blossoms. A sunset signals the day's end. We return to the family and Tsuruko pointing, not at the sunset, but at a last spectacular view of weeping cherries. Aspects of this long sequence suggest melancholy, nostalgia and transience: the rain, the petals fluttering down, the school children, the sunset. There is, throughout, a dreamlike quality, which suggests the fragility of all that we see. Nevertheless, these sequences, often shot from below or in close-up, burst out of the widescreen with such brilliant colour that they create a celebratory mood more than a nostalgic one.

The same treatment, though shortened, is given to the maple-viewing at Mino, Yukiko's third *omiai*. The sequence begins with a travelling shot down a waterfall with brilliant maples beside it, cuts to water splashing over rocks at the bottom of the waterfall, then to a long shot of people on a bridge viewing the waterfall. A closer shot of the *omiai* party walking under the maples is interrupted by a sequence of Taeko taking a bath back in Ashiya. Returning to Mino, we see a branch of maple leaves followed by two close-ups after which the *omiai* narrative resumes.

Not only the landscape receives this celebratory treatment, but so do all the aspects of traditional culture that the film includes. The inn sequence that comes between the many shots of cherry blossoms at the beginning contains a close-up of

Yukiko placing a tiny dish on her exquisitely arranged tea tray. Tsuruko joins the party late, and, as she takes off her *haori*, a close-up of her back reveals her elegant *obi*. In a later sequence in which Tsuruko tries on several different *obi*, the camera, accompanied by traditional string music, travels down her green silk kimono and over the half-dozen *obi* lying on the *tatami* floor.

The "old Japan" motifs coalesce in Yukiko's last *omiai*, which takes place at Viscount Higashidani's villa near Arashiyama. A temple bell tolls over shots of the Togetsu Bridge and again as the family walks toward the villa. Teinosuke comments on the wintry landscape, but the leaves are still a brilliant orange. The camera dwells lovingly on the architecture of the old villa. There is another disrobing shot in which a close-up of the Makioka crest on Sachiko's *haori* reveals her brocaded kimono as she takes the outer garment off. Inside the villa there is a close-up of the kettle used in boiling water for a tea ceremony. Two more shots of autumn leaves punctuate the *omiai* sequences, but "old Japan" is just beginning to build to its crescendo. The *omiai* sequence is followed by four shots of lanterns from a festival, which come toward the camera, blurring as they get very close. These are followed by a ten-shot kimono montage:

- A long shot of a blue kimono with cranes on a kimono rack
- A closer shot of the same kimono in which the camera travels up the kimono
- A close-up of cranes on the same kimono
- A close-up of a single crane on the kimono
- A gold kimono fluttering in front of the camera
- A travelling shot toward a beige kimono with wisteria
- A travelling shot toward a gold and white kimono
- Red kimono fluttering
- Part of a maroon kimono with a cherry blossom motif
- A long shot of silver brocade kimono on a rack to the right of Tatsuo, who is reading a map.

It turns out that *all* of these kimonos belong to Yukiko, and Tsuruko is airing them in anticipation of Yukiko's eventual marriage. The sequence thus has a narrative rationale, but it doesn't fit easily into the diegesis because we have to wonder who or what made them flutter. Certainly not Tatsuo, and Tsuruko comes into the room only after Tatsuo has put away his map. Existing somewhat outside the narrative, the sequence is pure celebration.[14]

That the kimonos are Yukiko's is important, for this celebration of old Japan devolves particularly on her, since, in looks and habits, she is the most old-fashioned of the sisters. The book also emphasizes this. Teinosuke's loss of her—and the film's thematic justification for his obsession with her—is our loss of old Japan. In this sense the film, unlike the book, concentrates not on the loss of a particular era, the

era of gracious living between the world wars, but on the loss of traditional Japanese culture generally.

This change is most clearly seen in the film's neglect of another aspect of the book: the constant presence of either Western friends or Western culture, which characterized the 1920s and 1930s in Japan. In the book, the house next to Sachiko's has been built for foreigners and, through the first half of the book, is occupied by the Stolzes, who become good friends. Taeko has befriended a White Russian family, the Kyrilenkos, with whom the rest of the Ashiya Makiokas become acquainted. References to Western books, films, music, as well as Western-style restaurants abound in the book, reminding us how much prewar Japan took Western culture for granted. Donald Keene comments, "The military authorities were right when they decided in 1943 that *The Makioka Sisters* was subversive, for in this novel Tanizaki indicates that Western elements had become precious parts of the lives of cultivated Japanese and were no longer merely affectations or passing crazes as in the days of Tanizaki's youth."[15]

Ichikawa is true to this aspect of the novel in several instances. For example, some of the characters, particularly Taeko, wear Western clothes. Sachiko has some Western-style rooms in her house, and the beautician/go-between Itani has a sign on her beauty salon that reads "Itani Beauty Shop" over the picture of a Western-coiffed woman. (This detail is actually at odds with the book, where Itani is teased because she *never* wears Western clothes. That she is teased, however, indicates how much Western dress was taken for granted at the time.) The *omiai* with Nomura takes place in a Chinese restaurant, which, ironically, becomes the locale of the characters' only discussion of the war in China. Beyond these instances, however, the film makes little reference to an international scene. Moreover, the Makiokas themselves, apart from Taeko's dress and Sachiko's Western parlour, seem little touched by things foreign. Yukiko's final, successful *omiai* is the all-Japanese one. (Although this meeting in Arashiyama with the groom's family takes place in the book, the initial *omiai* has taken place in a more informal, Westernized setting.) When, in the film, Tsuruko remonstrates against the move to Tokyo, Tatsuo counters, "It isn't a foreign country or the remote mountains." No foreigners appear in the film, and only the report that Miyoshi wants to "open a big club for foreigners in Kobe" acknowledges that such beings exist. One could argue that adding the foreign characters from the novel to the film would have made the already complex story too complicated; but Ichikawa could have created more of Tanizaki's international ethos through the dialogue or *mise en scène* much as Ozu did in all but his wartime films. That Ichikawa did not suggests that his focus lay more on traditional culture generally than on the particular culture of the 1930s.

No elegy, therefore, for the lost Japan of the 1930s, the film goes beyond nostalgia to an actual celebration of traditional Japan as seen in the overpowering fullness, brightness, beauty, and abundance of the shots in the "old Japan" sequences.

The culture on the screen seems not lost, but newly found—as in some sense it was for its 1983 audience. Not that they didn't know about cherry blossoms and maple leaves—seasonal fetishism has a long and present history in Japan—but to see them celebrated so gloriously was no doubt reassuring to Japanese re-emerging for the first time since the war as major players on the world's stage. With the outside world both more demanding and more accessible, there was a renewed interest in rediscovering Japanese identity.[16] The film thus dispenses "traditionalism" in the anthropological sense, meaning the way in which cultures create new traditions or adapt old ones to accommodate new developments.[17] According to Theodore Bestor, traditionalism seeks "to legitimate contemporary social realities by imbuing them with a patina of venerable historicity," and is "a common Japanese cultural device for managing or responding to social change."[18] While a *jidai-geki* would remind Japanese of their traditional culture, *The Makioka Sisters* served the particular purpose of legitimizing the new affluence of the 1980s by associating it with a traditional context. Rich, urban, and middle class, the Makiokas hail from the last great era of urban wealth in Japan. In a contemporary world where few youngsters sit regularly on *tatami* or know the features of a traditional house, where few women wear kimono and fewer still can afford to own one,[19] the film presents an image of urban, middle-class people enveloped by tradition—literally if one thinks of the extent to which the film dwells on the kimono—and invites audience members to identify with these people and reinvent their own Japaneseness.

To this end, the inclusion of 1930s foreigners would serve no purpose. With so many Westernized aspects integrated into the contemporary Japanese lifestyle and so many traditional habits lost (how to walk in a kimono, how to sit on one's knees for hours at a time), reminding audiences that Western influences were already pervasive in the 1930s would hardly be reassuring. For all that the film is politically liberal with respect to social class and war-guilt, it fully indulges the "myth of Japanese uniqueness,"[20] by creating a full-blown, all-Japanese fantasy world in many of its sequences.

Nornes's observation that the film structures itself around concepts of *uchi* and *soto* and thus reinforces the sense of Japanese homogeneity, in which everything non-Japanese is *soto,* is relevant here because this dichotomy likewise fulfilled a need for Japanese to be reassured of their particular identity as a people at a time when Japan was once again becoming more fully involved in world politics and economics.

A particular internal social change *The Makioka Sisters* attempts to mediate is the growing trend toward liberation among Japanese women. The film's insistence on the tenuous position of the *yoshi,* absent in the novel, suggests a new insecurity on the part of Japanese men, who may feel more at the mercy of women now than in the past.

At a time when Japanese women were just beginning to enter the workforce and seek careers, the film celebrated the physical, couturial, and behavioural perfection of traditional Japanese women, and this accounts for many of the major

changes from novel to film. The modification of Tanizaki's Taeko, for example, was necessary in order to keep her appearance and character more in line with that of the other sisters. Thus she was conceived of as more misguided than corrupt and shown as fully restored by the end of the film: a meek and subservient Japanese wife, serving tea. The film closes with the four Makioka sisters, perfect Japanese women all, under the cherry trees—Teinosuke's memory of the previous year's *hanami*—and any doubts we may have had of Taeko fitting this model have, by this time, been assuaged.[21] Teinosuke's obsession with Yukiko, also absent from the novel, underscores the film's dedication to the perfect Japanese woman, Yukiko being touted as the most traditional and old-fashioned of the sisters in both novel and film. Even the change in Yukiko's bridegroom's birthright, from bastard to legitimate son, while simplifying the story, serves to keep Yukiko unsullied (something Tanizaki's sense of irony would not permit, for the novel ends with the observation that Yukiko's pre-marital jitters resulted in diarrhea).

As noted before, Tanizaki's Tsuruko, burdened with children, economizing, vainly trying to exert some authority over her sisters, and reduced to tears when they snub her at one point near the end of the novel, is transformed in the film into a regal princess with real power over both her sisters and her husband. While the book's harried Tsuruko never considers an alternative to following her husband to Tokyo, the film's Tsuruko rebels against his decision, and this becomes one of the major conflicts the plot must resolve. Her eventual repentance and Tatsuo's moving gratitude for it suggest that women with freedom and choices should nevertheless choose to support their husbands.[22]

Evoking Ozu in the closing scene where Teinosuke is mourning Yukiko's marriage, Ichikawa weds one kind of traditionalism to another—tears for the perfect woman and a salute to Japanese cinema's Golden Age. Ozu, who was more Westernized and more liberal than most scholars and critics will acknowledge, is nevertheless still mythologized as the "most Japanese" of Japanese directors. It is fitting, therefore, for Ichikawa to close with a scene-long tribute to Ozu, who, if not really the "most Japanese" of directors was probably the one most obsessed by those "most Japanese" notions of transience and nostalgia. In fulfilling its nostalgic mission of saluting fifty years of Toho, the film also performed the important feat of reconnecting contemporary Japanese to their past, celebrating it, and disavowing certain uncomfortable present tendencies, freer women and greater internationalization.

Notes

1. While in Japanese, the novel is 1,000 pages, the English translation runs around 500 pages. The version quoted throughout this essay is Edward G. Seidenstecker's 1957 translation, ed. (New York: Alfred A. Knopf, 1975).

2. See Reiko Tsukimura, "The Sense of Loss in *The Makioka Sisters*," in *Approaches to the Modern Japanese Novel*, eds. Kinya Tsuruta and Thomas E. Swann (Tokyo: Kawata Press [Sophia University], 1976), 231–40.

3. Although Ichikawa stated in an interview (R5/S8 publicity notes) that he had retained all five of Yukiko's *omiai*, only four are actually staged in the film, those with Nomura, Hashidera, and Higashidani (the book's Mimaki), and a man from Toyohashi. The *omiai* with Seogishi, whose mother is discovered to be mentally ill, has taken place before the film begins, although it is alluded to in the first scene. The *omiai* with Sawazaki (which involves the firefly hunt) is omitted. In the book an *omiai* with a Mr. Saigusa from Toyohashi has taken place some ten years before the plot begins.

4. Ichikawa had, in fact, contributed to the *taiyozoku* genre with *Punishment Room* (*Shokai no heya*, 1956) and would make two subsequent films dealing with the problems/viewpoints of young people, *A Full-Up Train* (*Man'in densha*, 1957) and *Conflagration* (*Enjo*, 1958). See David Desser, *Eros plus Massacre: An Introduction to the Japanese New Wave Cinema* (Bloomington: Indiana University Press, 1988), 41–42.

5. Tanizaki had, in fact, had a serious love affair with the sister of his first wife, one reason that his marriage ended in divorce.

6. Tanizaki was famous for having a "foot fetish"; thus anyone familiar with his work could easily read far more into this passage than Tanizaki actually wrote. See Donald Keene, *Appreciations of Japanese Culture* (New York: Kodansha International, 1971), 172 f. Nevertheless, Tanizaki is explicit about Teinosuke's devotion to Sachiko and a paragraph that begins, "The most eager of all to keep Yukiko a little longer was Teinosuke," ends with the explanation that "his real motive" was to provide a distraction for Sachiko, who was still mourning over her miscarriage (*The Makioka Sisters*, 134).

7. "Context and *The Makioka Sisters*," *East-West Film Journal* 5, no. 2 (July 1991): 48–68. Nornes, perhaps inadvertently, implies that the relationship Ichikawa creates between Teinosuke and Yukiko originates in the novel, but it does not. Although Nornes has cultural evidence for male disdain of the *yoshi's* position (55), Tanizaki did not write it into the book, perhaps because the relationship between Sachiko and Teinosuke is based on Tanizaki's relationship with his second wife, Matsuko, and Tanizaki was not a *yoshi*. Ironically, his own father was one, and this apparently did cause problems in the parents' marriage.

8. For a discussion of the relationship in Japanese minds between illness and impurity, see Emiko Ohnuki-Tierney, *Illness and Culture in Contemporary Japan* (New York: Cambridge University Press, 1984), 34–35 ff; also see William Johnson, *The Modern Epidemic: A History of Tuberculosis in Japan* (Cambridge: Council on East Asian Studies, Harvard, 1997).

9. See Edwin O. Reishchauer, *Japan: Past and Present*, 3d ed. (New York: Knopf, 1969), 159–60.

10. Nornes, "Context and *The Makioka Sisters*," 58 f.
11. *Visions of Desire: Tanizaki's Fictional Worlds* (Stanford, Calif.: Stanford University Press, 1991), 205–6.
12. Nornes, "Context and *The Makioka Sisters*," 60.
13. See Kathe Geist, "Narrative Strategies in Ozu's Late Films," in Arthur Nolletti, Jr. and David Desser, eds., *Reframing Japanese Cinema: Authorship, Genre, History* (Bloomington: Indiana University Press, 1992), 92–111.
14. The celebration was literal as well as figurative, for the company that supplied the kimonos for the film was also celebrating its fiftieth anniversary.
15. Keene, *Appreciations*, 178.
16. Ross Mouer and Yoshio Sugimoto, *Images of Japanese Society* (London: Routledge & Kegan Paul, 1986), 389.
17. See Eric Hobsbawm and Terence Ranger, *The Invention of Tradition* (New York: Cambridge University Press), 4 f.
18. Theodore Bester, *Neighborhood Tokyo* (Stanford, Calif.: Stanford University Press, 1989), 10.
19. At least one well-heeled father I know of let his daughter choose between a formal kimono and a trip to Europe for her college graduation present; the cost for each is about the same.
20. Peter Dale has written extensively and quite polemically on Japanese self-mythologizing in *The Myth of Japanese Uniqueness* (Oxford: Oxford University Press, 1986). Hiroshi Minami discusses the sudden re-emergence of a Japanese obsession with Japaneseness in the early 1970s in "The Interpretation Boom," *Japan Interpreter* 8, no. 2: 159–73.
21. It has been argued that the film's women, even Yukiko, are all very strong-minded and rule the men in the film. True enough, but always within the home sphere. These kimono-clad beauties, with the exception of Taeko, do not work outside the home. Home and work, women's and men's worlds, are so completely separated in Japan that spouses are never invited to work-sponsored social events and business associates are not entertained at home. The particular threat that present-day women pose is precisely that of entering men's work world and shattering this carefully preserved distance; thus the importance of Taeko's new domesticity at the end of the film.
22. In fact, Japanese women today often stay behind when their husbands are transferred, not for themselves, but because their children cannot change schools easily. Tsuruko's decision to accompany Tatsuo creates a comforting fantasy for men while the fact of her acquiescence is an admonition to women to support their men, however they may. This, on larger scale, is precisely the decision Crown Princess Masako made in giving up her career to serve her country's traditionalism and save her prince from eternal bachelordom.

The Makioka Sisters

DAVID DESSER

Space and Narrative in *The Makioka Sisters*

THE TITLE OF THIS ESSAY deliberately invokes the title of one of the classic essays in Japanese cinema studies, Kristin Thompson and David Bordwell's "Space and Narrative in the Films of Ozu."[1] And it does so precisely to the extent that Kon Ichikawa's *The Makioka Sisters* itself intends to recall a classical Japanese cinema associated in Japan and in the West with Yasujiro Ozu. Made in conjunction with the fiftieth anniversary celebrations of Toho Studios, *The Makioka Sisters* is both tribute to and nostalgia for not simply a long-gone way of life, that of the upper-merchant class of pre-war Kansai, but also a long-gone way of cinema, a cinema which owed some of its aesthetic characteristics precisely to the culture represented by the Makioka family. By 1983, when Ichikawa's film was released, the classical Japanese cinema, exemplified by directors such as Ozu, Kenji Mizoguchi, Mikio Naruse, among others, was only a distant memory. Popular Japanese cinema, whose mainstay had for years revolved around various women's genres (romantic melodrama, family drama, mother films, etc.) had all but disappeared, replaced by *roman poruno* and various youth-oriented independent productions. Ichikawa's film, then, takes a classic novel by Junichiro Tanizaki, *Sasameyuki* (already well known in the West and far more "Western" in its expansiveness and realistic detail than much of his other works) and selects those elements of theme and incident most reminiscent of classical Japanese cinema and treats it with the stylistic traits also associated most closely with this kind of classicism. In Ichikawa's film, recollections of Ozu, with his focus on the inevitable dissolution of the family through changing times and marriage, and the stylistic traits for which he is famous—especially elliptical narrative and use of 360-degree space—are combined with a Mizoguchi-like focus on the power of women and their potential destruction at the hands of weak men to endow it with a self-conscious classicism.

This is apparent from the outset, in the film's lengthy, pre-credit scene, in which Ichikawa introduces most of the stylistic features and narrative strategies the film will adopt. Following the printed title *Sasameyuki*, Ichikawa offers us a long shot of a spring hillside. The English subtitled version superimposes "Kyoto" over this scene, but such a grounding is denied the Japanese audience, who may surmise the locale immediately or, more likely, afterwards, or "retrospectively." It is this principle of retrospectivity that is characteristic of Ozu, who often withholds establishing shots, transitional shots, or temporal cues until scenes are well underway, forcing the audience to postpone their desire for complete comprehension. Ichikawa follows this procedure throughout the opening sequence, in which location, spatial relationships, familial relationships, and narrative ellipses predominate. From the long shot of the hillside, he cuts to a long shot of a bridge set amidst a flowering landscape. As with Ozu, who often opens a film with landscape shots devoid of the main characters, the two shots are also visually related graphically, but the exact determination of how they relate spatially either has to wait for subsequent shots or, as in this case, remain indeterminate. These two shots force the (Japanese) audience to note the seasonal markers, something Ichikawa will insist upon as the film's greatest indicator of ellipses. The second shot intends to evoke subject matter typical of woodblock prints, such as landscapes with bridges, rivers, pedestrians seen in the distance. The third and fourth shots of this sequence, however, immediately invest themselves more deeply in Japanese tradition—perhaps the hoariest of traditional images, but no less effective for all that: cherry blossoms. Two close-ups of cherry blossoms in the rain comprise the content of shots three and four, with the year Showa 13 (1938) superimposed on the fourth shot after a few seconds. Cherry blossoms are, of course, the most popular of Japanese seasonal imagery, not only for their clear association with spring, but for their deeper meaning of evanescence. Cherry blossoms belong to the classical repertoire of Japanese painting, the so-called "bird-and-flower" motif that dominates hanging scrolls and standing screens. Indeed we may understand the first four shots of the film as recalling the landscape painting tradition known as *sansuiga* (mountains and rivers) popular since the fifteenth century. Perhaps that is why Ichikawa needs to superimpose "Showa 13" on the image, to provide some orientation to what might be seen at first glance to be any moment in Japanese history, at least since late Meiji (the bridge in shot two is clearly the product of an industrial culture). Of course, Showa 13 also brings with it a nostalgia all its own, a Japan not yet thoroughly embroiled in the disaster of the Pacific War. The invocation of the cherry blossoms here is also what allows Ichikawa to reinvoke their multiple meanings at film's end, when Teinosuke sits drinking sake beneath a cherry tree, savouring, as it were, the sense of completion at Yukiko's having married at last and a sense of loss at her parting.

These landscape shots finally lead to the introduction of the characters, but here again, Ichikawa postpones imparting certain kinds of information, in particu-

lar the spatial dimensions of the interior scene to which he cuts and the spatial relationships among the characters he will thereafter introduce. In addition, he leaves the social relations between his characters also somewhat vague. In a fine essay on the film, Markus Nornes notes that the opening sequence withholds "the common courtesy of an establishing shot" while cutting from face to face in a series of close-ups. "Eyelines shoot in every direction, forcing the spectator to guess spatial relationships as well as the presence of characters outside of the limited range of the frame."[2] He also notes that Ichikawa explained this strategy as "an introduction which blocks differentiation between the sisters; that will come in the course of the film."[3] In other words, two kinds of Ozu-like retrospectivity are at work here: the postponement of the spatial dimensions of the setting and the withholding of narrative information about the characters.

The first character we see is Sachiko, who utters the word "money?" (*okane*) in a tight close-up. She delivers her dialogue to an offscreen subject in a mostly frontal view. Here, again, Ichikawa recalls Ozu who used only the subtlest of eyeline glances in conversation scenes, preferring to allow his characters to talk to the camera. Sachiko's close-up is matched by a close-up of Taeko (also known as Koi-san), who says nothing. This is followed by a close-up of Sachiko and thereafter by almost two dozen more shots, all close-ups of the three sisters and, eventually of Teinosuke, twenty-six shots in all over the course of a minute and a half; both a long time to rely strictly on close-ups, but also producing an amazingly rapid-fire pace (3.3 seconds average shot length!). Here, again, the subtitles give more information to the Western audience than the Japanese-speaking audience receives. Characters' names appear in subtitles whereas they are not, in fact, spoken in the dialogue. This is a way of orienting the Western viewer, providing the information he expects, but denying the Japanese viewer the details he has learned to wait for after immersion in Ozu's films. But the Japanese viewer learns or experiences other things, if not yet the exact social or spatial relationships. As Nornes points out, the women speak "women's language, sister to sister, woman to woman, female character to female spectator in direct address, excluding the male spectator from the proceedings . . ."[4] Teinosuke, we soon learn, has also been excluded from the series of close-ups as he has been excluded from the conversation. The Japanese viewer will have noted the Kansai dialect in which the characters speak, therefore not needing the English-language title establishing the locale as Kyoto. Most doubts about the film's setting, were there any, have been dispelled by this strong emphasis on the dialect. The Kansai is, of course, the repository of Japan's traditional culture—the ancient capital at Nara, the Genji-era capital in Kyoto, and Osaka, long the heart of the country's mercantile culture.

By the end of this extraordinarily dense, rapidly paced sequence, it is probable that the major character relationships have been intuited. (The Japanese audience's likely familiarity with the novel's story would no doubt help.) But the spatial

relationship remains unclear until two shots follow the series of close-ups. The first, an over-the-shoulder shot, reveals that Yukiko sits opposite of Teinosuke; the second, a long shot, finds Koi-san sitting next to Yukiko with Sachiko opposite her, beside Teinosuke. Not surprisingly, they all sit in an elegant room, replete with *tatami* and *shoji*, further establishing the sense of Japanese tradition and the elegance of the world of the Makiokas. The colourful kimonos the sisters wear (different colours for each, helping define them for the audience, and because Toho Studios had involved a kimono company in the film's production) further intensifies this aestheticization. From the long shot that has established the precise spatial relationships among the characters, Ichikawa cuts to a close-up of Koi-san, which lasts only a few seconds. Then, he cuts to a medium long shot along the same axis as the previous long shot—from the left of and behind Yukiko in the first, to the right and behind her in the next. These two long shots reveal a different Japanese aesthetic strategy, the long take. The first shot is held for twenty-six seconds; the second a much longer forty-two seconds. Not surprisingly, it is within these two long takes that Ichikawa reflexively comments on Japanese tradition, first by having Teinosuke lecture the sisters on the proper, that is, Japanese, way of eating, in the manner of geisha, for instance, and then by introducing the question of Yukiko's marriage, to be handled in the traditional way by *omiai*. Her marriage is the major issue that drives the plot, and the series of *omiai* leading up to her eventual choice is the major structuring device of the narrative. The idea of arranged marriage—the go-between, the investigations of the prospective partners, the *omiai*—is also perhaps the single strongest invocation of Ozu, whose major films revolve around the vexing issue of marrying off a daughter none too anxious to leave her familial bonds. That this issue is brought up precisely during a cinematic moment which itself invokes Japanese tradition is surely no accident; the connection to Ozu is made even stronger by the handling of the appearance of oldest sister Tsuruko and the surprising spatial revelation it also entails.

Tsuruko's appearance at the gathering has certainly been anticipated, so that when an offscreen voice calls out to the sisters and Teinosuke it is perhaps no surprise. What is a surprise is Ichikawa's choice of camera angle, for it now reveals a previously unseen space. Essentially, Ichikawa cuts 90-degrees from the long shot behind Koi-san and Yukiko. After a couple of quick cuts, including one focusing on Tsuruko's elegant kimono and the sound it makes when she sheds her coat, he then allows her to walk into the room, where she sits next to her youngest sisters, thus aligning herself with them, a spatialization which will come into play a few moments later when she and Sachiko begin to argue. However, Ichikawa has yet another spatial surprise for us. When Tsuruko enters the main room and sits, Ichikawa delivers it in long shot, held for a lengthy thirty-eight seconds. The shot finds Tsuruko, Yukiko, and Taeko sitting screen right, foreground to background; Sachiko and Teinosuke sit screen left. The sisters converse in this long take until

Ichikawa cuts in a close-up of Sachiko. When he returns to a long shot (which would typically be from the same angle as the former one, were master shots used as a shooting procedure), we note that a visually disturbing change of angle has occurred. The protagonists have reversed screen direction—Taeko, Yukiko, and Tsuruko are now screen left, foreground to background, and Teinosuke and Sachiko are screen right and similarly flip-flopped front to back. Instead of using a master shot, then, Ichikawa cuts across the 180-degree line, placing his camera directly opposite of the previous long shot, which is also to say, 90-degrees from behind Sachiko's and Teinosuke's position, a space he never used before either. We now understand that Ichikawa invokes Ozu with his use of 360-degree space; all points of a location available for the camera's perspective. Ozu often "breaks" the 180-degree rule across a single cut; Ichikawa has employed a cut-away to Sachiko, using this delay to hide or disguise his spatial transgression. Nevertheless, such an obvious spatial "error" indicates Ichikawa's willingness to recall Ozu's cinematic aesthetics as part of his overall program to pay homage to Japanese tradition.

If I have spent a long time dissecting this opening scene, it is only to insist upon Ichikawa's deep foregrounding of classical Japanese cinema as part and parcel of the film's more overt tribute to Japanese aesthetics. In fact, it is only on a few occasions that Ichikawa is quite so transgressive of cinematic space. He returns to 360-degree space, for instance, in the confrontation scene between Sachiko and Okubuta in her home. Okubuta (also known as Kei-bon) has come to discuss his relationship and possible future with Koi-san. The scene begins with his voice-over (an interesting transition from a flashback, as will be discussed below) and he is seated in the Western-style room of Sachiko's house. They sit opposite each other, he screen left and she on the right side of the frame. A medium close-up of Sachiko interrupts this long shot for a few moments, and when Ichikawa cuts back to a long shot, Kei-bon and Sachiko have reversed screen direction—she is screen left and Kei-bon occupies screen right. A series of shot/reverse shots follows (the typical way of handling conversations in film), but when Ichikawa again goes to a long shot, Kei-bon is again screen left and Sachiko is screen right, just as the scene began.

This neatly dissects the space—showing where the door is, for instance, and how the furniture is arranged—but otherwise there is no reason to have these two flip-flops of screen direction. It is especially interesting to handle space in this manner in a Western-style room. For what makes Ozu's use of space so striking is that he adopts, so to speak, the particularities of traditional Japanese architecture in which space is modular. Opening and closing *shoji*, for instance, contract or expand room size; lowered entryways often ring a household, probably a remnant of the need to elevate living space in case of flooding, providing numerous points of entrance along the exterior. Ozu plays with the possibilities of changes in screen direction and exits and entrances, mirroring the possibilities of reconfiguring interior space. Ichikawa has utilized 360-degree space in a Western-style room, an homage to

The Makioka Sisters

Ozu despite changing times. It is also the case that this particular space, this room, is crucial to the film. In addition to the scene where Kei-bon's proposal comes at an inopportune time, many other scenes of intense drama or important plot points will take place here—such as Sachiko confronting Teinosuke about kissing Yukiko or the possible meeting with Higashidani, arranged by Mrs. Itani. Thus Ichikawa has embedded the space in our minds by dissecting it in this manner.

More interesting than his use of 360-degree space in the film is Ichikawa's manipulation of narrative time, particularly his use of narrative ellipsis and flashbacks. The flashbacks are both more interesting than one might first think, but less interesting than the use of ellipsis, from which the film draws most of its aesthetic appeal and emotional effectiveness.

Ichikawa's use of the flashback is quite deceptive. On the one hand, he relies on it to fill in narrative information that it is hinted at throughout the discourse, but which is postponed until it is provided by the flashback. This is a common strategy in film. We know something has occurred in the past and await its full revelation. Thus in *The Makioka Sisters* we are given some clear hints, aural and visual, about a scandal involving Koi-san and Kei-bon and that somehow implicated Yukiko as well. Ichikawa teases us at first with short scenes that don't necessarily make much sense until the full disclosure puts them into context. But they are clearly marked as flashbacks by black-and-white cinematography, so whet our appetite without particularly troubling our sense of narrative time or comprehension. Eventually, after a few, quite brief black-and-white segments, Ichikawa delivers the entire backstory about Koi-san's aborted elopement with Okubuta, the newspapers' incorrectly naming Yukiko as his partner and Tatsuo's disastrous attempt at obtaining a retraction. The least interesting of the flashbacks, its purpose is clearly indicated by the use of black and white and then, as the scene proceeds, colour bleeds in, after which, for the next nine minutes or so, the sequence essentially tells us what we already know. Perhaps the only important revelation to be found in this sequence is that Yukiko is extremely aggressive and opinionated, which perhaps allows her character a bit more depth in the present-day sections where we may now take her passivity as disguised aggressiveness.

On the other hand, Ichikawa utilizes flashbacks in a more interesting way, as deceptive scene changes and to recover elided information from the more pressing events of the present. A few instances are most notable. The first flashback comes when Tatsuo mentions a proposal to Tsuruko that his boss has brought forward. As Tsuruko worries about this, there is a very brief black-and-white insert of Koi-san and Kei-bon being apprehended by the police. We thus think this is the source of her concern, which it is. But we hear Kei-bon's voice-over in the present playing over this scene, before the film cuts to Kei-bon talking to Sachiko in the sequence described above. There is a brief flashback again after Kei-bon leaves, before a cut to the present, in colour, as Teinosuke appears to kiss Yukiko. The point of note

here is that Ichikawa never returns to Tsuruko and Tatsuo's discussion which motivated the flashback in the first place and, thus, over the flashback, the scene in the present has changed.

Another significant flashback lasts only for a moment, but it prepares us for the more lengthy and perhaps most interesting use of the technique in the film. Here, Ichikawa cuts not to the incident involving Koi-san and Kei-bon of five years earlier, but to a flashback that was essentially elided action in the film's present. Lasting only a moment, it occurs when Mrs. Itani brings up the potential *omiai* with Mr. Higashidani. She and Sachiko lament the failure of the budding relationship between Yukiko and Mr. Hashidera, a failure that occurred because of Yukiko's dislike of speaking on the phone. In this conversation between the older women, there is a brief insert of Yukiko holding the telephone at arm's length, a look of terror on her face. It is just a fleeting moment, but it reminds us of Yukiko's telling Sachiko earlier of Hashidera's phone call proposing a date that very day. This we did not see or hear, and the flashback lends perhaps more poignancy to yet another of Yukiko's failed relationships. More importantly, though, this flashback to an elided moment in the present perhaps prepares us for the flashback of Teinosuke's visit to Miyoshi, the bartender with whom Koi-san now lives.

Following the successful (or so we take it) *omiai* between Higashidani and Yukiko, Koi–san moves out. Sachiko persuades Teinosuke to check on her and bring her back home. We fully expect, therefore, to see Teinosuke do so; but we do not. Instead, some days pass (offscreen) and we next see Teinosuke at Tsuruko's home. We then learn that Teinosuke did indeed check on Koi-san. A visual flashback shows Teinosuke in the bar as his voice-over in the present recounts what happened. Moreover, Teinosuke then relates that Sachiko went to see Koi-san the next day—an incident not at all mentioned previously, and thus a surprise. It is then disclosed in a flashback, but not with voice-over, as Teinosuke's was; rather, Ichikawa allows the scene to play out as the two sisters have a heartfelt and very moving talk. Perhaps because it is shown in flashback, it takes on even more poignancy, for we know that Sachiko has come to see Koi-san's position and has resigned herself to it already.

These two flashbacks have indicated the use of ellipsis, though Ichikawa has chosen to elide these actions only momentarily and deliver them to us in flashback. But he uses ellipsis even more extensively, eliding important, indeed dramatic, action, and only relating it to us after the fact. The use of ellipsis not only brings with it the principle of retrospectivity, so crucial to elliptical narration, but it also postpones information that is especially dramatic or significant. The drama is not in the actions, but in their results. And it is in this use of ellipsis that Ichikawa most recalls Ozu.

Given the centrality of the issue of a daughter's marriage in so many of Ozu's mature films, it is not surprising that Ichikawa, in this aesthetic homage to Ozu,

uses the *omiai* as the structuring principle of the narrative, nor that most of the elisions cohere around the series of *omiai*. Ichikawa elides the results of the *omiai*—the inevitable rejection of the suitor—as well as much of the passage of time between *omiai*, always introducing long shots loaded with seasonal markers as the next *omiai* begins. This serves not only to record a certain period of time between these *omiai*, but also helps continue the association of the Makiokas, particularly Yukiko, with traditional Japanese aesthetics. The Makiokas' aesthetic sensibilities literally mark the seasons as they themselves comment upon them. Unlike Ozu, Ichikawa uses the *omiai* to emphasize both this aesthetic sensibility and Yukiko's quiet strength and fortitude. Ozu was known to omit the *omiai* which would be the first step in taking the daughter away from the family; omit, too, the wedding—the long-hoped for moment to which the narrative seemed to be heading; as well as the farewell and departure. Ozu's interest was not in the daughter's choice of marriage partner, but rather the effects upon the father (usually) when the daughter leaves, as she inevitably must. Ichikawa captures something of that flavour, too, that sense of loss, as we will see, but his handling of the *omiai* deserves our attention since the film, far from deleting the *omiai* as does Ozu, revels in them, while eliding or postponing their results.

The Makioka Sisters plays with Ozu's notorious eliding of *omiai* in the very first scene, when we learn that Tsuruko has cancelled a planned meeting. The first *omiai* mentioned never takes place, but it does return, in a way, much later in the film, when the go-between who arranged that first meeting apologizes for its necessary cancellation and promises to find a better suitor, which she eventually does. Thus an action only mentioned at the film's start and which never occurred, turns out to have significance. Aside from this first *omiai*-that-never-happens, there are four which do. In each instance, there is a certain aestheticization, whether of the season, the locale, or the participants themselves. And in each instance the results of the *omiai* are deferred, dramatic moments left hanging, and then usually provided second-hand.

The initial *omiai* is encouraged by Tatsuo, whose boss has arranged it. It eventually takes place in a Western-style private room in a restaurant, the group arranged at a table. It's very pretty and elegant, and that is all we see of it. There follows a direct cut and Tatsuo angrily complains that Yukiko waited a week and then refused the proposal. This is perhaps the most extreme example of simple elision, because we saw almost nothing of the *omiai* itself and nothing of Yukiko afterward. We are surprised at the amount of time that has passed since the *omiai* and that Yukiko has already turned down the proposal.

A shop-owner friend of Sachiko's has arranged the second *omiai*. We learn of it via a conversation between Koi-san and Itakura, who themselves talk of getting married. (It is an interesting structural feature of the film, by the way, that Koi-san's relationships are clustered around Yukiko's *omiai*.) It is summertime, at this point,

suggested first by the clear, bright blue sky which opens this scene, and certified by the hot train ride undertaken by Sachiko, Teinosuke, and Yukiko on their way to the meeting which takes place in Kobe. Thus we now see, too, that not only are seasonal markers important to this film, but so is place, whether it is a certain geographical region (Kyoto, Osaka, Kobe, Minoo, Saga) or the film's insistence on naming specific restaurants. In any case, this *omiai* is a disaster. Even before the hopeless bureaucrat–bachelor takes out his diplomas and certificates, we know the match is doomed when he says he doesn't like the theatre. A fade-out closes the *omiai* and a fade-in on a new scene finds Koi-san telling Itakura of Yukiko's refusal. Again, it isn't Yukiko herself whom we see, whom we experience, giving us this information, this drama; it is presented second-hand. In this case, it is entirely appropriate that Koi-san gives us the news, since it is she who informed us of the *omiai* in the first place.

The third *omiai* seems the most promising, once it is underway. It is claimed that this meeting with Mr. Hashidera, a widower with a teenage daughter, isn't truly an *omiai*, since the man is not anxious to remarry. Nevertheless, it is certainly treated as one by the Makiokas, who are resplendent in their fall maple-viewing outfits. Mr. Hashidera is quite handsome and charming, unlike the previous suitor, and Yukiko claims to like his daughter, who is rather quiet and shy, much like Yukiko herself seems. Given the appropriateness of this suitor, we feel a sense of urgency following the fading out of this scene. And it isn't until fully two minutes into the next scene that we learn how and why this relationship, too, is doomed.

The fourth time is the charm, as Mrs. Itani arranges a meeting with Mr. Higashidani, who is a son in a royal family. This meeting takes place in Saga, in full winter splendour, matched by the elegance of the family estate. The *omiai* takes place in a *tatami* room, replete with *tokonoma* and understated antique pottery. We see the suitability of this man immediately; no words are spoken, but the camera lovingly tracks the room and its occupants while the music from the opening cherry blossom sequence returns. Clearly, Yukiko is enchanted and we wonder what, if anything, can go wrong. As we learn later, discovering it, finally, from Yukiko herself, nothing does go wrong. We are nevertheless surprised to find out that Yukiko has seen Higashidani twice since the *omiai*, that they have discussed Koi-san's living arrangements with Miyoshi, that all is well on every account; surprised because even at this successful *omiai*, the solution to a long-lasting problem, we are denied the drama of Yukiko's acceptance, the drama and romance of a budding relationship. It is presented to us retrospectively, a *fait accompli* which took place offscreen.

Ichikawa does give us an emotional parting scene, but not the one perhaps, again, we might have expected. Instead of Yukiko's wedding and departure from Sachiko's home, we see the tearful goodbye to Tsuruko and her family as they leave for Tokyo. Yukiko, Teinosuke, and Higashidani are present and amidst a light,

falling snow the train pulls out. Ichikawa closes the film in a circular fashion—the snow recalls the falling cherry blossoms of the opening scene; Teinosuke sits in an elegant *tatami* room, as at the beginning, drinking sake, except now he is alone, the absence of the four sisters notable for all the changes that have occurred—Tsuruko's departure, Yukiko's imminent marriage, Koi-san's relationship with Miyoshi. Instead, however, of leaving us with the sight of this now-lonely man (as Ozu does at the end of *An Autumn Afternoon*) or cutting to a landscape shot void of human characters (Ozu's most typical ending in his later films), Ichikawa actually gives us a final flashback. We return to the film's opening scene of the sisters strolling through the lightly falling cherry blossoms with Yukiko, whose name refers to the *sasameyuki* of the Japanese title, the last sister we see.

Notes

1. Kristin Thompson and David Bordwell, "Space and Narrative in the Films of Ozu," *Screen* 17, no. 2 (summer 1976): 41–73.
2. Markus Nornes, "Context and *The Makioka Sisters*," *East-West Film Journal* 5, no. 2 (July 1991): 54.
3. Ibid., 64.
4. Ibid., 52.

Kon Ichikawa on the set of *Dora-Heita*

AARON GEROW

The Industrial Ichikawa: Kon Ichikawa after 1976

1

AT THE AGE of eighty-six, Kon Ichikawa is still making feature films. Kaneto Shindo at eighty-eight may surpass him as the oldest Japanese director active today, but while Shindo steadily reels out medium-scale films at his independent production company, Kindai Eiga Kyokai (Kindai Motion Picture Association), Ichikawa in the year 2000 is still helming large-budget, studio extravaganzas like *Dora-Heita*. In his collection of interviews with Ichikawa, Yuki Mori groups their talks about the post-1976 films under the title "At the Frontline of Japanese Film," which certainly refers not simply to Ichikawa's continued artistic originality, but to his persistent presence behind the camera of some of the industry's principal productions. This attests to his repeated commercial success: a number of his post-1976 works have finished in the top ten in the yearly box-office charts. Yet it also testifies to the fact that Ichikawa fits the industry well. While a director a year junior like Masaki Kobayashi could not make a film in the last eleven years of his life, and younger veterans like Yoshishige Yoshida can't find work today, the ever-productive Ichikawa actually managed to release two features in 2000. Apparently he is more accommodating to the way studios work than these more obstinate filmmakers. My intent, however, is not to criticize him on this point, but rather to use this as a stepping stone to a larger argument: that the Ichikawa who conforms so well to the film companies can tell us a lot about the contemporary industry, and, vice versa, that the structure of the movie business in Japan can give us clues as to the source of Ichikawa's recent success.

From early in his career, Ichikawa was rarely the rebel in what is a company business. Opposing the leftist leaders of the Toho strike, he took part in the formation

of Shintoho and got his first chance to direct there. Later on, he switched to Toho, Nikkatsu, and then Daiei at the request of friendly producers or in order to obtain better filming conditions, but never out of protest or a desire to go independent. Ichikawa did act as producer for a number of his own films, but his own company, "Kon Productions," was created only in order to make *The Wanderers*, not necessarily to pursue his own cinematic vision. For much of his later years, he has maintained a comfortable relationship with Toho, the studio that raised him, directing many of their spotlighted, commemorative works. Ichikawa's famous willingness to experiment or explore new horizons has then rarely been in conflict with commercial interests. In fact, the same eagerness brought him into early contact with television, directing dramas as early as 1959 and filming dozens of TV commercials. His *Kogarashi Monjiro*, a period TV drama from 1972–73, while undertaken in part to fund *The Wanderers*, actually became such a phenomenon it later sparked a sequel and bolstered the political career of its star, Atsuo Nakamura.

2

Especially after 1976, Ichikawa's name becomes frequently associated with films that symbolize important aspects of the movie industry. For instance, I would dare say that Ichikawa's *The Inugami Family*—not the more critically successful *The Makioka Sisters*—may be one of the most important works of the post-1970 era in Japanese film. This is not because of the film itself, although the star-studded cast and mystery narrative (based on a Seishi Yokomizo novel), combined with Ichikawa's tense but humorous, stylized but cool direction, certainly make it an enjoyable movie to watch. *The Inugami Family* is a significant milepost because it helped change the way films were marketed, distributed, and exhibited in Japan. To begin with, it was the first film produced by the Kadokawa Haruki Office (a subsidiary of the Kadokawa Publishing Company), founded by the young maverick Haruki Kadokawa after he inherited the book business from his father. The film's surprising success—1.56 billion yen in rentals, second best for the year—helped make Kadokawa a major player in the industry, as his company eventually made over sixty films until 1993, when Kadokawa's arrest for cocaine possession prompted his downfall. When most of the major studios—Toho, Toei, and Shochiku—were severely cutting down on in-house production, Kadokawa's productivity was a boost to the Japanese industry and his pursuit of sensational topics and Hollywood-style spectacle entertainment, as well as a commitment to supporting new talent (from the actress Hiroko Yakushimaru to directors like Shinji Somai, Yoshimitsu Morita, Kazuyuki Izutsu, and Yoichi Sai), helped infuse new life into a declin-

ing business. Haruki Kadokawa's own position as an interloper symbolized this new blood, but it also marked his challenge to existing commercial customs. The spirit expressed in his famous quote, "I love Japanese film; I hate the Japanese film world," found itself manifested in such actions as the lawsuit against veteran *Inugami* producer Kiichi Ichikawa and others for falsifying receipts on that film, an apparently not-uncommon practice in an industry infamous for its unmodern business practices. His desire to do it his own way actually produced *The Inugami Family*, after discussions went sour with Shochiku over producing *The 8-Tomb Village*—also based on a Yokomizo mystery and eventually made by Yoshitaro Nomura in 1977—because the studio wouldn't let him participate in production and release it according to his schedule.[1]

Kadokawa's influence, begun with *The Inugami Family*, also had more specific structural dimensions. First, *The Inugami Family* became the primary impetus behind the industry-wide shift away from program picture double-features towards single-feature *taisaku* (literally "big picture" blockbuster) releases. Although the Japanese film world had been suffering a decline from the early 1960s, a vertically integrated system of production/distribution/exhibition designed to feed theatre chains founded on block-booking contracts made it necessary for studios to produce large numbers of films to keep up the supply to theatres, especially in a releasing system that still changed product regularly. This over-production, begun in the mid-1950s with the revival of the double-feature, worsened, if not accelerated the industry's decline by straining studio resources and mass-producing cheap product that could not compete with Hollywood films which were not equally restricted and, after the easing of import restrictions in the early 1960s, which were more readily available in Japan. When major studios could not produce the necessary films for their chains, they either went bankrupt, as Daiei did in 1971, underwent restructuring, as Nikkatsu did the same year, or began to use independent production companies as essentially sub-contractors. Still, rentals for foreign films topped those for Japanese works for the first time in 1975, but *taisaku* movies like *Inugami* helped reverse that trend for several years in the late 1970s. That and subsequent Kadokawa features like *Proof of the Man* (*Ningen no shomei*, 1977), *Proof of Savagery* (*Yasei no shomei*, 1978), and *Day of Resurrection* (*Fukkatsu no hi*, 1980) caught the public's eye with their extravagant budgets, foreign locations, and phenomenal marketing, and *taisaku* soon took centre stage in the Japanese releasing line up.

It is important to note here that most of Ichikawa's films after *The Inugami Family* fall under the rubric of *taisaku*, because of their budgets, casts, or labelling as commemorative works. He made four more films based on Yokomizo novels at Toho (the Kadokawa Office continued to get prominent credit for "planning" [*kikaku*]), all starring Koji Ishizaka as the detective Kosuke Kindaichi, and all

featuring star-studded casts. *The Phoenix* was a much expected epic co-production with Osamu Tezuka, Japan's most famous *manga* artist, and *Ancient City* was the "retirement" film of Momoe Yamaguchi, the most popular "idol" singer of the 1970s, whose films with Miura Tomokazu (whom she was retiring to marry) were consistently successful. *The Makioka Sisters* was Toho's "50th Anniversary Film" and *Princess from the Moon* its 55th. *Tsuru* was specially made as the 100th film of Sayuri Yoshinaga, one of Japan's most beloved actresses since the 1960s, and even *47 Ronin* was Toho's "Centennial of Cinema" film. Perhaps only *Lonely Heart*, which was released in a double bill with *The Bell of Amore* (*Amore no kane*, Kunihiko Watanabe), and *Shinsengumi* can be considered Ichikawa's "smaller" films of the period.

Rarely did Ichikawa work with new or unknown actors, and thus his films were sold in part through their casts, which featured both veteran and contemporary stars such as Mieko Takamine, Keiko Kishi, Tomisaburo Wakayama, Reiko Ohara, Tatsuya Nakadai, Junko Sakurada, Yoshiko Sakuma, Ruriko Asaoka, Kiichi Nakai, Bunta Sugawara, Kirin Kiki, and Ken Takakura. The use of literary personalities like Chiyo Uno, Seishi Yokomizo, Yasunari Kawabata, and Yukio Mishima for the original stories helped these works as well, but it is worth noting that the name "Kon Ichikawa," usually preceded with titles like "great master" (*kyosho*) and "master craftsman" (*meisho*), was also featured prominently in advertisements. Ichikawa's television work helped maintain his name recognition even among younger audiences, but tactics like the stunning use of large, bold-faced Mincho fonts during a film's beginning credits (found in many of his works from *The Inugami Family* to *Dora-Heita*) and the consistent casting of familiar faces like Ishizaka have helped give his works a recognizable "Ichikawa brand" quality. This known quality was in part what producers of *taisaku* were buying when they hired Ichikawa. One of the problems with the *taisaku* policy was that it greatly favoured established, name-value veterans over new directorial talent, and this was one condition that helped keep Ichikawa busy after the 1970s.[2]

Ichikawa thus helped define the *taisaku* direction of the post-1970s industry, and that policy had profound effects on the film business. Big-budget films could not be expected to break even unless their run was extended, especially in the large urban theatres, given that many of the rural houses had disappeared during the 1960s and 1970s. That naturally upset the distribution system of first-, second-, third-, fourth-run (and so on) theatres, where films regularly moved down the line over a period of months. So on the one hand, *taisaku* further pushed out smaller rural theatres, which had a harder time obtaining films,[3] and on the other, it created a broader release system, with pictures opening all at once at over a hundred theatres for extended runs. By around 1980, the release line-up for the majors became centred on such single-feature *taisaku* and the limited number of series like Tora-

san that had proved to be consistent money-makers; what to do for the periods between such pictures remained a continual problem for distributors, especially since they were obligated to fill in such spots for their chain theatres.

The more pressing issue, however, was how to equal the *taisaku* Kadokawa was putting out. They had proven to be an effective measure against the Hollywood onslaught, but larger budgets also meant greater risk and the potential for drastic losses, especially after the public became more used to this new strategy and ceased to turn up for just any extravaganza. Already financially pressed, the majors needed some way to ease the load and spread the risk, and this prompted the increased reliance on independent producers and non-film industry capital. Kadokawa was the primary example of a well-financed independent producer from outside the movie industry making films and having them released through the majors' theatre chains, but entering the 1980s, one saw companies from a variety of areas, from construction to advertising, from toys to broadcasting, increasingly entering the film world. Ichikawa's *Rokumeikan*, for instance, was the third—and last—film produced by Marugen Buildings, a real-estate developer. With other companies taking up the burden, the established motion picture companies Toho, Toei, and Shochiku further decreased in-house production down to a handful of films each per year, and relied on co-productions or external productions for the bulk of their yearly line-ups. All three—especially Toho—essentially became distribution/exhibition companies instead of film producers. This not only put the nail in the coffin in the program picture system and the era of the studio, it revived a tendency from before the 1950s in which the interests of exhibitors dominated over those of producers. Kadokawa may have represented a new kind of maverick producer divorced of such exhibition interests, but his inability in the mid-1980s to start his own alternative distribution/exhibition system showed how the practical monopolization of exhibition by the three majors still held sway over the industry.

Almost all of Ichikawa's films after *The Inugami Family* were distributed by Toho, but few were really in-house productions. *Ancient City* was produced by Momoe Yamaguchi's talent agency Hori Productions, and *Lonely Heart* was made with For Life (a record company). *Harp of Burma* was co-produced with Fuji Television, Hakuhodo (an ad agency), and Kinema Tokyo; *Princess from the Moon* with Fuji; *47 Ronin* with Nihon Television and Suntory (a liquor company); and Ichikawa's 1996 version of *The 8-Tomb Village* was produced with Fuji and Kadokawa (now under the control of Haruki's brother). *Noh Mask Murders*, Ichikawa's second Kadokawa film, this time released by Toei, is a perfect example of this proliferation of investors: its "production committee" featured the participation of Nihon TV, Yomiuri TV, Kinki Railroads, Kinki Department Stores, Nara Kotsu (a transport company), Dentsu (an ad agency), IMAGICA (a film developer), Sagawa Kyubin (a delivery company), Bandai (the toy producer), Nihon Satellite,

Pioneer LDC, Chukyo TV, Miyagi TV, Kumamoto Kenmin TV, Hokutojuku, not to mention Kadokawa.

There were several reasons non-film companies would invest in what was supposed to be a declining industry. One was company prestige, another was tax benefits (money invested in film enjoyed faster depreciation rates, a loop-hole that provided a good haven for companies loaded with excess profits during the bubble economy). But the primary reason was to tie one's own products with the film. This was Haruki Kadokawa's main impetus for entering the film business. Before he became president of Kadokawa Publishing, he deftly used a tie-up with the release of Arthur Hiller's *Love Story* (1970) to sell the Japanese translation of the Erich Segal novel and an album of Francis Lai's music. His success in that experiment prompted his desire to make a film based on a Yokomizo novel (most of which were published by Kadokawa), but Shochiku would not release *The 8-Tomb Village* at the time he wanted to drum up a large-scale "Yokomizo Fair" in bookstores, so he went his own way with *The Inugami Family*. The combination of selling the film, the books, and the music, while not unprecedented, was more aggressive than ever before and extremely successful. Product placements and tie-ins had existed from before the war, and there were prior cases of non-film companies investing in the major movies. But while earlier cinema had tended to tie into the success of a novel or record after they were hits, Kadokawa used all forms of media to sell everything simultaneously. It was this "mixed-media" blitz that stunned the industry with its novelty.

Ichikawa's "Kindaichi" films thus found themselves advertised not only in bookstores and publications and on book covers, but even on lipstick (the advertising catch-phrase for *Queen Bee* was "A Mystery in Lipstick," an expression that, while certainly based in the plot, was not unrelated to the fact Kanebo Cosmetics had a tie-in with the production). The later films co-produced with television networks like Fuji enjoyed great media exposure, which especially helped with a film like *Harp of Burma*. Ichikawa's remake of his 1956 film was strongly pushed by Fuji TV, the most successful of the networks investing in the movies, particularly after it had in 1983 created the biggest box-office hit in Japanese film history up to that point, *Antarctica* (*Nankyoku monogatari*, Koreyoshi Kurahara). With Fuji's help, *Harp of Burma* for a time rose to number five on the all-time box-office list with rentals of 2.95 billion yen. Such media strategies did seem to have an effect: for instance, *The Inugami Family*, *The Devil's Bouncing Ball Song*, and *The Makioka Sisters* with the help of their ad campaigns all proved wrong the pessimistic box-office predictions in the press.[4]

3

Tie-ins and co-productions, however, did not completely eliminate the risk involved in high-budget *taisaku*, especially when a figure like Kadokawa was spending as much as 5 billion yen on *Heaven and Earth* (*Ten to chi to*, 1990, directed by Kadokawa himself). A more guaranteed return was necessary and this is where *maeuri*, or advance tickets entered the picture.[5] Discount advance tickets had had a long history and certainly were a beneficial option for many moviegoers facing an industry that continually compensated for the loss in revenue from declining attendance by raising ticket prices. But producers and distributors soon caught onto the idea that pushing advance ticket sales could be a means of ensuring earnings. In an early example, Kashima Construction helped finance *Skyscraper Dawn* (*Chokoso no akebono*, Hideo Sekigawa) in 1969, and pushed *maeuri* tickets on business partners and anyone else visiting company offices to recoup its investment. Kadokawa made an art out of selling advanced tickets. For *The Inugami Family*, Kadokawa was contractually obligated to the distributor Toho to sell 50,000 *maeuri* tickets, but boasted he had actually sold 60,000.[6] This figure escalated to nearly 4,800,000 tickets for *Heaven and Earth*.[7] What made Kadokawa infamous was reports that these sales were not simply based on effective media marketing and the box-office value of the film, but also on practices that touched on fair trade laws. Not only were business partners practically obligated to buy loads of tickets, but as one Kadokawa Publishing employee told a journalist, workers were simply given books of tickets and the cost deducted from their pay—all without their consent.[8] Into the 1980s, whether as legally questionable or not, *maeuri* driven movies became the focal point of the entire industry, with Ichikawa's *Harp of Burma* and *Princess from the Moon* being two prominent examples.

Let's take a look at *Princess from the Moon*, released on September 26, 1987, which sported one of the most aggressive sales strategies of the decade. The film was made by Toho and Fuji TV for 1.2 billion yen, but given publicity and other costs, the picture might have cost upwards of 2 billion yen. To recoup this, the sales campaign began by holding major previews inside and outside Japan starting on September 2 (including, eyeing the foreign market, New York, with prominent American politicians and financial and cultural figures in attendance). The film would also open the Second Tokyo International Film Festival, earning the attendant attention. Fuji TV would then begin its massive broadcasting campaign, just like the one that proved so successful in the case of *Antarctica* and *Harp of Burma*. At the same time, Kanebo, a sponsor of the film, would launch its "Princess Kaguya" line of cosmetics, advertised in television commercials aired from August 21 to mid-October and featured in magazines, newspapers, and subway ads. To sell advance tickets, Nihon Life Insurance, another co-sponsor, would

use its 80,000-person nationwide sales force to distribute tickets as "presents" to customers (probably in exchange for buying policies) and Fuji TV would push 50,000 special *maeuri* tickets that could be used for admission to *Princess* and two other Fuji-sponsored films: *Hawaiian Dream* (*Hawaian dorimu*, Toru Kawashima) and the double feature of *Take Me Skiing* (*Watashi o suki ni tsuretette*, Yasuo Baba) and *Eternal ½* (*Eien no ½*, Kichitaro Negishi). In total, Toho had printed four million advance tickets in the hope that 1.5 million would be sold. With an active effort to bring school groups to the theatres, 700,000 tickets were already reported sold by early August.[9] In the theatres, *Princess from the Moon* was not the hit *Harp of Burma* was. Total rentals were reported at 1.5 billion, second best for the year, but certainly less than the projected 2 billion yen in costs. However, given that *maeuri* campaigns also functioned as initial advertisement for video rentals, it is likely the film broke even in the end.

From a broad perspective, there were certainly many benefits to the *maeuri* system, beyond those to viewers who could see the films they wanted to see for less money. The sales campaigns themselves helped advertise the films and made Japanese cinema a more attractive event to choosy consumers. By guaranteeing returns, the system attracted more investment in a risky business and helped Japanese cinema produce the *taisaku* that could compete with Hollywood at home. Since the tickets ensured revenue not only for the distributor, but also for exhibitors, they helped maintain income and keep in business many of the theatres providing a showcase for Japanese films.[10] The guarantees also helped distributors convince foreign-film-speciality theatres (which are run on a free booking system) to show Japanese films in a broad release. Many theatres, in fact, still demand a guaranteed *maeuri* sales figure before agreeing to show a film. Investors in the project could get their money back faster, and even companies pushed to buy advance tickets could at least deduct the costs as business expenses. In the end, one could argue that the tickets are one of the main reasons the block-booking system for Japanese movies has not disintegrated and that the majors are still making and distributing Japanese films. To many, however, the detriments of *maeuri* tickets outweigh the benefits. Essentially, if a film's return is largely guaranteed before it is even released, with many of the tickets not being sold on the basis of the entertainment potential of the product itself, then it basically makes no difference whether the movie is good or not. This leads to inertia on the level not only of production, but even of the theatres, who with a guaranteed audience, need not think of new ways to attract customers or to improve viewing conditions. One can thus argue that the *maeuri* system is one of the central reasons in the decline in the quality of both film content and exhibition services.[11] Producers and investors, becoming accustomed to "sure" projects, increasingly shy away from using new talent or novel stories, and rely on established directors like Ichikawa and known narratives like *Harp of Burma* and *Princess from the Moon* to attract potential investors—who tend not to

have film experience. The majors stop working on smaller projects, investing in new equipment, or engaging in talent development, and the distribution system begins to lean towards wide releases, leaving little room for the narrower releases necessary for smaller films.[12] There are certainly cases of *maeuri* films that attracted audiences in droves, and Kadokawa in particular can be credited with maintaining a commitment to spectacle entertainment, but viewers did not remain ignorant of the hollowness of many of the blockbuster films. Advance tickets were sold, but many were not used, and in some horrible cases like *Fukuzawa Yukichi* (1991, dir. Shinichiro Sawai), less than half of those tickets actually turned up at the cinema. Thus one had the bizarre spectacle of theatres showing a film listed at the top of the box-office charts actually being largely empty.[13] The distributor not need care about the unused tickets since the money is already in hand and theatres are only paid their share on the basis of the tickets used (though the remaining portion is usually divided among the theatres, supposedly in part to support weaker cinemas in the chain[14]). Since Japanese houses, unlike their American counterparts, gain most of their revenue from the box office, not from concession sales, it doesn't really matter if there is an audience between the aisles or not. Seemingly, what was most important to the major players in the industry was not providing a good product or service to customers, but rather preserving their theatre chains. This was because, unlike the 1950s, when studios exercised almost autocratic power over exhibitors, theatres are now in the dominant position in the industry.[15] The Japanese industry is a film theatre industry, not a film industry,[16] and *maeuri* films came to the fore because they are good for exhibitors.

Advance tickets, however, can be detrimental to the public image of Japanese cinema. Not only are "top box-office films" shown at barren theatres, but unused *maeuri* tickets end up at discount ticket shops (which buy up and resell all sorts of tickets) selling for less than half their original price. This creates a definite embarrassment for the movie and its makers. One can thus argue that not only the lethargy encouraged in production by the *maeuri* system, but the results at the theatres and on the streets exacerbate the still persistent opinion among Japanese audiences that Japanese films are bad, only further scaring potential spectators away from the cinemas.

I certainly do not want to argue that Ichikawa's work after 1976 has in particular contributed to this disillusionment towards Japanese film among audiences. The success of many of his works in the yearly awards presentations testifies to their level of quality (though it is also undeniable that many of the domestic honours favour veterans and films distributed by the majors). Yet the relative lack of both commercial and critical success for his *taisaku* films after *Princess from the Moon* arguably testifies both to the fatigue of the system and to audience weariness. Perhaps as the *maeuri taisaku* system, which seemed to fit Ichikawa so well and which effectively matched the boom economy of the 1980s, declines in the years

after "the bubble," Ichikawa and the Japanese film industry are becoming less of a good match.

4

As one of most successful of directors after the 1970s, it is perhaps inevitable that Kon Ichikawa would have become associated with film projects that either furthered change or represented shifts in the way business was done in the movie world. Yet as I have argued, there were many structural factors which helped place Ichikawa at the centre of the Japanese film industry, primary of which is the tendency to favour saleable veteran directors when pushing *maeuri taisaku*. Ichikawa himself, being accommodating to projects offered by friendly producers, went along with these industrial trends. His personal tastes, for instance for detective fiction or animation, also helped him get work at a time when publishing houses were using film to sell mysteries and animation was topping the box-office charts (his role as supervisor for the hit *Galaxy Express 999* [*Ginga tetsudo 999*, 1979, dir. Rintaro] should not be forgotten). Further, his experience in television made him a good choice for networks increasingly entering film production (Fuji TV even brought him in to act as "cooperating director" on *The Adventures of Milo and Otis* [*Koneko monogatari*, 1986, dir. Masanori Hata], which went on to earn a phenomenal 5.4 billion yen in rentals). In some ways, Ichikawa was in the right place at the right time.

Yet as a way of concluding, one wonders whether there was not also something about his style and thematics which ensured his prominent place in the contemporary industry. This can involve the question of how well he corresponded to audience tastes or the mentality of the era, and one could argue his persistent irony and aversion to sentimental humanism matched a Japan increasingly disillusioned after the era of high economic growth and the failure of 1960s leftism. More importantly, his style also seemed to correspond to the industrial spirit of the time. Consider the statements of director Shunji Iwai, now famous for his films *Love Letter* (1995) and *Swallowtail Butterfly* (*Suwaroteiru*, 1996) popular with young Japanese. He recalls being captivated in middle school by the combination of an old style and a modern touch in *The Inugami Family*, and relates how Ichikawa afterward became his virtual textbook in film technique, especially editing.[17] This is understandable, given how Iwai's often narratively unmotivated use of editing flourishes recalls aspects of Ichikawa's editing style in *Inugami* and other films. The exploration of style for the sake of style, almost at the cost of content—a stylistic dandyism, a cool stylishness—was a tendency in Ichikawa's work from early on, but I would argue it becomes more of an industry norm from the 1980s, as evidenced by directors like Iwai, who see Ichikawa as a mentor more than they do Kurosawa or Oshima.

Nobuhiro Suwa (director of *M/Other*, 1999), in a discussion with Shinji Aoyama (director of *Helpless*, 1996 and *Eureka*, 2000), emphasizes how in the 1980s the central issue became not what to film but how to film it, as stylistic issues dominated at a time when most felt that all that could be shot had been shot.[18] As a result, cinema turned in on itself and there were many works, from Juzo Itami's *Tampopo* (1985) to Kaizo Hayashi's *To Sleep So as to Dream* (*Yume miru yo ni nemuritai*, 1986), that were films about film—just as were Ichikawa's *The Devil's Bouncing Ball Song* and *Actress*. It is tempting to analogically connect this kind of film to the industry that was behind it, for a cinema for the sake of cinema—as if viewing itself in a hall of mirrors—seems almost homologous to an industrial system in which a film's commercial value was a mere reflection of how many tickets its producers had forcibly sold. Just as many films ignored social or political issues for the pursuit of style, the movie market depended little on external factors like social fashions or audience pleasure, and was largely decided by how well corporate partners could manipulate the media and exert their influence to sell tickets. Whether in terms of its style or its box-office potential, a movie related to itself and nothing outside. One can certainly argue that Kon Ichikawa's cinema after 1976 possessed values beyond that, but it is undeniable that in many ways it fit well an industry that had so dangerously turned in on itself.

Notes

1. For accounts of Kadokawa's role in the industry, see Toshiyuki Matsushima, "Haruki Kadokawa no eiga shokku ryoho," in *Eiga 40-nen zenkiroku*, Kinema Junpo Zokan 929 (Kinema Junposha, 1986): 172–73; Hiroshi Okada, et al., "Kadokawa tataki, soshite yurimodoshi," *Eiga geijutsu* 370 (winter 1994): 5–26; Masaaki Nomura, "Eigakai o kasseikasaseta 'onikko' no jijitsu," *Kinema Junpo* 1117 (15 October 1993): 58–60; and Tatsuya Masuatari, "Kadokawa eiga ni ko wa attemo tsumi wa nai!" *Kinema Junpo* 1117 (15 October 1993): 61–63.
2. Ichikawa mentions that he had originally intended to leave *The House of Hanging* to a newer director, but Kadokawa objected. Kon Ichikawa and Yuki Mori, *Kon Ichikawa no eiga-tachi* (Tokyo: Waizu Shuppan, 1994), 409.
3. Bin Nagatsuka, "Nihon eigakai topikkusu '77," *Nihon eiga 1978*, eds. Tadao Sato and Sadao Yamane (Tokyo: Haga Shoten, 1978), 199–204.
4. For those predictions, see Kazuo Kuroi, "Kogyo kachi," *Kinema Junpo* 693 (15 October 1976): 178–79; Kazuo Kuroi, "Kogyo kachi," *Kinema Junpo* 705 (1 April 1977): 207; and Kenjiro Tachikawa, "Kogyo kachi," *Kinema Junpo* 860 (15 May 1983): 170–71.
5. My account of the *maeuri* system relies in part on that given by Shin'ichi Sano, *Nihon eiga wa, ima* (Tokyo: TBS Buritanika, 1996), 219–62.

6. Kon Ichikawa, Yuji Ono, Haruki Kadokawa, and Yoshio Shirai, "Nihon eiga no genjo no naka de eiga *Inugamike no ichizoku* ga motsu imi wa?" *Kinema Junpo* 692 (1 October 1976): 73.
7. Masuatari, "Kadokawa eiga," 61.
8. Sano reports (232): "I met a middle-level employee at Kadokawa Shoten, the company that was the largest cause of the introduction of *maeuri* movies, and which was still continuing to produce such *maueri* films as *Rex: A Dinosaur Story* (*Rex kyoryu monogatari*, 1993, directed by Haruki Kodokawa) at the time of the interview. When I touched on this subject, he suddenly lowered his voice. 'We are forced to buy tickets for company produced films all on the orders of those higher up. The amount is deducted from our salaries or bonuses. In my case, I had 200,000 yen deducted from my bonus.' "
9. This summary of the *Princess of the Moon* sales strategy is taken from "Kogyo kachi," *Kinema Junpo* 968 (15 September 1987): 166–67.
10. Sano reports that the fear in the industry was that if the *maeuri* system was eliminated, nearly half of the nation's theatres would go bankrupt and the number committed to showing Japanese films would plummet. Sano, 237.
11. For a stinging critique of Japanese movie theatres as a service industry, see Yoshiaki Murakami and Norifumi Ogawa, *Nihon eiga sangyo saizensen* (Tokyo: Kadokawa Shoten, 1999).
12. This reproduces the current situation in which there are very few opportunities for medium-size releases. Either a film opens nationwide through the majors at nearly 200 theatres, or at one independent cinema in Tokyo, in hopes that a handful of houses in other cities will also pick it up. There are few options in between. Many films have suffered from this inflexibility in the distribution system.
13. This is possible because box-office results—as opposed to attendance results—are tabulated by the industry itself based on tickets sold, not on tickets used. Not only are these figures suspicious, but even today the industry refuses to release numbers on theatre ticket grosses (as in the United States), and only makes public distributor income on rentals.
14. See Kazuaki Maruyama, *Sekai ga chumokusuru Nihon eiga no hen'yo* (Tokyo: Soshisha, 1998), 227–28. Office Kitano producer Masayuki Mori charges that the revenue from these unused tickets, even if distributed to theatres, is often hidden from the independent producer by the distributor, effectively defrauding it of its share.
15. This change is reflected in distribution rental rates. While in 1959, distributors could extract an average of 55 per cent of the ticket gross from theatres in the form of rentals, that figure fell to 37.2 per cent in 1973 as distributors/producers became weaker and weaker in comparison to exhibitors. See Eiga Bunka Kyokai, *Saikin Nihon eigakai no shomondai* (Eiga Bunka Kyokai, 1975).
16. A comment often heard in the film press. See, for instance, Eiichi Takahashi, et al., "80-nen eigakai sokatsu to 81-nen no tenbo o kataru," *Kinema Junpo* 805 (15 February 1981): 187.

17. Shunji Iwai, "Kyohon Inugamike no ichizoku," *Bessatsu Taiyo: Kantoku Ichikawa Kon*, ed. Yoji Takahashi (Tokyo: Heibonsha, 2000), 110–11.
18. See Nobuhiro Suwa and Shinji Aoyama, " 'Nani o' 'ika ni' o kyozetsusuru shizen gensho-eiga e," *Eiga Geijutsu* 389 (spring 2000): 82. An English translation by Michael Raine is available: "Cinema as a Natural Phenomenon: Rejecting the Distinction between the 'What' and the 'How,'" V'00 Viennale Vienna International Film Festival (Vienna: viennale Vienna International Film Festival, 2000): 246–254.

Kagi

PAULINE KAEL

Pauline Kael on Kon Ichikawa

Kagi

AMONG THE GOOD FILMS ignored or ludicrously misinterpreted by the critics is, currently, the Japanese film *Kagi*, or *Odd Obsession*, a beautifully stylized and highly original piece of filmmaking—perverse in the best sense of the word, and worked out with such finesse that each turn of the screw tightens the whole comic structure. As a treatment of sexual opportunism, it's a bit reminiscent of *Double Indemnity*, but it's infinitely more complex. The opening plunges us into the seat of the material. A young doctor, sensual and handsome, smug with sexual prowess, tells us that his patient, an aging man, is losing his virility. And the old man bends over and bares his buttocks—to take an injection. But the old man doesn't get enough charge from the injection, so he induces the young doctor, who is his daughter's suitor, to make love to his wife. By observing them, by artificially making himself jealous, the old man is able to raise his spirits a bit.

The comedy, of course, and a peculiar kind of black human comedy it is, is that the wife, superbly played by Machiko Kyo, is the traditional, obedient Japanese wife—and she co-operates in her husband's plan. She is so obedient and co-operative that, once aroused by the young doctor, she literally kills her old husband with kindness—she excites him to death. The ambiguities are malicious and ironic: the old man's death is both a perfect suicide and a perfect murder. And all four characters are observed so coldly, so dispassionately that each new evidence of corruption thickens the cream of the jest.

The title *Kagi*—the key—fits the Tanizaki novel, but does not fit the film, which might better be called the keyhole. Everybody is spying on everybody else, and although each conceals his motives and actions, nobody is fooled. The screen is *our* keyhole, and we are the voyeurs who can see them all peeking at each other. When the old man takes obscene pictures of his wife, he gives them to the young

man to develop. The young man shows them to his fiancée, the daughter, whose reaction is that she can do anything her mother can do.

But a further layer of irony is that she *can't*. For the film is also a withering satire on the Westernized modern Japanese girl. The mother—mysterious, soft, subtle—uses her traditional obedience for her own purposes. She never says what she thinks about anything—when she starts a diary she puts down romantic hypocrisy worthy of a schoolgirl—and she is infinitely desirable. The daughter, a college student who explains what is going on quite explicitly, is just as corrupt as her mother, but has no interest or appeal to her parents or even to her fiancé. In her sweaters and skirts, and with her forthright speech, she is sexually available but completely unattractive. When she tells her father that nothing so simple as adultery is being practised by her mother and the young doctor, she seems simply ludicrous; her mother can lower her eyes and murmur distractedly about the terrible things she is asked to do—and excite any man to want to try out a few.

The director, Kon Ichikawa, is probably the most important new young Japanese director. His study of obsessive expiation, *Harp of Burma*, was subjected to a brutal, hack editing job, and has reached only a small audience in this country; *Enjo*, based on Mishima's novel about a great crime, the young Zen Buddhist burning the Golden Pavilion, has not yet played here. (An earlier film of Ichikawa's—a puppet version of a *kabuki* dance—was destroyed by MacArthur's aides because, according to Japanese film historian Donald Richie, they regarded *kabuki* as feudalistic. What did they think MacArthur was?)

Kagi, made in 1959, took a special prize at the Cannes Festival in 1960 (the other special prize went to *L'Avventura*). *Kagi* was given "Special commendation for 'audacity of its subject and its plastic qualities.'" I've indicated the audacity of the subject; let me say something about the film's plastic qualities. It is photographed in colour, with dark blue tones predominating, and with an especially pale soft pinkish white for flesh tones. I don't think I've ever seen a movie that gave such a feeling of flesh. Machiko Kyo, with her soft, sloping shoulders, her rhythmic little paddling walk, is like some ancient erotic fantasy that is more suggestive than anything Hollywood has ever thought up. In what other movie does one see the delicate little hairs on a woman's legs? In what other movie is flesh itself not merely the surface of desire but totally erotic? By contrast, the daughter, like the exposed, sun-tanned healthy American girl, is an erotic joke—she is aware, liberated, passionate, and, as in our Hollywood movies, the man's only sexual objective is to get *into* her and have done with it. With Machiko Kyo the *outside* is also erotic substance.

Ichikawa's cold, objective camera observes the calculations and designs, the careful manoeuvres in lives that are fundamentally driven and obsessive; and there's deadly humour in the contrast between what the characters pretend they're interested in and what they actually care about.

Kagi is conceived at a level of sophistication that accepts pornography as a fact of life which, like other facts of life, can be treated in art. The subject matter is pornography, but the movie is not pornographic. It's a polite, almost clinical comedy about moral and sexual corruption. It even satirizes the clinical aspects of sex. Modern medicine, with its injections, its pills, its rejuvenating drugs, adds to the macabre side of the comedy. For *Kagi* has nothing to do with love: the characters are concerned with erotic pleasure, and medicine is viewed as the means of prolonging the possibilities of this pleasure. So there is particular humour in having the doctors who have been hastening the old man's death with their hypodermics try to place the blame for his death on the chiropractor who has been working on his muscles. They have all known what they were doing, just as the four principals all know, and even the servant and the nurse. The film has an absurd ending that seems almost tacked on (it isn't in the book); if it ended with the three survivors sitting together, and with Machiko Kyo reading her diary aloud, it could be a perfect no-exit situation, and the movie would have no major defects or even weaknesses.

Reading the reviews, you'd think that no American movie critic had even so much as heard of that combination of increasing lust and diminishing potency which destroys the dignity of old age for almost all men; you'd think they never behaved like silly, dirty old men. Japanese films in modern settings have a hard time with the art-house audience: perhaps the Americans who make up the foreign-film audience are still too bomb-scarred to accept the fact that business goes on as usual in Japan. In *Kagi* the beds—where a good part of the action takes place—are Western-style beds, and when the people ply each other with liquor, it's not sake, it's Hennessy. *Kagi* is the first Japanese comedy that has even had a chance in the art houses: if the judgements of incompetent critics keep people from seeing it, when will we get another? Crowther finds the husband of *Kagi* "a strictly unwholesome type." Let's put it this way: if you've never gotten a bit weary of the classical Western sex position, and if you've never wanted to keep the light on during intercourse, then you probably won't enjoy *Kagi*. But if you caught your breath at the Lady Wakasa sequences in *Ugetsu*, if you gasped when Masayuki Mori looked at Machiko Kyo and cried out, "I never dreamed such pleasures existed!" then make haste for *Kagi*.

1961

Fires on the Plain (Nobi)

Cautious as I am about superlatives, I think the term "masterpiece" must be applied to *Fires on the Plain*. It has the disturbing power of great art: it doesn't leave

you quite the same. A few hours after seeing it, or a few days or weeks, it rushes up and overwhelms you.

If Dostoevsky had been a filmmaker telling his Grand Inquisitor story with a camera, it might have been much like this great visual demonstration that men are not brothers. *Fires on the Plain* (1959) is an obsessive, relentless cry of passion and disgust. The subject is modern man as a cannibal, and after a few minutes of *Fires on the Plain*, this subject does not seem at all strange or bizarre: it seems, rather, to be basic. When violence is carried to the extremes of modern war, cannibalism may appear to be the ultimate truth.

The setting is Leyte. Tamura, the hero, is one of the stragglers of the disintegrating retreating Japanese army—terrified of the Americans, the Filipinos, and each other. Tamura walks across the plain unharmed because he is already a dead man; he is tubercular, no one wants his flesh. In the middle of this desolation, there are bonfires—ambiguous flames in the distance that kindle hope. (Perhaps they are signal fires? Perhaps Filipino farmers are burning corn husks? Perhaps there is still some normal life going on?) At the end Tamura approaches the flames and the last illusion is dispelled.

What can be said of a work so powerfully felt and so intensely expressed that it turns rage into beauty? *Fires on the Plain* is an appalling picture; it is also a work of epic poetry. The director, Kon Ichikawa, and the writer, his wife Natto Wada, are among the foremost screen artists of Japan; their other collaborations include *Harp of Burma*, *Enjo*, and *Kagi*. *Fires on the Plain* is based on the book by Shohei Ooka, the greatest Japanese novel to come out of the war, which, as the translator Ivan Morris says, draws a shocking analogy "between the cannibalism of the starving soldiers . . . and the Christian doctrine of the Mass."

Fires on the Plain is a passion film—and a new vision of hell. The passion that informs the character of Tamura is so intense, so desperate and overwhelming, that he seems both painfully close to us and at the same time remote, detached from what is ordinarily thought of as emotion. The atmosphere of the film is also remote from our normal world: there is nothing banal, nothing extraneous to the single-minded view of man *in extremis*. And what is both shocking and, in some terrible sense, beautiful is the revelation of man's extraordinary passion for life even in an inferno. The soldiers will commit any crime, will kill each other, devour each other, to go on living a few more minutes, a few more hours. Even though there is no future, they are trying to sustain life as if there were; it becomes the new variant of *La Grande Illusion*—that if they can just make it to this forest or that port, they will be saved. Historically, in terms of World War II, some *were* saved; but Ichikawa's film is not, at this level, realistic. It is not merely about World War II, or the experiences on Leyte; it is not an anti-war film in the usual sense. We see no causes, no cures, no enemy; it goes beyond nationalism or patriotism. All men are enemies. It is a post-nuclear-war film—a vision of the end, the final inferno. And

oddly, when survival is the only driving force, when men live only to live, survival comes to seem irrelevant.

There is a fiendish irony involved in the physical condition of the hero: he alone can be a hero—act human—because he can't save his own life anyway. He can be human because he is beyond self-interest; he becomes a Japanese Christ-figure. Tamura, so close to death, is passionately—instinctively and intellectually—committed to the amenities of humanity and civilization. He shares his potatoes with another man because this is how *men* behave; he refuses to eat human flesh because this practice is a destruction of human behaviour. It is the only place left to draw the line: Tamura has been degraded in every other way; he has murdered a helpless, terrified girl, but cannibalism is the final degradation. It is the line he will not cross: it becomes the only remaining dividing line, not between man and beast but between beast and beast who clings to the memory, the *idea* of man. Tamura's rejection of cannibalism is the only morality left. Yet, in the circumstances, his behaviour—obsessed with the image of man—is what is called "unrealistic"; that is to say, in total war, man preserves himself (if he is lucky) only by destroying his humanity. *Nothing* is left.

Just as Ivan Karamazov is obsessed with the evil in the world that stands in the way of believing in God because he *wants* to believe, Ichikawa's revulsion is the negative image of aspiration and hope. In this film, so harshly realistic, so apparently inevitable that it becomes surrealistic, man is defined as man who cannot forget he is man. As in Céline's novels, there is the poetry of disgust, of catharsis. There is even a black form of humour in a weird Mack Sennett-like sequence—the sudden astonishment of comedy as a succession of soldiers discard their shoes and put on the ones discarded by others.

The film follows the novel very closely except that in the novel Tamura does cross the line: he eats human flesh, or "monkey meat" as the soldiers call it (a term that's like a hideous self-inflicted use of the wartime American expression of contempt for the Japanese). And there is an epilogue to the novel which has not been filmed. At the end of the novel, several years have passed, and Tamura, who has been telling the story, is revealed to be a madman in a mental hospital near Tokyo. Guiltily, he believes that in rejecting the proffered flesh of a dying soldier who had raised his emaciated arm and said, "When I'm dead, you may eat this," he rejected God's flesh. His new formulation is that "all men are cannibals, all women are whores. Each of us must act according to his nature." In his madness, he concludes, ". . . if as a result of hunger human beings were constrained to eat each other, then this world of ours was no more than the result of God's wrath. And if I at this moment, could vomit forth anger, then I, who was no longer human, must be an angel of God, an instrument of God's wrath." Ichikawa (wisely, I think) has infused the whole story with this obsessive angelic wrath, rather than attempting to film the epilogue.

As an ironic aside to the subject of mankind devouring its humanity, man becoming "monkey meat," here is John Coleman's description in the *New Statesman* of an English audience's reaction to the film:

> *Fires on the Plain* is showing to an audience of turnip-headed morons . . . screams of laughter welcoming such acts as the impaling of a mad dog on a bayonet (the spray of blood that hit the ground really rolled them in the aisles), titters as the Japanese hero declines the invitation to cannibalism, bellows of fun as machine guns stuttered and gaunt men ran away.

I have seen just one review in a San Francisco paper: it seems to have been written by one of those turnip-headed morons. I don't know how American audiences—if there are any—will react. If it's anything like the English reaction, perhaps the mad Tamura is right and all men are cannibals.

1962

The Makioka Sisters: Golden Kimonos

A friend of mine says that when you go to a Kon Ichikawa film "you laugh at things, and you know that Ichikawa is sophisticated enough to make you laugh, but you don't know why you're laughing." I agree. I've just seen Ichikawa's 1983 *The Makioka Sisters*, and although I can't quite account for my response, I think it's the most pleasurable movie I've seen in several months—probably since *Stop Making Sense*, back in November. The last hour (the picture runs two hours and twenty minutes) is particularly elating—it gives you a vitalizing mix of emotions. It's like the work of a painter who has perfect control of what colour he gives you. At almost seventy, Ichikawa—his more than seventy movies include *Kagi, Fires on the Plain, An Actor's Revenge, Tokyo Olympiad*—is a deadpan sophisticate, with a film technique so masterly that he pulls you into the worlds he creates. There doesn't seem to be a narrative in *The Makioka Sisters*, yet you don't feel as if anything is missing. At first, you're like an eavesdropper on a fascinating world that you're ignorant about. But then you find that you're not just watching this film—you're coasting on its rhythms, and gliding past the precipitous spots. Ichikawa celebrates the delicate beauty of the Makioka sisters, and at the same time makes you feel that there's something amusingly perverse in their poise and their politesse. And he plays near-subliminal tricks. You catch things out of the corner of your eye and you're not quite sure how to take them.

The Junichiro Tanizaki novel on which the film is based was written during the Second World War and published in 1948, under the title *A Light Snowfall* (and it

has been filmed twice before under this title—in 1950, by Yutaka Abe, and in 1959, by Koji Shima), but it has become known here as *The Makioka Sisters*. The women are the four heiresses of an aristocratic Osaka family. Their mother died long ago, and their father, who was one of the big three of Japan's shipbuilders, followed. Tsuruko (Keiko Kishi), the eldest of the sisters, lives in the family's large, ancestral home in Osaka and controls the shrinking fortunes of the two unmarried younger girls. The film is set in 1938, and the traditions in which these women were raised are slipping away, along with their money. Tsuruko and the next oldest, Sachiko (Yoshiko Sakuma), have married men who took the Makioka name, but its prestige has been tarnished by the behaviour of the youngest of the sisters, Taeko (Yuko Kotegawa), who caused a scandal five years earlier, when she ran off with a jeweller's son and tried to get married, though the Makioka family's strict code of behaviour required that Yukiko (Sayuri Yoshinaga), the next to youngest, had to be married first. The scandal was augmented, because the newspaper got things wrong—wrote that Yukiko had eloped, and then, when Tsuruko's husband complained about the error, mucked things up more in correcting the mistake. Taeko still lives at Sachiko's home, along with Yukiko, but she's trying to achieve independence through a career. She wants to start a business, but Tsuruko won't give her her inheritance until she's married, and she isn't allowed to marry. It's Catch-22. She's flailing around, and waiting for the demure Yukiko to say yes to one of her suitors.

Each suitor is brought to a formal ceremony—a *miai*—where the prospective bride sits across a table from the prospective groom, with members of their families and go-betweens seated around them. At thirty, Yukiko is a veteran of these gatherings, but she has still not found a man to her liking. During the year that the movie spans, there are several of these *miai*—each a small slapstick comedy of manners. The last, when Yukiko finally meets what she has been waiting for (and the camera travels up the suitor's full height), has a special tickle for the audience, because you can see exactly why Yukiko said no to the others and why she says yes to this one.

These *miai* are just about the only formal, structured events; in between them, Taeko gets into highly unstructured emotional entanglements—falling in love with a photographer who becomes ill and dies, taking up next with a bartender, becoming pregnant, sampling a few lower depths, and planning to go to work, which means another scandal. While Taeko wears Western clothes and goes off on her own, the exquisite, subdued Yukiko stays in her sister's house. (The two married women's houses are like theatres-in-the-round, with the four sisters and the servants as each other's audience.) Is Yukiko the priss that her Southern-belle curls and her old-fashioned-girl manner suggest? Not by what you catch in glimpses. Yukiko, who clings to the hierarchic family values of the past, with all the bowing and the arch turning away of the head and the eyes cast down, is inscrutable, like Carole Laure in Blier's *Get Out Your Handkerchiefs*. But we see the come-on in her modesty. That's what's enchanting in the older sisters, too. Taeko, the animated

modern girl, the one asserting her sexual freedom, is the least teasing, the least suggestive, but when she's with the others and in a kimono she's lovely. They're beauties, all four of them, with peerless skin tones, and they move as if always conscious that they must be visual poetry. (And they are, they are.)

Yukiko appears to be the most submissive, but she's strong-willed, and she has a sly streak. Living in Sachiko's house, she dresses with the door open to the hall Sachiko's husband passes through. And when she sees him looking at her bare thigh, she covers herself slowly, seductively. Sachiko, who observes what's going on, gets so fussed she starts tripping on her kimono and bumping into things. When she sees her husband kissing Yukiko, she crushes a piece of fruit in her fist and shoves it into her mouth to keep from crying out. And she renews her efforts to find Yukiko a suitable husband.

Ichikawa has said, in an interview, that he took his cue from the book's original title, *A Light Snowfall*. He said that light snow, which melts away instantly, "expresses something both fleeting and beautiful," and that he looked at the sisters in these terms. And that may help to explain why it's so difficult to pin down the pleasure the film gives. It's like a succession of evanescent revelations—the images are stylized and formal, yet the quick cutting melts them away. It's not as if he were trying to catch a moment—rather, he's trying to catch traces of its passing. When the four stroll among the cherry blossoms in Kyoto, the whole image becomes cherry-toned and they disappear.

Ichikawa's temperament brings something more furtive and glinting to the material than Tanizaki gave it in the novel. (In its spirit, the movie actually seems more closely related to other Tanizaki novels, such as *Kagi*, than it does to this one.) The film builds to its last hour; what's distinctive about the build-up is that the darts of humour don't allow you a full release. Taeko's first bid for independence involves becoming an artist, and her sisters speak of her work in perfectly level, admiring tones. Sachiko even pays for a show at a gallery. Taeko's art is the creation of dolls—exact, lifelike small reproductions of girls in heavy makeup and elaborate gowns, and with eyes that open and close. They could be little Makioka sisters. This is sneak-attack humour, played absolutely straight—Ichikawa is satirizing the material from within. And when this kind of suppressed joke plays right next to sequences such as a display of shimmering golden kimonos that the Makioka girls' father had bought for Yukiko's wedding presents, with one after another placed centre screen—a glorious celebration of textures and colour—an unusual kind of tension and excitement builds in the viewer.

I don't know enough about the Osaka culture to interpret the film as social criticism or as an elegy to a vanishing form of feminine grace. (Ichikawa himself comes from the Osaka area.) But the actresses are perfectly believable as the works of art that women like the Makioka sisters were trained to be. And it's easy to be entranced with the world that the film creates. (The industrialization of Japan is

kept on the periphery.) When the banking company that Tsuruko's husband works for transfers him to Tokyo, and Tsuruko doesn't want to leave the Makioka home—a cool palace of polished wood that seems built on an intimate scale—you don't want to leave it, either. The rich colours, the darkness, the low-key lighting—they're intoxicating. When Tsuruko decides to make the move, and her husband falls to his knees to thank her, it has the emotional effect of a great love scene. But the film's finest moment comes at the very end. It's a variation of Joel McCrea's death scene in Peckinpah's *Ride the High Country*, when the old marshal falls out of the film frame. Yukiko is going off to be married; she boards the train in soft vanishing snow, and we realize that she meant far more to Sachiko's husband than a casual flirtation. We see him alone, getting drunk, and he looks terrible—he's all broken up. Then images of the four sisters among the cherry blossoms are held on the screen in slow motion that's like a succession of stills. At last there's only Yukiko's head in the centre of the screen, and the head of her disconsolate brother-in-law passes across the screen behind her and out of her life.

The horrible thing about Peckinpah's recent death was that he was the most unfulfilled of great directors. Like Peckinpah, Ichikawa has had more than his share of trouble with production executives, but he has weathered it, and there's a triumphant simplicity about his work here. This venerable director is doing what so many younger directors have claimed to be doing: he's making visual music. The themes are worked out in shades of pearl and ivory for the interiors and bursts of colour outside—cherry and maple and red-veined burgundy. He's making a movie that we understand musically, and he's doing it without turning the actors into zombies, and without losing his sense of how corruption and beauty and humour are all rolled up together.

1985

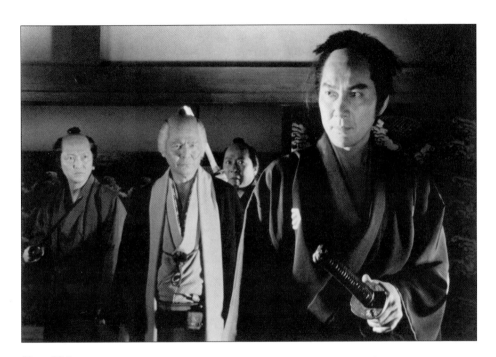

Dora-Heita

MARK SCHILLING

Kon Ichikawa at Eighty-six: A "Mid-Career" Interview

THIS INTERVIEW with Kon Ichikawa took place on July 7, 2000 at the director's home. A short taxi ride from Shibuya, a Tokyo entertainment district packed with seething crowds of under-twenty-fives most hours of the day and night, Ichikawa's neighbourhood is quiet, sedate, wealthy. His house, situated on a rise and flanked by high concrete walls, is barely visible from the street, much like a medieval castle keep.

The house itself, however, is less sixteenth-century Japan than modern-day California, with its small, but immaculately kept lawn, white exterior and large plate-glass windows. Greeting us at the door, Ichikawa was welcoming but a bit wary; he was still not altogether sure about the purpose of the interview.

After introductions and explanations, however, he answered our questions with the briskness and conciseness of the director as get-it-done dynamo. Impatient with inquiries related to the longevity of his career, or the wisdom he had supposedly gained thereby—he released his first film in 1948—he plunged into discussions about the process of filmmaking with frankness and enthusiasm. Though his trademark Camels hung from his lips throughout our hour and a half together, he gave an impression of mental alertness and physical vigour that had diminished hardly at all since our last meeting, nearly nine years ago. While having quite definite ideas about the art of filmmaking, he had few pretensions about himself as an artist, preferring instead the attitude of the hard-headed professional who gets the job done right, be it a personal project or work-for-hire, with the focus on the audience, not the auteur. He was also clear about which of his more than seventy films he considered good and bad—and which ones he could barely remember making at all.

In short, though willing to reminisce, Ichikawa was still very much in mid-career, with a new script underway and other projects in the works. That energy, sustained over five decades, is reflected in the following pages.

MARK SCHILLING: Before we plunge into the past, I'd like to ask you about the project you're working on now.

KON ICHIKAWA: I'm just getting started on my next film. It's still too early to talk about it in any detail. We're revising the script now—we're discussing it.*

SCHILLING: Will it be another period drama?

ICHIKAWA: Yes, a period drama.

SCHILLING: You recently did a program for Fuji TV.

ICHIKAWA: *Prime Minister of All Nations* (*Bangoku no shuso*)—that was a TV drama.

SCHILLING: Have you finished it?

ICHIKAWA: Yes, it's finished.

SCHILLING: You've been going back and forth between TV and films for a long time now.

ICHIKAWA: Television and films both basically look at life and human beings through a frame. From a director's point of view, they aren't much different in that regard. But in terms of style, there is a big difference. With films, the audience has made a choice to be sitting there in the dark. With television, I'm sitting here in my own house and the TV is telling me to watch something, whether I particularly want to or not. So there is a difference in that way. You have to change your method of filming accordingly.

SCHILLING: Technically, in terms of picture quality, films and TV are becoming more alike.

ICHIKAWA: That's true. Technically they are getting closer, but film is still film and television, television. Even with high-definition video, there is still a big difference in the way you go about filming—at least that's what I think. For example, with a TV drama, you have to do a lot of explaining—you have to tell the audience what's going on very directly. That's because they're sitting at home watching. With television, the phone is ringing, people are talking, drinking tea, and doing various other things. You're bringing this program to them, in the midst of their daily lives. You have to be aware of that. When I'm on the set, I'm not so aware of it, but I am conscious that some kind of explanation is necessary. With film, you're freer—you can create your own world. I'm not saying, though, that because you're making TV you can cheapen the content. Even with TV drama, you're examining life and human beings. So the basic approach is not all that different (between films and TV dramas). With both, you have something you want to say, a theme you want to express. Stylistically, though, they're somewhat different.

SCHILLING: You started out as animator. How did you get involved with that?

ICHIKAWA: Walt Disney made a series of shorts called *Silly Symphonies*. The trees in the forest move, the flowers sing, the animals talk. They are marvellous fan-

Kah-chan, which completed shooting in the spring of 2001. *Ed.*

tasies. Later Disney made a feature animation called *Fantasia*, with Leopold Stokowski and the Philadelphia Orchestra providing the music. At the beginning of the film Stokowski shakes hands with Mickey Mouse. I thought it was a masterpiece. Anyway, *Silly Symphonies* were the basic model for *Fantasia*. When I saw them I thought they were wonderful. That's what got me into animation.

At the time, the Japanese animation industry wasn't making the kind of commercial animation you see today. They were only making seven-or eight-minute shorts, just curtain raisers for the main drama. Commercially, those films couldn't stand alone. They gradually become longer and now we have feature-length animation. Today animators are doing a real business in the market with their work, but it wasn't like that then. At that time Nikkatsu studio had fifteen sound stages. They were making films there and I went to see what they were doing.

A director named Sadao Yamanaka was making some wonderful movies there, such as *The Village Tattooed Man* (*Machi no irezumimono*) and *Kouchiyama Sojun*. While drawing cartoons, I sometimes went to see what he was doing. I thought feature films were wonderful things. I made the switch to live action and became an assistant director. That's how I got into feature films.

SCHILLING: At that time it was easier to switch from one form of filmmaking to another.

ICHIKAWA: That's right, it was that kind of time.

SCHILLING: It's interesting that a film company would hire someone from the animation world.

ICHIKAWA: Well, they hired me, but I was just an assistant director, not a director. An assistant director was someone who would train for a number of years and then, maybe, become a director. All the company had to do was ask me to change my job. It was easy to switch back then.

SCHILLING: I've heard that Mansaku Itami's films made you want to become a director.

ICHIKAWA: Yes, that's so. I saw everything I could by Sadao Yamanaka and Mansaku Itami. I was a big film fan then. It's true that I got into films because of their work.

SCHILLING: I understand you especially liked Itami's *The Peerless Patriot* (*Kokushi muso*).

ICHIKAWA: Yes, *Kokushi muso*—that was a great film. It was a silent.

SCHILLING: Itami had a wicked sense of humour.

ICHIKAWA: That's right. He made satirical films. He was a bit critical of society. If you look closely at his films you can see they have that quality. He looked at humanity from a satirical angle. That was true of a lot of his films—many of which were masterpieces.

SCHILLING: The political situation was different then. There was less free expression. It was dangerous to criticize the government and the society.

ICHIKAWA: There was censorship. The censors would often tell you to cut a bit here or there. But by the time I became a director, censorship, particularly censorship from the Ministry of Culture, no longer existed. There was still Eirin [the Japanese film industry self-censorship body], though. Private citizens from the film world got together back then to form Eirin. You had to have an Eirin stamp on your film to get it shown. Eirin is still censoring films, particularly adult films, but the people doing it are from the private sector, that is, the film industry. In the old days, they were all "Mr. High and Mighty." (Laughs) By that I mean government officials. The only time I had a fight with Eirin was when I released *Kagi* (1959), a film based on a novel by Junichiro Tanizaki. The film had some female nudity, so Eirin had a big debate about it. They said, "We want you to cut this and that."

SCHILLING: Yasuzo Masumura, a director who was once of your assistants, wrote an essay about your films in which he said that people from the Kansai [a region in Western Japan encompassing Osaka, Kyoto, and Kobe] have a knack for seeing beneath the surface, into the heart of things. You're from the Kansai. Do you agree with him?

ICHIKAWA: Well, I wouldn't know about that. People who are not from the Kansai like to say that Kansai people enjoy seeing what goes on behind the curtain and all that. But that's not limited to the Kansai.

SCHILLING: So there isn't much of a difference.

ICHIKAWA: Not that I can see.

SCHILLING: But you have set a lot of your films in the Kansai. Any particular reason for that?

ICHIKAWA: I do have an interest in Kansai material, that's true. An interest in Kansai customs and mores. A film like *The Makioka Sisters* (*Sasameyuki*, 1983) could have only been set in the Kansai. I was interested in that material for a long time. From the time I was an assistant director, I wanted to make the book into a movie. One of my seniors told me that *Sasameyuki* had already been made into a movie, but I wanted to do it my way. That was a dream of mine for many years. Then I was finally able to make that dream a reality. So I do have a certain interest in stories from the Kansai, but it depends on the content. I don't want to do a film just because it's set in the Kansai.

SCHILLING: Japan's political and business power bases are all in Tokyo, which means that the Kansai is always number two. And that's given people in the Kansai a different outlook, I think. In the old days the samurai from Edo [the old name for Tokyo] had a lot of pride in their status and tried to protect it, whereas in the Kansai the merchants were able to lead freer lives, not worrying so much about their position in society.

ICHIKAWA: That was true in the old days. when people were wearing topknots. In the Kansai they had these *zaibatsu* [business combines] among the merchants, such as Sumitomo. That didn't really exist in Tokyo, which was a town the Tokugawa Shogunate had built that attracted people from all over the countryside. The Kansai, on the other hand, had Kyoto, with the Imperial Palace. It was the heart of Japan. Tokyo was a newly developed town by comparison.

Well, this has become a basic history lesson, but during the Meiji Restoration, Kyoto stopped being the capital. The Emperor came to Tokyo and Tokyo became the heart of Japan. Meanwhile, the *zaibatsu* continued to flourish and the Kansai became a money centre. Even so, I don't feel that because of that the Kansai and Kansai people are all that different from Tokyo and Tokyo people. Japan is a small country. In a big place like America you have these regional differences, but Japan is a small place, isn't it? I will say, though, that Kansai people have an image of Tokyo as being different. But that's true anywhere you go. In America, the east coast and west coast have certain images of each other. They feel that the people on the other coast think differently. That attitude certainly exists. But I don't feel that way myself.

SCHILLING: The samurai ethic is a big influence in Kurosawa's concept of the hero. His samurai heroes may have various faults, but they are still manly men, such as the samurai leader played by Takashi Shimura in *Seven Samurai*. That kind of hero is harder to find in your films.

ICHIKAWA: That depends on the material you're working with, doesn't it? I'm not trying to create a hero, but to depict certain types of human beings. You could hardly call them heroes.

SCHILLING: You seem to have no qualms about trying your hand at anything, but is there any kind of material you've tried to avoid?

ICHIKAWA: I've made about seventy films—that's a lot. When I was at my peak, I was making as many as three films a year. More than half of those films, though, were not ones I wanted to make, but ones that a company or producer or actor asked me to make. "I want to do this, so let's get Ichikawa." In that case, the problem becomes one of how to film the material. In other words, it's not material that I have developed myself, but that someone has brought to me. Even so, I have to do everything possible to make it my own. I have to ask myself whether the material allows me to do that. If I can't put my own stamp on it, I turn down the assignment. I feel a sense of responsibility for the assignments I take on. At the same time, if I can't make the material my own, I'll say no. I've made some dogs doing that. "Oh, no—what have I done!"—that kind of thing. (Laughs) But that's the way I make films. If something resonates within me when I read a certain piece of literature, I want to make it into a movie. That's how I make a novel mine.

SCHILLING: Speaking of literature, in 1955 you made *Kokoro* which you adapted

from the novel by Soseki Natsume. That was the first film of yours based on *jun bungaku* [a literary novel].

ICHIKAWA: Oh, really? I've forgotten. I might have been doing it before that. (Laughs)

SCHILLING: Perhaps you're right. (Laughs) In any case you've made several films based on literary novels. Did you first become interested in the novel, then decide to make the film?

ICHIKAWA: That's right. I studied literature with that purpose in mind—to make movies. I'm still doing it, in fact. From the age of about thirty-five to forty I became quite serious about studying human beings, life, and society. I thought that, for my age, I was under-educated. When I read works of literature, I would think, "Ah, so this is how Tanizaki sees life," or "So this is how Yukio Mishima views human beings." I would feel, "Ah, so this is the writer's view of life—it's totally different from mine." That made me want to turn the novel into a film. I wanted to express the writer's ideas, or rather the spirit of those ideas, in a film. I wanted to add a little richness to a philosophy of life that didn't have a lot in common with mine.

SCHILLING: So for you, making these films was a kind of philosophical investigation.

ICHIKAWA: Leaving aside the question whether my film version adds anything to the author's point of view, yes, that's how I felt about it. In the beginning I just wanted to try my hand at literature and so I did. I just kept making films based on literary works.

SCHILLING: You've made many films based on classic Japanese literature, while Kurosawa tended to take his material from Shakespeare and other foreign sources.

ICHIKAWA: Yes, we were different in that way.

SCHILLING: You were more of a domestic type. (Laughs)

ICHIKAWA: You might say that. (Laughs) I looked at it as a positive learning experience. I didn't believe in just mechanically transferring the novel to the screen. Then the film would just be a digest of the novel. Most film versions of Mishima's or Tanizaki's novels essentially present the plot of the novel. They're just digests. In that case, there's no point in making the film—it's better to read the novel. I don't want to do that. I want to combine my spirit and the spirit of the novel. With that goal in mind, I write the script and direct the film. I really have to study hard to make this method work. Naturally, I get into a lot of fights with the author.

SCHILLING: Because your vision differs from his?

ICHIKAWA: That's right. The authors say, "This is nothing like the novel." Yes, I've had a lot of fights, but it's all right if the film differs from the novel. The only thing that matters is the spirit of the original work. If I can communicate that

properly, then nothing else matters. Just changing words for images is a shabby way to make a movie. So the film and the movie are going to be different.

Here's a simple example of what I mean: I made a film of Tanizaki's *Kagi*. The hero in the novel is a college professor. I made him an antique dealer. He appraises old tea cups and wall hangings. By appraising I mean he tells people whether things are fake or real, old or new. In the novel, his being a college professor is not a problem. But in a movie if a college professor is taking nude photos of his wife and things like that, it doesn't work visually. So I changed his profession. When Tanizaki read the script, he immediately noticed what I had done and said, "This isn't right." I had to work hard to get him to understand my point of view but I was finally able to convince him. Whether the change was for the better or worse is not for me to judge. I can say, though, that I didn't film a digest of Tanizaki's *Kagi*. I feel proud of that film, and it has nothing to do with whether it was a hit or not, or even good or not. I made a lot of films by studying the original material that way.

SCHILLING: I read Tanizaki's *Sasameyuki* before I saw your film of the same title [in English, *The Makioka Sisters*]. I remember thinking how much you had shortened the novel.

ICHIKAWA: That was an extremely long novel, published in two volumes. If I had filmed every incident in the book, I would have had a ten-hour movie. That would have been idiotic. So I spent a year on various kinds of research and decided to telescope the events of the novel, which take place over the course of seven or eight years, into one year. The story starts in the spring, continues through the summer, fall, and winter. The snow falls and the story ends. I'm glad now that I did it that way.

SCHILLING: You also brought a visual beauty to the story.

ICHIKAWA: Ah yes, the visual beauty. But I was more interested in transferring the essential spirit of Tanizaki's writing in *Sasameyuki* to the screen. I'm satisfied with what I did. But that's what I have to do. I'm rather strict that way.

SCHILLING: I've heard that *Enjo* (1958) is your favourite among all your films. It was also derived from a literary work.

ICHIKAWA: That's another case where, if I had just filmed Mishima's novel as it was, I would have ended up with a digest. I had a lot of trouble with the script.

SCHILLING: What was the most difficult part for you?

ICHIKAWA: There's a kind of magic in Mishima's language. There are all these dazzling sentences, one after another, all the way through the novel. When Japanese people read it, they realize how wonderful the writing is. But for a filmmaker it's fatal to get too caught up in the beauty of the writing. "Oh, the sentences are so wonderful, so wonderful"—that kind of thing. Of course, because it's literature, it's better that the sentences be good ones. It's exactly the same in English or French. With a novel, you're reading sentences, but when you say, "Let's

make these wonderful sentences into a movie," you get into trouble. So I took all those wonderful sentences and threw them out. (Laughs) Instead I filmed Mishima's central ideas, the essence of what he was trying to say. After I finished, I could say to myself, "I've finally learned a little bit about films."

SCHILLING: When you read a novel, are the images more important than the words?

ICHIKAWA: More than the images, I'm looking for the spirit behind the words, the spirit of what the author wrote. You first have to understand what the author was trying to say. Then you have to ask yourself whether you agree with it, whether it makes sense to you. Those ideas are in the story; it's not necessary to think about the story per se. *Enjo* is about a young monk who burns a national treasure [the Temple of the Golden Pavilion]. The real incident on which it is based is all there in the novel. But Mishima didn't just write up newspaper articles into a story. Instead he had something more he wanted to communicate—his own thoughts regarding the tragedy. My job was to dig out those thoughts and then, when I wrote the script, decide what to emphasize: the hero's feelings, Mishima's feelings or my own feelings. I also had to decide whether all those elements complemented each other. Getting all that right was a struggle, a real struggle. But the struggle is what makes it interesting. Sometimes I fail. Occasionally I want to say, "What was I thinking?" Sometimes I decide to make a film a certain way, but when I see the result, I know it's no good. I'm not God, so I never know when it is going to happen. Now and again, after making a film, I say, "Oh, no!" and other times I think, "That's pretty good." Of course, at times the critics and the audience don't always agree with me. That's the way films are.

SCHILLING: You never know until you make them.

ICHIKAWA: That's right, you never know. Very often people will ask me if I can make a certain property into an interesting film. I tell them: "How do I know—why don't you ask God?" Really, unless you ask God, you're never going to know.

SCHILLING: When do you know whether a film is good or not? Only when you see it in a theatre?

ICHIKAWA: I don't have to see it in a theatre. I can get an idea from the pre-release screening. Before I see it in a theatre, I'll screen it with my staff. Watching the film, I have a lot of thoughts—"This is good, this is not so good"—but I don't tell them to anyone. (Laughs) If I can, sometimes I change a few things. But that's not often done in Japanese films because it costs money.

SCHILLING: So a film gets released regardless of what may be wrong with it.

ICHIKAWA: I've read that in America, they'll screen the finished film for ordinary fans in a movie theatre free of charge. They then have the audience write what they think was good or bad about the film. Looking at the responses, the star or director will sometimes try to reshoot the scenes the audience didn't like. They

don't reshoot the whole film, though, because it would cost too much money. Leaving aside the question of whether the audience's opinion is worth anything, that's really the ideal—to be able to go back and correct your mistakes. That attitude toward filmmaking is really conscientious; I think it's a great way to make films. The only problem is that it costs money. Once you've finished a film, you can dub, edit, and cut the negative, but that also means spending money—and no one wants to do that here. I do what I can, even though it isn't very much. I cut the negative when I see something that strikes me as bad. I'll say, "We don't need this scene." Sometimes, I'll go back and reshoot a scene, if the location is easy to get to—without telling the company of course. (Laughs)

SCHILLING: It's hard for perfectionists in the Japanese film industry. As you said, the budget is a big problem.

ICHIKAWA: The positions of the director and producer are a bit different. A director wants to be a perfectionist, to do everything as well as he can. But things happen that upset yours plans and the film doesn't go as you had hoped. Even so, you should be a perfectionist. But being a human being, it's not always possible. That applies not only to the making of films, but also to everyday life. It's impossible to be perfect, but imperfection is also what's interesting about human beings.

SCHILLING: How do you handle your actors? Do you expect perfection of them as well? I've heard that you were once rather strict.

ICHIKAWA: Acting is casting. And casting is the job of the director. I would say about seventy per cent of directing actors is casting them. The other thirty per cent is coordinating. I've had the experience again and again of a casting mistake spoiling the film. It's not a question of whether the actor is good or bad, and that goes for very great actors. Even if I give a part to someone who is supposed to be great at whatever he does, that part may not be right for him. I may have given him the part thinking that he would be good in it, but sometimes it doesn't turn out that way. If he doesn't belong in that role the film won't be any good. It's not the fault of the actor—it's the fault of the director. That's why casting is seventy per cent of the job. Depending on the film, sometimes the director does the casting, sometimes the producer does it. There are all kinds of situations. Even if the director says, "This guy is it," the producer may say, "No, cast this one instead." So we might have a discussion about that. But if we go with Mr. A and the part is not right for him, it's not going to work out, no matter how great an actor Mr. A is.

SCHILLING: I've also heard that you don't give a lot of specific directions on the set.

ICHIKAWA: Sometimes I give detailed instructions and sometimes I let things take their course. It depends on the situation. An actor may try this and that and, when I feel that he's hit on something, I don't say much—I let him run with it. Sometimes, though, I know I have to be pretty specific. So I give detailed instructions.

SCHILLING: What about Koji Yakusho in *Dora-Heita*? He's a veteran actor who can seemingly do anything. Did you let him run with it?

ICHIKAWA: No, I told him several times, "I want you to do it this way." First of all, I wanted him to create a distinctive character, who was cheerful and lively. Also, I wanted this character to be a great man—in other words, to be intelligent, well-dressed, good with a sword and all the rest. But at the same time, because he's a human being, he has to have his weak points—and know what they are. So I told Yakusho that I wanted him to play this rather ideal type of human being. After that I left the interpreting of this character up to him. I told him, "Feel free to do what you want." Sometimes, however, I will be fairly explicit in my instructions. Basically, though, after I give actors a general idea of what I want, I ask to them to interpret freely.

SCHILLING: What about Ken Takakura, who starred in *47 Ronin* (*Shiju-shichinin no shikaku*) six years ago, in 1994? Did you give specific instructions to him?

ICHIKAWA: No, not really—I didn't cast him in that movie. The top people at Toho wanted Takakura in the film from the beginning. I didn't know that. The role was that of Kuranosuke Oishi, a stock character. Well, "stock character" may be an odd way of putting it, but *Chushingura** has been filmed so many times that the audience has a definite opinion about which actors are most like the historical figure, Kuranosuke Oishi. And there were actors at the time who fit that bill.

It may sound strange to talk about the "author" of *Chushingura*, but Soichiro Ikemiya wrote the novel on which the film was based. He would tell us this person or that person was right for such-and-such a role, but he never mentioned Ken Takakura. Then Toho told us that they wanted us to use him. I thought, well, that's interesting. I had never thought of using him myself, but it was a stroke of brilliance, an excellent idea. So I went along with it. When I started filming, I was expecting him to be a terrific Kuranosuke Oishi and he didn't disappoint me.

He turned down Toho when they first approached him. I wasn't aware of it then. Toho went to him without telling us. Takakura said that he would never take the part because he wouldn't look right in a topknot. But I thought it was a wonderful piece of casting. I really wanted him, so I asked to meet him. When I did, I only said: "Please appear in our film." Then we shook hands and that was that.

SCHILLING: Many, if not most, of the famous actors of the postwar period have appeared in your films. Sayuri Yoshinaga, Tatsuya Nakadai, and so on. Was there

* A tale of forty-seven loyal retainers who sacrifice their lives to avenge their unjustly accused lord. Based on an actual incident in 1703, the Chushingura story first took dramatic form in a celebrated play by Chikamatsu. It has been filmed many times, Ichikawa's version being one of the latest.

ever anyone you wanted to work with, but for some reason couldn't?

ICHIKAWA: Yes, there have been cases like that. I can't give you any names offhand, but I've had that experience. I had wanted to work with Ken Takakura for a long time. He was at Toei, you see, so we just couldn't get together. When Toho wanted him for *47 Ronin*, I was very glad to hear it. Also, they wanted him for a specific role, as Kuranosuke Oishi. I thought, "Sometimes even a company like Toho does something right." (Laughs)

SCHILLING: I've recently seen *Ten Dark Women* (1961). The casting was superb. It was made nearly forty years ago, but still has a contemporary feel to it.

ICHIKAWA: When that film was released, it didn't get good reviews. It was a bit ahead of its time. It's the kind of story that would still work well today.

SCHILLING: Did you see it when it was re-released here in Tokyo last year?

ICHIKAWA: Yes. I hadn't seen it in a long time. A musician and composer named Mr. Konishi recommended that film for a revival. He's popular with young people. Anyway, he recommended it and he introduced it on opening night. I thought I would pay my respects, so I went to the theatre and was able to see the film for the first time in what must have been dozens of years.

SCHILLING: What was your impression? Was it a better film than you had thought?

ICHIKAWA: No, not at all. I didn't think of it as a "good film." I thought, "I was lucky to have survived that—I was young then." (Laughs) I thought, "I could never make that film now." My reaction had nothing to do with whether the film was good or not. I was thinking, "I really worked hard on that. I could do it because I was young."

SCHILLING: Was it difficult to deal with so many actors?

ICHIKAWA: No, the number had nothing to do with it. I don't know if I shot it properly or not. I don't remember anything about that time. All I know is I doubt if I could shoot that film now.

SCHILLING: Talking about difficult films to shoot, *Fires on the Plain* (1959) would seem to fall into that category. Do you think you could make that film now?

ICHIKAWA: No, never. At that time I was making a lot of films with Daiei: *Fires on the Plain*, *Kagi*, and *Ototo* (1960). I would submit a proposal and they would OK it. For example, when I told them I wanted to make *Fires on the Plain*, they said OK right away. Back then it was simple to do business.

SCHILLING: No one had any objections?

ICHIKAWA: None whatsoever. Now they'd say, "What's this?" and "Oh my God!" (Laughs) That's how different the film industry is today. With *Fires on the Plain*, they just went along—no problem. No one said we couldn't film a story about cannibalism. Instead they said "Oh, it's a war movie—OK."

SCHILLING: Five years ago, in 1995, Toho, Shochiku, and Toei all released films about World War II. When I saw them I thought *Fires on the Plain* was far more honest.

ICHIKAWA: I couldn't make it now. If I used my own money, then perhaps I could make it. But if I were to take it to a production company, they would turn it down flat. They would say, "No way, this is too much."

SCHILLING: A lot of your films from that period were either black comedies or had black comic touches. It's harder to find those kinds of films today.

ICHIKAWA: In general Japanese are not very good at comedy, compared with America, France, and places like that. It's the Japanese character. There's an expression *ningen higeki* [human comedy] in Japanese. You probably can't translate *higeki* as "comedy" in English. The character "hi" in *higeki* means to "be joyful," so *higeki* means something like "joyful play." Making a truly "joyful play" is the ultimate in films. Chaplin was the best at that. His films are *ningen higeki*. I think they're among the best films of their type ever made. In other words, I'm talking about good entertainment films. A good entertainment film is a good art film as far as I'm concerned. In the same way, a good art film is a good entertainment film. And that's what Chaplin made—good entertainment films that also happened to be good art films.

SCHILLING: He was doing what he liked, not what a producer told him to do.

ICHIKAWA: That's right. The way I see it, if a director is doing what he wants, he's more likely to make a film that is good art and good entertainment. But if a film is proclaiming, "This is art, this is art, this is art" and trying to be difficult, then I doubt whether it's really a good art film. I don't think a good art film has to be particularly difficult to understand. I just make what I want to make. I can't make a difficult film and pass it off as art. I just can't do it.

SCHILLING: Speaking of entertainment films, I saw *The Pit* (1957) recently. Visually, it's quite inventive and the film as a whole is quite entertaining. It's not high art, but the mystery story kept me guessing to the end.

ICHIKAWA: I'm not very proud of that one. It was like a cartoon.

SCHILLING: It reminded me of a Billy Wilder comedy from the 1950s.

ICHIKAWA: Yes, that influence was there.

SCHILLING: Were you seeing any other Hollywood films then that influenced you?

ICHIKAWA: I liked the films of Joseph Mankiewicz.

SCHILLING: *All About Eve*?

ICHIKAWA: Yes, that one. Also *A Letter to Three Wives*.

SCHILLING: I just saw it on video a couple of weeks ago.

ICHIKAWA: You *just* saw it? (Surprised) That's an example of a film that is good art and good entertainment. It's an entertainment film first, but it's also a good art film. I like it better than *All About Eve*. That's my personal taste, of course.

SCHILLING: *A Letter to Three Wives* keeps you guessing to the end. You have no idea who the guilty one is until the last scene.

ICHIKAWA: That's right. Mankiewicz was really wonderful. He became better in the latter part of his career, though. The kind of talent he had is lacking in

American movies today. When American movies were at their peak, you had films like David Lean's *Brief Encounter*. I learned a lot by watching American films from that period. Not so much from the new ones, though. The only recent American film that I really learned anything from was *Seven*. Now it's just "bang, bang, bang." Arthur Penn's *Bonnie and Clyde* was violent, but it also had deep insight into the nature of human beings.

SCHILLING: I know that you regard the script as highly important, but you don't always write it yourself. Instead you have often collaborated with others, including your late wife, Natto Wada. How did you go about writing scripts with your collaborators, especially your wife?

ICHIKAWA: I didn't discuss a lot with my wife. I would just say, "I'd like you to write this." Then she would say OK and write it for me. She wrote a lot of scripts for me, all kinds. We did argue once in a while, though. When you write a script, you're writing about life. So we would sometimes discuss our view of things, our philosophies of life if you will. She would say, "Your way of thinking isn't like mine," and I would say the same thing to her. So sometimes we would argue about that. We wouldn't speak to each other for two or three days. (Laughs) But that happened maybe two or three times in all the years we worked together. I don't even remember what we fought about. I don't think anyone would, really.

SCHILLING: How did you work with her on *Fires on the Plain*?

ICHIKAWA: I wrote very little of that script, almost nothing. The script she wrote was quite different from the novel. I read the novel on her recommendation and thought that I had to film it. I wanted to say that war is bad, which sounds like a slogan—"No more war"—but I thought it needed saying again and again.

Some might say that the war was a long time ago and we don't need any more war movies. I didn't agree. I thought it was still important for filmmakers to say "war is bad" in a film, whatever method they used or whatever their definition of "bad" happened to be. So I decided to make a war movie. *Fires on the Plain* dealt with the eating of human flesh—cannibalism. That was the hardest thing to film—the scene of the hero eating human flesh. The audience is never going to believe that it's really human flesh on the screen. They're always going to think the filmmaker is using beef or chicken or something similar. But human meat? No way—that's why it's difficult.

I was wondering what to do when she suggested that, when the hero tries to eat human flesh, he can't chew it because his teeth are rotten. That was not in the original story, but it turned out to be a wonderful solution. In the book the hero did turn cannibal, though. In literature, you can get away with that. When you're reading the story, you think "how awful." But with a film, when the audience sees a character chomping away at human flesh, they're going to think that it's an actor chewing on beef. I didn't want the film to have that kind of flaw.

SCHILLING: You made one other war film prior to *Fires on the Plain*, *Harp of Burma* (1956). That also had a big impact. Then nearly twenty years later, in 1985, you remade it in colour. Did you want to communicate the film's anti-war message to a new generation?

ICHIKAWA: Yes, that's partly why. For young people today, the hero is a wonderful man, an ideal Japanese.

SCHILLING: The film was not based on a true story was it?

ICHIKAWA: It was complete fiction. Michio Takeyama wrote the original novel. I heard the story from Takeyama when I met him. In the novel, the writer hears the story from a friend. It's written as though the events it describes really happened, but that's just a stylistic device. Takeyama had never even been to Burma. He's never gone there. He wrote the book based on second-hand sources. Our location crew had never been to Burma, though I had seen photos of possible locations. I didn't know these places, so I thought I'd ask Takeyama about them. I thought he would be an experienced Burma hand. Instead he said, "I don't know; I've never been there." "You wrote this without having ever gone there?" I asked. "Well, I had various sources," he said. He had been sent to the war zone in China, but had never gone to Burma. There was a lot of material about Burma in China at the time. A lot has probably changed there since then. He came up with that story when he was in China. But when he wrote about the song in the novel—well, there was no one song that Japan and China had in common. So he decided to use "Hanyu no yado," which was originally an English song. He chose it because British soldiers had fought in Burma. He thought of setting the story in Thailand, but decided on Burma instead because of that song.

SCHILLING: That's the first time I've heard that story.

ICHIKAWA: Takeyama started with that song.

SCHILLING: The music for many of your films from that period was quite contemporary—jazz, for example.

ICHIKAWA: Music is a very important element in films. It's been that way for a long time, but in Japanese films, not a lot of money is spent on music. The reason is that music is the last stage in the filmmaking process. First you have the treatment, then the script, then the pre-production preparation, then you go to the set and start filming. You shoot, edit, and finally add the music.

But by this time the budget is very tight. In the process of making the film, you gradually eat up the budget. The budget for music is small to begin with and it gets smaller as you go along. Films cost a lot of money to make—and music gets the leftovers. But as the budget gradually gets smaller, the music gradually gets worse. The composer will cut some corners. But if you want proof of how important music is, look at foreign films—the theme from *The Third Man* or *The Bridge Over the River Kwai*. If those films hadn't had that music what

would they be like? Carol Reed did a great job filming *The Third Man*, but if it hadn't had that zither theme, would it have had the same feeling? Or "Colonel Bogey's March" in *The Bridge over the River Kwai*. When the soldiers whistled that song, it made the film. You could have never gotten the same emotion from that scene without that music.

SCHILLING: On the other hand, *Dora-Heita* looks like a throwback to your films of the 1950s. The credits, the music are all retro but quite stylish.

ICHIKAWA: Well, as I said, music is very important. Everyone says how bad Japanese film music is, so I place a high priority on it. I want good music, like that wonderful theme song from *The Godfather*. Those opening bars make you feel how powerful the Godfather's gang is. When that romantic music plays, the film acquires a solidity—a kind of three-dimensionality. I really envy Coppola. (Laughs)

SCHILLING: The action scenes in *Dora-Heita* are also a throwback, especially the one in which Koji Yakusho takes on fifty opponents. Was it difficult to stage?

ICHIKAWA: Ah, that scene was a bit Westernized—it's not realistic. No one man could really take on so many opponents. We took the Japanese *satsujin* ["attacking group" of swordsmen often seen in period dramas] and Westernized it a bit.

SCHILLING: Was that your idea, to have fifty opponents?

ICHIKAWA: No, that was a request. In an ordinary film you would have about twenty attackers. I asked for fifty extras but I had them attack as though they were eighty. The idea was to film eighty attacking, but edit the number down to fifty. But even though you can count fifty, you can only see from two to thirty at any one time.

SCHILLING: You filmed it with a great panache, but with an undercurrent of humour as well.

ICHIKAWA: I didn't want the audience to take it too seriously—I just wanted them to enjoy it. The good guy defeats the bad guys. When you have a scene like that in a period film, the swords have to come out. And if you're making that kind of film, a big sword-fighting scene is essential. The original script didn't include one, but I wanted one, so I shot it.

SCHILLING: But otherwise you didn't drastically change the script that you and your collaborators (Akira Kurosawa, Keisuke Kinoshita, Masaki Kobayashi) wrote.

ICHIKAWA: No, it's pretty much the same as the one we wrote back in 1969, but the sword-fighting scene is new.

SCHILLING: Did you add anything else?

ICHIKAWA: I reworked the last part quite a bit, when the geisha appears [the lover of Koji Yakusho]. She was in the original story and in the script we wrote in 1969, but she made only a brief appearance. I expanded her role; I thought the film needed more of a female presence. So I gave a big part to Yuko Asano.

SCHILLING: What about the music—was that your idea as well?

ICHIKAWA: I asked Kensaku Tanikawa to compose the score. He did a fine job. I told him that the music had to have rhythm. I told him "I want rhythm!"

SCHILLING: We've talked about scriptwriters and composers, but not about cameramen. How did you work with your cameramen, especially Kazuo Miyagawa? He had his own approach to filming. Did it clash with yours at all?

ICHIKAWA: There are two types of cameramen. One is completely in tune with what the director is thinking and feeling. He first adapts himself to you and then reveals his own personality in his work. The other shoots the film his own way. If the director lets him get away with it, he drags the director along. Well, "drags" is an odd way to put it, but the point is, he takes the lead and the director follows.

There are both types among great cameramen, but Miyagawa was the former type. He would first try to understand what I wanted, then make something of his own. He would produce something that was Kazuo Miyagawa. When I first worked with Miyagawa, he tried hard to find out what I wanted to say in the film. He kept saying "I see," "I understand." Then I started to grasp his way of thinking. I saw how he would shoot scenes in his own style. He was a great cameraman.

SCHILLING: Do you work better with the former type than the latter?

ICHIKAWA: The latter type will definitely argue with the director at some point during the shoot. But there are some great cameramen of that type as well. One was Yoshio Miyajima; he was a good one. But Miyagawa wasn't like that; he would try to find my wavelength. But it's not enough for a cameraman just to be in tune with the director; he has to have his own opinion as well. He can't just wait for the director to tell him what to do. That's where Miyagawa was great—he could work well with Mizoguchi, with Kurosawa. He could adapt to Kurosawa as well as he did to me.

SCHILLING: You made several films with Miyagawa, but you didn't work with a certain *gumi* [staff, team or, more colloquially, family] in film after film, the way Kurosawa did.

ICHIKAWA: But Kurosawa changed his staff quite a bit. Journalists are always talking about the "Kurosawa family," but in fact he made a lot of changes.

SCHILLING: But you still worked with more people, changing more key staff from film to film.

ICHIKAWA: Well, that's true, but actually either way is all right. At first I thought it was all right to change my cameraman and staff frequently, but recently I've come to think that it's easier to have more consistency. With new people, I have to explain myself and find out what they're thinking. When I was young I had more energy. I used to say, "If you're the kind of cameraman I think you are, you're going to do such and such. You're going to get this show on the

road!" When you get older, you don't need that. Well, you need explanations, but it's better to avoid them. So now my cameraman and lighting people understand what I want. I just have to say a word or two and they know. That's why I don't change staff as much any more.

SCHILLING: Another difference between you and Kurosawa is productivity. He made half the number of films you did.

ICHIKAWA: He spent a long time on preparation, so he'd make one film a year or every two years. I'm an inexpensive director so my shooting schedules are always short. (Laughs)

SCHILLING: Hollywood directors with extremely long careers, such as Howard Hawks and Allan Dwan, had to master certain survival skills. In Hollywood, talent alone was never enough, as the career of Orson Welles proved. Do you have anything that you would call survival skills?

ICHIKAWA: I don't pay a lot of attention to that—how to survive. I don't think about it. If you're bad, you're bad. That's your fate.

SCHILLING: No advice for young directors then?

ICHIKAWA: No, no advice. The film industry has changed tremendously. The movies they are making now are very different from the ones I made when I was young. I can't say whether people in the industry are happier or unhappier as a result. Everything has changed so much.

SCHILLING: Kurosawa always used to tell his assistant directors to write scripts, but he complained that none of them listened.

ICHIKAWA: Well, people who can write are writing. When Kuro-san [Kurosawa] and I were assistant directors we would try hard to write scripts and sell them to the studio. We wanted them to make us directors as quickly as possible. Now there are no studios to speak of. There are still any number of assistant directors, but when Kuro-san and I were at Toho, they had fifty assistant directors running around. You had to fight to be picked from that group. So you worked hard at writing scripts. Kuro-san was the best of that lot. He wrote some wonderful scripts, so naturally he became a director. The studio only noticed the ones who could write scripts. They didn't say, "Let's give him a shot because he's tall and handsome." They said, "If he can write this script, he can probably make a good movie of it if we let him direct it." So we had something to aim for. Now there are hardly any studios worthy of the name. Everyone's a freelancer, so the situation is totally different.

SCHILLING: Do any young directors strike you as particularly promising?

ICHIKAWA: I spoke recently with Shunji Iwai. He's a wonderful talent.

SCHILLING: The cherry blossom scene in his *April Story* (*Shigatsu monogatari*, 1998) reminds me of the opening scene of your *Makioka Sisters*. Perhaps there's an influence there.

ICHIKAWA: I'm sure he made it in his own way. (Laughs)

SCHILLING: As you know, a series of your films is going on tour in North America and Europe. Is there one film that you especially want foreign audiences to see?

ICHIKAWA: I can't say. When I make a film, I never think about taking it to a foreign film festival or have foreigners watch it. When I make a film, it's for me. Of course, because I'm a Japanese I naturally want to screen it in Japan, but I never think that I want to show it in America or France, or Africa.

SCHILLING: No interest in the foreign market then?

ICHIKAWA: Not really. But films—I know I'm not saying anything original here—are a world language. That's what they should be, anyway. People of whatever race wonder about what happiness is, what life is and wrestle with those questions in the films they make. Even so, I never think about having people in America or Europe watch this or that film of mine. My films may be difficult for them to understand because of differences in culture or language or customs, but that can't be helped.

SCHILLING: But the same kind of culture gap also exists in Japan, between generations. One example is the Shibuya girl,* a type that is totally different from the traditional image of the Japanese woman. Do you think young Japanese have really changed, or is it more a matter of style and attitude?

ICHIKAWA: They've changed quite a bit. But the way of making movies here has changed more than the Japanese themselves. The *zeitgeist* is different and movies have changed to reflect that. And of course they should change. The problem is whether they change in a good way or a bad way.

SCHILLING: But human beings don't change as much as films do.

ICHIKAWA: No they don't. Cinematic styles change. After the war there was Italian neorealism, then the French New Wave. Various new approaches came in. We were influenced by all of them. And it's true that the way we made movies changed as a result. What hasn't changed is the basic way we look at human beings. Mores and manners change, the cut of a suit changes, but the way we look at human beings doesn't change so much.

SCHILLING: Do you think, then, that you could make a film about Shibuya girls?

ICHIKAWA: That would be really tough. I think, though, that if I could decide on my point of view, if I had the interest I could do it. But as long as I can't settle on a point of view, it would very difficult to do. I can only make movies in my own way. Why push myself to do the impossible? (Laughs) Leaving aside the question of whether those girls and their culture are good or bad, I just

*A trend of the late 1990s, the "Shibuya girl" emerged as a phenomenon of Tokyo youth and club culture, especially in the Hachiko Crossing area of Shibuya; vacuous and fashionable, she usually has elaborate "tea" (brown) or blonde hair, a studio tan with racoon rings of white make-up around the eyes, and wears very short skirts and towering platform shoes (though, at the time of writing, backless mules threaten to replace the latter as a Shibuya girl signature). *Ed*.

don't have a lot of interest in the subject. The Shibuya girls are a kind of social phenomenon. I wonder if you can call them a culture.

SCHILLING: I've noticed the cut-out dolls from your recent animated film *Shinsengumi* (2000) that decorate the room. With that film, I get the sense that you're returning to the starting point of your career. Do you see it that way?

ICHIKAWA: No, not at all. That film is not a return to the starting point. It's just a coincidence that I made it when I did. I didn't particularly want to make an animated film. It's just something that I happened to develop. It's not a return to the past. Of course, it was nostalgic for me to make an animated film, but I didn't do it for that reason. I'm only interested in making films that excite me, that I can make in my own way. That's all.

SCHILLING: The genre doesn't matter?

ICHIKAWA: I've made various types of films: period dramas, modern dramas, films set in the Meiji period. But I don't make any distinctions between them—they're all films. True, with a period drama, there are certain conventions. With a modern drama, there is a different style of shooting. So you have to make changes according to the genre, but I never think, "This is a period drama, so I have to shoot it in such and such a way." Films are films. If you don't understand that, then you start filming lies.

SCHILLING: Thank you very much for your time.

ICHIKAWA: I'm sorry I couldn't have been of more help.

Translated from the Japanese by Mark Schilling

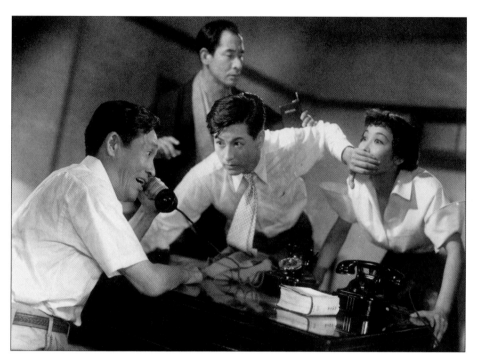
The Woman Who Touched Legs

Filmography

A Girl at Dojo Temple (*Musume Dojoji*)
1945 black and white 20 minutes
Production company: Toho Kyoiku Eiga
Screenplay: Keiji Hasebe
Cinematography: Jiro Kishi
Dolls: Puppe Kawasaki

A Flower Blooms (*Hana hiraku*)
1948 black and white 85 minutes
Production company: Shintoho
Original story: Yaeko Nogami
Screenplay: Tshio Yasumi
Cinematography: Joji Obara
Principal cast: Hideko Takamine, Ken Uehara, Susumu Fujita

365 Nights (*Sanbyaku-rokujugo ya*)
1948 black and white 119 minutes
Production company: Shintoho
Screenplay: Kennosuke Tateoka
Original story: Masajiro Kojima
Cinematography: Akira Mimura
Principal cast: Ken Uehara, Hisako Yamane, Hideko Takamine

Human Patterns (*Ningen moyo*)
Also known as **Design of a Human Being**
1949 black and white 89 minutes
Production company: Shintoho
Original story: Fumio Niwa
Screenplay: Yoshichi Yamashita, Natto Wada
Cinematography: Joji Obara
Principal cast: Ken Uehara, Toshiko Yamaguchi, Chiaki Tsukioka

Passion without End (*Hateshinaki jonetsu*)
Also known as **Endless Passion, The Passion without Limit**
1949 black and white 91 minutes
Production companies: Shintoho/Shinseiki Productions
Screenplay: Natto Wada
Cinematography: Joji Obara
Principal cast: Yuji Hori, Chiaki Tsukioka, Shizuko Kasagi

Sanshiro of Ginza (*Ginza sanshiro*)
Also known as **Sanshiro at Ginza, A Ginza Veteran**
1950 black and white 82 minutes
Production companies: Shintoho/Aoyagi Productions
Original story: Tsuneo Tomita
Screenplay: Naoyuki Hatta
Cinematography: Jun Yasumoto
Principal cast: Susumu Fujita, Takashi Shimura, Reikichi Kawamura

Heat and Mud (*Netsudeichi*)
Also known as **The Hot Marshland, Money and Three Bad Men**
1950 black and white 102 minutes
Production company: Shintoho
Original story: Soju Kimura
Screenplay: Kon Ichikawa, Ryoichi Itaya
Cinematography: Minoru Yokoyama
Principal cast: Susumu Fujita, Harue Tone, Yuji Hori

Pursuit at Dawn (*Akatsuki no tsuiseki*)
Also known as **Police and Small Gangsters**
1950 black and white 93 minutes
Production companies: Shintoho/Tanaka Productions
Original story: Jun Nakagawa
Screenplay: Kaneto Shindo
Cinematography: Minoru Yokoyama
Principal cast: Ryo Ikebe, Michitaro Mizushima, Yunosuke Ito

Nightshade Flower (*Ieraishan*)
1951 black and white 83 minutes
Production companies: Shintoho/Shoei Productions
Screenplay: Tateo Matsuura, Kon Ichikawa
Cinematography: Minoru Yokoyama
Principal cast: Ken Uehara, Asami Kuji, Harue Tone

The Sweetheart (*Koibito*)
Also known as **The Lover**
1951 black and white 70 minutes
Production companies: Shintoho/Shohei Productions
Original story: Haruo Umeda
Screenplay: Natto Wada, Kon Ichikawa
Cinematography: Minoru Yokoyama
Principal cast: Ryo Ikebe, Asami Kuji, Koreya Senda

The Man without a Nationality (*Mukokuseki sha*)
1951 black and white 85 minutes

Production companies: Toyoko Eiga/Shoei Production
Original story: Jun Takami
Screenplay: Toshio Yasumi
Cinematography: Minoru Yokoyama
Principal cast: Ken Uehara, Ichiro Sugai, Chikako Miyagi

Stolen Love (*Nusumareta koi*)
1951 black and white 89 minutes
Production companies: Shintoho/Aoyagi Productions
Original story: Jiro Kagami
Screenplay: Natto Wada, Kon Ichikawa
Cinematography: Minoru Yokoyama
Principal cast: Asami Kuji, Michiko Kato, Masayuki Mori

Bengawan Solo
1951 black and white 93 minutes
Production company: Shintoho
Original story: Shozo Kanegai
Screenplay: Natto Wada, Kon Ichikawa
Cinematography: Minoru Yokoyama
Principal cast: Ryo Ikebe, Asami Kuji, Hisaya Morishige

Wedding March (*Kekkon koshinkyoku*)
1951 black and white 83 minutes
Production company: Toho
Screenplay: Toshiro Ide, Natto Wada, Kon Ichikawa
Cinematography: Tadashi Iimura
Principal cast: Ken Uehara, Hisako Yamane, Yoko Sugi

Mr. Lucky (*Rakkii-san*)
1952 black and white 84 minutes
Production company: Toho
Original story: Keita Genji
Screenplay: Katsuhito Inomata
Cinematography: Tadashi Iimura
Principal cast: Keiju Kobayashi, Hiroshi Koizumi, Yukiko Shimazaki

Young People (*Wakai hito*)
Also known as **The Young Generation**
1952 black and white 114 minutes
Production company: Toho
Original story: Yojiro Ishizaka
Screenplay: Naoya Uchimura, Natto Wada, Kon Ichikawa
Cinematography: Kazuo Yamada
Principal cast: Ryo Ikebe, Asami Kuji, Yukiko Shimazaki

The Woman Who Touched Legs (*Ashi ni sawatta onna*)
1952 black and white 84 minutes
Production company: Toho
Original story: Bumatsu Sawada
Screenplay: Natto Wada, Kon Ichikawa
Cinematography: Jun Yasumoto
Principal cast: Fubuki Koshiji, Ryo Ikebe, So Yamamura

This Way, That Way (*Ano te kono te*)
1952 black and white 92 minutes
Production company: Daiei (Kyoto)
Original story: Nobuo Kyoto
Screenplay: Natto Wada, Kon Ichikawa
Cinematography: Senkichiro Takeda
Principal cast: Yoshiko Kuga, Masayuki Mori, Mitsuko Mito

Pu-san
Also known as **Mr. Pu, Mr. Poo**
1953 black and white 98 minutes
Production company: Toho
Original story: Taizo Yokoyama
Screenplay: Natto Wada
Cinematography: Asakazu Nakai
Principal cast: Yunosuke Ito, Fubuki Koshiji, Kaoru Yachigusa

The Blue Revolution (*Aoiro Kakumei*)
1953 black and white 107 minutes
Production company: Toho
Original story: Tatsuzo Ishikawa
Screenplay: Katsuhito Inomata
Cinematography: Masao Tamai
Principal cast: Koreya Senda, Sadako Sawamura, Yoichi Tachikawa

The Youth of Heiji Zenigata (*Seishun Zenigata Heiji*)
1953 black and white 94 minutes
Production company: Toho
Original story: Kodo Nomura
Screenplay: Natto Wada, Kon Ichikawa
Cinematography: Seiichi Endo
Principal cast: Tomoemon Otani, Yunosuke Ito, Yoko Sugi

The Lover (*Aijin*)
1953 black and white 87 minutes
Production company: Toho
Original story: Kaoru Morimoto
Screenplay: Natto Wada, Toshiro Ide
Cinematography: Masao Tamai
Principal cast: Ichiro Sugai, Fubuki Koshiji, Mariko Okada

All of Myself (*Watashi no subete o*)
Also known as **All about Me**
1954 black and white 85 minutes
Production company: Toho
Original story: Kazuo Kikuta
Screenplay: Haruo Umeda, Tatsuo Asano, Kon Ichikawa
Cinematography: Mitsuo Miura
Principal cast: Ryo Ikebe, Ineko Arima, Kinuko Ito

A Billionaire (*Okuman choja*)
1954 black and white 83 minutes
Production companies: Seinen Haiyu Club
Screenplay: Natto Wada
Cinematography: Takeo Ito
Principal cast: Isao Kimura, Yoshiko Kuga, Eiji Okada

Twelve Chapters about Women (*Josei ni kansuru junisho*)
Also known as **Twelve Chapters on Women**
1954 black and white 87 minutes
Production company: Toho
Original essays: Sei Ito
Screenplay: Natto Wada
Cinematography: Mitsuo Miura
Principal cast: Keiko Tsushima, Hiroshi Koizumi, Ken Uehara

Ghost Story of Youth (*Seishun kaidan*)
1955 black and white 114 minutes
Production company: Nikkatsu
Original story: Bunroku Shishi
Screenplay: Natto Wada
Cinematography: Shigeyoshi Mine
Principal cast: Mie Kitahara, So Yamamura, Tatsuya Mihashi

Kokoro
Also known as **The Heart**
1955 black and white 122 minutes
Production company: Nikkatsu
Original story: Soseki Natsume
Screenplay: Katsuhito Inomata, Keiji Hasebe
Cinematography: Takeo Ito, Kumenobu Fujioka
Principal cast: Masayuki Mori, Michiyo Aratama, Tatsuya Mihashi

Harp of Burma (*Biruma no tategoto*)
Also known as **The Burmese Harp**
1956 black and white 116 minutes
Original story: Michio Takeyama
Production company: Nikkatsu
Screenplay: Natto Wada
Cinematography: Minoru Yokoyama
Principal cast: Shoji Yasui, Rentaro Mikuni, Tanie Kitabayashi

Punishment Room (*Shokei no heya*)
1956 black and white 96 minutes
Production company: Daiei (Tokyo)
Original story: Shintaro Ishihara
Screenplay: Natto Wada, Keiji Hasebe
Cinematography: Yoshihisa Nakagawa
Principal cast: Hiroshi Kawaguchi, Ayako Wakao, Seiji Miyaguchi

Nihonbashi
Also known as **Nihombashi, Bridge of Japan**
1956 colour 111 minutes
Production company: Daiei (Kyoto)
Original story: Kyoka Izumi
Screenplay: Natto Wada
Cinematography: Kimio Watanabe
Principal cast: Chikage Awashima, Fujiko Yamamoto, Ayako Wakao

A Full-Up Train (*Man'in densha*)
Also known as **The Crowded Train, The Crowded Streetcar**
1957 black and white 99 minutes
Production company: Daiei (Tokyo)
Screenplay: Natto Wada, Kon Ichikawa
Cinematography: Hiroshi Murai
Principal cast: Hiroshi Kawaguchi, Chishu Ryu, Haruko Sugimura

The Men of Tohoku (*Tohoku no zummutachi*)
1957 black and white 59 minutes
Production company: Toho
Original story: Shichiro Fukazawa
Screenplay: Kurisutei (Ichikawa)
Cinematography: Kazuo Yamada
Principal cast: Hiroshi Akutagawa, Hajime Izu, Bokuzen Hidari

The Pit (*Ana*)
Also known as **Hole in One, The Hole**
1957 black and white 103 minutes
Production company: Daiei (Tokyo)
Screenplay: Kurisutei (Ichikawa)
Cinematography: Setsuo Kobayashi
Principal cast: Machiko Kyo, Eiji Funakoshi, So Yamamura

Enjo
Also known as **Conflagration**
1958 black and white 99 minutes
Production company: Daiei (Kyoto)
Original story: Yukio Mishima
Screenplay: Natto Wada, Keiji Hasebe
Cinematography: Kazuo Miyagawa
Principal cast: Raizo Ichikawa, Tatsuya Nakadai, Ganjiro Nakamura

Goodbye, Hello (*Sayonara, Konnichiwa*)
Also known as **Goodbye, Good Day**
1959 colour 87 minutes
Production company: Daiei (Tokyo)
Original story: Kurisutei (Ichikawa)
Screenplay: Kurisutei (Ichikawa), Kazuo Funabashi
Cinematography: Setsuo Kobayashi
Principal cast: Shin Saburi, Ayako Wakao, Machiko Kyo

Kagi
Also known as **Odd Obsession, The Key**
1959 colour 107 minutes
Production company: Daiei (Kyoto)
Original story: Junichiro Tanizaki
Screenplay: Natto Wada, Keiji Hasebe, Kon Ichikawa
Cinematography: Kazuo Miyagawa
Principal cast: Machiko Kyo, Tatsuya Nakadai, Ganjiro Nakamura

Fires on the Plain (*Nobi*)
1959 black and white 105 minutes
Production company: Daiei (Tokyo)
Original story: Shohei Ooka
Screenplay: Natto Wada
Cinematography: Setsuo Kobayashi
Principal cast: Eiji Funakoshi, Osamu Takizawa, Mickey Curtis

A Woman's Testament, Part Two: Women Who Sell Things at High Prices (*Jokyo II: Mono o takaku uritsukeru onna*)
Also known as **Code of Women**
1960 colour 102 minutes omnibus
Production company: Daiei (Tokyo)
Original story: Shofu Muramatsu
Screenplay: Toshio Yasumi
Cinematography: Setsuo Kobayashi
Principal cast: Fujiko Yamamoto, Eiji Funakoshi, Hitomi Nozoe

Bonchi
1960 colour 105 minutes
Production company: Daiei (Kyoto)
Original story: Toyoko Yamazaki
Screenplay: Natto Wada, Kon Ichikawa
Cinematography: Kazuo Miyagawa
Principal cast: Raizo Ichikawa, Ayako Wakao, Isuzu Yamada

Ototo
Also known as **Her Brother, Younger Brother**
1960 colour 98 minutes
Production company: Daiei (Tokyo)
Original story: Aya Koda
Screenplay: Yoko Mizuki
Cinematography: Kazuo Miyagawa
Principal cast: Keiko Kishi, Hiroshi Kawaguchi, Kinuyo Tanaka

Ten Dark Women (*Kuroi junin no onna*)
Also known as **Ten Black Women**
1961 black and white 103 minutes
Production company: Daiei (Tokyo)
Screenplay: Natto Wada
Cinematography: Setsuo Kobayashi
Principal cast: Eiji Funakoshi, Keiko Kishi, Fujiko Yamamoto

Hakai
Also known as **The Outcast, The Broken Commandment, The Sin**
1962 black and white 119 minutes
Production company: Daiei (Kyoto)
Original story: Toson Shimazaki
Screenplay: Natto Wada
Cinematography: Kazuo Miyagawa
Principal cast: Raizo Ichikawa, Hiroyuki Nagato, Rentaro Mikuni

I Am Two (*Watashi wa nisai*)
Also known as **Being Two Isn't Easy**
1962 colour 88 minutes
Production company: Daiei (Tokyo)
Original story: Michio Matsuda
Screenplay: Natto Wada
Cinematography: Setsuo Kobayashi
Principal cast: Hiroo Suzuki, Eiji Funakoshi, Fujiko Yamamoto

An Actor's Revenge (*Yukinojo henge*)
Also known as **The Revenge of Yukinojo**
1963 colour 114 minutes
Production company: Daiei (Kyoto)
Original story: Otokichi Mikami
Screenplay: Natto Wada
Cinematography: Setsuo Kobayashi
Principal cast: Kazuo Hasegawa, Fujiko Yamamoto, Ayako Wakao

Alone on the Pacific (*Taiheiyo hitoribotchi*)
Also known as **Alone Across the Pacific, My Enemy the Sea**
1963 colour 97 minutes
Production companies: Ishihara International Promotions/Nikkatsu
Original story: Kenichi Horie
Screenplay: Natto Wada
Cinematography: Yoshihiro Yamazaki
Principal cast: Yujiro Ishihara, Masayuki Mori, Kinuyo Tanaka

Money Talks (*Dokonjo monogatari*: *Zeni no odori*)
Also known as **The Money Dance**
1964 colour 90 minutes
Production company: Daiei (Tokyo)
Screenplay: Kurisutei (Ichikawa)
Cinematography: Kazuo Miyagawa
Principal cast: Shintaro Katsu, Chiemi Eri, Eiji Funakoshi

Tokyo Olympiad (*Tokyo Orimpikku*)
Also known as **Tokyo Olympics**
1965 colour 170 minutes documentary
Production company: Tokyo Olympic Film Association
Screenplay: Natto Wada, Yoshio Shirasaka, Shuntaro Tanikawa, Kon Ichikawa
Cinematography: Shigeo Hayashida and others

Topo Gigio and the Missile War (*Topo Jijo no botan senso*)
Also known as **Topo Gigio, La Guerra del Missile**
1967 colour 92 minutes
Production companies: Kingsmen Enterprises/Maria Perego Productions
Screenplay: Kon Ichikawa, Rokusuke Ei, Alberto Ongaro, Federico Caldura
Cinematography: Shigeichi Nagano
Puppeteer: Maria Perego
Principal cast: Meiko Nakamura (voice)

Youth (*Seishun*)
1968 colour 96 minutes documentary
Production companies: Asahi Shinbun/Ashai TV News
Screenplay: Masato Ide, Yoshiro Shirasaka, Kiyoshi Ito, Shuntaro Tanikawa
Cinematography: Eikichi Uematsu and others

Kyoto (*Kyo*)
1969 colour 38 minutes documentary
Production company: Olivetti
Screenplay: Shuntaro Tanikawa
Cinematograpy: Naoyuki Sumitani

Japan and the Japanese (*Nihon to Nihonjin*)
Also known as **Mt. Fuji, Fuji**
1970 colour 23 minutes documentary
Production company: Toho
Screenplay: Shuntaro Tanikawa
Cinematography: Rokuro Nishigaki and others

To Love Again (*Ai futatabi*)
Also known as **Pourquoi . . .**
1971 colour 96 minutes
Production company: Toho
Screenplay: Shuntaro Tanikawa
Cinematography: Kiyoshi Hasegawa
Principal cast: Renaud Verley, Ruriko Asoaka, Seiji Miyaguchi

The Wanderers (*Matatabi*)
1973 colour 96 minutes
Production companies: Kon Productions/ATG
Screenplay: Shuntaro Tanikawa, Kon Ichikawa
Cinematography: Setsuo Kobayashi
Principal cast: Kenichi Hagiwara, Ichiro Ogura, Isao Bito

Visions of Eight: The Fastest
1973 colour 111 minutes documentary omnibus
Production companies: David Wolper Productions
Screenplay: Shuntaro Tanikawa
Cinematography: Masuo Yamaguchi, Mike Davies

I Am a Cat (*Wagahai wa neko de aru*)
1975 colour 116 minutes
Production companies: Geiensha
Original story: Soseki Natsume
Screenplay: Toshio Yasumi
Cinematography: Kozo Okazaki
Principal cast: Tatsuya Nakadai, Yoko Shimada, Juzo Itami

Between Women and Wives (*Tsuma to onna no aida*)
Also known as **Between Wife and Woman**
1976 colour 111 minutes
Production company: Toho
Original story: Harumi Seotuchi
Co-director: Shiro Toyoda
Screenplay: Toshio Yasumi
Cinematography: Kiyoshi Hasegawa
Principal cast: Yoshiko Mita, Mayumi Ozora, Wakako Sakai

The Inugami Family (*Inugami-ke no ichizoku*)
Also known as **The Inugamis**
1976 colour 146 minutes
Production companies: Kadokawa Haruki Corporation
Original story: Seishi Yokomizo
Screenplay: Norio Osada, Shinya Hidaka, Kon Ichikawa
Cinematography: Kiyoshi Hasegawa
Principal cast: Koji Ishizaka, Mieko Takamine, Teruhiko Aoi

The Devil's Bouncing Ball Song (*Akuma no Temari-uta*)
Also known as **Rhyme of Vengeance**
1977 colour 144 minutes
Production company: Toho
Original story: Seishi Yokomizo
Screenplay: Kurisutei (Ichikawa)
Cinematography: Kiyoshi Hasegawa
Principal cast: Koji Ishizaka, Keiko Kishi, Tomisaburo Wakayama

Island of Horrors (*Gokumonto*)
Also known as **Hell's Gate Island, Island of Hell, The Devil's Island**
1977 colour 141 minutes
Production company: Toho
Original story: Seishi Yokomizo
Screenplay: Kurisutei (Ichikawa)
Cinematography: Kiyoshi Hasegawa
Principal cast: Koji Ishizaka, Reiko Ohara, Yoko Tsukasa

Queen Bee (*Joobachi*)
1978 colour 140 minutes
Production company: Toho
Original story: Seishi Yokomizo
Screenplay: Shinya Hidaka, Chiho Katsura, Kon Ichikawa
Cinematography: Kiyoshi Hasegawa
Principal cast: Koji Ishizaka, Kie Nakai, Tatsuya Nakadai

The Phoenix (*Hinotori*)
1978 colour 137 minutes
Production companies: Hintori
 Productions/Toho
Original story: Osamu Tezuka
Screenplay: Shuntaro Tanikawa
Cinematography: Kiyoshi Hasegawa
Principal cast: Tomisaburo Wakayama,
 Toshinori Omi, Mieko Takamine

The House of Hanging (*Byoinzaka no kubi kukuri no ie*)
1979 colour 139 minutes
Production company: Toho
Screenplay: Shinya Hidaka, Kurisutei
 (Ichikawa)
Original story: Seishi Yokomizo
Cinematography: Kiyoshi Hasegawa
Principal cast: Koji Ishizaka, Yoshiko
 Sakuma, Junko Sakurada

Ancient City (*Koto*)
Also known as **Koto the Ancient City**
1980 colour 125 minutes
Production company: Horikikaku
 Productions
Original story: Yasunari Kawabata
Screenplay: Shinya Hidaka, Kon Ichikawa
Cinematography: Kiyoshi Hasegawa
Principal cast: Momoe Yamaguchi, Keiko
 Kishi, Tomokazu Miura

Lonely Heart (*Kofuku*)
Also known as **Happiness**
1981 colour 106 minutes
Production companies: For Life
 Records/Toho
Original story: Ed McBain
Screenplay: Shinya Hidaka, Ikuko Oyabu,
 Kon Ichikawa
Cinematography: Kiyoshi Hasegawa
Principal cast: Yutaka Mizutani, Toshiyuki
 Nagashima, Rie Nakahara

The Makioka Sisters (*Sasameyuki*)
Also known as **Fine Snow**
1983 colour 140 minutes
Production company: Toho
Original story: Junichiro Tanizaki
Screenplay: Kon Ichikawa, Shinya Hidaka
Cinematography: Kiyoshi Hasegawa
Principal cast: Yoshiko Sakuma, Sayuri
 Yoshinaga, Keiko Kishi

Ohan
1984 colour 112 minutes
Production company: Toho
Screenplay: Kon Ichikawa, Shinya
 Hidaka
Cinematography: Yukio Isohata
Principal cast: Sayuri Yoshinaga, Koji
 Ishizaka, Reiko Ohara

Harp of Burma (*Biruma no tategoto*)
Also known as **The Burmese Harp**
1985 colour 133 minutes remake
Production company: Fuji Television
 Network, Hakuhodo, Kinema Tokyo
Original story: Michio Takeyama
Screenplay: Natto Wada
Cinematography: Setsuo Kobayashi
Principal cast: Kiichi Nakai, Koji Ishizaka,
 Tanie Kitabayashi

Rokumeikan
Also known as **The Hall of the Crying
 Deer, High Society of Meiji**
1986 colour 125 minutes
Production company: Marugen-Film
Original story: Yukio Mishima
Screenplay: Kon Ichikawa, Shinya Hidaka
Cinematography: Setsuo Kobayashi
Principal cast: Bunta Sugawara, Ruriko
 Asaoka, Koji Ishizaka

Actress (*Eiga joyu*)
Also known as **Film Actress**
1987 colour 131 minutes
Production company: Toho
Screenplay: Kaneto Shindo, Shinya Hidaka,
 Kon Ichikawa
Cinematography: Yukio Isohata
Principal cast: Sayuri Yoshinaga, Bunta
 Sugawara, Mitsuko Mori

Princess from the Moon (*Taketori monogatari*)
Also known as **Kaguya**
1987 colour 121 minutes
Production companies: Toho/Fuji Television Network
Screenplay: Ryuzo Kikushima, Mitsutoshi Ishigami, Shinya Hidaka, Kon Ichikawa
Cinematography: Setsuo Kobayashi
Principal cast: Yasuko Sawaguchi, Toshiro Mifune, Ayako Wakao

Crane (*Tsuru*)
1988 colour 93 minutes
Production company: Toho
Screenplay: Natto Wada, Kon Ichikawa, Shinya Hidaka
Cinematography: Yukio Isohata
Principal cast: Sayuri Yoshinaga, Hideki Noda, Kirin Kiki

Noh Mask Murders (*Tenkawa densetsu satsujin jiken*)
1991 colour 109 minutes
Production company: "Noh Mask Murders" Production Committee
Original story: Yasuo Uchida
Screenplay: Kurisutei (Ichikawa), Shinya Hidaka, Shinichi Kabuki
Cinematography: Yukio Isohata
Principal cast: Takaaki Enoki, Keiko Kishi, Naomi Zaizen

47 Ronin (*Shijushichinin no shikaku*)
1994 colour 129 minutes
Production companies: Toho/Nippon Television Network/Suntory
Original story: Shoichiro Ikemiya
Screenplay: Kaneo Ikegami, Hiroshi Takeyama, Kon Ichikawa
Cinematography: Yukio Isohata
Principal cast: Ken Takakura, Kiichi Nakai, Rie Miyazawa

The 8-Tomb Village (*Yatsuhaka-mura*)
1996 colour 127 minutes
Production companies: Fuji Television Network/Kadokawa Shoten Publishing/Toho
Original story: Seishi Yokomizo
Screenplay: Ikuko Oyabu, Kon Ichikawa
Cinematography: Yukio Isohata
Principal cast: Etsushi Toyokawa, Yuko Asano, Kazuya Takahashi

Shinsengumi
2000 colour 86 minutes
Production company: Fuji Television Network
Original story: Hiroshi Kurogane
Screenplay: Mamoru Sasaki, Kon Ichikawa
Cinematography: Yukio Isohata
Principal cast: Atsuo Nakamura (voice), Kiichi Nakai (voice), Koji Ishizaka (voice)

Dora-Heita
2000 colour 111 minutes
Production company: "Dora-Heita" Production Committee
Original story: Shugoro Yamamoto
Screenplay: Akira Kurosawa, Keisuke Kinoshita, Kon Ichikawa, Masaki Kobayashi
Cinematography: Yukio Isohata
Principal cast: Koji Yakusho, Yuko Asano, Bunta Sugawara

Kah-chan
2001 (in production) colour
Production companies: Eizo Kyoto, Nikkatsu Imagica, Shinano Kikaku
Original story: Shugoro Yamamoto
Screenplay: Natto Wada, Hiroshi Takeyama
Cinematography: Yukio Isohata
Principal cast: Keiko Kishi, Ryuji Harada, Shoichi Ozawa

Selected Bibliography

Compiled by Robin MacDonald

Allyn, John. *Kon Ichikawa: a guide to references and resources.* Boston: G.K. Hall, 1985.

Breakwell, Ian. *An Actor's Revenge.* London: British Film Institute, 1995.

Buehrer, Beverley Bare. *Japanese Films: A Filmography and Commentary, 1921–1989.* Jefferson, N.C.; London: McFarland, 1990.

Burch, Noël. "Film and 'Democracy'." In *To the Distant Observer: Form and Meaning in the Japanese Cinema,* revised and edited by Annette Michelson, 271–90. Berkeley; Los Angeles: University of California Press, 1979.

Champenier, George, Régis Lamiable and François Touze. "*Feux dans la Plaine* (Fires on the Plain)." *Image et son,* no. 214 (1968): 121–32.

Corman, Cid. "*Tokyo Olympiad.*" *Film Comment* 3, no. 3 (summer 1965): 38–40.

Demeure, Jacques. "*Tokio* [sic] *Olympiades*: un nouveau reportage." *Jeune Cinéma,* no. 21 (March 1967): 97–102.

Dewey, Langdon. "Kon Ichikawa." In *50 Major Film-makers,* edited by Peter Cowie, 116–21. South Brunswick, N.J.; New York: A.S. Barnes, 1975.

———. "Kon Ichikawa." In *International Film Guide 1970,* edited by Peter Cowie, 23–30. London: Tantivy, 1969.

Erens, Patricia. "Ichikawa, Kon." In *International Dictionary of Films and Filmmakers,* 3rd ed. Vol. 2, *Directors,* edited by Laurie Collier Hillstrom, 465–67. Detroit: St. James Press, 1997.

Fieschi, Jean-André, Claude Ollier, and Yamada Koichi. "Ichikawa Kon: *Tokyo Olympiades.*" *Cahiers du cinéma,* no. 168 (July 1965): 60–61.

Franklin, A. Frederic. "Kon Ichikawa: An Olympic Cinema." *International Press Bulletin* 1, no. 4 (1965): 46–49.

Galbraith, Stuart. *The Japanese Filmography: A Complete Reference to 209 Filmmakers and the Over 1250 Films Released in the United States, 1900 through 1994.* Jefferson, N.C.; London: McFarland, 1996.

Gillett, John. "772 Kon Ichikawa." *Film Dope,* no. 26 (January 1983): 29–31.

———. "Kon Ichikawa." In *Cinema: A Critical Dictionary. The Major Film-makers*. Vol. 1, edited by Richard Roud, 517–20. New York: Viking, 1980.

Gow, Gordon. "Bloody Movies." *Films and Filming* 20, no. 10 (July 1974): 52–55.

Ichikawa, Kon. *Kon: All Film Works of Kon Ichikawa*. Edited by Yoko Oba. [Kyoto]: Korinsha, 1998.

Ichikawa, Kon and Yuki Mori. *Ichikawa Kon no eigatachi* (The Films of Kon Ichikawa). Tokyo: Waizu Shuppan, 1994.

Kantoku Ichikawa Kon (Director Kon Ichikawa). Bessatsu taiyo. Tokyo: Heibonsha, 2000.

"Kon Ichikawa at the Olympic Games: Director From Japan." *American Cinematographer* 53, no. 11 (November 1972): 1265, 1318.

Manchel, Frank. *Film Study: An Analytical Bibliography*. Vol. 3. London; Toronto: Associated University Presses, 1990.

Masters, Patricia Lee. "Warring Bodies: Most Nationalistic Selves." *East-West Film Journal* 7, no. 1 (January 1993): 137–48.

McDonald, Keiko I. "Character Types and Psychological Revelations in Ichikawa's *The Harp of Burma*." In *Cinema East: A Critical Study of Major Japanese Films*, 88–100. East Brunswick, N.J.: Associated University Presses, 1983.

———. "Kabuki Stage and *An Actor's Revenge*." In *Japanese Classical Theater in Films*, 145–57. London; Toronto: Associated University Presses, 1994.

———. "Symbolism of *Odd Obsession* by Ichikawa." *Literature/Film Quarterly* 7, no. 1 (1979): 60–66.

Mellen, Joan. "The Anti-war Film in Japan." In *The Waves at Genji's Door: Japan Through Its Cinema*, 167–200. New York: Pantheon, 1976.

———. "Kon Ichikawa." In *Voices From the Japanese Cinema*, 113–30. New York: Liveright, 1975.

Milne, Tom. "Inside and outside." *Sight and Sound* 34, no. 1 (winter 1964–65): 9–11.

Monaco, James. "Ichikawa, Kon." In *The Encyclopedia of Film*, 272. New York: Perigee, 1991.

Nornes, Markus. "Context and *The Makioka Sisters*." *East-West Film Journal* 5, no. 2 (July 1991): 46–68.

Privett, Ray. "Bodies In Motion. The Olympics On Film: An Historical Perspective." *International Documentary* 19, no. 6 (July/August 2000): 25–26, 38.

Rhode, Eric. *A History of the Cinema: From Its Origins to 1970*. London: Allen Lane, 1976.

Richie, Donald. "Japan: the younger talents." *Sight and Sound* 29, no. 2 (spring 1960): 78–81.

———. *Japanese Cinema: Film Style and National Character*. Garden City, N.Y.: Doubleday, 1971. Originally published as *Japanese Movies*. Tokyo: Japan Travel Bureau, 1961.

———. *The Japanese Movie: An Illustrated History*. Tokyo: Kodansha International, 1966.

Sadoul, George. *Dictionary of Film Makers*. Translated, edited and updated by Peter Morris. Berkeley; Los Angeles: University of California Press, 1972.

Sato, Tadao. *Le cinéma japonais*. Translated by Karine Chesneau, Rose-Marie Makino-Fayolle and Chiharu Tanaka. 2 vols. Paris: Centre Georges Pompidou, 1972. Originally published as Nihon eiga shi, 4 vols. Tokyo: Iwanami Shoten, 1995.

Shipman, David. "The Japanese Masters." In *The Story of Cinema: A Complete Narrative History From the Beginnings to the Present*, 960–93. New York: St. Martin's, 1982.

Shira, Toshio. "Four Musketeers Speak." *Film World* 6, no. 2 (April 1970): 15.

Solmi, Angelo. *Kon Ichikawa*. Il Castoro Cinema, no. 17. Florence, Italy: La Nuova Italia, 1975.

Stein, Elliott. "Off-Screen: Konography." *Village Voice*, 2 August 1988, 64.

Svensson, Arne. *Japan*. Screen Series, ed. Peter Cowie. London: A. Zwemmer; New York: A.S. Barnes, 1971.

Tessier, Max. "Hommages: Kon Ichikawa." In *15th Festival International du film de La Rochelle*, 25–29. [Paris]: Festival International du film de La Rochelle, 1987.

Thomson, David. "Kon Ichikawa." In *A Biographical Dictionary of Film*, rev. and enl. ed., 363–64. London: André Deutsch, 1994.

Tucker, Richard N. "Kurosawa and Ichikawa: feudalist and individualist." In *Japan: Film Image*, 74–95. London: Studio Vista, 1973.

Vaughan, Dai. "Berlin versus Tokyo." In *For Documentary: Twelve Essays*, 90–110. Berkeley; Los Angeles: University of California Press, 1999. Originally published in *Sight and Sound* 46, no. 4 (autumn 1977): 210–15.

Wakeman, John, ed. "Ichikawa, Kon." In *World Film Directors*. Vol. 2, *1945–1985*, 442–51. New York: H. W. Wilson, 1988.

Williams, David. "*An Actor's Revenge*." *Screen* 11, no. 2 (March/April 1970): 3–15.

Yamada, Koichi. "Notes sur Ichikawa Kon." *Cahiers du cinéma*, no. 187 (February 1967): 10–11.

Text and Illustration Sources

Text Sources

Bock, Audie. "Kon Ichikawa" from *Japanese Film Directors*, copyright © 1978 Kodansha International Ltd. Reprinted by permission of the author.

Cazdyn, Eric. "The Ends of Adaptation: Kon Ichikawa and the Politics of Cinematization," copyright © 2001 Eric Cazdyn.

Cazdyn, Eric et al., "*Tokyo Olympiad*: A Symposium," copyright © 2001 Cinematheque Ontario.

Desser, David. "Space and Narrative in *The Makioka Sisters*," copyright © 2001 David Desser.

Ehrlich, Linda C. "Playing with Form: Ichikawa's *An Actor's Revenge* and the 'Creative Print,'" from *Cinematic Landscapes: Observations on the Visual Arts and Cinema of China and Japan*, eds. Linda C. Ehrlich and David Desser, copyright © 1994 University of Texas Press. Reprinted by permission of the University of Texas Press.

Geist, Kathe. "Adapting *The Makioka Sisters*," from *Word and Image in Japan*, eds. Dennis Washburn and Carole Cavanaugh, copyright © 2001 Cambridge University Press. Reprinted by permission of Cambridge University Press.

Gerow, Aaron. "The Industrial Ichikawa: Kon Ichikawa after 1976," copyright © 2001 Aaron Gerow.

Hauser, William B. "*Fires on the Plain*: The Human Cost of the Pacific War," abridged from *Reframing Japanese Cinema: Authorship, Genre, History*, eds. Arthur Nolletti Jr. and David Desser, copyright © 1992 Indiana University Press. Reprinted by permission of Indiana University Press.

Ichikawa, Kon. "Blown by the Wind," "Between Literature and Cinema," "The Summer of 1945," "A Record of *Ototo*," "The Reality of 1961," and "CinemaScope and Me," from *Seijocho 271 banchi*, copyright © 1962 Kon Ichikawa and Natto Wada, published by Shirakaba Shobo, Tokyo. Reprinted by permission of the author. English translations copyright © 2001 T. Goossen Education Services.

Ichikawa, Kon and Yuki Mori. "Name," "Beginnings," "*Ototo*," and "*The Inugami Family*" from *Ichikawa Kon no eigatachi* (The Films of Kon Ichikawa), copyright © 1994 Kon Ichikawa, Yuki Mori. Reprinted by permission of Kon Ichikawa, Yuki Mori, and Waizu Shuppan, Tokyo. English translation copyright © 2001 Daisuke Miyao.

Ichikawa, Kon et al., "The Uniqueness of Kon Ichikawa: A Symposium," *Cinema* 6, no. 2, copyright © 1970 Spectator International, Inc. Originally published in *Chuo Kuron*, May 1963. Reprinted by permission of Leonard Schrader.

Johnson, William. "Ichikawa and the Wanderers," *Film Comment*, September/October 1975, copyright © 1975 by the Film Society of Lincoln Center. All rights reserved. Reprinted by permission of the Film Society of Lincoln Center.

Kael, Pauline. "*Fires on the Plain* (*Nobi*)," "*Kagi*," "*The Makioka Sisters:* Golden Kimonos" from *For Keeps*, copyright © 1994 Pauline Kael. Published by Dutton. Reprinted by permission of the author.

Kliewer, Brent. "Escaping Japan: The Quest in Kon Ichikawa's *Alone on the Pacific*," copyright © 2001 Brent Kliewer.

Masumura, Yasuzo. "Kon Ichikawa's Method," from *Koza Nihon eiga*, vol. 5. Reprinted by permission of Iwanami Shoten, Publishers. English translation copyright © 2001 Michael Raine.

McDonald, Keiko I. "The Modern Outcast State: Ichikawa's *Hakai*," an abridged version of "The Modern Outcast State: Ichikawa's *The Broken Commandment*," from *From Book to Screen: Modern Japanese Literature in Film*, copyright © 2000 M.E. Sharpe, Inc. Reprinted by permission of M.E. Sharpe, Inc.

McDonald, Keiko I. "Viewer's View of *Kagi*," an abridged version of "Viewer's View of *Odd Obsession*" from *Cinema East: A Critical Study of Major Japanese Films*, copyright © 1983 Associated University Presses, Inc. Reprinted by permission of Associated University Presses.

Mellen, Joan. "Interview with Kon Ichikawa" from *Voices from the Japanese Cinema*, copyright © 1975 Joan Mellen. Reprinted by permission of Liveright Publishing Corporation.

Milne, Tom. "The Skull Beneath the Skin," *Sight and Sound* 35, no. 4 (autumn 1966), copyright © 1966 The British Film Institute. Reprinted by permission of Sight and Sound.

Mishima, Yukio. "Kon Ichikawa," preface from *Seijocho 271 banchi*, copyright © The Heirs of Yukio Mishima, published by Shirakaba Shobo, Tokyo. Reprinted by permission of The Sakai Agency, Inc. English translation copyright © 2001 Cody Poulton.

Nygren, Scott. "Inscribing the Subject: The Melodramatization of Gender in *An Actor's Revenge*," from *Melodrama and Asian Cinema*, ed. Wimal Dissanayake, copyright © 1993 Cambridge University Press. Reprinted by permission of Cambridge University Press.

Raine, Michael. "Contemporary Japan as Punishment Room in Kon Ichikawa's *Shokei no heya*," copyright © Michael Raine 2001.

Richie, Donald. "The Several Sides of Kon Ichikawa," *Sight and Sound* 35, no. 2 (spring 1966), copyright © 1966 The British Film Institute. Reprinted by permission of Sight and Sound.

Richie, Donald. "*Ten Dark Women*," copyright © 2001 Donald Richie.

Russell, Catherine. "*Being Two Isn't Easy*: The Uneasiness of the Family in 1960s Tokyo," copyright © 2001 Catherine Russell.

Sato, Tadao. "Kon Ichikawa" from *"Nihon eiga no kyoshotachi II"* (Great Masters in Japanese Films II), copyright © 1996 Tadao Sato, published by Gakuyo Shobo. Reprinted by permission of the author. English translation copyright © 2001 Anne McKnight.

Schilling, Mark. "Kon Ichikawa at Eighty-six: A 'Mid-Career' Interview," copyright © 2001 Mark Schilling.

Tessier, Max. "Kon Ichikawa: Black Humour as Therapy," copyright © Max Tessier 2001. Adapted from "Kon Ichikawa, un thérapeute de l'humeur noir," from *Images du cinéma japonais*, Éditions Henri Veyrier, 1990 and "Kon Ichikawa l'entomologiste," *Jeune Cinéma*, no. 21 (March 1967). English translation copyright © 2001 Kinograph.

Tessier, Max. "Nostalgia: An Interview with Kon Ichikawa," copyright © Max Tessier 2001. English translation copyright © 2001 Lara Fitzgerald.

Wada, Natto. "The 'Sun Tribe' and Their Parents" from *Seijocho 271 banchi*, copyright © 1962 Kon Ichikawa, Natto Wada, published by Shirakaba Shobo, Tokyo. Reprinted by permission of Kon Ichikawa. English translation copyright © 2001 T. Goossen Education Services.

Washburn, Dennis. "A Story of Cruel Youth: Kon Ichikawa's *Enjo* and the Art of Adapting in 1950s Japan," copyright © 2001 Dennis Washburn.

Illustration Sources

Stills courtesy of Kon Ichikawa; The Japan Foundation, Toronto; Daiei Co., Ltd., Tokyo; Toho Co., Ltd., Tokyo; Nikkatsu Corporation, Tokyo; Kawakita Memorial Film Institute, Tokyo; Kadokawa Shoten Publishing Co., Ltd., Tokyo; The Film Reference Library, Toronto; Museum of Modern Art, New York; The British Film Institute, London; and The National Archives (342-FH-3A-3888-A-58452), Maryland.

Actress © 1987 Toho Co., Ltd. All Rights Reserved; *The Makioka Sisters* © 1983 Toho Co., Ltd. All Rights Reserved; *The Woman Who Touched Legs* © 1952 Toho Co., Ltd. All Rights Reserved; *Pu-san* © 1953 Toho Co., Ltd. All Rights Reserved; *I Am a Cat* © 1975 Geiensha Co., Ltd. All Rights Reserved. *The Wanderers* © 1973 Art Theatre Guild of Japan Co., Ltd./Katsudoya. All Rights Reserved.

Clay Image (Haniwa), *Mountaineer*, *Song of Water A*, courtesy of the Cincinnati Art Museum, The Howard and Caroline Porter Collection; *Saga* courtesy of the Cincinnati Art Museum, The Howard and Caroline Porter Collection, lent by Mrs. Howard D. Porter, *Stone Cutter and His Apprentice* courtesy of the Cincinnati Art Museum, lent by Mrs. Howard D. Porter; *Sky Course* courtesy of Shegeki Kuroda.